ART AND ARCHITECTURE
OF THE MIDDLE AGES

ART AND ARCHITECTURE OF THE MIDDLE AGES

Exploring a Connected World

JILL CASKEY, ADAM S. COHEN, LINDA SAFRAN

GENEVRA KORNBLUTH, PHOTO EDITOR

CORNELL UNIVERSITY PRESS

ITHACA AND LONDON

Cover images (*left to right*): details from figs. I-6, 6-28, 8-17, 10-9
(top row); 1-33, 5-32, 3-6, 6-37 (second row); 3-33, 8-38, 9-4, 8-5 (third row);
10-24b (lower edge). See figure captions for copyright and identifying
information.

First published 2022 by Cornell University Press

Design by Julie Allred, BW&A Books, Inc.
Printed in South Korea

Library of Congress Cataloging-in-Publication Data

Names: Caskey, Jill, 1964– author. | Cohen, Adam S., author. |
 Safran, Linda, author.
Title: Art and architecture of the middle ages : exploring a connected
 world / Jill Caskey, Adam S. Cohen, Linda Safran.
Description: Ithaca [New York] : Cornell University Press, 2022. |
 Includes index.
Identifiers: LCCN 2021052225 | ISBN 9781501766107 (hardcover) |
 ISBN 9781501702822 (paperback)
Subjects: LCSH: Art, Medieval. | Art, Medieval—Themes, motives. |
 Architecture, Medieval. | Art and society.
Classification: LCC N5975 .C37 2022 | DDC 709.02—dc23/eng/20211028
LC record available at https://lccn.loc.gov/2021052225

To our families,
including those who arrived
and those who departed
while we were writing this book

CONTENTS

List of Figures, *viii*
List of Maps, *xviii*
Preface, *xix*
Note on Usage, *xx*

INTRODUCTION: FROM SANTIAGO TO
SAMARKAND, LINCOLN TO LALIBELA, 2
Box I-1. Time and Dates, *7*
Box I-2. How to Read Architectural Drawings, *12*
Box I-3. What's in a Name? *17*

1. THE ROOTS OF MEDIEVAL ART, 24
 Work in Focus: The Dura-Europos Synagogue, *35*
 Box 1-1. Judaism, *36*
 Box 1-2. Christianity, *40*
 Work in Focus: Lepcis Magna, *45*
 Box 1-3. Zoroastrianism, *47*

2. FOURTH AND FIFTH CENTURIES, 50
 Work in Focus: The Church of St. Peter, *53*
 Box 2-1. Early Ecumenical Councils and the
 Establishment of Church Doctrine, *57*
 Box 2-2. Scriptural Canons, *68*
 Box 2-3. Early Monasteries, *69*
 Work in Focus: Qal'at Sem'an, *72*

3. SIXTH TO MID-SEVENTH CENTURY, 76
 Work in Focus: Sutton Hoo, *87*
 Work in Focus: The Church at Mren, *95*
 Box 3-1. Islam, *101*

4. MID-SEVENTH TO LATE EIGHTH CENTURY, 104
 Work in Focus: The Dome of the Rock, *106*
 Box 4-1. Aniconism and Iconoclasm, *109*
 Work in Focus: The Lindisfarne Gospels, *122*

5. LATE EIGHTH CENTURY TO CA. 960, 126
 Box 5-1. Bronzes at Aachen, *132*
 Work in Focus: The Oseberg Ship, *140*
 Work in Focus: The Samanid Mausoleum, *146*
 Box 5-2. Lusterware, *152*

6. CA. 960 TO CA. 1070, 154
 Work in Focus: The Great Mosque of Córdoba, *156*
 Box 6-1. Trade across the Indian Ocean, *165*
 Box 6-2. Medieval Number Symbolism, *179*
 Work in Focus: Hosios Loukas, *182*

7. CA. 1070 TO CA. 1170, 186
 Box 7-1. "Romanesque," *189*
 Work in Focus: The Melisende Psalter, *195*
 Box 7-2. Craft Manuals and Market Regulations, *201*
 Work in Focus: The Abbey of Saint-Denis, *221*

8. CA. 1170 TO CA. 1250, 226
 Work in Focus: Canterbury Cathedral, *229*
 Box 8-1. Visuality, Optics, and Naturalism, *235*
 Box 8-2. "Gothic," *257*
 Work in Focus: The Hermitage of St. Neophytos, *257*

9. CA. 1250 TO CA. 1340, 260
 Work in Focus: The Compendium of Chronicles, *262*
 Box 9-1. Trans-Saharan Trade, *290*
 Work in Focus: The Birds Head Haggadah, *297*

10. CA. 1340 TO CA. 1450, 300
 Work in Focus: The Convent at Wienhausen, *303*
 Box 10-1. Mysticism among Jews, Christians, and
 Muslims, *313*
 Work in Focus: The Alhambra, *332*

11. AFTERLIVES OF THE MIDDLE AGES, 338

Glossary, *359*
Index, *367*

LIST OF FIGURES

Introduction

Fig. I-1a. Cross of Herimann and Ida, back, second quarter of eleventh century. Kolumba Museum, Cologne. *4*

Fig. I-1b. Cross of Herimann and Ida, front, second quarter of eleventh century. Kolumba Museum, Cologne. *4*

Fig. I-2. Lapis lazuli head, early first century, reused on Cross of Herimann and Ida, second quarter of eleventh century. Kolumba Museum, Cologne. *5*

Fig. I-3. Cartoon. Zozo, after *Calgary Herald*, Calgary, Alberta, Canada, March 23, 1991, comics p. 7. *6*

Fig. I-4. Tombstone of Katerina Ilioni, 1340, rubbing. Yangzhou Museum. *8*

Fig. I-5. Chungul Kurgan finds, ca. 1200, (*left*) pharmaceutical jar, Syria; (*center*) lidded drinking cup, northern Germany; (*right*) Byzantine silver cup. Muzei istorychnykh koshtovnostei Ukrainy, Kyiv. *9*

Fig. I-6. Reliquary of St. John the Precursor, fourteenth century. Mother See of Holy Etchmiadzin, Vagharshapat. *10*

Fig. I-7. Colophon, Hebrew Bible commentaries, 1232/33. Munich, Bayerische Staatsbibliothek, Cod. hebr. 5, vol. 2, fol. 252v. *10*

Fig. I-8a. Friday mosque, Tinmal, 1153, exterior from the west. *11*

Fig. I-8b. Friday mosque, Tinmal, 1153, interior toward mihrab. *11*

Fig. I-9. Friday mosque, Tinmal, 1153, architectural drawings. *11*

Fig. I-10. Cathedral, Lincoln, begun 1072. *13*

Fig. I-11. Utensils, (*top*) copper spoon, fourth–fifth century; (*bottom*) silver spoon, Lambousa Hoard, seventh century. (*t*) Art Museum University of Toronto, Malcove Collection; (*b*) British Museum, London. *14*

Fig. I-12. Lambousa Hoard, seventh century. British Museum, London. *14*

Fig. I-13. Capital, cathedral, Santiago de Compostela, late eleventh century. *16*

Fig. I-14a. House of Mary, Lalibela, ca. thirteenth century. *18*

Fig. I-14b. Funerary monument, detail, Aksum, fourth century. *18*

Fig. I-15. Lalibela, ca. thirteenth century, architectural drawings. *19*

Fig. I-16. Model of the Temple in Jerusalem before 70 CE. Israel Museum, Jerusalem. *19*

Fig. I-17. Ark of Melchizedek, Lalibela, late twelfth–first third of thirteenth century. *20*

Fig. I-18. Scene from Exodus, Hebrew Bible commentaries, 1232/33. Munich, Bayerische Staatsbibliothek, Cod. hebr. 5, vol. 1, fol. 47v. *21*

Fig. I-19. Ivory of Romanos II and Eudokia, ca. 945. Bibliothèque nationale de France, Cabinet des médailles, Paris. *21*

Fig. I-20. Freyr figurine, ninth–eleventh centuries. Historiska museet, Stockholm. *23*

Chapter 1

Fig. 1-1. Asklepeion, Corinth, fourth century BCE, plan. *26*

Fig. 1-2. Asklepeion votives, Corinth, sixth–fourth centuries BCE. Archaiologiko Mouseio Archaias Korinthou. *26*

Fig. 1-3. Tetradrachm of Alexander "the Great," ca. 320 BCE. Harvard Art Museums/Arthur M. Sackler Museum, Cambridge, MA. *27*

Fig. 1-4a. Persepolis, palace complex, ca. 520–486 BCE, site plan. *28*

Fig. 1-4b. Persepolis, palace complex, ca. 520–486 BCE, Palace of Darius in the 1930s. *28*

Fig. 1-5. Tapestry fragment, third–second century BCE. Xinjiang Regional Museum, Ürümqi. *29*

Fig. 1-6. Augustus Cameo, first century. Domschatzkammer, Aachen. *30*

Fig. 1-7. Ara Pacis, Rome, 13–9 BCE. Museo dell'Ara Pacis, Rome. *30*

Fig. 1-8. Ara Pacis, Rome, detail of female personification and flowering plants, 13–9 BCE. Museo dell'Ara Pacis, Rome. *30*

Fig. 1-9a. Tropaeum Traiani, Adamclisi, 109, reconstruction. *32*

Fig. 1-9b. Metope from the Tropaeum Traiani, Adamclisi, 109. Muzeul Tropaeum Traiani, Adamclisi. *32*

Fig. 1-10. Hadrian's Wall, England, ca. 125. *33*

Fig. 1-11. Battersea Shield, ca. 350–50 BCE. British Museum, London. *33*

Fig. 1-12. Snettisham Great Torc, 150–50 BCE. British Museum, London. *34*

Fig. 1-13. City plan with reconstructions of selected houses, Dura-Europos, before 256. *34*

Fig. 1-14. Mithraeum, Dura-Europos, ca. 240. Yale University Art Gallery, New Haven. *35*

Fig. 1-15. Tauroctony relief, Dura-Europos Mithraeum, ca. 170. Yale University Art Gallery, New Haven. *35*

Fig. 1-16. Synagogue assembly room, Dura-Europos, ca. 244, view toward the southwest. al-Mathaf al-watani, Damascus. *37*

Fig. 1-17. Torah niche in the west wall, Dura-Europos synagogue, ca. 244. al-Mathaf al-watani, Damascus. *37*

Fig. 1-18. Exodus scenes on west wall, Dura-Europos synagogue, ca. 244. al-Mathaf al-watani, Damascus, and ANU – Museum of the Jewish People, Tel Aviv. *38*

Fig. 1-19. Ezekiel scenes on the north wall, Dura-Europos synagogue, ca. 244. Copy at ANU – Museum of the Jewish People, Tel Aviv. *38*

Fig. 1-20a. Baptistery, Dura-Europos, ca. 230, view toward the northwest, former reconstruction. Yale University Art Gallery, New Haven. *39*

Fig. 1-20b. Baptistery, Dura-Europos, painting above the font, ca. 230. Yale University Art Gallery, New Haven. *39*

Fig. 1-21. Crucifixion amulet, second–third century. British Museum, London. *41*

Fig. 1-22. Painted panels with Isis and Serapis, first–second century. J. Paul Getty Museum, Malibu. *41*

Fig. 1-23. Detail of sarcophagus interior, Kerch, late first–early second century. State Hermitage Museum, St. Petersburg. *42*

Fig. 1-24. Funerary relief with butcher shop, Rome, second century. Skulpturensammlung, Staatliche Kunstsammlungen Dresden. *42*

Fig. 1-25. Shepherd sarcophagus, Rome, third quarter of third century. Musei Vaticani, Vatican City. *43*

Fig. 1-26. Jonah sarcophagus, Rome, late third century. British Museum, London. *43*

Fig. 1-27a. Column of Marcus Aurelius, Rome, 180–93. *44*

Fig. 1-27b. Rain personification, column of Marcus Aurelius, Rome, 180–93. *44*

Fig. 1-28. Lepcis Magna city plan, early third century. *45*

Fig. 1-29. Arcade in the forum of Septimius Severus, Lepcis Magna, early third century. *46*

Fig. 1-30a. Triumphal arch of Septimius Severus, Lepcis Magna, early third century. *46*

Fig. 1-30b. Triumphal arch of Septimius Severus, detail of frieze, Lepcis Magna, early third century. Assaraya Alhamra Museum, Tripoli. *46*

Fig. 1-31. Rock-cut relief with Shapur I, Naqsh-e Rostam, 260s. *48*

Fig. 1-32. Shapur I Cameo, ca. 260. Bibliothèque nationale de France, Cabinet des médailles, Paris. *48*

Fig. 1-33. Porphyry Tetrarchs, ca. 300. San Marco, Venice. *49*

Chapter 2

Fig. 2-1. Coin of Constantine, 327/28. Dumbarton Oaks, Washington, DC. *52*

Fig. 2-2. Lateran Baptistery, Rome, 320s, architectural drawings. *53*

Fig. 2-3. Vatican Hill (Rome), third century, reconstruction. *54*

Fig. 2-4. Ceiling mosaic, Tomb of the Julii, Vatican Necropolis (Rome), third century. *54*

Fig. 2-5. Church of St. Peter, Vatican (Rome), 320s, architectural drawings. *54*

Fig. 2-6. Holy Sepulcher complex, Jerusalem, fourth century, architectural drawings. *56*

Fig. 2-7. Seasons sarcophagus, fragment, Rome, ca. 300. Museo Nazionale Romano, Rome. *56*

Fig. 2-8. Arcosolium, Villa Torlonia Catacomb, Rome, mid-fourth century. *58*

Fig. 2-9. Bowl with gold-glass roundels, Cologne, fourth century. British Museum, London. *58*

Fig. 2-10. Projecta Casket, lid and front, Rome, fourth century. British Museum, London. *59*

Fig. 2-11. Ascension ivory, ca. 400. Bayerisches Nationalmuseum, Munich. *59*

Fig. 2-12. Obelisk base of Theodosius I, Constantinople, 390, southeast face. *60*

Fig. 2-13. Stilicho Diptych, ca. 400. Museo e Tesoro del Duomo, Monza. *61*

Fig. 2-14. Vermand Treasure, spear-shaft mounts and belt buckle, ca. 400. Metropolitan Museum of Art, New York. *62*

Fig. 2-15. Gilt-silver brooch, När, late fifth century. Historiska museet, Stockholm. *63*

Fig. 2-16. Gold collar, Ålleberg, second half of fifth century. Historiska museet, Stockholm. *63*

Fig. 2-17. Gold bracteate, Funen, fifth century. Nationalmuseet, Copenhagen. *64*

Fig. 2-18. Bahram Gur plate, fifth century. Metropolitan Museum of Art, New York. *64*

Fig. 2-19. Church of Santa Maria Maggiore, Rome, 432–40, nave toward the east. *65*

Fig. 2-20. Abraham and Melchizedek, church of Santa Maria Maggiore, Rome, 432–40, north nave wall. *65*

Fig. 2-21. Left half of apse arch, church of Santa Maria Maggiore, Rome, 432–40. *65*

Fig. 2-22. Aeneas and Achates, Vatican Vergil, ca. 400. Vatican City, Biblioteca Apostolica Vaticana, MS Vat. lat. 3225, fol. 45v. *67*

Fig. 2-23. Apse mosaic, Monastery of the Stoneworker, Thessaloniki, mid–late fifth century. *67*

Fig. 2-24. Neonian (Orthodox) Baptistery, Ravenna, ca. 458. *69*

Fig. 2-25a. Synagogue, Hammat Tiberias, late fourth–fifth century, reconstruction. *70*

Fig. 2-25b. Synagogue floor mosaic, Hammat Tiberias, late fourth–fifth century, view from entrance toward sanctuary. *70*

Fig. 2-26a. Synagogue, Sardis, fourth–seventh century, plan. *71*

Fig. 2-26b. Synagogue, Sardis, fourth–seventh century, view toward the west. *71*

Fig. 2-27. Samaritan synagogue floor mosaic, fragment, el-Khirbe, fourth century. Good Samaritan Museum, Israel. *72*

Fig. 2-28. Basilicas in monastery and pilgrimage complex, Qal'at Sem'an, late fifth century, architectural drawings. *73*

Fig. 2-29. Base of column of St. Symeon the Stylite, monastery and pilgrimage complex, Qal'at Sem'an, late fifth century. *73*

Fig. 2-30. St. Symeon token, sixth–seventh century. Walters Art Museum, Baltimore. *74*

Fig. 2-31. St. Symeon plaque, late sixth century. Musée du Louvre, Paris. *75*

Chapter 3

Fig. 3-1. Hagia Sophia Cathedral, aerial view, Constantinople, begun 532. *79*

Fig. 3-2. Hagia Sophia Cathedral, Constantinople, 532–37, architectural drawings. *79*

Fig. 3-3. Hagia Sophia Cathedral, Constantinople, begun 532, view toward the east. *79*

Fig. 3-4. Church of San Vitale, Ravenna, 526–48, architectural drawings. *81*

Fig. 3-5. Church of San Vitale, Ravenna, 526–48, sanctuary. *81*

Fig. 3-6. Justinian and Maximianus, church of San Vitale, Ravenna, 526–48, left apse wall. *81*

Fig. 3-7. Mosaics, church of Hagios Demetrios, Thessaloniki, (*left*) Demetrios before his ciborium, north aisle, mid-sixth century; (*right*) Demetrios with civic elites, nave pier, second quarter of seventh century. *82*

Fig. 3-8. Sion Treasure, third quarter of sixth century. Dumbarton Oaks, Washington, DC. *83*

Fig. 3-9. Gourdon Treasure, paten and chalice, ca. 500. Bibliothèque nationale de France, Cabinet des médailles, Paris. *84*

Fig. 3-10. Radegunde Lectern, Poitiers, third quarter of sixth century. Musée Sainte-Croix, Poitiers. *85*

Fig. 3-11. Renovated crypt and sanctuary screen, church of St. Peter, Rome, ca. 600, architectural drawing. *85*

Fig. 3-12. Inscribed brooch, Wittislingen, early seventh century. Archäologische Staatssammlung, Munich. *86*

Fig. 3-13. Drinking horn, Sutri, late sixth–early seventh century. British Museum, London. *86*

Fig. 3-14a. Sword, Vendel, ca. 600. Historiska museet, Stockholm. *87*

Fig. 3-14b. Sword detail, Vendel, ca. 600. Historiska museet, Stockholm. *87*

Fig. 3-15. Buried ship excavation in 1938, Sutton Hoo, Mound 1. *87*

Fig. 3-16. Purse lid, Sutton Hoo, early seventh century. British Museum, London. *88*

Fig. 3-17a. Belt buckle, Sutton Hoo, early seventh century. British Museum, London. *88*

Fig. 3-17b. Shoulder clasps, Sutton Hoo, early seventh century. British Museum, London. *88*

Fig. 3-18. St. Luke, St. Augustine Gospels, late sixth century. Cambridge, Corpus Christi College, MS 286, fol. 129v. *89*

Fig. 3-19. Rossano Gospels, sixth century, (*left*) resurrection of Lazarus, fol. 1r; (*right*) Jesus before Pontius Pilate, fol. 8r. Rossano, Museo dell'Arcivescovado (no shelf mark). *90*

Fig. 3-20. Holy Land relics box, ca. 600. Musei Vaticani, Vatican City. *91*

Fig. 3-21. Icon of Christ, ca. 600. Monastery of St. Catherine, Mount Sinai. *91*

Fig. 3-22. Hestia textile, Akhmim, first half of sixth century. Dumbarton Oaks, Washington, DC. *92*

Fig. 3-23a. Red Monastery church, Sohag, fifth–sixth century, plan. *93*

Fig. 3-23b. Triconch of the Red Monastery church, Sohag, paintings mostly early sixth century. *93*

Fig. 3-24. North lobe of triconch, Red Monastery church, Sohag, paintings mostly early sixth century. *94*

Fig. 3-25. Gospel book (Abba Garima III), fifth–sixth century, (*left*) St. Mark, (*center*) canon tables, (*right*) messianic Temple. Enda Abba Garima Monastery, MS 3. *94*

Fig. 3-26. David Plate, 629/30. Metropolitan Museum of Art, New York. *95*

Fig. 3-27. Church at Mren, ca. 640, exterior from the northwest. *96*

Fig. 3-28. Church at Mren, ca. 640, architectural drawings, including reconstruction of central apse paintings. *97*

Fig. 3-29. West portal, church at Mren, ca. 640. *97*

Fig. 3-30. North lintel, church at Mren, ca. 640. *97*

Fig. 3-31a. Church at Mren, ca. 640, view toward the east. *98*

Fig. 3-31b. Church at Mren, ca. 640, central dome on squinches. *98*

Fig. 3-32. Palace with Taq-i Kisra, Ctesiphon, ca. 540, photograph from 1932. *99*

Fig. 3-33. Stucco panel, Ctesiphon, sixth century. Metropolitan Museum of Art, New York. *99*

Fig. 3-34. Silk with winged horses, detail, fifth–seventh century. Metropolitan Museum of Art, New York. *100*

Fig. 3-35. Takht-e Soleyman, sixth century and later, architectural drawings. *100*

Fig. 3-36. Painted chamber, Afrasiab, ca. 660, south wall. Afrosiyob-Samarqand shahar tarixi muzeyi. *101*

Fig. 3-37. Ka'ba, Mecca, photograph from 2010. *102*

Fig. 3-38. House of Muhammad, Medina, ca. 622, architectural drawings. *103*

Fig. 3-39. Incantation bowl, Seleucia, sixth–seventh century. Kelsey Museum of Archaeology, University of Michigan, Ann Arbor. *103*

Chapter 4

Fig. 4-1. Dome of the Rock, Jerusalem, begun 691/92, exterior from the south. *106*

Fig. 4-2. Dome of the Rock, Jerusalem, begun 691/92, interior. *107*

Fig. 4-3. Dome of the Rock, Jerusalem, begun 691/92, architectural drawings. *107*

Fig. 4-4. Mosaics, Dome of the Rock, Jerusalem, ca. 691/92; (*left*) outer arcade; (*right*) inner arcade. *108*

Fig. 4-5a. Figural coin of 'Abd al-Malik, ca. 685–94. Penn Museum, Philadelphia. *110*

Fig. 4-5b. Epigraphic coin of 'Abd al-Malik, 698/99. Dumbarton Oaks, Washington, DC. *110*

Fig. 4-6. Coin of Justinian II, 692–95. Dumbarton Oaks, Washington, DC. *111*

Fig. 4-7. Great Mosque, Damascus, begun 705–15, architectural drawings. *111*

Fig. 4-8. Great Mosque, Damascus, begun 705–15, mosaic in courtyard. *112*

Fig. 4-9. Qur'an frontispiece, ca. 700. Sana'a, Dar al-Makhtutat, MS 20-33.1. *113*

Fig. 4-10. Church of St. Stephen, Kastron Mefa'a, eighth century, floor mosaic in the nave. *114*

Fig. 4-11. Floor mosaic detail, church of St. Stephen, Kastron Mefa'a, eighth century, east end of nave. *114*

Fig. 4-12a. Palace, Qusayr 'Amra, 724–43, plan. *115*

Fig. 4-12b. Palace, Qusayr 'Amra, 724–43, frescoes in reception hall. *115*

Fig. 4-13. Bathing scene, Qusayr 'Amra, 724–43, fresco in the bath. *115*

Fig. 4-14. Church of San Pedro de la Nave, late seventh–early eighth century, view toward the east. *116*

Fig. 4-15. Capital, church of San Pedro de la Nave, late seventh–eighth century. *116*

Fig. 4-16. Great Mosque, Córdoba, begun 784/85, plan. *117*

Fig. 4-17. Great Mosque, Córdoba, begun 784/85, interior. *117*

Fig. 4-18. Marriage ring, mid-seventh century. Dumbarton Oaks, Washington, DC. *118*

Fig. 4-19. Tara Brooch, early eighth century. National Museum of Ireland, Dublin. *118*

Fig. 4-20a. Nagyszentmiklós Treasure, Sânnicolau Mare, seventh–eighth centuries, complete treasure. Kunsthistorisches Museum, Vienna. *119*

Fig. 4-20b. Detail of flask, Nagyszentmiklós Treasure, Sânnicolau Mare, seventh–eighth centuries. Kunsthistorisches Museum, Vienna. *119*

Fig. 4-21a. Garment of Queen Bathild, ca. 680. Musée Alfred Bonno, Chelles. *119*

Fig. 4-21b. Detail of garment of Queen Bathild, ca. 680. Musée Alfred Bonno, Chelles. *119*

Fig. 4-22. Reliquary from Enger, late eighth century. Kunstgewerbemuseum, Berlin. *120*

Fig. 4-23. Crucifixion icon, eighth century. Monastery of St. Catherine, Mount Sinai. *121*

Fig. 4-24. Monastery, Skellig Michael, begun ca. sixth century. *122*

Fig. 4-25. St. Matthew, Lindisfarne Gospels, early eighth century. London, British Library, Cotton MS Nero D IV, fol. 25v. *123*

Fig. 4-26. Carpet page and Matthew incipit, Lindisfarne Gospels, early eighth century. London, British Library, Cotton MS Nero D IV, fols. 26v–27r. *124*

Chapter 5

Fig. 5-1. Apse mosaic, Hagia Sophia Cathedral, Constantinople, 867. *128*

Fig. 5-2. Crucifixion and iconoclasts, Khludov Psalter, mid-ninth century. Moscow, Gosudarstvennyi istoricheskii muzei, MS D.129, fol. 67r. *129*

Fig. 5-3. Abbey church of Saint-Denis, Saint-Denis, 775, plan. *130*

Fig. 5-4. Coin of Charlemagne, 813/14. Münzkabinett, Staatliche Museen zu Berlin. *130*

Fig. 5-5a. Palace chapel, Aachen, ca. 800, architectural drawings. *131*

Fig. 5-5b. Palace chapel, Aachen, ca. 800. *131*

Fig. 5-6. Quadriga silk, eighth century. Musée de Cluny, Paris. *133*

Fig. 5-7. Fountain of Life, Saint-Médard de Soissons Gospels, early ninth century. Paris, Bibliothèque nationale de France, MS lat. 8850, fol. 6v. *133*

Fig. 5-8. Rock crystal with Crucifixion, 825–950. Trésor, Conques. *134*

Fig. 5-9. Prayer book of Charles "the Bald," 846–69. Munich, Schatzkammer der Residenz (no shelf mark), fols. 38v–39r. *134*

Fig. 5-10. Mosaic above central door, inner narthex, Hagia Sophia Cathedral, Constantinople, ninth–early tenth century. *135*

Fig. 5-11. David as harpist, Paris Psalter, mid-tenth century. Paris, Bibliothèque nationale de France, MS gr. 139, fol. 1v. *135*

Fig. 5-12a. Mosque of al-Mutawakkil, Samarra, 848–52, plan. *137*

Fig. 5-12b. Minaret, Mosque of al-Mutawakkil, Samarra, 848–52. *137*

Fig. 5-13. Stucco panel, Samarra, ninth century. Museum für Islamische Kunst, Berlin. *137*

Fig. 5-14. Madinat al-Zahra', 936–1031, aerial view. *138*

Fig. 5-15. Salón Rico, Madinat al-Zahra', 953–57. *139*

Fig. 5-16. Ship, Oseberg, ca. 834. Vikingskipshuset, Oslo. *140*

Fig. 5-17. Carved cart, eighth century, in Oseberg ship burial, ca. 834. Vikingskipshuset, Oslo. *140*

Fig. 5-18. Back of carved cart, eighth century, in Oseberg ship burial, ca. 834. Vikingskipshuset, Oslo. *141*

Fig. 5-19. Animal-head post, Oseberg ship burial, ca. 834. Vikingskipshuset, Oslo. *141*

Fig. 5-20a. Bucket with enamels, detail of seventh-century component, Oseberg ship burial, ca. 834. Vikingskipshuset, Oslo. *142*

Fig. 5-20b. Tapestry fragment, Oseberg ship burial, ca. 834. Vikingskipshuset, Oslo. *142*

Fig. 5-21. Picture stone, Tjängvide, ninth–tenth century. Historiska museet, Stockholm. *142*

Fig. 5-22a. Picture stone, side with cross, Aberlemno, eighth or ninth century. *143*

Fig. 5-22b. Picture stone, side with battle scene, Aberlemno, eighth or ninth century. *143*

Fig. 5-23a. Koimesis church, Skripou, 873/74, exterior from the northeast. *144*

Fig. 5-23b. Koimesis church, Skripou, 873/74, detail of central apse. *144*

Fig. 5-24. Tokalı Kilise complex, Göreme, tenth century, plan. *145*

Fig. 5-25. New Tokalı Kilise, Göreme, tenth century, interior toward the east. *145*

Fig. 5-26a. Samanid mausoleum, Bukhara, ca. 907, architectural drawings. *146*

Fig. 5-26b. Samanid mausoleum, Bukhara, ca. 907, exterior from the southeast. *146*

Fig. 5-27. Portal detail, Samanid mausoleum, Bukhara, ca. 907. *147*

Fig. 5-28. Interior with squinches, Samanid mausoleum, Bukhara, ca. 907. *147*

Fig. 5-29. Epigraphic bowl, tenth century. Harvard Art Museums/Arthur M. Sackler Museum, Cambridge, MA. *148*

Fig. 5-30. Altar of Sant'Ambrogio, Milan, 825–59. *149*

Fig. 5-31. Rear doors, Altar of Sant'Ambrogio, Milan, 825–59. *149*

Fig. 5-32. Blue Qur'an, tenth century. New York, Metropolitan Museum of Art (2004.88). *150*

Fig. 5-33. Great Mosque, Kairouan, 850s, architectural drawings. *150*

Fig. 5-34a. Great Mosque, Kairouan, 850s, central aisle. *151*

Fig. 5-34b. Great Mosque, Kairouan, 850s, mihrab, minbar, and maqsura. *151*

Fig. 5-35. Plan of St. Gall, ca. 820. St. Gallen, Stiftsbibliothek, Cod. Sang. 1092, recto. *152*

Fig. 5-36. Medical procedure, surgery manuscript of Niketas, ca. 900. Florence, Biblioteca Medicea Laurenziana, MS Plut. 74.7, fol. 203v. *153*

Chapter 6

Fig. 6-1. Great Mosque, Córdoba, eighth–tenth century, plan. *157*

Fig. 6-2. Maqsura, Great Mosque, Córdoba, 961–76. *157*

Fig. 6-3. Antemihrab dome, Great Mosque, Córdoba, 961–76. *158*

Fig. 6-4a. Mihrab, Great Mosque, Córdoba, 961–76, entrance. *159*

Fig. 6-4b. Mihrab vault, Great Mosque, Córdoba, 961–76. *159*

Fig. 6-5a. House of Ja'far, Madinat al-Zahra', before 971, plan. *160*

Fig. 6-5b. House of Ja'far, Madinat al-Zahra', before 971, facade of reception hall. *160*

Fig. 6-6. Leire Casket, 1004/5. Museo de Navarra, Pamplona. *160*

Fig. 6-7. Aljafería Palace, Saragossa, 1064–82. *161*

Fig. 6-8. South gallery mosaic, Hagia Sophia Cathedral, Constantinople, 1028–55. *161*

Fig. 6-9. Byzantine crown, back, 1074–77. Országház, Budapest. *162*

Fig. 6-10. Metal standard, Söderala, ca. 1000. Historiska museet, Stockholm. *163*

Fig. 6-11. Amulet case (kaptorga), Bodzia, ca. 980–1030. Państwowe Muzeum Archeologiczne, Warsaw. *163*

Fig. 6-12. Lusterware bowl with musician, eleventh century. Mathaf al-Fann al-Islami, Cairo. *164*

Fig. 6-13. Gold ring, tenth–eleventh century. Aga Khan Museum, Toronto. *164*

Fig. 6-14. Printed paper amulet, eleventh century. New York, Metropolitan Museum of Art (1978.546.32). *166*

Fig. 6-15. Sura 1 and beginning of 2, Qur'an of Ibn al-Bawwab, 1000/1. Dublin, Chester Beatty Library, MS K. 16, fol. 9v. *166*

Fig. 6-16. Scriptorium and bell tower, Beatus from Tábara, 970. Madrid, Archivo Histórico Nacional, MS 1097B, fol. 167v. *167*

Fig. 6-17. Reliquary plaque with goldsmiths, ca. 1060–80. State Hermitage Museum, St. Petersburg. *167*

Fig. 6-18. Rock-cut settlement near Çanlı Kilise, tenth–eleventh centuries. *168*

Fig. 6-19. Gold enkolpion, tenth–eleventh century. British Museum, London. *169*

Fig. 6-20. Reliquary of St. Demetrios, 1059–67. Gosudarstvennyi istoriko-kul'turnyi muzei-zapovednik "Moskovskii Kreml'." *169*

Fig. 6-21. Majesty of St. Foy, ca. 1000. Trésor, Conques. *170*

Fig. 6-22. Hebrew primer, ninth–twelfth century. Cambridge, University Library, T-S K5.13. *171*

Fig. 6-23. Carpet pages, St. Petersburg Bible, 1008–10. St. Petersburg, Rossiiskaia natsional'naia biblioteka, Firkovitch MS B 19A, fols. 477v–478r. *171*

Fig. 6-24a. Mosque of al-Hakim, Cairo, ca. 990–1013, plan. *173*

Fig. 6-24b. Mosque of al-Hakim, Cairo, ca. 990–1013, portal from the west. *173*

Fig. 6-25a. Sviata Sofiia Cathedral, Kyiv, plan, with 1037–46 phase in black. *174*

Fig. 6-25b. Sviata Sofiia Cathedral, Kyiv, 1037–46, view toward the east. *174*

Fig. 6-26a. Commemorative stone, Jelling, side with main inscription, ca. 965. *174*

Fig. 6-26b. Commemorative stone, Jelling, side with interlaced beasts, ca. 965. *175*

Fig. 6-26c. Commemorative stone, Jelling, side with Crucifixion, ca. 965. *175*

Fig. 6-27. Ship setting, Jelling. *176*

Fig. 6-28. Harold swears on relics, Bayeux Embroidery, ca. 1080. Musée de la Tapisserie de Bayeux. *177*

Fig. 6-29. Harold enthroned and Halley's Comet, Bayeux Embroidery, ca. 1080. Musée de la Tapisserie de Bayeux. *177*

Fig. 6-30. Lothar Cross, front and back, ca. 1000. Domschatzkammer, Aachen. *178*

Fig. 6-31. Bernward's Column, ca. 1020. Hildesheim Cathedral. *179*

Fig. 6-32a. Veroli Casket, later tenth or early eleventh century, top and front. Victoria & Albert Museum, London. *180*

Fig. 6-32b. Detail of back, Veroli Casket, later tenth or early eleventh century. Victoria & Albert Museum, London. *180*

Fig. 6-33a. Mold for St. Symeon the Younger pendant, late tenth century. Kelsey Museum of Archaeology, University of Michigan, Ann Arbor. *181*

Fig. 6-33b. Modern impression for St. Symeon pendant, late tenth century. Kelsey Museum of Archaeology, University of Michigan, Ann Arbor. *181*

Fig. 6-34a. Monastery of Hosios Loukas, Steiri, second half of tenth–first half of eleventh century, plan. *182*

Fig. 6-34b. Monastery of Hosios Loukas, Steiri, second half of tenth–first half of eleventh century, exterior from the east. *182*

Fig. 6-35. Katholikon, monastery of Hosios Loukas, Steiri, first half of eleventh century. *183*

Fig. 6-36. Doubting Thomas scenes, monastery of Hosios Loukas, Steiri, first half of eleventh century, *(left)* crypt fresco; *(right)* narthex mosaic. *184*

Fig. 6-37. Pseudo-Kufic brickwork, Panagia church, monastery of Hosios Loukas, Steiri, second half of tenth century. *185*

Chapter 7

Fig. 7-1a. Abbey church of Sainte-Foy, Conques, late eleventh century, architectural drawings. *190*

Fig. 7-1b. Abbey church of Sainte-Foy, Conques, late eleventh century, view toward the east. *190*

Fig. 7-2. Tympanum, abbey church of Sainte-Foy, Conques, early twelfth century. *190*

Fig. 7-3a. Cathedral, Durham, begun 1093, architectural drawings. *191*

Fig. 7-3b. Cathedral, Durham, begun 1093, view toward the east. *191*

Fig. 7-4. Cuthbert heals a pilgrim, Life of St. Cuthbert, fourth quarter of twelfth century. London, British Library, MS Yates Thompson 26, fol. 83r. *192*

Fig. 7-5. Holy Sepulcher complex, Jerusalem, rebuilt first half of twelfth century, plan. *194*

Fig. 7-6a. Castle, Kerak, 1142–thirteenth century, plan. *194*

Fig. 7-6b. Castle, Kerak, 1142–thirteenth century, exterior from the east. *194*

Fig. 7-7. Ivory covers, Melisende Psalter, 1131–43, front and back. London, British Library, MS Egerton 1139/1. *195*

Fig. 7-8. Deesis, Melisende Psalter, 1131–43. London, British Library, MS Egerton 1139, fol. 12v. *196*

Fig. 7-9. Temptation of Christ, Melisende Psalter, 1131–43. London, British Library, MS Egerton 1139, fol. 4r. *197*

Fig. 7-10a. Cappella Palatina, Palermo, 1130–ca. 1160, architectural drawings. *198*

Fig. 7-10b. Cappella Palatina, Palermo, 1130–ca. 1160, view toward the east. *198*

Fig. 7-11. Muqarnas ceiling, Cappella Palatina, Palermo, 1130–ca. 1160. *199*

Fig. 7-12a. Marble throne, front, ca. 1170. Church of San Nicola, Bari. *199*

Fig. 7-12b. Marble throne, detail of back, ca. 1170. Church of San Nicola, Bari. *199*

Fig. 7-13. Mantle of Roger II, 1133/34. Kaiserliche Schatzkammer, Vienna. *200*

Fig. 7-14. Burgo de Osma silk, early twelfth century. Museum of Fine Arts, Boston. *201*

Fig. 7-15. Stavelot Triptych, eleventh century and 1150s. Morgan Library & Museum, New York. *202*

Fig. 7-16. Khakhuli Triptych, first half of twelfth century. Sak'art'velos khelovnebis muzeumi, Tbilisi. *203*

Fig. 7-17. Lisbjerg Golden Altar, ca. 1135. Nationalmuseet, Copenhagen. *204*

Fig. 7-18. Wood statue of Mary, twelfth century. Historiska museet, Stockholm. *205*

Fig. 7-19. Bratilo Chalice, late eleventh–early twelfth century. Novgorodskii gosudarstvennyi ob"edinennyi muzei-zapovednik, Novgorod. *206*

Fig. 7-20. Shrine of St. Patrick's Bell, 1091–1105. National Museum of Ireland, Dublin. *206*

Fig. 7-21a. Stave church, Urnes, late eleventh–twelfth century, architectural drawings. *207*

Fig. 7-21b. Stave church, Urnes, late eleventh–twelfth century, exterior from the northwest. *207*

Fig. 7-22. North side of stave church, detail, Urnes, ca. 1070. *207*

Fig. 7-23a. Parish church, Kilpeck, ca. 1140, exterior from the south. *208*

Fig. 7-23b. Sheela-na-gig, parish church, Kilpeck, ca. 1140. *208*

Fig. 7-24. Bobrinsky Bucket, 1163. State Hermitage Museum, St. Petersburg. *209*

Fig. 7-25a. Ribat-i Sharaf, Khorasan, 1114–55, plan. *210*

Fig. 7-25b. Ribat-i Sharaf, Khorasan, 1114–55, view from the south. *210*

Fig. 7-26. Great Mosque, Isfahan, *(left)* tenth century; *(right)* after 1121, both within outline of later mosque, architectural drawings. *211*

Fig. 7-27. South antemihrab dome, Great Mosque, Isfahan, 1086. *211*

Fig. 7-28. Bronze griffin, late eleventh–early twelfth century. Museo dell'Opera del Duomo, Pisa. *212*

Fig. 7-29a. Pisa, cathedral complex, 1063–1372, plan. *213*

Fig. 7-29b. Pisa, cathedral complex, 1063–1372, view from the west. *213*

Fig. 7-30a. Pantokrator Monastery, Constantinople, 1118–36, plan. *214*

Fig. 7-30b. Pantokrator Monastery, Constantinople, 1118–36, exterior from the east. *214*

Fig. 7-31. Pavement detail, katholikon, Pantokrator Monastery, Constantinople, 1118–36. *214*

Fig. 7-32. Author image and Anastasis, Homilies of Gregory of Nazianzos, 1136–55. Mount Sinai, Monastery of St. Catherine, MS gr. 339, fols. 4v–5r. *215*

Fig. 7-33a. Church of the All-Holy Mother of God of the Spurges, Asinou, ca. 1100–1330s, architectural drawings. *216*

Fig. 7-33b. Church of the All-Holy Mother of God of the Spurges, Asinou, ca. 1100–1330s, exterior from the southwest. *216*

Fig. 7-34. Saints Constantine and Helena, church of the All-Holy Mother of God of the Spurges, Asinou, 1105/6, south wall of naos. *216*

Fig. 7-35. Cloister with Durandus pier, abbey of Saint-Pierre, Moissac, 1100. *217*

Fig. 7-36. Cloister capital, abbey of Saint-Pierre, Moissac, 1100. *217*

Fig. 7-37. Fontenay Abbey, 1140s–60s, plan. *218*

Fig. 7-38. Fontenay Abbey, church, 1147, view toward the east. *218*

Fig. 7-39. Cloisters Cross, ca. 1150–60, front and back. Metropolitan Museum of Art, The Cloisters Collection, New York. *219*

Fig. 7-40. Central medallion on back, Cloisters Cross, ca. 1150–60. Metropolitan Museum of Art, The Cloisters Collection, New York. *220*

Fig. 7-41. *Scivias*, 1140s, (*left*) inspiration of Hildegard, fol. 1; (*right*) Creation and Fall, fol. 4. Formerly Wiesbaden, Landesbibliothek, MS 1, copy by nuns at Eibingen Abbey, 1927–33. *221*

Fig. 7-42. Abbot Suger in the Infancy window, abbey church of Saint-Denis, Saint-Denis, 1140s. *222*

Fig. 7-43. Facade, abbey church of Saint-Denis, Saint-Denis, ca. 1140. *222*

Fig. 7-44a. Abbey church of Saint-Denis, Saint-Denis, 1140s, plan. *223*

Fig. 7-44b. Chevet, abbey church of Saint-Denis, Saint-Denis, 1140s. *223*

Fig. 7-45. Tree of Jesse window, abbey church of Saint-Denis, Saint-Denis, 1140s. *224*

Fig. 7-46. Eleanor Vase, metalwork 1137–47. Musée du Louvre, Paris. *225*

Chapter 8

Fig. 8-1. Cathedral, Canterbury, 1175–84 (east end), late fourteenth century–1405 (nave), plan. *229*

Fig. 8-2. East end, Canterbury Cathedral, 1175–84. *230*

Fig. 8-3. Miracle windows, Trinity Chapel, Canterbury Cathedral, ca. 1213–20, (*left*) dead son revived; (*right*) knight's son healed. *231*

Fig. 8-4. Becket souvenirs, (*left*) ampulla, mid-thirteenth century; (*right*) badge, fourteenth century. Museum of London. *231*

Fig. 8-5. Becket reliquary, Limoges, ca. 1180–90. Victoria & Albert Museum, London. *232*

Fig. 8-6a. Vestments, Göss Abbey, 1250s, chasuble back. Museum für angewandte Kunst, Vienna. *233*

Fig. 8-6b. Vestments, Göss Abbey, 1250s, cope detail, with kneeling abbess originally on chasuble. Museum für angewandte Kunst, Vienna. *233*

Fig. 8-7. Drawings, portfolio of Villard de Honnecourt, ca. 1220–40. Paris, Bibliothèque nationale de France, MS fr. 19093, fols. 14v and 18r. *234*

Fig. 8-8. Historiated initial, De Brailes Bible-Missal, ca. 1234–40. Oxford, Bodleian Library, MS Lat. bib. e. 7, fol. 5r. *236*

Fig. 8-9. Vita icon of St. Panteleimon, ca. 1200. Monastery of St. Catherine, Mount Sinai. *236*

Fig. 8-10. Altarpiece of St. Francis, 1235. San Francesco, Pescia. *237*

Fig. 8-11. Bilateral icon, Kastoria, last quarter of twelfth century. Byzantino Mouseio Kastorias. *238*

Fig. 8-12. City seal matrix, Esztergom, first half of thirteenth century. Magyar Nemzeti Múzeum, Budapest. *240*

Fig. 8-13. Merchant's house, Lincoln, ca. 1170. *240*

Fig. 8-14a. Sultan Han, Konya, 1229 and 1278, architectural drawings. *241*

Fig. 8-14b. Sultan Han, Konya, 1229 and 1278, entrance wall. *241*

Fig. 8-15. Slave market, *Maqamat*, 1237. Paris, Bibliothèque nationale de France, MS ar. 5847, fol. 105r. *242*

Fig. 8-16. Training falcons, *Art of Hunting with Birds*, 1258–66. Vatican City, Biblioteca Apostolica Vaticana, MS Pal. lat. 1071, fols. 91v–92r. *244*

Fig. 8-17. Rooster ewer, ca. 1200. Musée du Louvre, Paris. *244*

Fig. 8-18. Mina'i bowl with couple in garden, ca. 1180–1220. Metropolitan Museum of Art, New York. *244*

Fig. 8-19. Sgraffito bowl with dancer, thirteenth century. Mouseio Benaki, Athens. *245*

Fig. 8-20. Centaur aquamanile, 1200–50. Magyar Nemzeti Múzeum, Budapest. *245*

Fig. 8-21. Baptismal font, late twelfth century. Church of San Esteban, Renedo de Valdavia. *246*

Fig. 8-22a. Mikvah, Friedberg, 1260, architectural drawing. *247*

Fig. 8-22b. Mikvah, Friedberg, 1260, view down to pool. *247*

Fig. 8-23. Heavenly Ladder icon, late twelfth century. Monastery of St. Catherine, Mount Sinai. *248*

Fig. 8-24. Khatchkar, Lori Berd, early thirteenth century. Hayots' patmut'yan t'angaran, Yerevan. *248*

Fig. 8-25. Tomb effigy of Eleanor of Aquitaine (with Henry II), Fontevrault Abbey, early thirteenth century. *248*

Fig. 8-26. Shrine of the Three Kings, ca. 1180–1220s. Cologne Cathedral. *249*

Fig. 8-27. Lamentation, church of St. Panteleimon, Nerezi, 1164. *250*

Fig. 8-28a. Church of Hagia Sophia, Trebizond, 1250s, architectural drawings. *251*

Fig. 8-28b. Church of Hagia Sophia, Trebizond, 1250s, view from the southeast. *251*

Fig. 8-29a. Cathedral of St. Dmitrii, Vladimir, 1190s, south exterior. *252*

Fig. 8-29b. Detail of Alexander "the Great," cathedral of St. Dmitrii, Vladimir, 1190s, south exterior. *252*

Fig. 8-30a. Friday mosque, Ribat al-Fath (Rabat), 1195–99, plan. *253*

Fig. 8-30b. Friday mosque, Ribat al-Fath (Rabat), 1195–99, view toward the minaret. *253*

Fig. 8-31a. Mosque-hospital complex, Divriği, 1229, plan. *254*

Fig. 8-31b. Mosque-hospital complex, Divriği, 1229, north portal of mosque. *254*

Fig. 8-32. Wood Calvary sculptures, Urnes stave church, mid-twelfth century. *254*

Fig. 8-33. Cathedral, Chartres, 1145 and later, view from the west. *255*

Fig. 8-34a. Cathedral, Chartres, 1194–fourteenth century, plan. *256*

Fig. 8-34b. Cathedral, Chartres, 1194–fourteenth century, interior toward the east. *256*

Fig. 8-35. Masons and sculptors, ambulatory window, Chartres Cathedral, ca. 1220. *256*

Fig. 8-36. Hermitage of St. Neophytos, near Paphos, 1159–early thirteenth century, architectural drawings. *258*

Fig. 8-37. Deesis with Neophytos, cell, hermitage of St. Neophytos, near Paphos, 1183. *258*

Fig. 8-38. Neophytos escorted to heaven, bema, hermitage of St. Neophytos, near Paphos, 1183. *258*

Fig. 8-39. Passion scenes near opening to elevated cell, naos ceiling, hermitage of St. Neophytos, near Paphos, ca. 1200. *259*

Fig. 8-40. Frescoes over the tomb of Neophytos, hermitage of St. Neophytos, near Paphos, 1183. 259

Fig. 8-41. Ascension, bema, hermitage of St. Neophytos, near Paphos, 1183. 259

Chapter 9

Fig. 9-1. Moses, *Compendium of Chronicles*, 1314/15. Edinburgh, University Library, Or MS 20, fol. 8r. 263

Fig. 9-2. Negus of Abyssinia (top), Birth of Muhammad (center), Shakyamuni and the devil (bottom), *Compendium of Chronicles*, 1314/15. (t, c) Edinburgh, University Library, Or MS 20, fols. 52r, 42r; (b) London, Nasser D. Khalili Collection of Islamic Art, MS 727, fol. 34a. 264

Fig. 9-3. Mappa mundi, ca. 1300. Hereford Cathedral. 266

Fig. 9-4. Astrolabe, ca. 1180–1300. Germanisches Nationalmuseum, Nuremberg. 267

Fig. 9-5. Story of the Jewish moneylender, *Cantigas de Santa María*, ca. 1270–84. El Escorial, Real Biblioteca de San Lorenzo, MS T.I.1, fol. 39r. 268

Fig. 9-6. Inlaid basin, ca. 1320–40. Musée du Louvre, Paris. 269

Fig. 9-7. Headpiece, Lectionary of Het'um II, 1286. Yerevan, Matenadaran MS 979, fol. 293r. 270

Fig. 9-8a. Mausoleum of Uljaytu, Sultaniyya, 1305–14, architectural drawings. 271

Fig. 9-8b. Mausoleum of Uljaytu, Sultaniyya, 1305–14, view from the northwest. 271

Fig. 9-9a. Qala'un complex, Cairo, 1284–85, plan. 272

Fig. 9-9b. Mausoleum facade, Qala'un complex, Cairo, 1284–85. 272

Fig. 9-10. Mausoleum interior, Qala'un complex, Cairo, 1284–85. 273

Fig. 9-11a. 'Attarin Madrasa, Fez, 1323–25, plan. 273

Fig. 9-11b. Courtyard, 'Attarin Madrasa, Fez, 1323–25. 273

Fig. 9-12. Merton College Quadrangle, Oxford, ca. 1288–1310. 274

Fig. 9-13a. Chora Monastery, Constantinople, eleventh–sixteenth centuries, plan. 275

Fig. 9-13b. Mosaic above central door, inner narthex, Chora Monastery, Constantinople, ca. 1315–21. 275

Fig. 9-14. Parekklesion, Chora Monastery, Constantinople, ca. 1315–21, (left) interior toward the east; (right) frescoes and top of Theodore Metochites's tomb. 275

Fig. 9-15. Scrovegni Chapel, Padua, ca. 1305, (left) view toward the east; (right) Lamentation. 276

Fig. 9-16a. Detail of Last Judgment, Scrovegni Chapel, Padua, ca. 1305. 277

Fig. 9-16b. Tomb of Enrico Scrovegni, Scrovegni Chapel, Padua, ca. 1336. 277

Fig. 9-17. Monastery church, Dečani, 1322–31. 277

Fig. 9-18. Monastery church, Dečani, 1332–55, choros and interior toward the southwest. 278

Fig. 9-19. Serbian royal family tree, narthex, monastery church, Dečani, 1332–55. 278

Fig. 9-20a. Sainte-Chapelle, Paris, 1239–48, architectural drawings. 279

Fig. 9-20b. Sainte-Chapelle, Paris, 1239–48, view from the southwest. 279

Fig. 9-21. Upper church, Sainte-Chapelle, Paris, 1239–48, view toward the east. 280

Fig. 9-22a. House of St. George, Lalibela, ca. thirteenth–fifteenth century, architectural drawings. 281

Fig. 9-22b. House of St. George, Lalibela, ca. thirteenth–fifteenth century, exterior. 281

Fig. 9-23. Passover preparations and Jews leaving synagogue, Sarajevo Haggadah, ca. 1325–50. Sarajevo, Zemaljski Muzej (no shelf mark), fols. 33v–34r. 282

Fig. 9-24a. Altneuschul, Prague, 1260s and later, plan. 282

Fig. 9-24b. Altneuschul, Prague, 1260s, view toward the west. 282

Fig. 9-25. Altar panel of St. Olav, early fourteenth century. Museet Erkebispegården, Trondheim. 283

Fig. 9-26. Palazzo Pubblico, Siena, 1297–1348, view from the northwest. 283

Fig. 9-27. Effects of Good Government, Hall of the Nine in the Palazzo Pubblico, Siena, 1338–39. 284

Fig. 9-28. Altar frontal of St. Eugenia, ca. 1330. Musée des Arts Décoratifs, Paris. 285

Fig. 9-29. Historiated initial, Gradual of Gisela von Kerssenbrock, ca. 1300. Osnabrück, Diözesanarchiv, Ma 101, fol. 13v. 286

Fig. 9-30. Nuns, Bebaia Elpis convent typikon, 1330s. Oxford, Bodleian Library, Lincoln College MS gr. 35, fol. 12r. 287

Fig. 9-31. Betrayal of Christ and Annunciation, Hours of Jeanne d'Evreux, 1325. New York, Metropolitan Museum of Art, The Cloisters Collection, 1954 (54.1.2), fols. 15v–16r. 288

Fig. 9-32. Dietmar von Aist as peddler, Manesse Codex, first half of fourteenth century. Heidelberg, Universitätsbibliothek, Cod. Pal. Germ. 848, fol. 64r. 289

Fig. 9-33. Mirror back with chess players, ca. 1300. Victoria & Albert Museum, London. 289

Fig. 9-34. South gallery Deesis mosaic, Hagia Sophia Cathedral, Constantinople, ca. 1265. 291

Fig. 9-35. Narthex frescoes, church of the All-Holy Mother of God of the Spurges, Asinou, late twelfth century–1330s, view toward the south. 291

Fig. 9-36a. Cathedral, Naumburg, ca. 1250, plan. 292

Fig. 9-36b. Cathedral, Naumburg, ca. 1250, west choir. 292

Fig. 9-37. Ekkehard and Uta sculptures, Naumburg Cathedral, ca. 1250. 293

Fig. 9-38. West choir screen, Naumburg Cathedral, ca. 1250. 293

Fig. 9-39. Epitaphios of Stefan Uroš II Milutin, early fourteenth century. Muzej Srpske pravoslavne crkve, Belgrade. 294

Fig. 9-40. Baptismal font, 1290. Church of St. Mary, Rostock. 295

Fig. 9-41. Table fountain, ca. 1320–40. Cleveland Museum of Art. 295

Fig. 9-42. Arm reliquary of St. George, first quarter of fourteenth century. Metropolitini Kapitula u. Sv. Vita, Prague. 296

Fig. 9-43. Jewish wedding ring, second quarter of fourteenth century. Museum für Ur- und Frühgeschichte Thüringens, Weimar. *296*

Fig. 9-44. Exodus scenes, Birds Head Haggadah, ca. 1300. Jerusalem, Israel Museum, MS 180/57, fols. 24v–25r. *297*

Fig. 9-45. Seder scene, Birds Head Haggadah, ca. 1300. Jerusalem, Israel Museum, MS 180/57, fol. 26v. *298*

Fig. 9-46. Last cup of wine and messianic Temple, Birds Head Haggadah, ca. 1300. Jerusalem, Israel Museum, MS 180/57, fols. 46v–47r. *299*

Chapter 10

Fig. 10-1a. Convent, Wienhausen, ca. 1330, plan. *303*

Fig. 10-1b. Convent, Wienhausen, ca. 1330, exterior from the southwest, with nuns' choir at right. *303*

Fig. 10-2. Crucifixion window, south cloister range, Wienhausen Convent, ca. 1330. *304*

Fig. 10-3. Nuns' choir, Wienhausen Convent, mid-fourteenth century, view toward the east. *304*

Fig. 10-4a. Sculpture of Risen Christ, 1290s. Wienhausen Convent. *305*

Fig. 10-4b. Sculpture of Christ in painted sarcophagus, Christ effigy, late thirteenth century; sarcophagus, 1448. Wienhausen Convent. *305*

Fig. 10-5. Tristan and Isolde embroidery, early fourteenth century. Wienhausen Convent. *306*

Fig. 10-6. Christus dolorosus from Wrocław, 1370s. Muzeum Narodowe v Warszawie, Warsaw. *307*

Fig. 10-7a. Shrine Madonna, closed, early fifteenth century. Musée de Cluny, Paris. *307*

Fig. 10-7b. Shrine Madonna, open, early fifteenth century. Musée de Cluny, Paris. *307*

Fig. 10-8a. Peribleptos Monastery katholikon, Mystras, ca. 1365–74, view from the south. *308*

Fig. 10-8b. Marian scenes, Peribleptos Monastery katholikon, Mystras, ca. 1365–74. *308*

Fig. 10-9. Painted panel with Coronation of Mary, ca. 1420. J. Paul Getty Museum, Malibu. *309*

Fig. 10-10. Painted panel with Mary in a church, ca. 1440. Gemäldegalerie, Staatliche Museen zu Berlin. *309*

Fig. 10-11a. Shrine of Ahmad Yasavi, Yasa (Turkistan), 1389–1405, architectural drawings. *310*

Fig. 10-11b. Shrine of Ahmad Yasavi, Yasa (Turkistan), 1389–1405, view from the southeast. *311*

Fig. 10-12a. Central dome, shrine of Ahmad Yasavi, Yasa (Turkistan), 1389–1405. *311*

Fig. 10-12b. Bronze cauldron, 1399. Shrine of Ahmad Yasavi, Yasa (Turkistan). *311*

Fig. 10-13. Transfiguration, Gospel book, late fourteenth–early fifteenth century. New York, Metropolitan Museum of Art, acc. no. 1998.66, fol. 9r. *312*

Fig. 10-14. Theological writings of John VI Kantakouzenos, 1370–75, (*left*) Transfiguration, fol. 92v; (*right*) John as emperor and as monk, fol. 123v. Paris, Bibliothèque nationale de France, MS gr. 1242. *314*

Fig. 10-15a. Castle, Karlštejn, 1348–65, plan. *315*

Fig. 10-15b. Castle, Karlštejn, 1348–65, view from the west. *315*

Fig. 10-16. Scenes with relics, Chapel of Our Lady, Lesser Tower, Karlštejn Castle, 1348–65. *316*

Fig. 10-17. Chapel of the Holy Cross, Great Tower, Karlštejn Castle, 1348–65, (*left*) north wall; (*right*) St. Maurice, east wall. *316*

Fig. 10-18. January image, *Très Riches Heures*, ca. 1411–16. Chantilly, Musée Condé, MS 65, fol. 1v. *317*

Fig. 10-19. Layla and Majnun at school, *Quintet*, 1431/32. New York, Metropolitan Museum of Art, (1994.232.4). *318*

Fig. 10-20a. Bibi Khanum Friday mosque, Samarkand, 1399–1405, plan. *318*

Fig. 10-20b. Bibi Khanum Friday mosque, Samarkand, 1399–1405, view from the northeast. *318*

Fig. 10-21a. Gur-i Mir, Samarkand, 1400–1404, view from the northwest. *319*

Fig. 10-21b. Tomb chamber, Gur-i Mir, Samarkand, 1400–1404. *319*

Fig. 10-22a. Sultan Hasan complex, Cairo, 1356–63, architectural drawings. *320*

Fig. 10-22b. Sultan Hasan complex, Cairo, 1356–63, view from the citadel toward the mausoleum. *320*

Fig. 10-23. Mosque lamp, 1356–63. National Museum of Asian Art, Smithsonian Institution, Washington, DC. *321*

Fig. 10-24a. Samuel Halevi Synagogue, Toledo, 1357, plan. *321*

Fig. 10-24b. Samuel Halevi Synagogue, Toledo, 1357, view toward the southeast. *321*

Fig. 10-25. Sant Llorenç retable, ca. 1390. Church of Sant Llorenç, Lleida. *322*

Fig. 10-26. Major Sakkos of Photios, front, 1414–17. Oruzheinaia palata, Moscow. *323*

Fig. 10-27a. St. Vitus Cathedral, Prague, begun 1344, plan. *324*

Fig. 10-27b. St. Vitus Cathedral, Prague, begun 1344, south exterior mosaic, ca. 1370. *324*

Fig. 10-28. Bust of Peter Parler, St. Vitus Cathedral, Prague, last quarter of fourteenth century. *325*

Fig. 10-29. Memorial brass, ca. 1400. Parish church, Northleach. *325*

Fig. 10-30. Apocalypse Tapestry, ca. 1377–82, (*left*) approximately half of the tapestry; (*right*) Whore of Babylon scene. Musée de la Tapisserie, Chateau d'Angers. *326*

Fig. 10-31. Richard and Jeanne de Montbaston at work, *Romance of the Rose*, mid-fourteenth century. Paris, Bibliothèque nationale de France, MS fr. 25526, fol. 77v, detail. *327*

Fig. 10-32. Dream of the Rose, *Romance of the Rose*, mid-fourteenth century. Paris, Bibliothèque nationale de France, MS fr. 25526, fol. 1r. *327*

Fig. 10-33. Scenes from *Book of the Great Khan*, ca. 1400–1410, (*left*) banquet, fol. 239r; (*right*) barons, fol. 242v. Oxford, Bodleian Library, MS Bodl. 264, pt. III. *328*

Fig. 10-34. Catalan Atlas, sheets 5–12, 1375. Paris, Bibliothèque nationale de France, MS esp. 30. *328*

Fig. 10-35. Mansa Musa, detail of Catalan Atlas, sheet 6, 1375. Paris, Bibliothèque nationale de France, MS esp. 30. *329*

Fig. 10-36. Writings of Pseudo-Dionysios, 1403–5, (*left*) St. Dionysios, fol. 1r; (*right*) family of Emperor Manuel II Palaiologos, fol. 2r. Paris, Louvre, Département des Objets d'Art, MR 416. *330*

Fig. 10-37. Guide for the Perplexed, 1347–48, (*left*) Aristotle with astrolabe, fol. 114a; (*right*) Ezekiel's vision, fol. 202a. Copenhagen, Det Kongelige Bibliotek, Cod. Heb. 37. *331*

Fig. 10-38. Saltcellar with khamsa, fourteenth century. Museo Nacional de Cerámica y de las Artes Suntuarias "González Martí," Valencia. *332*

Fig. 10-39. Alhambra, Granada, plan. *333*

Fig. 10-40. Comares Tower/Hall of the Ambassadors, Alhambra, Granada, 1333–54. *334*

Fig. 10-41. Court of the Lions, Alhambra, Granada, 1354–91. *335*

Fig. 10-42. Ceiling with chivalry scenes, Hall of Justice/Hall of the Kings, Alhambra, Granada, 1354–91. *335*

Fig. 10-43. Hall of the Two Sisters, Alhambra, Granada, 1354–91. *336*

Fig. 10-44. Lindaraja mirador, Alhambra, Granada, 1354–91. *337*

Chapter 11

Fig. 11-1a. Cathedral, Milan, begun 1386, architectural drawings. *341*

Fig. 11-1b. Cathedral, Milan, begun 1386, view from the northwest. *341*

Fig. 11-2a. Monastery of Santa Maria de Vitória, Batalha, 1388–1533, plan. *342*

Fig. 11-2b. Founder's chapel, monastery of Santa Maria de Vitória, Batalha, 1426–34. *342*

Fig. 11-3. Queen Mary Harp, fourteenth–fifteenth century. National Museum of Scotland, Edinburgh. *343*

Fig. 11-4. John VIII Palaiologos medallion, ca. 1438. Yale University Art Gallery, New Haven. *343*

Fig. 11-5. Iconostasis, Annunciation Cathedral, Kremlin, Moscow, begun 1484. *344*

Fig. 11-6a. Icon of St. Luke as painter, 1560–67. Mouseio Benaki, Athens. *345*

Fig. 11-6b. Painting of St. Luke, ca. 1605. Toledo Cathedral. *345*

Fig. 11-7a. Monastery katholikon, Moldovitsa, 1532–37, view from the southwest. *346*

Fig. 11-7b. Detail of siege of Constantinople, monastery katholikon, Moldovitsa, 1532–37. *346*

Fig. 11-8a. Mosque in Suleymaniye complex, Istanbul, 1550s, architectural drawings. *347*

Fig. 11-8b. Suleymaniye complex, Istanbul, 1550s, aerial view from the south. *347*

Fig. 11-9. Cathedral (former Great Mosque), Córdoba, aerial view from the southwest. *348*

Fig. 11-10. Ship of Shi'ism, *Book of Kings (Shahnameh)* of Shah Tahmasp, ca. 1530–35. New York, Metropolitan Museum of Art, acc. no. 1970.301.1, fol. 18v. *349*

Fig. 11-11. Album sheet with Sufis, ca. 1640. British Museum, London. *350*

Fig. 11-12. Tughra of Suleyman, from a document of ca. 1555–60. New York, Metropolitan Museum of Art (38.149.1). *351*

Fig. 11-13. Illuminated page with metal badge, book of hours, ca. 1490. Oxford, Bodleian Library, MS Douce 51, fol. 45v. *351*

Fig. 11-14. Printed page, Prague Haggadah, 1526. Braginsky Collection, Zurich. *352*

Fig. 11-15. "Jewish Sow" and Crucifixion, two sides of a woodcut print, fifteenth century. Harvard Art Museums/Fogg Museum, Cambridge, MA. *353*

Fig. 11-16. "Insula hyspana," woodcut print in Christopher Columbus, *Letter on the Recently Discovered Islands*, 1494. Washington, DC, Library of Congress, Incun. 1494.V47 Vollbehr Collection. *353*

Fig. 11-17. World map, 1513. Istanbul, Topkapı Sarayı Müzesi Kütüphanesi, Revan Köşkü 1633 mük. *354*

Fig. 11-18. Unfinished mausoleum, monastery of Santa Maria de Vitória, Batalha, 1433–1533. *355*

Fig. 11-19a. The Cloisters, New York, view of the Cuxa Cloister, ca. 1130–40. Metropolitan Museum of Art, New York. *356*

Fig. 11-19b. The Cloisters, New York, view of the Gothic Chapel, with windows (fourteenth century) and tombs (thirteenth–fourteenth century). *357*

Fig. 11-20a. Museum of Islamic Art, Doha, Qatar, 2006–8. *358*

Fig. 11-20b. Courtyard, Mosque of Ibn Tulun, Cairo, 876–79. *358*

LIST OF MAPS

Introduction: From Santiago to Samarkand, Lincoln to Lalibela *2*

Chapter 1: The Roots of Medieval Art *24*
 Empire of Alexander "the Great" *27*
 Roman Empire *31*
 Sasanian Empire *47*

Chapter 2: Fourth and Fifth Centuries *50*
 Roman Empire *55*
 Age of Migrations *61*

Chapter 3: Sixth to Mid-Seventh Century *76*
 Byzantine Empire under Justinian *80*
 Europe and the Mediterranean ca. 630 *83*
 Western and Central Asia ca. 630 *93*

Chapter 4: Mid-Seventh to Late Eighth Century *104*
 Major States ca. 750 *110*

Chapter 5: Late Eighth Century to ca. 960 *126*
 Western Europe ca. 814 *130*
 Islamicate World and Byzantium ca. 900 *136*
 Vikings 8th to 10th Century *139*

Chapter 6: ca. 960 to ca. 1070 *154*
 Major States ca. 1035 *163*

Chapter 7: ca. 1070 to ca. 1170 *186*
 Pilgrimage Routes to Santiago de Compostela *189*
 Major States ca. 1130 *193*

Chapter 8: ca. 1170 to ca. 1250 *226*
 Europe ca. 1210 *239*
 Islamicate World ca. 1185 to 1200 *241*
 Eastern Mediterranean ca. 1180 to ca. 1250 *243*

Chapter 9: ca. 1250 to ca. 1340 *260*
 Major States ca. 1300 *270*

Chapter 10: ca. 1340 to 1450 *300*
 Major States ca. 1400 *310*

Chapter 11: Afterlives of the Middle Ages *338*

PREFACE

Medieval art history is vibrant and intellectually challenging, but the dynamism of the field has not been readily apparent in survey texts. The primary aim of this book is to provide students and other readers with a broad overview of European, Byzantine, and Islamicate art and architecture during the Middle Ages and to do so in a way that conveys the discipline's diverse and compelling approaches to research and historical problems.

The book reflects our training in North America in the late twentieth century and our teaching in a variety of North American institutions in the twenty-first. This education and experience have contributed to our desire for greater inclusiveness and our disinclination to assert a single overarching idea or theory that weaves all of medieval art and architecture into one tidy story. That being said, we have arranged the book chronologically because people in the Middle Ages knew about and often intentionally evoked the past. This chronological structure also helps highlight the complex and ever-changing relationships among peoples, religions, and regions that are often seen—and taught—as separate or autonomous entities.

One of the greatest challenges we faced in writing this book was selecting what to include. Our goal was to examine a greater variety of monuments from a wider range of places and peoples than that found in other introductory texts. This geographical and chronological scope means that some well-known works and favorites are missing, and no object or monument is treated exhaustively. Each chapter does, however, include two "works in focus" that are discussed at greater length and accompanied by more illustrations. These discussions provide a richer account of the complexity of these works and their contexts, and they can serve as models for deeper examination of any medieval monument or object. Because the Middle Ages may be unfamiliar to many readers, we have tried to make the material accessible in different ways. We begin each chapter with a map of works discussed and places cited and a brief historical overview. Within the chapters are smaller maps and explanatory boxes; unfamiliar words are defined when they first appear in the text and are also included in a glossary. Finally, a dynamic website complements the book and provides additional material for classroom use and for further research. Artofthemiddleages.com has hundreds of illustrated short essays on a wide range of objects and monuments, only some of which are included in the printed book. It has interactive timelines and maps, as well as an illustrated glossary. Primary sources that illuminate works in the book have been newly translated from multiple languages. In addition, there are podcasts on such themes as race, gender, sexuality, and more.

The authors are indebted to countless students and teaching assistants, as well as to numerous colleagues whose innovative scholarship informed our work in important ways. Several individuals made profound contributions and deserve to be singled out here. Genevra Kornbluth expertly coordinated and processed all of the photographs, taking many of them herself and acquiring the rest. Erika Loic developed the website that accompanies the book, populated it with its first 350 entries, and provided advice on matters large and small; she also played a major role in the volume's final phases. Navid Jamali created all the architectural drawings, and Jeff Allen made all the maps; their meticulous work significantly enriches the book. Sasha Gorjeltchan did research for the maps and timelines, Esther Dongwon Kim worked on primary sources, and Samantha Chang set up our database. In addition, the following students and colleagues provided photographs, information, or advice: Ladan Akbarnia, Nora Berend, Rebecca Blakeney, Elizabeth Bolman, Andrzej Buko, Quitterie Cazès, Jasmina S. Ćirić, Anastasia Drandaki, John Freed, Giovanni Gasbarri, Sharon Gerstel, Michael Gervers, Sarah M. Guérin, Renata Holod, Brad Hostetler, Elena Iourtaeva, Zsombor Jékely, Ruba Kana'an, Dana Katz, Etele Kiss, Dimana Kolarova, Rachel Koopmans, Derek Krueger, John Lansdowne, Katarina Ljahovic, Christina Maranci, Vasileios Marinis, Anna McSweeney, Brent Miles, Marcus Milwright, Heba Mostafa, Mikael Muehlbauer, M. Michèle Mulchahey, Kathleen Nolan, Bernard O'Kane, Robert Ousterhout, Georgi Parpulov, Heather Pigat, Mariam Rosser-Owen, D. Fairchild Ruggles, Gili Shalom, Marianna Shreve Simpson, Zaza Skhirtladze, Harriet Sonne de Torrens, Alice

Isabella Sullivan, Wenwei Tan, Misha Teramura, Lioba Theis, Erik Thunø, Marta Tryshak, Ian Turner, Tolga Uyar, Henry Visscher, Lori Walters, Julia Walworth, Yudong Wang, and Nancy Wicker. Two focus groups at Kalamazoo were more helpful than they know, as were the book's anonymous reviewers.

We want to thank the institutions that helped fund our work: the Social Sciences and Humanities Research Council of Canada; Dean Amrita Daniere and the Office of the Vice-Principal Academic and Dean at the University of Toronto Mississauga; and the University of Toronto's ATLAS grant program in the Faculty of Arts & Science. Margaret English in the Art Library was indispensable, as was the incomparable library system at the University of Toronto.

Last but not least, we must thank Cornell University Press's former editor in chief, Peter Potter, for championing our ambitious project, and the people who made the book a reality, above all Mahinder Kingra, Bethany Wasik, Karen Hwa, and Julie Allred.

Note on Usage

We have followed or simplified standards of transliteration developed in various fields of study and use the most common English names for places and for well-known people. Current country names are given, usually in parentheses, after the names of cities or sites. Biblical passages are from the New International Version. Qur'anic excerpts are based on the translation by M. H. Shakir in the Perseus Digital Library. Measurements are in meters and kilos. Capital C is used for the Church as an institution or concept and lowercase c for church buildings. In captions, manuscript is abbreviated as MS; sizes are for a single folio. For two-dimensional works, dimensions are given as H × W; for three-dimensional works, H × W (or L) × D. All dates are CE unless otherwise indicated. Life spans are given in parentheses, as are years of rule (preceded by r.) or year of death (preceded by d.). The maps and glossary are not meant to be comprehensive resources but are keyed specifically to the contents of the book.

ART AND ARCHITECTURE
OF THE MIDDLE AGES

INTRODUCTION

From Santiago to Samarkand, Lincoln to Lalibela

Legend

- ☐ **Location or findspot**
 - *Monument/object*
- • Additional site
- ○ *Approximate place of production*

Friday mosque, Tinmal

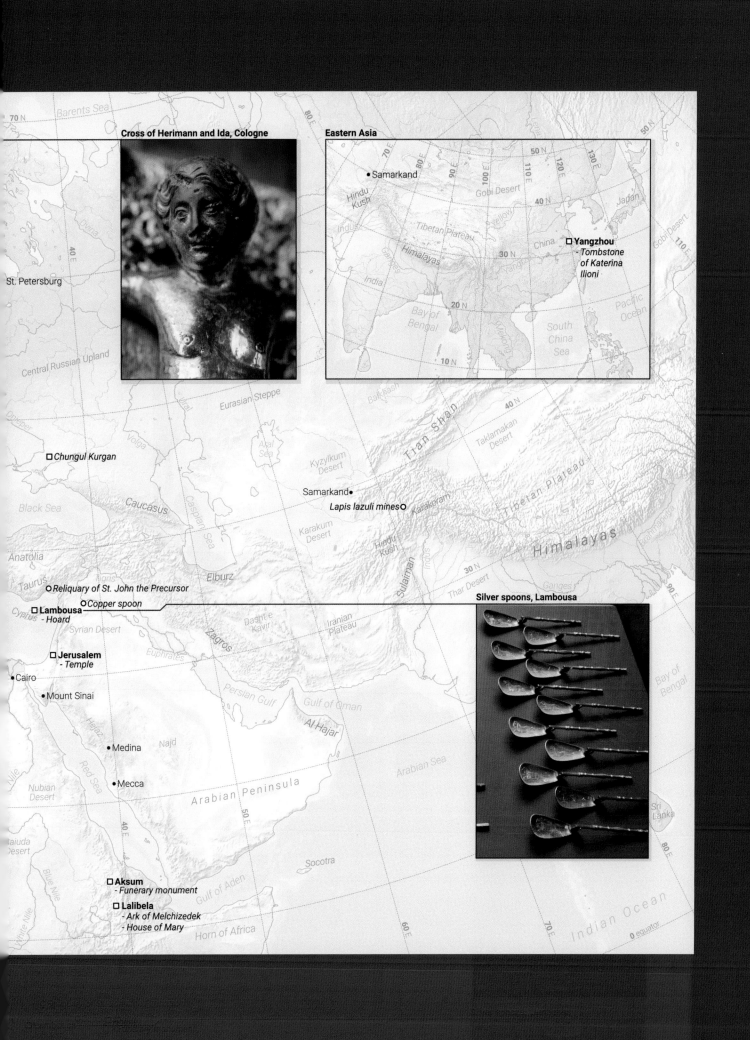

Cross of Herimann and Ida, Cologne

St. Petersburg

Central Russian Upland

Eastern Asia

Samarkand

Hindu Kush

Indus

Gobi Desert

Tibetan Plateau

Yellow

China

□ **Yangzhou**
- *Tombstone of Katerina Ilioni*

Ganges

Himalayas

Yangtze

India

Bay of Bengal

South China Sea

Pacific Ocean

Japan

Gobi Desert

Barents Sea

Dvina

Eurasian Steppe

Balkhash

Tian Shan

Taklamakan Desert

□ *Chungul Kurgan*

Volga

Aral Sea

Kyzylkum Desert

Samarkand•

Lapis lazuli mines○

Karakoram

Tibetan Plateau

Black Sea

Caucasus

Caspian Sea

Karakum Desert

Hindu Kush

Indus

Himalayas

Brahmaputra

Anatolia

Taurus

Tigris

Elburz

Sulaiman

Ganges

Thar Desert

○ *Reliquary of St. John the Precursor*

○ *Copper spoon*

□ **Lambousa**
- *Hoard*

Cyprus

Syrian Desert

Dasht-e Kavir

Iranian Plateau

Silver spoons, Lambousa

□ **Jerusalem**
- *Temple*

Euphrates

Zagros

Persian Gulf

Gulf of Oman

Al Hajar

Bay of Bengal

• Cairo

• Mount Sinai

Hejaz

Najd

• Medina

Red Sea

Arabian Sea

Sri Lanka

• Mecca

Arabian Peninsula

Nile

Nubian Desert

aiuda Desert

Blue Nile

White Nile

Socotra

Gulf of Aden

Horn of Africa

Indian Ocean

0 equator

□ **Aksum**
- *Funerary monument*

□ **Lalibela**
- *Ark of Melchizedek*
- *House of Mary*

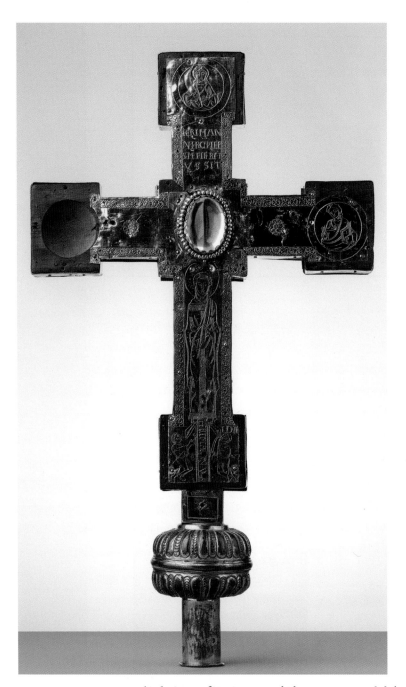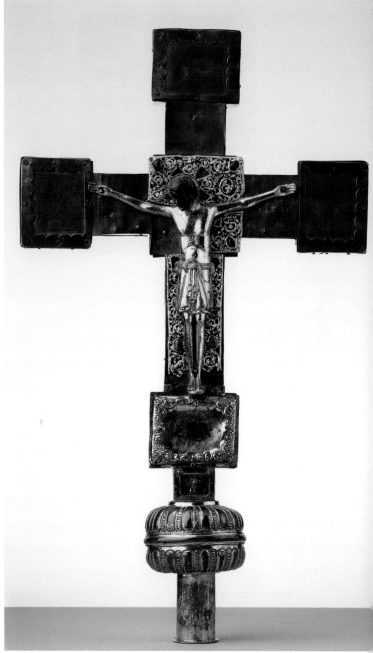

Figs. I-1a and I-1b. Cross of Herimann and Ida, 33.3 × 28 cm, (*left*) back, (*right*) front, second quarter of eleventh century. Kolumba Museum, Cologne. © KOLUMBA; Köln.

Two small figures incised on a copper plaque kneel awkwardly and gaze up at a female figure several times their size (fig. I-1a). Latin labels identify the man to the left as Herimann and the woman to the right as Ida. An inscription in the wide panel at the top of the cross says, "Archbishop Herimann ordered that I be made." The object thus speaks and tells us something of its origins. Ida reaches up to kiss the shoe-clad foot of the large woman, who lacks a label but can be identified by her halo, veil, and outstretched hands as Mary, the mother of Jesus. Her tall body stretches along the vertical axis of a cross. Turn the cross over, and Mary's son is revealed in three dimensions, his arms outstretched and hands affixed to the cross with tiny nails; this depicts Jesus's death on the cross, a pivotal event in Christianity (fig. I-1b). His bronze body rests against a plaque of swirling gold vines studded with blue gems. Their colors draw attention to Jesus's bright-blue head, which is made of lapis lazuli, a highly prized stone mined in Afghanistan. Look closely, and you see that the head is a woman's (fig. I-2).

How are we to understand this object? The inscriptions help situate the cross in time and space. We know from other historical sources that Herimann and Ida were siblings and leaders of major religious institutions in a prominent city in Germany: he became archbishop of Cologne in 1036, and she became the abbess of a convent in the same city that year. The inscriptions do not help explain the extraordinary blue head, however. Art historians have analyzed the style of the carving—that is, its particular formal characteristics, like the way the thick, wavy hair frames the lifelike face, in contrast with the exaggerated elongation of Christ's body and the linear patterns of his garment—and determined that it is an ancient Roman portrait head made in the first century CE. Where did it come from? Why was it reused one thousand years later? What did it add to the meaning of the cross? Who would have seen it, and under what circumstances?

These are the types of questions probed in *Art and Architecture of the Middle Ages: Exploring a Connected World.* Works like the Cross of Herimann and Ida allow us to encounter the past and explore the experiences and worldviews of people who lived in the Middle Ages. The cross's blend of old and new materials and of historical and contemporary figures was common in medieval art, even if it may seem unusual today. Yet this object, and many other works of medieval art and architecture, can also speak to current perspectives, priorities, and problems in surprising ways. This book seeks to make familiar what at first glance seems distant or strange. It considers Christian art and architecture, as the cross suggests, but it paints a more complete picture of the range of faiths and religious practices of the Middle Ages. It also demonstrates that not all art served religious

Fig. I-2. Lapis lazuli head, 2.55 cm, early first century, reused on Cross of Herimann and Ida, second quarter of eleventh century; Kolumba Museum, Cologne. © KOLUMBA; Köln.

purposes. This survey breaks new ground by being the first to dismantle the religious, political, and geographical walls that have traditionally separated medieval art and architecture into three distinct categories. It treats not only western Europe, the home of Herimann and Ida, but also considers the Byzantine Empire, from the foundation of Constantinople in 324 to its demise with the Ottoman Turkish conquest in 1453. Furthermore, it examines nine hundred years of art in the Islamicate world—lands where Islam was the dominant religion, although rarely the only one—beginning with the emergence of the new faith in the seventh century. These three categories—Islamicate, Byzantine, and western European—are not treated as separate entities, without connections or contemporaneity; they are interwoven in a single chronological framework. The book also addresses religious and ethnic groups who rarely appear in introductory texts, including polytheists (pagans) who were numerous until the eleventh century and flourished in parts of Asia throughout the medieval centuries. This expanded view reveals the wide scope of visual, artistic, and architectural experiences in the Middle Ages among a wide range of makers, users, and viewers. Elucidating the diversity of medieval art is the primary goal of the book.

The Middle Ages in Time and Space

Although the title *Art and Architecture of the Middle Ages* may seem straightforward, each of its words requires some explanation. *Middle Ages* and the related adjective *medieval* stem from the Latin *medium aevum*, which literally means "middle age." This long era is traditionally understood to encompass the time between Greek and Roman antiquity and the revival of classicism in western Europe in the fourteenth to sixteenth centuries. This "middle age" was an invention of Italian Renaissance thinkers, a way to characterize the time that separated them from the classical past. They perceived that time as inferior, backward, and debased, for it had strayed from the artistic and cultural forms they sought to revitalize (*Renaissance* means "rebirth"). In other words, *medieval* was a derogatory term meant to disparage a period and people whose interests and art forms were thought to fall short of ancient Greek and Roman ideals.

This idea of three stages of history—ancient, medieval, rebirth—raises many thorny issues, including the equation of the middle period with cultural decline. It was not: the notion of the so-called Dark Ages as an era of anarchy, illiteracy, and ignorance has been thoroughly debunked for decades. Another problem with this tripartite idea is that the Italian Renaissance was not the first revival of Greek and Roman antiquity in Europe. Many cases of medieval art production consciously looked to ancient models and even reused ancient objects, as the Cross of Herimann and Ida did. Furthermore, antiquarian interest was neither the only cultural change in the fifteenth and sixteenth

centuries nor apparent outside particular European settings; consequently, historians now use the more neutral label *early modern* for that era. Finally, some medieval artistic practices survived well into the fifteenth century and beyond, even continuing today in some places. Given all of these complexities, is it possible to assign dates to the beginnings and ends of classical antiquity, the Middle Ages, or the early modern Renaissance? Many writers from the sixteenth century to the present thought so, an idea playfully mocked in this modern cartoon (fig. I-3). To be fair, outlining and characterizing historical periods—what is called periodization—do help make sense of the past, but contemporary scholars agree that neat separations between one historical period and the next are misleading and impossible to pinpoint.

Take the case of defining the end of the Roman Empire, which many historians argue was a meaningful break between the ancient and medieval worlds. When did that happen? With the legalization of Christianity in 313, the sack of the city of Rome in 410, or the death of the last emperor in Italy in 476? The Byzantine emperors in Constantinople maintained until 1453 that they ruled the Roman Empire, and they called themselves Romans. Looking at other types of evidence—architecture, for instance, instead of governance, or finds in Cologne instead of Rome—yields different results. New evidence also can challenge long-held assumptions. Recent examinations of ice cores, tree rings, and rat DNA have highlighted environmental factors alongside human agency as determinants of historical change. Such research has discovered that in the sixth and seventh centuries, the Mediterranean region experienced outbreaks of bubonic plague (*Yersinia pestis*) and sudden climate cooling due to volcanic activity. These upheavals spurred population decline and widespread political, economic, and social shifts. These findings underline the long, slow, and continuous nature of historical change. The past, like the present, was messy and thwarts efforts to make clean demarcations in time. Because of the highly constructed and artificial character of historical periods, this book sees the beginnings and ends of the Middle Ages as fluid. The book spans from about 200 CE to around 1450 CE, with an emphasis on "about" or "around," the Latin *circa* (abbreviated as ca.).

Not many medieval artists dated their works, so art historians need other tools to determine when something was made. Documentary (textual) sources and inscriptions can anchor art in time and space, as with the Cross of Herimann and Ida. Analysis of style and comparisons with other, more firmly dated works can also help determine when something was made; for instance, coins found in archaeological excavations help date the objects or structures around them. Scientific approaches are useful as well. DNA analysis, dendrochronology (analyzing growth of tree rings), and carbon-14 (based on the time elapsed since an organic material was destroyed) are among art

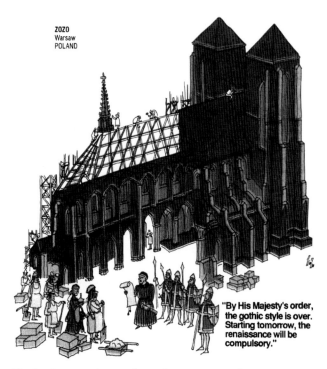

ZOZO
Warsaw
POLAND

"By His Majesty's order, the gothic style is over. Starting tomorrow, the renaissance will be compulsory."

Fig. I-3. Cartoon. Zozo, after *Calgary Herald*, Calgary, Alberta, Canada, March 23, 1991, comics p. 7. © Cartoonists & Writers Syndicate.

history's newer dating tools. Sometimes scientific analyses yield results that are surprising or controversial. For instance, a book containing the four Gospels of the Christian Bible (collection of sacred texts), from a monastery in Ethiopia, was long thought to have been made in the tenth or eleventh century, but recent carbon dating seemingly places it in the fifth or sixth century, making it the world's earliest complete illustrated Gospel book (fig. 3-25).

Just as *Art and Architecture of the Middle Ages* spans more than twelve centuries, its geographical range is also very wide. It addresses objects, buildings, and cities across northern Africa and western Eurasia—Europe, western Asia, and Central Asia—without insisting on precise and consistent political, religious, or cultural boundaries. In Asia, the expanse of territory considered here evokes the ancient empire of Alexander "the Great" (d. 323 BCE), its areas of cross-fertilization, and its impact on medieval art farther west. Those contours, however, constantly changed. Take, for example, the Umayyad and Abbasid dynasties that ruled much of the Islamicate world for centuries. While the Umayyads expanded their territories to the Indus River in the eighth century, as Alexander had done, their successors, the Abbasids, pushed the boundaries east of that river but lost lands to the northeast to other Muslim rulers. To this apparent fluidity must also be added one of the dominant features of the Middle Ages: migration. The movement of Turkic peoples from East and Central Asia into the western parts of the continent demonstrates the permeability of borders, as does the migration of Scandinavians into Europe and the islands of the North Atlantic Ocean. This book introduces the art and architecture of many peoples who lived within this vast Eurasian territory, such as Armenians, Avars, and Sogdians, whose works rarely appear in previous surveys of medieval art. It also examines where the boundaries associated with Alexander "the Great" and his successors dissolve or break out in new directions: along the Silk Routes to China, for instance, or up the Nile River to Ethiopia. Overall, the book seeks to explore episodes of cultural encounter while indicating differences and points of rupture, but it does not claim to cover every population and location equally.

This wide geographical scope complicates the conventions of periodization discussed above. Because the concept of the Middle Ages derives from European and specifically Italian ideas of a distinct middle period, the viability of "Middle Ages" or "medieval" outside Europe poses problems and therefore needs some explanation. Islam emerged during Europe's "middle" era, and the Islamicate world was never completely removed from medieval Europe or its inhabitants, but applying the term *medieval* to Islamicate contexts—particularly during its first centuries—stretches the literal meaning of the term. Similarly, the Sogdians, who flourished in Samarkand (Uzbekistan) and other cities along the Silk Routes in Central Asia and China, had a long history as traders, from the time of Alexander "the Great"

Box I-1. TIME AND DATES

In the last several decades, efforts to develop dating systems that are globally applicable have suggested the use of BCE (Before the Common or Current Era) and CE (Common/Current Era) as international standards. Medieval peoples and societies measured the passage of time in different ways, calculating years in relation to an important event. Jewish dating systems in the Middle Ages were based on the creation of the world, which was calculated to have occurred in 3761 BCE. The Byzantine calendar also measured time from creation, thought to be 5,508 or 5,509 years (depending on the month) before the birth of Christ. The Christian calendar used in medieval Europe considered the life of Jesus as the critical moment; the years leading up to his birth are designated BC (Before Christ) and those after it AD (*Anno Domini*, meaning "Year of the Lord" in Latin). The Islamic calendar pivots around an event in Muhammad's life, his move to Medina (Saudi Arabia); his teachings had become so controversial that he and his followers were forced to leave Mecca, where God had revealed the new faith to him. This event is called the hijra (meaning "migration" in Arabic). Islamic calendars thus use AH (*Anno Hegirae*, "Year of the Hijra"), which corresponds to the year 622 CE. The BCE/CE solution is practical but imperfect; it turns a system that acknowledged its Christian foundations into something that is allegedly "common" but still based on Christian understandings of time. It also does not align perfectly with dates in cultures whose years do not begin in January. For instance, the Hebrew year 4993, depending on the month, could correspond to either 1232 or 1233 CE; it is therefore written as 1232/33. Despite these problems, BCE and CE have become common, and we use them in this book.

through the eighth century CE. Their artistic heyday was in the seventh century, which was not their "middle age." *Art and Architecture of the Middle Ages* considers works and the societies that produced them that are coeval with the European Middle Ages, but it does not suppose that they relate to the original European concept of "medieval" or the primary cultural features associated with it, such as Christianity or the inheritance of ancient Rome. While

Fig. I-4. Tombstone of Katerina Ilioni, H 58 cm, 1340, rubbing; Yangzhou Museum. © Yangzhou Museum.

some concepts explored here were widespread—including the exalted status of rulers, a desire to link the present with a glorious and sometimes imagined past, and ostentatious display on the part of elites—that does not necessarily mean that examples of such concepts shared fundamental features or emerged from the same past. The works of art and architecture created by the societies and religious groups addressed in this book are included because they are compelling and creative, expressing the fluidity of cultural and political boundaries in their very wide and often interconnected world. Considering all of these peoples and religions under the admittedly imperfect rubric of the Middle Ages signals, above all, their contemporaneity during a particular slice of the historical timeline; it does not suggest their shared participation in a single story or overarching paradigm. This is why we do not give thematic titles to the book's chapters: to do so would be to claim falsely that everything that happened in a given slice of time can be reduced to a single idea.

A singular group of objects indicates the artificial and limited nature of the usual geographical definitions of the Middle Ages. Around 1340, the merchant Antonio Ilioni and his sister Katerina, who were from Genoa (Italy), were buried in the commercial city of Yangzhou in eastern China. Their graves were provided with tombstones (fig. I-4). Katerina's depicts a seated Virgin Mary holding the baby Jesus and, below that, the torture on a spiked wheel and then the beheading of St. Catherine of Alexandria (Egypt), all

common subjects in medieval Christian art. However, the free-floating placement of these carved figures reveals their basis in illustrated Buddhist teachings, images that were familiar to the Chinese artists responsible for carving the stones for these Christian foreigners. The decorated tombstones fall within the time span generally assigned to the Middle Ages, and their subject matter is in keeping with long-standing medieval Christian traditions, but their location in China and their style set them apart from carved tombstones in contemporary Italy. For these reasons, they are rarely studied by historians of European medieval art. Yet the tombstones provide important insight into the experience of medieval people—including women—as protagonists in cross-cultural encounters and as patrons or recipients of works of art meant to commemorate them.

Katerina Ilioni's tombstone shows that the movements of medieval people unsettle traditional ideas about the geographical and cultural underpinnings of the Middle Ages. Another burial, this one from the steppes (grasslands) of southern Ukraine, shows that the movement of objects also disrupts those categories. The monumental Chungul Kurgan was excavated in the 1980s (*chungul* means "boggy" and is the descriptive place-name; a *kurgan* is an artificial mound marking a grave); it held the body of an unidentified man, along with forty items intended to secure his well-being in the afterlife. This "prince" belonged to the Kipchak people, Turkic nomads who lived in the region north of the Black Sea and traded with settled populations near and far. In addition to many weapons and pieces of armor, the objects placed in the man's burial include an ornamented ceramic jar for holding pharmaceuticals (likely made in Syria), a large, ornate metal drinking cup with a lid (crafted in northern Germany), and a silver cup with glass inlay (probably made in Constantinople) (fig. I-5).

Brought together in the decades around 1200, these varied objects indicate the elite dead man's connections to faraway places via long-distance trade networks. They also show how the imported goods were put to new uses in this particular cultural context. For example, the lidded cup from Germany, a type used for sharing drinks at a banquet, was placed at the shoulder of the deceased and tilted toward his mouth; it contained a liquid with local herbs and flowers that have medicinal properties, including valerian, rose, borage, belladonna, and mint. Given that the man's skeleton bears signs of arthritis and a partially healed trauma to the skull, the vessels and their contents suggest his community's desire to comfort him in his afterlife. Taken as a whole, such buried objects can be understood as forms of wealth that have been removed from circulation to benefit the dead and to indicate the status of the entombed person. The burials of the Kipchak man and Katerina Ilioni demonstrate that the geographical boundaries conventionally used to characterize medieval art are both artificial and porous.

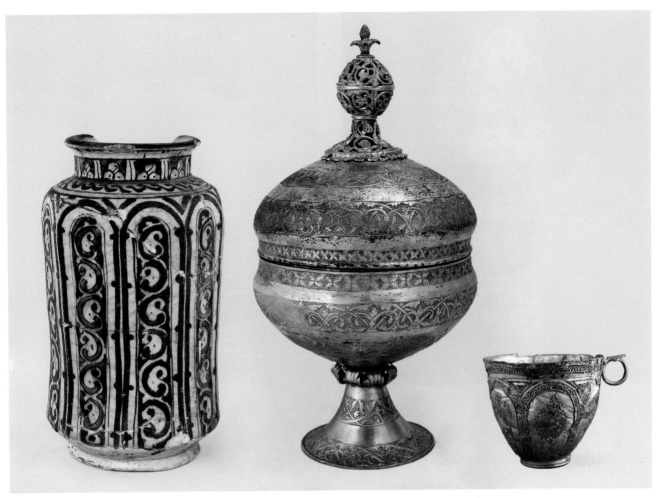

Fig. I-5. Chungul Kurgan finds, to scale, ca. 1200, *(left)* pharmaceutical jar, Syria; *(center)* lidded drinking cup, northern Germany; *(right)* Byzantine silver cup, 8.3 × 9 cm. Muzei istorychnykh koshtovnostei Ukrainy, Kyiv. *(l)* © D. V. Klochko; *(c)* © D. V. Klochko; *(r)* © Yuri Rassamakin.

Defining "Art" and "Architecture"

The buried objects, tombstone, and cross discussed so far prompt questions about what the word *art* in the book's title means. Today, artists, critics, viewers, and politicians debate what constitutes art and who has the authority to determine its characteristics. Many people in North America and Europe tend to think of art as paintings on canvas or sculptures on pedestals—the mainstays of famous museums and blockbuster exhibitions. That perspective partly derives from the priorities and attitudes of the Italian Renaissance (yet again!) and the prominence of that era in the nineteenth and early twentieth centuries, a critical time in the history of collecting, museums, and the academic discipline of art history. Also reflecting earlier priorities are the working methods of early art historians, who often highlighted the formal and stylistic features of works of art—such as the particular use of lines, colors, or spatial depth—and the status of these works as "art for art's sake." Questions about context, function, or meaning were less frequently probed.

In the Middle Ages, "art" was not an autonomous concept pertaining to isolated objects meant to be admired primarily for their originality or aesthetic qualities. The Latin word from which *art* derives, *ars*, means "skill" or "craft." Medieval artifacts—things made with skill or craft—have aesthetic qualities that can be described according to stylistic and other criteria (such as whether a composition is symmetrical), but medieval people invested objects with these characteristics for reasons that have little to do with modern concepts of art. For example, among the most highly prized and revered medieval objects in Christian settings were reliquaries; these containers hold relics, the bodily remains of holy figures like Jesus and Mary or objects associated with them that are thought to possess and transmit sacred power. Many reliquaries are fashioned of precious metals and encrusted with gems; some are decorated with scenes of the holy person's life. One cross-shaped reliquary made of gold and a variety of polished gemstones depicts a large hand at the center (fig. I-6). Crafted in the thirteenth or fourteenth century in the Armenian Kingdom of Cilicia (southern Turkey), it held relics of St. John

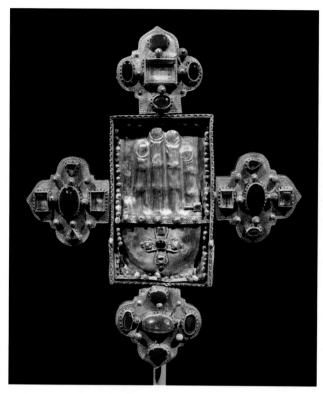

Fig. I-6. Reliquary of St. John the Precursor, 26.5 × 22 cm, fourteenth century; Mother See of Holy Etchmiadzin, Vagharshapat. Photo by the authors.

Fig. I-7. Colophon, Hebrew Bible commentaries, 39 × 28.5 cm, 1232/33; Munich, Bayerische Staatsbibliothek, Cod. hebr. 5, vol. 2, fol. 252v. Photo from Bayerische Staatsbibliothek München.

the Precursor, the holy man also known as John the Baptist, who preceded Christ. The reliquary's lifelike representation of the back of John's right hand emphasizes the importance of actions John performed with that hand, especially pouring water from the Jordan River onto Jesus's head and blessing him. This event became the model for acceptance into Christianity, and the rite, called baptism, remains a significant event for many Christians today. The design and materials of the reliquary celebrate John's continuing presence and power in the relics and allude to the rituals that priests performed when emulating him.

Whereas the Cross of Herimann and Ida tells us that Archbishop Herimann had it made, some objects reveal who actually produced them and why. A large volume of Hebrew commentaries on the Bible has a colophon (words added to a book that describe its production or ownership) that says, "I, Solomon ben [son of] Samuel from the city of Würzburg [Germany], have written these commentaries . . . for Joseph ben Moses in the year 4993 after the creation of the world [1232/33]. And may God give him the merit to study them and to bequeath them to his sons and grandchildren until the end of all the generations, Amen" (fig. I-7). The word *written* here does not mean that Solomon was the author of this volume of commentaries, the bulk of which had been assembled in the late eleventh century in Troyes (France) by the Jewish legal authority Rabbi ("teacher" or "master") Solomon ben Yitzhak, known by the acronym Rashi (1040–1105). Solomon ben Samuel was

the scribe, the professional who wrote out the book's words by hand, even though it is clear from the script that he had a helper write some parts of the book (this person was not named in the colophon). The techniques, materials, and artistic styles of the Jewish book and the Christian cross are important features for art historians to consider, but such objects were particularly meaningful because of the roles they played in the societies that produced them. In other words, stylistic and material qualities helped make these objects beautiful, luxurious, or captivating, but the objects were not created for the sole purpose of being beautiful, luxurious, or captivating; rather, they were powerful ways to express ideas about piety and holiness.

This idea of emphasizing the sacred through ornamentation also dominates medieval architecture. The congregational mosque in Tinmal (Morocco) was commissioned by the ruler 'Abd al-Mu'min around 1153 for the local Muslim community's Friday services, at which a public sermon was delivered—hence its designation as a Friday mosque or

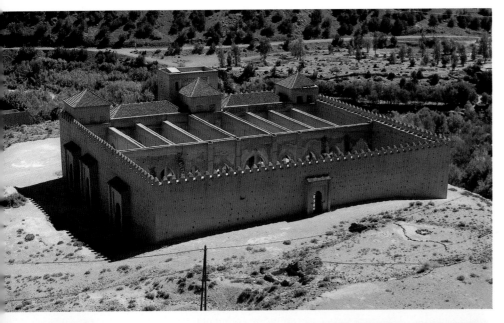

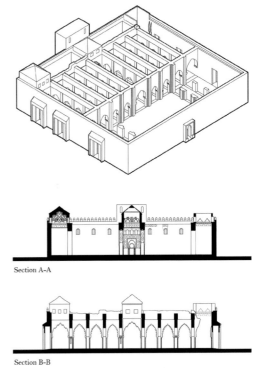

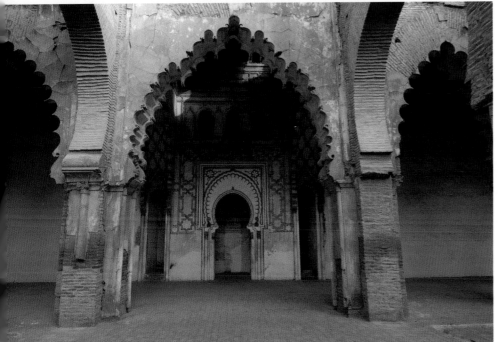

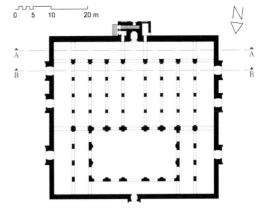

Figs. I-8a and I-8b. Friday mosque, Tinmal, 1153, *(top)* exterior from the west; *(bottom)* interior toward mihrab. *(t)* © Peter Nagy/Manar al-Athar, CC BY-NC-SA 2.0; *(b)* mauritius images GmbH/Michael Runkel/Alamy Stock Photo.

Fig. I-9. Friday mosque, Tinmal, 1153. Drawings by Navid Jamali.

a *masjid al-jami'* (communal mosque). The mosque's thick, undecorated walls reveal little of what lies behind them (fig. I-8a). The main portal opens into a small courtyard, defined by rows of columns to the right and left and with the entrance to the prayer hall straight ahead. Inside this hall, rectangular brick supports carry wide horseshoe-shaped arches that lead viewers and their eyes toward the most important place in the mosque: the qibla wall, which marks the direction of prayer toward Mecca. The arches in front of this wall are more ornate than others in the mosque, with scalloped profiles instead of smooth ones (fig. I-8b). The ornament intensifies around the mihrab, the niche

in the qibla wall before which the prayer leader stood. On the face of the mihrab, geometric patterns in brick contrast with those in white carved plaster, and an elaborate dome rises above. Degrees of ornamentation signal degrees of holiness and help guide worshipers through the space.

With its extensive workmanship and careful coordination of visual and functional features across multiple spaces, the Tinmal mosque fits conventional definitions of "architecture." In 1943 an influential scholar wrote, "A bicycle shed is a building; Lincoln Cathedral is a piece of architecture. . . . The term architecture applies only to buildings designed with a view to aesthetic appeal"

Box I-2. HOW TO READ ARCHITECTURAL DRAWINGS

Because buildings are three-dimensional structures that cannot be fully appreciated and comprehended with a single image, architects have developed conventions of graphic representation to help understand and convey the built environment. Architectural drawings reveal key features of a building, including its shape, dimensions, and configuration; they also show how the exterior relates to the interior and how spaces are arranged and shaped. The most common type of architectural drawing is a **plan**, which shows the layout of a building. A plan is generated by imagining a horizontal slice, usually a meter or so above the floor, that cuts through solid walls and other vertical elements; it represents solid parts as black and open spaces as white. At the Tinmal mosque, the outer crenellated walls seen in the photograph translate into the thick rectangular outline of the plan (compare figs. I-8a and I-9 *top, bottom*). The imagined horizontal slice cuts through many vertical supports, whose varying shapes help create differences in the interior spaces. Simple piers (rectangular supports) appear on the left and right sides of the courtyard, and cross-shaped piers demarcate the wall marking the entrance to the prayer hall; compound piers (vertical supports composed of multiple shafts around a central core) emphasize the qibla wall. The design of a pavement or ceiling may also be included in a plan; to differentiate them from the plan itself, pavements are generally drawn as thinner lines and ceilings as dashed lines. In the Tinmal plan, the lighter dashed lines connecting the piers represent the arches that supported the ceiling, some of which are visible in the photograph. The dashes indicate

that the prayer hall is divided into nine aisles that run perpendicular to the qibla wall.

Another common type of architectural drawing is a **section**, a vertical slice through a specific part of a building (fig. I-9 *middle two*). Sections show how the different levels of a building, including stories, staircases, ceilings, and domes, relate to one another. As with plans, solid structures that the vertical slice cuts through are shown as black. A dashed line and arrows on an accompanying plan indicate precisely where the section cut occurs (at Tinmal, there are two section cuts in front of the qibla wall). **Elevations** are representations of the vertical face of a structure, showing added details like the design of a window frame or position of wall paintings. They can represent the interior or exterior of a building. Elevations are often combined with sections; for example, Tinmal section A–A shows the detailed ornamentation of the qibla wall that rises up behind the section cut (compare fig. I-8b). **Axonometric reconstructions**, informally known as axons, combine plans, sections, and elevations to convey a three-dimensional sense of a building. Axons are generated by rotating a plan 45 degrees and then projecting section and elevation details up from the plan (fig. I-9 *top*). This book uses these conventions of architectural representation to show the features of extant buildings and to convey the character of lost ones. While such graphic devices have been an important part of architectural practice for centuries, used even in ancient Rome, they were rarely made in the Middle Ages. The plans included here and in similar books derive from generations of efforts to measure, draw, or reconstruct the components of medieval buildings.

(fig. I-10). Historians today dispute this definition mainly for two reasons. First, even the most rudimentary do-it-yourself project can be made with an aesthetic intent. Second, as researchers in archaeology and material culture have long argued, all artifacts are expressive of the cultures that made and used them, whether they are huge and elaborate buildings like Lincoln Cathedral or vessels such as those found at the Chungul Kurgan. Even a bicycle shed can communicate a great deal about its builders and users, such as their access to and use of particular building materials, their design sensibilities, and their attitudes toward the body, work, leisure, and the natural world. A few similarly utilitarian structures survive from the Middle Ages, including forts and baths, although many others are known from archaeological investigations. Whether standing, in ruins, or excavated, they are as worthy of study as ornate works like the Tinmal Friday mosque or the cathedral of Lincoln.

The ideas and values underpinning that 1943 definition were once widespread among art historians. Painting, sculpture, and architecture were thought to have high economic, social, and intellectual value and consequently

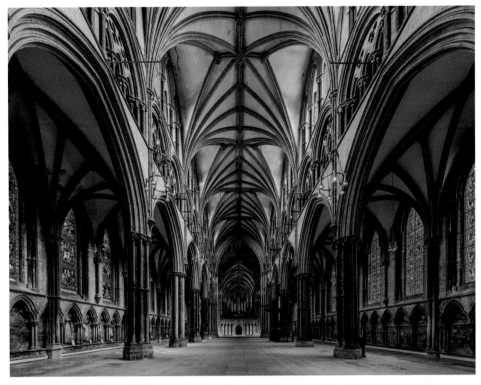

Fig. I-10. Cathedral, Lincoln, begun 1072. Wikimedia Commons/David Iliff, CC BY-SA 3.0.

were called high or fine arts; they were considered superior to so-called low, applied, or minor arts—works considered less sophisticated and associated with crafts, daily life, or popular culture (for instance, needlework, coins, or graffiti). Textbooks tend to reinforce these ideas by emphasizing "masterpieces," works that were very influential and considered exceptional by art historians. *Art and Architecture of the Middle Ages* takes as its starting point broader and more flexible definitions of art and architecture; it is not limited to "fine" examples or masterpieces but encompasses works of varying quality, use, ambition, and influence. It includes monuments that belong to the canon of medieval art, the body of works that earlier generations of scholars established to give shape to and teach the field. However, because art history's canons were built on suppositions, priorities, or ideals that now seem outdated or difficult to support, including the high-low distinction, this book also explores works that illuminate the day-to-day experiences of less privileged people in medieval society. It covers all scales and media, from cities to gems, from spectacular one-of-a-kind monuments to mass-produced works. Yet because of the limitless array of medieval works and the limited format of a book, our selections cannot suit all purposes; many could be replaced by other examples and supplemented with additional comparisons—tasks facilitated by the website that complements this book, as described in the preface. What these objects share is that even when their function was basically utilitarian, they received additional workmanship or decoration and were thereby invested with heightened significance.

The point can be demonstrated with two spoons from the Byzantine world, one from the fourth or fifth century, the other from the seventh. The earlier one consists of an oval bowl and a handle terminating in short prongs, perhaps for breaking seafood or eggshells; about the same size as a typical household teaspoon today, it is made of copper and lacks decoration (fig. I-11 *top*). The other example is much larger—it weighs five times more—and is fashioned from silver with decoration on both sides of its bowl and handle (fig. I-11 *bottom*).

Both utensils are now in museum collections because of their rarity and age, and art historians have analyzed them because both reveal something about the cultures that produced them. Yet the second one reveals more: it was purposefully given aesthetic qualities that differentiate it from other objects of its type. The inside of the curved bowl displays a running lion, its mouth open as if in mid-roar; the body of the animal protrudes, and shallow incised lines represent fur. A palm frond is engraved on the back of the bowl. The iconography (subject matter) suggests attitudes toward the natural world, perhaps in this case hunting and domination. This hypothesis can be advanced because the spoon was found with at least ten others of the same design but featuring different animals, including a tiger, stag, bear, bull, and hare (fig. I-12). They form part of the Lambousa Hoard (a group of precious objects deliberately hidden with the intent to retrieve them later) found in Cyprus. Hunting was a common aristocratic pastime in medieval societies. The spoon's expensive material, refined workmanship, and iconography thus tie

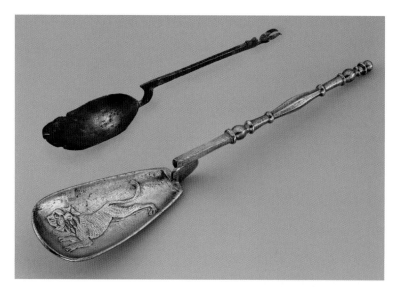

Fig. I-11. Utensils, *(top)* copper spoon, 4.2 × 17.5 cm, fourth–fifth century; *(bottom)* silver spoon, Lambousa Hoard, 4.65 × 25.5 cm, seventh century. (*t*) Art Museum University of Toronto, Malcove Collection M82.423, Gift of Dr. Lillian Malcove; © Art Museum University of Toronto; (*b*) British Museum, London; © Trustees of the British Museum; all rights reserved.

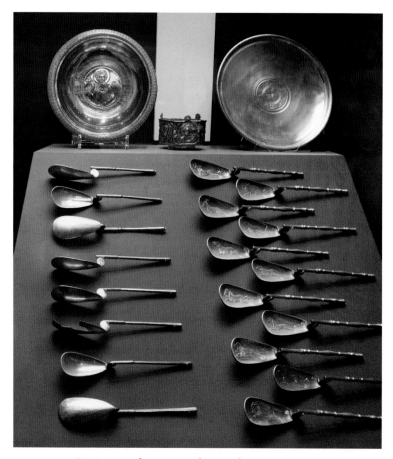

Fig. I-12. Lambousa Hoard, seventh century; British Museum, London. Wikimedia Commons/Jononmac46, CC BY-SA 3.0, and Francesco Gasparetti, CC BY 2.0.

it to elite users and differentiate them from people who used less spectacular implements, like the copper spoon or the wood and bone ones used by most medieval people.

The silver spoon from the Lambousa Hoard signals three important things to keep in mind about medieval art that affect its interpretation (fig. I-11 *bottom*). First, the works that survive from this period represent only a small fraction of what was originally made or built. The spoon's survival depends on a chain of arbitrary events: its owners likely gave it to a local church to express their piety; it was buried for safekeeping during a period of upheaval; it was not discovered until 1897; it was not melted down, as were some other spoons in the same hoard; and it was sold to the British Museum in London (England). If all of these events had not happened, the spoon surely would have been re-cycled into something else or melted down for its cash value. People have tried to quantify how much medieval art has been lost; it has been hypothesized that only 2 per-cent of one type of Byzantine enamel work has survived, and the loss rate for precious metalwork, fragile textiles, or parchment (animal skin used for many medieval books) is probably comparable. Some buildings, such as churches or mosques, are more likely to have been appreciated than barns or poor domestic shacks, and they have a better sur-vival rate than smaller monuments, but even these were subject to losses from such natural and human forces as earthquakes, floods, fires, wars, or reconstructions.

This brings us to the second characteristic of most me-dieval art and architecture. Human activities and natural events, along with simple wear and tear, mean that extant medieval buildings survive only in part (note Tinmal's lost roof, fig. I-8) or have been repaired or partially rebuilt at least once, and often several times, during the centuries since they were first constructed. One job of art histori-ans is to figure out what is original in a work of art, along with when and why repairs or renovations took place. This holds true for all types of art, from sprawling building complexes to wall paintings to jewelry. On the Cross of Herimann and Ida (fig. I-1b), Jesus's left forearm clearly has been replaced, and his side of the cross probably had three more plaques of gold vines like the one behind his body. These changes alter our understanding of the object's orig-inal appearance.

The third feature that shapes interactions with and per-ceptions of medieval art is that most surviving objects are displayed in cases in museums, like the spoons from the Lambousa Hoard (fig. I-12). They clearly were meant to be handled and viewed in other environments. Art histo-rians try to determine how works of art were used, seen, and understood both at the time of their production and in later periods. Each artifact would have been placed in a space that supported particular activities, in concert with other things that had their own material and visual features. We can infer that the elaborate spoons from

the Lambousa Hoard played a role in Byzantine feasts, in which diners were likely using additional glass, metal, or ceramic tableware; perhaps some of them were eating the very animals depicted on their utensils. The imagery of the beasts might invite their eyes and minds to connect the food they were sharing to the hunting activities that brought the meat to the table. At the same time, the spoon also brought other senses into play. A diner would feel its complexity as he or she manipulated it, from the spherical finial at the tip through the varying beadlike bumps along the handle. (Note that the design privileges a right-handed user; lefties would see the animal upside-down.) The diner also might feel the spoon's temperature change, for silver conducts heat very quickly. If the spoon were used to scoop food from the table to the mouth, it would bring the meal's aromas closer to the nose; the bowl's protruding furry animal and incised palm fronds could be felt in the mouth, creating sensations that supplemented the taste, smell, and look of the food. The spoon, then, was part of a complex web of sensation, expression, and meaning in which people, objects, animals, and food interacted in a specific social setting. This larger environment reminds us that medieval art and architecture are often considered exclusively *visual* arts, but they can and did register well beyond the realm of sight.

Organizing Principles

The wide geographical and chronological scope of *Art and Architecture of the Middle Ages* creates opportunities as well as challenges. Most surveys focus on the arts of western Europe or Byzantium or Islam—three major medieval entities shaped by political, religious, social, and/or linguistic ties. Those books highlight monuments that belong to an established canon of influential works of art that tend to tell a particular story about art's progress through time, what scholars call a master narrative. But when the walls separating the three entities come down, the story changes; and when groups outside those three major ones are considered, it changes again. This book does not uphold any overarching master narrative or attempt to generate a new one; it is organized chronologically, which respects the unfolding of events in time, but it does not tell one single story. We have identified five broad themes that resonate across the medieval world: (1) artistic production, (2) status and identity, (3) connection to the past, (4) ideology, and (5) access to the sacred. These themes, which often overlap, provide a new and productive structure for discussions of specific works; at the same time, they permit a flexible comparative framework in which objects and buildings from diverse settings appear together and are in dialogue.

Artistic production addresses such issues as workshop practices, the use of copies and models, materials, and

techniques. The Byzantine lion spoon is again instructive (fig. I-11 *bottom*). As with most medieval objects, the specific artist or group of artists who made it is unknown, but close inspection of the piece reveals the techniques that the maker(s) used. Its two main pieces were produced separately and then joined, as was typical of silver spoons at this time. The pieces were themselves produced in different ways. The handle's varied beadlike geometric forms suggest that it was made in a mold, and the ten other animal spoons in the hoard have the same handle, indicating standardized production. By contrast, the bowl of the spoon appears to have been formed by manipulating a sheet of silver. The relief (projecting form) of the lion was likely created by hammering the sheet from the front and back; once its basic shape was created, the lion was finished with small sharp tools that incised not only the fur patterns but also the palm leaf on the back of the bowl. In other words, the spoon reveals aspects of how it was made centuries ago. An analysis of facture—how an artifact shows the manipulation of specific materials and techniques—requires some familiarity with those materials and techniques. Analysis of facture also requires close looking, an essential skill that anyone studying art history must practice. Close looking, or visual analysis, focuses on the building blocks of a work of art, including its color, line, shape, texture, and space; it is a method that can be applied to anything, from silver spoons to medieval mosques to today's shopping malls.

Art and Architecture of the Middle Ages also explores the social dimensions of making art, including the status of artists and the roles and motives of patrons, the people who commissioned or otherwise caused a work to be made. Far less is known about medieval artists than about their successors; most medieval artists remained anonymous, and relatively few signed their works, although artists' signatures were more common in the Islamicate world. This does not mean that artists lacked creativity or interest in the things they made; on the contrary, they were highly inventive, and no two medieval objects are exactly alike. Nevertheless, most medieval societies did not celebrate individual artistic talent in the way that ours does; contemporary art's cult of originality and rule breaking played no role in medieval ecosystems of cultural production. The social status of artists was generally low, except in the Islamicate world where the skill of calligraphy (*kalos* means "beauty" and *graphe* means "writing" in Greek) was revered because Muslims believe that the Qur'an, the holy book of Islam, was dictated by God to Muhammad via the angel Gabriel, and consequently Qur'ans merited embellishment with beautiful writing. Even when there is evidence of an artist's name, the historical record usually has not left enough details to reconstruct that person's training or identify more than a few works by his or her hand. In the case of Solomon ben Samuel, who copied the Hebrew Bible commentaries for Joseph ben Moses,

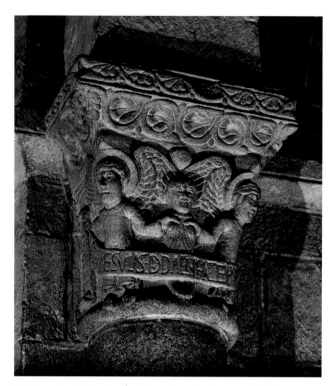

Fig. I-13. Capital, cathedral, Santiago de Compostela, late eleventh century. Album/Alamy Stock Photo.

everything we know about his training as a scribe derives from examining the book itself. In addition, the book's colophon provides evidence of how he understood his artistic work: as an enduring heirloom that would facilitate the devotional practices of Joseph's family until the end of time (fig. I-7). Solomon's scribal activity also enhanced his own religious status, enabling him to incorporate himself into prayers for Joseph and his family; as he wrote in the colophon, "May the heavenly spirit be poured out onto us and may his secrets illuminate our eyes" and lead to "our" redemption before God.

The cathedral of Santiago de Compostela in Spain shows what the evidence for medieval artistic production often looks like. This church held the remains of St. James the Greater, a follower of Jesus who allegedly converted Spain to Christianity. Santiago became a popular destination for Christian pilgrims (people traveling primarily for religious purposes) who sought proximity to the sacred relics of St. James in that place. Christians often appealed to saints like James to intercede with God for their salvation. To accommodate growing crowds, construction of a larger church began in the last quarter of the eleventh century. By studying the styles, techniques, and iconography of the architecture and sculpture, art historians have offered hypotheses about where the artists named in the textual sources—Bernard the Elder, Rotbertus, and Mateo—learned their skills and where they worked later. Yet we know next to nothing about the lives of these individuals.

Only for the last centuries of the Middle Ages is there a well-documented body of works for some named artists and architects (what art historians call a corpus or oeuvre) accompanied by detailed biographical information.

Medieval sources pay more attention to the patrons, the people who commissioned works of art and architecture, like Archbishop Herimann of Cologne or 'Abd al-Mu'min at Tinmal. Some medieval texts describe the activities and motives of patrons in detail, often exaggerating or downplaying them for self-serving purposes. Works of art also glorify patrons. At Santiago, a carved capital (the top of a column) in the main chapel behind the tomb of St. James features a figure linking arms with angels; the accompanying inscription identifies him as Diego Pelaez, the bishop who initiated construction of the church (fig. I-13). Text and image work together to attribute his blessed state in heaven to his patronage. His actions, like those of Solomon ben Samuel, served God and the faithful. Unlike Solomon, however, Diego did not make anything; his contribution was administrative and financial. At Santiago de Compostela, and at myriad other places across the medieval world, patrons are more prominent in the historical record—and in the works of art themselves—than artists and builders, who have largely remained anonymous.

This emphasis on patrons derives in part from the fact that in most medieval settings, works of art were commissioned rather than produced to sell on the open market. Yet artists still contributed a great deal to the project, even if patrons held the purse strings and had some authority over the work. Overemphasizing patronage can obscure aspects of a work's genesis and meaning. Archbishop Herimann commissioned the cross, but it is possible that he had it made for his sister, Ida; she is depicted in a far more active pose than he is. If the object was a gift, then the questions we ask of it change. Does the cross still convey Herimann's ideas and taste? Does it reflect well-informed opinions about what his sister would like or need? Or might it embody opinions about what she *should* like or need? If we move from patronage to reception—that is, how a work was received and perceived by its users—then we would need to look at Ida and the community of nuns over which she presided, not at Herimann. That, however, would take us away from artistic production and on to the book's other themes.

Ideas and attitudes about **status and identity** animate many works of medieval art and architecture. When people paid for a building or object in the Middle Ages, they had certain expectations about what they would receive, as they do today; in many cases, their commissions relay information about what they thought of themselves and the image they wished to project. With the volume of Hebrew Bible commentaries, Joseph ben Moses brought a classic religious text into his home, signaling his family's literacy and facilitating their participation in local circles of study

Box I-3. WHAT'S IN A NAME?

Medieval works of art and architecture were not given proper names like many later works, such as *The Scream* by Edvard Munch (1893) or *Campbell's Soup Cans* by Andy Warhol (1962). This absence has practical implications: what we call medieval objects is usually descriptive and therefore not italicized. An exception is the *Très Riches Heures* (French for *Very Rich[ly Decorated] Hours*). This book received the nickname in an inventory made when its owner died, probably to differentiate it from other, less sumptuous prayer books of the same type (hours are the specific times of Christian prayer), and the name stuck (fig. 10-18). Many medieval books are designated by their contents and current location, such as the Rossano Gospels now in Rossano, Italy, but certainly not made there (fig. 3-19). Others, like the Lindisfarne Gospels (figs. 4-25 and 4-26), are known by their probable place of production (although it now is housed in the British Library in London). Manuscripts also are referred to by their shelf mark, a unique descriptive institutional identifier that is often a combination of numbers and letters similar to a library call number (the shelf mark of the Lindisfarne Gospels is Cotton MS Nero D IV); these are included in the captions of our book's illustrations but not in the main text. Medieval buildings are usually identified by their institutional type and location, sometimes in conjunction with the name

of a founder, like the complex of Qala'un in Cairo, Egypt (fig. 9-9). Some medieval works are designated by their findspot, meaning where they were discovered in an archaeological context, such as the Lambousa Hoard. Other monuments can be identified by their current location in a museum, archive, or library; some bear the name of a collector who owned it long ago, like the Bobrinsky Bucket now in the State Hermitage Museum in St. Petersburg, Russia (fig. 7-24). But most works are designated and identified by some combination of characteristics: the type of thing it is, imagery, material, technique, and location. The array of methods used to identify medieval works of art means that designations may change as new information surfaces or attitudes shift. For instance, the Cross of Herimann and Ida was called the Cross of Herimann before historians began paying attention to medieval women. When conventional names are misleading, we have changed them for accuracy and clarity. For example, the famous textile made for and still located in Bayeux (France) is here called the Bayeux Embroidery, not the Bayeux Tapestry as it is traditionally known, because it is embroidered (stitched by hand) and not woven on a loom as tapestries are (figs. 6-28 and 6-29). Naming and renaming things are practical matters, but they also reflect changing emphases within society and art history.

and prayer. Yet the commission broke with conventions of contemporary Hebrew book design by adding painted narratives to the text. This innovation required collaborating with Christian artists, who were used to painting the stories found in the Christian Old Testament (which is based on the Jewish Bible). With over five hundred large folios, fifteen narrative scenes, and additional painted diagrams and decorations, the sumptuous book expressed Joseph's dedication to learning but also boldly asserted his wealth, sophistication, and ability to mediate between Christians and Jews. The patron's image, however, was not included. By contrast, when Herimann commissioned the personalized cross he must have wanted to emphasize his relationship to his sister and ensure that they be remembered: to that end, he had both their names and images incised on the work. The object also must have been intended to convey and recall the archbishop's wealth and power, which were materialized in gems and gold, visualized in the staff

he is shown holding, and spelled out in his title. Although these examples are religious works of art, issues of status and identity are no less prevalent in secular spheres, as the Lambousa spoon suggests.

Connection to the past is another major theme treated in the book. In some cases, works were made to refer consciously to older models whose form, style, material, or imagery was deemed significant. In others, references to the past reflect inherited knowledge or aspects of an overall conservatism, but they also can appear in a radical new guise or reveal great creativity. The lapis lazuli female head used for Jesus on the Cross of Herimann and Ida illustrates a particular kind of material reference to the past: *spolia*, meaning older, often ancient materials that were redeployed in European, Byzantine, and Islamicate art during the Middle Ages. Reusing the ancient Roman head may have indicated the distinguished history and wealth of Herimann and Ida's family, but it also must have asserted

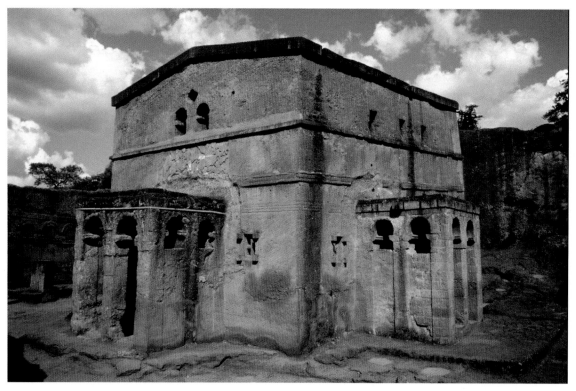

Fig. I-14a. House of Mary, Lalibela, ca. thirteenth century. © SZ Photo/Hans Winter/Bridgeman Images.

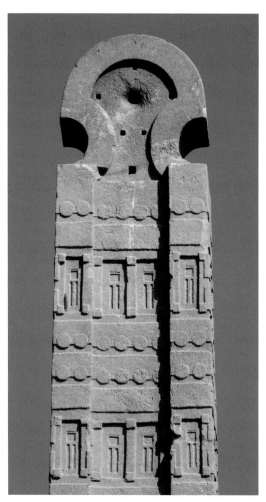

Fig. I-14b. Funerary monument, detail, Aksum, fourth century. Wikimedia Commons/O. Mustafin, CC0 1.0.

something about Jesus: that he, too, was of another time, rare, precious, as well as nurturing and motherly—and of uncanny power. Although we will never know exactly why the blue head appears on this cross, considering a range of hypotheses moves us closer to uncovering the meanings of medieval objects that reemploy ancient materials.

The use of older forms may be seen in a complex of buildings spread across approximately two square kilometers near Lalibela in Ethiopia. Some buildings there may have reconfigured older houses and fortifications, but most were reshaped as Christian churches under the patronage of King Lalibela (r. ca. 1200–25), after whom the complex is now named. Stringcourses (protruding horizontal bands) wrap around the exterior of the House (i.e., church) of Mary, Beta Maryam; rectilinear beamlike shapes, some of which are set perpendicular to the walls, articulate the window openings on the lower floor (fig. I-14a). These forms replicate those found in palaces and multistory funerary monuments in Aksum (Ethiopia), the capital of one of the world's first Christian kingdoms, established in the fourth century (fig. I-14b).

There is, however, a major difference: the earlier Aksumite style derives from the use of wood beams as the primary building material, and Lalibela translates that into stone. Furthermore, the building technique shows remarkable ingenuity. Most built environments are made by adding materials to empty space, but Lalibela was created in the opposite way, by removing earth and rock from natural terrain. The House of Mary is what remains after years of artful quarrying: a freestanding structure composed of a

single mass of stone (fig. I-15). The section drawing of the House of Mary gives a sense of how much of the hill has been removed to create the building and how much architectural ornament was carved in the church's hollowed-out interior. The references to Aksumite buildings linked King Lalibela to that earlier era of Ethiopian history and its prestigious rulers, while placing the references in a wholly new setting that expressed his piety and power.

Some works of art linked contemporary religious ideas to the past in order to make connections across time and space. King Lalibela commissioned multiple altarlike supports for the complex of churches in Ethiopia. Each was carved from a single piece of wood, like the churches carved from a single block of stone. Some were called a *tabot*, and others supported a tabot, which in Ge'ez, the language of the Ethiopian Church, is the word used for the Ark of the Covenant, the container made to protect the Tablets of the Law (the Ten Commandments) that God gave to Moses on Mount Sinai. In the tenth century BCE, King Solomon built a temple in Jerusalem to house the Ark and its contents; they were kept in its innermost chamber, the Holy of Holies. Understood as the house of God on Earth, the Temple became the center of Jewish religious practices, activities, and aspirations. It was rebuilt twice according to the Bible's descriptions of its original layout (1 Kings 6), but not reconstructed after the Romans dismantled it in 70 CE (fig. I-16). The Ethiopian national epic, the *Glory of the Kings* (*Kebra Negast*), connects Lalibela's kingdom to these biblical events. Probably edited in the early fourteenth century, it asserts that the Ark of the Covenant had flown from Jerusalem to a new home in Ethiopia, where it could rest permanently among the chosen people descended from King Solomon and the queen of Sheba (1 Kings 10; 2 Chron. 9), who resided in the region. By calling these wooden objects "arks," Lalibela aligned himself with Moses and Solomon, the site with the Temple of Jerusalem, and his people with the biblical Jews.

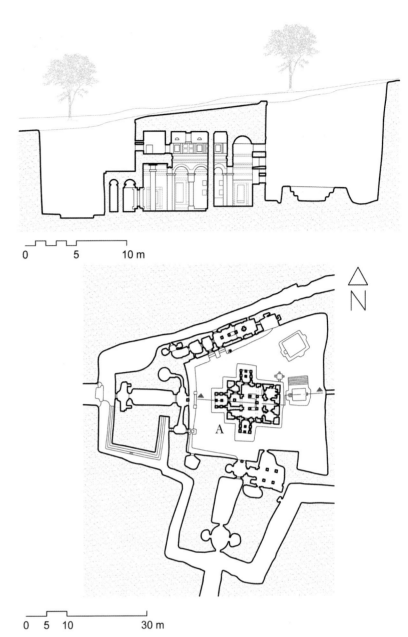

Fig. I-15. Lalibela, ca. thirteenth century; A=House of Mary. Drawings by Navid Jamali.

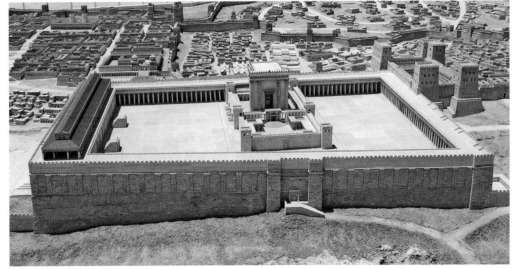

Fig. I-16. Model of the Temple in Jerusalem before 70 CE; Israel Museum, Jerusalem. Wikimedia Commons/ Ariely, CC BY 3.0.

Fig. I-17. Ark of Melchizedek, Lalibela, 72 × 33 × 36 cm, late twelfth–first third of thirteenth century. Photo by Michael Gervers.

Another connection to the past is evident in the dedication of one of Lalibela's arks to Melchizedek, the king and priest named in the first book of the Jewish Bible and Christian Old Testament (Gen. 14:18–20) (fig. I-17). The inscription says, "Melchizedek, priest of the Lord, intercede and pray for me, Lalibela, sinner and wrongdoer, so that God may be merciful and have pity on me." Melchizedek offered bread and wine to Abraham, the Jewish patriarch; because Jesus later told his followers that bread was his body and wine his blood, Christians see Melchizedek as a precursor of Jesus and of Christian priests who performed the ritual mass in church. The ark's dedication to this biblical figure connected the Ethiopian priests who used it to both Melchizedek and Jesus. Its form supports this function, for a hinged door provides access to holy substances inside. Interpreting episodes in the Old Testament as prefigurations of the New Testament is called typology, and Melchizedek is a type (antecedent) for Christ, his blessing a type for the Christian mass. Typological imagery was a potent way to assert Christianity's roots in Judaism and thus make Christianity seem an inevitable part of God's unfolding plan.

The fourth major theme explored in this book is **ideology**. Like many terms discussed in this introduction, this word requires some explanation. *Idéologie* was coined in France in the 1790s to criticize French revolutionaries for allegedly promoting policies based on ideas rather than facts. Since then, the meanings and implications of the word have been elaborated, studied, and debated, from Karl Marx's critiques of capitalism in *Das Kapital* (1867) to scholarship in many fields, including philosophy, political science, and literary criticism. *Art and Architecture of the Middle Ages* uses the term in precise and limited ways suited to an introductory survey. In short, ideology is a belief system, here expressed in works of art, that relates to power structures. Ideological works of art can stabilize or legitimize the power of a dominant individual, group, or community, but they can also promote alternative, destabilizing ideas. How works of art do this is an important aspect of ideology. They may exaggerate or idealize forms to make a claim; they may add inscriptions to emphasize that claim. Through imagery, inscriptions, or materials, they may denigrate people or ideas that challenge dominant views.

In medieval art, ideology often has to do with religious doctrine (teachings held to be true) and with establishing correct interpretations of a theological point, such as the permissibility of images of the divine. One of the ten Laws given by God to Moses on Mount Sinai prohibits making, worshiping, and adoring images and sculptures; only God himself should be worshiped, not images of him (the second commandment; Exod. 20:4–5 and Deut. 5:8–9). This commandment led to representations of God being strictly prohibited by Jews and at times seriously debated by Christians. Two ideological approaches to divine representation clash in the Hebrew manuscript copied by Solomon ben Samuel. While the book's Christian painters must have worked closely with the scribe and patron, they either were not familiar with or did not respect Jewish prohibitions against representing the divine. In a depiction of God's promise to the three founding Jewish forefathers or patriarchs (Abraham, Isaac, and Jacob), God was shown in the sky at the upper right, following Christian conventions. This detail was unacceptable to the book's Jewish owners, so it was scraped until the parchment surface was nearly blank (fig. I-18). Similarly, the faces of other figures were rubbed until their features were faint, indicating anxiety about any sort of figural representation. In its current state, the manuscript's erasures demonstrate that medieval art could be fraught; it could undermine or sustain ideas and the communities that held them.

Ideology may also support a particular type of political organization or rule. A plaque of ivory, carved from an elephant tusk, depicts a Byzantine emperor and empress wearing clothing and accessories associated with their imperial roles, including jeweled crowns with crosses at the top and pendants along the ears (fig. I-19). Identified by Greek inscriptions as Romanos and Eudokia, they are probably Romanos II (939–63) and his western European wife, Bertha. Bertha was quite young at their wedding in

Fig. I-18. Scene from Exodus, Hebrew Bible commentaries, 1232/33; Munich, Bayerische Staatsbibliothek, Cod. hebr. 5, vol. 1, fol. 47v. Photo from Bayerische Staatsbibliothek München.

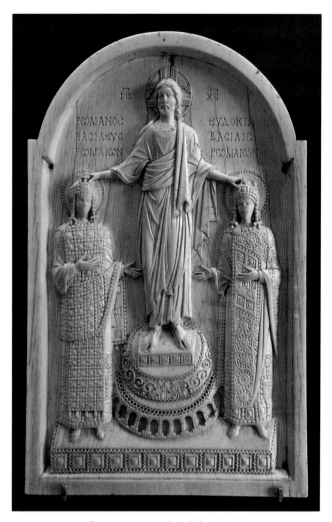

Fig. I-19. Ivory of Romanos II and Eudokia, 24.6 × 15.5 × 1.2 cm, ca. 945; Bibliothèque nationale de France, Cabinet des médailles, Paris. Photo by Sarah M. Guérin.

944, when she took the Greek name Eudokia, and Romanos himself was only five years old. Neither is depicted as a child, however, although Romanos lacks a beard, the usual signifier of age and wisdom. The plaque commemorates the couple's coronations as junior emperor and empress in 945; the emperor has the favored position, on Christ's right (placement to the right of Christ, near his blessing hand, normally signals superior status in Christian medieval art). By placing crowns on both heads, Christ both blesses their union and asserts that the couple's right to rule comes from God. This divine approval made Romanos and Eudokia powerful authorities on Earth, despite their youth. As this ivory and the Hebrew Bible commentary show, works of art can make ideological arguments using visual forms of communication.

The Friday mosque at Tinmal again helps make this point clear (figs. I-8 and I-9). It was built in part to commemorate the founder of the Almohad dynasty, Ibn Tumart (ca. 1080–1130), who resided in Tinmal during his rise as a visionary reformer and conqueror. Territories under Almohad rule eventually stretched from Teruel (Spain) to Sijilmasa, a major hub of trans-Saharan trade, and along the northern coast of Africa to Tripoli (Libya). Ibn Tumart's tomb at Tinmal quickly became a pilgrimage site for those who revered him, so the new mosque, commissioned by his successor 'Abd al Mu'min (r. 1147–63), served pious visitors as well as locals. The Almohads rose to power largely

because they and their followers considered the rulers before them too ostentatious and materialistic. Almohad architecture therefore expressed a more ascetic view, and their buildings carried a political message. Tinmal's materials are more modest than those of many earlier mosques in northwestern Africa; its walls and piers are made of brick rather than marble or stone, and the ornamented surfaces of the mihrab are of carved stucco rather than ceramic, stone, or mosaic. Although it is not uniformly austere—subtle degrees of ornamentation help guide people through the space—Tinmal's restraint expresses the ethical and political views of the Almohads and critiques earlier rulers and their opulent places of prayer. During the Middle Ages, relationships among beauty, luxury, and holiness shifted frequently and at times prompted intense debate. How art and architecture responded to theological, political, and social changes and helped shape ideas and experiences in diverse religions is a central concern of this book.

The Tinmal mosque also helps introduce the final theme of *Art and Architecture of the Middle Ages*: how art and architecture provided **access to the sacred**. The Middle

Ages has often been called "the age of faith" because religion was a critical facet of the period, in both theory and practice; this formulaic phrase, however, simplistically assumes that the faith is Christianity and also that there is only one Christianity. *Faith* and *religion* are complicated terms that require explanation so readers can better understand the discussions of religious art that are prominent in this book. In a very general sense, religion can be defined as a set of ideas and practices that help people apprehend and live in harmony with the divine—that is, with a superhuman force or forces, God or gods. These ideas may prompt particular actions, principles, or beliefs that help express and maintain that relationship with the divine, fellow humans, and the natural world. In some religions, the actions, principles, and beliefs are systematized, but not always. Often, even in such highly organized religions as Judaism, Christianity, and Islam, structure does not mean uniformity of belief and practice, either centuries ago or today. One goal of the book is to convey the diversity of arts and beliefs associated with some of the world's important religions.

During the Middle Ages, art and architecture played significant roles in expressing and even shaping religious ideas and practices, as the Tinmal mosque, Hebrew Bible commentary manuscript, and Cross of Herimann and Ida have shown. Some other works discussed here are associated with religious systems based on the existence of multiple deities; the technical term for such religions is polytheism (in Greek *poly* means "many" and *theos* "god"). Ancient Greek and Roman religion was polytheistic: it held that gods, goddesses, and lesser deities presided over natural events and human endeavors. The passing of days and seasons, the conditions of seas and rivers, food supply, and stable governments all involved the gods, as did human experiences like success in love and freedom from want. In some settings, the dead were thought to have a similar presence and ability to exert power on the living. Adherents of these ideas kept the gods and the dead on their side by reciting prayers and making offerings to them, sometimes privately and sometimes in public rituals. These practices constitute cult, a word that derives from the Latin word for worship, *cultus*. The related verb, *colere*, can mean to protect or cultivate or look after; thus, cultic practice means tending to the needs of the revered god or person.

Greco-Roman polytheists also approached the divine through myth—legends about the gods and goddesses that were first relayed orally and then written down in various literary genres. While people today say something is a myth if it is believed by people but has no facts to support it, myth in history and in this book has a more precise meaning and does not involve judgments about truth. Myths are narratives that probe human behavior, the natural world, and the larger cosmos through the actions of gods, personifications, and heroes usually understood to have taken place in a distant past. By the time stories about

Zeus's sexual appetite, Athena's wisdom, and Hercules's strength were recorded in literary form, these myths were often seen as metaphors or historical lessons that illuminated the place of humans in a larger universe. Because their insights into major themes resonated well beyond antiquity, these myths informed aspects of art and culture throughout the Middle Ages.

Adherents of this flexible Greco-Roman religion were called pagans by some early Christians. The word stems from the Latin *paganus*, signifying rural dweller, civilian, or outsider, and it often had a derogatory meaning. Today, *pagan* and *polytheist* are imperfect terms; neither was used by its adherents at the time, and some so-called pagans actually favored one god, thereby diminishing the "poly" in polytheism. Both words for Greco-Roman religion are used here, depending on which term tells us the most about the context in question. Other polytheistic traditions that today are often called pagan include Egyptian, Celtic, Norse, and Germanic religions. They feature similar narratives about gods, heroes, and the larger sweep of human history, from creation to a predicted cataclysmic end, but because they are removed from the Roman context of the term *paganus*, we refer to them as polytheistic.

Norse and Germanic polytheisms are more difficult to summarize because sources about them were written by outsiders, or by people who sought to codify their narratives long after the myths had currency. While some outsider texts can be extremely useful for imagining cult activities, we have to acknowledge that they were written in opposition to the groups they claim to describe, often by people who found their practices objectionable. For instance, in the late eleventh century the Christian chronicler Adam of Bremen described sacrificed dogs, horses, and men hanging from trees around a polytheistic temple at Uppsala (Sweden). His lurid words likely exaggerated what he knew about cult practices in Sweden in order to promote Christianization efforts there. As with Greco-Roman polytheism, myths joined cult as an important dimension of the religions of northern Europe. Most of what is known of the Norse gods stems from the work of Snorri Sturluson (ca. 1179–1241), an Icelandic scholar-poet who served in one of the world's oldest parliaments, at Thingvellir, and systematized the beliefs of his ancestors. His work tells us about Odin, the wise chief god who oversees Valhöll (Valhalla), the eternal Great Hall where brave warriors reside after their deaths in battle; about the goddess Frigg, who possesses knowledge of everyone's fate, controls love and marriage, and is married to Odin; and Thor, who defends the gods against giants and has a hand in the weather and seafaring. Snorri's writings reveal connections to ideas and characters in other northern European myths, including Germanic narratives. Because these stories were transmitted orally in multiple languages and across many centuries, they have no single original source, and there was no single authoritative version. As with Greco-Roman

religion, these narratives about the gods are not made-up myths because other religions came along and made them obsolete; rather, they are more usefully thought of as narratives that helped people think about metaphysical questions and make sense of their environment.

Based on orally transmitted legends and cult practices, these religions stand in contrast to belief systems based on scripture, meaning sacred texts thought to have divine authority. The main scriptural religions discussed in this book are Judaism, Zoroastrianism, Christianity, and Islam, all of which are monotheistic, meaning that they revere one divinity. Judaism (based on the Hebrew Bible), Zoroastrianism (based on the collection of texts known as the Avesta), Christianity (based on the Old and New Testaments), and Islam (based on the Qur'an) figure prominently in *Art and Architecture of the Middle Ages*. Because of their enormous impact on art production, the major tenets of these scriptural religions are discussed in boxes in early chapters.

Adherents of all of the religions discussed here carried amulets, small objects endowed with spiritual efficacy that helped them communicate personally with supernatural forces, often to protect them from harm. A bronze figurine from Rällinge (Sweden) depicts the Norse god Freyr; it was made sometime between the ninth and eleventh centuries (fig. I-20). While Snorri saw Freyr as bold in battle, he is more often associated with agricultural abundance and male sexuality. Incised swirls representing muscles ripple across the figurine's shoulders and buttocks, showing his strength. His oversize erect penis signals his sexual prowess and, by extension, his role in securing agricultural fertility; the tall pointed helmet repeats the phallic form, adding warfare to this visualization of Norse masculinity. The amulet's owner would have carried Freyr in a pouch, hoping to bring the god's multiple powers into his or her world.

As a functional object endowed with aesthetic properties, the Freyr figurine is in many ways representative of the art of the Middle Ages. Along with the Cross

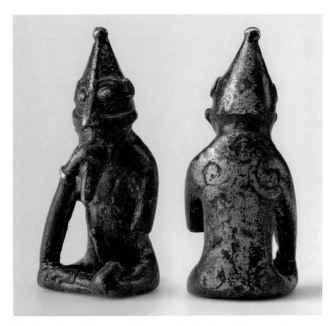

Fig. I-20. Freyr figurine, H 7 cm, ninth–eleventh centuries; Historiska museet, Stockholm. © Historiska museet 2011. Gabriel Hildebrand SHM 2011-11-08; CC BY 2.5 SE.

of Herimann and Ida, the Tinmal mosque, the Hebrew manuscript, and the Byzantine spoon, it signals how this book considers a vast geographical area and chronological sweep. All the works are examined as expressions of one or more of the five themes delineated above, but each one could generate discussions of multiple themes or prompt ideas and interpretations not explored here. Given the book's broad mandate, no monument is dealt with exhaustively, and *Art and Architecture of the Middle Ages* was written with an awareness that it can tell only parts of many stories. We hope that our book will encourage readers to recognize the richness and complexity of medieval art and architecture and appreciate how they shaped a vibrant, connected world.

CHAPTER I

The Roots of Medieval Art

Legend

- □ **Location or findspot**
 - *Monument/object*
- • Additional site
- ○ *Approximate place of production*

Rome

- *Ara Pacis*
- *Augustus Cameo*
- *Column of Marcus Aurelius*
- *Funerary relief with butcher shop*
- *Jonah sarcophagus*
- *Shepherd sarcophagus*

Hadrian's Wall — Vindolanda

□ **Snettisham**
- *Great Torc*

London □
- *Battersea Shield*

Trier •

La Tène •

Milan • • Venice

□ **Rome** • Sirmium

Adamclisi
- *Tropaeum Traiani*

Amphipolis □
- *Tetradrachm of Alexander the Great*

Corinth □
- *Asklepeion*
- *Votives*

Triumphal arch of Septimius Severus

Lepcis Magna

- *Basilica*
- *Colonnaded street*
- *Forum*
- *Temple*
- *Triumphal arch of Septimius Severus*

□ **Lepcis Magna**

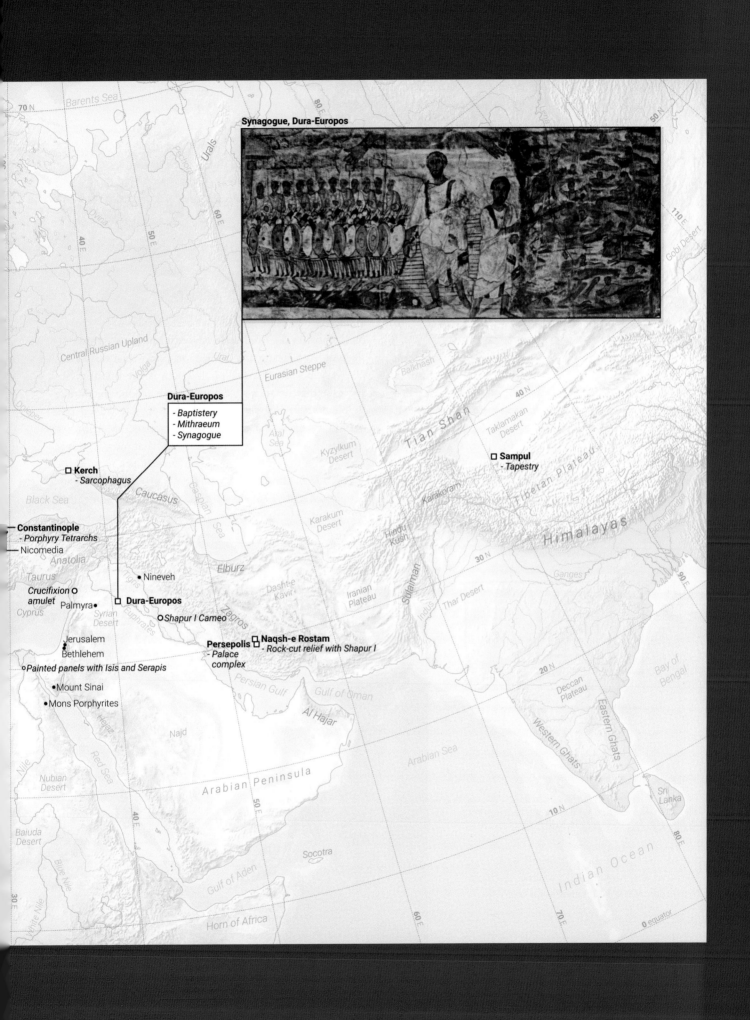

Synagogue, Dura-Europos

Dura-Europos
- Baptistery
- Mithraeum
- Synagogue

□ **Sampul**
- Tapestry

□ **Kerch**
- Sarcophagus

Constantinople
- Porphyry Tetrarchs
— Nicomedia

Anatolia

Taurus

• Nineveh

Crucifixion ○
amulet
Palmyra• □ **Dura-Europos**

Cyprus Syrian
Desert

○ Shapur I Cameo

Jerusalem □ **Naqsh-e Rostam**
Bethlehem **Persepolis** — Rock-cut relief with Shapur I
○Painted panels with Isis and Serapis - Palace
complex

•Mount Sinai

• Mons Porphyrites

Medieval art, like the Middle Ages, did not emerge fully formed at a single date or place. Rather, it developed from earlier forms of visual expression that included Celtic, Germanic, Greek, Roman, and Iranian arts. A constant feature of the premodern world was the movement of people, ideas, and materials westward from Asia. Some of these migrating people established kingdoms and empires, and others remained nomadic pastoralists, but all of them created works of art that expressed their beliefs or desires. Because many of these ancient works continued to influence human behavior, material culture, and the built environment for centuries after their creation, they can set the stage for the medieval art and architecture that emerged, broadly speaking, about 300 CE.

An Ancient Healing Shrine

A shrine at Corinth (Greece) is a work whose ideas, forms, and rituals echoed through the Middle Ages in different ways. It is an Asklepeion, a building complex sacred to the Greek healing god Asklepios and his daughter Hygeia (Health). Several of these shrines were huge sites that attracted an international clientele of visitors who sought the god's help; the one at Corinth was a smaller, more local version begun in the fifth century BCE and renovated in the late fourth century BCE (fig. 1-1). At the heart of this complex is a temple, which contained a statue of Asklepios; an altar stood before it, and a covered colonnade (stoa) is on the north side. Additional spaces for medical treatment, sleeping, and eating are in the courtyard to the west.

An important feature of this plan is the hierarchy of spaces, from the accessible public space around the temple to the less accessible ones, such as the separate walled area behind it, the *abaton*. Here people practiced incubation—sleeping in the sacred space in the hope that the god would appear in a dream and provide a cure. The ramp on the south side of the complex may have provided access for people with physical disabilities, and it was also used to lead mammals to the animal sacrifice performed at the

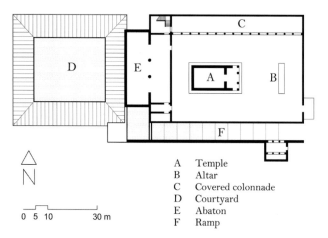

A Temple
B Altar
C Covered colonnade
D Courtyard
E Abaton
F Ramp

0 5 10 30 m

Fig. 1-1. Asklepeion, Corinth, fourth century BCE, plan. Drawing by Navid Jamali.

Fig. 1-2. Asklepeion votives, Corinth, sixth–fourth centuries BCE; Archaiologiko Mouseio Archaias Korinthou. www.HolyLandPhotos.org.

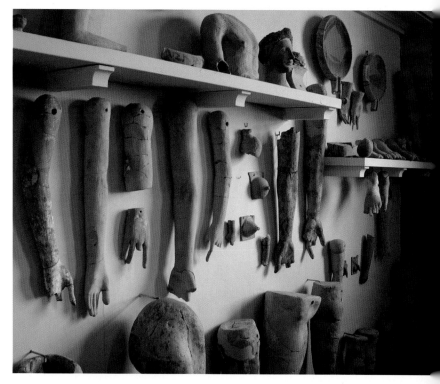

altar. People who sought healing often prayed to the gods or thanked them by purchasing votive objects. *Votive* indicates something related to a vow (Latin *votum*), but votive objects can represent a wider range of personal relationships with a divinity. These offerings, hung or displayed in the temple or the stoa, helped advertise the god's power to others. They included coins, pottery, figurines, and life-size terra-cotta models of body parts that had been healed—arms, legs, eyes, ears, and more (fig. 1-2). About 125 hands, 65 breasts, and 35 male genitalia are preserved, with female body parts painted white and male parts red in accord with Greek conventions. Like the other works discussed in this chapter, many of the strategies and visual practices evident in Corinth remained important in medieval art and architecture. These include multiple stages of rebuilding, spatial differentiation that is both functional and hierarchical, prescribed ritual practices, fragmented bodies, and objects that promote access to the sacred.

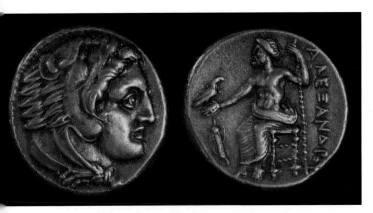

Fig. 1-3. Tetradrachm of Alexander "the Great," 2.3 cm, ca. 320 BCE; Harvard Art Museums/Arthur M. Sackler Museum, Cambridge, MA, unspecified collection. © President and Fellows of Harvard College.

The Era of Alexander "the Great"

At about the time the Asklepeion was first renovated, almost all of the Greek city-states were united in war against the Achaemenid Empire in Iran (550–330 BCE). The Greek force was led by Alexander of Macedon (356–323 BCE), better known as Alexander "the Great," who went on to control the whole landmass from Greece and Egypt to Central Asia and India until his death in 323 BCE. Many medieval leaders tried to emulate Alexander's military success. His exploits became the stuff of legend—for example, he was said to have been lifted up to heaven in a chariot drawn by griffins (composite creatures with eagle heads and lion bodies)—and these stories were often represented in medieval art.

The obverse (front) of this silver tetradrachm coin (minted in Amphipolis, Greece, ca. 320 BCE) depicts Herakles (Latin Hercules) wearing the lion skin that he obtained in one of his adventures (fig. 1-3 *left*). The Macedonian dynasty claimed him as their ancestor, and Alexander himself was described as lionlike, so users of the coin likely connected Alexander to the famous hero, as his successors did. Only after Alexander's death did portraits of rulers first appear on coins, a practice that continued in many of the cultures discussed in this book. On the reverse of the coin, the inscription "of Alexander" appears in Greek behind a seated god (fig. 1-3 *right*). He is probably Zeus, the head of the Greek pantheon, but the figure is so generic that he may have been understood by non-Greeks as one of their own divinities. The eagle and ruler's staff were insignia (emblems of authority) widely imitated in later art.

Under Alexander and his successors, Greek artifacts, artistic styles, and figural iconography spread to all of the conquered lands and affected existing local artistic production in different ways. The silver tetradrachm was not for

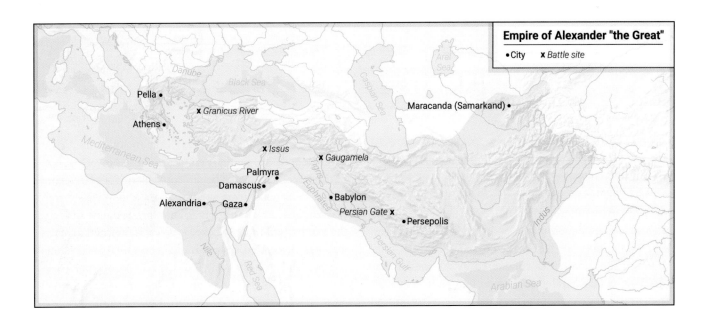

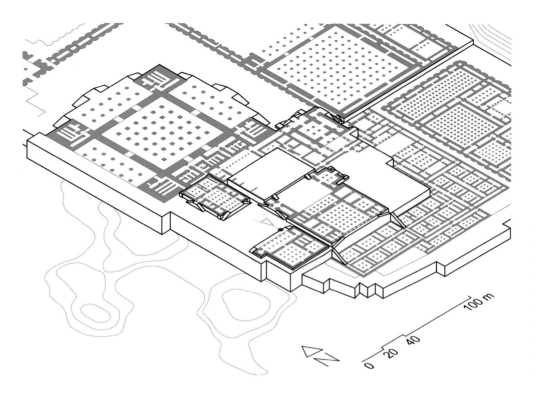

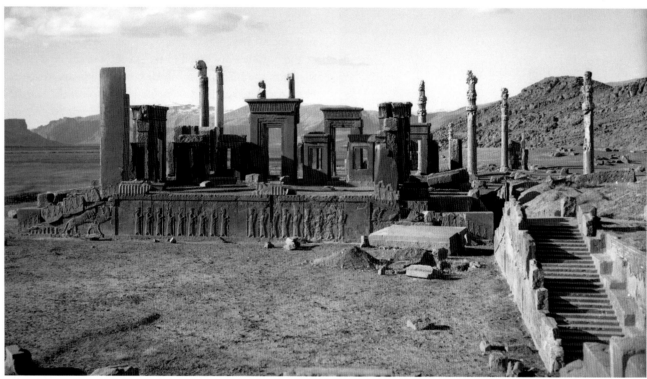

Figs. 1-4a and 1-4b. Persepolis, palace complex, ca. 520–486 BCE, (*top*) site plan; (*bottom*) Palace of Darius in the 1930s, seen from red point on site plan. (*t*) Drawing by Navid Jamali; (*b*) Courtesy Oriental Institute of the University of Chicago.

purchases in the marketplace; it was a valuable coin, used for such state expenditures as paying soldiers. The later Roman historian Plutarch (46–120 CE) wrote that Alexander controlled his image by personally choosing artists to represent him in different media. Because coins are among the most widely disseminated and standardized images, they play an important role in the history of art.

One of the great cities conquered by Alexander was the Achaemenid capital, Parsa, better known by its Greek name, Persepolis ("city of the Persians"). For two hundred years the Achaemenids ruled the vast territory of ancient Iran, a geographical landmass that includes but is not equivalent to the modern country. These powerful rivals of the Greek city-states began constructing a palace complex at Persepolis in 515 BCE (fig. 1-4). Although the terrain was rugged, arid, and irregular, they brought order to the site by building massive terraces, monumental stairs, elaborate irrigation systems, and ceremonial processional routes. The palace's individual spaces also emphasized geometric regularity. A dominant feature is its large rectangular halls articulated by a grid of columns, a type of structure called a hypostyle hall. (*Hypostyle* means many

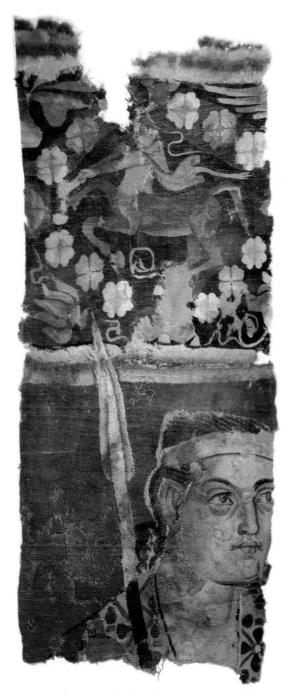

Fig. 1-5. Tapestry fragment, 230 × 48 cm, third–second century BCE, buried in Sampul cemetery in the first century BCE; Xinjiang Regional Museum, Ürümqi. © Daniel C. Waugh.

Sampul (Shanpula) in what is now the province of Xinjiang in northwestern China (fig. 1-5). Dry air and soil helped preserve this textile and thousands of others at the edge of the Taklamakan Desert. The Sampul cemetery—for humans and sacrificed horses—contained objects buried over at least seven hundred years. This textile, originally a wall hanging, likely dates to the third or second century BCE. After decades of use, it was cut down to create a pair of men's pants and, in the first century BCE, interred with the wearer in a pit with more than one hundred other individuals. Following excavation in the 1980s, the pants were disassembled and reconstructed as the left edge of the original hanging. The principal fragment contains twenty-four colors of dyed wool. It shows a centaur, a half-man and half-horse creature from Greco-Roman myth, whose image spread eastward with the armies of Alexander. Here, however, that image was modified: unlike Greco-Roman centaurs, this one plays a horn and wears a cap and a lion-skin cloak. Similarly, the over-life-size, blue-eyed soldier below has hair arranged in rows—not a Greek hairstyle. His hair, garments, and weapons, visible on another fragment, have parallels in western Asian and Central Asian art; these features show the ways in which artists might transform imported ideas and forms. The three-dimensional modeling of the figure, with shadows and bags under the eyes, indicates that it was made in a skilled center of textile weaving, perhaps in Asia Minor (modern Turkey), the northern Black Sea region, or the Bactrian kingdom (roughly equivalent to modern Afghanistan). These were all areas where Alexander and his successors were in close contact with Iranians and nomadic peoples of the Eurasian steppe.

The Roman Imperium

Like his predecessor Alexander "the Great," the first Roman emperor recognized the importance of standardized heroic imagery. This large sardonyx cameo of Augustus shows him in profile, as on a coin, holding a staff topped by an eagle (fig. 1-6); these features accompanied the seated god on the earlier coin of Alexander and are associated with Zeus's equivalent, Jupiter, in the Roman pantheon. Augustus wears a laurel wreath, a symbol of victory borrowed from Greece (worn by winners at the Olympics, for example), which the Romans had conquered in the centuries preceding his rule. Alexander died young and was always represented as a young man, and Augustus, despite his long life (63 BCE–14 CE), was also eternally youthful even in images made at the end of his life. Creating a hardstone cameo, a technique first perfected in the third century BCE, involves cutting into the outer plane of the stone (brown, in this case) to reveal a different color underneath (white); the artist uses the natural properties of the material to create color contrasts, shading, and relief.

columns under a roof; here the roofs are gone.) Images that expressed imperial might, including ranks of soldiers and fierce lions attacking gazelles, appear in symmetrical reliefs carved into the vertical faces of the terraces. Many of the features seen at Persepolis, including hypostyle halls, monumental reliefs, and images of animal combat, remained prestigious points of reference in this region for centuries.

At the same time, the Mediterranean art and iconography seen on Alexander's silver tetradrachm were widely disseminated, as is clear from a woolen tapestry found at

Moreover, the semiprecious sardonyx came from India, so its possession in Rome likely expressed cultural sophistication and wealth. This particular example encapsulates Roman imperial ideology, which medieval rulers tried to imitate. The cameo was repurposed in a tenth-century work discussed in chapter 6.

The Ara Pacis Augustae—Altar of Augustan Peace—was erected by the Senate in Rome in 13–9 BCE to commemorate the first emperor's peace treaties with Hispania and Gallia, provinces that correspond roughly to modern Spain and France. The marble enclosure of the outdoor altar is covered with carving; figures in high relief project toward the viewer and those in low relief create the illusion of receding space (fig. 1-7). The upper register depicts a horizontal band of figures moving in a stately procession; led by Augustus, this parade includes imperial family members of all ages. The front and back, interrupted by openings that give access to the altar itself, contain panels with mythological and allegorical imagery. One such panel shows a personification of fertility and abundance, a woman with chubby Roman children and fruits on her lap, flanked by personifications of Earth (*left*) and Sea (*right*) (fig. 1-8). Below a border decorated with a Greek meander pattern (continuous angular or curved lines), the lower register on all four sides contains animals and over fifty identifiable species of plants shown blooming symmetrically and simultaneously, despite the fact that their flowering does not coincide in nature. This plant imagery, far from being ornamental and without meaning, suggests a desire and ability to dominate, systematize, and correct the unruly natural world and is therefore part of a larger imperial political ideology.

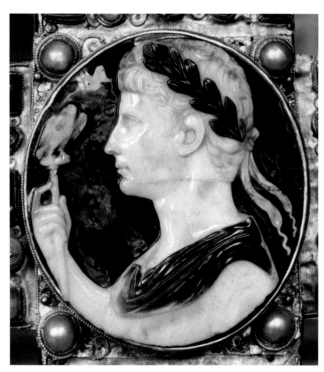

Fig. 1-6. Augustus Cameo, 8 × 7 cm, first century; Domschatzkammer, Aachen. © Genevra Kornbluth.

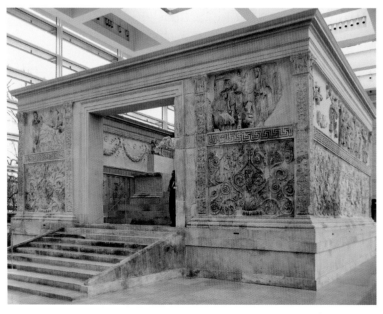

Fig. 1-7. Ara Pacis, Rome, 13–9 BCE; Museo dell'Ara Pacis, Rome. Wikimedia Commons/Manfred Heyde, CC BY-SA 3.0.

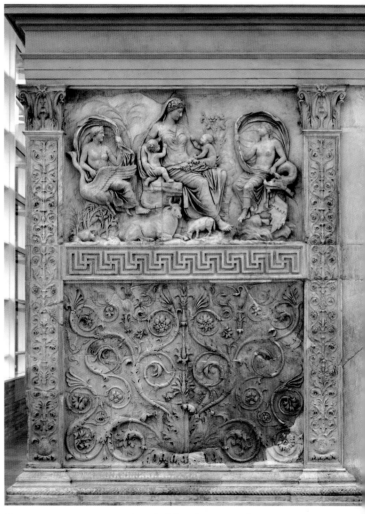

Fig. 1-8. Ara Pacis, Rome, detail of female personification and flowering plants, 13–9 BCE; Museo dell'Ara Pacis, Rome. © Mark Ynys-Mon, flickr.com/mymuk.

The human figures on the Ara Pacis represent the epitome of the classical style. Their idealized proportions, impassive faces, and convincing corporeality were intended to emulate Greek sculpture of the fifth century BCE. The garments (called "drapery" in art history) fall in deeply carved, natural-looking folds. All of this idealization is ideological: it signified a "golden age" under Augustus, flattering both the emperor and the Roman people after a period of civil war. The Ara Pacis was reconstructed from fragments by Mussolini, the Fascist ruler of Italy during the Second World War, who wanted to establish an Italian empire in the twentieth century and exploited the symbolic value of the Roman work. By his time the pieces had lost their color, but, like the votives at Corinth, the sculpted people, drapery, plants, and animals were originally brightly colored—an aesthetic preference that continued in medieval art.

This classical style was not the only option in Roman art. As the empire expanded, reaching its greatest extent under Trajan (r. 98–117 CE), artists in the outer provinces encountered Roman visual culture in the same way that Iran and Central Asia were exposed to Greek arts after Alexander's conquests. The Tropaeum Traiani (Trophy of Trajan) was commissioned by that emperor to celebrate his hard-fought conquest of the wealthy province of Dacia, which corresponds roughly to modern Romania, and the extension of Roman power north of the Danube River (fig. 1-9a). Located in Adamclisi (Romania), the monument testifies to the blending of cultures on this frontier. Reconstructed based on where the surviving components had fallen, it consisted of a circular limestone base girded by two carved friezes and fifty-four figural metopes (rectangular panels). A stepped, tiled roof was topped by a tall support for carved images of armor—the trophy—a representation imitating the centuries-old practice of displaying actual captured armor. The best-preserved parts of the monument are the metopes, which show Roman cavalry and infantry defeating pants-wearing Dacians and other soldiers, Trajan on campaign, and the capture of prisoners (fig. 1-9b).

The depicted action takes place in empty space devoid of ground lines, and the iconography of combat is stripped down to just the protagonists, who are shown as stylized figures, abstract and simplified, with squat proportions and without nuanced bodily volume. Measuring about thirty meters across and forty meters high, the Tropaeum Traiani prominently advertised Roman might, which was also asserted by a new town a kilometer away where the emperor settled some of the veterans. Its sculptural messages were directed toward the newly conquered inhabitants of the Danubian frontier. Why the Tropaeum was rendered in this more straightforward style is debated; it was perhaps more useful for portraying raw power than the classical style used on Trajanic monuments in the city of Rome, but it may also reflect different technical competencies or approaches to carving.

On the opposite side of Europe from Adamclisi, the Romans expanded their control of Britain and mustered a different kind of visual propaganda on their northern frontier. A wall in northern England stretching 130 kilometers long was built in the 120s by Trajan's adopted son, the emperor Hadrian (r. 117–38), to control the imperial border and the

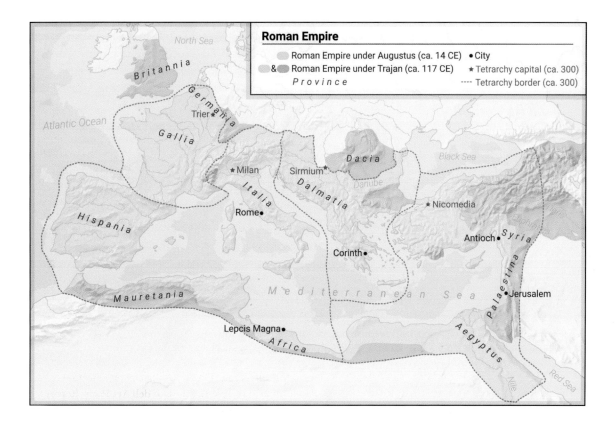

Figs. 1-9a and 1-9b. Tropaeum Traiani, Adamclisi, 109, (*left*) reconstruction.; (*right*) metope, Muzeul Tropaeum Traiani, Adamclisi. (*l*) Alexandru Panoiu, CC BY 2.0; (*r*) Wikimedia Commons/Cristian Chirita, CC BY-SA 3.0.

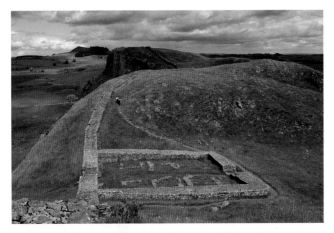

Fig. 1-10. Hadrian's Wall, England, ca. 125. Wikimedia Commons/Adam Cuerden, public domain.

commercial activities around it. Hadrian's Wall is an ambitious work of defensive architecture (fig. 1-10). Built of stone and, in the west, of turf, it was flanked by a deep ditch on the north side and a raised double earthwork with its own ditch to the south. There was a gateway every Roman mile (literally, 1,000 paces; approximately 1,481 m) and two towers between each gate. Construction was undertaken by Roman soldiers from across the empire, including some five hundred Syrian archers who were famed for their use of the recurved bow (its arrows went farther). The wall incorporated existing landscape features and, about every eleven kilometers, a fort, where a legion (troop of soldiers) was stationed. Aqueducts brought water from the north to the forts, which meant that Roman control extended well beyond the wall. Excavations at the bustling trading center of Vindolanda uncovered baths, houses, and shops. This evidence for military and civilian life along the border wall is enhanced by wooden writing tablets that contain letters and documents written in ink in the early second century; they comprise the earliest written material from Britain.

Celtic Metalwork

The dominant cultural group in northern and western Europe before, during, and after the Roman Empire is usually called the Celts. Unlike the Greeks and Romans, the Celts preferred art with nonnaturalistic figures and abstract patterns. For example, the bronze cover of the Battersea Shield includes three panels decorated with opaque red glass and curving designs in the repoussé technique (hammered from the back), the whole held together by hidden rivets (fig. 1-11). The decorative forms are associated with La Tène, a findspot of numerous artifacts in Switzerland and the name used for a Celtic style characterized by symmetrical geometric patterns. Nevertheless, the palmette shapes (radiating palm leaves) indicate that the northern artists, like those in Central Asia, had some familiarity with Mediterranean ornamental forms. Probably a ceremonial or votive

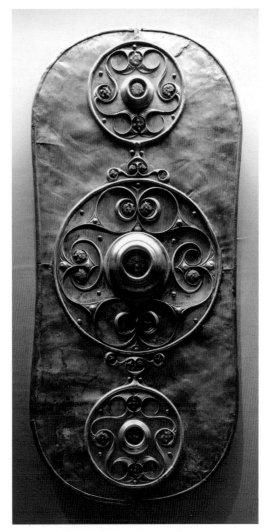

Fig. 1-11. Battersea Shield, 77 × 35 cm, ca. 350–50 BCE; British Museum, London. © Genevra Kornbluth.

object rather than a piece made for battle, the metal cover for the lost wooden shield was found in the Thames River (London) and likely made in Britain, but without close comparisons it is difficult to date it more precisely than ca. 350–50 BCE. The styles preferred in such early Celtic metalwork continued long into the Middle Ages in northern Europe. This Celtic culture should not be confused with the culture and language of Ireland and parts of Britain that much later were called Celtic.

Many other Celtic objects are also associated with warriors. The Snettisham Great Torc (or torque) is a neck ring made from a gold alloy (mixture) of two parts silver to three parts gold (fig. 1-12). Formed into wires, the metals were twisted into ropes and then attached to terminals made using the lost-wax method, a casting technique in which wax molds are covered with plaster; after the wax is melted away, molten metal is poured into the plaster cast to produce the desired form. The torc was further decorated with basketweave and other motifs made by punching (decorating with a pattern of small depressions) and

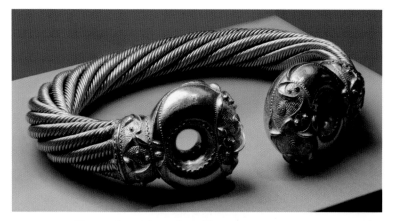

Fig. 1-12. Snettisham Great Torc, W 19.9 cm, 150–50 BCE; British Museum, London. Photo by the authors.

chasing (decorating with a hammer or other tools without a cutting edge). The metalwork objects found near Battersea, Snettisham, and elsewhere are products of a sophisticated culture; they required the extracting and processing of metals, long-distance trade, and consummate artistic skill. Snettisham itself was the site of at least fourteen separate metalwork hoards that included 158 fragmentary and an astonishing 60 complete torcs. We do not know why so many torcs were brought together in Snettisham. They may have been buried in the hope of being retrieved later, or perhaps these deposits were associated with some ritual activity. There are many examples across the world of valuable objects being deliberately defaced, destroyed, or made inaccessible, perhaps as a symbolic display of wealth or power.

In the third century, the large town of Dura-Europos was located strategically on the Roman-Iranian frontier in what is now Syria. Its remains, excavated in the 1930s, provide evidence for many religions, including one favored by soldiers and merchants (fig. 1-13). The cult of Mithras is known from about 120 worship sites and nearly one thousand images that reach from the Euphrates River to the Sahara and northern Britain. Unlike most religious rites in antiquity, which took place at outdoor altars—witness the Asklepeion at Corinth and the Ara Pacis—worship of Mithras, which was restricted to men, was often underground. Soil conditions at Dura-Europos precluded such a design, so the local Mithraeum was a long, narrow room in a private house, constructed about 165 CE and enlarged twice in the third century (figs. 1-13A and 1-14). Like other cult sites in Dura-Europos discussed in this chapter, it was preserved because the Roman soldiers defending the city had filled it in with earth to strengthen the walls against a powerful new Iranian dynasty, the Sasanians.

As in all Mithraea, the visual focus was an image of the god known as the tauroctony (killing of a bull), in which Mithras plunges a dagger into the neck of a bull as a dog and snake lick the blood. Because of the complete absence of Mithraic religious texts, however, little is known about their beliefs, and the precise meaning of this iconography remains unclear. Mithras wears Iranian attire: a soft peaked hat, a billowing cloak, and trousers. In the Dura-Europos Mithraeum, two tauroctony reliefs of painted and gilded stucco (plaster made of lime, sand, and water) inlaid

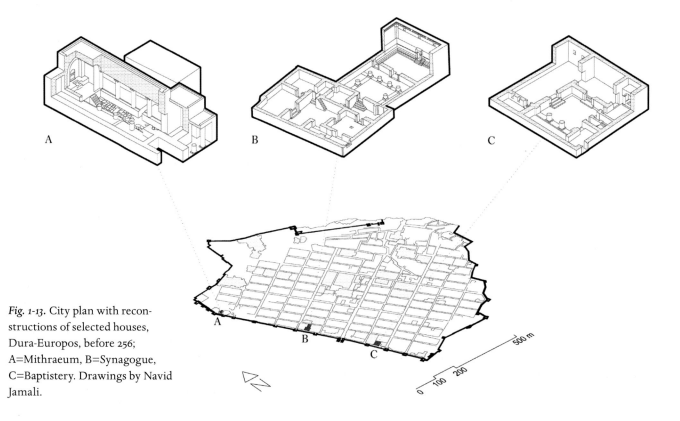

Fig. 1-13. City plan with reconstructions of selected houses, Dura-Europos, before 256; A=Mithraeum, B=Synagogue, C=Baptistery. Drawings by Navid Jamali.

with colored stone suggest the potential for faithful members of the cult to achieve personal salvation after death. The arch at the top of the larger scene contains signs of the zodiac between personifications of the Sun and Moon, above a bust of the Sun wearing a rayed crown (fig. 1-15). Five worshipers are shown in the right half, and three of them are named in Greek. The largest man places incense on an altar, and the inscription below reveals that he donated the plaque: "For the god Mithras. Made by Zenobius . . . commander of the archers, in the year 482 [170/71 CE]." Zenobius was an archer from Palmyra (Syria) who served in the Roman army, like the Syrian archers who protected Hadrian's Wall. The inscription is in Greek because that was the dominant written language of the eastern half of the Roman Empire.

The walls of the Mithraeum contain painted scenes of Mithras as a mounted archer hunting animals (which must have resonated with the donors of the relief panels) and Mithras banqueting with Sol, a sun god, even though Mithras himself was also understood as the sun. One of his Latin titles was "Deus Sol Invictus Mithras" (Mithras the Divine Unconquered Sun). Mithras was originally a west Asian divinity, but the explosive growth of his cult occurred in the Roman Empire. Like other so-called mystery cults, Mithraism fostered emotional experiences that enhanced worshipers' feelings of closeness with the god. These included rituals of initiation, communal meals, and the promise of salvation after death. This more personal kind of interaction with the divine differed from what could be experienced in the Roman public cults. The virtual presence of community members on the side walls and the banquets in imitation of Mithras's own ensured the perpetual interaction of the faithful with the god.

Work in Focus:
THE DURA-EUROPOS SYNAGOGUE

Dura-Europos was also home to followers of other religions. The Jewish community remodeled a private house for their communal and ritual activities, and its size indicates the relatively high social status of the local Jews (fig. 1-13B). The house was redecorated in 244/45 and preserved because it was incorporated into the Romans' defensive wall in 256. The largest room served as a synagogue and is the oldest known Jewish place of worship with preserved wall and ceiling art. When it was discovered in 1932, the synagogue's narrative figural paintings undermined the long-held but mistaken view that Judaism was hostile to images. This view was based on the assumption that Jews upheld a strict interpretation of the second commandment, which says, "You shall not make for yourself an image in the form of anything in heaven above or on the earth beneath or in the waters below. You shall not bow down to them or worship them" (Exod. 20:4–5; Deut. 5:8–9). The synagogue's figural art ranges from paintings without religious significance to complex biblical narratives; it shows clearly that at least some Jews embraced images in their religious environments.

As evidenced by *tituli* (labels or captions) and scratched or painted graffiti, the Jewish community at Dura-Europos comprised a mix of Romans, Syrians, and Iranians who had the economic means to enlarge and redecorate their place of worship. The assembly room (13.6 × 7.6 m) could accommodate about 125 people (fig. 1-16). Two of the 234 surviving terra-cotta ceiling tiles list donors to the synagogue, in Aramaic and Greek, including a "proselyte" (convert). Other tiles show fanciful creatures (including centaurs), real animals, women's heads, vegetation, and magical, protective images, all of which were part of the generic decorative

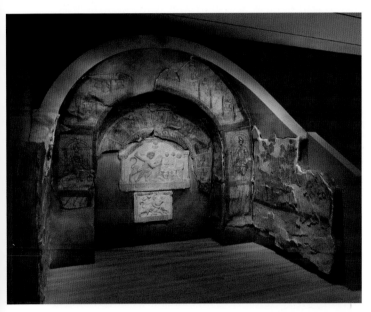

Fig. 1-14. Mithraeum, Dura-Europos, ca. 240; Yale University Art Gallery, New Haven. Photo from Yale University Art Gallery.

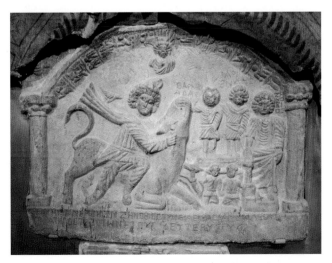

Fig. 1-15. Tauroctony relief, Dura-Europos Mithraeum, 76 × 106 cm, ca. 170; Yale University Art Gallery, New Haven. Photo by Brad Hostetler.

Box 1-1. JUDAISM

Judaism was the first enduring monotheistic faith. Its story began in Mesopotamia (in what is now Iraq) with Abraham, a descendant of Adam (Gen. 11), whom God instructed to go west to the land of the Canaanites. God tested Abraham's faith by asking him to kill his son Isaac, and he was prepared to follow those instructions until an angel stopped the murder. Abraham received God's promise that his descendants are the chosen people, a covenant (pact) that was renewed periodically—or, according to Christians and Muslims, revisited and revised. Jewish identity was forged during the Exodus from Egypt, led by Moses (ca. 1200 BCE). Moses received the oral and written Law (the Torah) from God on Mount Sinai, including the stone tablets inscribed in Hebrew with the Ten Commandments. The Israelites wandered for forty years, carrying the Law in a portable tabernacle, and after the death of Moses they conquered the land of Canaan (Israel).

The descendants of Abraham included Judah, after whom Judaism is probably named; David, the shepherd-warrior who became king in Jerusalem; and David's son Solomon, who built the Temple in Jerusalem according to instructions from God. The most sacred part of the Temple, closed by a curtain or veil and accessed by a high priest only once each year, housed the Ark of the Covenant containing the Ten Commandments. Jewish men were supposed to make a pilgrimage to the Temple and offer animal sacrifices there three times each year. Solomon's Temple was destroyed by the Babylonians in the sixth century BCE, when many Jews were sent into exile in Mesopotamia; it was rebuilt at a smaller scale after the return of some of those exiles, and then built once again under King Herod around the time of the birth of Jesus. This Temple, which looms large in the Christian New Testament, was destroyed by the Romans in 70 CE. Since then Jews have prayed and studied not in new temples but in synagogues (a Greek word meaning "place of assembly"), until a future era when the Messiah (literally, anointed one) will arrive, rebuild the Temple, and resurrect the dead. The Jewish religion requires male circumcision and a particular diet. During the Middle Ages, when Jews lived in all of the areas considered in this book, there were important variations in practice.

vocabulary of the wider Roman Empire. (Such protective instruments are called *apotropaia*, from a Greek word that means "to turn away": apotropaic devices avert evil and envy by turning them back on their sources.) The lowest decorated wall zone, the painted dado above the benches that encircle the whole interior, depicts wild animals and masks that would have looked familiar to people of any faith. The artists worked in the medium of tempera, in which pigments are mixed with a binder, usually egg yolk, and then applied to the plastered wall surface with a brush.

The architectural focus of the large room, shown here as reconstructed in the National Museum of Damascus, was a canopied niche on the west wall supported by two fake-marble columns (fig. 1-17). The niche held the first five books of the Hebrew Bible, known as the Torah; this sacred text was written on a long scroll (a roll of parchment) that was read aloud during the liturgy (this broad term, derived from the Greek *leitourgeia*, "public duty," refers to the general body of any religion's public rituals). The large shell was a feature of Roman art and architecture, but its significance here is unclear. The painting immediately above the niche shows the gold facade of the lost Temple of Jerusalem, along with a golden menorah (a stand for oil lamps) that had adorned the Temple and two more gold objects used during the fall pilgrimage festival of Sukkot (box 1-1). At the right, Abraham wields a knife in order to offer his son Isaac on the tall altar; in front, shown below, is the ram that will be substituted for him; and in the back is a tent with a small figure inside, probably his wife, Sarah. At the top center, the hand of God emerges to stop the sacrifice and affirm his commitment to Abraham: a pivotal moment in God's connection to the Jewish people. God could not be depicted in his entirety, but this focal point of the assembly room concisely combines a foundational Jewish story with symbols of the Temple, thereby asserting the long-standing relationship between the Jewish people and God.

Above this panel, on the west wall itself, are the faint remains of the first phase of the synagogue's decoration, consisting of a large vine and images associated with King David. This is flanked by standing male figures, of whom only the one at the upper right is securely identifiable. It is Moses, who has removed his shoes to climb the holy Mount Sinai, where divine presence is visualized through God's hand and the burning bush (Exod. 3:1–5). Immediately to the right is the foundational, salvific scene of the Israelites crossing the Red Sea (Exod. 14). To emphasize its importance, multiple moments are represented in a single frame, a device called simultaneous narrative. The story moves from right to left—the way Hebrew is read—beginning with an oversize, Roman toga–clad Moses leading the Israelites out of a walled Egypt (fig. 1-18). The narrative continues in a second panel, in which the Egyptian soldiers

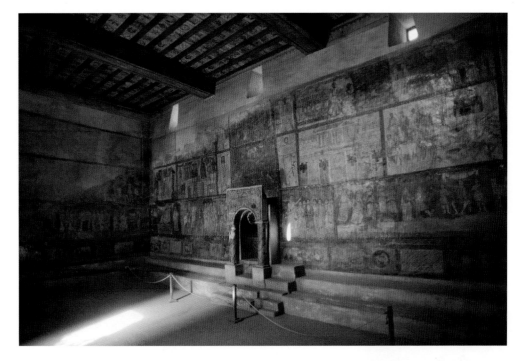

Fig. 1-16. Synagogue assembly room, Dura-Europos, ca. 244, view toward the southwest; al-Mathaf al-watani, Damascus. akg-images/Philippe Maillard.

Fig. 1-17. Torah niche in the west wall, Dura-Europos synagogue, ca. 244; al-Mathaf al-watani, Damascus. © Art Resource, NY.

founder in the water as Moses waves his staff; and on the left, the Jews, in twelve lines corresponding to their twelve tribes, safely cross the sea into which Moses dips his staff. The outstretched left and right hands of God seem to embrace the action and relate literally to the biblical verse, "the Lord brought us out of Egypt with a mighty hand and an outstretched arm" (Deut. 26:8). Throughout the synagogue, the flattening of space and the simplified and largely frontal figures, with greater scale accorded the protagonists and cookie-cutter treatment of groups, is consistent with much Roman artwork; it is also found in Sasanian art, discussed later in this chapter.

On the north wall, the whole lower register depicts the visions of the prophet Ezekiel, who lived in Babylonia (near Dura-Europos) in the sixth century BCE (fig. 1-19). He envisioned a messianic future when the Jews would live united in the land of Israel and the descendants of David would forever rule. This narrative moves from left to right. The outsized figure of the prophet, dressed in Iranian trousers, is shown three times at the left. Hands of God dynamically direct the narrative as the first one grasps Ezekiel's head to instigate his vision of the Valley of the Dry Bones (Ezek. 37). Despite the text's emphasis on the dryness of the bones, it is fleshy body parts that lie on the ground, perhaps because the artist in a military garrison had battlefield carnage in mind. More body parts emerge from an earthquake-ravaged mountain, described not in the biblical account but in a midrash, an ancient or medieval commentary on scripture; the bones are resurrected by divine breath, represented by flying personifications familiar from classical iconography. Farther to the right, Ezekiel wears Roman clothing as the ten dispersed Jewish tribes, each represented by a toga-wearing man, are reunited in the messianic era and the children of Israel are resurrected

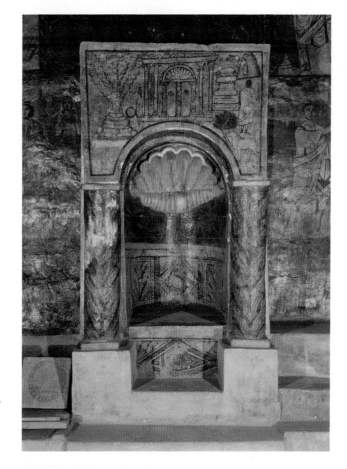

from the dead. Such scenes of resurrection resonated for many visitors, because Zoroastrians, Christians, and most polytheists hoped for the same outcome of life after death (boxes 1-2 and 1-3).

In the Dura-Europos synagogue, events from sacred history were selected to remind local Jews (and non-Jewish visitors) of their enduring covenant with God, thereby

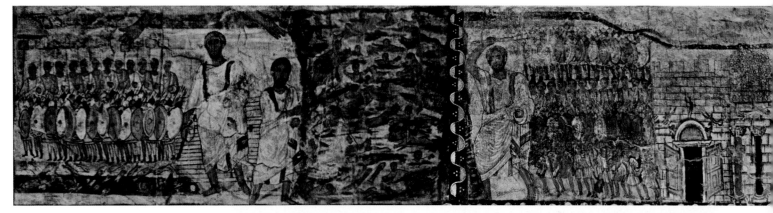

Fig. 1-18. Exodus scenes on the west wall, Dura-Europos synagogue, ca. 244; al-Mathaf al-watani, Damascus. Photo from Carl H. Kraeling, *The Excavations at Dura-Europos, Final Report 8, Part 1, The Synagogue* (New Haven: Yale University Press, 1956), by permission; with addition by Gili Shalom from copy at ANU – Museum of the Jewish People, Tel Aviv.

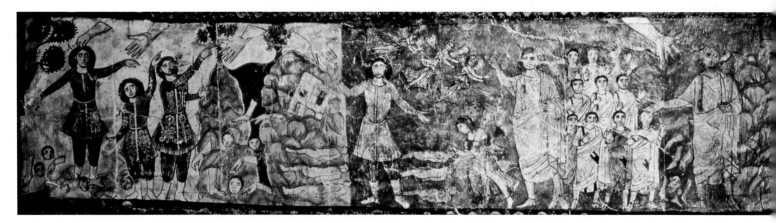

Fig. 1-19. Ezekiel scenes on the north wall, Dura-Europos synagogue, ca. 244; al-Mathaf al-watani, Damascus. Photo from copy at ANU – Museum of the Jewish People, Tel Aviv, the Oster Visual Documentation Centre, Core Exhibition.

affirming Jewish identity and status in the diverse demographic, linguistic, and religious landscape of the town. A number of figures in Iranian garb have had their eyes gouged out of the plaster, most likely by Roman soldiers building up the defensive wall against the Sasanians. Blinding a figure in this symbolic way was supposed to render him powerless, but this effort did not work in the case of Dura-Europos, for the town fell to the Sasanians in 256 and was soon abandoned.

A Ritual Space for Christians at Dura-Europos

In addition to the earliest surviving extensively decorated synagogue, archaeologists at Dura-Europos found the earliest decorated baptistery. The Christian community responded not only to the presence of the Jewish synagogue about two hundred meters away but also to local adherents of Mithras and various polytheistic divinities (fig. 1-13C). Like those other religious buildings, the baptistery was constructed in a renovated private house at the

edge of the city (where it too became part of the Romans' defensive embankment) and was decorated in stages, the last about 240. And like the Mithraeum, the baptistery was transported to Yale University, where many of the archaeologists worked. The wall surfaces are so damaged that the reconstruction shown here is no longer on display, but restorations undertaken in 2010 successfully stabilized some of the paintings (fig. 1-20a).

Christianity, like most religions, required a ritual of initiation: in this case baptism, which involved some form of immersion in water. According to the Gospels, when Jesus was baptized in the Jordan River by John, his divinity was revealed by the descent of the Holy Spirit (Matt. 3:16, Mark 1:10, Luke 3:22, John 1:32). The Father, Christ the Son, and the Holy Spirit compose the three-part God (the Trinity). Therefore, an individual's immersion in the water of a baptismal font (basin) was understood as imitating Christ.

The Dura-Europos baptistery was a small room (7.5 × 4.2 m) in the southeast corner of the house, across a courtyard from a large, unpainted assembly room. A font, about one meter deep, was installed under a canopy painted with

Figs. 1-20a and 1-20b. Baptistery, Dura-Europos, ca. 230, *(top)* view toward the northwest, former reconstruction; *(bottom)* painting above font, 130 × 150 cm. Yale University Art Gallery, New Haven.

Box 1-2. CHRISTIANITY

Christians believe that Jesus is the Messiah mentioned in the Hebrew Bible (like the Hebrew word *Messiah*, the Greek word *Christ* means "anointed"—that is, chosen and marked by God). According to Christian scripture, Jesus was born in Bethlehem, near Jerusalem, to a Jewish virgin, Mary, whose pregnancy was announced to her by an angel in an event called the Annunciation. Jesus was baptized by his cousin, John; he performed numerous healing miracles and attracted followers, including a dozen disciples who are called the apostles. Jesus asserted that the Jews, and in particular the priests of the Temple in Jerusalem, were no longer following God's will. The Roman rulers of the province of Judaea crucified Jesus for claiming that he himself had a kingdom and that God's kingdom was more important than the Roman Empire. After Jesus's resurrection from the dead three days later and his bodily ascension to heaven forty days after that, his apostles spread the "good news" (*evangelion* in Greek, *gospel* in Middle English) to Jewish and other communities around the Mediterranean.

Saul was originally a Jewish critic of Jesus, but he converted, changed his name to Paul, and encouraged non-Jews to follow the faith by dispensing with Jewish dietary laws and male circumcision. Paul wrote the earliest Christian texts, known as the Epistles or Letters, between 40 and 64, when he was martyred in Rome. To help spread the new faith, the Gospels were written by the evangelists Mark (ca. 70), Luke (ca. 80; Luke is also credited with Acts), Matthew (85–90), and John (90s). The early Christians were persecuted intermittently for following a new faith and refusing to participate in public sacrifices on behalf of the Roman Empire; those killed were considered martyrs who died for their beliefs. Key issues in Christianity—the relationship of Christ to God, the role of Mary, the degree of Jesus's humanity versus his divinity, the role of images in Christian worship—were debated in international councils between the fourth and eighth centuries that divided the Church into major competing groups. At the heart of Christian ritual is the Eucharist, when bread and wine are transformed into the body and blood of Christ during the mass and then consumed by members of the Church. Christians believe that salvation depends on Christ: he is the Savior who will return at the end of time—his Second Coming—and grant eternal life to the faithful dead.

stars at the west end. An adult kneeled, sat, or squatted in it while being anointed with oil that evoked the Holy Spirit (John 3:5). The walls' paintings are now faint, but their subjects are clear. Behind the font was an image of Christ as the Good Shepherd (John 10:11–16), standing with one sheep on his shoulders and the rest of the flock in the landscape to the right (fig. 1-20b).

By the third or fourth century, Psalm 23, "the Lord is my shepherd," was used in the baptismal ritual to emphasize that new Christians joined the flock of believers. Below the shepherd is a small image of Adam and Eve, the first humans created by God. The book of Genesis describes how they defied God by eating fruit from a forbidden tree and were therefore expelled from the Garden of Eden, that is, from paradise. They were included in the baptistery to emphasize how this original sin could be redeemed, and humanity saved, through baptism. Scenes on the side walls also relate to salvation, including such water-related miracles as Jesus walking with the apostle Peter on the Sea of Galilee. The procession of torch-bearing women approaching a tomb shows that women played an important role in the biblical stories of salvation and in contemporary Christian life. An image of David demonstrates the distinctive polysemy of medieval Christian art—the multiple possible meanings and allusions in a single image. David was originally a shepherd (like Jesus), then an anointed king (as Jesus was understood by his followers) and an ancestor of Mary, so he provides a powerful genealogical link in the messianic chain that leads to Christ. David was also the traditional author of the book of Psalms, which was a rich source for Christian art.

Although less extensive than the paintings at the synagogue, those in the baptistery also visualize complex theological concepts in a condensed fashion, as the Mithraeum does as well. Like many other cities in the third century, Dura-Europos was a kind of marketplace of religions, whose followers used similar strategies to communicate their differing beliefs. In the following centuries Mithraism disappeared and Judaism became increasingly restricted, but Christianity flourished, and its arts continued to develop the features first apparent in the Dura-Europos baptistery.

Basic theological concepts were expressed not only in communal settings like the Dura-Europos baptistery but also on more personal objects used by individual members of the faith. The earliest surviving depiction of the crucified Jesus is on a late second-century green-and-red jasper (bloodstone) gem that was likely made somewhere in the eastern Mediterranean area (fig. 1-21). Long-haired, bearded, and nude, Jesus is attached to a T-shaped cross by straps around his wrists. The tiny stone is incised on both sides in Greek. The obverse reads, "O Son, Father, O Jesus Christ . . . cross(-beam) of the Redeeming Son," emphasizing the premise that Jesus is the Son of God and that God has three components, the Father, Son, and Holy Spirit. The inscription also includes syllables and vowels that can be interpreted as magical. Such formulae are well attested in polytheistic and Jewish magical texts and amulets, which were ubiquitous in antiquity and the Middle Ages because they were thought to be effective in aiding the bearer or warding off natural and supernatural dangers. The reverse of the gem contains more vowels and standard magical names, including Emmanuel from the Hebrew Bible (meaning "God is with us"; Isa. 7:14); this was understood by learned Christians as foretelling the arrival of Christ. The Gospel texts state that Jesus was nailed to the cross, not suspended from it, but this Crucifixion image was produced at a time before the Gospels were widely known. Even without the nails, the tiny stone emphasizes that the death of the "redeeming son" was painful and yet made possible the salvation and eternal life of Christians. The reddish stone was likely selected to amplify the notion of a bloody death. The idea of Jesus as the source of salvation dominated how medieval Christians produced, used, and viewed works of art. In this case, the small size of the gem requires that it be examined closely to make out the details of the image, an intimate interaction between viewer and object that makes the message of crucifixion and salvation a very personal one.

Two first- or second-century panels now at the J. Paul Getty Museum were also created with the idea of presenting deities in an intimate setting (fig. 1-22). While the paintings convey the lively presence of the Egyptian goddess Isis and her consort, Serapis, through carefully modeled eyes, mouths, hair, and clothing, the abundant grain and foliage that sprout from the gods' heads indicate their role in earthly fertility. Made from the wood of a sycamore fig tree and glue derived from cowhide to bind the pigments, the two panels appear to be doors and were probably used to close a three-dimensional portable shrine containing a sculpture of a god; the three divinities thus communed with one another when the shrine doors were closed. This kind of revelation and concealment is important in medieval art. The eventual representation of Christian holy figures on panels, alone or in two- or three-

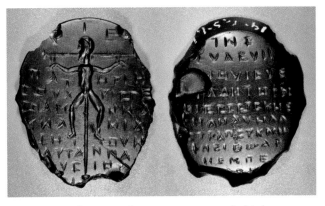

Fig. 1-21. Crucifixion amulet, 3 × 2.5 cm, second–third century; British Museum, London. © Genevra Kornbluth.

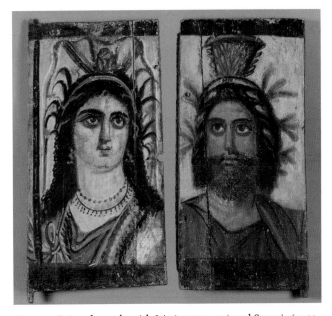

Fig. 1-22. Painted panels with Isis (40 × 19 cm) and Serapis (39 × 19 cm), first–second century; J. Paul Getty Museum, Malibu. Digital image courtesy of Getty's Open Content Program.

part folding works, is closely related to these Roman-era forebears.

Attitudes toward death were quite varied in the ancient world. Until the second century in the area of modern Europe, bodies were often cremated, and this practice did not disappear until the fifth century. In the eastern part of the Roman Empire and in Mesopotamia, many elites were buried in elaborately sculpted stone coffins called sarcophagi (the Greek word means "body eater," reflecting the bodily decomposition spurred by limestone). This practice then spread back to Rome and farther west as followers of different cults began to value the preservation of the dead body with an eye toward an afterlife. In Iran and its sphere of influence, the Zoroastrian religion prohibited burial and cremation and mandated exposure to flesh-eating animals (excarnation), but the absence of traces of excarnation by dogs or birds on bones found in archaeological contexts suggests that this practice was not

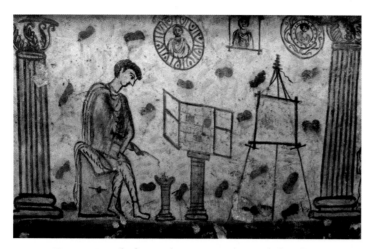

Fig. 1-23. Detail of sarcophagus interior, Kerch, late first–early second century; State Hermitage Museum, St. Petersburg. © Genevra Kornbluth.

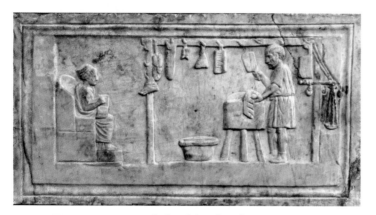

Fig. 1-24. Funerary relief with butcher shop, Rome, 38 × 68.4 cm, second century; Skulpturensammlung, Staatliche Kunstsammlungen Dresden. © Mark Ynys-Mon, flickr.com/mymuk.

always followed. Central Asian nomads continued to favor inhumation (burial in the ground).

Some sarcophagi in the Roman world are very explicit about their occupants, including, on rare occasions, working-class individuals. An example from the Kerch peninsula in Crimea is roughly dated by the coins and other objects found nearby to the late first or early second century CE, when the northern Black Sea coast was under Roman control following the conquests of Trajan. Although most sarcophagi are decorated only on the outside, the interior of this limestone burial casket was plastered and then painted with eight figural scenes on the sides and plants, birds, and fruits on the lid. The scenes, divided by painted columns, include a young man with a horse, musicians, and a banquet; such images refer to a pleasant afterlife, as does the lid with its references to some form of paradise. The detail shown here depicts a solitary artist in his workshop, probably the occupant of the sarcophagus who painted it before his death (fig. 1-23). Despite the absence of naturalistic space, the action is clear: the artist heats a tool that will help him blend colors on the triptych

(three-part folding panels) before him. Three framed bust-length portraits hang on the wall above an easel that supports an empty panel. The *clipeus* (Latin for shield-shaped, or round) format of two of the hanging panels derives from honorific public portraits; here the form is imitated in a private funerary context. As is the case with some other works in this chapter, there is no sense of depth, and the artist's figure reads more like an outline than a convincingly solid body. The man wears the long pants of a non-Roman and a *chlamys*, a long cloak, that elevates his status beyond what he enjoyed in his lifetime.

Similarly, a funerary relief found in Rome must have marked the burial place of the butcher-shop owners whose activity it depicts (fig. 1-24). The relief is dated to the first half or middle of the second century by the hairstyle of the woman seated at left; she is writing on a wax tablet, which suggests her literacy or numeracy. Her thronelike chair, ornate coiffure, and the numerous cuts of meat (mostly pork) on display in the shop indicate that the couple's prosperity was due to the hardworking butcher represented with cleaver in hand and, perhaps, the business acumen of his record-keeping wife. The relief is shallow and the butcher's proportions are stocky, but the work is still firmly in the classical tradition, unlike the painter in his sarcophagus. Like the images of Alexander and Augustus discussed above, the "portraits" of the butcher and the Kerch artist are not precise likenesses because the aim of the person who commissioned them was to re-present the individual: make him or her present by evoking some characteristics, such as profession or hairstyle, without the goal of close visual fidelity.

In Rome itself, carved marble sarcophagi became popular for the wealthy beginning in the second century. As the empire expanded, artistic ideas in the eastern provinces were brought west, and notions of an afterlife that required bodily preservation became widespread. A classicizing example from Rome, datable on stylistic grounds to the third quarter of the third century, shows a shepherd carrying a sheep on his shoulders (fig. 1-25). The deceased are the two seated figures, a married couple flanked by attendants; the man is represented as a Greek philosopher and the woman addresses him, holding a scroll (she is implicitly literate, like the wife of the butcher). Giant sheep guard the sarcophagus ends, protecting both the carved figures and the bodies within. Such shepherd images were enormously popular, attested by over two hundred sarcophagi between about 260 and 320. As celebrated in ancient poetry, they represent the peaceful, joyful world of leisure and nature, far from the cares of urban public life that occupied the living. This image of idealized tranquillity was an appealing metaphor for death, and it was adopted by Christians with the additional understanding that Christ was the Good Shepherd.

A late third-century sarcophagus, carved in Italy of eastern Mediterranean marble but found in England, bears

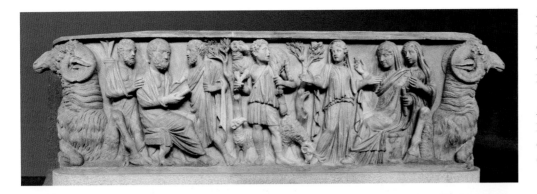

Fig. 1-25. Shepherd sarcophagus, Rome, 69 × 238 × 73 cm, third quarter of third century; Musei Vaticani, Vatican City. © Genevra Kornbluth.

Fig. 1-26. Jonah sarcophagus, Rome, 60 × 192 × 77 cm, late third century; British Museum, London. © Genevra Kornbluth.

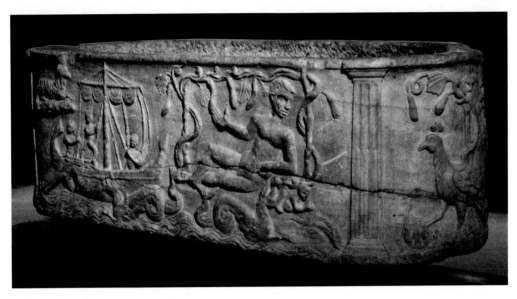

scenes in low relief from the life of Jonah, a Hebrew prophet (fig. 1-26). It is not a Jewish sarcophagus, however; the story of Jonah served a clear typological function for Christians, and the sarcophagus tells the story in an economical fashion. The prophet Jonah, not wanting to preach repentance in the great city of Nineveh (Iraq) as God instructed him, tried to hide on a boat, but a terrible storm threatened, as depicted on the left. Jonah took responsibility for the storm and, when thrown overboard, was swallowed by a huge fish or sea monster sent by God; this beast is shown menacing the ship. Jonah's three days in the belly of the monster were considered a type for Christ's three days in the tomb between his crucifixion on (Good or Holy) Friday and resurrection on (Easter) Sunday. In the scenes at the right, the creature casts out a tiny Jonah while a much larger one reclines under a gourd vine, looking toward a peacock on the short end of the sarcophagus. Once ejected by the sea monster Jonah did go to Nineveh, where God threatened to destroy the evil inhabitants. This entirely Jewish narrative was Christianized on the sarcophagus by the inclusion of a sheep on a cloud who looks down at the scene, "the Lamb of God, who takes away the sin of the world" (John 1:29), and by the peacock, which, according to ancient Greek legend, had flesh that did not decay and regularly grew new feathers, making it a potent symbol of immortality highly prized in Christian funerary arts.

Questions of Style

The carving of the Jonah sarcophagus does not show the idealized classical style seen, for example, in the Ara Pacis, with its naturalistically proportioned figures in well-contoured drapery moving convincingly in space. The more abstract styles that were seen in the Roman provinces had begun to appear in official imperial arts by the late second century, as evident in works in Rome and North Africa. A sculpted column in Rome dedicated to Marcus Aurelius was begun in 180 and completed in 193. Like most Roman emperors before him, Marcus Aurelius was deified (hailed as a god) upon his death, and the column was part of a temple complex built in his honor (fig. 1-27a). At one hundred Roman feet tall, it was exactly the height of the column built to honor Trajan (and hold his ashes) eighty years earlier; in addition, both are distinctive for their continuous spiral of relief carving that illustrates their respective military campaigns, Trajan's in Dacia and Marcus Aurelius's in Germanic tribal lands north of the Danube. The reliefs on the later column are larger, the scenes more clearly separated, and the figures stand out because of a technical innovation: drills, used to cut deeply into the stone and create strong light-dark contrasts.

There are also important iconographic and stylistic differences between the first- and second-century Roman

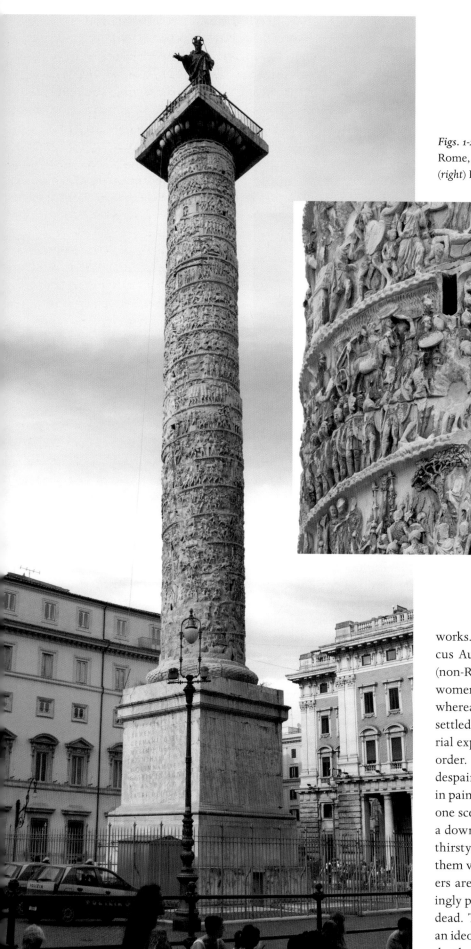

Figs. 1-27a and 1-27b. Column of Marcus Aurelius, Rome, 180–93, (*left*) whole column, 29.6 × 3.7 m; (*right*) Rain personification. Photo by the authors.

works. A high proportion of scenes on the column of Marcus Aurelius are devoted to violence—the "barbarians" (non-Romans) are clubbed, stabbed, or beheaded, the women dragged by their hair under the emperor's gaze—whereas on Trajan's column these enemies are calmly resettled in newly built camps as part of a strategy of imperial expansion based on the imposition of Roman law and order. On the Aurelian column the poses and faces of the despairing tribesmen are highly expressive and distorted in pain, in contrast with the more stoic Roman soldiers. In one scene, a monstrous personification of Rain represents a downpour that textual sources credit with reviving the thirsty soldiers of Rome's Twelfth Legion and bringing them victory (fig. 1-27b). The bodies of the Germanic fighters are piled vertically, while the Roman soldiers, seemingly perched on one another's shoulders, tower above the dead. This emphasizes the Romans' superiority, making an ideological statement by visual means. The omission of depth and abandonment of naturalistic, classical space is a hallmark of much medieval art.

Work in Focus:
LEPCIS MAGNA

After the murder of Marcus Aurelius's son and four years of civil war, during which several rivals competed for the imperial throne, Septimius Severus emerged victorious (r. 197–211). He legitimated his reign in three ways: by claiming he had been adopted into the preceding ruling dynasty (he had not); by demonstrating military might (he expanded the army and defeated the Persians, sacking their capital at Ctesiphon); and by initiating building projects in both Rome and North Africa. One such project was the ambitious rebuilding of the city of his birth, Lepcis Magna,

in present-day Libya (fig. 1-28). The modernization of this city on the north coast of Africa illustrates that the imperial ideologies manifest in other works could also operate on a grand, urban scale. Septimius's commission ranged from the highly functional new harbor and lighthouse to the showpieces of imperial prestige and power clustered around the new forum, the center of civic and commercial life. A wide colonnaded street featuring columns over ten meters high linked these two nodes of activity.

The strong axis of the colonnaded street is replicated in the adjacent large forum (almost 10,000 m²) that culminates in an elevated temple. Other features wove the spaces and buildings together. The colossal columns carry

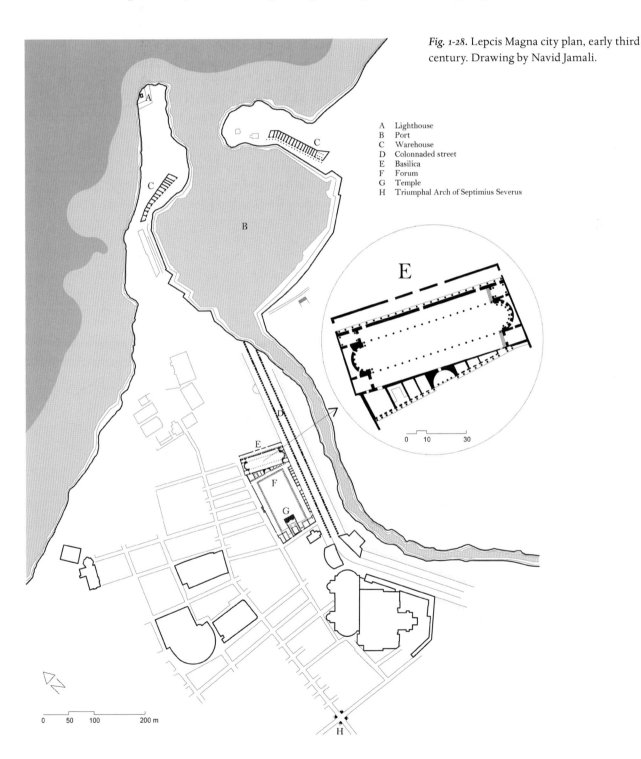

Fig. 1-28. Lepcis Magna city plan, early third century. Drawing by Navid Jamali.

A Lighthouse
B Port
C Warehouse
D Colonnaded street
E Basilica
F Forum
G Temple
H Triumphal Arch of Septimius Severus

arches in both the forum and street, an innovative design (figs. 1-28F and 1-29); previous imperial porticoes (roofed spaces open on one side) supported a straight entablature (parts of a wall supported by columns). This configuration created new spaces for sculpture in the spandrels between the arches. Here they feature snaky-haired Gorgon heads in relief, perhaps related to actual decapitations—Septimius had the head of one of his opponents displayed in Rome—and a signal to viewers that, like the Greek hero Perseus who slayed the Gorgon, he had divine support in defeating his enemies. Such heads also appear on Severan

coinage with the word *Providentia* (Providence), as if his rule were inevitable and the future of the empire foretold.

Septimius's project also included an important building type, the basilica, a roofed meeting hall for official and unofficial business (fig. 1-28E). This longitudinal structure has a wide and tall central aisle, or nave, that is separated from its narrower flanking aisles by colonnades. There is a semicircular apse (large recess) on each short side. All of these monumental public works are strong statements of imperial ideology and dynastic identity. Septimius Severus, like emperors before him, created a fictive genealogy that linked him to Hercules, the great-grandson of Perseus, to whom—along with Bacchus, the wine god—the basilica was dedicated. The emperor adopted both gods as his personal divinities, and parts of the basilica bear relief carving with stories from their lives.

During the visit of the imperial family to Lepcis Magna, perhaps in 207, a monumental four-sided triumphal arch was dedicated in their honor at one of the city's major intersections (figs. 1-28H and 1-30a). The marble for the arch came from Asia Minor, as did the inspiration for the broken pediments (triangular elements) that crown it. Much of its sculpture deals with the family's ceremonial activities, with figural reliefs on the exterior and interior, including references to Bacchus and Hercules. One of the four multislab friezes in the attic (upper story) depicts a procession with Septimius Severus and his two sons in a chariot decorated with reliefs of the local gods and the personification of Lepcis (fig. 1-30b). At the right, the city's new lighthouse towers above two rows of bearded male figures. The protagonists

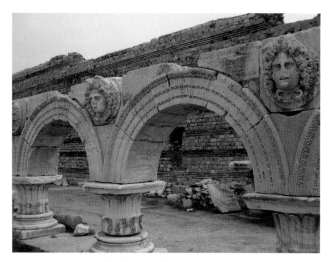

Fig. 1-29. Arcade in the forum of Septimius Severus, Lepcis Magna, early third century. © Joe & Clair Carnegie/Libyan Soup.

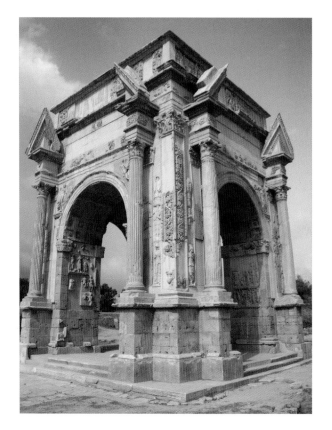

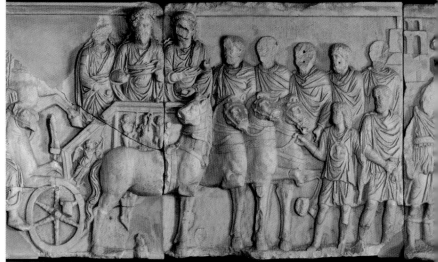

Figs. 1-30a and 1-30b. Triumphal arch of Septimius Severus, Lepcis Magna, early third century, (*left*) in situ; (*right*) detail of frieze, H 172 cm; Assaraya Alhamra Museum, Tripoli. (*l*) Wikimedia Commons/David Gunn, public domain; (*r*) akg-images/Gilles Mermet.

Box 1-3. ZOROASTRIANISM

The religion of the Sasanian Empire was Zoroastrianism, named after its first prophet-philosopher, Zarathustra or Zoroaster. He may have lived in the northern steppes during the Bronze Age, before the southward migration of the Iranian tribes, although later sources place him in Central Asia. He allegedly ascended to heaven to converse with the chief god, Ahura Mazda or Ohrmazd ("All-Knowing Lord"). Zoroastrianism is a dualist faith, with Ahura Mazda, embodying goodness and light, eternally opposed to Ahreman, who represented evil and darkness. Ahura Mazda created humans, dogs, and birds, and Ahreman responded with reptiles, insects, and all decaying matter. The two waged war in the space between them, Earth, where Mithras was a mediating figure. Zoroastrians worshiped the gods in fire temples, and rituals were conducted in the presence of a sacred fire by ritually pure priests. The dead were supposed to be exposed to the elements and wild animals rather than be buried or cremated, which defiles the earth. Extensive rituals of death and commemoration

ensured that on the fourth day after the funeral the soul departed for judgment.

From the outset, the Sasanian rulers were identified on their coin obverses as Mazda worshipers, and sacred fires were depicted on the reverse. A dominant theme in early Sasanian history was the unity of all Iranians under a divinely sanctioned emperor, the *shahanshah* (king of kings), which was accomplished in part by restructuring and centralizing Zoroastrianism as a tool of statehood. This may have been inspired by the rise in the third century of Christianity to the west of Iran and Buddhism to the east, both of which actively sought converts. Zoroastrians who converted were persecuted, and a failed attempt was made to force Armenia, the first kingdom to convert to Christianity (under King Trdat IV, ca. 300), to return to Zoroastrianism. By the late Sasanian period the shahanshah was less the earthly representative of Ahura Mazda and more a descendant of the semilegendary ruling dynasty of the Iranians described in the Avesta and, later, in the *Book of Kings* (*Shahnameh*), the Iranian national epic.

and the bearded men face stiffly forward, perpendicular to the horizontal movement of the horses, and the men of the imperial family are larger than all the other figures. Exaggerated height and frontality, first seen in imperial Roman art in the early third century, are abstract indications of power in medieval art as well.

The Sasanians

The Sasanians who conquered Dura-Europos had defeated the preceding Persian-speaking Parthian dynasty (247 BCE–224 CE) in 224, and thereafter they controlled an even larger empire, from Armenia, Georgia, and Syria to the borders of China and India, until their defeat by the Muslims in 651. Among the most able Sasanian rulers was the second, Shapur I (r. ca. 240–72). He strengthened the government, continued his father's reform of the coinage, and supported the Zoroastrian religion, although he was also tolerant of Jews and Christians. The idea of an empire of the Iranians, *Eranshahr*, was a Sasanian invention, an ideological strategy to link the new dynasty with its distinguished ancient predecessors.

In 260 Shapur I captured the Roman emperor Valerian,

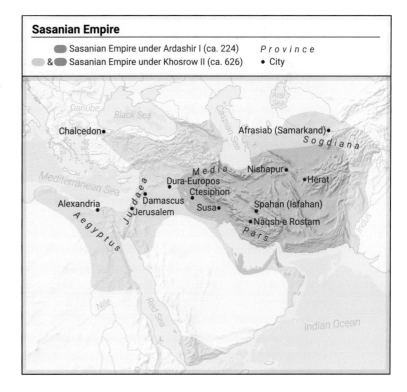

Sasanian Empire

- Sasanian Empire under Ardashir I (ca. 224)
- & Sasanian Empire under Khosrow II (ca. 626)

Province
- City

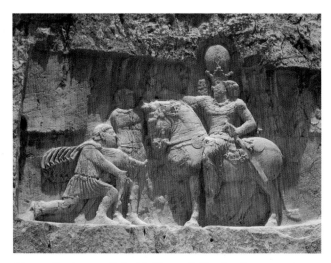

Fig. 1-31. Rock-cut relief with Shapur I, Naqsh-e Rostam, 260s. Wikimedia Commons/Fabienkhan, CC BY-SA 2.5.

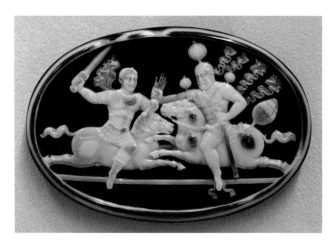

Fig. 1-32. Shapur I Cameo, 6.8 × 10.3 cm, ca. 260; Bibliothèque nationale de France, Cabinet des médailles, Paris. © Genevra Kornbluth.

who was seen as an embodiment of Ahreman, and this event was celebrated in several media. Cut high into the cliffs at Naqsh-e Rostam ("Throne of Rustam," a legendary Iranian hero), near the former capital of Persepolis, were tombs and funerary reliefs of four Achaemenid rulers. The Sasanians explicitly tied themselves to the Iranian past by adding nine rock-cut reliefs below the older ones (another thirty Sasanian reliefs survive elsewhere in Iran and Central Asia). The intent was to create a picture of seamless historical continuity. These reliefs all show scenes of military victory or royal investiture (ceremonial conferring of symbols of office, especially robes). They could only be viewed from below, not head-on, so the figures are larger at the top in order to look properly proportioned (fig. 1-31).

This relief depicts Shapur I wearing the type of crown used earlier by Achaemenid rulers and in representations of Ahura Mazda. He is seen on horseback towering over two Roman emperors. Shapur simultaneously receives the submission of Philip "the Arab" in 244 and takes Valerian prisoner in 260: the relief is a symbolic snapshot, melding

different events into one heroic image executed soon after the second event. The identity of the characters is not in doubt, because the two Romans are named in nearby inscriptions written in Greek and two different Persian languages. Valerian is the standing figure in the background whom Shapur grasps by the upraised wrists—the Persian sources say "we [Shapur] captured Valerian with our own hands"—and Philip is the one in the foreground who bends his knee in homage (a figure at right, behind the horse, is a later addition). The half-kneeling figure has greater visual prominence, suggesting that for the Sasanians the handover of money and promise of future tribute—a recognition of Sasanian superiority that humiliated the Romans—was more important than the physical capture of an individual ruler, even though this was the first time the Romans had suffered such a loss. A standing loser still possessed higher status than a kneeling one.

This image of the shahanshah triumphing over Roman emperors became the standard iconography of power in early Sasanian art. It was used on gold coins and on a cameo now in Paris (fig. 1-32). Here Valerian, mounted on horseback and wielding a sword, is almost equal in size to the victorious Shapur who nevertheless grasps him by the wrist, just as on the Naqsh-e Rostam relief. The sardonyx is the same material as the cameo of Augustus discussed above; its challenging facture made such cameos a sign of wealth in diverse cultures. Shapur's richly bedecked horse wears a ribboned plume and tassels, including a large flywhisk at the back. The billowing military cloak of Valerian and the ribbons attached to Shapur's diadem, shoulder bands, and footwear are precisely detailed despite the miniature medium. Shapur's hair is piled high in an exaggerated bun (*korymbos*), which along with the diadem (long worn by Mesopotamian and Iranian kings) represents his luminous, divine glory and his legitimacy as the ruler of Eranshahr. (Glory was later communicated in Sasanian art by a nimbus or halo, a colored disk around the head, just as it was in late Roman and medieval art.) In some inscriptions and coins produced after 260, Shapur claims to be shahanshah not only of the Iranians but of non-Iranians as well, as trumpeted in both the cameo and the Naqsh-e Rostam relief.

The Late Roman Tetrarchy

The works associated with Shapur clearly reveal Sasanian imperial ideology, and the final work in this chapter on the roots of the Middle Ages displays Roman ideology at the turn of the fourth century. It also points to the future in important ways. After the troubled period shown on the column of Marcus Aurelius, things got worse for the Roman Empire, as evidenced by the fate of Valerian. Most third-century emperors lasted only a few years. For this reason, the emperor Diocletian (r. 284–305) conceived a

new system of government that could respond better to threats on the frontiers and to the problem of imperial succession. This system was the Tetrarchy: four rulers—two *augusti*, senior emperors, and two caesars, junior ones—who were supposed to divide the empire among them, the caesars succeeding augusti who would retire peacefully and appoint new junior partners. The tetrarchs initiated a series of reforms to strengthen the empire, including a unified coinage, standardized prices, and an emphasis on the traditional Roman imperial cult that included empire-wide persecution of Christians, who were seen as disruptive to the smooth operation of the state. The tetrarchs themselves claimed divine ancestry, as Roman rulers had long done. Rome was no longer the capital, however, because it was too far from the imperial borders; instead, the capitals were initially Nicomedia and Sirmium in the east, Milan and Trier in the west. The planned transition of power broke down entirely by 308, however, when four men claimed to be augusti. The conclusion of the power struggle is discussed in chapter 2.

This chapter has shown numerous ways that rulers could be depicted, but during the Tetrarchy, individualized representation was unimportant. A statuary group now in Venice is actually two separate pairs that were originally attached to columns (fig. 1-33). All four figures wear military dress and bearskin caps, and they are nearly identical, although one in each pair has a very slight beard and may represent the senior emperor. The figures are squat and stiff; the clothing is mostly a repetitive pattern of lines with no relationship to the body underneath. Unlike previous representations of emperors, which were personalized to some extent even when idealized, here the choice was made to erase individual features in favor of an overall abstraction that emphasizes unity, concord, and stability. This choice was strengthened by the material: the figures are carved from very hard reddish-purple porphyry, a stone quarried only at Mons Porphyrites in Egypt's eastern desert. Porphyry, along with the use of the color purple, was an imperial monopoly beginning in the first century: Roman organizational might and imperial desire were required to exploit the remote site and transport the heavy stone. During the third-century crisis the quarrying of porphyry declined, but the tetrarchs revived it and used the material for portraiture for the first time. The blocky tetrarchic style resulted partly from the difficulty of carving the stone, but it was more a symbolic expression of solidity and solidarity in troubled times than a technical limitation. The quarry was not worked after the early fifth century, but valuable porphyry pieces were moved and reused throughout the Middle Ages. The group in Venice is now at the corner of the cathedral of San Marco; it was brought there from Constantinople in 1204, and the missing foot of one of the tetrarchs (here replaced in white stone) can still be seen in Istanbul, the modern name for Constantinople. That city became the capital of

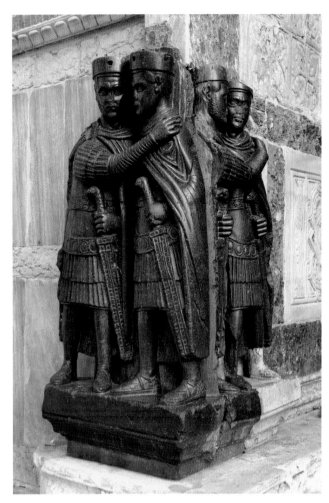

Fig. 1-33. Porphyry Tetrarchs, H 136 cm, ca. 300; San Marco, Venice. Wikimedia Commons/Nino Barbieri, CC BY 2.5.

the (eastern) Roman Empire of the Middle Ages, usually called Byzantium.

The shifting and in many ways declining fortunes of the Roman Empire are one of the major phenomena that defined the transition to the medieval period. Not only Rome but also adjacent and competing empires developed artistic and architectural conventions that expressed the power of the ruler and supporting institutions. Such conventions were often shared among different political, religious, and cultural groups, and borders between them were usually fertile areas for cross-cultural exchange and artistic innovation. This is particularly evident in the interplay of classical and nonclassical styles and in the manipulation of art's formal properties to communicate ideological messages. Although the patronage of large-scale works of art and architecture often involved rulers and other elites, the first centuries of the Common Era are marked by the desire of people across the economic spectrum to express their increasingly personal religious beliefs in material and visual ways, especially in the funerary realm. At this point, Christianity was only one of many choices in the religious marketplace, and the earliest arts of its adherents demonstrate indebtedness to many existing traditions.

CHAPTER 2

Fourth and Fifth Centuries

Legend

☐ Location or findspot
 - Monument/object
• Additional site
○ Approximate place of production

Ålleberg ☐
 - Gold collar

När ☐
 - Gilt-silver brooch

Funen ☐
 - Gold bracteate

Vermand ☐
 - Treasure

Cologne ☐
 - Bowl with roundels

Trier •

Bordeaux •

○ Stilicho Diptych
○ Ascension ivory

Milan

Ravenna ☐
 - Neonian (Orthodox) Baptistery

☐ **Rome**

Thessaloniki ☐
 - Monastery of
 the Stoneworker

Constantinople

Chalcedo

Carthage •

Olympia • Ephesus • ☐

Alps

Church of St. Peter, Rome

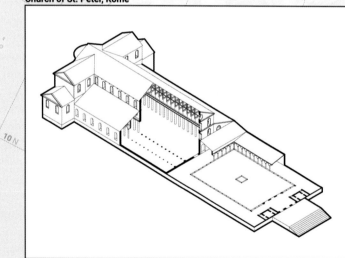

Rome

- Church of Santa
 Maria Maggiore
- Church of St. Peter
- Lateran Baptistery
- Projecta Casket
- Seasons sarcophagus
- Tomb of the Julii
- Vatican Vergil manuscript
- Villa Torlonia Catacomb

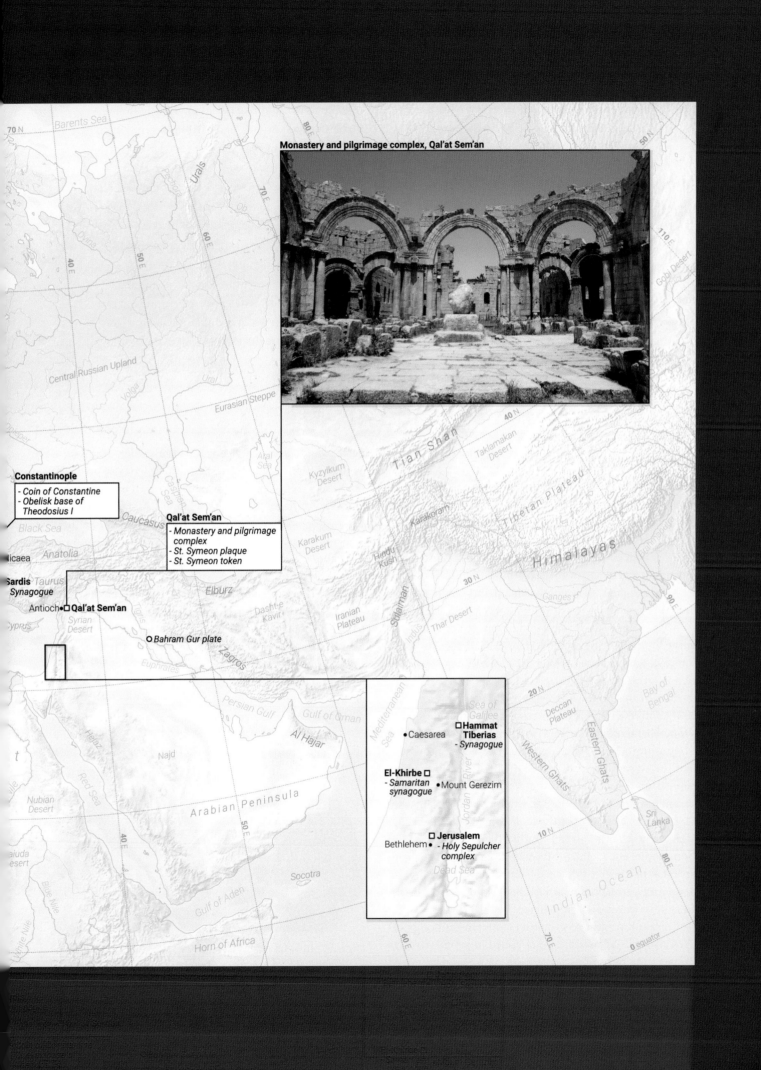

Monastery and pilgrimage complex, Qal'at Sem'an

Constantinople
- Coin of Constantine
- Obelisk base of
 Theodosius I

Qal'at Sem'an
- Monastery and pilgrimage
 complex
- St. Symeon plaque
- St. Symeon token

Sardis Taurus
Synagogue

Antioch • □ **Qal'at Sem'an**
Syrian
Desert

○ *Bahram Gur plate*

• Caesarea □ **Hammat
 Tiberias**
 - *Synagogue*

El-Khirbe □
- *Samaritan
 synagogue* • Mount Gerezim

 □ **Jerusalem**
Bethlehem • - *Holy Sepulcher
 complex*

These two eventful centuries saw Christianity spread farther around the Mediterranean and into the Sasanian realm with imperial Roman support. The emperor was no longer based in Rome, however, but in a new capital to the east, at the edge of Asia: Constantinople. The old imperial borders were constantly threatened by migrations of nomadic peoples who originated in eastern Europe, Central Asia, or the steppes to its north. The Huns attacked the Sasanian Empire and then the Roman one, while Rome itself was sacked by the Visigoths (fleeing the Huns) in 410. In 439 the Vandals conquered Carthage (in modern Tunisia), and in 476 the Ostrogoths deposed the last Roman ruler in Italy. The Romans withdrew from Britain, and parts of it were settled by Angles and Saxons; the Merovingian dynasty of the Franks took control in western Europe and converted to Roman Christianity. Increasingly aggressive legislation outlawed the public performance of pagan sacrifices, although some individuals—ranging from high court officials to unlettered peasants—continued to practice polytheism in the Roman Empire for many centuries. Because the Roman world was transformed between the third and the seventh centuries while maintaining many of its structures, that period is often called late antiquity.

Constantine and Monumental Christian Building

One person was largely responsible for some of the dramatic shifts in power around the Mediterranean basin in the fourth century CE: Constantine, the first Roman emperor to legitimize and embrace the Christian faith. Before that happened, the Tetrarchy collapsed because of the individual ambitions of the sons of two senior emperors who had resigned. To strengthen his claims on the empire, one of those sons, Maxentius, inaugurated an enormous building program in Rome itself, despite it not being one of the four tetrarchic capitals. He was challenged by Constantine, who defeated him in 312 in a battle north of the city. Polytheist and Christian authors reported that before the battle Constantine had a vision, a heavenly sign, which he then marked on his troops' shields, but they disagreed about what that sign was and what it meant. Decades later, Constantine's biographer, Eusebius of Caesarea, insisted that the sign was a cross and that Christ himself had explained its significance to the would-be emperor. This account served to promote Christianity and explain why Constantine had become the first Roman ruler to recognize the new faith. In the Edict of Milan, issued in 313 by Constantine and Licinius, his co-emperor in the east, property that had been confiscated from Christians during the periods of persecution was restored to them, and Christianity was declared a legal religion.

Constantine went on to defeat Licinius in 324. A copper-alloy *nummus* (a low-value coin) issued in 327/28 portrays Constantine in profile on the front with the abbreviated Latin legend "Constantine the Greatest Ruler" (fig. 2-1). He wears the diadem long associated with rulers east of the Roman Empire, which had begun to appear in portraits on Roman coins as a symbol of divine rule. On the reverse, a Roman military standard—a banner adorned with medallions depicting the ruler and his sons—pierces a limp serpent that symbolizes the emperor's defeated foe. Above the banner is the Christogram or Chi-Rho, in which the first two letters of "Christ" in Greek (X + P) are superimposed. The inscription says "Spes Publica," Hope of the Public. This coin publicized Constantine's promotion of the Christian faith, but in a subtle way; not everyone in the empire would have recognized the symbolic Christogram.

As sole emperor in western Europe even before the defeat of Licinius, Constantine completed some of his predecessor's projects in Rome, including a huge basilica in which he installed a colossal statue of himself to replace

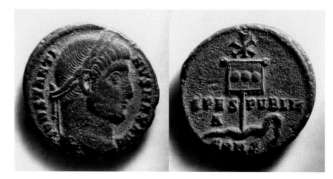

Fig. 2-1. Coin of Constantine, 1.9 cm, 327/28; Dumbarton Oaks, Washington, DC. © Genevra Kornbluth, courtesy Dumbarton Oaks, Byzantine Collection, Washington, DC.

the planned image of Maxentius. Along with the triumphal arch erected by the Roman Senate in his honor, such construction established that Constantine was the culmination of a long line of distinguished imperial predecessors. Entirely novel, however, was Constantine's patronage of the first large-scale Christian churches. On an imperial property called the Lateran outside Rome's civic center, he commissioned a basilica later dedicated to the Savior and then to St. John to serve as the cathedral of Rome. A cathedral is a church, of any size or style, that houses the cathedra (throne) of a bishop. Bishops preside over major Church districts called bishoprics, sees, or dioceses, which contain a network of clergy and faithful organized in smaller units known as parishes. Next to the basilica Constantine commissioned a baptistery, which was built over an earlier bath complex and reused its plumbing. Unlike the baptismal room in the renovated house at Dura-Europos (fig. 1-20a), this was a sizable, purpose-built structure, octagonal in plan and about twenty meters high and twenty meters wide. The Lateran Baptistery has been renovated several times, so a reconstruction of its fourth-century core is shown here (fig. 2-2).

The font, in which adults submerged for the baptismal ceremony on the Saturday night before Easter Sunday, was encircled by eight reused porphyry columns supporting an architrave (horizontal beam). A sixth-century collection of biographies of the bishops of Rome reports that Constantine donated seven silver stags that served as waterspouts as well as life-size images of Christ and John the Baptist (all of them disappeared long ago). The deer were metaphorically drinking the water of life (Ps. 42:1), and the architrave bore an eight-line poem that read, in part, "This is the font of life that bathes the whole world; its origin is Christ's wound. Those reborn in this font can hope for the kingdom of heaven." Many later baptisteries were also octagonal because the number eight had symbolic significance for Christians: Jesus's resurrection occurred on the eighth day of God's original creation.

Underscoring this metaphor of life from death was the architectural similarity between the centrally planned baptistery and similar Roman tomb structures. Just as Christ's own resurrection had demonstrated the possibility of life after death, Christians understood baptism as the death of their old life and the birth of a new one. Yet the large-scale sculpture that decorated the basilica and baptistery at the Lateran made many Christian thinkers nervous. They feared that this Roman sculptural tradition might lead to Roman-style idolatry—that is, to the worship of a statue as if it were itself a divinity rather than a representation of one. For this reason, very few examples of freestanding sculpture were produced between the early fourth century and the revival of that classical medium in the ninth.

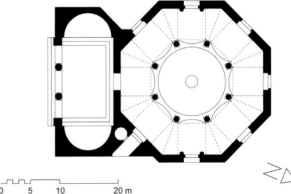

Fig. 2-2. Lateran Baptistery, Rome, 320s. Drawings by Navid Jamali.

Work in Focus:
THE CHURCH OF ST. PETER

The most famous of Constantine's projects in Rome was the church he commissioned in the 320s in honor of St. Peter, to whom Jesus had said, "on this rock (Greek *petros*) I will build my church" (Matt. 16:18). The site, on the Vatican Hill west of the city, had previously been occupied by the circus (chariot racetrack) of Emperor Nero, where in 64 Peter had allegedly been put to death during one of the empire's sporadic local persecutions. By the mid-second century, Christians identified a particular grave as that of Peter, whom they considered the founder of the institutional Church and the first bishop of Rome; they isolated the grave from its neighbors and monumentalized it with a columned aedicula (small freestanding structure) (fig. 2-3).

In the third century, the area east of Nero's circus, which was no longer in use, became an open-air necropolis (Greek for "city of the dead") containing the brick tombs of Roman families. One of these tombs, that of the Julii (Julian family), received expensive colored-glass mosaic decoration, a technique that uses tiny tesserae (cubes) to create images or patterns. The mosaics covering the tomb's walls and vault confirm that it was used for a Christian family member or members, doubtless someone who wanted to be buried near the disciple of Jesus (fig. 2-4). On a gold background covered by green vines, a charioteer guides

Fig. 2-3. Vatican Hill (Rome), third century, reconstruction; A=aedicula marking tomb of St. Peter, ca. 160, with apse outline of later church; B=necropolis. Drawing by Navid Jamali.

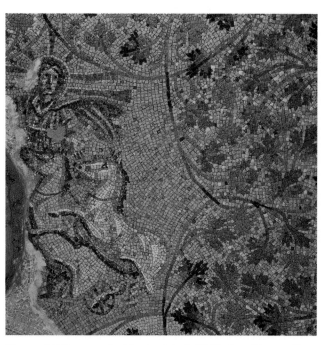

Fig. 2-4. Ceiling mosaic, Tomb of the Julii, Vatican Necropolis (Rome), third century. © 2020. Photo Scala, Florence.

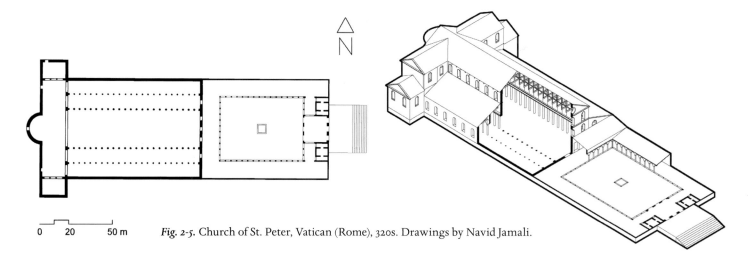

Fig. 2-5. Church of St. Peter, Vatican (Rome), 320s. Drawings by Navid Jamali.

two (originally four) white horses at the center of the ceiling. The cross form of the rays that emerge from his head suggest that this figure is Christ and not the polytheistic sun god, although the idea of Christ as Sol Invictus, the unconquered sun—a title used for gods and rulers for centuries, including Mithras at Dura-Europos—cannot have been far from the artist's mind. The identification as Christ is confirmed by the scenes originally on the side walls of the tomb, a fisherman (probably Peter) and Jonah being cast from the ship. The figures and ornament depicted in the mosaics indicate awareness of the concepts behind such Gospel passages as "I am the true vine, and my Father is the gardener" (John 15:1). While wall mosaic was not a new technique, it quickly became the paradigmatic decorative medium for early Christian churches, and its use here in a funerary context indicates the high economic status of members of the Julian family.

Some years after Christianity became a legal religion and probably after he defeated Licinius, Constantine ordered an enormous amount of earth to be cleared from the Vatican Hill to create a large platform that could support a new basilica over the grave of Peter. The second-century aedicula poked through the floor of the new church and was further monumentalized by a baldachin, or canopy, supported on six spiral columns donated by Constantine (these were later thought to have come from the Temple of Solomon, but they probably date to the second century CE). This fourth-century church is often called Old St. Peter's to distinguish it from the sixteenth-century replacement visible today. Architecturally, the new Christian basilicas were much like the multipurpose Roman basilicas that preceded them, such as the one at Lepcis Magna (fig. 1-28E): they featured a long, broad nave flanked by aisles (fig. 2-5). This form was eminently suitable for sheltering a large number

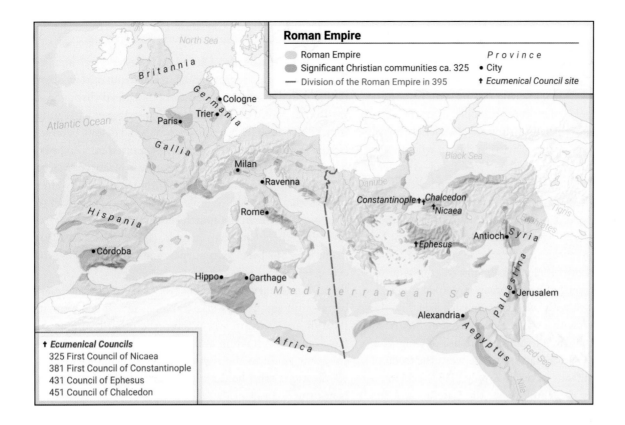

Roman Empire

Roman Empire
Significant Christian communities ca. 325
— Division of the Roman Empire in 395

Province
• City
† Ecumenical Council site

† Ecumenical Councils
325 First Council of Nicaea
381 First Council of Constantinople
431 Council of Ephesus
451 Council of Chalcedon

of people, but the longitudinal focal point housed an altar rather than an imperial statue (the focus at St. Peter's was not an altar but, rather, the baldachin over the old aedicula marking Peter's grave).

A notable architectural innovation here was the transept, a wide aisle perpendicular to the nave and side aisles that created a large, distinct area around the baldachin. Rows of columns along the seam between the transept and nave aisles created a permeable barrier that helped separate the large number of visitors from the shrine and the clergy who took care of it. The resulting T-shaped plan became an important model for medieval churches north of the Alps, but with a major difference: both St. Peter's and the Lateran Basilica were occidented churches, meaning that their apses projected to the west, whereas almost all medieval churches are oriented, with the apse in the east toward the rising sun and, according to the Gospels, the direction of Christ's Second Coming (e.g., Matt. 24:27). Christians wanted to be buried near the grave of one of Jesus's closest followers, who was revered for his miracles, evangelizing activities, and martyrdom. Peter's physical remains—his sacred relics—were a potent connection to the saint in heaven with Christ. For these reasons, the basilica was soon filled with graves, and additional tombs were built outside. In this way, too, St. Peter's was a model for later churches.

Constantinople and the Holy Land

In 324 Constantine decided to establish a new capital closer to the empire's eastern border. He selected Byzantion, at the easternmost edge of the European landmass on a channel linking the Aegean to the Black Sea. It already had the essential features of a small Roman city—temples, walls, public baths, a hippodrome (circus)—thanks to the patronage of Septimius Severus around 200. Consecrated in 330, it was known thereafter as Constantinople—literally, City of Constantine—even after its conquest by the Turks in 1453, when the name Istanbul was gradually adopted. The copper coin discussed above was minted in this new Roman capital, which became the center of the eastern Roman Empire (Byzantium). The foundation of this "New Rome" shifted Roman political and economic power eastward, toward Sasanian Iran and Central Asia.

New Rome imitated Old Rome in several respects: it had seven hills and fourteen districts, and it was adorned with large quantities of sculpture, prized works of art that included the famous statue of the enthroned Zeus from his temple at Olympia in Greece. In 334 the monk Jerome, paraphrasing Eusebius, wrote that "Constantinople was dedicated by denuding almost all other cities [of sculpture]." He was criticizing the rapaciousness of the collectors, not the pagan subject matter of the works. Constantine did not close any of the temples operating in the new capital, and he did not build extensively for his Christian subjects there, although he did establish a cathedral for the city's bishop. Only after his death in 337 were the remains of important Christian holy men and women brought to

Constantinople, making the city the single greatest repository of Christian relics for most of the Middle Ages.

Constantine attempted to impose imperial control over the institutional Church by calling the First Ecumenical (worldwide) Council—a gathering of Christian bishops—at Nicaea (now Iznik), near Constantinople, in 325 (box 2-1). Perhaps it was there that the bishop of Jerusalem brought to his attention the plight of Christian sites in what by the fifth century would be called the Holy Land—the area where Jesus and his followers had lived and died. The burial place of Jesus was hidden under a pagan temple, the emperor learned. Constantine sent funds to demolish the offending building and, later legend has it, sent his mother, Helena, to ascertain the precise site of the tomb. The Holy Sepulcher complex was begun in 326. Its monumental entry from the main Roman street led to a five-aisle basilica (a nave with two aisles on each side, like the church of St. Peter) with a western apse (fig. 2-6). Behind it, a colonnaded courtyard surrounded the hill of Golgotha, the site of the crucifixion; farther to the west, the tomb of Jesus was isolated from its original rock. This occidented arrangement, like the churches at the Lateran and the Vatican in Rome, was a topographical necessity that also evoked the layout of the Jewish Temple, which stood in ruins nearby.

In 335 Constantine urged all Christian bishops to assemble in Jerusalem for a dedication ceremony that imitated the consecration of the Temple described in the Bible (1 Kings 8). Under Constantine's son and successor, Constantius I, the tomb itself was enclosed in a large rotunda dedicated to the *Anastasis* (Greek for resurrection). Its circular colonnade embellished the holy space and shaped its meaning, for it had twelve columns, representing the apostles, alternating with piers. The colonnade also helped create two distinct spaces: the center, usually reserved for high-ranking Church officials, and the outer ring, customarily for visitors. This mid-fourth-century rotunda came to symbolize the entire Holy Sepulcher complex and was widely imitated in later Christian contexts.

Constantine made the Christian religion legal and its places of worship monumental, but he did not outlaw other faiths. Polytheism continued to be practiced throughout the Roman world despite increasingly stringent legislation in the fourth and fifth centuries. Judaism had long been accepted as an ancient and therefore permitted religion, perhaps because the Jewish population was never very large and posed no threat to the Roman Empire, especially after the destruction of the Temple in Jerusalem. Jewish art in the city of Rome in the fourth century demonstrates that Jews, like their Christian neighbors, continued to adapt Roman art for their own purposes, as they had done for centuries.

A fragmentary sarcophagus front carved of white marble around 300 depicts classical-looking winged personifications of Autumn and Winter (the other two seasons have been lost) holding animals appropriate to each season; they stand to the right of symmetrical Victory personifications who hold aloft a clipeus (fig. 2-7). Inside it is not the portrait of the deceased that appears on many Roman sarcophagi, however, but a large menorah that emphasizes the faith of the occupant. Under the clipeus,

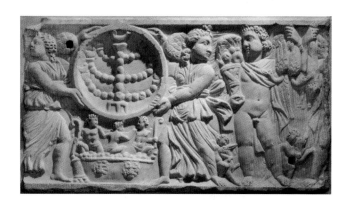

Fig. 2-7. Seasons sarcophagus, fragment, Rome, 70 × 126 cm, ca. 300; Museo Nazionale Romano, Rome. © Genevra Kornbluth.

Fig. 2-6. Holy Sepulcher complex, Jerusalem, fourth century; A=tomb of Jesus, B=Anastasis Rotunda, C=crucifixion site, D=basilica. Drawings by Navid Jamali.

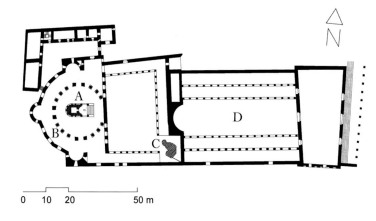

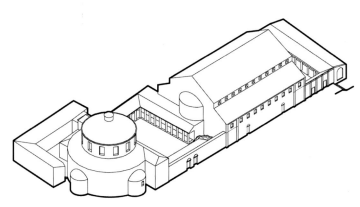

Because Christian scripture is complex, often met-aphorical, and at times ambiguous, it has prompted a variety of interpretations. A challenge faced by leaders in the early centuries of Christianity was to structure the faith as a coherent and consistent belief system—in other words, to provide strong founda-tions for an institutional Church. Church officials met periodically to discuss vexing theological mat-ters and arrive at a consensus about them, thereby establishing Christian doctrine. Accepted doctrine provided the basis for orthodoxy; rejected ideas were considered heretical, and those who believed in them, heretics, were rejected by the Church.

The First Council of Nicaea (325) set the date of Easter, formulated an early version of the Christian creed (known as the Nicene Creed), and censured a priest named Arius for believing that Christ was created by God the Father and therefore not quite equal to him. The position embraced by Arius and his followers, the Arians, was deemed heretical and countered by arguments asserting that the Son was the same essence as the Father. Nevertheless, many Christians agreed with Arius, including several of Constantine's successors and a number of Germanic peoples who had converted to Christianity.

In Constantinople in 381 the bishops finalized the Nicene Creed and addressed the problem of the third component of the Christian Trinity, the Holy Spirit. If Christ was equal to God, was the Spirit also an agent of *theosis*, human union with God? The decision, formulated in Greek philosophical terms, was that the three persons of the Trinity are distinct but still one and the same God; they are one substance composed of three parts. The divinity of Christ was thus doctrinally established. Unlike the more inclusive nature of Roman religion, alternative ways of thinking about or practicing Christianity were criticized by the "winners," the Christians who followed the ecumenical councils' decisions. Yet the "losers" were often fervent Christians; their marginalization resulted in their disaffection with the Roman Empire and easier absorption into the Islamic realm in the seventh century.

Ecumenical councils held in the fifth century dealt with the precise nature of the union of God and man in Christ. In 431 at Ephesus (Turkey), Nesto-rios, the patriarch (archbishop) of Constantinople, argued that there were two persons in Christ, the son of the woman Mary and the son of God; only the former was born, crucified, and died. Moreover, he insisted that Mary was the mother of Christ but not the *Theotokos* (Greek for "God-bearer"). The majority of bishops at the third council, however, argued that God really did become man and that Mary truly was the Theotokos and mother of God. The Nestorians nevertheless retained many adher-ents in western Asia and eventually spread as far as China.

Much of early Christian and medieval art expressed the theological ideas debated and for-malized at these councils, but it is often difficult to discern differences between works produced by "heretics" and their "orthodox" rivals. The Neonian Baptistery in Ravenna, discussed below, is often called the Orthodox Baptistery to differentiate it from the Arian Baptistery built there a few decades later. Yet the two look remarkably similar on the outside and contain analogous mosaics on the inte-rior, providing no clear indication of which features might be heretical or orthodox.

three putti (Cupidlike toddlers) tread grapes in a wine vat, while others frolic alongside the seasons. With the ex-ception of the menorah, which was the most widespread symbol of Judaism in the ancient and medieval worlds, all of these iconographic elements are drawn from the rep-ertoire of Roman imagery available to polytheists, Chris-tians, and Jews alike. The purchaser probably bought the partly carved Seasons sarcophagus from a stonecutter's shop and requested a made-to-order menorah; similar fin-ishing touches were also required when individuals were depicted in the clipeus. Workshops that sold their products to purchasers of different faiths were the norm in fourth-century Rome and elsewhere.

The original location of the sarcophagus fragment is unknown, but it probably came from a Jewish catacomb on the outskirts of Rome. There were six such under-ground Jewish cemetery complexes, and radiocarbon dat-ing suggests that some of them predate the more numer-ous Christian ones. At the Villa Torlonia complex, in use between the mid-second and the fifth century, surviving

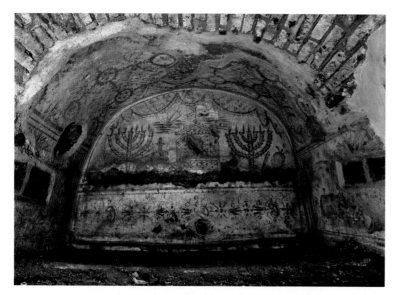

Fig. 2-8. Arcosolium, Villa Torlonia Catacomb, Rome, mid-fourth century. Photo courtesy Ministry of Cultural Heritage and Activities, Museo Nazionale Romano.

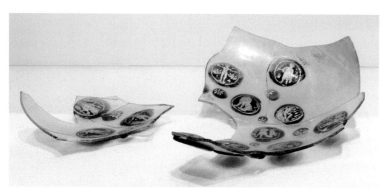

Fig. 2-9. Bowl with gold-glass roundels, Cologne, largest fragment L 16.5 cm, fourth century; British Museum, London. © Genevra Kornbluth.

inscriptions are in Latin or Greek (Jews in Italy did not use Hebrew to mark graves until the ninth century). Branching corridors less than one meter wide hold over thirty-eight hundred burial niches, some as much as nine meters below ground. An arcosolium (arched wall tomb) assigned to the mid-fourth century by carbon-14 dating is painted with numerous Jewish symbols displayed under a fictive curtain that probably evokes the Temple veil (fig. 2-8). Directly below a large central star, and between the sun and moon partly hidden by striped clouds, an open cupboard displays six Torah scrolls on shelves. This is flanked by two menorahs that support burning oil lamps. To the left are a palm branch associated with the festival of Sukkot, a round red fruit (pomegranate?), and a two-handled vase. On the right are a ram's horn, a knife (?), and a citron, also for Sukkot. These objects, associated with the lost Temple and its festivals, unambiguously identify the arcosolium's occupant as Jewish. Images of peacocks, birds, dolphins, and sarcophagi with lion heads elsewhere in the catacomb again

indicate that much of the late Roman artistic vocabulary was acceptable in a Jewish setting. The depicted celestial bodies suggest that the patrons of the arcosolium were concerned with cosmic time passing until the coming of the Messiah, when the Temple veil would be restored and Temple implements could once again be used properly. This is a more complex presentation of the idea of time than that suggested on the Seasons sarcophagus fragment.

Catacombs were excavated for Jews, polytheists, and Christians wherever bedrock was soft, and those in Rome have yielded hundreds of gold-glass roundels: thin gold leaf sandwiched between clear glass. Inexpensive to produce, they bear a wide range of incised images and texts valued by adherents of different faiths. Such roundels were stuck into the plaster around the sealed cavities that held the dead, facilitating their identification because the gold leaf flickered in the light of oil lamps. Twenty of them were discovered in a different context in Cologne (Germany), pressed into a shallow glass bowl in the late fourth century; here the gold leaf is fused to cobalt rather than clear glass (fig. 2-9). The larger medallions depict such Old Testament figures as Jonah, Adam and Eve, and Daniel in the lions' den (Dan. 6). In the late fourth century, typological Old Testament scenes still predominated in Christian works of art, whereas such scenes were exceedingly rare in Jewish contexts. Depositing objects alongside a corpse was an ancient practice continued by many Christians during the Middle Ages, despite the Church's objections. We can speculate that the family of the deceased buried the bowl because its gold-glass images promised salvation to a Christian who knew those stories, but it is also possible that it was interred with a polytheist who valued it not for its religious iconography but for its workmanship. Religious identity was not always sharply defined in this period, and many people sought divine aid wherever they felt they could find it.

Classical and Christian

The pace of Christianization differed across the Roman world. For at least half a century after Constantine's legendary vision, male status in the ancient capital continued to depend on public adherence to the traditional cults and support for them. For this reason, women tended to convert to Christianity before their male relatives, and many families—like many grave sites—contained both pagans and Christians (Jews seem to have had separate cemeteries from the first century onward). A hoard of silver objects deliberately buried on the Esquiline Hill in Rome, doubtless by individuals who hoped to collect them after an unfolding crisis had passed (perhaps the sack of Rome in 410), illustrates this social reality. This Esquiline Treasure, containing over sixty pieces, was discovered in the late eighteenth century in the ruins of a Roman house.

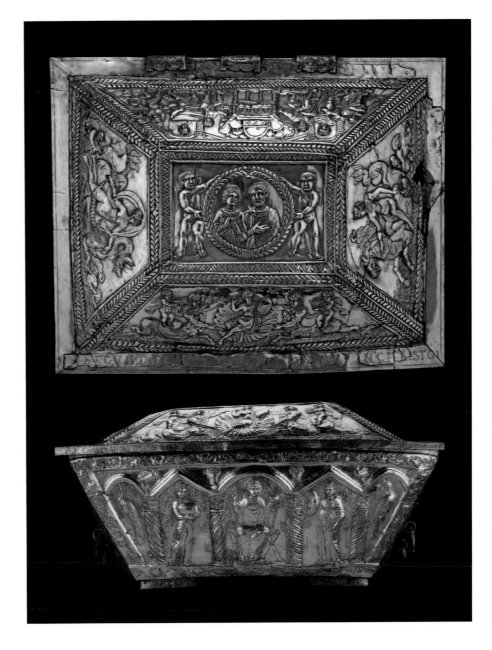

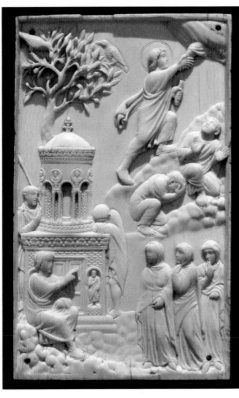

Many of these domestic objects are decorated with classical imagery, such as Tyches (female personifications of cities) likely used as furniture finials and Muses that adorn a container for perfume bottles. The largest is a gilt-silver (gilded silver) box with elaborate relief decoration that shows Venus at her toilette, flanked by a marine entourage, and a Roman matron going to the public baths and preparing to be similarly adorned (fig. 2-10).

On the lid is a couple in a clipeus supported by classical putti; the woman resembles the matron in the other scenes as well as Venus directly below her. Along the rim of the lid a Latin inscription urges Secundus and Projecta to live in Christ; for this reason, the work is commonly known as the Projecta Casket (a casket is a portable box or chest). Because no specifically Christian imagery is present, the Christian exhortation was likely added as a finishing touch to an item purchased, perhaps as a wedding gift, in a shop that could customize luxury wares for buyers of any faith. The images and letterforms on the casket and other objects

in the hoard are dated to the mid- or late fourth century on the basis of style. External evidence suggests that it was Projecta who was Christian, while Secundus was more likely in a gray area between polytheism and Christianity; none of the other contents of the hoard suggest that members of the household professed the new faith. In any case, comparing a Christian wife to a Roman divinity evidently posed no conflict to the makers, users, or viewers of this work.

There is no religious ambiguity about a small ivory panel now in Munich (fig. 2-11). The quality of the carving is evident from the impression of depth in the shallow plaque. On stylistic grounds the work is thought to have been carved about 400 in northern Italy. Two different narrative moments are presented here simultaneously. The domed building represents the Holy Sepulcher of Christ as a nourishing shrine whose qualities are echoed in the fruitful tree above, but the depicted architecture bears no relation to the real complex in Jerusalem except that both

have a dome. The three women at lower right who come to visit the tomb are told by the angel that Christ has risen; meanwhile, one of two oversize Roman soldiers guarding the sepulcher sleeps soundly while the resurrected Christ strides purposefully toward heaven, grasped by the hand of God and witnessed by two men. The artist has focused on the varied psychological and physical responses to the dual miracles of Jesus's resurrection and ascension, which, according to the Gospels, occurred forty days apart but are shown here simultaneously. As in so many works of medieval art, the artist of the Ascension ivory was not directly illustrating the scriptural text or texts, which contain very few detailed descriptions of people and things that might guide artists. Rather, he knew the essence of the story—that Jesus rose from his tomb and ultimately ascended to heaven—and interpreted it in a venerable Roman classical style and in a novel way.

The Changing Roman Empire

In the course of the fourth and fifth centuries, there was increasing pressure on both non-Christians and "heretical" Christians to accept the faith. Theodosius I (r. 379–95) was the first emperor to ban pagan sacrifices entirely, a significant step in the eradication of polytheism in the Roman world. Yet on the carved base of the Egyptian obelisk that was erected in 390 in the hippodrome of Constantinople, Theodosius is shown with his family, guards, and members of the court without any references to Christianity at all (fig. 2-12). On all four sides, the setting is the imperial box of the palace adjacent to the circus. Architectural fidelity is greater here than on the Ascension ivory—after all, spectators could readily compare the depicted architecture with the actual building in front of them, whereas

Fig. 2-12. Obelisk base of Theodosius I, Constantinople, 390, southeast face. Photo by Vasileios Marinis.

viewers of the ivory knew nothing about Christ's tomb in faraway Jerusalem—but naturalism was not the goal. Instead, each side of the base presents a vision of imperial ideology. As on the arch of Septimius Severus at Lepcis Magna (fig. 1-30b), the emperor is frontal, larger than his companions, and immobile. On the southeast face, shown here, Theodosius extends a wreath to the successful (but not represented) charioteer, while dancers and musicians celebrate; the emperor is timeless, the perpetual bestower of victory and honor, while the others are captured in mutable movement. His immobility connotes imperial stability, whereas their more active poses communicate the transitory lives of regular people.

After the death of Theodosius in 395, his sons divided the Roman Empire between them. The younger, Honorius, took the western part (essentially Europe west of the Adriatic Sea) and the elder, Arcadius, the eastern (from Greece to the border with Iran). In 410, Old Rome was sacked by the Visigoths, the first time that the city's defenses had been breached in eight hundred years. The eastern half of the empire was unaffected, but the increasing threat of non-Roman peoples on the move inspired the construction of new defensive walls around Constantinople under Emperor Theodosius II (r. 408–50). Those walls were not breached until Turkish cannons broke through them in 1453 and brought an end to eleven hundred years of Christian rule in New Rome.

As the attention and resources of the empire shifted eastward, the breakdown of central government and reduction in the manufacture and circulation of goods that had marked life under Roman rule led to fundamental shifts in most aspects of life in Europe. Urban centers declined when they could no longer count on regular tax revenues or food from outlying farms, buildings were no longer constructed in stone, and the familiar Roman civic and social customs that had held sway for centuries disappeared. Groups that had remained beyond the reach of the empire maintained their own religious, political, and artistic practices to varying degrees. Relations between Rome and the people at its borders (including, but not limited to, Angles, Avars, Bulgars, Frisians, Huns, Ostrogoths, Picts, Suebi, Vandals, and Visigoths) were exceedingly complex in the third, fourth, and fifth centuries, when many groups migrated west across Central Asia, stimulating collaboration and conflict with one another and with the Sasanians and Romans.

For the Roman Empire, co-opting non-Roman groups was an efficient way to manage resources and keep the borders quiet, and for these non-Romans, allying with Rome brought economic and cultural benefits. By the end of the fourth century, more than half of the officers in the Roman legions were so-called barbarians. This negative term, which ultimately derives from a Greek word for those who could not speak, read, or write that language, was not used by any of the groups under discussion here.

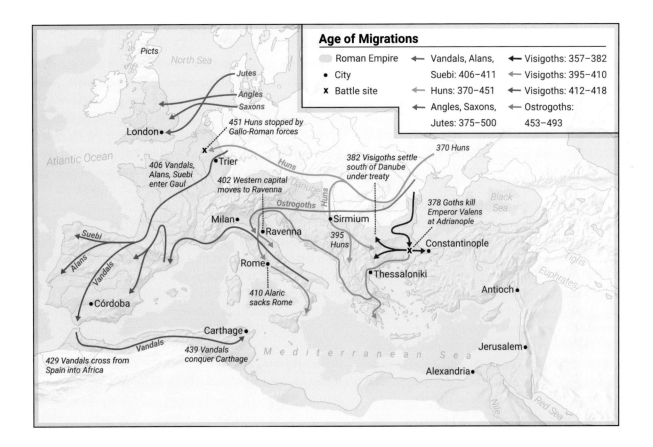

Different cultural groups are often thought to reflect fixed ethnicities, but ethnicity—from *ethnoi*, the Greek word for peoples—is mutable; it has to be learned, and it can change. Members of ethnic groups are taught to do certain things—speak a particular language, dress in certain ways, worship, bury their dead—based on the expression of a real or assumed shared culture and common descent.

One person who illustrates the fluidity of this period, in which culture and language were undergoing profound transformation, is Stilicho, whose father was a Vandal cavalry officer and whose mother was Roman. He became the head of the army, wed the niece of Emperor Theodosius I, and married a daughter to Honorius; in all but name, he ruled the western half of the empire between 395 and his assassination in 408. The appearance of Stilicho, his wife, Serena, and their son, Eucherius, on an ivory diptych (two hinged panels) of about 400 demonstrates the general's adoption of Roman style and status (fig. 2-13). The diptych could have enclosed an official message, such as an imperial appointment; Eucherius carries a closed example. The presence of a woman on a late antique ivory diptych is exceptional, but Serena, whom Theodosius had adopted as his daughter, was the linchpin of Stilicho's identity and guarantor of his quasi-imperial status. The couple's daughters are not included, which indicates that this is not so much a family portrait as an announcement of Stilicho's dynastic ambitions on the model of Theodosius and his sons, who appear in the diptych in a clipeus on Stilicho's shield.

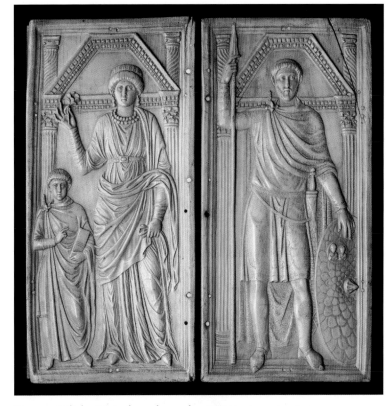

Fig. 2-13. Stilicho Diptych, each panel 33 × 16 × 0.9 cm, ca. 400; Museo e Tesoro del Duomo, Monza. © Museo e Tesoro del Duomo di Monza, photo by Piero Pozzi.

Luxury Metalwork

A prominent part of the dress of both Stilicho and his son is the fibula, the large brooch (pin) on the right shoulder that was both a practical item and a symbol of military status. Such ornamental metalwork was produced in great quantity for soldiers throughout the empire, including a warrior buried in Vermand (France) in the early fifth century (Romans were not interred with their possessions). His sarcophagus, inside a masonry (cut stone) tomb, contained an ax, a sword, a conical shield boss, and, shown here, spear-shaft mounts and a belt buckle made from molds and then gilded and inlaid with niello, a black metallic substance that highlighted the intricate designs (fig. 2-14). Although cast, the objects were made to look like the surface had been chipped away; the style is called chip-carved. These objects have complex abstract and animal patterns of a type found throughout Europe, and the largest has the decorative or protective motif of a six-pointed star (not commonly associated with Jews until the nineteenth century). The quality of the craftsmanship and the preciousness of the materials indicate that the individual buried at Vermand was of very high status, perhaps the leader of a legion of Germanic troops in the service of the Roman Empire, although whether he was buried in his own homeland or in an area where he was posted cannot be determined.

Fig. 2-14. Vermand Treasure, spear-shaft mounts, tallest 12.2 cm; belt buckle, 6 × 4.5 cm, ca. 400. Metropolitan Museum of Art, New York. Gift of J. Pierpont Morgan, 1917 (17.192.145). Image © Metropolitan Museum of Art.

The techniques and styles of such objects were soon copied for people who wanted the cachet of prestigious Roman objects and designs, although most of them were executed in less valuable copper alloy. These works were buried with individuals as a sign of status, an expression of religious beliefs, or both. Objects of similar style found in modern-day Spain, France, Germany, Italy, Hungary, Romania, Bulgaria, England, and Sweden testify to their wide distribution. An example from the end of the fifth century is a gilt-silver brooch with garnet inlays from När on Gotland (an island off the coast of Sweden) (fig. 2-15). Around the garnets are abstract spiral and chip-carved patterns, and the edges of both ends feature small birds with long necks, large round eyes, and prominent hooked beaks. At the ends are zoomorphic (animal-shaped) masks, an eagle head and a cow or bull. Many of these figures are difficult to identify because naturalistic representation was not the artist's goal; instead, abstract and decorative renderings were probably meant to suggest, channel, or deflect supernatural forces. Both the eagle and cow/bull were later associated with the god Odin (or Woden) who, in one myth, transformed into an eagle to make his escape after stealing a magical beverage, the "mead of poetry," that turned drinkers into sages and storytellers. Yet not every creature can be, or needs to be, associated with a story. "Barbarian" groups may not have transmitted their stories in writing, but their material record reveals rich cultural traditions and artistic ingenuity.

A remarkable gold collar found at Ålleberg is one of three similar high-status finds from Sweden (fig. 2-16). It was made in the second half of the fifth century from tubes of gold, soldered together with over one hundred miniature golden animals, hybrid creatures, human figures, and geometric shapes embellished with gold granulation (tiny grainlike balls) or filigree (thin wires). Each form was carved by hand except for the forty human faces, perhaps masks (approx. 4 mm across), which were cast from molten gold in a clay mold. Even though the goldsmiths continued Celtic and late Roman techniques and probably obtained the gold from Roman coins or medallions, their approach to imagery was different: there are no suggestions of narrative. Some scholars suggest that much of the imagery can be related to myths about Odin, who was known to have sacrificed an eye in exchange for great wisdom; this might explain the profusion of repeated faces with staring eyes on the collar. Or perhaps they were meant to be protective, like apotropaic eyes in the Mediterranean region. It is unclear whether there are specific meanings to unlock in objects like the Ålleberg collar, but what is beyond doubt is the expertise of the Scandinavian artists, who demonstrated a keen understanding of material properties. In the collar, for example, hinges are made of a stronger alloy than the decorative parts. The artists paid meticulous attention to details of both figural imagery and ornament in creating these costly works for personal adornment.

Fig. 2-15. Gilt-silver brooch, När, L 15 cm, late fifth century; Historiska museet, Stockholm.
© Historiska museet 2011, Charlotte Hedenstierna-Jonson SHM; CC BY 2.5 SE.

Fig. 2-16. Gold collar, Ålleberg, W 20.3 cm, second half of fifth century; Historiska museet, Stockholm.
© Historiska museet 1996, Sören Hallgren SHM; CC BY 2.5 SE.

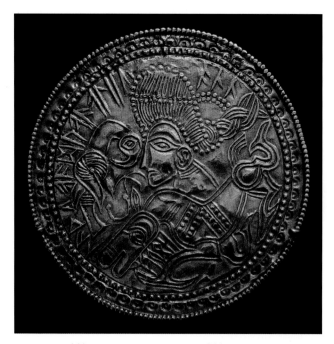

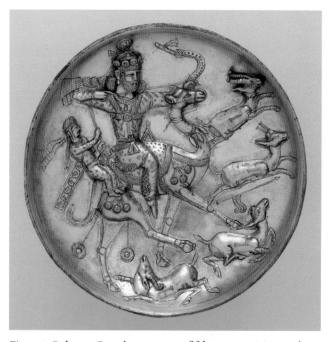

Fig. 2-17. Gold bracteate, Funen, 3.7 cm, fifth century; National-museet, Copenhagen. Wikimedia Commons/Bloodofox, CC BY-SA 3.0.

Fig. 2-18. Bahram Gur plate, 20.1 cm, fifth century. Metropolitan Museum of Art, New York. Purchase, Lila Acheson Wallace Gift, 1994 (1994.402). Image © Metropolitan Museum of Art.

A more common type of gold object is the bracteate, a thin piece of gold foil stamped on one side. Over one thousand survive from the fifth and sixth centuries, mostly in southern Scandinavia. This example from Funen (Denmark) dates to the fifth century (fig. 2-17). Its inspiration was a gold medallion, minted by Roman emperors for special occasions, that imitated gold coins in showing the emperor's head in profile. Several such medallions have been found in Scandinavia; they may have been gifts or payments to northern soldiers that were carried home after their army service concluded. The thick medallions, or local imitations of them, in turn inspired the thin bracteates. On the Funen piece, the warrior with a prominent knot or braid in his hair—a style associated with the Suebians and depicted on the Tropaeum Traiani metopes (fig. 1-9b)—faces left, eye to eye with a beaked bird of prey; both seem to be perched on a stylized horse that faces left. An inscription in runic letters (an angular alphabet) fills the available circumference, and one of its words is a title for Odin. A male warrior is represented here, but most bracteates with a secure findspot were found in women's graves. Many have a loop, indicating that they were displayed on the body, and they may have had a protective function, as some of the inscriptions suggest. In short, at the northern and western boundaries of the Roman Empire, prestigious metal objects of the fifth century reveal a continuing reliance on traditional Roman forms, but these forms were altered for new cultural groups and individuals. The display of gold always connoted status, but the imagery on the Funen bracteate asserted an explicitly Scandinavian identity.

Also outside the Roman borders, but in this case to the east, the Sasanian rulers used precious metalwork to communicate their own messages of status and identity. Like the Stilicho Diptych and the Projecta Casket, hammered gilt-silver plates were presented as gifts; they were a royal monopoly. One such plate depicts the Sasanian emperor Bahram V (r. 420–38), better known as Bahram Gur, who was famed for his skill at archery (fig. 2-18). When he asked his beloved musician-slave, Azadeh, which antelope he should shoot, she set him three impossible tasks to ensure that he would not slay any: he must change a male antelope to a female and vice versa, then shoot a pebble into the ear of a gazelle and, when the creature raises its leg to scratch, pin the limb to the ear. Bahram Gur, of course, performs expertly: he shoots off the male's horns to make it look female, he embeds two arrows in the head of the female to make it resemble a male, and he pins the leg of the third to its ear. (The bowl does not show the end of the story: Azadeh denounces his skill as demonic and Bahram Gur tramples her with the camel.) This tale, among others about legendary and historical Iranian shahs (kings), would be written down for the first time in the *Book of Kings* (*Shahnameh*), an epic poem composed in Persian around 1000 that became an iconographic sourcebook for artists and patrons in western and Central Asia. Following the victories against the Romans commemorated in works discussed in chapter 1 (figs. 1-31 and 1-32), Sasanian territory contracted and expanded repeatedly, and in the fifth century the kings were forced to pay tribute to the Huns. Nevertheless, the successful hunter became the standard image of the Sasanian shahanshah, whose person was sacred and whose well-being was essential to the empire's welfare.

By the early fifth century, imperial patronage was much less common in western Europe than it was in Byzantium. This was due to the decreasing power of the emperors and the increasing influence of bishops, especially that of Rome. As the bishopric founded by St. Peter, Rome was the major see in Europe, and by the fifth century its bishop was called the pope. The church of Santa Maria Maggiore

(St. Mary Major) attests to this shift in patronage and also contains some of the best remaining examples of early church wall decoration (fig. 2-19). This basilica, the first in Rome dedicated to Mary, dates to the reign of Pope Sixtus III (r. 432–40), who may have built it in part to affirm the elevation of Mary as Theotokos at the council of Ephesus in 431 (box 2-1).

Sixtus's grand basilica deliberately evoked older imperial churches in Rome in its architecture and mosaic decoration. The nave colonnade actually supports arches, but these were filled in with brick, wood, and stucco to imitate the horizontal entablatures at the Lateran Basilica and the church of St. Peter. Small mosaic panels adorn the nave walls and cover the arch before the apse. (The original apse does not survive; the current one dates to the thirteenth century.) On the left side of the nave, moving from the arch toward the entrance, there are scenes from the lives of Abraham, Isaac, and Jacob; on the right are stories of Moses and Joshua. These Old Testament scenes lead the viewer's eye to the triumphal images of Mary and the early life of Jesus on the arch. In this way, the Old Testament provides the foundations for and culminates in the New, with the Theotokos as the key figure in this transition.

The typological intent is clearly expressed in a panel adjacent to the arch that surrounds the apse; it was very visible to a priest celebrating mass at the altar below (fig. 2-20). Melchizedek, the priest-king of Genesis 14:18, presents bread and wine to Abraham (and to God). God is represented here as the cross-nimbed Christ (a halo with a cross), and the offering parallels the eucharistic offerings at the altar below. The scene was displaced from its chronological order to stress the liturgical analogies and bring it closer to the images of Christ on the arch. On the arch itself, the scenes unfold along the left side and then move to the right (fig. 2-21). Because these are among the earliest representations of the stories, their iconography at times

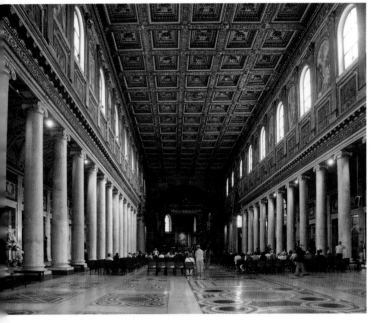

Fig. 2-19. Church of Santa Maria Maggiore, Rome, 432–40, nave toward the east. Wikimedia Commons/Dnalor 01, CC BY-SA 3.0.

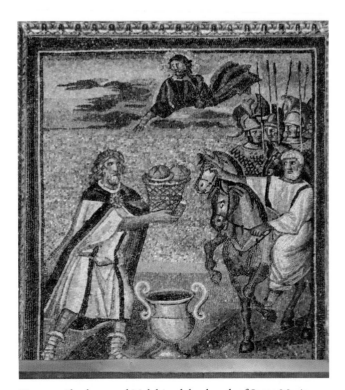

Fig. 2-20. Abraham and Melchizedek, church of Santa Maria Maggiore, Rome, 432–40, north nave wall. Photo by John Lansdowne.

Fig. 2-21. Left half of apse arch, church of Santa Maria Maggiore, Rome, 432–40. Photo by the authors.

differs from what prevailed in later centuries when key narrative episodes became relatively standardized.

The creators of the earliest Christian art faced major challenges and also opportunities because the conventions guiding Christian architecture and storytelling had yet to be established. What did God the Father look like? How should Jesus be depicted? What would Mary wear? Scripture itself offered few answers to such fundamental questions, so artists offered interpretations that drew on what they already knew—more often than not, Roman conventions of representation—as well as on their imaginations. In the Santa Maria Maggiore Annunciation scene at the top left of the arch, Mary is clad in golden aristocratic garb instead of a humble dark veil, and her husband Joseph is young rather than white-haired. In the second register, the child Jesus is enthroned between his gold-robed mother and a woman who may personify divine wisdom or another aspect of Mary; debate continues about the identification of specific figures and scenes and even the meaning of the church's pictorial program as a whole. One aspect of the program is very clear. At the apex of the arch is a prepared throne (Hetoimasia), the expected seat of Christ at the end of days. It is flanked by Peter, Paul, and symbols of the evangelists (discussed below), along with the patron's inscription: "Sixtus, bishop to the people of God." The pope was communicating that Christians were the new "chosen people" (Deut. 14:2), the culmination of the distinguished line from Abraham to Joshua whose history was represented in the nave. He was also underscoring Mary's role in the unfolding of history from the Old Testament through the end of time.

Among the questions raised by Santa Maria Maggiore is the source of its extensive narratives. Even though the column of Marcus Aurelius (fig. 1-27) and the Dura-Europos synagogue (fig. 1-16) exemplify earlier large-scale works with dense cycles of illustrated scenes, the mosaicists of Santa Maria Maggiore may have found inspiration in the illustration of manuscripts, books written (Latin scriptus) by hand (manus). Painting with pigments on parchment and setting colored cubes of glass or stone into a plastered wall require different artistic skills, but artists could have been trained in more than one medium. Because the mosaics and contemporary manuscripts share a conceptual approach to the illustration of stories, whoever planned the program at Santa Maria Maggiore may have been trying to make a deliberate connection between the two media. The message would have been that the Hebrew scriptures—now cast as the Old Testament—were part of a new Christian epic narrative, in the manner of classical bestsellers like the Iliad or Aeneid.

In ancient Rome, the physical medium for serious writing was the scroll, or roll. Typically these were between twenty-five and thirty-three centimeters high, and the length was determined by the number of (normally papyrus) sheets stitched together. In theory, an unlimited number could be used to make a long scroll, but most were about ten meters long, which seems to have been the most practical size for reading, handling, carrying, and storage. Consequently, long works like Homer's or Vergil's epics were divided into a number of scrolls; the twenty-four books in modern editions of the Iliad each correspond to an individual ancient roll. In Egypt, which was a source of papyrus reeds, important texts like the Book of the Dead were written on long rolls, and the Torah was also transmitted on scrolls made of parchment. In short, important texts in the ancient world were copied by hand in rolls.

For more practical matters, like taking dictation or making shopping lists, people used another ancient format, the diptych—usually two hinged pieces of wood containing wax that could be inscribed with a pointed stylus and then wiped clear for reuse. In the second century CE people started making multipage diptychs of wood, papyrus, or parchment to hold larger amounts of text. Over time, this codex—the Latin term for the physical object of the book—became the standard format for writing texts. The codex had definite technological advantages, especially when made of parchment sheets: it was more durable than the scroll, could contain a larger amount of text in a single unit, and was more readily navigable and user-friendly. The flat pages of codices were also more suitable for painted decoration, as pigments had a tendency to peel off papyrus scrolls that were repeatedly unrolled and rolled up during reading. Each page or leaf of a codex is called a folio, abbreviated as fol.; the front of the leaf is called the recto, abbreviated as r, and v indicates the verso, the back or reverse of the page.

Despite the advantages of the codex, it took hundreds of years to displace the scroll as the dominant book format. It has been suggested that early Christians consciously adopted the new codex format as a way of distinguishing themselves from both the pagan and Jewish users of scrolls, and the increasing acceptance of Christianity brought with it a growing reliance on the codex. Whether or not this was the case, by the late fourth century books were widespread throughout the Mediterranean world and in some cases were decorated with painted images, called illuminations.

The oldest surviving illuminated codex is a sizable fragment of Vergil's Aeneid, probably made in Rome around the year 400 (fig. 2-22). Now containing seventy-five folios, with fifty pictures distributed throughout the text, the manuscript is known as the Vatican Vergil because of its current location in the Vatican Library. On the pages with illuminations, roughly the same amount of room is given to the words, written in stately Roman capital letters (majuscule), and the pictures, set off by a red frame and painted to give the illusion of atmosphere and depth. Here the hero Aeneas and his companion Achates stand before a classical

temple and prepare an animal sacrifice. Both in style and in content, the Vatican Vergil shows that there were wealthy people interested in keeping the heritage of Rome alive. Classical education and culture lay behind this work, just as it did the Projecta Casket, and the numerous pictures depicting sacrificial activities suggest that the patron was preserving and broadcasting classical polytheistic values.

There were Christian books by the fourth century, but all the illuminated ones have been lost. The most common book among early Christians was the Gospels, the accounts of Christ's life by the four evangelists. John's Gospel opens with "In the beginning was the Word, and the Word was with God, and the Word was God." Equating God (Christ) and the Word meant that Gospel books, which contain the authoritative words about Jesus's life and teachings, were themselves sacred. They were often covered in precious materials to express their exceptional, holy status.

Books and texts loom large in an apse mosaic from Thessaloniki (northeastern Greece). The apse is all that remains of the mid- or late fifth-century decoration of the main church, the *katholikon*, in the Monastery of the Stoneworker (Mone Latomou); it is also known as Hosios (Holy) David (fig. 2-23). As the focal point of a church, the apse quickly became a prominent place for expressing fundamental Christian messages in visual form. This one depicts a youthful Christ seated on a rainbow within a circular mandorla (full-body halo). At his feet are four rivers associated with paradise (Gen. 2:10–14), which lead to a lush landscape. Supporting the mandorla are the four winged creatures that symbolize the evangelists. Counterclockwise from the upper left, the man, lion, ox, and eagle

Fig. 2-22. Aeneas and Achates, Vatican Vergil, 22.5 × 20 cm, ca. 400; Vatican City, Biblioteca Apostolica Vaticana, MS Vat. lat. 3225, fol. 45v. © 2020 Biblioteca Apostolica Vaticana, by permission, all rights reserved.

Fig. 2-23. Apse mosaic, Monastery of the Stoneworker, Thessaloniki, mid–late fifth century. Wikimedia Commons/Nord794ub, public domain.

Box 2-2. SCRIPTURAL CANONS

The Hebrew scriptures—what Christians call the Old Testament and what Jews call the Bible—consist of twenty-four books: the five books of Moses (in Hebrew *Torah*, the Law; in Greek *Pentateuch*, five books); eight books of prophets and history (e.g., Isaiah, Ezekiel); and eleven books called the Writings (Psalms, Proverbs, etc.). Additional books were available but were not included in the Hebrew canon—the group of writings considered sacred and authoritative—when it was established between the second century BCE and second century CE. These were the scriptures known to Jesus and his apostles.

The Septuagint, a Greek translation of the Hebrew scriptures produced in Egypt between the third and first centuries BCE, also included books that were not part of the canon. These additional books are called "apocryphal," meaning "things hidden"; Jews considered these texts to be of questionable authenticity. The Septuagint was used by the early Christian Church when it expanded to Greek-speaking, non-Jewish communities. It constitutes the Old Testament of the Christian Bible.

The New Testament comprises the four Gospels, the Acts of the Apostles, and the Epistles. As the Church grew, additional books like the *Protoevangelion of James* and the *Infancy Gospel of Thomas* (both second century) were produced to fill gaps in the Gospels and other early writings. Christian theologians struggled to decide which of these additional books were genuine. Eusebius, the biographer of Constantine and the first Church historian, refers to disputed books and personally rejected the book of Revelation (also called the Apocalypse). By the end of the fourth century the Christian scriptural canon had largely been agreed upon and was deemed complete and authoritative. Athanasius, a bishop of Alexandria who fought against Arius (box 2-1), composed a list of New Testament books in 367 that was accepted by major Christian centers. This list of twenty-seven books still represents the Christian canon for today's Roman-rite Catholics, Eastern Orthodox (including Greek and Russian Orthodox), and Protestant churches; Ethiopic Bibles vary from this model and include eight more books. The monk Jerome's Latin translation of the Christian Bible, the Vulgate, was completed in the late fourth century and helped fix the scriptural canon in much of Europe and North Africa.

Zoroastrian beliefs and rituals are deduced from an ancient textual corpus known as the Avesta, compiled (probably in Central Asia) over a long period in its own language, Avestan. It contains a small, older core, traditionally attributed to Zarathustra himself, as well as a larger group of texts that rely on the older ones. The codification of the Avesta by the Sasanians in the sixth century, using a special script, resulted in an increased number of rules, especially regarding purity, to be overseen by powerful priests.

correspond to Matthew, Mark, Luke, and John, respectively. These animal personifications appear in the New Testament book of Revelation (4:7) but derive from the Hebrew prophet Ezekiel's vision of God in heaven (1:1–14). Because Revelation was a canonical book in the Roman Church, the four creatures are very common in western European medieval art but rarer in the Byzantine Empire, where Revelation was not accepted in the scriptural canon until the fourteenth century.

Christ's unfurled Greek scroll modifies an inscription from the Septuagint (Isa. 25:9–10): "Behold our God in whom we hope, and we rejoice greatly in our salvation; may he rest in this house." The "house"—this church, as well as the larger Christian community with Christ as its head—recurs in the Greek inscription at the base of the mosaic, which credits the work to an unnamed woman: "This most honorable house is a life-giving source, receiving and nourishing faithful souls. Having made a vow, I [feminine] . . . fulfilled it." The church was thus a monumental votive object, functionally similar to the body-part votives in the Asklepeion at Corinth (fig. 1-2).

The enthroned Christ displays Isaiah's words on an old-fashioned scroll, emphasizing their ancient origins and typological importance. By contrast, the evangelist symbols carry thick codices with jeweled covers, copies of their Gospels that define the new relationship between people and God. On the left, the prophet Ezekiel stands in amazement before this image rooted in his own earlier vision; on the right, the seated John contemplates an open codex, his book of Revelation. The interplay of text and image can be seen in another detail: the feminine appearance of the all-powerful Christ, which seems to visualize the terms "life-giving source" and "nourishing" in the inscription. The landscape and rivers teeming with life below his feet

Box 2-3. EARLY MONASTERIES

Monasteries, from a Greek word meaning "to live alone," were a Christian innovation of the late third century, although their roots are older: a first-century CE Jewish philosopher from Egypt, Philo, described a contemporary group of Jewish men and women who distanced themselves from society to maintain contemplative lives. Only under Christianity, however, did living away from the world and adopting a variety of ascetic practices become a widespread ideal. Beginning in Egypt with St. Paul of Thebes and the more famous St. Anthony, monasticism spread throughout the Christian world. Monks either lived alone as hermits (eremitic monasticism) or together in communities (cenobitic monasticism). An authoritative abbot or abbess

(meaning father or mother) oversaw daily life and spiritual growth within their communities. Another early kind of monasticism was practiced by Roman matrons unwilling to remove themselves too far from their homes; several of these fourth-century "house monastics" studied scripture with Jerome, who was translating the Bible. When he was forced to leave Rome because one of his young followers had died from excessive fasting, they followed him to the Holy Land and established important cenobitic communities. Jerome died as a hermit near Bethlehem and was later considered a saint. In the early Middle Ages each monastic community was independent, and no overarching regulations linked one foundation to another.

further elaborate this theme. This small apse mosaic represents and recombines an array of textual sources and visual motifs to express multilayered theological ideas.

Contemporary with the Monastery of the Stoneworker apse and sharing its repeated depictions of scrolls and books is the Neonian or Orthodox Baptistery in Ravenna (Italy) (fig. 2-24). Named after Bishop Neon (r. ca. 450–73), who enlarged it about 458, it is the only early medieval baptistery that is mostly intact. Like the (much altered) Lateran Baptistery (fig. 2-2), the structure is a brick octagon. Its octagonal font made of reused marble and porphyry slabs is medieval, but it postdates the fifth century; the original font was circular, about three meters across, used for adult baptisms on the eve of Easter Sunday so that converts would be reborn with Christ. The lavish interior decoration was intended to make an indelible impression on new Christians, who would experience baptism only once in their lives.

The surfaces of the walls create the impression of increasing dematerialization as the eye moves upward. Above mosaics that represent vine scrolls interspersed with unidentified men are arches filled with stucco reliefs. The stuccoes form fictive recesses in which niches and the figures standing in them seem to pop out of the wall. Stucco as a material had ancient roots, but here it helped emphasize the building's hierarchy of holiness: it was used for the protruding prophets on the upper walls, which contrast with the apostles depicted in mosaic higher up. At the base of the dome, which rises about fourteen meters above the original floor level (several meters below the current pavement), illusionistic gardens, architecture, and furnishings are executed in mosaic. Open Gospel books

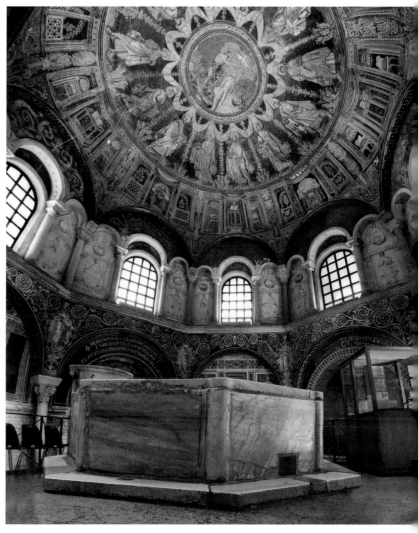

Fig. 2-24. Neonian (Orthodox) Baptistery, Ravenna, ca. 458. © Genevra Kornbluth.

alternate with prepared apocalyptic thrones (the Hetoimasia). Above this register, twelve apostles carry golden crowns as if offering them both to Christ above and to the newly baptized Christians below. Christ appears at the apex of the dome in the scene of his baptism, and a personified river god (labeled "Jordanus") is behind him. The dome mosaic was restored in the nineteenth century, but the original iconography is largely intact.

In the Neonian Baptistery, the bodies of new Christians were surrounded by figures rendered in varying degrees of corporeality, from the three-dimensional Old Testament prophets to the two-dimensional New Testament apostles. The visual and spiritual progression upward culminates in a porthole into heaven in which the gold background removes the scene from the natural world and highlights the supernatural, timeless qualities of baptism. By undertaking this ritual of initiation, individuals imitated Jesus and hoped to join him and the apostles in the eternal heavenly sphere. In this carefully conceived and sumptuously decorated environment, initiates became active participants in a spatial drama rich in theological, liturgical, and social significance.

Just as Christian books and their interpretation proliferated in the fourth and fifth centuries, so did Jewish texts. Two massive commentaries on the Torah, the Talmuds, were compiled in the Galilee (northern Israel) in the early fifth century and in Babylonia (Iraq) in the sixth. The Babylonian Talmud, not the so-called Jerusalem one, would become the principal Jewish law code of the Middle Ages.

As was the case for early Christian texts and art, there were no normative texts for Jewish art—nothing that said "decorate places of worship this way"—and the result was great variety. No surviving fourth- or fifth-century synagogue rivals the third-century one at Dura-Europos in its extensive program of wall paintings illustrating the long span of Jewish history (fig. 1-16). There is, however, abundant evidence for mosaic pavements with figural imagery in synagogues. At Hammat Tiberias on the Sea of Galilee, four superimposed synagogues were excavated in the 1960s. The one in stratum IIA, in use from the later fourth through the fifth century, had its sanctuary wall facing south toward Jerusalem (fig. 2-25a). Adjacent to the sanctuary is a panel showing a Torah shrine that evokes the facade of the lost Temple (fig. 2-25b). It is flanked by menorahs and other implements used when the Temple

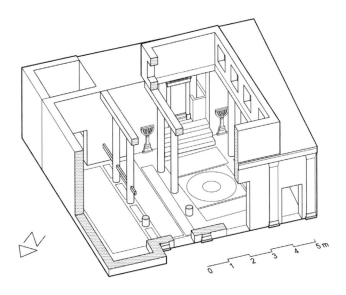

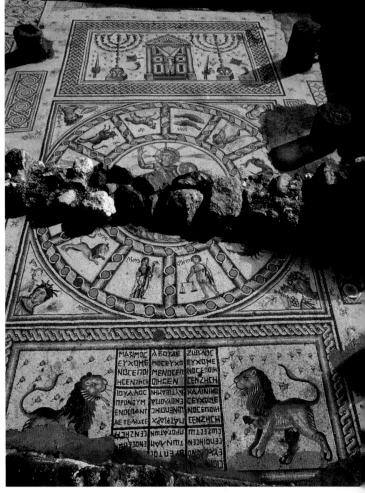

Figs. 2-25a and 2-25b. Synagogue, Hammat Tiberias, late fourth–fifth century, (*left*) reconstruction; (*right*) floor mosaic, view from entrance toward sanctuary. (*l*) Drawing by Navid Jamali; (*r*) Zev Radovan/BibleLandPictures/Alamy Stock Photo.

was the center of Jewish life, before its destruction in 70 CE: shofars (ram's-horn trumpets), palm branches and citrons, and shovels for incense (to make sweet-smelling offerings to God), objects also seen in the Dura-Europos synagogue and the Villa Torlonia catacomb. After 70, synagogues had replaced the Temple and the Torah had supplanted the Temple implements as the focal point of Jewish ritual activities. The pavement's visual allusion to the Temple expressed hope for its future rebuilding and asserted the antiquity and authority of Judaism—the words of God in the Torah shrine—over the newer Christian faith.

In the center of the nave at Hammat Tiberias is a personification of the Sun in his chariot encircled by zodiac signs, labeled in Hebrew; personifications of the four seasons appear in the corners. The circular image evokes a heavenly dome transposed to the floor and probably suggested to viewers the Jewish solar calendar, just as the Temple implements recalled the annual festivals. Similar calendar imagery adorns at least five other synagogues dated between the fourth and the sixth centuries. Closer to the entrance are dedicatory texts in Greek that name the patrons of this phase of the building. The main donor was Severus, who is identified in two inscriptions at the entrance and a longer one in the eastern aisle. From the entrance to the sanctuary, the floor mosaic progresses from the present (living donors) to the future (the rebuilt Temple, complete with implements), and from earth through heaven (the sun and zodiac), to recall God's promise of future redemption when the Temple will be rebuilt. Sacred time and space are united in the synagogue in much the same way as in medieval churches, although the messages

about what the future holds for the faithful have very different components.

A very different-looking synagogue was in use in Sardis (western Turkey) from the fourth to the seventh century. A wing of what was originally the city's bath-gymnasium complex, and in the third century a Roman civic basilica, was renovated by the Jewish community as the largest ancient or medieval synagogue (fig. 2-26a). A porticoed atrium (unroofed courtyard surrounded by covered arcades), paved with mosaics displaying votive inscriptions, precedes a sixty-four-meter-long sanctuary that could hold about one thousand people. To either side of the sanctuary entrance, on the wall facing Jerusalem, were large masonry aediculae that contained Hebrew inscriptions and parts of a large marble menorah. One of these shrines held the Torah scrolls, like the niche at Dura-Europos (fig. 1-17), which was also on the Jerusalem-facing wall to indicate the direction of prayer. At the opposite end was a tier of semicircular benches, doubtless for important elders (fig. 2-26b). The walls were clad with colorful patterned marble slabs, and the floor featured more mosaics, including such Greek inscriptions as, "Sardis city councilor Aurelios Alexandros, also known as Anatolios, paid for the mosaics in the third bay." Some late antique Jews held high-status positions in their communities.

Most of the materials used to embellish the Sardis synagogue were spolia reused from earlier structures. These include huge eagle reliefs, flanked by freestanding lions, on the central stone table on which the Torah was chanted by a reader facing east. Images of animals and birds abound, but only one human form has been found: a fragmentary

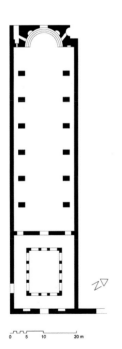
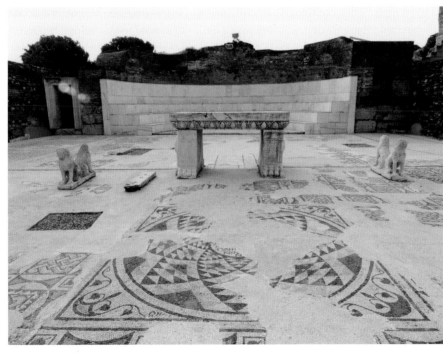

Figs. 2-26a and 2-26b. Synagogue, Sardis, fourth–seventh century, (*left*) plan; (*right*) view toward the west. (l) Drawing by Navid Jamali; (r) © Anita Gould.

Fig. 2-27. Samaritan synagogue floor mosaic, fragment, el-Khirbe, fourth century; Good Samaritan Museum, Israel. Photo by the authors.

panel of Daniel in the lions' den, originally on a wall of the atrium. As with spolia in Christian churches, it is not clear whether their function was utilitarian or ideological or simply testifies to the Jewish community's easy acceptance of classical culture and its imagery. The Jews' prominence in Sardis continued until the Sasanians destroyed the city in the early seventh century.

The Samaritans were another monotheistic group in the eastern Mediterranean region who claimed to know the true laws of God. Their name was said to come from the Hebrew term for "keepers of the Law," and the Torah was their only holy book: they rejected other Jewish legal texts, including the Talmud. In the fourth and fifth centuries a sizable population of Samaritans lived not far from Hammat Tiberias (Jesus meets one in John 4:1–26). They claimed that Mount Gerezim, west of the Jordan River, was the original Israelite holy place where God had chosen to build his temple. They continually rebuilt their version of the holy temple there until it was destroyed by the Byzantine emperor Zeno (r. 474–91), who built a monastery on the summit.

Like the Jews, the Samaritans used smaller houses of worship to read the Torah, pray to God, and host community functions. Unlike the Jewish synagogues, these were built outside of settlements to ensure a view of the sacred mountain. The fourth-century Samaritan synagogue at el-Khirbe (Israel) has the entrance wall facing Mount Gerezim. Its mosaic floor represents the Tabernacle that God commanded the Israelites to carry after the Exodus (Exod. 25–31, 35–40), the table displaying the daily bread offering, and the menorah and shofars (fig. 2-27)—all things that Jews associated with the Temple in Jerusalem and Samaritans associated with their rival temple on the mountain. No living creatures appear on the floor because of the Samaritans' strict interpretation of the second commandment. Just as the same artists created works for Christians and polytheists, one father-son pair of artists inscribed mosaic floors in both a Samaritan and a Jewish synagogue in the sixth century.

Work in Focus:
QAL'AT SEM'AN

Emperor Zeno destroyed the Samaritans' holiest site and may also have been responsible for one of the greatest Christian monastic and pilgrimage complexes of late antiquity. Qal'at Sem'an (Arabic for Fortress of Symeon, in northwestern Syria), was built around the column on which the saintly monk Symeon had spent four decades (figs. 2-28 and 2-29). Living atop a column was a particularly rigorous form of asceticism, but Symeon the Elder (so called to distinguish him from a later imitator, Symeon the Younger) had already been expelled from one monastery for such excessive practices as self-starvation and binding himself with palm fronds to the point of unconsciousness. Symeon was the first and most famous of the stylite saints (from *stylos*, the Greek word for column), and although increasing the height of his column enabled him to stay removed from visitors, he nevertheless attracted many followers and eventually dispensed his counsel from some seventeen meters up. A fifth-century bishop, Theodoret of Cyrrhus, gave a contemporary account of the crowds drawn to the saint before his death in 459: "Not only do people gather there who live nearby, but also Ishmaelites [Arabs], Persians and their Armenian subjects, Iberians [Georgians], Himyarites, and men from even farther away; and also many from the far west—Spaniards, Britons, the Celts who live between them, and too many Italians to mention." Even discounting the rhetorical embellishment, Qal'at Sem'an certainly became a significant monastery and pilgrimage destination.

After Symeon's death an enormous fortified complex was constructed of precise ashlar (cut stone) masonry; the scale and sculptural quality suggest imperial patronage, but this is not confirmed in any texts. Visitors entered through a triple-arched portal that led to a large open area containing water cisterns and a few tombs. Triple arches across the Roman world had long been associated with imperial victory, but here the victory was connected

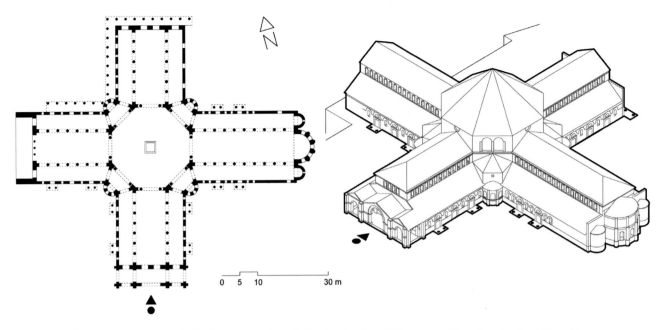

Fig. 2-28. Basilicas in monastery and pilgrimage complex, Qal'at Sem'an, late fifth century. Drawings by Navid Jamali.

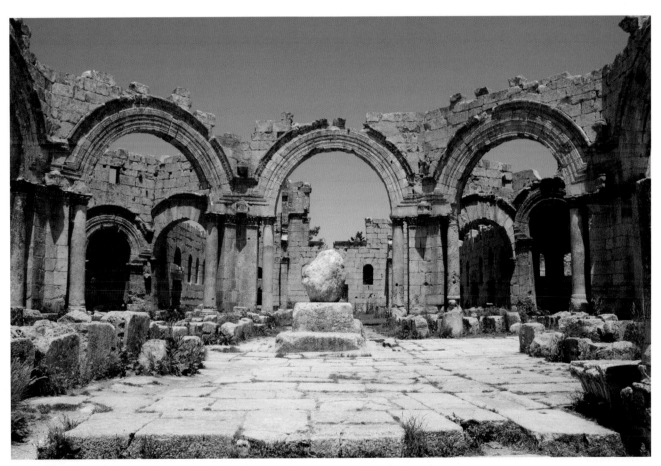

Fig. 2-29. Base of column of St. Symeon the Stylite, monastery and pilgrimage complex, Qal'at Sem'an, late fifth century. Wikimedia Commons/Arian Zwegers, CC BY 2.0.

Fig. 2-30. St. Symeon token, 2.8 × 2.2 × 1.2 cm, sixth–seventh century; Walters Art Museum, Baltimore. Museum purchase, 1991. Photo from the Walters Art Museum, CC0.

with Christianity. Another monumental entry led into an even larger space surrounded by multistory hostels and a centrally planned baptistery that permitted pilgrims to formally enter the faith at an especially potent site. From this vast open space, the visitors ascended toward the main entrance into the cruciform shrine centered on Symeon's column, which was surrounded by four monumental triple arches. This "martyrium"—for Symeon's time on his column was a kind of bloodless martyrdom, the predominant type of martyrdom available to Christians after Constantine—consisted of four basilicas radiating around Symeon's former column. Men could enter the church complex and circumambulate (walk around) the column's octagonal enclosure, which originally had a wooden roof, before turning east into the triple-apsed basilica for a mass that marked the liturgical culmination of their visit. Women were barred from entering the churches and approaching the column, as they had been during Symeon's lifetime. Southeast of the church complex, with a separate entry into the eastern basilica, were the monastic buildings that housed the site's caretakers. The monks' proximity to a site validated by such a holy figure, even though it lacked any bodily relics (Symeon's bones rested sixty kilometers away in Antioch), was thought to make their own devotions particularly effective.

Visitors to such early Christian sites as the Holy Sepulcher, the church of St. Peter, and Qal'at Sem'an took away objects known as "blessings," which might be as simple as

a piece of bread. At many sites these blessings took the form of ampullae, small flasks that could hold a substance sanctified by proximity to a saint, usually water, oil, or dust from his or her tomb or from lamps burning nearby. Surviving examples date to the late sixth or early seventh century. At Qal'at Sem'an, coin-size tokens made from the earth around the column were sold or given to pilgrims (fig. 2-30). In addition to evoking memories of one's visit, the souvenirs had more practical applications. Theodoret notes that people in Rome set up small images of Symeon in their workplaces to ward off danger. Symeon's blessings were also used medicinally, either crumbled and then applied to an affliction or swallowed outright. Many bear stamped images that show Symeon atop his column, with angels above and supplicants below, but some depict New Testament scenes that seem unrelated to the site. A large number show the Adoration of the Magi (Matt. 2), when "wise men from the east"—likely Zoroastrian priests—journeyed to venerate the infant Jesus and brought him gifts. It is likely that pilgrims were encouraged to see themselves as latter-day Magi, travelers from afar who recognized and revered a sacred figure and site.

Some well-to-do visitors also brought gifts to leave at Qal'at Sem'an. An example from the late sixth century, discovered nearby, is a gilt-silver repoussé plaque whose unnamed donor states in Greek, "In thanks to God and St. Symeon I have offered [this plaque]" (fig. 2-31). The thin sheet of silver was probably made to attach to a wooden object, perhaps the liturgical furnishings of the eastern basilica. The iconography is peculiar. The large serpent could be a generic symbol of evil or relate to a specific event in the saint's life (Symeon was said to have cured a snake). The shell is often associated with sanctity and immortality, and the pearl in the shell may signify the saint's spirit or his eternal reward; medieval tradition held that pearls were celestial in origin. Even if the iconography is not entirely comprehensible today, it is significant that figural images appear on objects taken away from Qal'at Sem'an and on those left behind. Plain silver was not a sufficient gift, for the representation of the saint supplied enhanced value and meaning, just as the earth sanctified by proximity to the column was rendered more potent with St. Symeon's features stamped onto it. Images had powerful roles to play in expressing sanctity and transferring it to a distant location.

Pilgrimage was attractive to many Christians, including, in the fourth and fifth centuries, many aristocratic women, who came to experience sacred sites in the eastern Mediterranean from as far away as modern-day Spain. The practice was not accepted by all, however. The theologian and later saint Gregory of Nyssa (ca. 335–ca. 395) argued that religious travel was not only unnecessary but also potentially harmful and at odds with Christian modesty. It put women's virtue at risk, particularly when they traveled to the dangerous city of Jerusalem; and, more important,

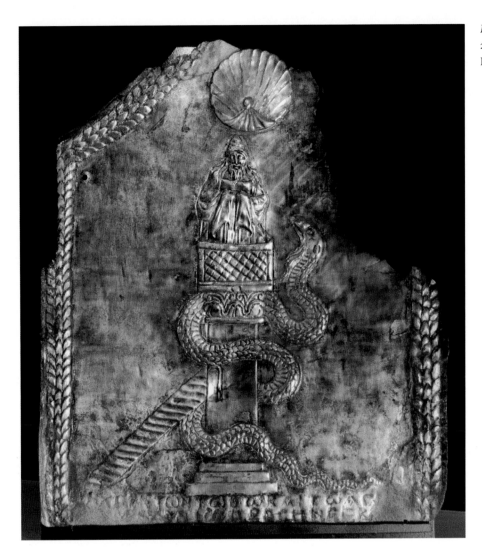

Fig. 2-31. St. Symeon plaque, 29.6 ×
25.5 cm, late sixth century; Musée du
Louvre, Paris. © Genevra Kornbluth.

what kind of Christian needed to visit the Holy Sepulcher in order to believe in Christ's resurrection? Divergent opinions about the value of pilgrimage can be traced throughout the Middle Ages, yet for most of the Christian faithful it was a pious exercise with spiritual and practical benefits that outweighed its risks.

Qal'at Sem'an fell into disrepair in the 600s during early Muslim expansion, but it flourished again briefly in the tenth and eleventh centuries when the Byzantines reconquered the area. In its heyday it demonstrated several of the important developments outlined in this chapter. Its scale alone underscores the degree to which the legalization and diffusion of Christianity around the Mediterranean basin brought sweeping changes to the architectural and artistic landscape. Imperial power had already shifted away from the city of Rome under the Tetrarchy; when it moved to Constantinople, a new group of patrons—wealthy and powerful churchmen, particularly the bishops of Rome and other major sees—filled the void. Individual holy men and women formed the nucleus of new communities of monks and nuns, and proximity to them became the objectives of long-distance and regional travelers who still relied on the old Roman road system. Christian pilgrimage developed into an industry, although some of its practices were rooted in the healing sites of antiquity, like the Asklepeion at Corinth (figs. 1-1 and 1-2). New art forms emerged to help believers embrace the new faith, from the illustrated codex to the apse mosaic, while such traditional forms as the triple arch and basilica continued to signal important spaces.

CHAPTER 3

Sixth to Mid-Seventh Century

Legend

- □ **Location or findspot**
 - *Monument/object*
- • *Additional site*
- ○ *Approximate place of production*

Faroe Islands

Norwegian Sea

North Sea

Ireland

British Isles

Baltic Sea

Vendel □
- Sword

North European Plain

Canterbury•

□ **Sutton Hoo**
- Belt buckle
- Buried ship
- Purse lid
- Shoulder clasps

Bay of Biscay

Seine

Poitiers □
- Radegunde Lectern

□ **Gourdon**
- Treasure

Wittislingen □
- Inscribed brooch

Alps

Atlantic Ocean

Azores

Pyrenees

Iberian Peninsula

Corsica

•Marseilles

Ravenna
- Church of San Vitale
□

Dalmatia

Danube

Sutri
□ *- Drinking horn*
Rome ○ *St. Augustine Gospels*
- Church of St. Peter

Sardinia

Madeira

Thessaloniki □
- Church of Hagios Demetrios

Carpathians

Canary Islands

Sicily

Aegean Sea

Kumluc
- Sion Treasu

Atlas Mountains

Mediterranean Sea

Cape Verde Islands

Sahara Desert

Alexandri

Sohag
- Red Monastery church

Purse lid, burial mound 1, Sutton Hoo

Tibesti

Lake Chad

Marrah

Niger

Benue

Gulf of Guinea

0 equator

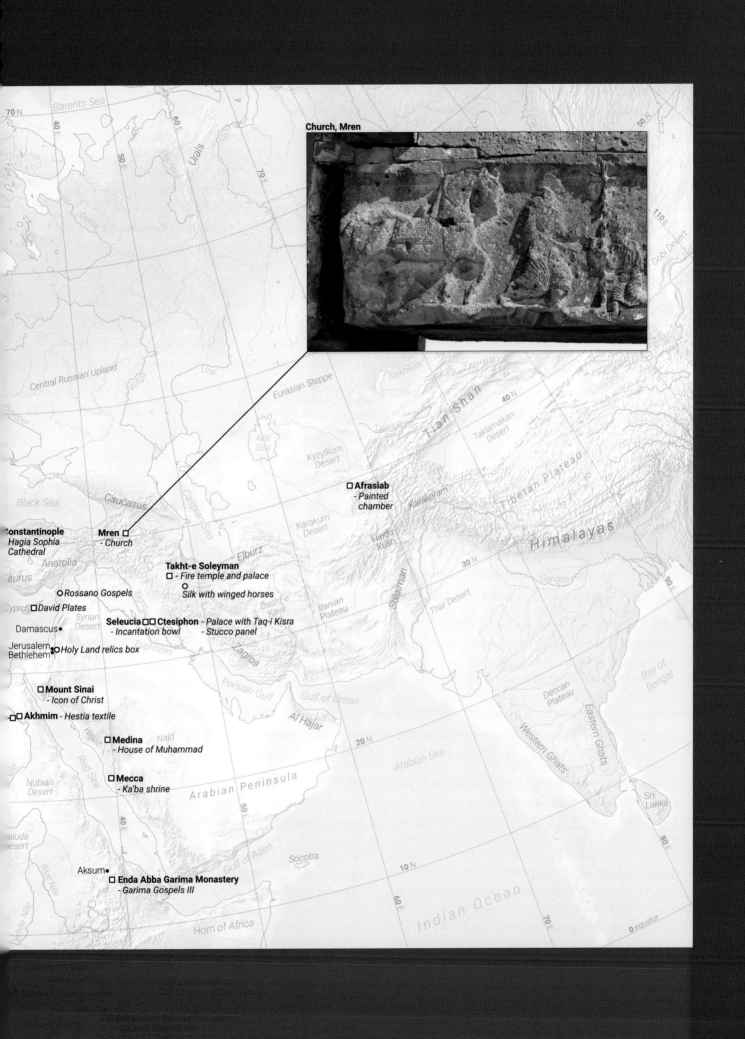

Church, Mren

70 N

Barents Sea

Central Russian Upland

Black Sea

Constantinople
*Hagia Sophia
Cathedral*

Anatolia

aurus

○ Rossano Gospels

○ David Plates

Damascus •

Jerusalem
Bethlehem •○ Holy Land relics box

□ **Mount Sinai**
 - *Icon of Christ*

□○ **Akhmim** - *Hestia textile*

□ **Medina**
 - *House of Muhammad*

□ **Mecca**
 - *Ka'ba shrine*

Nubian
Desert

Aksum •

□ **Enda Abba Garima Monastery**
 - *Garima Gospels III*

Eurasian Steppe

Mren □
 - *Church*

Takht-e Soleyman
□ - *Fire temple and palace*
 ○ *Silk with winged horses*

Seleucia □□ **Ctesiphon** - *Palace with Taq-i Kisra*
 - *Incantation bowl* - *Stucco panel*

□ **Afrasiab**
 - *Painted
 chamber*

Arabian Peninsula

Indian Ocean

In the mid-sixth century the Byzantine Empire—whose rulers and inhabitants called themselves Romans—reached its greatest physical extent. Emperor Justinian I (r. 527–65) reconquered territory in southern Spain, North Africa, Italy, and the eastern Adriatic seacoast that had long been home to the Visigoths, Ostrogoths, Vandals, and other peoples who had migrated there in the preceding centuries. However, much of the newly reacquired Byzantine territory was soon lost to the promoters of a new faith, Islam, that did not exist during Justinian's lifetime. Western Europe in this period was marked by theological disagreements among Christians and an increasing engagement with polytheism, which continued to thrive in the north. The whole northern hemisphere was affected by periods of extreme weather. As the Byzantine historian Procopius reported, "the sun gave forth its light without brightness, like the moon, during this whole year [536], and it seemed exceedingly like the sun in eclipse, for the beams it shed were not clear or as it is accustomed to shed." Likely caused by volcanic ash, this phenomenon has been confirmed by tree-ring and ice-core analyses as well as by textual accounts from Iceland to China. Its effects were compounded by the earliest historically recorded outbreak of bubonic plague, which affected populations from Central Asia to the Mediterranean. By the mid-seventh century, the large-scale migration of peoples into western Europe had ended, the Sasanian Empire had disappeared, and Islam was rapidly expanding. These changes mark the end of late antiquity and signal a period of transition that is, in some settings, called the early Middle Ages.

Building Byzantium

The greatest architectural achievement under Emperor Justinian was the magnificent cathedral dedicated to Hagia Sophia—Holy Wisdom—which had been constructed originally in the mid-fourth century as the seat of the patriarch of Constantinople, the leader of the Orthodox Church (fig. 3-1). Hagia Sophia burned down in 532 during an urban riot that destroyed much of the city. The complete rebuilding of the church took only five years (532–37) thanks to Justinian's financial support; a contemporary source says that "a river of money was flowing." According to a later writer, the emperor boasted that his architectural marvel surpassed King Solomon's Temple. Credit for Hagia Sophia's remarkable structure goes to its designers, Anthemios of Tralles and Isidore of Miletus. Their names are known to us because they were engineers and mathematicians who enjoyed high status at the imperial court; in the ancient and late antique Mediterranean, what we think of today as architects tended to be theoreticians of this sort. Although they were probably polytheists, Anthemios and Isidore designed a cathedral that transformed religious architecture for centuries to come.

One of the striking features of the building is how it showcases the ceremonies that took place inside it. While structuring how the liturgy was performed and viewed, it also expressed hierarchies of power in which the emperor increasingly asserted authority over the Church. Preceded on the west side by a large atrium and two narrower narthexes (vestibules preceding the entrance), access into the church proper was through several openings (fig. 3-2). Justinian and his entourage made their dramatic entrance through the largest, central portal, known as the imperial door. The interior of the church facilitated processions of the court and clergy because it is longitudinal, with a projecting apse. Yet at the same time, this wide nave, or naos (the main worship space of a centrally planned Byzantine church), is dominated by an enormous dome, thirty-one meters across, which creates a dynamic tension between the horizontal and vertical components of the space (fig. 3-3).

The massive dome rests on curved triangular pendentives that make a smooth transition to the four huge piers that define the square sanctuary. It is buttressed by half-domes on the east and west sides, each of which is further reinforced by two smaller half-domes. The heavy dome was not sufficiently supported on the north and south, however, and its shallow profile pushed the walls and piers (made of thin bricks with wide mortar beds) outward. It collapsed in 558, crushing the gold canopied altar and other furnishings below. Rebuilt two meters taller to redistribute its weight down rather than out, the current dome suffered partial falls in later centuries, but for the most part, the building that stands today is what Anthemios and Isidore built for Justinian.

Every surface of Hagia Sophia's interior was highly or-

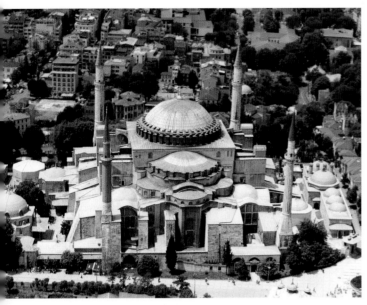

Fig. 3-1. Hagia Sophia Cathedral, aerial view, Constantinople, begun 532. Photo from iStock.com/beyhanyazar.

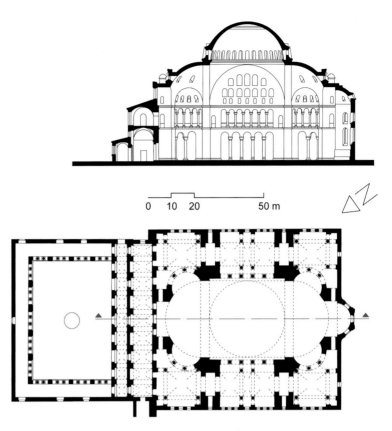

Fig. 3-2. Hagia Sophia Cathedral, Constantinople, 532–37. Drawings by Navid Jamali.

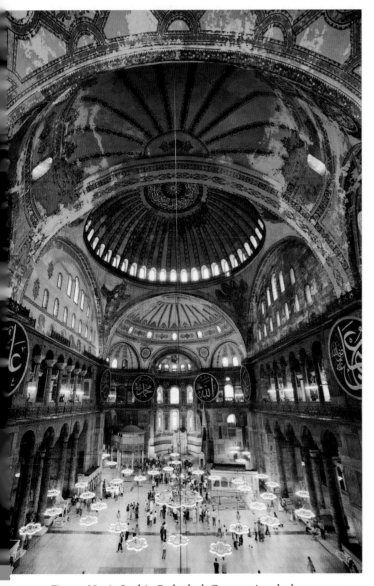

Fig. 3-3. Hagia Sophia Cathedral, Constantinople, begun 532, view toward the east. rognar©123RF.com.

namented. The church is paved in a sea of white marble, and its lower walls are covered in revetment (cladding or facing added to a surface). Many of these multicolor slabs are book-matched panels, formed by slicing marble vertically and opening it like a book to create mirror images of veining. Nearly ten thousand square meters of the sixth-century interior were adorned with gold or silver mosaics with contrasting geometric patterns. The enormous quantity of mosaic tesserae was made by sandwiching gold or silver foil, less than one micron thick, between pieces of clear glass. Many of the mosaic patterns imitate precious Sasanian textiles, creating the impression that the interior is swathed in silk. This material was so prized that silk-worm eggs were reportedly smuggled from China's secretive imperial workshops during Justinian's reign, which led to the establishment of a Byzantine silk industry under imperial control. Sculptural elaboration is concentrated on the cornices and basket-shaped marble capitals, which are deeply undercut in lacelike patterns and bear the monograms of Justinian and his wife, the empress Theodora. The sculpture and mosaics seemingly dematerialize the interior surfaces, an effect that is further emphasized by the dramatic play of light in the building. The dome rests on a row of forty arched windows such that it appears to be "suspended from heaven by a golden chain," as Procopius noted, making the whole church a "temple of light" and reinforcing the association of God with light. At Hagia Sophia this light was harnessed to glorify imperial power

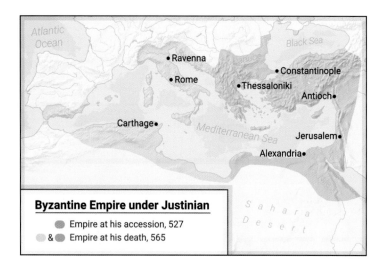

Byzantine Empire under Justinian
- Empire at his accession, 527
- & Empire at his death, 565

and authority within and outside of the church. Even though the scale of the cathedral was never repeated, the centralizing effect of the dome and its implicit connotation of heaven were imitated in almost all Byzantine churches built after it. Hagia Sophia was not the first domed church, not even in Constantinople, but it was the most important and authoritative model for Orthodox churches.

In 540 Justinian's generals, with help from the Franks, conquered northeastern Italy from the Arian Christian Ostrogoths as part of the effort to restore the old Roman Empire and extend the reach of Orthodoxy. Construction of the church of San Vitale in Ravenna (Italy) was already in progress under the patronage of church officials who were inspired by domed churches in Constantinople (fig. 3-4). Yet San Vitale looks very different from Hagia Sophia. The church is not rectangular in plan, but octagonal with a projecting apse; with its outer ambulatory (aisle for circulation) surrounding a tall central core, San Vitale more closely resembles such centralized buildings as the Lateran Baptistery in Rome and the Anastasis Rotunda of the Holy Sepulcher in Jerusalem (figs. 2-2 and 2-6). In fact, the form of the church fuses ideas from two building types: the martyr's grave (or martyrium, which the Holy Sepulcher epitomizes) as a place where a martyr's holy powers are present and accessible; and the baptistery, where initiation into Christianity creates the potential for salvation and eternal life. In Ravenna, the commemorated martyr is Vitalis, who according to legend was stoned to death in the second century on the site of the future church.

Like Hagia Sophia, San Vitale was conceptualized as a place for liturgical processions and display, as its unusual plan indicates. The atrium and narthex are laid out on the same axis, with straight paths leading toward the church, but this rectilinearity abruptly ends at the seam between narthex and church because the church is on a different axis. This shift creates two distinct paths that lead to separate entrances on adjacent sides of the octagon. The portal on the left opens into the main axis of the church, leading to the altar and projecting apse, while the portal on the right goes into the ambulatory. The oblique plan thus establishes and differentiates the paths used by clergy (north) and congregants (south). This differentiation is reinforced by the eighteen columns that, along with the eight polygonal piers supporting the dome, create a permeable "fence"; the columns and piers did not conceal the liturgical celebrations from the congregants.

San Vitale's austere brick exterior contrasts vividly with its interior (fig. 3-5). Like the finest churches in the Byzantine capital, it is clad with book-matched marble panels in the lower zones and mosaics above. The glass mosaics in the sanctuary survive, and with the original colored-glass windows the interior was originally even richer than it is today. The visual focus of the mosaic program is the apse conch, where a youthful, beardless Christ presents Vitalis with a wreath, an appropriation of a Greco-Roman victory symbol (fig. 1-6) awarded to Christian martyrs (derived from Rev. 2:10, "Be faithful, even to the point of death, and I will give you life as your victor's crown").

Local history and politics are amplified in the mosaics on the lower apse walls, especially in the image of Emperor Justinian and Archbishop Maximianus (fig. 3-6). San Vitale was completed under Maximianus, but the church, which likely dates between 526 and 548, was probably begun by his predecessor, Victor, whose monogram appears on the ground-floor capitals. Maximianus inserted his own head in place of Victor's (using stone tesserae instead of glass), and he further emphasized himself by adding his name in large letters. The archbishop's status is underscored by his proximity to the emperor, but there is a visual tension between the two principal figures: Who is more important? Justinian is haloed, like Roman and Sasanian rulers before him (showing divine support for his rule), and his left arm seems to be in front of the archbishop, but Maximianus alone is labeled, and his feet suggest that he stands in front of Justinian. The mosaic communicates the archbishop's importance and Justinian's support of his church, even though the emperor was never actually in Ravenna.

Many of the themes evident in San Vitale also can be seen in the large five-aisle basilica of Hagios (saint) Demetrios at Thessaloniki (Greece). The church was built in the fifth century in honor of the local martyr (d. 306) and renovated after an earthquake in 620. In its nave stood a hexagonal marble ciborium, an open canopylike structure that was understood as the dwelling place of the saint. The original marble ciborium was replaced by one of silver-plated wood, possibly donated by Justinian; this later one is represented as the backdrop for a large standing figure of St. Demetrios in a mosaic in the north colonnade (fig. 3-7 left). Pilgrims could enter the ciborium and see a holy relic: the saint's nearly two-meter-long bed. Just as at the Holy Sepulcher, oil from lamps burning nearby was said to work miracles, and a hospital adjacent to the basilica provided complementary methods of healing. The mid-sixth-century mosaics in the nave arcade show local elites with

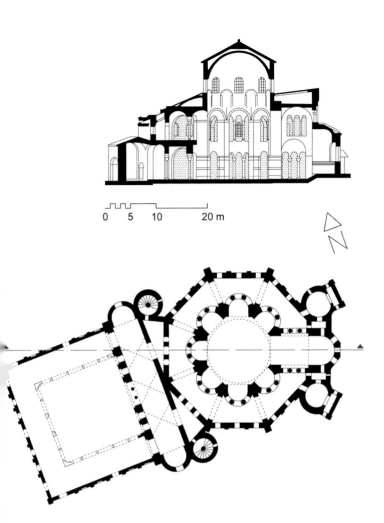

Fig. 3-4. Church of San Vitale, Ravenna, 526–48. Drawings by Navid Jamali.

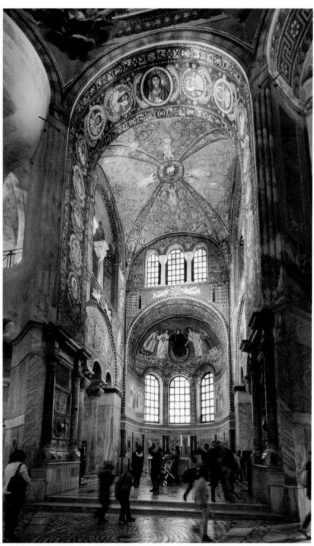

Fig. 3-5. Church of San Vitale, Ravenna, 526–48, sanctuary. Wikimedia Commons/Isatz, CC BY-SA 4.0, cropped.

a personal relationship to St. Demetrios: he is depicted interacting with grateful individuals or families, often in the church itself, interceding on their behalf with Mary and Christ. By the second quarter of the seventh century, the mosaics show him less as a healing saint and more as the city's protector (fig. 3-7 *right*). In these later images Demetrios accompanies civic and religious elites who represent Thessaloniki; these static figures hold symbols of their authority and have square haloes to indicate that they are still living. In late antiquity, responsibility for urban protection and maintenance shifted from local aristocrats and their personal largesse to the Church, civic elites, and saints. In addition to documenting changes in patronage and ideas about the saint's power, the mosaics also chart changes in style: whereas the sixth-century images include landscape backgrounds and spatial depth, with St. Demetrios standing on a convincingly three-dimensional footrest, the later mosaics feature flatter figures floating on pointed toes with little sense of receding space.

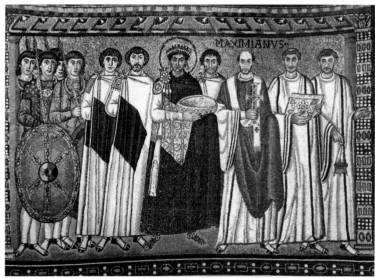

Fig. 3-6. Justinian and Maximianus, church of San Vitale, Ravenna, 526–48, left apse wall. © Genevra Kornbluth.

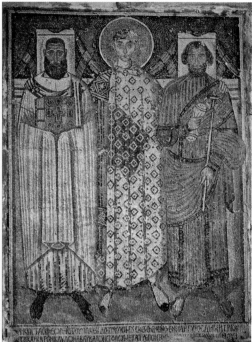

Fig. 3-7. Mosaics, church of Hagios Demetrios, Thessaloniki, (*left*) Demetrios before his ciborium, north aisle, mid-sixth century; (*right*) Demetrios with civic elites, nave pier, second quarter of seventh century. akg-images/André Held.

Adorning the Altar and Approaching the Saints

The detailed mosaics of Thessaloniki and Ravenna help reconstruct the acts of devotion that took place in their churches. On the sanctuary walls of San Vitale, the emperor and empress, along with their retinues, are shown making offerings to the church (fig. 3-6). Justinian, clad in imperial purple and wearing a crown and enormous fibula, holds a large gold paten (plate to hold bread in the mass) while his advisers and armed guards (wearing torcs) look on. The archbishop holds a jeweled cross, and alongside him deacons (clergy below the rank of priest) hold a Gospel book and censer. Theodora, on the opposite wall, is flanked by the women of her court and preceded by two beardless eunuchs; she offers a chalice, like the Magi depicted on the hem of her cloak who bring gifts to the infant Jesus. The imagery relates to the theme of offerings highlighted in several mosaics on the upper apse walls; it also links the imperial couple to the eucharistic vessels and situates them permanently at the site of liturgical celebration.

It may seem surprising to connect the objects used in the performance of the mass with laypeople like Justinian and Theodora, who as nonclerics were not permitted to handle them during the mass itself. But the imagery indicates how gifts from elites helped shape liturgical space and how precious such gifts could be. Although early vessels for holding the Eucharist could be made of any material, Christians increasingly sought to use luxurious objects whose material value and craftsmanship were considered suitable for holding the even more precious body and blood of Christ in the ritual of the mass. More gen-

erally, altars and their furnishings were often richly embellished: in Constantinople's Hagia Sophia, the richest church in eastern Christendom, the silver and gold altar furnishings are reported to have weighed eighteen thousand kilos, all destroyed when the dome collapsed.

We can get a sense of what might have been used in Hagia Sophia and other well-appointed churches across the Byzantine Empire by looking at the so-called Sion Treasure, a hoard of over seventy liturgical objects buried in the sixth century at Kumluca, in southern Turkey (fig. 3-8). The treasure takes its name from the inscription "Holy Sion" on one of the objects, and a monastery of that name existed in the early Byzantine period about one hundred kilometers from the findspot. Many of the objects, whose total weight was roughly 225 kilos, were rolled up before being buried, perhaps in the early seventh century, by people who hoped to recover them later. The hoard contains liturgical objects of the types depicted in the Ravenna mosaics: patens, chalices, and a processional cross. It also has censers, which were swung on chains to circulate smoke and the smell of incense, openwork polykandela (metal lighting fixtures) that held multiple glass oil lamps, and the silver cladding for the wooden altar table itself. Almost every object contains a text naming an individual who was thereby present symbolically each time the piece was used. One paten is inscribed in niello, "This was made in the time of our most holy and most blessed bishop, Eutychianos," and Eutychianos is also named as the donor of two other patens and a hexagonal censer decorated with peacocks and roundels of Christ, Peter, and Paul. All of the objects associated in some way with Eutychianos can be dated between 550 and

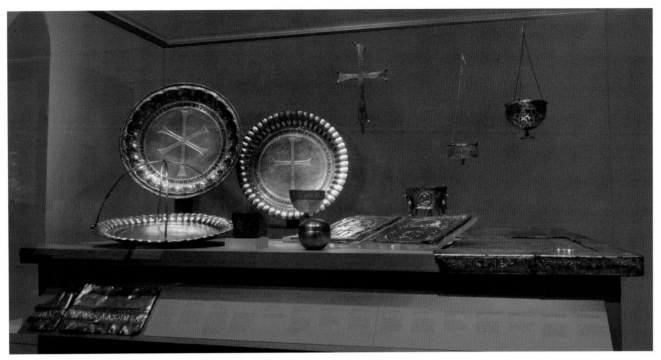

Fig. 3-8. Sion Treasure, third quarter of sixth century; Dumbarton Oaks, Washington, DC.
© Genevra Kornbluth.

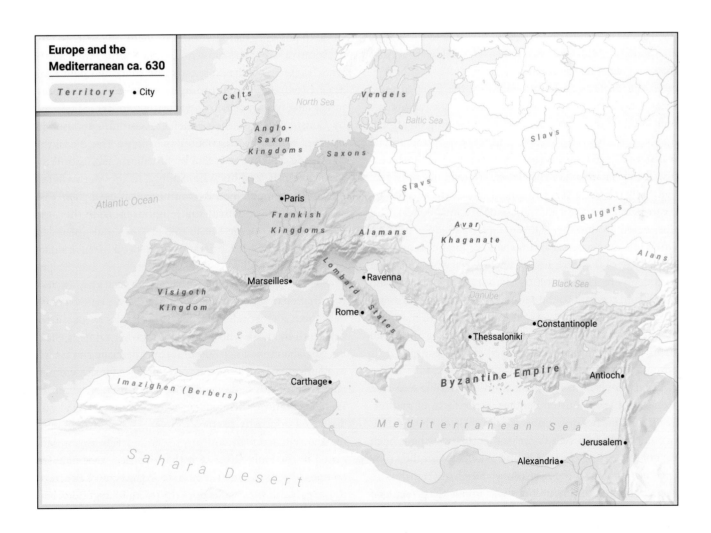

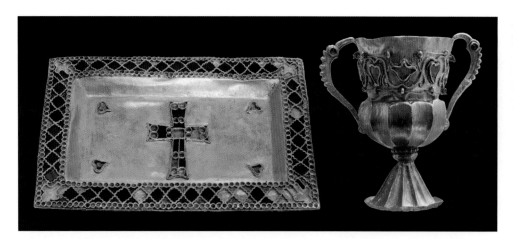

Fig. 3-9. Gourdon Treasure, paten (12.5 × 19.5 cm) and chalice (7.4 × 4.4 cm), ca. 500; Bibliothèque nationale de France, Cabinet des médailles, Paris. © Genevra Kornbluth.

565 because they bear imperial stamps used for controlling the silver industry. The decoration on many of the pieces relates to basic Christian theology and the meanings of the liturgy. Peacocks, for instance, symbolized immortality because their flesh was thought to be incorruptible. The theologian St. Augustine (354–430) tested this ancient idea by roasting a peacock and observing it; after a year, he found it not putrid but merely shriveled. Two gilt-silver book covers are decorated in repoussé with a cross between leaves inside an elaborate architectural niche; this imagery evokes the Tree of Life in paradise (Gen. 2:9, 3:22, and elsewhere) and perhaps the crucifixion of Jesus, the biblical sacrifice that is recreated in the eucharistic liturgy.

In the sixth and seventh centuries, the form of most objects used in the mass was consistent, but the artistic realization of those objects changed depending on region, techniques, materials, and style. In western Europe metal was not required for liturgical vessels until the ninth century, but a paten and chalice from Gourdon not only provide early testimony for Christianity in southeastern Gaul (France) but also indicate the use of precious materials in this region around the year 500 (fig. 3-9). Made of gold set with cloisonné garnets and malachite, the items are representative of the intricate metalwork of the Merovingian period, an era named after the dynasty of the Franks who ruled from the fifth to the seventh century. The cloisonné technique, which was very common in late Roman and early medieval metalwork, involves attaching thin gold strips at right angles to a base and filling the resulting cells with glass or gems. The use of undecorated foils under each garnet, visible through the translucent stone, was rare after about 500. Unusual handles in the form of griffins' heads with garnet eyes embellish the chalice. The diminutive size of these vessels suggests that they may have been part of a traveling cleric's kit, and at some point they may have been given to the monastery church at Gourdon; in exchange, the unknown donor was implicitly present on the sacred altar whenever and wherever the eucharistic mass was celebrated. Throughout the sixth and seventh centuries, churches and monasteries increasingly served as magnets for donations of precious objects, amassing

collections—treasuries—of offerings and sacred objects. Many treasury objects can still be seen in their original churches; others became the property of secular museums in the eighteenth through twentieth centuries. In the case of the Gourdon Treasure, which was rediscovered in 1845, Byzantine coins buried with the paten and chalice indicate that the objects were deliberately hidden after about 530.

In the sixth and seventh centuries, Byzantium was the source not only of coins but also of Christian relics. Control of the Holy Land meant that the Byzantine Empire came to possess great quantities of them, rivaling the city of Rome. Among the most precious of these holy objects were fragments of the cross on which Jesus died (called the True Cross), which, according to a legend first recorded in the late fourth century, was miraculously discovered by Constantine's mother, Helena. These rare and potent pieces of wood were distributed sparingly across the Christian world, and one was sent by Justinian's successor, Emperor Justin II, and his wife, Sophia, to the Merovingian queen Radegunde. The Byzantine rulers used their vast stock of relics as political and religious tools, in this case perhaps to encourage the Frankish kings and queens to adopt the Orthodox Christianity practiced in the eastern Mediterranean and western Asia.

For Radegunde (ca. 520–87), receiving such a prestigious relic demonstrated both piety and status. We know a great deal about Radegunde from several accounts written after her death by those who revered her for her saintly behavior. She abandoned her husband to be dedicated to Christ as a nun, after which she founded a hospice for sick women and then, in the 550s, a monastic institution. Located in Poitiers (France), this convent (women's monastery) was dedicated originally to the Virgin Mary, but after obtaining the relic from Byzantium the foundation was rededicated to the Holy Cross. For that occasion, hymns were composed to welcome the relic to Poitiers, and although these texts still survive (as does the poem Radegunde commissioned to be read at the Byzantine court to express her gratitude), the Byzantine jeweled reliquary that housed the fragment itself does not. We know from various sources, however, that the relic was displayed twice each week for

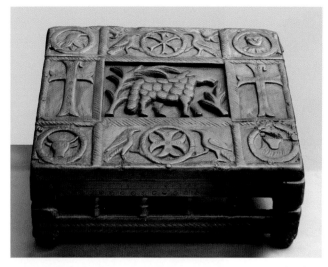

Fig. 3-10. Radegunde Lectern, Poitiers, 16 × 26 × 22 cm, third quarter of sixth century; Musée Sainte-Croix, Poitiers. Photo by the authors.

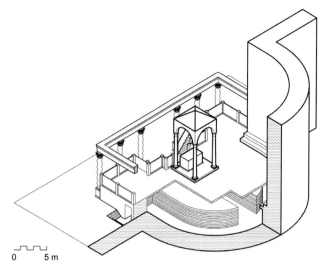

Fig. 3-11. Renovated crypt and sanctuary screen, church of St. Peter, Rome, ca. 600. Drawing by Navid Jamali.

the aristocratic women who populated the convent, and it was said to have performed numerous healing miracles.

In addition to the luxurious reliquary, Radegunde also received an illuminated Gospel book. It too has disappeared, but a carved wooden lectern may well have supported that book during the mass (fig. 3-10). Its main decoration suggests such a function: evangelist symbols in the corners represent the four Gospel authors; the lamb in the center signifies the sacrificial, life-giving aspect of Jesus; and the flanking stylized crosses refer, once again, to the power of the True Cross and Radegunde's piece of it. It is unclear where the lectern was made because of the lack of extant works of similar form and function. The unusual survival of this wooden object is due to the fact that it was traditionally associated with Radegunde and for this reason was deemed a holy relic. During her lifetime she was considered a miracle worker, especially for people imprisoned unjustly or possessed by demons. Her miracles, her personal piety, and the prestige of the convent she founded and sanctified with the relic of the True Cross led her to be revered as a saint throughout the Middle Ages.

Most medieval saints, like Radegunde or Symeon the Stylite, did not die as martyrs for their faith, but those who did, such as Vitalis, were especially venerated. The popes in Rome possessed the bodies of numerous early Christian martyrs, including two of the most famous, Peter and Paul. The popes refused to share any local bodily relics at this time, but they were not averse to encouraging pilgrimage to holy graves and disseminating contact relics, created by placing items in proximity to sacred bones. About 600, the east end of the church of St. Peter was renovated under Pope Gregory I to better control access to Peter's burial spot (fig. 3-11). The floor level of the apse was raised 1.5 meters so that the tomb aligned with the new altar above. This close association of altar and relics conforms to a verse in Revelation (6:9): "I saw under the altar the souls of those who had been slain for the word of God and the testimony they had maintained." The new arrangement also served practical purposes. An annular (ring-shaped) crypt under the raised floor allowed pilgrims to enter on one side of the transept, proceed down the corridor to see the tomb, and then exit on the other side. Peter's remains were also accessible through a small window in the crypt; the faithful might lower strips of cloth into it, creating sacred contact relics that they could keep. Pilgrims gained closer access to the holy grave while remaining separated from the clergy's space around the altar. The six spiral columns from Constantine's first baldachin were repositioned in front of the apse to emphasize this separation and to enhance the meaning and visual prominence of the basilica's liturgical space (six more columns were added to the screen in the eighth century).

Trappings of the Dead

For the vast majority of medieval people, material expressions of identity or piety were not on the monumental scale of St. Peter's. Portable objects, many of which were placed in graves and discovered centuries later by archaeologists, shed light on the more typical priorities, beliefs, and migrations of both elite and less well-off individuals.

A large brooch from a young woman's grave at Wittislingen in southern Germany dates about a century later than the Gourdon chalice and paten (fig. 3-12). The brooch was the finest of several metal artifacts found in the tomb. In addition to cloisonné garnets and green glass on a base of silver, the craftsman used gold filigree to create a complex interweaving of abstract animal forms and ribbon interlace. Because these features appear in many media across Europe, a system of classification has been devised to differentiate their forms; this one is termed Style II Animal

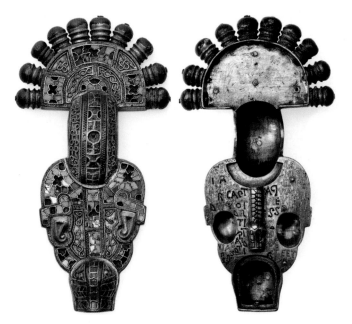

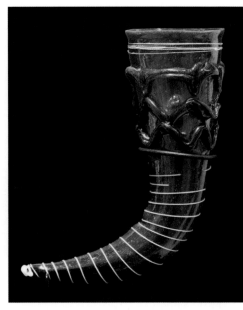

Fig. 3-12. Inscribed brooch, Wittislingen, 15.5 cm, early seventh century; Archäologische Staatssammlung, Munich. © Stefanie Friedrich; Archäologische Staatssammlung München.

Fig. 3-13. Drinking horn, Sutri, 23 cm, late sixth–early seventh century; British Museum, London. © Genevra Kornbluth.

Art. The Wittislingen pin is called a bow fibula (for its resemblance to a crossbow) or a digitated fibula (for its fingerlike projections); it was worn at the shoulder to close a cloak, like the mantles of Stilicho or Justinian's advisers at San Vitale (figs. 2-13 and 3-6). Its place of manufacture is uncertain, and even if that could be determined, it would not necessarily indicate the ethnicity of the deceased. In any case, the luxurious brooch demonstrated the wealth and status of the woman, though whether it was made for her or was inherited from an ancestor is impossible to say. Its form, decoration, and function are typical of such fibulae, but this particular brooch also contains an inscription on the back that was incised and filled with niello to enhance its visibility. Its faulty Latin makes it a challenge to understand fully, but the essence is clear: it is a prayer that the deceased woman, named Uffila, should live happily (after death) with God. The use of Latin and references to her faithfulness to a single divinity signal that she was a Christian. Even more remarkable is that the inscription ends by saying "Wigerig fecit"—Wigerig made [this]. This is presumably an early and unusual example of an artist's "signature"; most early medieval objects cannot be attributed to a named individual, although, as at Hagia Sophia, the names of architects were occasionally recorded. Without any corroborating evidence it is difficult to say much about Wigerig, but the presence of his name indicates that he took pride in his work and was respected by others.

A woman's grave at Sutri (central Italy), containing a coin of the Byzantine emperor Tiberius II (r. 578–82) that helps place it in time, held a rich assemblage of metal items, including a small cross, earrings, and a brooch very similar in form to the one at Wittislingen. The most striking item in the burial hoard is a cobalt-blue drinking horn that demonstrates the survival of Roman glass techniques into the early Middle Ages (fig. 3-13). It was made by blowing a cone of glass and adding a white trail of glass and blue

latticework around the neck. The fragility of the thin glass core and the delicacy of the three-dimensional ribbons of blue and white ornamentation indicate that the horn was probably made for display, not for frequent use or travel. Yet travel they did, for such objects, which vary in color and decoration, are associated with high-status Germanic graves mostly along the Rhine River. The craftsman and the woman buried at Sutri were likely part of the Lombard kingdom, whose leaders migrated south and controlled much of Italy in the mid-sixth century and remained in power in places for five hundred years.

The migration of large groups of people, which is reflected in the movement of such objects as the Wittislingen fibula or the Sutri horn, is characteristic of Europe in the sixth and seventh centuries. In Scandinavia, where such migratory patterns had slowed, this era is often called the Vendel period, named for a boat-grave cemetery in southern Sweden. A sword and scabbard made around 600, found in Grave I at Vendel, reveals close contact between the Germanic culture of early medieval Scandinavia and that of Britain and the European mainland (fig. 3-14). The cemetery had been looted, with most of the human bones and objects removed, probably when the local church was constructed in the thirteenth century. Grave I, however, was intact, and its artifacts suffered damage only when it was discovered in 1881 (a visiting smith tested the iron sword and broke it). Weapons feature prominently among the grave goods, an indication of their importance both as functional items in conquest during life and as status items for warriors in death. The sword hilt is made of gilded silver with niello and garnets. In the recesses that accommodate the user's fingers, the gilding has largely worn away. The pyramidal pommel at the top (now replaced by a modern reconstruction) was attached to a ring whose function is unclear; it may have symbolized an oath. Like the hilt, the gilded fittings for the (lost leather)

scabbard are adorned with interlaced animal forms, some with garnet eyes, which have the sinuous lines characteristic of the Vendel style. The sword was buried in the first half of the seventh century, roughly contemporary with the best known and richest assemblage of material objects from this period, at Sutton Hoo in southeastern England.

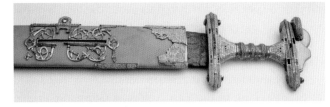

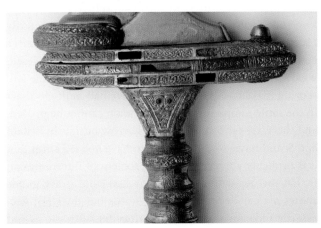

Figs. 3-14a and 3-14b. Sword, Vendel, ca. 600, *(top)* upper guard W 10.8 cm; *(bottom)* handle L 12 cm; Historiska museet, Stockholm. © Historiska museet 2014. Charlotte Hedenstierna-Jonson SHM; CC BY 2.5 SE.

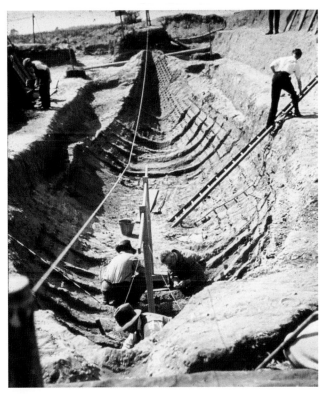

Fig. 3-15. Buried ship excavation in 1938, Sutton Hoo, Mound 1. © Trustees of the British Museum; all rights reserved.

Work in Focus:
SUTTON HOO

Sutton Hoo is a site on the Deben River that comprises a large cemetery used for cremations and burials between the late fifth and mid-seventh centuries. At that time, the area was part of a small kingdom called East Anglia, which competed for territory and resources with such other nearby kingdoms as Kent, Wessex, and Mercia. There was no unified country called England, and early medieval sources speak about different local and migrant groups that included Britons, Angles, Northumbrians, Picts, and Saxons. It has been conventional to use the term Anglo-Saxon to refer broadly to the shared early medieval culture of the diverse peoples who inhabited the territory roughly corresponding to modern England.

Discovered a few days before the start of the Second World War, the Sutton Hoo site had to be covered and reexcavated decades later. Among at least eighteen barrows (burial mounds), two contained ships that had to be dragged about eight hundred meters inland. The large size of the ships means that this move required considerable human, animal, and material resources, suggesting the ceremonial nature of the burial and an assumed audience for it. In Mound 1, the twenty-seven-meter-long wooden ship had completely deteriorated in the acidic sand, like all the organic material inside it, including a body, but the impressions of the boat and its metal rivets were well preserved (fig. 3-15). Over 250 grave goods, many of them lavish works, had been laid out in an organized fashion inside a wooden chamber on the ship.

Among the impressive finds were the gold frame of a purse lid decorated with gold, garnets over stamped gold foil, and blue glass, originally hinged to a leather or fabric bag (fig. 3-16). The Merovingian gold coins once inside the purse were minted between about 595 and 613. The central plaques depict interlaced horses above two birds of prey attacking ducks; the flanking plaques each show a mustached man between two wolflike beasts. Like many of the groups in northern Europe at this time, the people who produced this purse lid were not part of a literate culture that recorded their religious beliefs, stories, and songs in texts, so it is difficult to know the precise meaning of these representations. It is clear, however, that the pairings on the purse lid, variations of which can be found on Scandinavian objects, communicate the theme of combat and perhaps even humanity's struggle with the natural world.

A cast gold belt buckle also reflects Germanic metalworking traditions known since the fifth century, with its upper surface completely covered with sinuous interlacing birds and beasts outlined in niello (fig. 3-17a). It requires great effort to pick out and identify these attenuated animal forms, as is the case also on a pair of curved shoulder clasps, where thin-bodied birds outline the central rectangles and two large boars overlap on the rounded

edges (fig. 3-17b). Boars were appreciated as fierce creatures, and they may have had personal, tribal, or military significance. The clasps are made of gold, glass, and garnets using both cloisonné and millefiori techniques. In the latter, rods of different-colored glass were fused together and then sliced. These millefiori pieces were recycled, either taken from old Roman objects or created anew from Roman glass rods, probably in the later sixth century.

Quantities of weaponry were also present at Sutton Hoo, including a ceremonial helmet that amplified the voice of its wearer, a decorated shield, and the remains of an iron mail tunic. There were numerous vessels, probably associated with communal or funerary feasting, including bronze hanging bowls; drinking vessels made from the horns of aurochs, the wild bulls long extinct in England—a more durable version of the Sutri horn; and Byzantine

silver bowls with imperial stamps that date them to the sixth century. Two spoons in Mound 1 were inscribed "Paulos" and "Saulos," Paul and Saul, perhaps marking someone's conversion. Along with the crosses incised on the silver bowls, these are the only possible referents to Christianity in the Sutton Hoo ensemble. They may have been recognized as such in early seventh-century Britain, but they do not necessarily tell us about the beliefs of the occupant of the grave. Few, if any, of the objects in Mound 1 were made locally, testifying to the movement of objects via trade, pillage, or gift exchange.

One candidate for burial in Mound 1 is Raedwald (d. ca. 625), king of the East Angles, a Germanic people from the coasts of the Baltic Sea who settled in southeast England. That name was attached to the grave primarily because it is known from an eighth-century text, Bede's *Ecclesiastical History of the English People*, in which Raedwald is criticized for converting to Christianity while still serving his old gods (he is said to have had multiple altars in the same temple). This identification cannot be proved, and there are far too many elite barrow burials in Britain and Scandinavia for all of them to have housed kings, but it is probably correct. Another problem of interpretation is that the deposition of so many luxurious grave goods shows a clear desire to display status but does not necessarily indicate a belief in the afterlife. With the spread of Christianity, the frequency and quantity of objects in graves declined but did not disappear altogether, despite the Church's criticism of the practice. Indeed, the cluster of burials at Sutton Hoo, several of which show evidence of human and animal sacrifice, may well represent

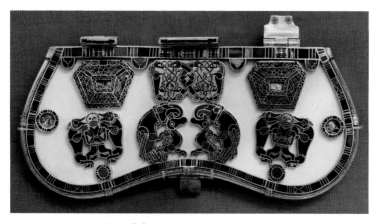

Fig. 3-16. Purse lid, Sutton Hoo, 8.3 × 19 cm, early seventh century; British Museum, London. © Genevra Kornbluth.

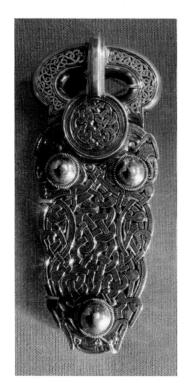
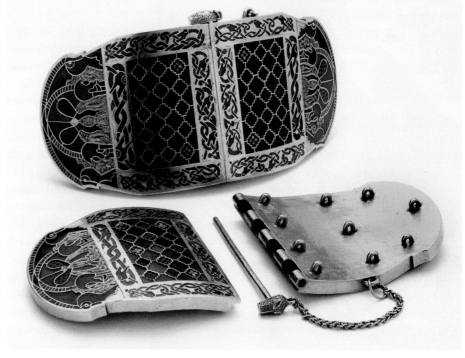

Figs. 3-17a and 3-17b. Sutton Hoo, early seventh century; British Museum, London, (*left*) buckle, 5.6 × 13.2 cm; (*right*) shoulder clasps, each 5.4 × 12.7 cm. (*l*) © Genevra Kornbluth; (*r*) © Trustees of the British Museum; all rights reserved.

a conscious and powerful public statement of allegiance to venerable polytheistic practices under pressure in a slowly expanding Christian landscape.

Christian missionaries from Gaul and Ireland had tried to convert the illiterate and polytheist Anglo-Saxons with only sporadic success until a concerted effort was made by Pope Gregory I. In 597 he sent a monk named Augustine to Canterbury (in Kent), not far from Sutton Hoo. A book now called the St. Augustine Gospels was an important item in his ideological toolkit (fig. 3-18). After converting the local king, Aethelbert, to Christianity, Augustine became the first archbishop of Canterbury (his successors to this day assume the leadership of the Church of England in a ceremony using this very Gospel book). The book now preserves only two full-page illuminations. The Gospel of Luke begins on fol. 129v. Luke's symbol, the ox, appears in the lunette (half-moon shape) over the seated "portrait" of that evangelist; comparable author images must originally have introduced the other Gospels, too. Luke is shown as a pensive philosopher, seated on a cushioned throne within a classicizing architectural frame and holding his Gospel book open in his lap. The Latin text on the entablature quotes from a fifth-century poem: "Luke maintains the office of the priesthood with the face of an ox." Flanking him, between columns painted to look like veined marble, are small scenes from the life of Jesus, who is identifiable by his cross-nimbus. The other illuminated page in the book contains twelve small scenes of the Passion of Christ arranged in a grid. We cannot really know how Augustine might have used this Gospel book in his effort to convert Aethelbert, in whose culture figural painting—and books altogether—were alien. But sometime in the seventh or eighth century, small captions in the Anglo-Saxon language were added in the margins of the book; someone was interested in making sure that a local audience could identify the scenes in the illustrated Gospels. The idea of using images as teaching aids had been addressed by Pope Gregory I, who around 600 wrote two letters on the subject to Serenus, the bishop of Marseilles, advising him not to destroy pictures that could be used to teach non-Christians and illiterates. These letters became the foundation of ongoing intellectual arguments in defense of images in medieval Europe.

Evocations of the Holy Land

Even before the production of the St. Augustine Gospels in Italy, a very different-looking New Testament manuscript was made somewhere in the eastern Mediterranean region. The Rossano Gospels, named for its current location in southern Italy, is an exceptionally luxurious book: it was written with gold and silver inks on dyed parchment that ranges from purple to red. It is now incomplete, containing only the Gospel of Matthew and most of Mark. Like the

Fig. 3-18. St. Luke, St. Augustine Gospels, 24.5 × 19 cm, late sixth century; Cambridge, Corpus Christi College, MS 286, fol. 129v. Photo from the Parker Library, Corpus Christi College, Cambridge.

St. Augustine Gospels, it preserves a single evangelist's portrait, in this case Mark, writing on a scroll while a female muse, possibly a personification of wisdom, inspires him. The first extant folio, however, is typological (fig. 3-19 *left*). In the lower half are the Old Testament prophets Hosea and Isaiah and King David, the latter shown twice, all displaying their texts that, by the early sixth century, were understood as foretelling Christ. They point up toward a scene from John 11, when Christ, haloed and wearing a golden mantle, brings the entombed Lazarus back to life. Lazarus is depicted as an upright corpse, wrapped like a mummy, and the man closest to him covers his nose because of the smell of decomposition (as predicted by Lazarus's sister Martha in John 11:39). The Rossano manuscript also contains two pages with unusual compositions that lack typological meaning (fig. 3-19 *right*). Both are scenes of Jesus before Pontius Pilate, the Roman prefect of Judaea (r. 26–36) who, according to all four Gospels, reluctantly condemned Jesus to death. At the bottom of fol. 8r, Judas tries to return to the Jewish priests the thirty pieces of silver he received for betraying Jesus; at the lower right he hangs himself. The

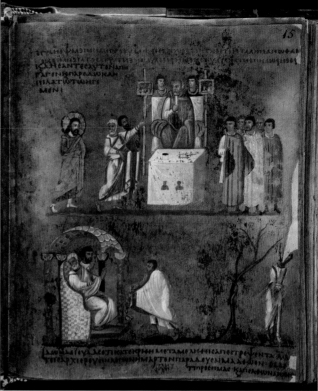

Fig. 3-19. Rossano Gospels, 30.8 × 26.4 cm, sixth century, *(left)* resurrection of Lazarus, fol. 1r; *(right)* Jesus before Pontius Pilate, fol. 8r; Rossano, Museo dell'Arcivescovado (no shelf mark). © 2020. Photo Scala, Florence.

arched blue outline above the scenes suggests that the artist might have been trying to place the scene in a particular architectural setting, or was copying an image in an apse—perhaps the Praetorium in Jerusalem where Pilate's sentence was issued. The Roman emperor who grants Pilate his authority is represented in the courtroom by the busts of co-emperors depicted on the standards behind him. By evoking the courtroom setting, the artist of the Rossano Gospels has sought to make the location described in the Gospel texts more vivid for the viewers.

The circuit of Old and New Testament sites to be visited became more firmly set in the sixth century, when Justinian rebuilt some of the premier shrines in Christendom, including the Church of the Nativity (Jesus's birth) in Bethlehem. Evidence for Christian pilgrimage in this period ranges widely in scale, from monumental architecture to portable ampullae that held water poured over relics or oil from lamps burning at holy sites. A unique box of stones and fragments of wood gathered at the sacred sites is preserved at the Vatican (fig. 3-20). Some retain labels in Greek: "from Bethlehem," "from Zion," "from [the place of] the life-giving resurrection." The exterior of the sliding lid depicts a cross atop a mound, indicating the site of the crucifixion on Golgotha, which was also supposedly the place of the burial of the first man; following medieval typological thinking, Christ is the new Adam who redeems the old Adam's sin and fall from grace. Inside the lid, seen here, are vignettes of the most important events in the life

of Jesus, which evoke the pilgrim's itinerary: starting at the lower left, the nativity, baptism, crucifixion, the Marys visiting the empty tomb of Christ, and the ascension. The tomb is shown as an aedicula covered by a rotunda, accurately reflecting the monumentalization of the Holy Sepulcher in the mid-fourth century. In the crucifixion scene, Jesus has short hair and a minimal beard and wears a long tunic; neither his facial features nor his clothing were standardized yet, and both had to be invented because there were no first-century descriptions or portraits of Jesus. While the images emphasize holy places, they also indicate the sacred events that shape the Christian calendar, from Christmas to Easter to Ascension Day. By the turn of the seventh century when this box was painted and presumably filled, the detailed story of Christ was imagined not only by Holy Land pilgrims but also by those who performed or observed its perpetual reenactment in church liturgy.

Images and Media in Northeastern Africa

Mount Sinai, where Moses received the Law from God, was not only a pilgrimage site but also a flourishing monastery with a church built by Emperor Justinian. Its sixth-century fortifications, basilica, and mosaics are well preserved, and its isolated location in the rugged Sinai Peninsula of Egypt has also contributed to the preservation of both an extensive

Fig. 3-20. Holy Land relics box, 24 × 18.4 cm (lid), ca. 600; Musei Vaticani, Vatican City. Box, photo by the authors; lid, © Genevra Kornbluth.

library of medieval manuscripts and an unparalleled collection of icons. The Greek word *eikon* means "image" and can apply to revered images in any medium, but the term *icon* is often used more narrowly for painted panels on wood with one or more frontal, half-length figures of Christ, the Virgin Mary, or saints. One of the earliest extant icons, of about 600, depicts Christ making a blessing gesture and holding a jeweled Gospel book (fig. 3-21). The technique used here is encaustic, in which pigments are mixed with melted wax and applied in layers. Because the two halves of the face of Jesus are so different and the eyes are not aligned, some scholars think that the icon shows the two natures of Christ, human and divine. Christ's nature was a subject of controversy (box 2-1), and the Fifth Ecumenical Council, held in Constantinople in 553, continued to refine the Orthodox understanding of Christ's deified humanity. Other scholars, pointing to late Roman painted panels such as the ones from Egypt in fig. 1-22, see the asymmetry as an artistic attempt to convey Christ's beneficent and judgmental roles or to make the figure seem more alive; human faces, after all, are asymmetrical, and the way Christ's eyes are painted creates a sense of movement.

Witnessing the liturgy and venerating relics were important ways for faithful Christians to access the sacred, but icons were a potent means to do this in a face-to-face manner. The first accounts of miraculous images of Christ appeared in the sixth century, in tales of him wiping his face on a towel and leaving an imprint that then reproduced itself on other media. Some of these miraculous images, called *acheiropoieta*—Greek for "not made by

Fig. 3-21. Icon of Christ, 84 × 45.5 cm, ca. 600; Monastery of St. Catherine, Mount Sinai. By permission of Saint Catherine's Monastery, Sinai, Egypt.

(human) hands"—were displayed and processed in public, where they disseminated their protective power on an urban scale. This notion of an authoritative model or prototype (the actual holy person) yielding a faithful and powerful copy (the image) underscores the validity of all icons, even those made by human hands. Yet the Sinai Christ looks nothing like the crucified Jesus on the contemporary Holy Land relics box or the majestic Christ on a rainbow in the apse of the Monastery of the Stoneworker (fig. 2-23). Rather, the Sinai image seems to draw upon ideas about wisdom and divinity from the ancient world, in which gods and philosophers were older and bearded. Tensions about images and their relationship to the holy person depicted led to fierce debates and periods in which icons were destroyed, as discussed in chapter 4.

Although the haloed, enthroned woman in this colorful wool tapestry shares the frontal quality of the Sinai icon, she is not a Christian saint (fig. 3-22). Rather, a woven inscription identifies her in Greek as Hestia, the classical personification and pagan divinity of the hearth, and Polyolbos, "rich in blessings." She has been updated, however, with contemporary clothing and jewelry. The six small putti alongside her hold disks inscribed with the blessings she confers—wealth, joy, praise, abundance, virtue, and progress—all underscored by the lush flowering background that suggests the bounties of nature. The two figures at the sides are also personifications; the female at the right displays a plaque that says "Light," but the message of her male equivalent at the left is lost. The textile probably was hung in a prosperous Egyptian house as a way of encouraging the blessings that it names. This is one of many textiles allegedly found in a large cemetery at Panopolis (now Akhmim, in Egypt), where it served a new function, that of wrapping a body. It is a good example of

Fig. 3-22. Hestia textile, Akhmim, 114.5 × 138 cm, first half of sixth century; Dumbarton Oaks, Washington, DC. © Genevra Kornbluth.

the abstract style popular in the first half of the sixth century across the Mediterranean world: the composition is symmetrical, with little modeling of bodies and faces, and the figures are arranged vertically in a flat space. (By contrast, the contemporary icon of Christ from Sinai is much more naturalistically modeled, with the Gospel book rendered as a three-dimensional object and the background as a classicizing building.) The term *Coptic* is often used for such textiles, but properly speaking that refers only to the Christian population of Egypt after the ninth century. It is difficult to associate the Hestia hanging with any single religious or cultural group; its familiar imagery and reference to blessings would have resonated with people of diverse faiths.

Akhmim is just across the Nile from the settlement of Sohag and the Red Monastery church, named for the color of its brick walls. It was part of a federation of men's and women's monastic communities, as well as hermits, that flourished in Egypt from the fifth to the fourteenth century. These Byzantine monks were Miaphysites, whose belief about the relationship between the human and divine aspects of Christ diverged from the Orthodox dictates of the Fourth Ecumenical Council (Chalcedon, 451). They believed that Christ was divine and human, but that the two qualities were perfectly united in one nature (Greek *mia*, one; *physis*, nature); Chalcedonians, by contrast, posited that two natures are preserved in Christ, although they are inseparable and indivisible. Given the subtleties of these interpretations, Miaphysites were not considered heretics—Empress Theodora was one—but the difference of interpretation led to fragmentation within the Christian leadership and its communities.

The Red Monastery church was built in the fifth century. Its exterior resembles an ancient Egyptian temple with its angled, rectangular massing. It is a basilica with a triconch (triple-apse) sanctuary at the east end, divided from the long nave by a tall and ornate transverse space that creates a monumental limestone facade for the sanctuary (fig. 3-23a). This space, known as a *khurus*, is a feature of churches in Egypt that served to separate the altar area and its celebrants from congregants in the nave. Unlike the fencelike columns at St. Peter's, however, this architectural element was a wall that obstructed views of the liturgy, thereby enhancing the mystery of the ceremonies. The paintings of the triconch, which date mostly to the sixth century, are a riot of polychromy and patterning that seem to destabilize the architectural structure (fig. 3-23b). No other painted church from this period preserves so much color and such a quantity of architectural sculpture, both real and fictive.

In the northern lobe, the early sixth-century figures are characterized by flat bodies and wide, staring eyes (fig. 3-24). Peter and Paul are represented as supporting columns, and Old Testament prophets holding scrolls flank Mary and Jesus. Mary, shown breastfeeding her child, is a metaphor

for the Eucharist. The theologian Clement of Alexandria (d. 215) wrote that Mary's milk represented Christ's flesh and blood; here she is the altar table who holds Christ, the sacrifice, while the angels swing censers around them. Just as her milk feeds the body that grows, dies on the cross, and is resurrected, suggesting the unified nature of Jesus's humanity and divinity, so the bread and wine offered on the altar transform into his body and blood. These eucharistic elements feed the monks at Sohag to help them attain salvation and eternal life. The scene takes place in a spatially bewildering setting, a two-level arcade from which hang numerous painted lamps, censers, and crosses. One register below, real and painted niches depict busts of four leaders of the monastic federation (including Pshoi, founder of the Red Monastery), while three early patriarchs of Alexandria (Egypt) are represented at floor level. Issues of cenobitic identity and church hierarchy are paramount and focus on local or personal networks; the famous founders of eremitic monasticism, including St. Anthony, are excluded (box 2-3). The decorative program of the Red Monastery church surrounded the monks in a painted environment of holy figures whose presence was meant to situate the community in the wider Christian world and inspire deeper levels of spirituality.

Similar examples of the monastic use of painted images can be found in another Christian kingdom with a distinct history and visual culture. Aksum (Ethiopia) had a prominent role in the trade routes between the old Roman Empire and South Asia. Aksum's King Ezana had adopted Christianity from Egypt in the second quarter of the fourth century, making it one of the earliest Christian kingdoms. In the early sixth century, under the pretext that Christians were being persecuted, the Aksumites conquered the Jewish Himyarite kingdom across the Red Sea (in modern Yemen) and thereby secured control over lucrative Red Sea trade routes. At the same time, at least one Ethiopian monastery was founded and enriched by the copying and illumination of new books.

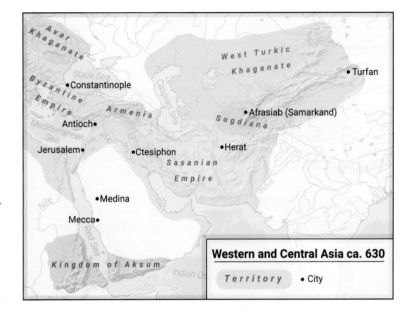

Figs. 3-23a and 3-23b. Red Monastery church, Sohag, fifth–sixth century, (*left*) plan; (*right*) triconch, paintings, mostly early sixth century. (*l*) Drawing by Navid Jamali; (*r*) Reproduced by permission of the American Research Center in Egypt; project funded by the United States Agency for International Development (USAID).

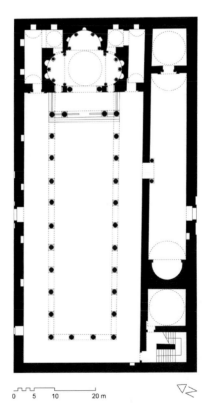

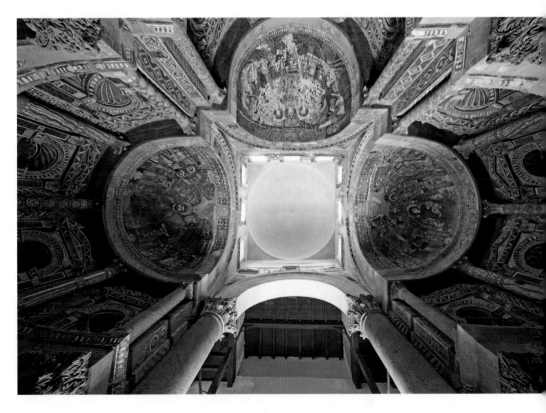

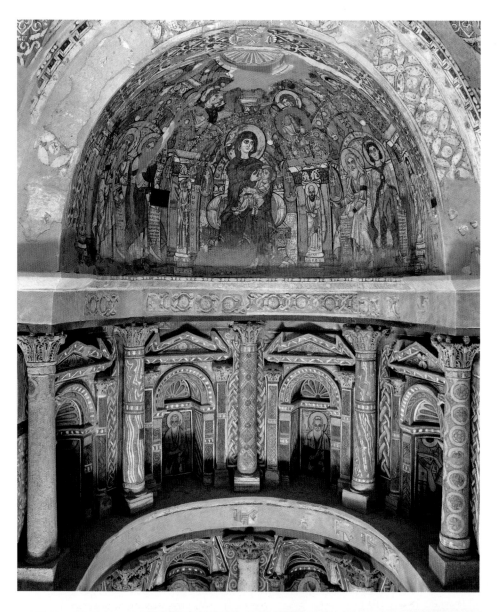

Fig. 3-24. North lobe of triconch, Red Monastery church, Sohag, paintings mostly early sixth century. Reproduced by permission of the American Research Center in Egypt; project funded by the United States Agency for International Development (USAID).

Fig. 3-25. Gospel book (Abba Garima III), 33.2 × 25.4 cm, fifth–sixth century, *(left)* St. Mark, *(center)* canon tables, *(right)* messianic Temple; Enda Abba Garima Monastery, MS 3. Photos by Michael Gervers.

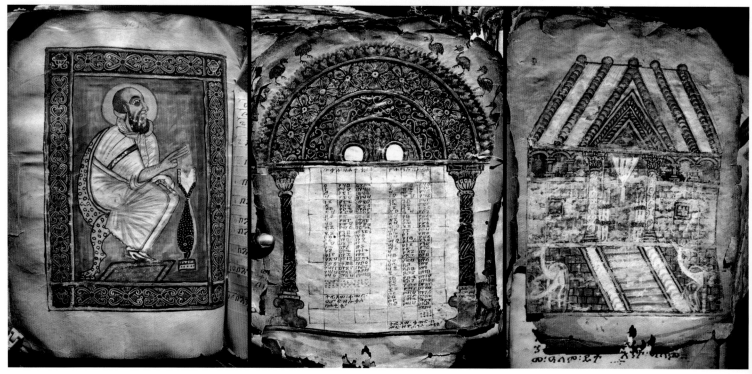

The monastery of Enda Abba Garima, near Aksum, houses three decorated Gospel books long thought to date between the eighth and thirteenth centuries. The books have been redated between the fourth and the mid-seventh century on the basis of stylistic analysis and carbon-14 testing of selected pages. They are written in Ge'ez, the ancient Semitic language of the Miaphysite Ethiopian Orthodox Church, although their textual model was Greek. Garima III, probably fifth–sixth century, was painted by a single local artist and may be the oldest extant Gospel book to preserve all four evangelist portraits and decorated canon tables. Mark is seated on a leopard-covered throne that might evoke the leopard skins worn by ancient Egyptian priests and allude to his missionary success in Alexandria (fig. 3-25 *left*). Canon tables present the relationships among the four Gospels visually, by numbered section in parallel columns, so that a reader can easily see where a particular story from the life of Christ appears in the different Gospel texts (fig. 3-25 *center*). This device is credited to Eusebius, the bishop of Caesarea and biographer of Constantine. Ethiopian monks celebrated these navigational aids as miraculous images of Gospel harmony worthy of pious contemplation. The variegated fictive marble, abundant flora, and birds atop the arcades suggest that these are evocations of paradise.

After the canon tables, a building with a pitched roof represents the restored Jerusalem Temple envisioned by the prophet Ezekiel (Ezek. 40:1–43:17) (fig. 3-25 *right*). The white stags that find shelter in the building's base, one on the right and two on the left, underscore the idea of salvation. They should be understood as drinking from the water of life that flows from the Temple's threshold, just like the silver deer in the fourth-century Lateran Baptistery in Rome. Even as the images throughout Garima III link the book to visual and theological traditions across the Christian world, the window shapes of the Temple painting seem to be drawn from Aksumite architecture (fig. I-14b), thereby making the book's messages especially meaningful to the local audience, a strategy seen also at San Vitale and the Red Monastery.

Byzantines and Armenians in Western Asia

The so-called David Plates, part of a hoard of gold, silver, and bronze objects found in Cyprus, communicate how at least one Byzantine emperor was conceptualized in the seventh century. Superbly worked in solid silver, in a style that demonstrates a continued adherence to classical forms, this set of nine plates contains scenes from the life of King David, a biblical model for Herakleios (r. 610–41), during whose rule the plates were produced; control stamps on the back narrow the date to 613–29/30 (fig. 3-26). Herakleios, the first Byzantine soldier-emperor since Theodosius I, paid off the attacking Avars and in 628/29 defeated the formidable

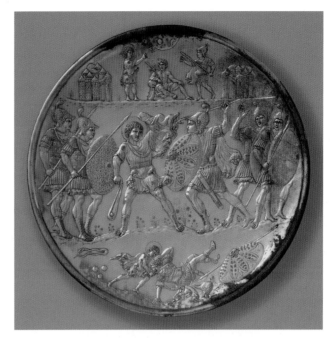

Fig. 3-26. David Plate, 49.4 cm, 629/30. Metropolitan Museum of Art, New York. Gift of J. Pierpont Morgan, 1917 (17.190.396). Image © Metropolitan Museum of Art.

Sasanians under Khosrow II, who had captured Damascus, Jerusalem, and Alexandria and threatened the Byzantine Empire. He may even have engaged in single combat with a Sasanian general, much like David and Goliath. The scene on this plate includes a classical river personification at the top to indicate where David obtained his stones; at the bottom, David beheads the giant (1 Sam. 17:41–51). Ultimately, Herakleios was able to recapture the relic of the True Cross that the Sasanians in 614 had taken from Jerusalem, David's capital, and he returned it there in 630. Despite the biblical subjects, these plates were not used in a church; rather, they were displayed as tableware in an elite home and were probably hidden when an Islamic army attacked Cyprus in the mid-seventh century.

Work in Focus:
THE CHURCH AT MREN

Herakleios was represented by and for those subjected to his rule on a church at Mren (fig. 3-27), located on the contested frontier between Byzantium, the Sasanian Empire, and the principality of Armenia (it is now in northeastern Turkey). Here, however, the emperor was endowed with Christlike powers rather than Davidic ones. Mren was a strategically important site that reflects several agendas: the Byzantine imperial project of political and religious consolidation; local Armenian leaders vying for enhanced power and prestige; and concerns about the future of the Holy Land that were shared by Orthodox and Armenian Miaphysite Christians, who otherwise disagreed about the nuances of major theological issues.

The church at Mren—by the tenth century and perhaps already in the seventh a cathedral—is a large, domed basilica built of red and grey masonry (fig. 3-28). The imposing height of its domed mass is as striking as its colorful walls; it dominates the landscape, a treacherous plateau cut with deep gorges and ravines. The church has deteriorated significantly in recent years—the south wall collapsed in 2008 and the north and west walls tilt outward—but what remains indicates the ambitious ways Armenian elites monumentalized their religious ideas and practices. Mren's complex architecture, elaborate exterior sculpture, and interior decoration define sacred space in diverse ways; some features correlate with those we have seen in other works of art, whereas others are entirely new or unique to this Armenian setting.

The concentration of sculpted figures and inscriptions on the exterior of the building contrasts with churches in other regions, where austere exteriors mask lavish interiors. A fragmentary Armenian inscription across the west facade requests God's intercession for the salvation of one family, the Kamsarakan clan; they were likely patrons of this church, which was built on their extensive lands but served the local population. This inscription extends beyond local power structures, however, for it also refers to the "happily victorious" Herakleios, who may have been of Armenian descent. Figural sculptures continue this juxtaposition of local and imperial concerns. On the west portal (fig. 3-29), the lintel (horizontal element over an opening) features a low relief of Christ flanked by saints Paul and Peter, who may have represented the hoped-for concord of the Armenian and Byzantine Orthodox Churches; the latter holds the oversize keys to the kingdom of heaven given to him by Christ as recorded in the Gospel of Matthew

(16:19). Peter addresses a bishop holding a book, and the outermost two figures are local noblemen who wear striking Iranian riding coats, made of fur with very long sleeves—symbols of status and wealth that the sculptors have rendered in detail. The man at the left is Nerseh Kamsarakan, a member of the elite family seeking holy intercession in the inscription above; on the right is Dawit' Saharuni, whom Herakleios designated prince of Armenia in 637/38 in order to shore up the vulnerable borderlands facing pressures from Sasanian and Muslim forces. Called "Prince of Armenia and Syria" in the west facade inscription, Saharuni probably completed the church. Above the lintel, in the tympanum (semicircular surface above a door), is a relief of the archangels Michael and Gabriel holding imperial orbs and scepters. The west portal thus presents models for the smooth transfer of authority, from Christ to Peter and from Herakleios to Dawit' Saharuni, and both are represented as divinely sanctioned Christian triumphs overseen by protective angels.

The parallels between Herakleios and Christ are stronger on the lintel of the north portal, which depicts a nearly contemporary historical event (fig. 3-30). At the center is a cross, approached by the kneeling man at the left with a long mustache. The figure is Herakleios, identifiable from his coin images and from the context: as noted above, he returned the True Cross relic to Jerusalem. This is the earliest representation of an event that rapidly attained mythic status across the Christian world. Herakleios is shown without any imperial insignia after humbly dismounting from his horse; he presents the cross to a cleric holding a censer. At the far right, past a kneeling figure, is a leafy symmetrical tree, which represents the living cross growing from the hill of Golgotha. Medieval viewers probably associated Herakleios with Christ, who also entered Jerusalem humbly (on a donkey; Matt. 21:2–10), much as the David Plates associate the emperor with the Old Testament king. Nevertheless, by the late 630s Byzantine power on the eastern frontier was crumbling before Muslim victories across western Asia, culminating in their conquest of both Jerusalem and Ctesiphon (Iraq) in 637. The triumphant return of the cross to the Christian holy city therefore was very short-lived, even if Christian devotion to the cross never ceased.

Mren's lintels and tympanum are very early examples of large-scale figural sculpture on church portals, an art form that became widespread in later centuries. In a general sense, Mren's portals are typical of many cultural traditions in which spaces of transition become places of architectural and artistic elaboration. Within medieval Christian environments, the impetus to embellish portals was made stronger by Jesus's assertion that "I am the gate; whoever enters through me will be saved" (John 10:9). Doors and gates had theological significance; they symbolized the entrance into the Heavenly Jerusalem, the eternal paradise to which Christ offered access. At Mren, visitors

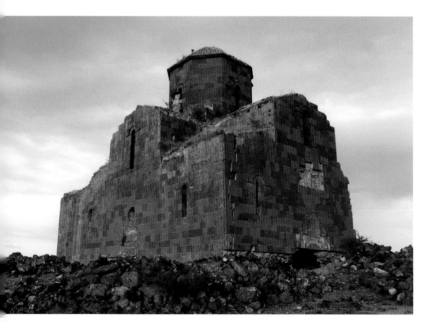

Fig. 3-27. Church at Mren, ca. 640, exterior from the northwest. Photo by Christina Maranci.

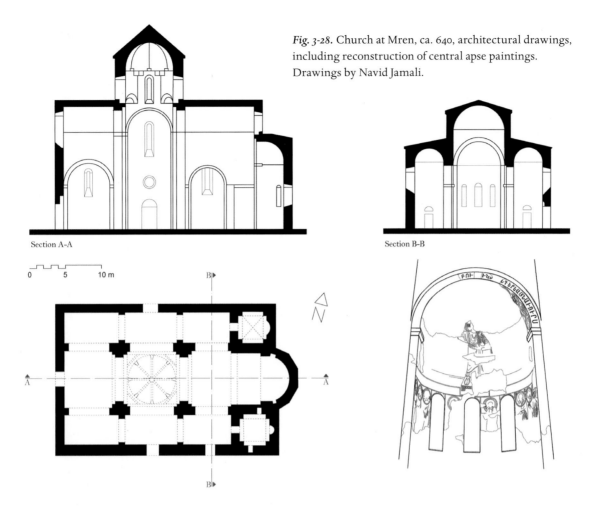

Fig. 3-28. Church at Mren, ca. 640, architectural drawings, including reconstruction of central apse paintings. Drawings by Navid Jamali.

Section A-A

0 5 10 m

Section B-B

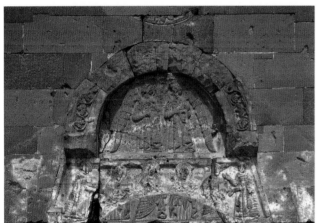

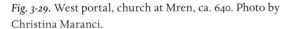

Fig. 3-29. West portal, church at Mren, ca. 640. Photo by Christina Maranci.

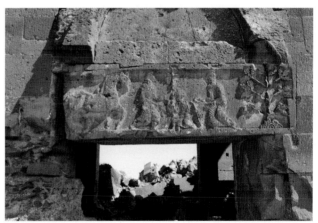

Fig. 3-30. North lintel, church at Mren, ca. 640. Photo by Christina Maranci.

approaching the north portal faced the actual city of Jerusalem; they saw the image of the emperor and prepared themselves to enter sacred space humbly, just as Christ and Herakleios entered the holy city.

The relief sculptures have many compositional and iconographic analogies with apse decoration in the Mediterranean region. Such works visualize hierarchies of the living and the holy dead, showing believers views of the divine and their relationship to it. The interior of Mren, like its portals, expresses similar hierarchies of (divine)

power in both texts and images (fig. 3-31a). The sacredness of the space is proclaimed by an inscription on the tall arch over the sanctuary and altar: "Holiness adorns your house, Lord, for endless days" (Ps. 93:5). The accompanying wall paintings are in poor condition (fig. 3-28 *lower right*), in part because they were applied to a very thin layer of plaster laid directly on the masonry, but the basic compositions, illusionistic style, and main ideas are apparent. Here, as elsewhere, the apse displays the largest figure at the center of the conch, a standing Christ bedecked in purple and

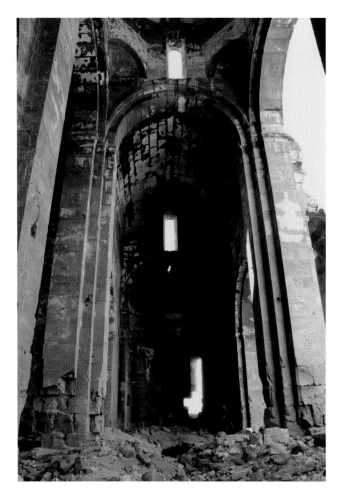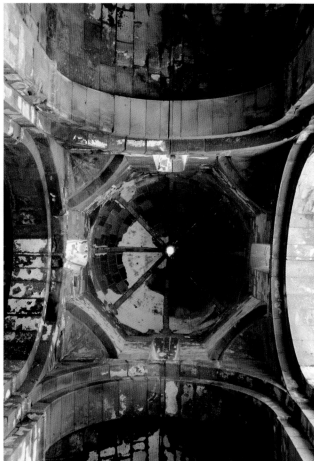

Figs. 3-31a and 3-31b. Church at Mren, ca. 640, *(left)* view toward the east; *(right)* central dome on squinches, H ca. 8 m. Photos by Christina Maranci.

holding a scroll, addressing the apostles who listen below him, ready to act on his commands.

The towering octagonal dome rises from the walls of the crossing on squinches—angled, recessed sections of masonry that, like pendentives, link rectangular bays and domes (fig. 3-31b). The dome has ribs (bands of protruding masonry) that divide it into eight segments, as well as four windows; along with three large windows in the apse, these openings illuminate the paintings. Light therefore served practical and devotional purposes while also manifesting theological ideas that equate it with the divine, as seen in haloes, mandorlas, and churches (Hagia Sophia is the prime example). Mren is representative of church interiors that were imagined as heaven on earth and so became places of intense artistic energy. The composition, style, inscriptions, and iconography of the paintings show connections between the church and other works of seventh-century art and architecture, as its portals do as well. Mren was a frontier town, but it was not isolated.

Sasanians and Sogdians in Western and Central Asia

From its beginnings in southern Iran in the third century, the multiethnic Sasanian Empire (224–651) grew to encompass not only Iran and Iraq but also much of Central Asia, the Caucasus, and parts of modern Syria, Egypt, and Turkey. Eranshahr's capital was the metropolis of Ctesiphon on the Tigris River (Iraq), where rulers of an earlier Iranian dynasty, the Parthians, had also resided. The city was protected by an enormous wall, ten meters thick, inside of which were metalworking, glass, and plaster workshops, residential and administrative areas, and a royal palace used only in the winter. Nothing remains of the palace except one huge vault of a large audience hall and part of the adjacent walls (fig. 3-32). Built of fired bricks and gypsum mortar, this vault is called an *eyvan* in Persian and *iwan* in Arabic, meaning a vault that spans a space walled on three sides. Known as the Taq-i Kisra, it was probably built by the shahanshah Khosrow I (r. 531–79) to commemorate his victory over the Byzantines at Antioch in 540. At thirty-five meters high and over forty-three meters deep, it was the largest vault built by any culture to that date and expressed Sasanian ruler ideology at a grand scale. Khosrow II successfully defended Ctesiphon against the

Byzantine emperor Herakleios in 628, but only a few years later, in 637, the city fell to Islamic troops. They carried off its fabulous treasures, including the "Spring of Khosrow," a huge carpet (approx. 27 m²) that may have covered the floor of the audience hall. Embroidered in silk with gems, gold, and silver, it represented a paradisiacal garden full of flowering plants; according to a later historian, when one sat upon it in the winter, it seemed to be spring.

Stucco reliefs decorated not only palaces like that at Ctesiphon but also elite homes and the exterior of some fire temples. This sixth-century example comes from the iwan of an aristocratic residence near Ctesiphon (fig. 3-33). Inside a pearled roundel are outstretched wings bearing Persian letters and a lunar crescent. The design replicates the basic form of the diadem worn by the later Sasanian rulers, an image disseminated through coinage. The half-palmettes in the corners were likely repeated on adjacent reliefs to form an overall pattern. The owners of this house showed their support for the shahanshah by incorporating such motifs into their residential environment, just as the owners of the David Plates used their silver tableware to demonstrate an affiliation with Herakleios.

The pearl roundel was frequently used in a similar organizational way on patterned textiles. In this example it encloses winged horses interspersed with stylized trees, both motifs typical of Sasanian works in different media (fig. 3-34). Although the pattern seems repetitive at first glance, the horses alternate facing left and right, and the pearl dots are interrupted by concentric squares. The ball-and-crescent headdress on each horse and the flying scarves are similar to depictions of royal insignia on the earlier Shapur Cameo and other works (fig. 1-32). Although the specific places of production of woven silks like this one, made between the fifth and seventh centuries, remain unknown, the fact that they were traded along the length of the Silk Routes indicates how valued they were in different communities throughout western Asia and the eastern Mediterranean.

The Sasanian emperors were Zoroastrians, and imperial cult practices focused on fire temples (box 1-3). One of the most important was at Ganzak (now Takht-e Soleyman); both newly crowned rulers and regular Zoroastrians made a pilgrimage to this sixty-meter-high oval hill in northwestern Iran (fig. 3-35). Spiritually resonant on account of its thermal lake and nearby volcano, it became a site of monumental architecture in the fifth century but was especially built up in the sixth when Khosrow I moved the sacred fire known as "Adur Gushnasp" (Fire of the Warrior Kings) there. The Zoroastrian god Ahura Mazda was believed to have created the sacred fire, and a hoard of clay pieces stamped with his name was found at the site. The baked-brick temple itself was, like most fire temples, a domed square supported on four arches, called a *chahar taq* ("four arches"). It was probably surrounded by a covered ambulatory used for ritual circumambulations

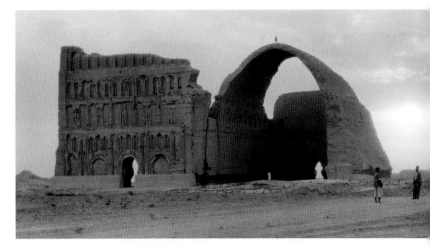

Fig. 3-32. Palace with Taq-i Kisra, Ctesiphon, ca. 540, photograph from 1932. Washington, DC, Library of Congress, Prints & Photographs Division, LC-DIG-matpc-13136.

Fig. 3-33. Stucco panel, Ctesiphon, 39 × 41 cm, sixth century. Metropolitan Museum of Art, New York. Rogers Fund, 1932 (32.150.48). Image © Metropolitan Museum of Art.

of the perpetual fire; pilgrims and devotees offered wood, incense, or animal fat to feed the flames. The temple was enclosed in a thirteen-meter-high stone wall with thirty-eight towers—a symbolic enclosure rather than a protective one, because its entrances had no gates. Structures adjacent to the temple included a treasury for donations, a royal palace, and a monumental stone platform that probably supported the king's throne. According to Byzantine sources, the audience hall of the palace depicted Khosrow II in the vault, surrounded by celestial bodies and attendants; through some mechanism, the king could produce rain and thunder at will. Whether or not the text in fact referred to a representation of Ahura Mazda rather than the Sasanian ruler, the imagery indicated that the shahanshah's power was cosmically ordained. The Byzantines sacked the site in the 620s, but some sources say that the holy fire burned for another two centuries.

East of the Sasanian Empire, the principal merchants along the Central Asian section of the Silk Routes were the Sogdians, who for the most part were Zoroastrians. Sometimes allied with the Turkic khagans (territorial chieftains) who ruled the Eurasian steppe in the sixth century, the Sogdians bypassed the Sasanians and their high taxes to establish direct trade with both Byzantium and China. A

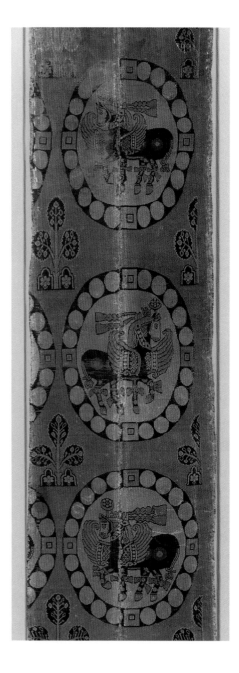

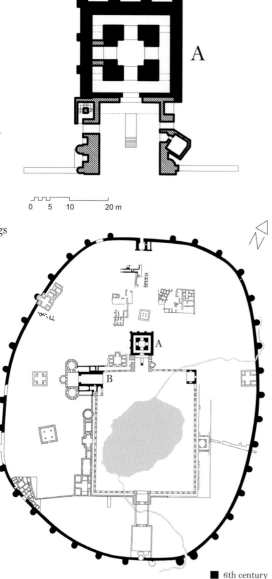

(left) *Fig. 3-34.* Silk with winged horses, detail, total H 106.7 × 19.1 cm, fifth–seventh century. Metropolitan Museum of Art, New York. Purchase, Friends of Inanna Gifts and Rogers Fund, 2004 (2004.255). Image © Metropolitan Museum of Art.

(right) *Fig. 3-35.* Takht-e Soleyman; A=fire temple; B=palace (Ilkhanid), sixth century and later. Drawings by Navid Jamali.

0 5 10 20 m

■ 6th century
▨ 13th century

0 20 40 100 m

large residential building at Afrasiab (ancient Samarkand, in modern Uzbekistan) preserves Sogdian wall paintings of about 660. Fragmentary inscriptions mention King Varkhuman, whom the Chinese emperor recognized as governor of Samarkand and Sogdiana twice in the 650s. On the west wall of one room, approximately eleven meters square, superimposed rows of figures bring gifts to a now-lost recipient during Nowruz, the Zoroastrian new year's festival being held at Afrasiab. The south mural continues the Nowruz festivities, with women and men riding horses, camels, and an elephant toward a royal ancestral mausoleum alongside an oversize King Varkhuman (fig. 3-36). The bright-blue background is precious lapis lazuli.

People of diverse cultural groups—Turks, Iranians, Tibetans, Koreans, Chinese, and others—are identifiable by clothing and hairstyle. Some wear patterned silk garments decorated with Sasanian pearl-rim roundels, and

some have a cloth covering the mouth, the *padam* worn by Zoroastrian priests to maintain purity and preclude blowing out the sacred fire. In scenes likely copied from Chinese scroll paintings, the north wall represents a Chinese dragon-boat festival for the new year and a Tang emperor hunting panthers. Poorly preserved scenes on the east wall probably refer to India. Interpretation of all of the scenes is facilitated by contemporary descriptions of these events found in the Chinese *Chronicle of the Tang Dynasty (Tang-shu)*. The murals celebrate Afrasiab's importance as a hub where global trade routes converged. They also proclaim the status of the local ruler and his distant overlord, revealing that the Sogdians pinned their hopes on Tang China to the east rather than the Sasanian Empire, which had already fallen to Muslim armies, in the west. Between the eighth and tenth centuries, the Sogdians in Central Asia also converted to Islam.

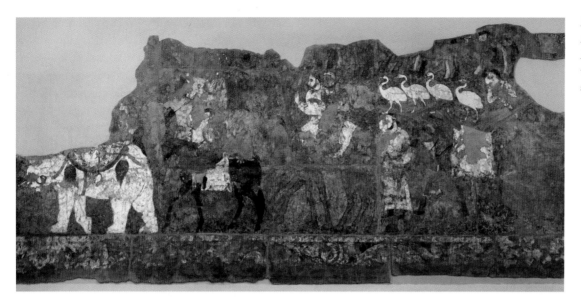

Fig. 3-36. Painted chamber, Afrasiab, ca. 660, south wall; Afrosiyob-Samarqand shahar tarixi muzeyi. Photo by the authors.

Box 3-1. ISLAM

According to tradition, Islam, which means "submission" (to Allah, Arabic for God), began when the angel Gabriel revealed the words of God to his prophet, Muhammad (570–632). Muhammad's efforts to convert followers prompted resistance from his tribe, the Quraysh, which protected the polytheistic Arab shrine of the Ka'ba in Mecca (Saudi Arabia). Muhammad was compelled to flee with his closest supporters to the city of Medina in 622; this move, the hijra, marks the beginning of the Islamic calendar. His return to Mecca in 629, known as the hajj, culminated in the purging of the Ka'ba's idols and became the model for the pilgrimage to Mecca required of all Muslims. Muhammad linked the Ka'ba to Abraham (Arabic Ibrahim), claiming that the Jewish patriarch and his son Ishmael had established it as a place of monotheistic worship and effectively were the first Muslims. In the century after Muhammad's death, proponents of the new faith conquered territory across Arabia and North Africa to the Iberian Peninsula (Spain and Portugal) in the west; in 651 they overthrew the Sasanian Empire. In 751 the Muslims defeated Tang dynasty forces at the Talas River (on the Kazakhstan-Kyrgyzstan border) but went no farther. Muslim control over this vast Islamicate area in the Middle Ages helps define the geographical extent of this book.

Muslims are expected to follow the Five Pillars of Islam: profess the *shahada* ("There is no God but God, and Muhammad is his [last] prophet" or messenger); pray five times each day; fast during the lunar month of Ramadan; give alms; and undertake the hajj at least once. The Muslim holy book is the Qur'an (Arabic for recitation), the unfiltered word of God in Arabic. It is divided into 114 suras (chapters) that were revealed to Muhammad over the course of twenty-three years. Islam builds on the earlier monotheistic faiths of Judaism and Christianity, and such figures as Jonah, John the Baptist, and Jesus all appear in the Qur'an as prophets of God. The Qur'an calls Jews, Christians, and Zoroastrians "people of the book," but they are believed to have an incomplete knowledge of divine will because, among other things, they have strayed from God and do not accept God's last prophet. Polytheists and other sinners are condemned to eternal damnation, while believers who follow God's will attain eternal salvation in paradise.

While all Muslims follow the Qur'an and to varying degrees the sayings or traditions (hadith) and practices of Muhammad, the leadership of Islam fractured soon after the Prophet's death. Sunni Muslims (*al-ha-Sunna*) hold that their caliphs (literally, successors—that is, successors of Muhammad) trace their right to rule to Muhammad's father-in-law and uncle; subsequent generations of caliphs were chosen by community consensus. Shi'i Muslims (*Shi'at 'Ali*), by contrast, believe that Muhammad designated 'Ali, his cousin and the husband of his daughter Fatima, as his successor, and that the leaders of Muslims should be direct descendants of the Prophet. After 'Ali and his son Husayn were killed by rival factions, the family's line of succession became disputed. Shi'i leaders—called imams, not caliphs—are thought by their followers to be God's representatives on earth. Twelver Shi'i hold that the twelfth imam, who went into hiding in the tenth century, will reappear in the messianic future to guide the community on Judgment Day.

The First Islamic Monuments

This chapter introduces the two earliest works associated with the last major religion of the Middle Ages, Islam. The first is the Ka'ba, the shrine toward which Muslims direct their prayers (fig. 3-37). This ancient cubelike stone structure (*ka'ba* is Arabic for cube) has seen extensive repairs over the centuries. It measures fifteen meters high, twelve meters wide, and ten meters deep, and its corners align with the compass points. The Ka'ba has one door, about two meters above ground level; previously there were two, giving access to an interior divided by columns that support the wooden roof. A ninth-century hadith held that when Muhammad cleansed the shrine of idols and paintings he permitted images of Mary and Jesus to remain, but the interior is now empty. Muhammad is also said to have moved the miraculous black stone from inside the shrine to the exterior southeast corner; Muslim pilgrims pray before this stone and kiss it during their circumambulations around the Ka'ba. Since pre-Islamic times the Ka'ba has been draped in textiles, and since the eighth century these have been made of silk and embroidered with Qur'anic verses. Known collectively as the kiswa, the pieces of cloth are now replaced annually during Ramadan. Donating the kiswa is the prerogative of the ruling dynasty and validates its religious authority. The kiswa matches the color of the ruling house and therefore has varied over the centuries. The main fabric is called a dress, the horizontal band of inscriptions a belt, and the door cover a *sitara* (married woman's veil). A desire to veil the sacred is found in many cultures (the Temple in Jerusalem, for example, had a famous curtain [2 Chron. 3:14]).

The second work associated with early Islamic art is Muhammad's own mosque, or *masjid* (Arabic for prayer space, from *yasjud*, prostration), in Medina. It no longer exists in its original form, but its basic layout can be reconstructed because it served as the model for later Islamic places of prayer. This Friday mosque for the nascent community had an open courtyard (*sahn*) enclosed by a covered portico (fig. 3-38). Sheltered from the elements, the faithful prayed in parallel lines facing Mecca. Eventually an empty niche, the mihrab, commemorated the place where Muhammad stood while preaching. It is unclear whether this first mosque was previously or simultaneously Muhammad's own house; no houses in Arabia were so large, though, and contemporary reports praise the Prophet's modest lifestyle. Rebuilt many times and later demolished, this earliest Muslim prayer space was likely built of sun-dried bricks and palm-tree trunks, with a floor of sand; apartments for Muhammad's family and followers were built along the exterior of the enclosed worship space. The hadith reveal that many activities besides prayer occurred there, and in this way, too, the original masjid in Medina prefigured later mosques in serving political, judicial, social, and educational functions.

Like the spread of Christianity, the rise of Islam radically changed the landscape of western Eurasia and North Africa during the Middle Ages. The sixth and seventh centuries experienced great upheavals that were a mixture of religious and political contests. In their competition for control over land and resources, the great Byzantine and Sasanian empires sought temporary alliances with smaller groups like the Franks, Armenians, Sogdians, and Turks, and they expressed similar ideas of divinely sanctioned

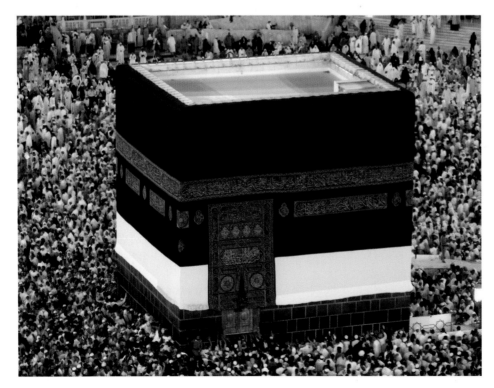

Fig. 3-37. Ka'ba, Mecca, photograph from 2010. flickr/ Citizen59, CC BY-SA 2.0.

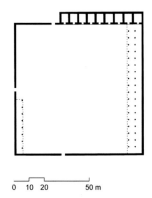

Fig. 3-38. House of
Muhammad, Medina,
ca. 622. Drawings by
Navid Jamali.

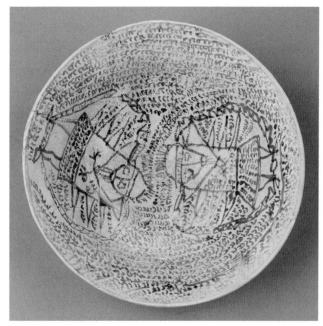

Fig. 3-39. Incantation bowl, 5.4 × 17 cm, Seleucia, sixth–seventh
century; Kelsey Museum of Archaeology, University of
Michigan, Ann Arbor, KM 3.3756. Photo from Kelsey Museum
of Archaeology.

authority and majesty through their art and architecture,
even though the forms were often different. On a more
limited scale, rulers like Aethelbert of Kent may have ad-
opted Christianity as a way to consolidate power by cre-
ating alliances with other Christian political groups. Such
ties were not merely political; the relic and reliquary of
the True Cross that Radegunde received from Byzantium
were prized primarily for their religious significance.
Throughout the medieval world, political and religious
ideas were so closely intertwined that it is difficult and at
times impossible to disentangle them. In short, the sixth
and seventh centuries witness a tension between increas-
ing pressure to conform to different molds of orthodoxy,
on the one hand, and great cultural and religious diversity,
on the other.

No medieval empire or polity contained people of only
one religion, and a final object can summarize both the
diversity and shared concerns expressed in visual culture.
As discussed in chapter 1, many faiths coexisted in third-
century Dura-Europos, and evidence from the region
shows that this trend continued under the Sasanians. This
so-called incantation bowl, found in Seleucia (Iraq), would
have been placed upside-down at a threshold or interior
corner to trap demons so they could not harm the occu-
pants (the room adjacent to the baptistery at Dura-Europos
had such a bowl above a lintel) (fig. 3-39). Thousands of
these ceramic apotropaic devices survive from domestic
settings in Mesopotamia and western Iran, all produced
there between the fifth and the eighth century. They re-
veal a pervasive fear of malign forces among Jews, Chris-
tians, Zoroastrians, and polytheists living in the Sasanian
Empire. In this example, two demons are shown with their
hands tied and feet chained, and they are circled by lines
of pseudoscript that immobilize them further. Most bowls
contain legible charms—in an Aramaic dialect, which in-
cludes Jewish Aramaic and Syriac, or in Middle Persian or
Arabic, in varying degrees of literacy—and not all bowls
have figures. Texts and images were complementary, but
both were not required for the device to be effective. Such
fears existed in other places, too, where other kinds of apo-
tropaia, amulets, and religious objects served comparable
functions. The seemingly universal nature of such anxiet-
ies means that protective objects remained commonplace
throughout the Middle Ages and beyond.

CHAPTER 4

Mid-Seventh to Late Eighth Century

Legend

□ **Location or findspot**
 - *Monument/object*

• Additional site

○ *Approximate place of production*

Iona•

Skellig Michael □
 - *Monastery*

Tara Brooch Durham• □**Lindisfarne**
 Whitby• - *Gospels*

□ **Enger**
 - *Reliquary*

•□**Chelles**
Paris - *Garment of Queen Bathild*

Poitiers•

Church of San Pedro de la Nave □

Ravenna•

•Toledo

•Rome

□ **Córdoba**
 - *Great Mosque*

□ **Sânnicolau Ma**
 - *Nagyszentmik*
 Treasure

Constantinople
 - *Coin of*
 Justinian II

Dome of the Rock, Jerusalem

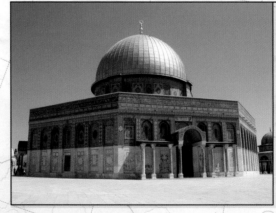

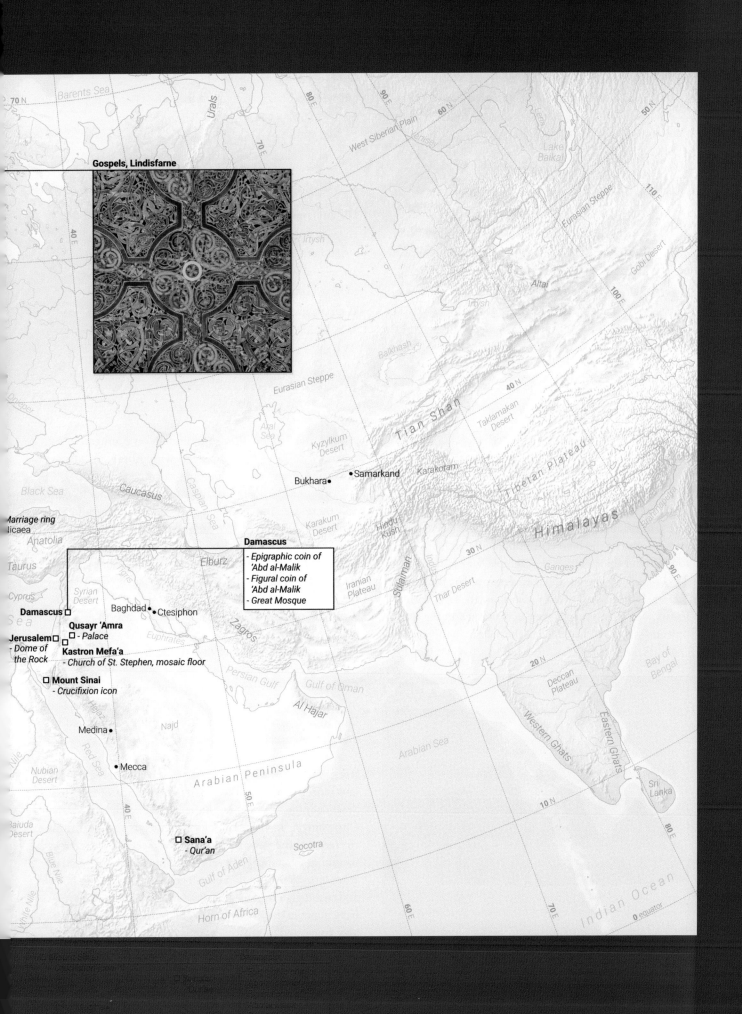

Gospels, Lindisfarne

Marriage ring
Nicaea

Anatolia

Taurus

Cyprus

Black Sea

Caucasus

Damascus □

Damascus

- *Epigraphic coin of
 'Abd al-Malik*
- *Figural coin of
 'Abd al-Malik*
- *Great Mosque*

Baghdad • • Ctesiphon

Elburz

Syrian
Desert

Qusayr 'Amra
□ - *Palace*

Jerusalem □
- *Dome of*
 the Rock

Kastron Mefa'a
- *Church of St. Stephen, mosaic floor*

□ **Mount Sinai**
- *Crucifixion icon*

Euphrates

Zagros

Iranian
Plateau

Medina •

Najd

Hejaz

• Mecca

Red Sea

Nubian
Desert

Baiuda
Desert

Blue Nile

White Nile

Nile

Arabian Peninsula

Persian Gulf

Gulf of Oman

Al Hajar

Sulaiman

Indus

Thar Desert

Ganges

Brahmaputra

Himalayas

Tibetan Plateau

Deccan
Plateau

Western Ghats

Eastern Ghats

Bay of
Bengal

Sri
Lanka

Arabian Sea

□ **Sana'a**
- *Qur'an*

Socotra

Gulf of Aden

Horn of Africa

Indian Ocean

equator

Urals

Barents Sea

West Siberian Plain

Yenisey

Eurasian Steppe

Lake
Baikal

Irtysh

Altai

Gobi Desert

Eurasian Steppe

Tian Shan

Taklamakan
Desert

Karakoram

Hindu
Kush

Karakum
Desert

Kyzylkum
Desert

Aral
Sea

Balkhash

Bukhara • • Samarkand

Caspian Sea

After the death of Muhammad, Muslims under a series of caliphs conquered vast territories in the formerly Byzantine and Sasanian lands, North Africa, and the Iberian Peninsula. Their expansion farther into Europe was stopped by Christian armies near Poitiers, in central France, in 732. That battle marked the rise of the Frankish leader Charles Martel ("the Hammer") and his successors, later known as the Carolingians. Around the same time, a major dynastic change saw the Umayyad caliphate (political-religious state ruled by a caliph), based in Damascus (Syria) since 661, fall to the Abbasids, who moved the capital to Baghdad (Iraq) in 762. The last Umayyad, 'Abd al-Rahman, fled to Spain and established a competing kingdom, and ultimately a self-proclaimed caliphate, at Córdoba (755–1031). Byzantine Ravenna, reconquered from the Ostrogoths by Justinian's generals in 540, fell to the migrating Lombards in 751, while the rest of the Byzantine Empire was embroiled in the first of two periods of iconoclasm (726–87, 815–43) in which Christian attitudes toward sacred images were hotly contested. Different ideological questions occupied Christians elsewhere: What was the proper date of Easter? What haircut was appropriate for monks? Practices associated with the papacy in Rome gradually came to be accepted over those of such rivals as the Irish Church, as occurred in England after the Synod of Whitby in 664. This chapter unfolds against a backdrop of constant and often violent change.

Work in Focus:
THE DOME OF THE ROCK

The Dome of the Rock (Arabic *Qubbat al-Sakhra*) in Jerusalem is the oldest Islamic monument to survive in more or less its original form (fig. 4-1). The building encloses the rock on which Jews believe Abraham offered his son Isaac to God and upon which the Temple was built by Solomon, rebuilt by Herod, and then destroyed by the Romans (fig. 4-2). Muslims eventually associated the rock with Muhammad's Night Journey (*isra'*), mentioned in the Qur'an (17:1 and 53:1–18) and detailed in the hadith; in this spiritual voyage, the Prophet flew to Jerusalem on a winged steed, ascended to heaven, and prayed with Abraham, Moses, Jesus, and other prophets before returning to Mecca.

Although the Dome of the Rock is octagonal in plan and therefore similar to the Lateran Baptistery and San Vitale (figs. 2-2 and 3-4), local buildings likely inspired its distinctive double-ambulatory design (fig. 4-3). The nearby Kathisma church also focuses on a geological formation and is octagonal with two ambulatories; it was erected in the fifth century around the stone on which Mary rested on the way to Bethlehem to give birth to Jesus, an event recorded in Christian apocryphal texts as well as in Qur'an 19:23–26. Octagons had sacred connotations across the Mediterranean world: they were linked not only with Christian baptism and resurrection but also with Muslim descriptions of eight paradises with eight doors. The Qur'an also says that God's throne will be supported by eight angels on Judgment Day (69:17).

A tenth-century source records that the Dome of the Rock was meant to rival Christian churches in the region, and indeed, it evokes the Anastasis Rotunda of the Holy Sepulcher (fig. 2-6), although the Islamic work exceeds the Christian one in visibility. A local context is also clear from the fact that the two architectural overseers for the project named in later sources were Yazid ibn Salam, a Christian from Jerusalem, and Rajah ibn Haywah, a Muslim scholar and theologian from nearby Baysan (Bet She'an), who may have planned the inscriptions. The centralized form probably suggested to most viewers a commemorative shrine, such as the Anastasis Rotunda.

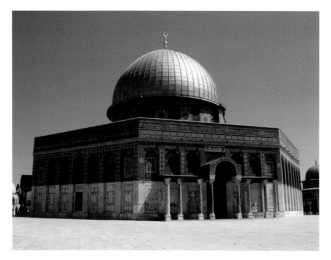

Fig. 4-1. Dome of the Rock, Jerusalem, begun 691/92, exterior from the south. Photo by the authors.

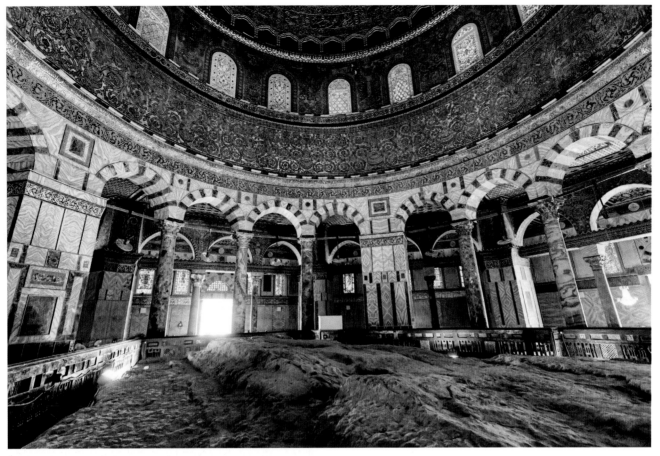

Fig. 4-2. Dome of the Rock, Jerusalem, begun 691/92, interior. © Damon Lynch.

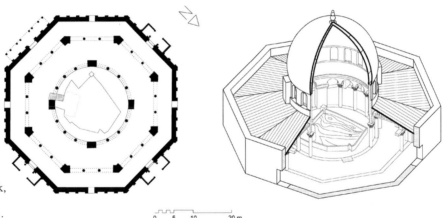

Fig. 4-3. Dome of the Rock, Jerusalem, begun 691/92. Drawings by Navid Jamali.

0 5 10 20 m

The primary function of the Dome remains unclear. It was not designed as a mosque for communal prayer; it may have been intended as a site of pilgrimage, given that its plan facilitates movement around the central rock and its encircling inscriptions encourage circumambulation. It may have provided, briefly, an alternative direction of prayer for Muslims when the Ka'ba in Mecca was in rival hands (during the civil war of 680–92). The Dome of the Rock's unprecedented decorative and epigraphic (monumental text) program, coupled with its significant location and formal qualities, suggests that the building was above all an assertion of the power of the Umayyad dynasty and of Islam.

The building's unit of measure is the cubit, derived from the length of a grown man's arm from the elbow to the tip of the middle finger (roughly 0.31 m), which was also used for the Temple of Solomon on that very site and for the nearby Holy Sepulcher. The dome span and some other measurements are almost identical to those of the Anastasis Rotunda; both domes were covered with lead plates and gilded, drawing those two Jerusalem buildings into a deeper visual dialogue. At the center, extending below floor level, is the irregular rock that gives the building its name (fig. 4-2). It is surrounded by a circle of four piers and twelve columns, which together support arches that carry the tall drum that bears the dome. Beyond this

Fig. 4-4. Mosaics, Dome of the Rock, Jerusalem, ca. 691/92, *(left)* outer arcade; *(right)* inner arcade. © 1992 Said Nuseibeh.

central core are the two ambulatories, divided into inner and outer corridors by an octagonal arcade about ten meters high, composed of eight polygonal piers and sixteen marble columns. Light enters through four doors facing the cardinal points and abundant windows, thirty-six in the lower zone and sixteen in the upper drum.

On the exterior, above marble spolia panels, modern tiles imitate the Turkish ones that were installed in the sixteenth century to replace mosaic (fig. 4-1). Inside, the building contains revetment of book-matched spolia, colorful alternating voussoirs (wedge-shaped stones that create an arch), and, in the upper zones, nearly thirteen hundred square meters of mosaic (over nineteen million tesserae). Mosaics cover the drum, the exterior of the circular arcade, all the soffits (undersides of the arches), and both faces of the octagonal arcade, which bears a mosaic inscription on each side (fig. 4-4). The inner and outer inscriptions both begin on the south side of the arcade, but because they appear on opposite sides of the same wall, they flow through the space in opposite directions, as would the people reading them. Both inscriptions are composed of gold letters on a variable blue-green background, and both contain the *basmala* ("In the name of God, the merciful, the compassionate"), the shahada (repeated several times in the outer inscription), and Qur'anic excerpts. Both inscriptions include passages from the Qur'an about the oneness of God, but the inner text is more specifically critical of the Christian Trinity ("do not say three") and the status of Jesus, whom Muslims revere as a prophet but not as the son of God. This text specifically addresses Jews, Christians, and Zoroastrians, "people of the book" whose religious beliefs are anchored in texts, warning them not to "exceed the limits in your religion, and do not speak [lies] against God, but the truth" (Qur'an 4:171).

The outer arcade inscription cites the year 691/92, which is the date of either the building's foundation or completion. It included the name of the original patron, 'Abd al-Malik, the fifth Umayyad caliph (r. 685–705), but, as the squeezed letters and changed background color make clear, a later caliph (the Abbasid al-Ma'mun, r. 813–33) replaced the founder's name with his own (fig. 4-4 *left*). The inscriptions are the earliest written passages from the Qur'an and also the first monumental mosaic texts in Arabic, although artists from Byzantium were called to execute them. The mosaicists laid them out from left to right, as if the text were in Greek, rather than right to left as required by Arabic; as a result, the beginning of the text, executed last, is compressed to fit into the available space. Even if the ambulatories were originally roofed differently, the inscriptions are not easy to read, despite the use of a new standardized script promoted by 'Abd al-Malik. These inscriptions—together over 250 meters long, drawn from eleven different suras of the Qur'an—stand at the beginning of a long history of monumental epigraphy in the Islamicate world.

Unlike Byzantine and western European church interiors, there are no figures in the mosaics. On the outside of the octagonal arcade, bands of rosettes and vegetation frame large stylized plants that recall Sasanian patterns. Some are interspersed with fictive jewelry. On the arcade's inner face, many of the plants are even less naturalistic: emphasized by the incorporation of gold and mother-of-pearl tesserae, they are adorned with crowns and pectorals (chest ornaments) that feature hanging pearls, like Byzantine imperial regalia (fig. 4-4 *right*). Around the circular arcade, vegetation with spiraling branches sprouts from large acanthus plants or jeweled vases; and in the drum, above a later inscription, pearl-studded vegetal spirals sprout from vases encrusted with imperial jewelry, including winged crowns worn by the Sasanian shahanshahs

Box 4-1. ANICONISM AND ICONOCLASM

There are several, sometimes interrelated, reasons why groups or individuals in the Middle Ages either chose to create nonfigural art forms or suppressed figural imagery after it was made; this tendency is called aniconism. Jews and Christians could adhere to a literal interpretation of the second commandment; and some strict Sunni Muslims maintained, in accordance with certain sayings of Muhammad, that only God could create living things and that artists should not attempt to do so through skillful representation. Beginning in 726, Byzantine emperors actively worked to eliminate figural imagery from religious art, perhaps partly in response to the success and threat of the Islamic caliphate. Nevertheless, such remote repositories as Mount Sinai preserved their icons (fig. 3-21), and the apse of the Monastery of the Stoneworker in Thessaloniki was concealed rather than destroyed (fig. 2-23). This first period of Byzantine iconoclasm ended in 787 at the Second Council of Nicaea, when Empress Irene, regent for her young son, reinstated the veneration of holy icons (although a second period of iconoclasm prevailed from 815 to 843). When the Acts of the council of Nicaea reached Rome, they were mistranslated into Latin in a way that suggested the Orthodox were worshiping icons—that is, treating the physical objects as divine—rather than venerating and showing reverence toward the subject depicted in the material images, the sacred prototype. The iconophile position in favor of icons asserted that whereas God explicitly prohibited idol worship, he permitted imagery (e.g., Exod. 25:18–20). Byzantine iconoclasm poses great challenges to historians because most of the sources about the debate were manufactured later by icon supporters—an example of winners writing history and suppressing opposing voices.

(fig. 3-33) and pieces of Byzantine inspiration. More vases and vegetation are shown above this frieze, between the windows. The abundant vegetation probably connoted the heavenly paradise that awaits those who accept the messages of the inscriptions, while the regalia and jewelry highlight themes of opulence and victory.

There have been many interpretations of the location, form, and decoration of the Dome of the Rock. 'Abd al-Malik almost certainly wanted to underscore an association with Jerusalem's biblical kings David and Solomon and with Jesus, all of whom are prophets in the Qur'an. He also must have wanted to advertise his authority over local Jews, Christians, and Zoroastrians, whose imperial regalia were represented as trophies displayed inside the Islamic building. The interior inscriptions emphasize that Islam is the true faith, there is one God, and the devout caliph is God's deputy and leader of the faithful. These theological and ideological statements were directed to non-Muslims and Muslims alike in these formative decades of Islam. The new faith's superiority is demonstrated by the representation of other cultures' regalia, and a later source describes an actual Sasanian crown suspended in the building among other precious objects and trophies. The Dome of the Rock generated multiple ideological meanings when it was built in the late seventh century, but its initial functions remain elusive.

Images of Authority, Large and Small

After defeating his rivals and asserting control over Mecca and Medina, 'Abd al-Malik presided over a consolidation of the Umayyad state. His efforts included standardizing the text of the Qur'an and the script used to write it and requiring that all government business be conducted in Arabic rather than in local languages. He also expanded the activities of the Damascus mint, encouraging the production of coins that clarified and spread religious and caliphal identity and authority. Previous Muslim governors had issued coins that largely imitated those of their non-Muslim predecessors; when using Byzantine models with crosses, they neutralized the Christian content by removing the horizontal bar of the cross. Under 'Abd al-Malik, this was taken further: the modified cross was now topped by a globe so that it matched the staff held by the Byzantine ruler and his sons, and the former cross was encircled by the shahada (fig. 4-5a). The resulting pole on steps has been interpreted as an image of Muhammad's staff or as a victory symbol. The shahada coin was soon amended to replace the three figures with that of a single standing caliph holding a sword, but this version of the coin was also short-lived.

The new dinars (gold coins) struck for 'Abd al-Malik in Damascus beginning in 697 rejected the ancient heritage of figural coinage by replacing images with phrases

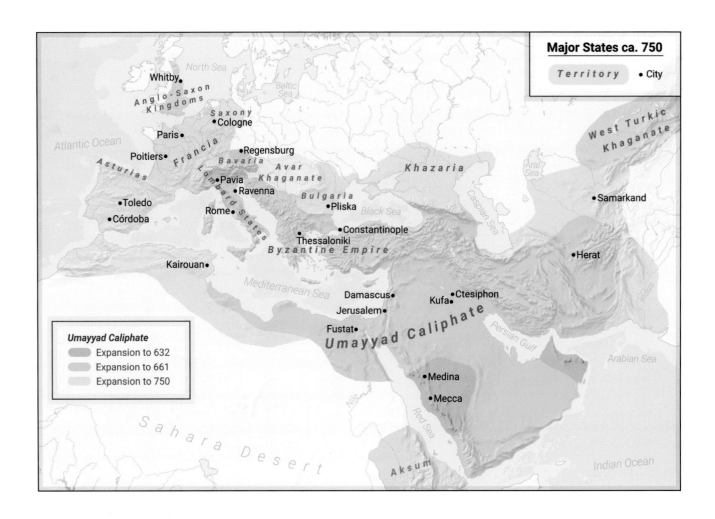

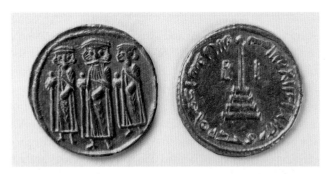

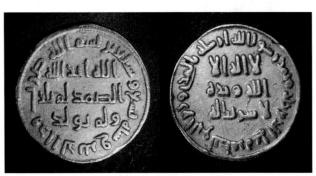

Figs. 4-5a and 4-5b. Coins of 'Abd al-Malik, *(top)* figural, 1.9 cm, ca. 685–94; *(bottom)* epigraphic, 2 cm, 698/9. *(t)* Courtesy Penn Museum, Philadelphia, #29-231-67; *(b)* © Genevra Kornbluth, courtesy Dumbarton Oaks, Byzantine Collection, Washington, DC.

drawn from the Qur'an (fig. 4-5b). On one side, the center has a variant of the shahada that supplements "there is no God but God alone" with "he has no associate," an anti-Trinitarian, anti-Byzantine phrase. These three lines of Arabic are encircled by a text read counterclockwise from the top: "Muhammad is the Prophet of God; God sent him with guidance and the true religion to make it victorious over every religion." On the other side, the oneness of God and rejection of the Trinity are reaffirmed: "God is one, he is eternal, he did not give birth and he was not born" (from sura 112, one of the first Qur'anic chapters memorized by Muslims). This is encircled by "In the name of God; this dinar was struck in the year 79." All of the Qur'anic phrases appeared earlier in the Dome of the Rock. These entirely epigraphic coins flooded the market, eliminating the authority of the Byzantine nomisma coin (the Greek term for the Roman solidus) in Islamicate lands. They were reproduced almost unchanged until the thirteenth century because they carried God's words and proclaimed a clear message of communal faith, unity, and caliphal authority. The angular Arabic script known as Kufic made the dinars immediately identifiable as Islamic, from Spain and Morocco to Central Asia, rather than being associated with any specific place. At the same time, the coins promoted aniconic decoration as a meaningful characteristic of most Islamic public art.

'Abd al-Malik's radical change to the coinage was a product of Umayyad numismatic developments, but it may also have responded to a new type of Byzantine gold coin issued by Emperor Justinian II (r. 685–95, 705–11) around 692 (fig. 4-6). This was the first Byzantine coin to represent a bust-length Christ on the obverse, paralleling the image of the emperor on the reverse; the close connection between the heavenly and earthly ruler is underscored in image and text. The prominent cross behind Christ's head is echoed by the large cross on steps held by Justinian II. Around the head of the long-haired, bearded Christ is a Latin inscription that calls him "king of kings," while the short-haired, bearded emperor on the reverse is labeled "servant of Christ." Earlier seventh-century nomismata (the plural of nomisma) featured an imperial portrait on one side and either the emperor's sons or a cross on steps on the other. The new hierarchy of power, with Christ at the top, was an assertion of imperial piety and connections to God—and possibly a plea for divine assistance in the wake of Umayyad victories against the Byzantine army. The new coin, however, is surprising, given contemporary debates about how and where to portray holy figures. A Byzantine council in 692 (the Quinisext Council) prohibited such figures on floors, where they might be stepped on and thereby subjected to accidental disrespect or damage. Given that coins were frequently handled, they would be prone to comparable risks, and perhaps this is why Justinian II's immediate successors did not copy his numismatic innovation. Christ was only reintroduced on gold coins after the end of iconoclasm, in 843. The mature, bearded face of Jesus on this and later coins helped disseminate the image in Christian art, and the earlier youthful, beardless type eventually disappeared.

Under 'Abd al-Malik's son al-Walid (r. 705–15), the Umayyad caliphate expanded west into Iberia and east across Central Asia, conquering such important cities as Bukhara and Samarkand and reaching the Indus River. Al-Walid consolidated his rule with several large architectural projects, most notably the mosque on the site of Muhammad's house in Medina and the Great Mosque in Damascus, which communicated directly with the caliphal palace. This new masjid al-jami' reused an ancient Roman temple enclosure but razed the Byzantine church that had been built inside it to enshrine the head of John the Baptist (fig. 4-7). The Christian history of the site was not erased, however; John's relics were placed in a prominent shrine in the mosque's prayer hall, because Muslims saw Islam as the culmination of earlier monotheisms and John is the prophet Yahya in the Qur'an.

At Damascus, a large courtyard containing a fountain and an elevated treasury is surrounded on three sides by shallow porticoes. On the fourth side, the south, the qibla is indicated by multiple rows of columns, roofed to shelter the lines of worshipers praying toward Mecca. Such hypostyle halls were typical of ancient Egypt and Iran, as at

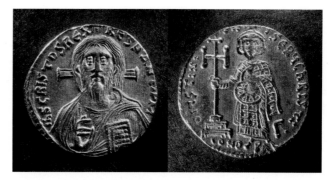

Fig. 4-6. Coin of Justinian II, 1.9 cm, 692–95; Dumbarton Oaks, Washington, DC. © Genevra Kornbluth, courtesy Dumbarton Oaks, Byzantine Collection, Washington, DC.

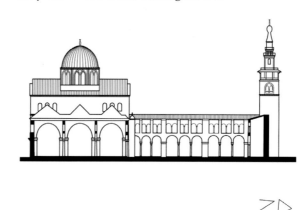

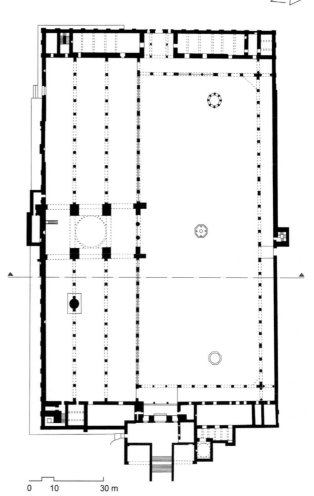

Fig. 4-7. Great Mosque, Damascus, begun 705–15, minaret added by ninth century. Drawings by Navid Jamali.

Fig. 4-8. Great Mosque, Damascus, begun 705–15, mosaic in courtyard. © Bruce Allardice 2019.

Persepolis (fig. 1-4), which was conquered by the Muslims in the 640s. Early mosques are wide rather than deep, inverting the proportions of a typical Christian basilica and thereby differentiating themselves from that faith and its architectural forms. At Damascus the two-story colonnades of the prayer hall are interrupted at the center by a broad aisle, divided by piers into three bays, of which the central one is domed. This aisle, called the transept because it cuts across the colonnaded aisles, has as its focus the mihrab, the semicircular niche in the qibla wall. Commemorating the place occupied by Muhammad when he led prayers in his house at Medina, the mihrab signaled the direction of Mecca and was where the caliph, and later the imam (community leader), led prayers and modeled movements for the faithful who stood behind him. At the Great Mosque it was studded with large jewels, and a second mihrab to the east marked the spot where, according to legend, the Muslim conqueror of Damascus had prayed. Furniture near the mihrab included a screen to enclose the *maqsura*, the caliph's private prayer space, and, perpendicular to the qibla wall, a minbar, a wooden pulpit on steps from which the Friday sermon was delivered.

The original decoration of the hypostyle hall is lost, but some mosaics are partly preserved in the western part of the courtyard and in a large panel above the entrance to the prominent transept (fig. 4-8). Scholars disagree about the meaning of these very detailed mosaics of cities, gardens, and rivers. An eighth-century poet reports that they represent the architectural landscape of Syria; others recognize the *dar al-Islam*, the whole Islamic world unified by the Umayyad caliph; still others read the lush landscape as paradise, where pious Muslims ultimately will dwell (as in Qur'an 29:58). Like many works of medieval art, the mosaics probably were intended to convey multiple meanings.

They also provide more evidence of early Islamic attitudes to art, for no images of people or animals appear in these landscapes and cityscapes despite their canopies, boats, and other signs of human habitation. This aniconism was a feature of the Dome of the Rock, and like that building, the Great Mosque also has connections to Byzantine art. The gold mosaic background is identical to that used for depictions of the heavens in Byzantine churches, and there is little doubt that Byzantine artists executed the Damascus mosaics using glass tesserae they brought with them. Later sources report that al-Walid threatened to destroy churches in his realm if the Byzantine emperor failed to provide the requested artisans and materials for Damascus and Medina.

The Great Mosque of Damascus became the architectural model for many Friday mosques in western Asia and North Africa. Among the activities that took place in such congregational mosques was the public reading of the Qur'an on Fridays; the book was also used on Thursdays for ritual supplications. Muslim tradition holds that manuscripts of the Qur'an were first compiled and standardized under 'Uthman, the third caliph (r. 644–56), but the oldest extant fragments are from several decades later. They are written in Arabic, the language of their delivery to Muhammad, and they were to be handled in a state of ritual purity and committed to memory. The need to disseminate the Qur'an in newly conquered regions stimulated the development of Arabic calligraphy, initially in a slanted script and ultimately in the proportional, vertical script often called "Kufic." It was introduced by 'Abd al-Malik for official and Qur'anic texts, such as the inscriptions on his coins and in the Dome of the Rock.

Qur'ans were written with ink on parchment until the tenth century, when paper began to be used. Two large pages from a fragmentary example of about 700 from Sana'a (Yemen) depict idealized hypostyle mosques (fig. 4-9). Both feature multiple arcades illuminated by hanging lamps, with paradisiacal trees and plants behind the qibla wall and an open courtyard-like square in the center. This folio shows a mihrab framed by pseudomarble columns, and the other has a flight of steps leading to the mosque. Such images underscore the ability of architecture—whether constructed or painted—to help believers enter holy space and enhance their spiritual and devotional experiences so that they may enter paradise after they die. The sacred text is also akin to a building whose threshold the reader must cross. Some theologians opposed the inclusion of images, however, and later Qur'ans do not contain representational imagery even when they are extensively decorated. In addition, the roughly square format of the Sana'a Qur'an pages was soon superseded by a horizontal one, further distinguishing the Islamic holy text from the taller Christian Bible codex.

Architectural representations were common in Christian churches in the eastern Mediterranean. The mosaic

Fig. 4-9. Qur'an frontispiece, ca. 51 × 47 cm, ca. 700; Sana'a, Dar al-Makhtutat, MS 20-33.1. akg-images, Jean-Louis Nou.

floor in the nave of the church of St. Stephen at Kastron Mefa'a (now Umm er-Rasas, Jordan), built in the sixth or seventh century but repaved in 718 and 756 (according to inscriptions in the nave and apse, respectively), depicts numerous miniature cities (fig. 4-10). Around a vine scroll that sprouts roundels enclosing scenes of the grape harvest, ten Egyptian sites are set into a watery Nile delta, and seventeen additional walled towns located east and west of the Jordan River are represented between the (now lost) columns of the nave. The placement of Jerusalem and an oversize Kastron Mefa'a at the east end, closest to the altar, emphasizes their importance. Some of the urban vignettes contain architectural features that are recognizable as real structures, and perhaps originally they all did. This urban network is almost entirely ecclesiastical, emphasizing the seats of bishops who metaphorically lead the faithful toward the heavenly city, Jerusalem, which awaits pious Christians in the future. Indeed, twelve bishops, holding books or censers and identified in devotional inscriptions, were shown standing between fruit trees just outside

the chancel barrier, the low stone screen that separated a church sanctuary from its nave and aisles (fig. 4-11). Kastron Mefa'a is presented as an essential site in the region's religious landscape, and St. Stephen's is part of a sizable complex of churches that suggests the town was a pilgrimage destination. Its importance in transregional economic networks is indicated by the scenes of wine production, fruit trees, and fish in the Nile.

All of the human and animal figures represented in St. Stephen's reveal evidence of deliberate damage. Their tesserae were carefully plucked out and then filled in, leaving the outlines of the earlier forms legible. The same type of targeted defacement also altered many synagogue floors in this period. Who was responsible for this iconoclasm, which occurred at many but not all of the region's churches? Were the same people also responsible for filling in the missing figures? The answer to the latter question seems to be yes, because sometimes the original tesserae were scrambled and reused as filler. While we might assume that Muslims were behind the image destruction,

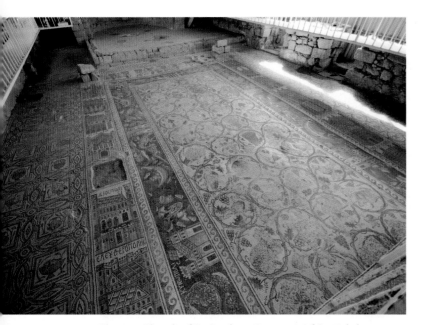

Fig. 4-10. Church of St. Stephen, Kastron Mefaʻa, eighth century, floor mosaic in the nave. Juergen Ritterbach/Alamy Stock Photo.

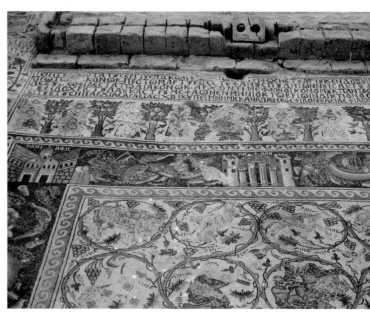

Fig. 4-11. Floor mosaic detail, church of St. Stephen, Kastron Mefaʻa, eighth century, east end of nave. Judith McKenzie/Manar al-Athar, CC BY-NC-SA 2.0.

given their disinclination to represent living creatures in places of worship, there is no evidence that Muslims cared about the decoration in churches or synagogues apart from a short-lived ban on figural imagery by Caliph Yazid II (r. 720–24). It is more likely that iconophobic Christians and Jews were responsible for altering their own places of worship, and several repairs at Kastron Mefaʻa even contain a cross. These changes are not evidence for imperially sanctioned iconoclasm, however; the pavement of St. Stephen's did not depict the kinds of sacred images whose destruction was mandated by Byzantine emperors. Rather, the defacement was a local Christian response to stringent Muslim and Jewish attitudes toward images of living things. Christians were permitted to maintain and redecorate their churches under Muslim rule, and their own attitudes toward images could change.

Concerns about the representation of living creatures did not extend to domestic decoration in the early Islamicate world. Qusayr ʻAmra is the best preserved of a network of palace complexes built in the eighth century on the Jordanian plains, on the route between Damascus and Mecca (fig. 4-12). In addition to hydraulic and defensive structures, the site contains a bath complex and a three-aisle reception hall topped with a barrel vault (a continuous semicircular, tunnel-like vault). Qusayr ʻAmra boasts the largest extant ensemble of early Islamic figural paintings. They were executed in fresco, a technique in which pigments mixed with water are painted onto fresh, wet plaster, making the color a permanent part of the wall. Even if figural images were absent from Islamic religious sites, they were marks of prestige and wealth in other spaces used by Muslims. Thus the reception hall of the palace is frescoed with scenes of

princely pastimes, such as hunting, dancing, and sports; vignettes of buildings under construction; personifications; and even the biblical and Qurʼanic prophets Jonah and Job (fig. 4-12b). In a niche opposite the entrance, a figure flanked by attendants is enthroned under an inscription that refers to "a prince of the Muslim men and women." Who was the prince who originally sat below this image? An Arabic inscription below the prophets urges God to make al-Walid ibn Yazid virtuous like them. This al-Walid was briefly the Umayyad caliph (r. 743–44), but because the inscription omits any caliphal epithets (descriptive titles), it must predate his rule; therefore, Qusayr ʻAmra was likely built and decorated for prince al-Walid ibn Yazid during the long reign of his uncle Hisham (r. 724–43), the son of ʻAbd al-Malik. Another panel, in poor condition, depicts six men, of which four retain labels in Greek and Arabic: "Caesar" (an unnamed Byzantine emperor), "Roderic" (the last Visigothic king of Spain, r. 710–12), "Khosrow" (a former Sasanian shahanshah), and "Negus," a title used by the king of Ethiopia; the two missing titles were probably those of the Chinese emperor and Turkic khagan. Some of the political entities represented by this illustrious (if anachronistic) group had already fallen to the Umayyad caliphate, and presumably the others would soon follow.

Heating under the floor controlled temperatures in the elaborately painted three-room bath. The changing room is decorated with paintings of animals and the warm room with nude women bathing (fig. 4-13). In the dome of the hot room, above pendentives and niches decorated with mosaics now fallen from the walls, a heavenly map with constellations and the zodiac was painted inside the cupola. This type of celestial representation harks back to Roman

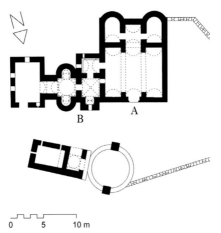

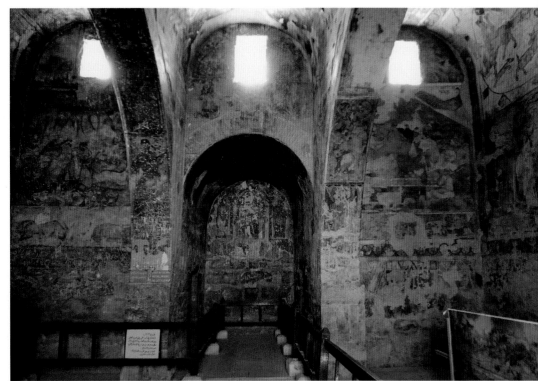

Figs. 4-12a and 4-12b. Palace, Qusayr 'Amra, 724–43, (*left*) plan, A=reception hall, B=baths; to the north are a well, water wheel, and cistern; (*right*) frescoes in reception hall. (*l*) Drawing by Navid Jamali; (*r*) Photo by Heba Mostafa.

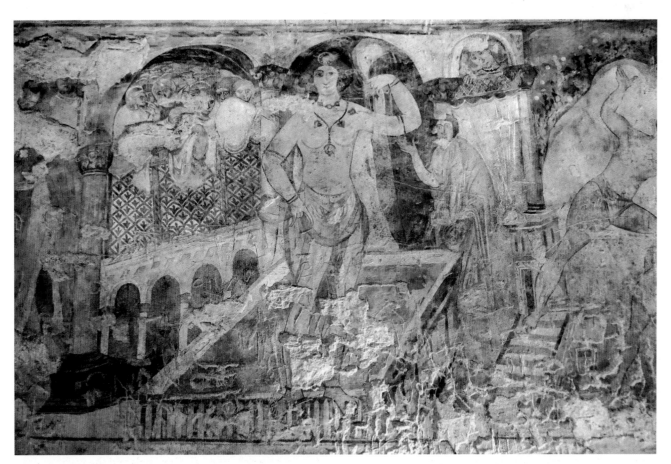

Fig. 4-13. Bathing scene, Qusayr 'Amra, 724–43, fresco in the bath. Photo by Heba Mostafa.

models. The rest of the decoration at Qusayr 'Amra draws on varied pre-Islamic traditions, especially Sasanian iconography, although the construction scenes are exceptional and the figural style has no surviving parallels. The prince or other representatives of the caliph entertained local leaders in this luxurious complex, exercising a kind of soft power in which images of rulers and the cosmic dome helped to underscore Umayyad authority, not only over the visitors but over the painted humans and animals as well. Hierarchies of gender are also in play in the bath. Who were these women painted without clothes? They are unnamed, in contrast to the male dignitaries depicted elsewhere in the building. The anonymous women seem to be there to augment the power of the real men assembled below. Painted with their torsos prominently displayed, the women were evidently designed for the visual pleasure of men—what recent theorists have called the "male gaze." Their painted flesh perhaps mirrored the real flesh of the women who likely served the men gathered in this bath complex.

Identities in Multicultural Spain

Early medieval Spain (named for the Roman province of Hispania) was ruled by the Visigoths, whose king converted from Arian to Roman Christianity in 589; by the seventh century they controlled most of the Iberian Peninsula from their capital at Toletum (Toledo). Their churches feature ashlar masonry, vaulting, and figural sculpture, but it is not clear if these represent continuity with Roman practice or were Visigothic innovations. San Pedro de la Nave in northwestern Spain is probably a work of the late

seventh or early eighth century, despite recent studies that redate it and similar churches to the ninth or tenth century (fig. 4-14). Close analysis of the masonry indicates that the church was built in a single phase, incorporating some Roman funerary slabs. The trees used for its beams were felled between 499 and 595, according to carbon-14 and dendrochronological analyses, and radiocarbon dating of wood cramps (staple-like fasteners that connect masonry blocks) yield a date of 648–95. The long beams could have been reused, but the cramps must have been carved in situ as needed. In the 1930s, the church was moved stone by stone a few kilometers away from its original site to make way for a reservoir.

San Pedro de la Nave is a short, three-aisle basilica with a projecting square apse and lateral porches and a crossing bay with a squat tower. The interior is divided into a series of discrete spaces, emphasized by a high chancel screen, now lost. The arches are horseshoe-shaped, a form typical of Visigothic structures but with late Roman roots. San Pedro and some contemporary churches provide important evidence for narrative figural sculpture in an early medieval church. Based on analysis of style, art historians have attributed the decoration to two sculptors. One specialized in nonfigural forms and carved the geometric and foliate frieze that encircles the sanctuary and windows, as well as the capitals and blocks that frame the apse; his style resembles the chip-carving that is common on Germanic metalwork. The other sculptor executed the six figural capitals and the impost blocks above them in flat relief. These include the biblical salvation scenes of Daniel in the lions' den and Abraham offering Isaac (Gen. 22), both flanked by standing New Testament figures (fig. 4-15). The Abraham scene is identified above in Latin ("where Abraham offered

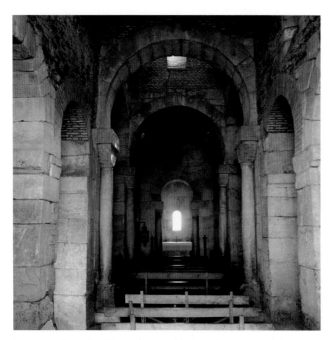

Fig. 4-14. Church of San Pedro de la Nave, late seventh–early eighth century, view toward the east. Index/Heritage Images.

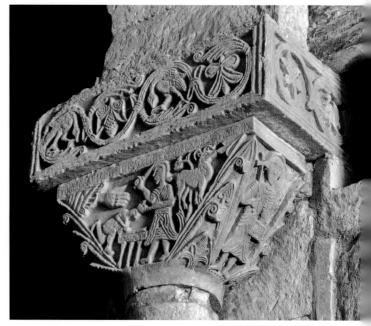

Fig. 4-15. Capital, church of San Pedro de la Nave, late seventh–eighth century. Photo from Ángel M. Felicísimo, CC BY-2.0.

his son Isaac as a sacrifice to the Lord"), and so are the liturgically significant inanimate objects. *Liber*, the Latin word for book, is on the codex held by St. Peter on the narrow end of the capital. A cross and the word *altare* on the table onto which Abraham seems to pull Isaac make the typological meanings of the scene apparent. The style of the sculptures—marked by abbreviated forms and shallow relief with minimal three-dimensional modeling—suggests that the artists sought to reduce biblical narratives into easily readable compositions.

In 750 the Umayyad dynasty in Damascus was overthrown by the Abbasids, who traced their origins to Muhammad's uncle Abbas. One member of the caliphal family escaped and made his way across the Mediterranean to the Iberian Peninsula, almost all of which had been conquered by Arab-led armies in 711. 'Abd al-Rahman I (r. 756–88) founded an independent state, later called a caliphate, with its capital at Córdoba. Like his predecessors, he cemented his authority and announced the Muslim presence with ambitious building campaigns and urban development. The Great Mosque at Córdoba, begun in 784/85, measured about 160 by 200 cubits (fig. 4-16). It occupied the site of the Visigothic cathedral, and spolia columns in its prayer hall supported a two-tier arcade with alternating red and white voussoirs (fig. 4-17). The qibla at Córdoba faced south rather than southeast; the architects may have wished to imitate the orientation of the Great Mosque in the Umayyads' lost capital, Damascus, which properly faced Mecca to its south. 'Abd al-Rahman I's mosque in Córdoba was enlarged by later rulers who wanted to leave a personal mark on the most important Umayyad foundation in Spain.

Precious and Personal Objects

Most objects that communicate religious or personal identity are much smaller than Córdoba's Great Mosque. A gold ring inlaid with niello, one of several very similar examples, communicates the marital and Christian status of the Byzantine man or woman who wore it in the mid-seventh century (fig. 4-18). The most prominent image, incised on the flat bezel (the top of a ring, attached to the hoop), depicts Christ twice, seeming to use two hands to crown the husband on one side and the wife on the other (crowning both spouses is still part of the Orthodox wedding ceremony today). The scene is prominently and appropriately captioned "Harmony" in Greek. The couple, whose bodies were probably set with gemstones, are protectively encircled on the bezel edge by an individualized inscription, "Lord, help your servants Peter and Theodote." The faceted hoop depicts seven Christological scenes—the Annunciation, Visitation, Nativity, Presentation in the Temple, Baptism, Crucifixion, and Christ appearing to the women in the garden after his resurrection—and these are framed by a biblical citation at top and bottom: "Peace I leave with you," "My peace I give you" (John 14:27). These scenes, associated with famous sites in the Holy Land, recall those on the reliquary box (fig. 3-20) and likely reinforced the protective function of the ring's octagonal form. Because the specific narrative scenes also match the major holidays of the liturgical year, they also show the place of the faithful couple within Christian cycles of time. The ring advertises the wearer's Christian piety, which promises to preserve marital concord and protect the newlyweds from temptation and other sins.

Fig. 4-16. Great Mosque, Córdoba, begun 784/85, plan. Drawing by Navid Jamali.

Fig. 4-17. Great Mosque, Córdoba, begun 784/85, interior. Photo by the authors.

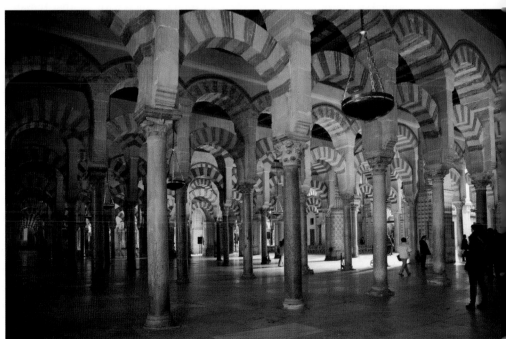

Fig. 4-18. Marriage ring, bezel H 2.3 cm, hoop D 3.2 cm, mid-seventh century; Dumbarton Oaks, Washington, DC. © Genevra Kornbluth, courtesy Dumbarton Oaks, Byzantine Collection, Washington, DC.

Fig. 4-19. Tara Brooch, W 8.6 cm, pin L 22 cm, early eighth century; National Museum of Ireland, Dublin. Reproduced with the kind permission of the National Museum of Ireland.

The Tara Brooch, given that name in the nineteenth century to link the piece to a site associated with ancient Irish kings, is an outstanding work of Irish craftsmanship (fig. 4-19). Made in the early eighth century of cast and gilded silver, the front features delicate filigree panels with a remarkable array of imagery that includes tiny fish-tailed animals, birds' heads, human faces, and abstract motifs, separated by glass, enamel, and amber studs. The flatter decoration on the reverse, consisting of scrolls, spirals, and a procession of chip-carved birds, recalls much earlier La Tène–style work (fig. 1-11). The artist who made the ring-shaped brooch laid out the designs with a compass and adopted materials and techniques found in Anglo-Saxon and Germanic metalwork. Many of the forms appear in contemporary manuscript illuminations, including the Lindisfarne Gospels, discussed below. The brooch was fastened horizontally behind the circular head, which would have been sewn onto a cloak, and further secured by wrapping the silver chain around the pin. The absence of wear suggests that the brooch belonged to a dignitary who donned it only on special occasions. Men wore such a brooch on the right shoulder, in line with Roman, Byzantine, and Germanic practice, whereas women wore it on the chest. Legal texts indicate that fancy pins were associated with royal status and were dynastic heirlooms.

Other objects made of gold express ideas about family and group identity and status. The twenty-three objects in the Nagyszentmiklós Treasure, deliberately buried together at Sânnicolau Mare (Romania), comprise high-quality tableware made by Avar goldsmiths between the mid-seventh and the late eighth century (fig. 4-20a). The source of the gold was the enormous tribute that the Byzantine emperors paid to prevent Avar raids, thereby freeing the imperial army to face the Sasanians to the east. Between 574 and 626 this tribute totaled about six million nomismata (1 nomisma = 4.55 g of gold), before peace was concluded in 678 (in 626 the Avars and Sasanians teamed up to attack Constantinople but were turned back). The whole Nagyszentmiklós Treasure weighs about ten kilos, as much as twenty-two hundred coins, so it represents only a tiny fraction of Avar wealth. For comparison, the Byzantine bishop Eutychianos donated eighteen kilos' worth of gold to what became the Sion Treasure in the sixth century (fig. 3-8), but Nagyszentmiklós is extremely rich by the standards of central and eastern Europe in the seventh and eighth centuries.

The vessels formed a prized collection that was altered over the years. They show few signs of use and may have been displayed at high-status feasts rather than used for eating and drinking on a regular basis. They are adorned with figural, vegetal, and abstract ornament created using the techniques of repoussé and punching. A few objects feature pierced work or glass inlay, and several have inscriptions in Greek letters or in ancient Turkic scripts, many added in the second half of the eighth century. Some of the Nagyszentmiklós objects have no known precedents in form, such as the two small cups (13 cm long) with backward-turning bulls' heads and three paws. Also unusual is the figural ornamentation; it was inspired by Greco-Roman classicism that remained popular in the early Byzantine period, but it was handled in a way that seems unique to Avar culture. One flask features four large roundels: an animal combat and a man hunting, both containing hybrid creatures; a woman being carried by an eagle; and a mounted rider holding a prisoner, both wearing chain mail, with a severed head attached to his saddle (fig. 4-20b).

Images of nomadic, equestrian warriors predominate, and the Nagyszentmiklós objects appear to be of local manufacture even though they refer to Byzantine techniques and styles. The origins of the artists are unknown, but compared with other luxury metalwork objects found in tombs across central and eastern Europe and the Eurasian steppe, these were made with exceptional skill; the flask was hammered from a single plate of gold, a difficult task. The Nagyszentmiklós vessels were highly valued, perhaps by members of a single family (that of the Avar khagan?) who collected them over a century and a half, used them as props to stage their social status, and ultimately buried them for safekeeping. Three bowls feature crosses and two bear inscriptions about baptism, so it is

possible that one of the collectors was a Christian. But it may be that the pieces were valued for their weight and artistry regardless of religious significance, as at Sutton Hoo. The Avar khagans officially adopted the Roman form of Christianity after they were defeated by Charlemagne and lost their entire treasury in 796.

A linen garment has traditionally been associated with Bathild, an enslaved Anglo-Saxon woman who became a Merovingian queen (d. 680/81). It is decorated with silk embroidery stitched to form two lavish necklaces, from one of which "hangs" a large, gemmed pectoral cross on a chain (fig. 4-21). Below the cross are figural medallions, birds, and a plant with animal heads that perhaps are to be understood as part of a third, longer necklace. Only the front of the tunic-like garment is preserved, but its sides were never sewn to a missing back, so if it was ever worn it hung from the shoulders. The depicted jewelry is very close to actual Byzantine items that may have been known

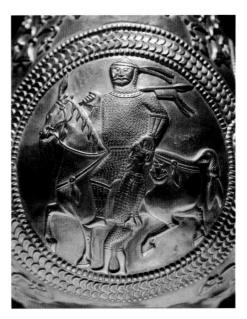

Figs. 4-20a and 4-20b. Nagyszentmiklós Treasure, Sânnicolau Mare, seventh–eighth centuries, (*left*) complete treasure; (*right*) detail of flask, H 22 cm; Kunsthistorisches Museum, Vienna. (*l*) Erich Lessing/Art Resource, NY; (*r*) © Genevra Kornbluth.

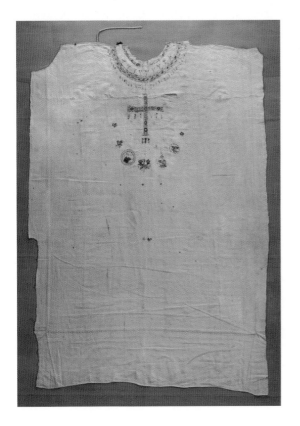
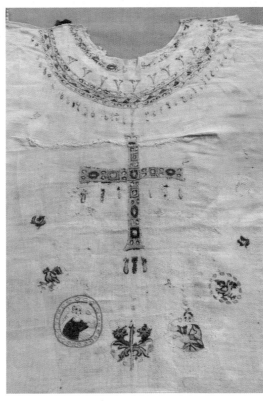

Figs. 4-21a and 4-21b. Garment of Queen Bathild, 117 × 84 cm, ca. 680; Musée Alfred Bonno, Chelles. © Genevra Kornbluth.

at the Merovingian court, where Bathild presided after the death of King Clovis in 657. Whereas brooches had long been the premier sign of status for women in western Europe, the Byzantine preference for necklaces with pendants spread westward and supplanted the prestige associated with fancy pins. Bathild may have worn just such finery before she became a nun, although eventually she opted to give it away.

The garment itself was preserved at the convent that Bathild refounded at Chelles, near Paris, one of several monasteries she established or supported. Its nuns were skilled in the art of needlework and also were noted as active Latin scribes and manuscript illuminators. The textile's intact state reveals that it cannot have been Bathild's funeral garment. She may have worn it during her lifetime, or it might have been made by the nuns to complement the account of her life (usually referred to by the Latin term *vita*, life) written soon after her death. When Bathild was formally recognized as a saint two centuries later, her body was translated (disinterred and transferred) to a place behind the high altar at Chelles, and the garment became one of the earliest extant clothing relics in Europe. Her vita imitated that of Radegunde, the Merovingian queen-saint discussed in chapter 3, and so did her garb: Radegunde reportedly wore an unusual linen "apron" decorated with gold and jewels, and the conspicuous gemmed cross on Bathild's garment evokes the relic of the True Cross that Radegunde had obtained from the Byzantine emperor. Whereas Bathild's queenly status was once expressed with costly personal ornaments, her monastic identity made such objects unnecessary and perhaps even objectionable. The nuns of Chelles used their artistic skills to transform Bathild's precious accessories into embroidered depictions, thereby preserving ideas about her royal status but utilizing

materials more in keeping with monastic life and ideals. In addition, the represented jewelry and the garment itself tied Bathild explicitly to the earlier saintly queen and her devotion to the cross. Regardless of whether Bathild herself imitated Radegunde or the learned nuns created the pious fiction after her death, the embellished textile became a powerful link in a chain of Merovingian female sanctity.

Approaching the Christian Divine

Like their predecessors, seventh- and eighth-century Christians could come close to God by diverse means: living ascetic lives, participating in Church liturgies, producing Christian books, and venerating icons or relics of saints. While relics were important for all Christians, icons are associated especially with Orthodox Christianity. Some images were simultaneously relics, like the miraculous copies of Christ's face that appeared in the sixth century, and some relics were accompanied by images. The painted wooden box of Holy Land blessings differs from later relic containers in its humble material, detailed Christological scenes, and the accessibility of its precious contents: the box opens (fig. 3-20). By contrast, the late eighth-century Enger Reliquary (fig. 4-22)—named for the Saxon monastery in modern-day Germany that housed it—enclosed its relic in a sealed cavity inside a purse-shaped wooden core covered with gold and gilded silver, enamel, glass, and gems, including four reused ancient intaglios (stones with incised images). On the front, overlapping vertical and diagonal crosses are suggested by the placement of the gems; a new technique, cloisonné enamel made with powdered glass (versus the garnets used at Sutton Hoo), is used to form stylized animals. On the reverse, repoussé

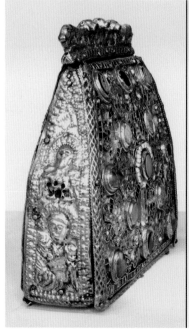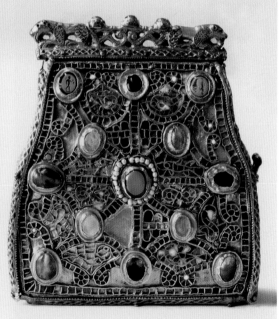

Fig. 4-22. Reliquary from Enger, 16 × 14 × 5.3 cm, late eighth century; Kunstgewerbemuseum, Berlin. © Genevra Kornbluth.

arches frame Christ flanked by angels above the Virgin and Child, Peter, and Paul. The two short sides have additional haloed figures, and at the top five cast lions form a pseudo-clasp and symbolically guard the contents. Stylistically, the reliquary combines Merovingian garnet and glass-paste inlay with human figures in arcades, showing the Frankish artist's familiarity with late antique Mediterranean compositions.

The reliquary's purse form, especially popular between the seventh and tenth centuries, may derive from a Gospel verse that exhorts Christians to "Sell your possessions and give to the poor. Provide purses for yourself that will not wear out, a treasure in heaven that will never fail. . . . For where your treasure is, there your heart will be also" (Luke 12:33–34). The saintly relic is the enduring treasure, not the golden cladding, but the glittering, bejeweled exterior elicited veneration and reminded the faithful of descriptions of heaven (e.g., Rev. 21). Such a setting honored and protected the relic while giving no clue about the specific contents. Metal tabs on both sides show that the "purse" could be suspended on a strap around a cleric's neck, making the sacred portable when the reliquary was not displayed in a church or church treasury, where collections of such precious objects, books, and other valuables were usually kept.

Despite the two periods of iconoclasm in the Byzantine world, the remote monastery on Mount Sinai in Egypt seems to have been unaffected; it not only preserved its older sacred images but also attracted new donations. One such work is an eighth-century icon that depicts Christ, dressed in a long purple tunic and labeled "King of the Jews," dying on the cross as indicated by his closed eyes and slightly inclined head (fig. 4-23). Angels adore him from above, and he is flanked by the two men crucified alongside him, in accord with all four Gospels. Both are named in Greek, but only Gestas is well preserved: wide-eyed, he recognizes Christ's divinity. Mary and John the Evangelist stand below, while miniature Roman soldiers gamble for Jesus's clothing at the foot of the cross, not understanding the significance of the event taking place above them. The Sinai icon is the earliest known image of the dead Christ on the cross, the type that will predominate in the rest of the Middle Ages; in previous representations, he is alive (figs. 1-21 and 3-20). Showing Jesus's body as dead emphasized his human nature and his suffering, which would lead to the redemption of Christians. This is also the first depiction of Christ wearing the crown of thorns, which further emphasizes his misery. Blood and water flow from his side, a reference both to scripture (John 19:34) and to the mixing of wine with water at the Eucharist, as decreed at the Quinisext Council in 692. This double stream helps link Christ's sacrifice on the cross to its regular evocation at the church altar during the mass. Unlike the public liturgy performed by a priest, however, access to the icon

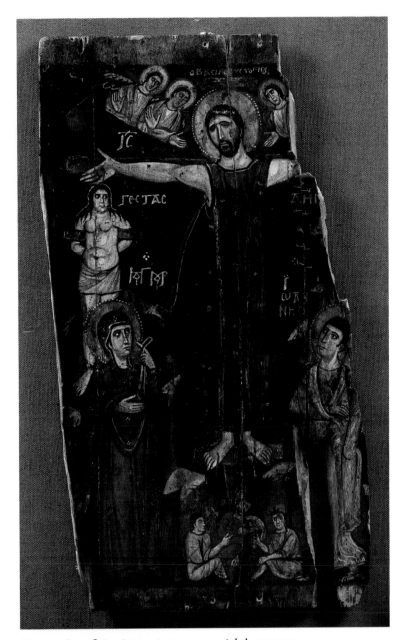

Fig. 4-23. Crucifixion icon, 46.4 × 25.1 cm, eighth century; Monastery of St. Catherine, Mount Sinai. By permission of Saint Catherine's Monastery, Sinai, Egypt.

offered the possibility of private communion with the divine. It could be touched, kissed, and addressed directly by one or more pious monks.

At the other end of the Christian world, cenobitic monasticism took a different form in a no less remote location. Skellig Michael (from the Old Irish *sceillec*, steep rock) is a rocky island twelve kilometers off the southwest coast of Ireland. Christian ascetics may have established a monastery there in the sixth century, the same time as the Sinai monastery was built by Justinian, but the Irish foundation never had royal support. Monks sought seclusion from society in order to focus their attention on spiritual matters. Like St. Symeon the Stylite atop his column at Qal'at Sem'an (fig. 2-29), their spiritual capacities grew

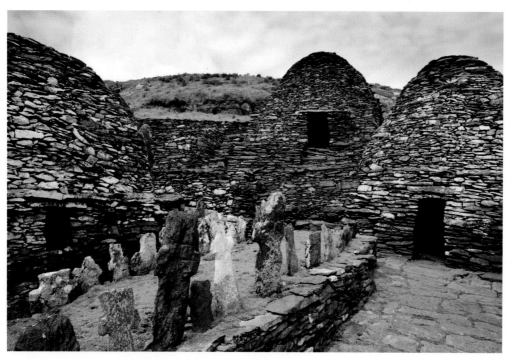

Fig. 4-24. Monastery, Skellig Michael, begun ca. sixth century. David Chapman, Alamy Stock Photo.

with the physical suffering they endured—in this case, suffering increased by isolation, cold, and wind. The monks at Skellig Michael knew that they were at the edge of the world, a bulwark against the menacing unknown to the unexplored west. The dedication to Michael (first recorded in the twelfth century, but presumed to be earlier) underscores the remote location, since this archangel was believed to conduct souls to the afterlife and, according to Irish tradition, the dead would gather on a nearby peninsula. The island's isolation was highlighted when it served as the hideaway for Luke Skywalker in *The Last Jedi* (2017).

The monks at Skellig Michael built a series of walled terraces to provide flat, protected surfaces for their buildings and cultivated areas. Inside were three churches (a fourth was added in the tenth or eleventh century), six so-called beehive cells (*clocháin*) for dwelling and communal use, cisterns, and a cemetery (fig. 4-24). High atop the island's other peak is a smaller hermitage. All of the built structures, except for the later church, are made of corbeled stones that overlap without mortar. The largest church has a rectangular base and an elongated, dome-like superstructure. There are also two rectangular stone structures whose function is unclear—they may have been prayer stations or commemorative sites—and over one hundred stone crosses, or slabs with incised crosses, that range in size from 0.3 to over 2 meters tall. A row of freestanding crosses marks the west side of the monastic graveyard. By the seventh century the cross was a focal point for monastic devotion and spirituality, and it became increasingly common in nonmonastic settings as Christianity spread across Europe.

Work in Focus:
THE LINDISFARNE GOSPELS

Isolated island monasteries were found all over the British Isles, and some of them became important centers of religious and artistic activity. These communities gave rise to a distinctive culture and style often called Insular (*insula* is Latin for "island"). The monastery of Lindisfarne, on a tidal island off the northeast coast of England, was established by Irish monks from Iona (Scotland) in 635, before the formal submission of Irish Christianity to Roman authority (this took place at the Synod of Whitby in 664, over which Abbess Hilda, Whitby's founder, presided). The saintly abbot of Lindisfarne, Cuthbert (d. 687), added greatly to the community's stature because of the miraculous cures said to have occurred at his tomb and the discovery that his body remained intact eleven years after his death. In 698 Cuthbert was translated to a more prominent location in the Lindisfarne monastery's main church—his decorated wooden coffin still survives—and three *vitae* (lives) were written about him, enhancing the monastery's reputation despite its stubborn adherence to certain local traditions, such as the Irish method of calculating the date of Easter.

The imposing Gospel book made to commemorate St. Cuthbert is remarkable for several reasons. It is full of paintings of extraordinary intricacy and is one of the earliest copies of Jerome's Vulgate translation. It also has an informative colophon, written in the mid-tenth century by a priest named Aldred who also added a vernacular (local language) translation between the lines of the Latin Gospel text—the earliest example of the Gospels in English, in

a form now known as Old English. The colophon says that the book was written "for God and for St. Cuthbert and for all the saints whose remains are on the island" by the scribe Eadfrith, "bishop of the Lindisfarne church," and was bound by Aethelwald (later a bishop) and encased in metal and jewels by Billfrith the anchorite (hermit). The Old English text is followed by a synopsis in Latin, and the same names appear at the end of Matthew's Gospel: "You living God, remember Eadfrith and Aethelwald and Billfrith and Aldred, a sinner; these four, with God, were involved with this book." Aldred deliberately drew a parallel between the four contributors to this Gospel book and the four authors of the original Gospels. Although no date is given, the book must have been written after the death of Cuthbert in 687, most likely between his translation in 698 and the death in 721 of Eadfrith, a Lindisfarne monk who became both abbot of the monastery and bishop of the larger region. While medieval monastic forgeries are surprisingly common because they could contribute to an abbey's status by invoking a venerable past, the colophon seems to record a long oral tradition, rather than inventing one outright, that the book was a relic connected to Cuthbert. Analysis of the script supports the colophon's suggestion that the entire book was written by a single hand. Eadfrith was probably also the artist, so it must have taken many years for him to produce it. Making the book demonstrated Eadfrith's single-minded devotion to honoring God and Cuthbert through his labor.

Two openings—the pages that face each other when the book is open—are representative of the manuscript's visual character. For the first opening, a "portrait" of St. Matthew on the left (fig. 4-25) faces a blank page on the recto. The portrait page is labeled, in a mix of Greek and Latin, "O Agios Mattheus" (the St. Matthew), the two languages perhaps intended to suggest the extent of the Christian world stretching far to the east. In an earlier evangelist image, that of St. Luke in the St. Augustine Gospels (fig. 3-18), the evangelist sits upright, facing forward like an icon and displaying the book in his lap. In the Lindisfarne Gospels, by contrast, Matthew is actively writing, but the image is hardly realistic: books were not written out when they were already bound. The picture's style emphasizes bold colors and a flattened space, transforming its Mediterranean iconographic model. Matthew's symbol, the winged man, perches above him, and, curiously, another haloed man peeks from behind a curtain. Although some have identified this figure as Christ, metaphorically opening the door for the evangelist, he likely represents Moses or Ezra, both givers of laws and books in the Old Testament. The curtain would then suggest the "veiling" and incompleteness of Judaism that only became fully revealed with Jesus and the Gospels. The monks no doubt understood the page in different ways; medieval figures and motifs were polysemic and could accommodate a range of interpretations.

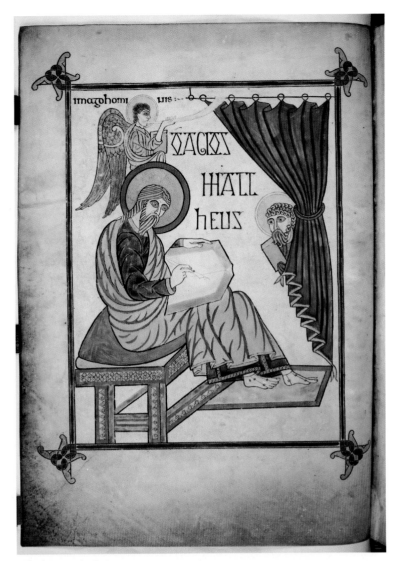

Fig. 4-25. St. Matthew, Lindisfarne Gospels, 36.5 × 27.5 cm, early eighth century; London, British Library, Cotton MS Nero D IV, fol. 25v. © British Library Board. All Rights Reserved/ Bridgeman Images.

The facing recto (fol. 26r) is blank, but an attentive reader can make out the guidelines (called rules) and pinpricks that preceded the final coloring of the page on the reverse (fol. 26v). The scribe-artist may have kept this page undecorated to call attention to the process of designing the page that follows, much as the adjacent evangelist pens a blank page. Elsewhere, uncolored patches in some otherwise fully decorated pages further emphasize the process of creating the book, which has been interpreted as a metaphor for the physical incarnation of Christ himself.

When this blank page is turned, the reader encounters an opening bursting with color and an almost kinetic energy (fig. 4-26). The left side, commonly referred to as a carpet page, is entirely covered with complex ornament, in which a cross outlined in red is enmeshed in a dynamic pattern of interlace and animals. Using only a compass and straightedge, the artist produced a composition that suggests both the orderly geometry and the complexity

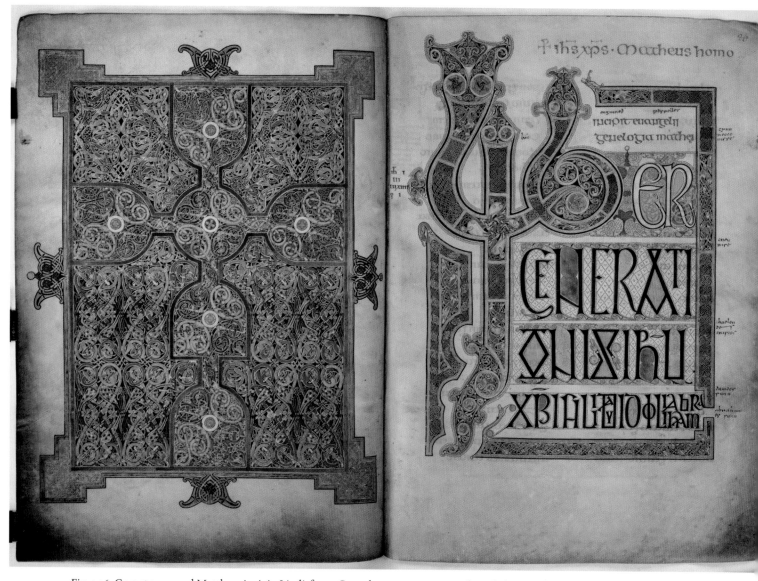

Fig. 4-26. Carpet page and Matthew incipit, Lindisfarne Gospels, 36.5 × 27.5 cm, early eighth century; London, British Library, Cotton MS Nero D IV, fols. 26v–27r. © British Library Board. All Rights Reserved/ Bridgeman Images.

of God's creation; here, the cross stabilizes it all. Some of the swirling patterns derive from the Celtic La Tène tradition, as seen on the Battersea Shield (fig. 1-11) and the Tara Brooch. The artists and scribes of such cross-carpet pages, which precede each Gospel and are found in many other contemporaneous manuscripts, left no textual record indicating what these illuminations were supposed to mean. Scholars have proposed that they were simultaneously aids to meditation, apotropaic devices, evocations of cosmic order, and visualizations of the complexity and beauty of scripture.

The facing incipit (opening words) on the right side of the opening dramatically proclaims the beginning of Matthew's Gospel in Latin, with a single letter in Greek: "Liber generationis Ie(s)u Chri(sti) filii David ϕilii Abraham" (Book of the generation of Jesus Christ son of David son of Abraham). The *Lib* of *Liber* in particular echoes the complexity of the cross-carpet page, and other decorative choices—swaths of color, the red-dotted diapered (repeated diamond) background—are meant above all to enhance the sacred text. At the same time, early medieval scribes and book artists like Eadfrith were experimenting with layouts and letter designs to enhance the reader's experience and increase the layers of meaning on the page. Manipulating the size and shape of letters and decorating them with representational elements like animals or human figures became recurring features of medieval European books.

In the Lindisfarne Gospels, the intense concentration required to create and follow these intricate designs is a kind of meditation on divine geometry. Monks needed to take an active role in making sense of the ornamental and textual complexities on the pages before them. That the scribe had the reader in mind when producing pages like this is evident in the lower right corner. The text, which is written in lines of decreasing size, leads the eye to the bottom of the page, where the ornamental border opens with a small gap as if to allow the text to flow to the next page, inviting the reader to follow.

The Lindisfarne Gospel book is an exceptional example of Insular style, which synthesizes elements from local Celtic forms and imported traditions. On the one hand, it uses bright colors and intricate linear patterns rather than naturalistic space or bodily proportions: consider the footstool that floats without support, or the elongated legs of Matthew. On the other hand, it drew on Mediterranean models for the text, the evangelist images, and the relatively new format of the Christian codex—all rarities in a still largely polytheistic region. This synthesis declared Lindisfarne's identity after the Synod of Whitby, and the book's quality displayed the monks' piety and the stature of their patron saint. Yet Aldred's colophon was not written at Lindisfarne. The community was sacked in 793—the first documented attack on a Christian site by the Scandinavian raiders known as Vikings—and repeatedly thereafter. In 875 the remaining monks took the sarcophagus with St. Cuthbert's body to safety inland, along with this book, carrying them from place to place for over a century before finally settling at Durham in 995. The saint continued to inspire the production of works of art: the cathedral of Durham and an illustrated vita discussed in chapter 7 demonstrate the ongoing veneration of Cuthbert, and of the Gospel book associated with him, over hundreds of years.

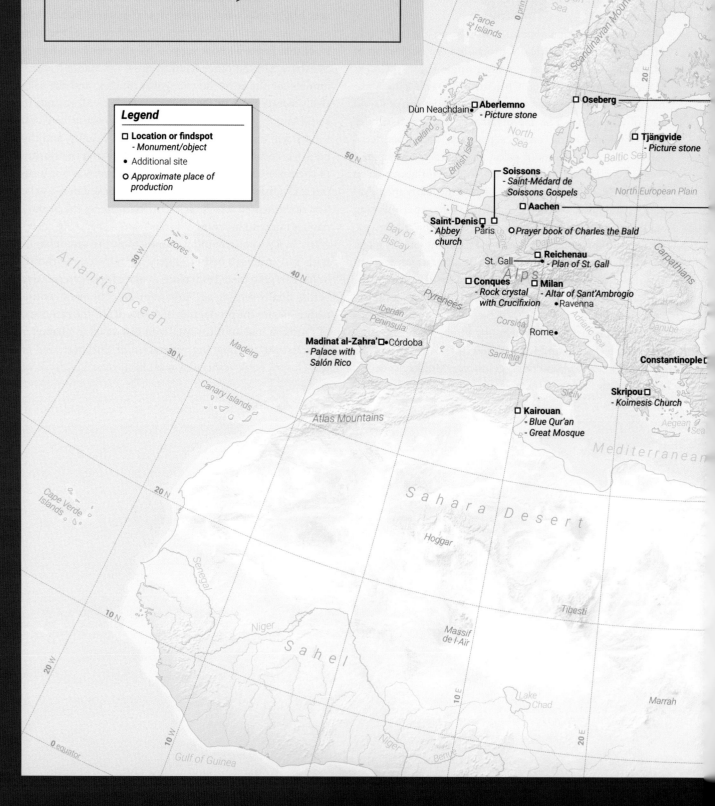

CHAPTER 5

Late Eighth Century to ca. 960

Legend

□ **Location or findspot**
- *Monument/object*

• Additional site

○ *Approximate place of production*

□ **Aberlemno**
- *Picture stone*

Dùn Neachdain•

□ **Oseberg**

□ **Tjängvide**
- *Picture stone*

Soissons
- *Saint-Médard de Soissons Gospels*

□ **Aachen**

Saint-Denis □
- *Abbey church* Paris ○*Prayer book of Charles the Bald*

St. Gall □ **Reichenau**
• - *Plan of St. Gall*

□ **Conques** □ **Milan**
- *Rock crystal with Crucifixion* - *Altar of Sant'Ambrogio*
•Ravenna

Rome•

Madinat al-Zahra'□•Córdoba
- *Palace with Salón Rico*

Constantinople□

□ **Skripou**
- *Koimesis Church*

□ **Kairouan**
- *Blue Qur'an*
- *Great Mosque*

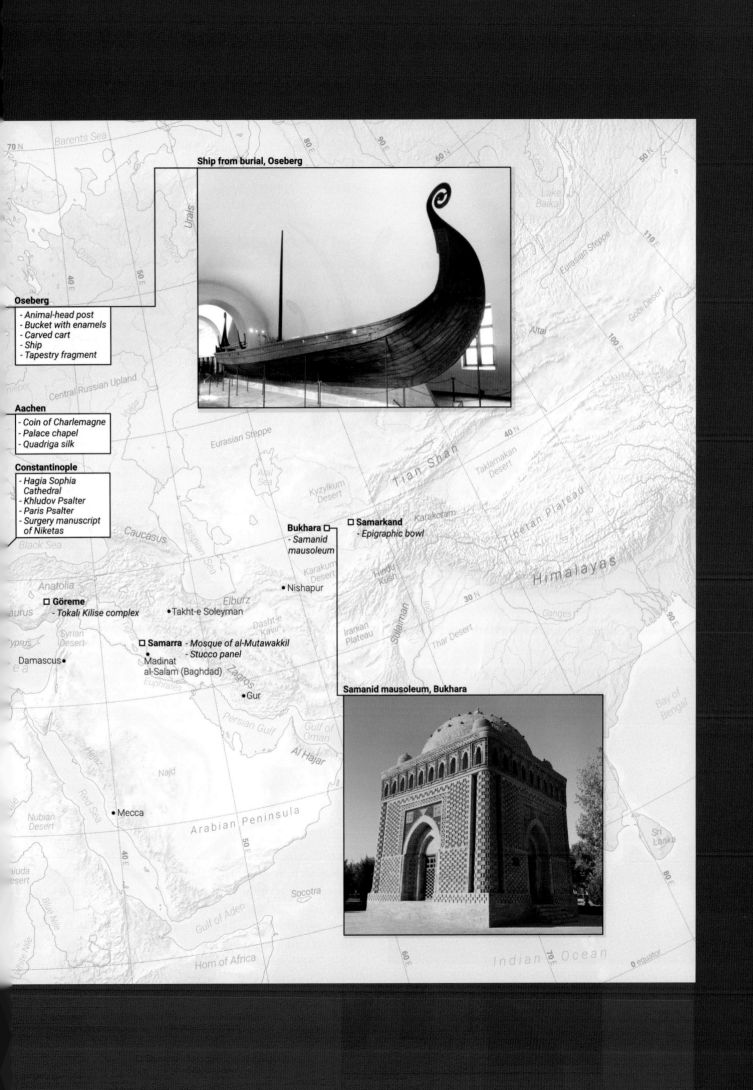

Ship from burial, Oseberg

Oseberg

- *Animal-head post*
- *Bucket with enamels*
- *Carved cart*
- *Ship*
- *Tapestry fragment*

Aachen

- *Coin of Charlemagne*
- *Palace chapel*
- *Quadriga silk*

Constantinople

- *Hagia Sophia Cathedral*
- *Khludov Psalter*
- *Paris Psalter*
- *Surgery manuscript of Niketas*

□ **Göreme**
 - *Tokalı Kilise complex*

□ **Samarra** - *Mosque of al-Mutawakkil*
 - *Stucco panel*

Bukhara □
- *Samanid mausoleum*

• Nishapur

□ **Samarkand**
 - *Epigraphic bowl*

• Takht-e Soleyman

Damascus •

• Madinat al-Salam (Baghdad)

• Gur

• Mecca

Samanid mausoleum, Bukhara

oward the end of the eighth century, North Africa, Europe, and western Asia emerged from two centuries of environmental crisis fueled by bubonic plague and atmospheric effects that caused less solar energy to reach Earth's surface. The new era inaugurated a warmer period (ca. 850–1300) in which grapes were grown in England and wheat in Norway. The population doubled in Europe, and new cities were built. Improvements in technology, including crop rotation, smelting, plowing, horse harnesses, and stirrups, also affected the Eurasian economy (many of these innovations originated in China and were carried westward). A new Roman emperor crowned in 800, Charlemagne, capital-ized on environmental and political changes and attempted to unify Europe. At the same time, Byzantium and the Abbasid caliphate continued to expand their spheres of influence. Rejecting overtures by the Roman Church, the Bulgarian khan (Turkic for ruler) accepted Orthodox Christianity in 864. Despite Abbasid political weakness, the independent dynasties that emerged in western and Central Asia continued to recognize the caliph as their religious leader. By contrast, a new group, the Fatimids, began to conquer North Africa in 909, and sixty years later they declared a separate, Shi'i caliphate much larger than the vestigial Umayyad caliphate in southern Spain.

Image Issues

When Byzantine iconoclasm ended (box 4-1), the iconophiles quickly set about restoring images and demonizing the former image-breakers. They reinforced the notion that material images pointed to the represented holy person or prototype and that images must not be treated as sacred in and of themselves. One mosaic in Hagia Sophia in Constantinople associated with the restoration of image veneration is in the conch of the apse (fig. 5-1). Mary is enthroned with Jesus on her lap; they are placed against a gold ground, accompanied by two archangels in the soffit of the vault. Only a few letters of the original inscription remain, but it was recorded in a later text: "The images that the imposters had cast down here, pious emperors have set up again." The "pious emperor" was Basil I (r. 867–86), initiator of the Macedonian dynasty (867–1056). In the first year of his rule he sponsored the four-meter-tall apse image, which was simultaneously a reminder of the past (iconoclasm), a celebration of the present (the triumph of Orthodoxy), and a message of hope for the future. Patriarch Photios (r. 858–67, 877–86) celebrated the new mosaic with a sermon read in Hagia Sophia on Holy Saturday (the day before Easter Sunday), although his description does not correspond perfectly with the image. To Byzantine viewers the Theotokos and Child were lifelike, even alive (the tesserae of their faces and hands are pinkish marble rather than glass), and the way that sunlight passes across the image throughout the day enhances the illusion of movement. The images and their placement in the apse of Byzantium's most important church countered iconoclast aversion to figural art by affirming the legitimacy of images and visualizing powerful theological ideas. They proclaimed Mary's role in salvation history and linked the flesh and blood of the depicted child with the bread and wine of the eucharistic liturgy celebrated at the altar below. This became the standard imagery in Orthodox apses for the rest of the Middle Ages, and it endures to this day.

It is possible that Photios conceived the illustrations for the Khludov Psalter, produced in mid-ninth-century Constantinople and named after its nineteenth-century

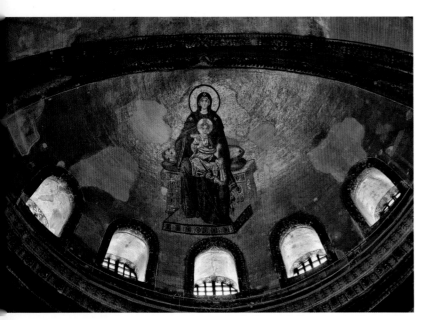

Fig. 5-1. Apse mosaic, Hagia Sophia Cathedral, Constantinople, 867. Photo from iStock.com/ihsanGercelman.

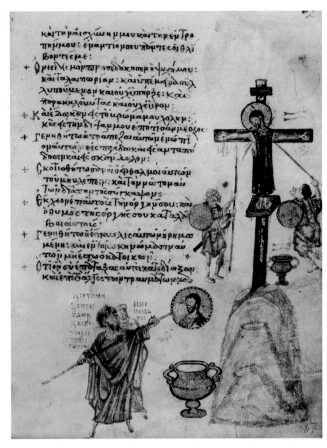

Fig. 5-2. Crucifixion and iconoclasts, Khludov Psalter, 19.5 ×
15 cm, mid-ninth century; Moscow, Gosudarstvennyi
istoricheskii muzei, MS D.129, fol. 67r. The Picture Art
Collection/Alamy Stock Photo.

the Khludov Psalter enriched those connections. Just as
the Roman soldier at the right extends a lance topped with
a vinegar-soaked sponge to Jesus on the cross, so too does
the frizzy-haired John "the Grammarian," patriarch of
Constantinople (accompanied by a second figure), bran-
dish a long-handled sponge to whitewash a circular icon
of Christ. The use of red for garments of the evildoers and
the classical-looking vessels for vinegar and whitewash
are identical in the two scenes. Labeled "Eikonomachoi"
(image battlers), the iconoclast patriarch and his backer
are likened to the torturers of Christ, and the violence in-
flicted on the icon is paralleled to violence toward Christ
himself. With the Old Testament text suggesting the New
Testament imagery, and that imagery then shifting to in-
corporate recent political debates, the page makes multiple
typological arguments. The relationship between past and
present is further underscored by the Greek inscriptions
next to each scene: "They [mixed] vinegar and gall" next
to the Crucifixion and "They mixed water and lime on his
face" next to the iconoclasts. One reader's response to the
page reveals the power of images in another way: he or
she has scraped away the face of John "the Grammarian"—
an act of image destruction by a supporter of icons. The
Khludov Psalter thus testifies to the provocative potential
of images and asserts that the use of icons and images had
prevailed in mid-ninth-century Byzantium.

Charlemagne and the Carolingians

Pippin (or Pepin) "the Short" (714–68) was educated at
Saint-Denis, an abbey north of Paris built in honor of the
first bishop of that city. It had been enlarged by King Da-
gobert (r. 629–39), a member of the Merovingian dynasty
that united Gaul, ruled it for three centuries, and used
Saint-Denis as a royal mausoleum. After Pippin usurped
power from the Merovingians, the abbey was the setting
for his coronation as the first king of the Franks, performed
by the pope in 754. Pippin began to build a larger church,
which was completed by his son Charles I, called "the
Great" and better known by his name in French, Char-
lemagne; it was dedicated in 775 under Abbot Fulrad (r.
ca. 750–84) (fig. 5-3). Associated with Charlemagne's family
of rulers, known as the Carolingians, this version of Saint-
Denis was intended to continue as a dynastic mausoleum,
although Charlemagne was eventually buried elsewhere
(see below). The church was rebuilt in the twelfth and thir-
teenth centuries (chapter 7), but archaeological evidence
and medieval descriptions are detailed enough to support
a basic reconstruction. The west facade of Saint-Denis in-
corporated Pippin's tomb and was monumentalized with
low twin towers that marked the entrance into a T-shaped
basilica. The columns that divided the nave and aisles
were spolia, probably from Dagobert's church, reused de-
liberately to connect the new building to the earlier royal

Russian owner (fig. 5-2). Psalters are books that contain the
psalms, texts associated with King David in the Hebrew
Bible. The Psalter was at the heart of devotion across medi-
eval Christianity, and it was also the main textbook for el-
ementary education. The psalms were recited in the mass,
in which laypeople could participate, and beginning in the
sixth century, psalms were sung in the monastic services
that took place day and night. Monks therefore learned the
Psalter by heart (it takes about four hours to recite all the
psalms).

As poetic meditations on people's relationship to God,
the psalms do not lend themselves as easily to illustration
as biblical narratives do. Medieval artists and patrons like
Photios wrestled with this problem, and works like the
Khludov Psalter show how creative their solutions could
be. The manuscript has lively vignettes in the margins,
several of which feature polemical, anti-iconoclast imag-
ery. The illustration for Psalm 69 takes its cue from one
of its lines ("they put gall in my food, and gave me vin-
egar for my thirst") and depicts the Crucifixion because
Matthew 27:34 also refers to gall and vinegar ("There they
offered Jesus wine to drink, mixed with gall; but after tast-
ing it, he refused to drink it"). The New Testament often
alludes to passages in the Hebrew Bible that help set the
stage for the story of Christ, and the artists of fol. 67r in

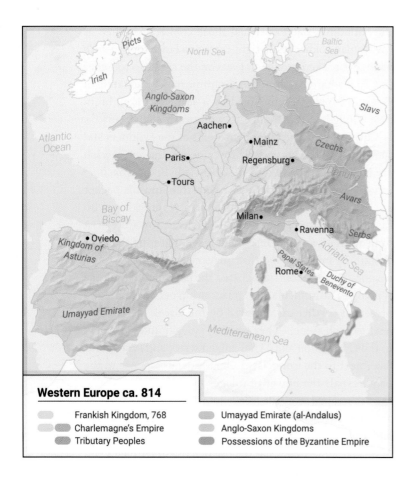

Western Europe ca. 814

- Frankish Kingdom, 768
- Charlemagne's Empire
- Tributary Peoples
- Umayyad Emirate (al-Andalus)
- Anglo-Saxon Kingdoms
- Possessions of the Byzantine Empire

Fig. 5-3. Abbey church of Saint-Denis, Saint-Denis, 775, plan. Drawing by Navid Jamali.

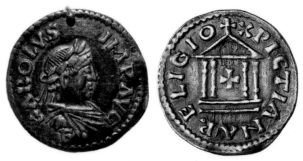

Fig. 5-4. Coin of Charlemagne, 2 cm, 813/14; Münzkabinett, Staatliche Museen zu Berlin. (*left*) © Genevra Kornbluth; (*right*) bpk Bildagentur/Münzkabinett, SMB/Lübke & Wiedemann/ Art Resource, NY.

foundation. A semicircular apse topped a sizable annular crypt that housed the remains of St. Denis and accommodated pilgrims who came to venerate them. A wall divided the nave from the projecting continuous transept, likely to separate the primary space of monastic liturgies from lay visitors and to help regulate the flow of devotees to the crypt. The atrium, projecting transept, separated altar area, use of spolia, and annular crypt—the first example of such a crypt north of the Alps—signal that an important model for the Carolingian reconstruction of Saint-Denis was St. Peter's in Rome (fig. 2-5), which Fulrad knew well. This emulation reflected the Franks' alliance with the papacy and their desire to link the first bishop of Paris to the first bishop of Rome.

Charlemagne (ca. 747–814) was an ambitious ruler, uniting much of what is now France, Germany, and northern Italy and imposing tribute on central European groups, such as the Avars. He supported the Roman Church, ordering the restoration of church buildings and overseeing the standardization of liturgy, education of the clergy, and reform of the monks. He promoted a new, more legible Latin script, known as Caroline minuscule, to encourage literacy and copying of texts at court and throughout the realm. In addition, he standardized weights and measures and oversaw the exclusion of foreign coins and minting of a new one, the *livre*, divided into 240 *denarii*; one *denarius* could buy a dozen large loaves of bread, four of them

a sheep or pig. In the late eighth century, the coins bore Charlemagne's monogram and a cross. After the pope crowned Charlemagne in Rome on Christmas Day, 800, he became the first Roman emperor in western Europe in almost 350 years. In conjunction with this title, a new type of Carolingian coin was minted during the final years of the emperor's reign (fig. 5-4). The Latin legend "Karolus imp[erator] Aug[ustus]" (Charles the august emperor) encircles his wreath-wearing profile, which evokes ancient Roman ruler coins like that of Constantine (fig. 2-1). Such an overt connection to the Roman past, along with other aspects of ninth-century culture, has led some historians to call this period the Carolingian Renaissance. The term used by Carolingian authors to refer to their political, cultural, and religious project was not *renaissance* but *renovatio*, by which they meant a renewal of the prestigious Christian Roman past. Indeed, the legend on the reverse of the coin says "Christian religion," with Greek letters among the Latin ones (including X and P at the beginning); it encloses a schematic classical-looking building with one cross inside and another on the roof.

The architectural model for the coin may have been the chapel of Charlemagne's palace at Aachen, the main seat of his itinerant (traveling) administration. Aachen, the site of a Roman villa and then a Frankish hunting lodge, was chosen for its central location in the expanded Carolingian realm and also for its nearby stone quarries and hot

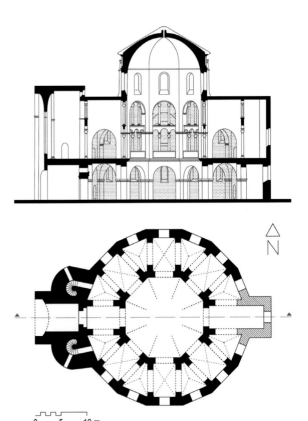

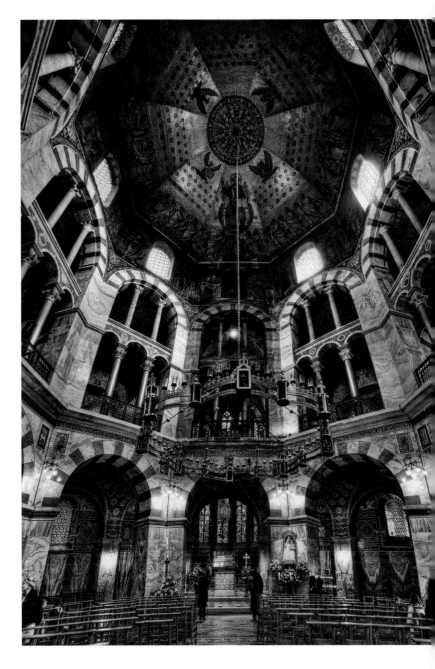

Figs. 5-5a and 5-5b. Palace chapel, Aachen, ca. 800, *(left)* plan and section; *(right)* interior. (l) Drawings by Navid Jamali; (r) Lukas Bischoff ©123RF.com.

springs, which Charlemagne reportedly enjoyed. It was also far from Paris, one of the cities where the Merovingian dynasty had established roots. Built by Odo of Metz (about whom nothing else is known) and dedicated in 805, the palace chapel—which was also a parish church and therefore open to all—was described by Charlemagne's biographer Einhard as "a truly remarkable construction" (fig. 5-5a). Funded in part by booty obtained from the Avars in 796, it was one of the tallest buildings north of the Alps until the twelfth century. Its two-story monumental westwork (entrance with two towers and an upper-story chamber), built to resemble a tall Roman triumphal arch, was a Carolingian innovation that had a long afterlife in western European medieval architecture. The chapel was part of a complex that contained a gatehouse and apsed audience hall modeled on Roman imperial basilicas; the complex does not survive but has been partly reconstructed based on archaeological and other evidence.

With its octagonal plan, the chapel at Aachen imitated the Lateran Baptistery in Rome and San Vitale in Ravenna (figs. 2-2 and 3-4), linking Charlemagne to Constantine, to Theoderic, the Germanic Ostrogoth who ruled in Ravenna before its Byzantine reconquest, and to Justinian. The length of the chapel measured 144 Carolingian feet (the east end was extended in the fourteenth century)—an imitation of the Heavenly Jerusalem described in Revelation 21:17, which measures 144 cubits. The future Jerusalem is

also said to have walls of jasper and of pure gold, its foundations garnished with precious stones. This description, and the Ravennate and Roman models, inspired the chapel's interior; it is embellished with colored stone, gold mosaics, new bronze work, and spolia columns and capitals brought from Ravenna (fig. 5-5b).

The vault mosaic dates to the 1800s, but it echoes the medieval iconography that was recorded in a seventeenth-century drawing. Against a gold background, the twenty-four elders mentioned in Revelation (4:4) offer crowns to the enthroned Christ, a choice of imagery related to Charlemagne who was enthroned immediately below in the second-story gallery. The throne was elevated on steps like the biblical throne of Solomon (1 Kings 10:19), across from an altar to the Savior and above the main altar to Mary on the ground floor. This arrangement of thrones and altars

Box 5-1. BRONZES AT AACHEN

Large-scale works in bronze, both ancient spolia and new objects, adorned the Aachen chapel and the atrium in front of it, communicating important messages about the Carolingian Empire's connections to the past and its technological abilities. Among the reused statues, a lifelike she-bear may have reminded visitors of the wolf that nourished Romulus and Remus, the founders of ancient Rome, and a monumental pinecone likely imitates one at the church of St. Peter in Rome. There was also an equestrian statue of Theoderic, who was understood as the first Germanic Roman emperor and thus Charlemagne's predecessor; this was brought from Ravenna. The sixth-century statue of Theoderic, now lost, had been cast in bronze using the ancient lost-wax method—a technique revived at Aachen in the ninth century. In this process, a model of the work is made of wax, encased in plaster, and then fired; the wax melts and drains out of a hole, but its contoured form remains imprinted inside the plaster. Then, hot liquid bronze is poured into the mold through a tube attached to the hole from which the wax drained. When the bronze cools, the mold is broken to reveal the contoured bronze form within; the tube through which the molten bronze was poured is sheared off and the hole sealed. The resulting bronze object then receives its final surface

treatment and polishing. This technique was used in ninth-century Aachen to make railings, window screens, and three pairs of bronze doors with lion-head knockers; the main, western doors are almost four meters high. Originally the doors were shiny and reflective, like ancient Roman mirrors also made of bronze. Casting took place in what must have been a large workshop near the palace, where molds for the railings were found. The renewal of this ancient casting technique accords with other Carolingian renovatio initiatives. The bronze objects at Aachen also displayed wealth and prestige. Large quantities of copper and tin (the main components of bronze), lime for plaster molds, firewood, and wax—and the labor required to get them to Aachen—were needed to produce the new works, and political might and logistical skill were necessary to acquire the old ones and transport them over the Alps. These works also demonstrate the impressive technological skills of the artists working for the emperor. In 802 the bronze collection at Aachen was augmented by a water clock sent to Charlemagne by the Abbasid caliph in Baghdad, Harun al-Rashid. Einhard described this device as "marvelously made by mechanical means"—another example of rulers using artistic ingenuity and technology to assert their power and enhance their reputation.

in the chapel at Aachen emphasized that Charlemagne was the representative of Christ on Earth and, as the legend on his coin declared, the defender of the Christian religion in the new Frankish Empire. Yet Charlemagne's palace soon fell into disuse: Vikings raided the site in 881 and purportedly used the chapel as a stable for their horses.

When Charlemagne died, he was buried outside the west door at Aachen, allegedly wrapped in a piece of Byzantine samite (a lustrous, heavy silk made with a compound twill technique) likely woven in the eighth century (fig. 5-6). The dark-blue silk is decorated in yellow with a charioteer driving a quadriga, a chariot with four horses, approached on two sides by small men bearing victory crowns; at the bottom, two smaller men pour money onto a table or altar. This pattern is repeated in other medallions, all framed by a stylized heart motif and separated by paired ibexes. A charioteer's victory in the hippodrome was a symbol of imperial triumph in late Roman and Byzantine art (fig. 2-12). In 798 Alcuin, an intellectual at

Charlemagne's court, dedicated an instructional dialogue to one of Charlemagne's sons in which the *quadriga mundi* (chariot of the world) is equated with the cycle of the year and with a ruler making the rounds of his palaces. Other commentators saw the quadriga in biblical terms, connecting the four horses to the four evangelists pulling Christ and Christians to eternal life. The choice of this Byzantine silk for the emperor's shroud reflected Carolingian ideas about power, status, and the potential sanctity of the ruler, while also appropriating Roman and Byzantine ideas of purplish hues as the color of imperial power. It supposedly continued to wrap Charlemagne's bones when he was canonized in 1165. From 1215 the silk and bones were preserved in a two-meter-long golden reliquary of Charlemagne, the Karlsschrein (Charles Shrine). In the nineteenth century the silk was cut and a large piece taken to Paris.

Charlemagne's sole legitimate son and successor, known as Louis "the Pious" (778–840), gave a Gospel book made for his father to the monastery of Saint-Médard at

Fig. 5-6. Quadriga silk, 75 × 72.5 cm, eighth century; Musée de Cluny, Paris. Jean-Gilles Berizzi; © RMN-Grand Palais/Art Resource, NY.

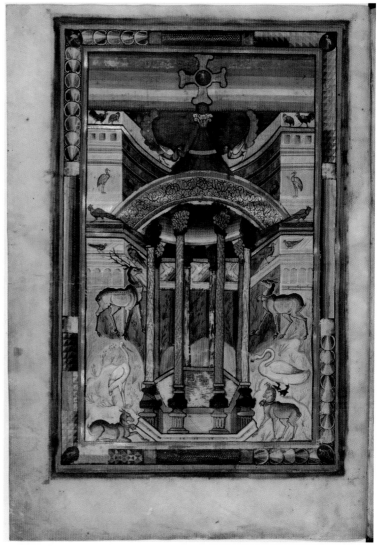

Fig. 5-7. Fountain of Life, Saint-Médard de Soissons Gospels, 37.5 × 28.5 cm, early ninth century; Paris, Bibliothèque nationale de France, MS lat. 8850, fol. 6v. Photo from Bibliothèque nationale de France.

Soissons (France) when he visited it at Easter in 827. The Vulgate text is entirely written in gold uncials (rounded capitals). The full-page illumination on fol. 6v precedes the canon tables (fig. 5-7). It was clearly a special page, the only one that uses lapis lazuli for the bright blues rather than the cheaper alternatives, indigo and azurite, used elsewhere in the book. Despite its apparently straightforward, nonnarrative imagery, the illumination is rich in symbolism. It depicts a baptismal font that nourishes the creatures around it, hence its designation as the Fountain of Life (*fons vitae* in Latin). The presence of eight pseudo-marble columns shows that the artist intended to paint an octagonal font, and the image was likely inspired by the one in Rome's Lateran Baptistery where one of Charlemagne's sons had been baptized (fig. 2-2). That font was originally surrounded by silver sculptures of deer, and the four harts in the Soissons Gospels recall its symbolism of deer drinking the water of life (Ps. 42:1). They thirst for the four rivers of paradise (Gen. 2:10–14), which spout from a cylinder in the center of the painted font. The deer and rivers work typologically to evoke the four Gospel authors. The large ibis or crane (left) and the swan (right) are aquatic birds probably meant to suggest the apostles, two of whom are identified in the Bible as "fishermen" (Matt. 4:19), whereas the peacocks that flank the roof of the canopy are symbols of immortality. The golden cross atop the Soissons font aligns it visually with a Christian tomb, perhaps specifically with the Holy Sepulcher, while the purple gem at the heart of the cross and those at the corners of the page echo the use of such gems in contemporary crosses and reliquaries. The space represented on the page

is illusionistic, and the curved building in the background is much like the one behind Christ in the early icon from Sinai (fig. 3-21). It is a late Roman building type, and its inclusion in the Soissons Gospel book offers further evidence for the Carolingian renovatio.

A similar awareness of ancient art informed the production of a large rock-crystal gem featuring a representation of the Crucifixion (fig. 5-8). It was carved between about 825 and 950 in the intaglio technique practiced by ancient Roman gem carvers; in this case, the image was cut into the back of the transparent stone and meant to be seen through the front. Christ on the cross is flanked by personifications of the sun and moon above and by Mary and John the Evangelist to his right and left sides; here the cross pierces a large coiled serpent, demonstrating Christ's triumph over evil and death. The intricacy is remarkable for such a small object, under four centimeters wide. Subtle differences in carving depth show the contours of

bodies under billowing drapery; thin, shallow lines represent outstretched fingers and the fangs of the menacing serpent, a drilled hole its prominent eye. The crystal was made for close viewing—for contemplation of its theological meaning as well as its exceptional workmanship—as its polished convex top magnifies the image. It must have been given by a wealthy Carolingian to the abbey of Sainte-Foy (St. Faith) at Conques, in southern France, where it

now adorns a statue of the saint. Local sources attest that such gifts of precious jewels helped raise the profile of the monastery and the status of the miracle-working Foy, a girl who was martyred in the third or fourth century (discussed further in chapter 6). Donations were offered to encourage a saint's help or to give thanks for it, as well as to enlist a particular church's assistance; such exchanges confirm the contractual aspects of Christian devotion.

Venerating the cross by first kneeling and then kissing it was part of the ninth-century Carolingian liturgy for Good Friday, and a suggestion of this devotion is evident in the small prayer book made between 846 and 869 for Charlemagne's grandson, Charles "the Bald" (823–77), who succeeded his father, Louis "the Pious," as king of West Francia, king of Italy, and eventually Roman emperor. The only paintings in the book face each other and make an argument about the relationship of the Carolingian ruler to Christ (fig. 5-9). On the right is an image of the Crucifixion with a subtle but important innovation. The hand of God emerges from the top of the page to crown Christ with a jeweled wreath, which emphasizes both his status as a humble martyr who accepts his violent death and his elevation as king of heaven. On the facing page is the earthly king, Charles "the Bald," whose regalia indicates his political status. Yet this ruler is also shown kneeling, and his act of humility mirrors that of Jesus. By sharing in both Christ's humility and his elevated power, Charles hoped to be rewarded for his piety with eternal life. More broadly, the pictures constructed a Carolingian ideology that made the ruler the representative and image of Christ on Earth, worthy of governing the people of God.

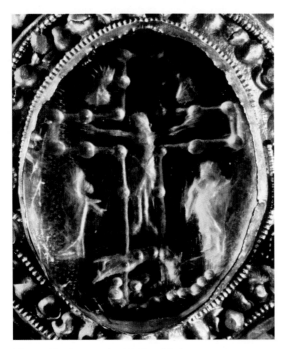

Fig. 5-8. Rock crystal with Crucifixion, 4.9 × 3.9 cm, 825–950; Trésor, Conques. © Genevra Kornbluth.

Fig. 5-9. Prayer book of Charles "the Bald," 13.7 × 10.2 cm, 846–69; Munich, Schatzkammer der Residenz (no shelf mark), fols. 38v–39r. © Bayerische Schlösserverwaltung, Maria Scherf/Rainer Herrmann, München.

Other Christian and Muslim monarchs expressed their legitimacy and power in diverse ways. After Byzantine iconoclasm ended definitively in 843 and the Theotokos mosaic was installed in the apse of Hagia Sophia, a figural mosaic was placed in another visually and liturgically significant location in the church: over the central door, the threshold between the sparsely lit inner narthex and the bright domed space of the naos (fig. 5-10). The lunette depicts a nimbed emperor in *proskynesis*, prostrate before the enthroned Christ who holds an open Gospel book inscribed in Greek, "Peace be with you; I am the light of the world" (combining John 20:19 or 20:26 with John 8:12). The text promises salvation to those who follow Christ—in this case, to the emperor whom Christ blesses. Mary appears in a medallion and gestures toward her son, asking him to show mercy to the imperial supplicant; on the other side is an archangel, most likely Michael. The mosaic acknowledges the emperor's centrality in Orthodox liturgy, for he would enter the light-filled naos through this very door during important religious celebrations. Yet the image also reminded him that, despite his considerable wealth and power on Earth, the emperor must remain subservient to God to maintain his status and ensure salvation—a forceful message to absorb as he entered sacred space. Despite the prominent location of the mosaic, the prostrate figure is not identified; it can only be dated on the basis of style to the ninth or early tenth century. Perhaps the lunette was intended to emphasize the consistent and eternal foundation of imperial rule: the close relationship between all Byzantine emperors and Christ.

A book of psalms made in Constantinople, but called the Paris Psalter for its current location, is thought to be associated with Emperor Constantine VII (r. 945–59). It deals with the challenge of illustrating the nonnarrative psalms by emphasizing the texts' putative author, King David, and making explicit connections between this figure and the Byzantine ruler (fig. 5-11). As seen already in the David Plates (fig. 3-26), the author of the biblical psalms was a type for Christ because he was a shepherd, like the Good Shepherd, who with God's help battled enemies like Goliath; and he was also a model for rulers because of his military skill, his elevation of Jerusalem, his wise rule, and his penitence after committing adultery. The political use of the Old Testament is clear from the full-page illuminations in this large luxury manuscript, which served as a model for later artists. Eight of the fourteen illuminations focus on David, all but one grouped together before the text of the psalms. The first page, shown here, depicts the young author playing the harp and tapping his foot next to a personification labeled Melody who inspires him. His audience consists of a personification of Mount Bethlehem, the male figure in the lower right corner (the city of Bethlehem is at the upper left); an unidentified female

Fig. 5-10. Mosaic above central door, inner narthex, Hagia Sophia Cathedral, Constantinople, ninth–early tenth century. Wikimedia Commons/Myrabella, CC0 1.0.

Fig. 5-11. David as harpist, Paris Psalter, 37 × 26.5 cm, mid-tenth century; Paris, Bibliothèque nationale de France, MS gr. 139, fol. 1v. Photo from Bibliothèque nationale de France.

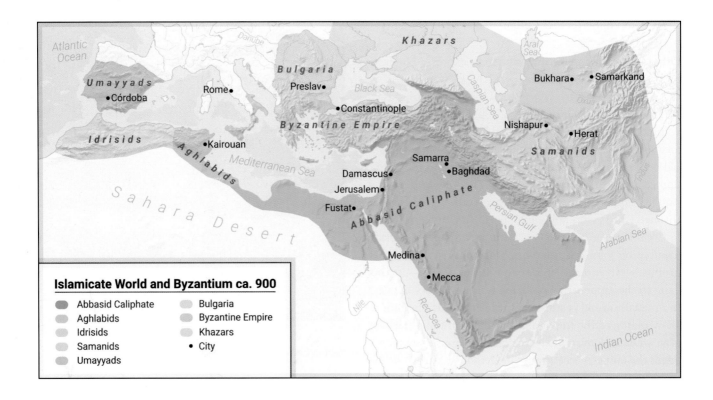

Islamicate World and Byzantium ca. 900

- Abbasid Caliphate
- Aghlabids
- Idrisids
- Samanids
- Umayyads
- Bulgaria
- Byzantine Empire
- Khazars
- • City

spectator, half hidden behind a column, who may represent Echo; and numerous sheep and other animals, tamed by the shepherd's music just as Orpheus in ancient art and literature tamed wild animals by playing his lyre. A tenth-century Byzantine court poet praised an unnamed ruler as a new Orpheus, able to tame the wild and bring harmony and peace to his kingdom. David's pacification of his surroundings is therefore analogous to that of the Byzantine emperor. The abundance of personifications (not part of the biblical text), corporeality of the figures, and convincing treatment of natural-looking space demonstrate the continuation of classical-looking arts in the Byzantine world, especially during the later ninth and tenth centuries.

After the Abbasids defeated the Umayyad dynasty in 750, the second Abbasid caliph, al-Mansur (r. 754–75), moved the capital to Madinat al-Salam (City of Peace) on the site of modern Baghdad, a location approved by court astrologers. Nothing remains of early Abbasid Baghdad, which was built of unfired brick beginning in 762, but Arab geographers reported that it was a round city, surrounded by walls and a moat, with four main streets and four monumental gates facing the cardinal directions. Isolated in the open central plaza were a mosque and a palace topped by a massive green dome: the caliph ruled at the center of the city and, symbolically, the center of the universe. This diagrammatic expression of power on a huge scale emulated Sasanian urban planning, including the round city of Gur (now Firuzabad, Iran) built by the first Sasanian ruler, Ardashir I; Gur had a palace and fire temple at its center.

Baghdad was a cosmopolitan city with a population of Sunni and Shi'i Muslims, Zoroastrians, Jews, and Chris-

tians, especially Nestorians (box 2-1). This diverse population helped Baghdad become an international center of learning. Among other activities, the caliphs supervised an extensive project to translate ancient Greek authors into Arabic; many Greek books were acquired from the Byzantines, and other texts were translated from Syriac and Persian. This translation activity helped disseminate ancient Greek knowledge in the Arabic-speaking world and prompted ambitious research projects, including the construction of an observatory to test the theories of Ptolemy, the second-century astronomer and geographer whose ideas endured throughout the Middle Ages. Furthermore, this research carried an ideological and theological charge, because it fueled the formation of Islamic philosophy and expressed the potent idea that the Abbasids, rather than the Byzantines, were the inheritors and protectors of classical knowledge.

In 836 the caliphs abandoned Baghdad—mostly to escape conflicts between the local citizens and the Turks from Central Asia who composed the army—in favor of a new capital constructed at Samarra, 125 kilometers up the Tigris River to the north. Samarra is a shortened form of Surra man ra'a, "He who sees it is delighted." The palace was in the northern part, and gardens, elite residences, military barracks, and markets were organized along a grand avenue running south for seven kilometers. Under Caliph al-Mutawakkil (r. 847–61), a large new palace expanded the complex to the north. The main construction material for the city was fired mud brick, readily produced in huge quantities along the banks of the Tigris. The fragility of this material, along with centuries of looting, means that few buildings remain at full height. One structure that

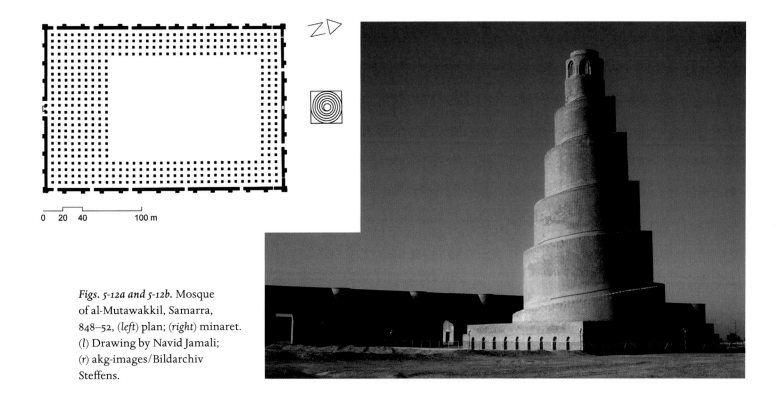

Figs. 5-12a and 5-12b. Mosque
of al-Mutawakkil, Samarra,
848–52, (left) plan; (right) minaret.
(l) Drawing by Navid Jamali;
(r) akg-images/Bildarchiv
Steffens.

does is the striking tower (*manara* or minaret) that stood outside al-Mutawakkil's first mosque (848–52), which at that time was the largest Islamic prayer hall in the world (fig. 5-12). This expansive hypostyle hall, with its dense grid of columns, emulated Achaemenid forms like those at Persepolis (fig. 1-4), thereby bringing up to date the local vocabulary of imposing scale, authority, and prestige. The minaret rises over fifty meters from a square base; its exterior ramp makes five complete turns up to a cylindrical platform. More than six thousand cubic meters of fired bricks were used for the spiral tower, which may have been inspired by a nearby ancient ziggurat (stepped pyramid). Whereas earlier mosques might have one or more towers, usually at the corners of the courtyard, al-Mutawakkil's minaret helped standardize mosque design under the Abbasids. Such tall minarets, erected on the opposite side of the complex from the qibla wall and often on the same axis as the central mihrab, were built to be visible from afar to proclaim the presence of Islam and identify the location of the Friday mosque. Only later did minarets become the place from which the faithful were summoned to prayer.

The mosque, palaces, and elite houses at Samarra were lavishly decorated with stucco, marble, wood, glazed ceramic tiles, mosaics made of imported tesserae, and inlays of locally produced clear, purple, and millefiori glass. Figural wall painting was used in domestic settings. Stucco had been an important material in late antiquity, used at the Neonian Baptistery in Ravenna (fig. 2-24), in Sasanian Ctesiphon (fig. 3-33), and in some Umayyad palaces. At Samarra, the malleable material provided a relatively inexpensive way to finish the mud-brick walls and add layers of visual complexity to them. It was used mostly to ornament

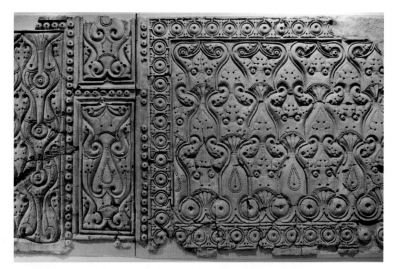

Fig. 5-13. Stucco panel, Samarra, 130 × 225 cm, ninth century; Museum für Islamische Kunst, Berlin. Wikimedia Commons/ Miguel Hermoso Cuesta, CC BY-SA 4.0, modified.

the dado zone of reception rooms, decorative niches, and mihrabs. The more naturalistic vegetal designs, derived from earlier models, were carved into a dry stucco panel into which details were then drilled or incised, whereas in the more abstract and geometric examples, repeating three-dimensional patterns were created by pressing a mold into wet stucco, cutting into the surface at oblique angles (fig. 5-13). This so-called beveled style was an artistic innovation created in ninth-century Baghdad or Samarra that was widely imitated in other media (wood, marble, glass) and disseminated across the Islamicate world. It contributed to the development of continuously repeating,

abstract vegetal or geometric designs called arabesques that frequently embellish later Islamicate arts.

The best-preserved caliphal city is Madinat al-Zahra' (Shining City), near Córdoba (Spain), begun by the Umayyad ruler 'Abd al-Rahman III in 936 soon after he declared himself caliph (fig. 5-14). This declaration had no impact in the eastern Islamic lands because the Umayyads did not oversee the Muslim sacred places in Arabia, but it was an assertion of power directed at Muslims and Christians in the western Mediterranean region. The elevated site was easily visible during ceremonial processions from Córdoba, but entry was strictly controlled. The city occupied a large rectangular area, about 750 by 1,500 meters, surrounded by a double stone wall. It was built on three terraces, with the lowest containing markets, barracks, and homes of the artisans and workers; gardens and orchards were in the middle; and the administrative and residential buildings of the court were higher up. The city's elaborate sanitary infrastructure, with 1,800 meters of subterranean water channels fed by an old Roman aqueduct, was unparalleled at that date. A Friday mosque—properly oriented toward Mecca, unlike the Great Mosque in Córdoba—was built on its own platform for easy access by the dignitaries living above it and the poor living below.

As at Samarra, several structures afforded dramatic views over the gardens and countryside. One such mirador (place for viewing) is the so-called Salón Rico ("rich chamber"), a wooden-roofed, three-aisle reception hall that opens to the valley to the south, overlooking a quadripartite garden and pool containing another viewing pavilion (fig. 5-15). Miradors were not only places for pleasure but also ideological statements; the caliph's ability to survey the lands under his control expressed and enhanced his dominance. The architecture of the Salón Rico displays horseshoe arches and red and white voussoirs similar to those in Córdoba's Friday mosque (fig. 4-17), to which 'Abd al-Rahman III added a monumental minaret like the one at Madinat al-Zahra'. The caliph's place in the room was signaled by a decorated blind arch, called a mihrab by contemporary viewers. This evocation of sacred architecture reflected the caliph's status as leader of the faithful. Marble from North Africa was used for the wall revetment and the deeply carved, lacelike column bases and capitals, many of them signed by the artists. Such signatures remind us of the ability of the caliph to marshal large numbers of artists whose expertise helped create a sophisticated planned city. The stucco decoration in the audience hall was carved, not molded; inscriptions record the names of an overseer and various carvers and provide a date for the decoration between 953 and 957. The framing of the caliph's power in

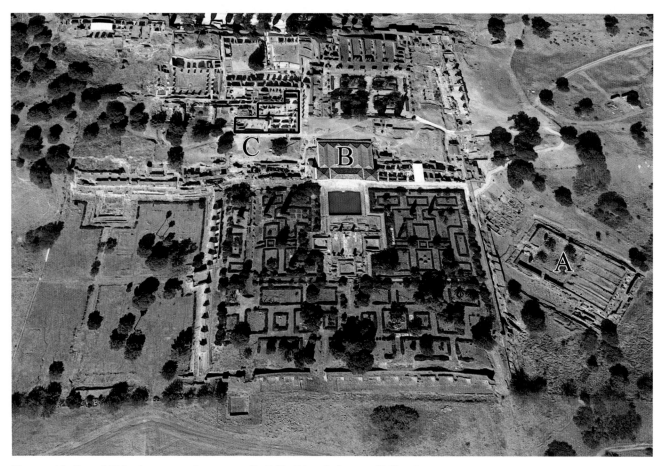

Fig. 5-14. Madinat al-Zahra', 936–1031; A=mosque, B=Salón Rico, C=house of Ja'far. © 2019 Google, © 2019 Instituto de Cartografía de Andalucía, Maxar Technologies, Map data © 2019.

this architectural setting was complemented by the display at Madinat al-Zahra' of locally sourced Roman statues and sarcophagi. Even though such a display was unparalleled, it was part of the Islamicate world's larger valorization of antique culture, often manifested in the copying of classical and Persian texts. 'Abd al-Rahman III wanted his cultural capital to compete with Samarra and Baghdad both in learning and in luxury, and building continued on the site under his son and successor al-Hakam II. Nevertheless, when the Umayyad caliphate was dissolved in 1031, Madinat al-Zahra' was looted and forgotten until excavations began in 1910.

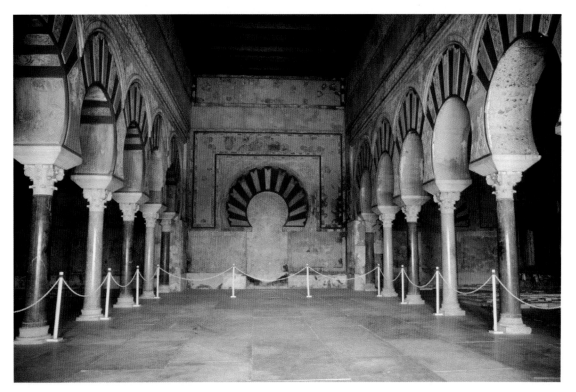

Fig. 5-15. Salón Rico, Madinat al-Zahra', 953–57. Photo by D. Fairchild Ruggles.

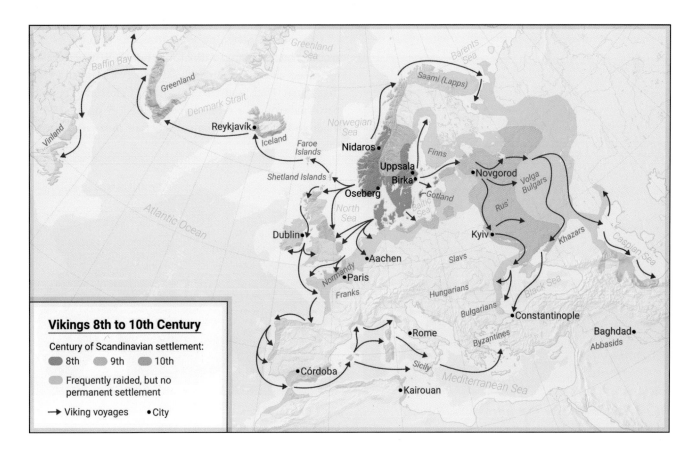

Work in Focus:
THE OSEBERG SHIP

Unlike the boat buried in Mound 1 at Sutton Hoo in the seventh century (fig. 3-15), the ship discovered under a mound at Oseberg in eastern Norway in 1903 is almost intact (fig. 5-16). This elegant wood vessel, its curving prow and stern decorated with interlaced animal figures carved in relief, could accommodate thirty oarsmen. It was pulled ashore to serve as the final resting place for two women, who were laid out on a bed in a wooden chamber dated by dendrochronology to 834. Surrounding the bodies were numerous animals (cows, horses, dogs), sailing and farming gear, furniture and household equipment (including six looms), food, and items of dress and personal adornment, presumably things the women had used while alive. Their high social status is evident from the quantity and quality of grave goods. Although their precise identities are unknown, scientific studies have revealed a lot about them. One had been in good health when she died in her fifties, and the other, suffering from cancer and multiple injuries, was over eighty years old (carbon-14 dating of the women's bones confirmed the tree-ring dating). DNA analysis suggests that the younger woman came from a genetic group unknown among modern Europeans but common in Iran. Nevertheless, the type of ship and grave goods show that this was a Viking burial. The eighth through the eleventh centuries are commonly called the Viking Age in northern Europe. The polytheistic Vikings (from the Old Norse word for raider or pirate; also known as Northmen or Norsemen) traveled widely from their homeland in Scandinavia, trading and raiding in Britain, Europe, and as far away as Constantinople, Rus', and the east coast of modern Canada. The finds from Oseberg provide the largest and richest assemblage of art and artifacts from the early Viking period.

Among the wooden objects, a large cart made of oak, ash, and iron was already old when it was placed into the Oseberg ship (figs. 5-17 and 5-18). Its back is carved with felines and writhing serpents; the front has men being attacked by snakes. It is likely that both scenes relate to the origins of the cosmos and the interaction of gods, people, and the natural world. Norse myths recorded in the thirteenth-century *Völsunga Saga* (heroic family history) may provide an interpretive key to the cart's imagery. The man among serpents could be Gunnar, who was thrown into a pit of poisonous snakes by his sister's husband, Attila the Hun, who sought to terrify her into submission to gain the siblings' gold. Given that heroes frequently fight fierce animals and supernatural beasts in Norse literature, however, the cart's imagery may be more general.

Other finds in the burial that relate to the menacing natural world include five curved wooden animal-head posts that resemble lions and wolves, depending on ear shape (fig. 5-19). They have pronounced eyes, open mouths, and visible teeth and were linked by rope through the mouths, as if with a rein. Stylistically they show the continuation of the Animal Style typical of earlier northern European art (fig. 2-15). The posts were found together with five objects conventionally identified as rattles. Composed of iron rings and lashed to the animal-head posts with rope, these noisemakers were evidently used in the burial ritual. Placed around the corpses, they either protected the dead women or safeguarded the living from them.

One of the intriguing finds from the ship burial is a wooden bucket bound with bronze hoops. Where the handle meets the bucket on each side is a cross-legged figure (fig. 5-20a). Each body is composed of cloisonné enamel patterns around a cross-shaped millefiori panel. Likely made in Ireland some centuries before they were reused

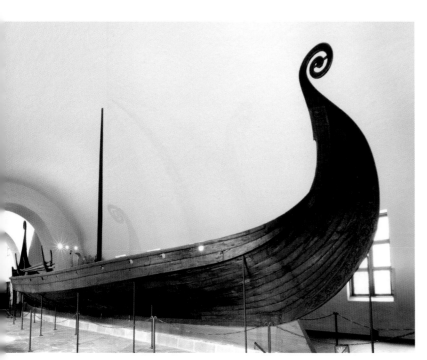

Fig. 5-16. Ship, Oseberg, ca. 5.1 × 21.5 m, ca. 834; Vikingskipshuset, Oslo. © Genevra Kornbluth.

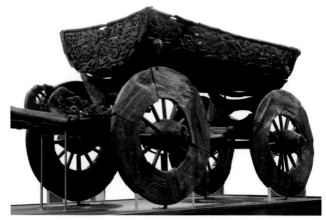

Fig. 5-17. Carved cart, L 263 cm, eighth century, in Oseberg ship burial, ca. 834; Vikingskipshuset, Oslo. © Genevra Kornbluth.

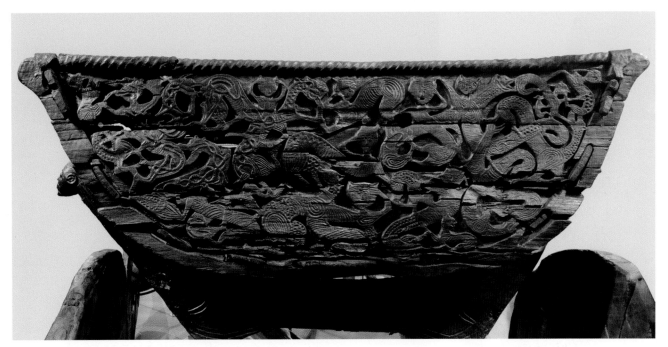

Fig. 5-18. Back of carved cart, W 169 cm, eighth century, in Oseberg ship burial, ca. 834; Vikingskipshuset, Oslo. © Genevra Kornbluth.

on the bucket at Oseberg, the schematic figures resemble those in early medieval metalwork (fig. 3-16). Their cross-legged pose is derived from that of the ancient Celtic deity Cernunnos, who was often represented as squatting. The artifact may have been taken in a raid, kept as an heirloom, and then reused on the bucket, but whether the figures were meant to refer specifically to Cernunnos cannot be determined.

The huge quantity of textiles found in the Oseberg ship varies widely in material, technique, and quality. The multicolored wool-and-flax tapestry found in fragments in the burial chamber depicts houses, people, animals, and carts, all moving toward the left in a processional scene that probably derived from Norse religion or history (fig. 5-20b). Norse sagas include many references to noblewomen embroidering, weaving, and sewing, which suggests that women made these complex works and that such textiles were highly esteemed in Viking society. Additionally, over one hundred pieces of samite were folded and stitched to garment hems, a widespread decorative practice in the medieval world. The oldest embroidery found in Scandinavia, multicolored silk with animal, vegetal, and geometric patterns, probably decorated clothing as well. Recent analyses reveal that the silk came from three sources: lower-quality pieces from Sogdian Central Asia, marked by unevenness and errors; a higher-quality group from Byzantium or the eastern Mediterranean region, notable for such costly dyestuffs as kermes (a red color obtained from a louse that lives in oak trees near the Mediterranean); and a final group, from Central Asia or China, that contains unspun fibers. Silk was scarce in ninth-century Scandinavia, and some of the samite strips were recycled, turned inside out

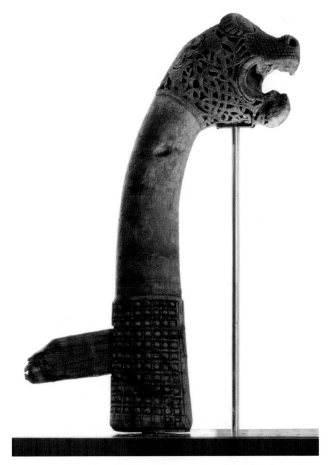

Fig. 5-19. Animal-head post, H ca. 50 cm, Oseberg ship burial, ca. 834; Vikingskipshuset, Oslo. © Genevra Kornbluth.

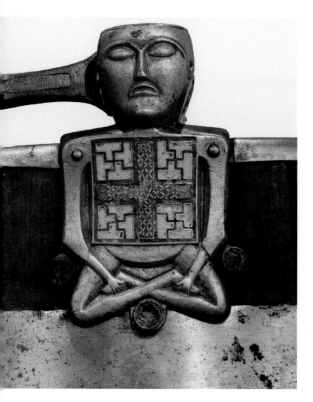

Figs. 5-20a and 5-20b. Oseberg ship burial, *(left)* bucket with enamels, detail of seventh-century component, ca. 7 × 3.5 cm, seventh century; *(right)* tapestry fragment, H 23 cm, before 834; Vikingskipshuset, Oslo. © Genevra Kornbluth.

when the shiny face became dull. Silk arrived in Norway via long-distance trade or as gifts or loot. Like the figure on the bucket, the Oseberg textiles demonstrate how extensively ninth-century Norsemen participated in commercial networks. The many different objects in the burial show technological expertise and the ability to produce intricate figural and decorative imagery. Vikings were not only the destructive invaders imagined in modern culture.

Memory and Memorialization

Four widely separated monuments show how the memories of individuals, families, and whole communities could be integrated into public and semipublic settings. The first example is a large sculpted rock, one of about six hundred so-called picture stones that date from the second to the twelfth century and illuminate different aspects of Scandinavian art and culture. This one from Tjängvide, on Gotland (Sweden), likely dates to the ninth or tenth century and depicts in its lower register a longship with curving ends like the one buried at Oseberg (fig. 5-21). This suggests that such stones can be used to reconstruct material culture, and it also provides insights into the processes of artistic production. The horse, the dog or wolf (on the lower left in the upper zone), the sail, and several of the interlace patterns were all drawn with templates, possibly made of lead or leather and reused over a long period, indicating mass production and standardization of imagery in this

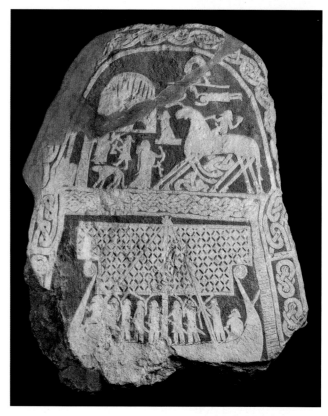

Fig. 5-21. Picture stone, Tjängvide, 170 × 120 cm, ninth–tenth century; Historiska museet, Stockholm. © Historiska museet 2017. Ola Myrin; CC BY 2.5 SE.

type of work. It is also clear that the images and accompanying runic inscription were designed together; the text along the right inner border of the lower zone accommodates the spear tip that projects from the ship.

Many of the carved motifs belong to the realm of Norse sagas and legends, although the precise identity of the main figures has been debated. The upper narrative includes an eight-legged horse facing a long-haired woman who holds a drinking horn, and around them are a house, a dead figure, and the dog or wolf. The horse has been identified as Sleipnir, who transported the Norse god Odin through multiple worlds; this would make the woman a Valkyrie, a spirit who helped Odin select warriors to die and join him. Sleipnir is not the only horse with this powerful attribute, however. The hero Sigurd rides a horse descended from Sleipnir in the *Völsunga Saga*; might his story be depicted here? Sigurd was most famous as a dragon slayer, and the interlaced coils under the horse may represent such a beast. If the rider is Sigurd, then the other figure is likely

Brynhild, who greets her lover Sigurd with a drink when he arrives holding a fabulous engagement ring (the saga also recounts that she made a tapestry of his heroic deeds). In the later Middle Ages Sigurd and Brynhild were considered the ancestors of the Norwegian royal house (they are known as Siegfried and Brunhilda in the German tradition). Scenes of heroism, romance, and betrayal appear on many of the Gotland picture stones. At the same time, the prominent horse on the Tjängvide monument could allude to funerary rituals; fifteen horses were buried in the Oseberg mound. The runic texts, only partly preserved, refer to the stone being "raised in memory of his brother, Hjôrulfr," so it is certainly a commemorative work. The red background color was added in the mid-twentieth century to make the images more legible, an enhancement that would never be done today.

A tall sandstone slab served as a site of memory for Pictish people in Aberlemno (Scotland), probably in the eighth or ninth century (fig. 5-22). The Picts, who lived north of

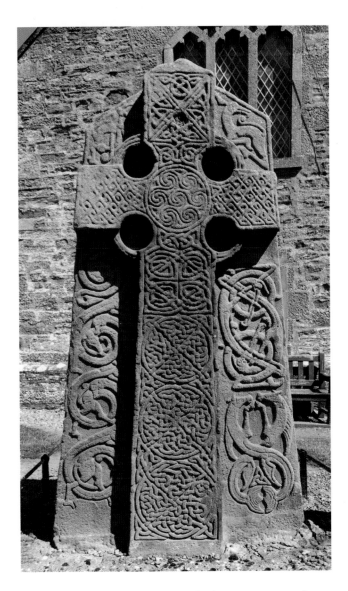
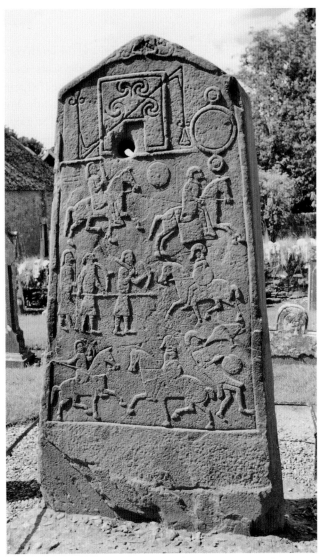

Figs. 5-22a and 5-22b. Picture stone, Aberlemno, H 229 cm above ground, maximum W 127 cm, eighth or ninth century, (*left*) side with cross; (*right*) side with battle scene. (*l*) Photo by the authors; (*r*) Photo by Michael Bradley.

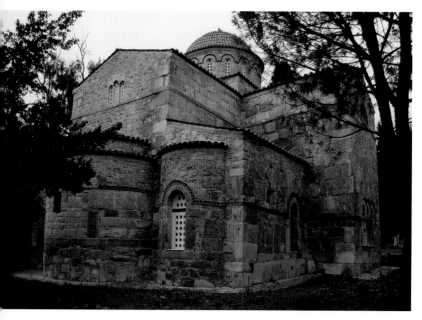

Figs. 5-23a and 5-23b. Koimesis church, Skripou, 873/4, *(left)* exterior from the northeast (Lioba Theis); *(right)* detail of central apse. *(l)* Photo by Lioba Theis; *(r)* Photo by Brad Hostetler.

Hadrian's Wall between about the third and the tenth centuries, when they were amalgamated with the Scots, were so named by the Romans because of their "painted" (Latin *picti*) or tattooed skin. Picts left few written records, but they are mentioned in such sources as the *Life of St. Cuthbert*. Pictish picture stones first appeared in the eighth century, a date derived from the depiction of weaponry, which is sometimes datable from archaeological contexts. On one side of Aberlemno 2, one of four such slabs in that town, a cross carved in high relief is ornamented with interlace and other repeating patterns and surrounded by interlaced and isolated animals that are characteristic of Pictish art. On the other side, a battle on foot and horseback unfolds beneath a series of incised symbols. Battle scenes are rare on Pictish stones and in early medieval art in general, and this may be a specific one: the Picts' victory over the Anglo-Saxons at Dùn Neachdain (Nechtansmere) in 685. The Angles wear helmets; the one at lower right is being pecked by a raven. That battle was long thought to have occurred only five kilometers from Aberlemno, but its precise location is now disputed. Even if the scene does not depict a specific event, the carvings exhibit both the success of Christianity (introduced in the sixth century) and the continued existence in the region of a pre-Christian symbolic language. This and other stones were evidently erected to commemorate local power in the context of land ownership and boundary marking; an original connection with burial cannot be confirmed despite the current churchyard cemetery setting of Aberlemno 2.

A large domed church dedicated to the Koimesis (Dormition or Sleep) of the Virgin at Skripou, in central Greece,

in 873/74 demonstrates how local memory could be integrated architecturally and epigraphically in a Byzantine work (fig. 5-23). Skripou was on the site of the ancient Greek city of Orchomenos, the legendary home of the Three Graces, and ancient blocks, columns, and funerary markers were reused as spolia in the walls of the church. That the patron, a high-ranking court dignitary named Leo who probably retired to Greece from Constantinople, did this deliberately is clear from the numerous inscriptions displayed on the exterior. Three prose texts placed on the eastern, more sacred part of the church express hope that Mary will ensure salvation for Leo and his family, while an epigram (poem) on the west facade, near Leo's tomb in the narthex, celebrates the patron whose "work"—the church and its inscriptions—will never be forgotten. The poem's emphasis on "endless cycles of time" relates to the rare ninth-century sundial set into the south wall, which marks the passing of time each day. The presence of the sundial, abundant spolia, and multiple Greek inscriptions underscores the patron's learned, antiquarian tastes, which corresponds with contemporary interests not only in Byzantium but, as noted above, in the Islamic courts as well.

The proliferation of inscriptions is an important feature in Byzantine posticonoclastic art, and the Tokalı Kilise (Buckle Church, named for a now lost decoration) complex in Göreme (in modern Turkey's Cappadocia region) also contains many such texts. A fragmentary dedicatory inscription credits someone named Constantine with commissioning the church paintings, and another cites Nikephoros as the artist, with funding from Leo, son of Constantine. All the scenes and figures are also labeled,

and, exceptionally, the words spoken by many of the protagonists are inscribed. For example, the Roman soldier in a depiction of the Crucifixion says, "Surely he was the son of God" (Matt. 27:54), which helps the picture come alive for the spectator.

The Tokalı Kilise complex is evidence of the growing importance of Cappadocia in the ninth century. After the Umayyad invasions of 717–18, the population moved from the cities to small fortified towns, with economic growth grounded in large agricultural estates owned by local elites. Both domestic and religious structures were carved into the region's soft volcanic rock. One of these was the cell of an unknown hermit (presumably a man), and the presence of this local holy figure motivated the excavation in the second decade of the tenth century of an adjacent church (fig. 5-24). Known as Old Tokalı Kilise, it was a single-nave, barrel-vaulted space preceded by a vestibule. About 960, a transverse, barrel-vaulted nave with three apses and an attached funerary chapel (parekklesion) replaced the east end of the older church, creating a combined T-shaped space. This larger church, known as New Tokalı Kilise, contains high-quality frescoes in which blue pigment derived from lapis lazuli predominates; the haloes of Christ and his mother are gilded (fig. 5-25). The richness and quality of the paintings have led scholars to conclude that New Tokalı Kilise was a product of imperial patronage. The church does testify to the quality of Byzantine painting in a period when nothing is preserved in Constantinople, but art of high quality need not be imperial; local elites were wealthy enough to afford the commission. It has been estimated that New Tokalı took about four man-years to excavate, meaning that if four men did the work, it would have taken one year. A calculation of their salary, plus the expense of gold, lapis, and other supplies, yields a total cost of about thirty-seven pounds of gold (2,664 nomismata)—about the same price as constructing a village or acquiring a personal library and well within the reach of an elite resident of Cappadocia.

The paintings in New Tokalı Kilise depict conventional Christological scenes and images of saints on the walls, and stories from the life of Christ continue on the nave vault. The choice to replace the customary Theotokos and Child in the central apse with a Crucifixion was probably meant to emphasize themes of death and afterlife, underscoring the new funerary function. A lower church hewn at the same time that the old church was extended provided additional burial spaces (fig. 5-24). An interesting feature of the complex is the small hole cut through the rock between the hermit's cell and the old church, which provided the hermit with a privileged view of the original Old Tokalı apse and the later Crucifixion. Such devices were not uncommon in medieval Christian buildings, for they allowed a recluse to be physically removed from others but still have visual access to church services and imagery. A

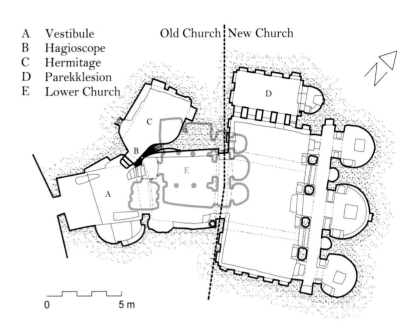

A Vestibule
B Hagioscope
C Hermitage
D Parekklesion
E Lower Church

Old Church | New Church

0 5 m

Fig. 5-24. Tokalı Kilise complex, Göreme, tenth century, plan. Drawing by Navid Jamali.

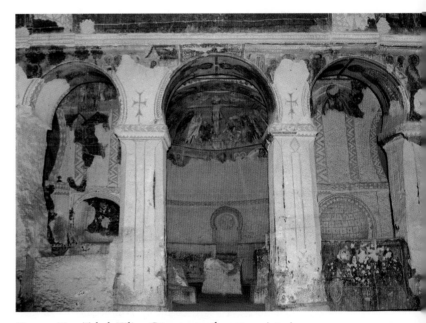

Fig. 5-25. New Tokalı Kilise, Göreme, tenth century, interior toward the east. © Mustafa Uysun.

person standing in the vestibule of Old Tokalı Kilise had a different sightline, however, directed to a small niche to the left of the Crucifixion apse, which contains an image of Mary tenderly holding Jesus (fig. 5-25). This icon was covered with pious graffiti and soot from candles, which means that it inspired particular devotion. As a whole, Tokalı Kilise responded to the needs of both living viewers and the deceased buried inside and underneath, for whom the decorative program offered hope of salvation.

Work in Focus:
THE SAMANID MAUSOLEUM

Even though the Abbasids remained the titular heads of the Muslim world until the Mongols arrived in the thirteenth century, considerable power was in the hands of other groups who pledged allegiance to the caliphs in Baghdad but were essentially independent. The Samanids were among the most important of these dynasties, from the time of their unification in 892 until their defeat in 999 by a Turkic dynasty, the Qarakhanids (r. 999–1211). The Samanid emirate (province ruled by an emir, Arabic for

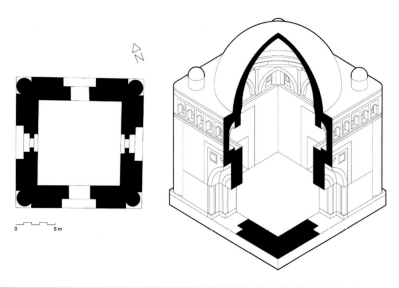

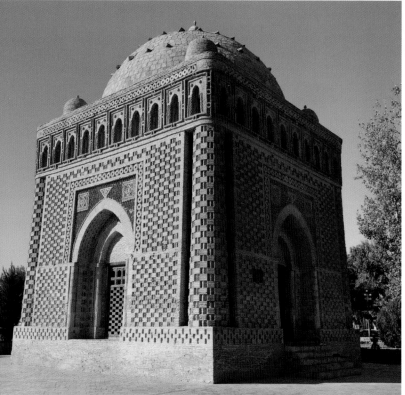

Figs. 5-26a and 5-26b. Samanid mausoleum, Bukhara, ca. 907, (*top*) plan and section; (*bottom*) view from the southeast. (*t*) Drawings by Navid Jamali; (*b*) Photo by the authors.

commander) controlled major trade routes in what had been Sogdian territory—roughly modern Uzbekistan and neighboring states. They minted their own currency, and huge quantities of Samanid dirhams (silver coins) have been found in Russia, Ukraine, and especially Sweden; the coins were acquired by the Vikings in exchange for fur, slaves, amber, and weapons. The Samanids were thus essential participants in trade between northern Europe and Central Asia, the so-called Fur Route, which went through the Jewish Khazar kingdom in the southern Russian steppes and then along the Volga River. The Samanids also traded with Turkic nomads to their north (and were the main emporium for Turkish slaves) and with China to the east. Their capital at Bukhara and their principal mint at Samarkand were important trading centers on the overland Silk Routes, the ancient network of roads that linked China with western Asia, Byzantium, and Europe.

The Sunni Samanids claimed to be descendants of the Sasanians and promoted Persian as the language of government and literature. Even though this revitalized Persian literature was written in Arabic script, it forged connections between the distinguished Sasanian past and the Sunni present and fueled a sense of Iranian identity. The greatest Persian poet of the Middle Ages, Abu'l Qasim Ferdowsi (or Firdausi), author of the Iranian national epic known as the *Book of Kings* (*Shahnameh*), was born in the Samanid realm around 940, although his chief patron was the first Ghaznavid sultan, who helped overthrow the Samanids in the 990s. Samanid literary and artistic production demonstrated that Islam could extend beyond the Arabian peninsula and the Mediterranean region to become a multilingual and multicultural faith. For a century Bukhara was a thriving cultural center that rivaled Baghdad and Córdoba.

Central Asia had no pre-Islamic tradition of monumental tombs because the Sogdians and the Sasanians before them followed the Zoroastrian practice of exposing the dead body, not preserving it. The Samanid mausoleum in Bukhara stands at the head of a long line of domed square mausolea in the Muslim world (fig. 5-26). This cubic building, measuring about ten meters on a side, reuses the basic plan of Sasanian fire temples in Iran, the chahar taq open on four sides (fig. 3-35), making a clear reference to the Samanids' invented ancestry but without any of the original Zoroastrian associations. Built for Isma'il ibn Ahmad (r. 892–907), the founder of the dynasty, the tomb uses baked bricks for both construction and decoration. Previously the region's important buildings had been built of unbaked brick, covered with stucco; the exception to this rule is the sixth-century fire temple at Takht-e Soleyman, which was made of baked bricks. Despite the apparent geometric rigor of the mausoleum's design, not all of it serves structural purposes; the four tiny rooftop domes are not supported by, and indeed are offset from, the four engaged columns at the corners.

The Samanid mausoleum is notable for its structural ornament—that is, walls built of bricks laid in elaborate patterns. This contrasts with Sasanian, Umayyad, and Abbasid architectural ornament, which tends to be applied to the wall surface. On the uppermost register of the walls is an arcade with columns made of carved stucco, and at the very top of the walls and around each door is a band of brick circles that evokes a pearl border. Such borders have a long history in Sasanian and Sogdian arts, especially metalwork and textiles (fig. 3-34), but here they take on monumental proportions. The spandrels of the door frames contain geometric motifs; centered above each door is a triangle whose stylized decoration may represent a pair of wings, such as those found on Sasanian crowns (fig. 5-27; compare fig. 3-33). Because of its potential for ornamental elaboration, laying baked bricks in different orientations became a characteristic feature of eastern Islamic architecture from the tenth century onward.

On the interior, the transition from the cubic base to the circular dome is made by four squinches placed diagonally across the right angle of each corner (fig. 5-28). The squinch was not new—it may have originated in Sasanian Iran, and it was used occasionally in Roman and early Christian architecture (fig. 3-31b)—but here it is divided by a central rib, decorated with carved stucco and brick, that creates two concave, windowed triangles. This fragmentation of the squinch surface into multiple planes foreshadows or

may even be the first example of the Islamic architectural ornament known as *muqarnas*. This surface treatment, essentially a multiplication of tiny squinches, is discussed at length in chapter 7.

The Samanid mausoleum also has the earliest surviving building inscription from the Iranian Islamicate world, on the wooden lintel above the eastern entrance. Now almost illegible, it seems to name Nasr II, who was buried at the site in 943. Three tombs were found under the floor: for Nasr II, his grandfather Isma'il (the patron of the building), and Isma'il's father. Isma'il was revered locally as a

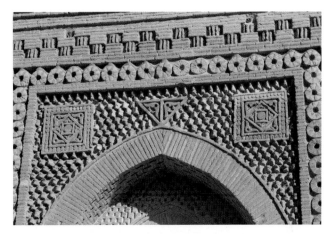

Fig. 5-27. Portal detail, Samanid mausoleum, Bukhara, ca. 907. Photo by the authors.

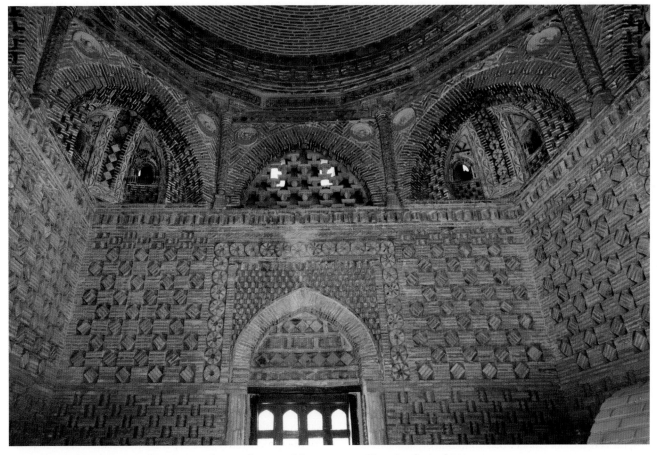

Fig. 5-28. Interior with squinches, Samanid mausoleum, Bukhara, ca. 907. Photo by the authors.

saint, which in this setting meant that he was endowed with *baraka* (Arabic for blessing; spiritual power) and could receive intercessory appeals. Despite the Qur'an's insistence on monotheism and concerns about improper worship, veneration of such local figures was not uncommon. Before a recent clearing of the area, the mausoleum was surrounded by the graves of those who wanted to be buried near the Samanid emirs, much like the proliferation of tombs around the bodies of Christian saints. Isma'il ibn Ahmad's building successfully redirected pilgrimage away from the preexisting tombs of two legendary pre-Islamic heroes at the gates of Bukhara and toward the new mausoleum of the Muslim dynasty. This kind of pilgrimage is called *ziyara* (visit) in Arabic (*ziyarat* in Persian) to distinguish it from the hajj to Mecca required of all Muslims.

Working with Words

While inscriptions vary widely in purpose and effect, many in this period draw attention to the skills of the artist or scribe. Samanid epigraphic pottery attests to the growing importance of text and calligraphy in Islamicate arts. These ceramics were typically made of reddish clay covered with a white slip (watery clay) and decorated with short sayings written with a reed pen or stenciled in black (manganese and iron) or red (iron) slip; vessels then received a clear lead glaze before firing (fig. 5-29). The white ground was almost certainly meant to imitate Chinese porcelain, widely acknowledged in the Middle Ages as the finest ceramic. These plates and bowls ornamented only

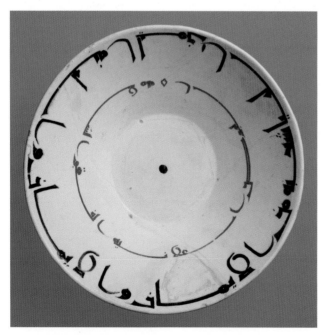

Fig. 5-29. Epigraphic bowl, 9.6 × 26.9 cm, tenth century; Harvard Art Museums/Arthur M. Sackler Museum, Cambridge, MA, the Norma Jean Calderwood Collection of Islamic Art. © President and Fellows of Harvard College.

with script stand apart from contemporary and earlier wares decorated with polychromy and often with figural imagery. Surviving in large quantities, epigraphic ceramics were made in only two places, Nishapur (Iran) and Samarkand, and then exported across eastern Iran and Central Asia. The tenth-century bowl shown here is inscribed in black, "Modesty is a branch of faith, and faith is in paradise" and in red, "Greed is a sign of poverty." Anonymous proverbs and good wishes are the most common texts, but these lines are drawn from sayings attributed to Muhammad and 'Ali. An extra word was added between the end of the sentence and its beginning: "felicity" in the outer circle and "health" in the inner one. The painter took great care designing the letters, the lengths of their horizontals, and the gaps between words so they fill their ring-shaped space. Beautifying the text was the point, not legibility; the elongated letters of the Kufic script are hard to read. In addition, the words are in Arabic, even though that language was not spoken in Central Asia and the Samanids are associated with the promotion of Persian. About 20 percent of the known vessels are signed by the calligraphers who painted them, which reveals their pride in transforming utilitarian vessels into works of art. From the tenth century onward, calligraphy was a ubiquitous and revered form of Islamicate art.

Prominent inscriptions serve different functions on the ninth-century Altar of Sant'Ambrogio in the church in Milan (Italy) dedicated to its fourth-century bishop Ambrose. This is the oldest surviving golden altar revetment from across medieval Europe (fig. 5-30). On the front, facing the worshipers and the priest celebrating mass, twelve New Testament scenes flank an enthroned Christ in Majesty, four evangelist symbols, and twelve apostles, all worked in repoussé and separated by strips of gems, pearls, and enamel. The short sides depict pairs of bishops and martyrs, and on the back are another twelve scenes in partly gilded silver that narrate the life of St. Ambrose. Rectangular door panels give visual access, when open, to the porphyry sarcophagus that contains the relics of Ambrose and two early Christian martyrs whose bodies he discovered. A long inscription on the back by the "famed" bishop Angilbertus II (r. 824–59) identifies him as the patron of the "arca" and asks for God's blessing. The Latin term *arca* refers to a box for valuables, such as the Ark of the Covenant, and it could also refer to the tomb shrine of saints. Here, the glittering materiality was intended to transport viewers metaphorically to the paradisiacal Heavenly Jerusalem where the immaterial saints reside, as with other precious-metal reliquaries (fig. 4-22). Twelve gems surround the central Christ and twelve pearls adorn his halo, and these embellishments, along with the abundant gold, evoke the city described in Revelation 21:19–21. The doors on the back represent the entry to paradise, opened by means of saintly (and especially episcopal) intercession, proper liturgical participation, and devotional practice.

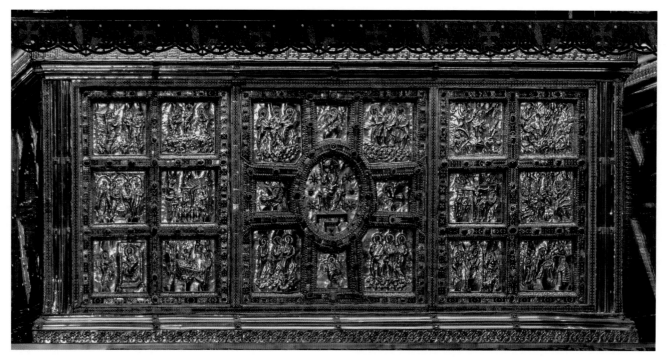

Fig. 5-30. Altar of Sant'Ambrogio, Milan, 85 × 220 cm, 825–59. © Mark Ynys-Mon, flickr.com/mymuk.

Of all the images, those on the doors are most informative about attitudes toward artistic production (fig. 5-31). On the left, St. Ambrose crowns Angilbertus, the patron of the altar, who is shown donating a cubic arca to the saint. The bishop's square halo indicates that he is living. In a mirror image on the right, Ambrose crowns the goldsmith who fabricated the work, Wolvinus, who extends empty hands toward the saint. This scene is inscribed "VVOLVINU(S) MAGIST(ER) PHABER" (Wolvinus [or Wolvinius] the master maker). We have encountered few named artists so far; they are identified much less often in medieval art than patrons, and the depiction of Ambrose crowning both patron and artist with eternal life is unprecedented. The imagery may be evoking biblical ideas, with Wolvinus representing Bezalel, the principal craftsman of the biblical Tabernacle and the Ark of the Covenant. Only the most privileged people would have seen these details, but the presence of the artist and patron on the altar—in both text and image—ensured that they would always be next to Ambrose's relics and their efforts not forgotten.

Medieval Islamic religious arts avoided figural images in the belief that God was the sole creator and artists should not usurp that role. The earliest Qur'ans received architectural imagery (fig. 4-9), but in one unusual manuscript the decoration is coloristic as well as calligraphic. This so-called Blue Qur'an is written in Kufic script on lightly ruled parchment colored with indigo or woad (fig. 5-32). Each large horizontal page (requiring about three hundred sheepskins for the entire book) has exactly fifteen lines of golden text with verses and sura headings marked in silver (now tarnished). Artists created the text by applying gold leaf to letters written in a transparent adhesive made

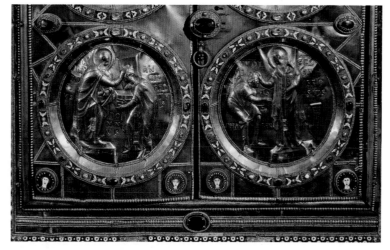

Fig. 5-31. Rear doors, Altar of Sant'Ambrogio, Milan, 825–59. © 2020. Photo Scala, Florence.

of egg white, gum, or sap, then burnishing the gold and outlining each letter in dark ink. The gold-on-blue format makes it resemble mosaic inscriptions in the Dome of the Rock. Over one hundred of the book's original six hundred pages are preserved, now scattered across three continents. Suggested places of manufacture include Abbasid Baghdad and Umayyad Spain, but most of the extant leaves are in Tunisia; it seems most likely that the Blue Qur'an was produced there in the early or mid-tenth century, using gold from sub-Saharan sources. Although the patron and artists of the Blue Qur'an are not known by name, they must have been familiar with luxury book production around the Mediterranean. Here, an exceptional quantity, quality, and handling of materials embellished the sacred book of Islam.

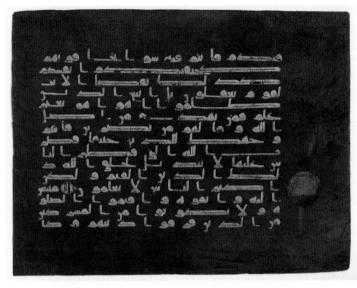

Fig. 5-32. Blue Qur'an, 30.4 × 40.2 cm, tenth century; New York, Metropolitan Museum of Art. Purchase, Lila Acheson Wallace Gift, 2004 (2004.88). Image © Metropolitan Museum of Art.

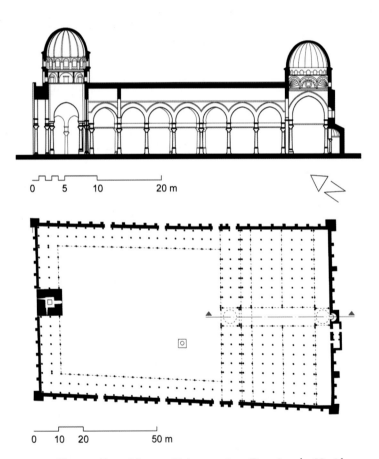

Fig. 5-33. Great Mosque, Kairouan, 850s. Drawings by Navid Jamali.

Until the mid-twentieth century, many leaves from the Blue Qur'an were housed in the Great Mosque of Kairouan (or Qayrawan), a cosmopolitan city that in the ninth century was the administrative center of the Aghlabids, who, like the Samanids, were ostensibly subordinate to the Abbasid caliphs but in reality were independent. They promoted the study of jurisprudence, medicine, astronomy, engineering, and translation. Kairouan's reputation as an international center of learning rivaled Baghdad's, and scholars from across the Islamicate world used and donated books to the extensive library of the Great Mosque. This Friday mosque was on the site of a seventh-century building notable for being the first mosque in the western Mediterranean (it was founded by a companion of the Prophet). Rebuilt in 836 by the Aghlabid emir Abu Muhammad Ziyadat Allah (r. 817–38), it was funded in part by the conquest of the island of Sicily from the Byzantines, which began in 827 (and was completed in 902). The mosque's location is broadcast by the massive minaret that stands opposite the single mihrab and was originally outside the mosque walls; as such, it echoed the layout of al-Mutawakkil's mosque at Samarra and signaled the patron's allegiance to the Abbasid caliph there (fig. 5-33). Nevertheless, many of the mosque's features highlight local materials and designs. The tiered three-story minaret resembles a Roman lighthouse like the one in nearby Lepcis Magna (fig. 1-30b, upper right), and the courtyard and prayer hall are full of Roman and Byzantine marble spolia.

The large hypostyle prayer hall is preceded by an irregular rectangular courtyard and is properly oriented toward the southeast. In plan, the wider aisle along the qibla wall and the central longitudinal aisle perpendicular to it form a *T* that can be compared with Christian basilicas with transepts. Here, however, the T shape highlights the processional route of the Aghlabid emirs and other dignitaries. This central aisle is differentiated from the rest of the hypostyle by greater height as well as width. Most of the columns that line the aisle are spolia, with impost blocks and a cornice placed on top of their capitals to create the tall horseshoe arcade that supports the flat roof (fig. 5-34a). A ribbed stone dome on shell-shaped squinches was erected immediately in front of the mihrab, embellishing and monumentalizing the space where the two wide aisles converge. The central axis leads to the maqsura, screened for the ruler's private prayer, located to the right of the mihrab adjacent to the qibla (fig. 5-34b). It is one of the oldest extant maqsuras, with wooden walls dating to the eleventh century.

In the 850s Emir Abu Ibrahim Ahmad (r. 856–63) oversaw several changes to Kairouan's mosque. He added a second ribbed dome over the central entrance to the prayer hall to enhance the T-plan's spatial differentiation. The stepped minbar associated with him is the oldest dated

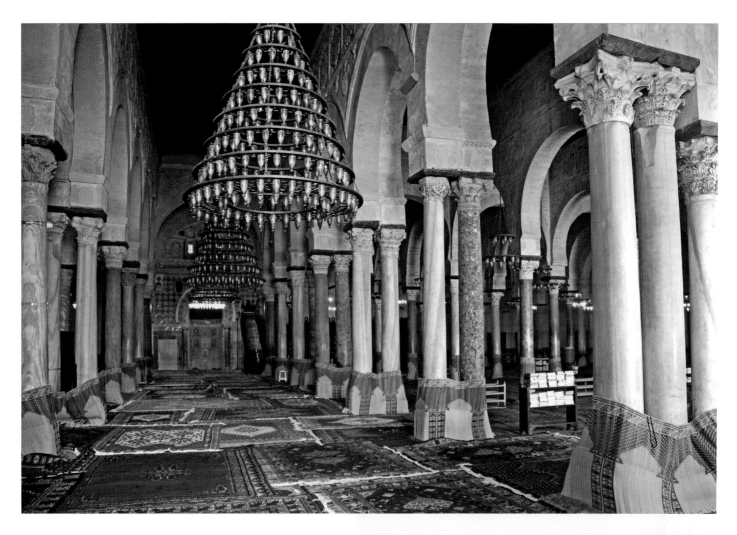

Figs. 5-34a and 5-34b. Great Mosque, Kairouan, 850s, *(top)* central aisle; *(bottom)* mihrab, minbar, and maqsura. *(t)* Dennis G. Jarvis, CC BY-SA 2.0; *(b)* Wikimedia Commons/IssamBarhoumi, CC BY-SA-4.0, cropped.

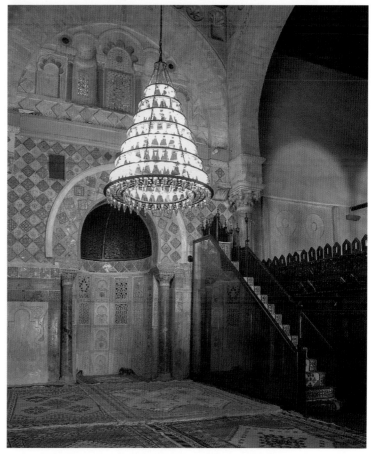

example in the Islamic world; the teak for the panels was imported from southeast Asia but probably carved in Iraq with vegetal and geometric patterns. The rebuilt mihrab was lined with white marble panels that were likely carved in Spain—an inscription credits a slave from al-Andalus, Abu' l-'Afiya, with the work (al-Andalus is the Arabic name for the Islamicate part of the Iberian Peninsula). A second inscription critiques the Christian Trinity: "God is one, he is eternal, he did not give birth and he was not born." The mihrab is further framed with lusterware tiles (box 5-2), all imported from Samarra or Baghdad, the epicenters of Abbasid power. In part because of its artistic elaboration and status as an important center of learning, the Great Mosque at Kairouan became the principal model for later mosques in northwestern Africa and southern Spain.

A very different center of learning is represented on the Plan of St. Gall, a carefully devised, schematic rendering of an entire monastic complex (fig. 5-35). Housed at the monastery of St. Gall in Switzerland, the plan was drawn

Box 5-2. LUSTERWARE

The luster-painted tiles around the mihrab at Kairouan were originally sent from Iraq to adorn the palace of Abu Ibrahim Ahmad. There was already a long tradition of glazed ceramics in Iraq, but a fashion for Chinese white ceramics helped spur the production of Abbasid finewares (as opposed to utilitarian wares for cooking, storage, etc.). Adopting an opaque white glaze created opportunities for highlighting decoration in blue and metallic luster. By the tenth century, whitewares were being produced across the Islamicate world (they also formed the technical basis for medieval European ceramics), but cobalt and luster decoration remained an Iraqi monopoly for over a century. Unlike many other pottery techniques, lusterware technology is not simple and could only have traveled with experienced artisans. Pigment containing diluted silver and copper oxides is applied to a white-glazed, fired vessel; it is then refired at a low temperature so the metal oxides are incorporated into the clear glaze, producing a lustrous sheen. The iridescent luster ranges from yellow and brown to red, purple, and green, and multiple colors are possible on a single piece, although golden monochrome luster eventually prevailed. The double firing increased the cost of the vessel substantially, but pricey Abbasid lusterware was exported west as far as Córdoba and North Africa and east to India and Thailand. By the eleventh century production ceased in Abbasid Iraq, which was then in economic decline, and the finest lusterware was made in Egypt under the Fatimids (chapter 6).

Fig. 5-35. Plan of St. Gall, 112 × 77.5 cm, ca. 820; St. Gallen, Stiftsbibliothek, Cod. Sang. 1092, recto. Photo from Stiftsbibliothek St. Gallen.

on five pieces of parchment stitched together. An inscription in the upper margin—one of over three hundred on the plan—says that it was designed for Gozbert, the abbot of St. Gall (r. 816–37), to "exercise your ingenuity and recognize my devotion." This devoted sender was probably Haito, the abbot of the nearby monastery at Reichenau (r. 806–23), which like St. Gall was an important religious, intellectual, and artistic center with a prominent scriptorium (room for writing books and documents). A large basilica dominates the plan, laid out in modular bays with an apse at each end; the west facade is flanked by two towers, as in the contemporary churches at Saint-Denis and Aachen. Crosses inside indicate multiple altars, permitting numerous masses to be conducted each day (an altar could be used for mass only once a day). Just to the north (left) of the east apse is the scriptorium (labeled "sedes scribentium," seats of the scribes), and above this room is the library. To the south of the church is the monastic cloister, site of many communal activities, with the adjacent dormitory (seventy-seven beds), refectory (dining hall), and pantry. North of the church is a large school as well as housing for the abbot and monastery guests, and to the east is an infirmary complex. Many other buildings for people and animals are identified, including workshops for craftsmen (e.g., goldsmith, blacksmith, potter, shield maker) at the southern edge. The St. Gall plan represents an idealized monastery; it was not a construction blueprint. When Gozbert did build a new church at St. Gall in the 830s, he did not follow this plan, which was poorly suited to the local terrain.

The ruler at the time of the plan's formulation was Charlemagne's son Louis "the Pious," who tried to reform monastic practices in the kingdom, including stipulating that all monasteries should follow the sixth-century Rule of St. Benedict, one of several early medieval guides for governing communal monastic life. Many monasteries did adopt the Benedictine Rule, but a great variety of practices remained because there was no formal and centralized "Benedictine Order." During the Carolingian period, monasteries were built and renovated at a scale unprecedented since monasticism emerged in late antiquity, and the Plan of St. Gall shows that monasteries were conceived not only as centers of prayer but also as places where specialized knowledge was preserved and transmitted. Documents from St. Gall record the work of a monk named Tuotilo, who lived there from 873 to about 913. In addition to directing the hospital and supervising the kitchen and treasury, he composed liturgical music and worked as an artist both inside and outside the monastery, making a golden statue, a processional cross, and ivory book covers, all destined to embellish the liturgy at St. Gall or elsewhere.

The St. Gall plan includes an herb garden and infirmary (and the ninth-century library had six medical books), but the practice of medicine in western Europe was less advanced than in Byzantium and the Islamicate world until the twelfth century, when Europeans became aware of those medical practices. By the sixth century the large Sampson Hospital near Hagia Sophia served rich and poor alike, with dedicated rooms for surgery and for eye diseases. Eyewitnesses in Constantinople reported the surgical separation in the mid-tenth century of a pair of adult conjoined twins after one of them had died. The other twin also died after the surgery, but the doctors managed to keep him alive for three days (the first known successful separation of conjoined twins only took place seven centuries later). Around the year 900, a physician named Niketas copied several ancient treatises on surgery, all of them dated before the seventh century. Two artists painted thirty full-page illustrations and sixty smaller ones, replicating those that accompanied the ancient texts (fig. 5-36).

On fol. 203v, a surgeon resets a patient's dislocated vertebrae with his heel while the ailing man lies facedown on a bed that two attendants are stretching with winches—a kind of traction. This and other realistic images confirm that Niketas wanted his manuscript to serve as a surgical manual, a usage reiterated by verses that praise the book as a teaching aid for young doctors and a reference work for experienced ones. This luxurious copy must have been made for a hospital library, and a later marginal note places it in a specific hospital in Constantinople. The nudity of all the figures was not realistic—neither ancient nor medieval doctors performed in the nude—but it emphasizes their classical origin, like the naked Jordan River personification in the Paris Psalter. In late ninth- and mid-tenth-century Constantinople, compiling, studying, and copying ancient

Fig. 5-36. Medical procedure, surgery manuscript of Niketas, 36.5 × 25 cm, ca. 900; Florence, Biblioteca Medicea Laurenziana, MS Plut. 74.7, fol. 203v. Reproduced with permission of MiBACT. Further reproduction by any means is prohibited.

texts were often done under imperial auspices, although Niketas makes no mention of such sponsorship in his book.

One Byzantine emperor can be connected with an illustrated medical manuscript. In 948, Romanos II (then junior emperor; fig. I-19) sent a copy of *On Medicinal Materials* (*De Materia Medica*) by the famous first-century CE physician and botanist Dioskorides as a diplomatic gift to Caliph 'Abd al-Rahman III in Spain. According to a later Arabic source, the accompanying letter said that the book could not be used without the help of someone familiar with Greek and with the drugs concerned: "if someone in your country is equipped with the necessary knowledge, you will, O king, derive great profit from the book." The Byzantines were insisting that they were the true guardians of ancient knowledge and that their book was superior to the Arabic translation of Dioskorides produced a century earlier. Like many medieval diplomatic gifts, this offering from one powerful ruler to another was intended to demonstrate cultural dominance.

CHAPTER 6

ca. 960 to ca. 1070

Legend

☐ **Location or findspot**
 - *Monument/object*

• Additional site

○ *Approximate place of production*

☐ **Söderala**
 - *Metal standard*

☐ **Jelling**
 - *Commemorative stone*
 - *Ship setting*

•Canterbury

Hastings •

☐ **Hildesheim**
 - *Bernward's Column*

☐ **Bodzia**
 - *Amulet case (kaptorga)*

Bayeux ☐
 - *Embroidery*

Aachen ☐
 - *Lothar Cross*

Santiago de Compostela •

☐ **Esztergom**
 - *Byzantine crown*

☐ **Conques**
 - *Majesty of St. Foy*

Monastery of San Salvador de Tábara ☐
 - *Beatus manuscript*

Rome •

Constantinople
 - *Hagia Sophia Cathedral*

Madinat al-Zahra' ○☐ **Córdoba**
 - *House of Ja'far* - *Great Mosque*

Bari •

Thessaloniki •

Steiri ☐
 - *Monastery of Hosios Loukas*

Fustat
 - *Hebrew prim*
 - *St. Petersbur Bible*

Great Mosque, Córdoba

Pamplona

San Millán ☐
de la Cogolla
 - *Reliquary plaque with goldsmiths*

☐ **Monastery of San Salvador de Leire**
 - *Leire Casket*

Saragossa ☐
 - *Aljafería Palace*

Monastery of Hosios Loukas, Steiri

•Novgorod

Kyiv
- *Sviata Sofiia Cathedral*

- *Gold enkolpion*
- *Reliquary of St. Demetrios*
- *Veroli Casket*

•Manzikert

□ **Çanlı Kilise**
 - *Rock-cut settlement*

Antioch Qal'at Sem'an
Miraculous □ ●•Aleppo
Mountain
 Mold for St. Symeon pendant

□ **Baghdad**
 - *Qur'an of Ibn al-Bawwab*

•Jerusalem

Cairo
 - *Mosque of al-Hakim*
 - *Gold ring*
 - *Lusterware bowl with musician*
 - *Printed paper amulet*

•Medina

Madayi•

Cochin•
•Kollam

Aden•

In the period covered by this chapter, a new imperial dynasty, the Ottonians, came to power in north-western Europe. Otto I defeated the pagan Magyars in 955, ending Hungarian incursions into Europe; in 962 he was crowned emperor by the pope in Rome, on the model of Charlemagne. Throughout western Europe, agricultural productivity improved dramatically with the introduction of the heavy plow around the year 1000; as a result, population and urbanization also increased. Christianity continued to spread: King Stephen of Hungary adopted Roman-rite Christianity around 1000, and Iceland, Norway, and Denmark also became Christianized to some degree. After supposedly sending ambassadors to observe the practices of various religions and being most impressed by Hagia Sophia, Prince Vladimir of Kyiv adopted the Orthodox faith on behalf of the people of Kyivan Rus' in 988. Newly established Christian kingdoms in Aragón, Castile, and León in northern Spain fought to contain the Muslims in al-Andalus. This became easier after the Umayyad caliphate collapsed in 1031 and was replaced by smaller *taifas* (principalities) ruled by competing emirs. The Abbasid caliphs continued as nominal heads of Islam in the east, although real power was in the hands of autonomous dynasties, including the Buyids in Iran and Iraq (945–1055), who revived pre-Islamic Iranian tradi-

tions, and the Seljuqs, the first Muslim rulers of Turkic descent.

In 909 the Fatimids, Isma'ili Shi'i who claimed direct descent from Muhammad through his daughter Fatima and his cousin and son-in-law 'Ali, proclaimed their own caliphate in North Africa, building a new capital at al-Qahira (Cairo, "the victorious"), north of Fustat, in 969. They ruled from Tunisia to Syria, including Sicily, and were involved in long-distance trade as far away as China. By the late eleventh century, Fatimid territories in the eastern Mediterranean region were threatened by the Seljuqs, and the Normans (or Norsemen, former Vikings who had settled in France) began their conquest of southern Italy. Before they took Sicily, the Normans crossed the English Channel to defeat King Harold in 1066, and five years later they vanquished the Byzantines at Bari, ending two centuries of Byzantine rule in southern Italy. In the same year, 1071, the Seljuqs defeated the Byzantines in Asia Minor; the Byzantine Empire began to shrink, although its cultural prestige remained intact. Mutual excommunications—ejecting each other from the Church—in 1054 reflected increasing polarization between the patriarch and the pope. And in 1068/69, the Fatimid treasury in Cairo was looted by soldiers who had not been paid; as a result, countless books and objects were dispersed, with many ending up in Europe.

Work in Focus:
THE GREAT MOSQUE OF CÓRDOBA

'Abd al-Rahman I founded the mosque at Córdoba in the eighth century, and his descendants transformed it over several building campaigns. The most extensive changes took place under 'Abd al-Rahman III's son and successor, Caliph al-Hakam II (r. 961–76). Al-Hakam extended the prayer hall to the south and constructed a new mihrab and maqsura, all completed in 965 (fig. 6-1). Approached by a wide aisle with a painted and gilded ceiling, the maqsura is set off by a double-tier screen of intersecting arches, whose gray and white forms stand out from the red and white horseshoe arches that unify the rest of the interior (fig. 6-2; compare fig. 4-17). Each of its three bays aligns with a horseshoe-arched opening in the qibla wall, and each bay

has a ribbed vault raised on squinches, marking this royal enclosure as distinct from and more ornate than the flat-roofed prayer hall. An additional rib-vaulted bay marks the beginning of the wide central aisle of al-Hakam's addition (fig. 6-1), initiating and highlighting the caliph's path to the mihrab, pious prayer, and, ultimately, salvation.

Degrees of ornamentation signal degrees of status and sacredness. The wide aisle leads to an antemihrab dome that is wider, taller, and more elaborate than the flanking vaults. Its prominent intersecting ribs spring from paired colonnettes to form an eight-pointed star above arched windows, with a lobed dome at the apex (fig. 6-3). The ensemble is decorated with stylized vegetal ornament on a gold mosaic ground, generally thought to represent the heavenly sphere of paradise. Curved tiles form a light-colored cornice that emphasizes the unusual shape of the

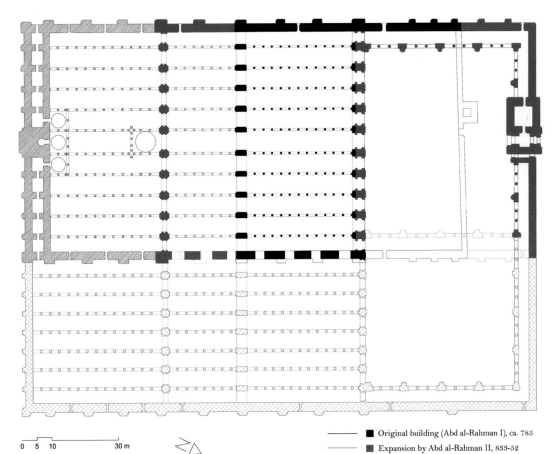

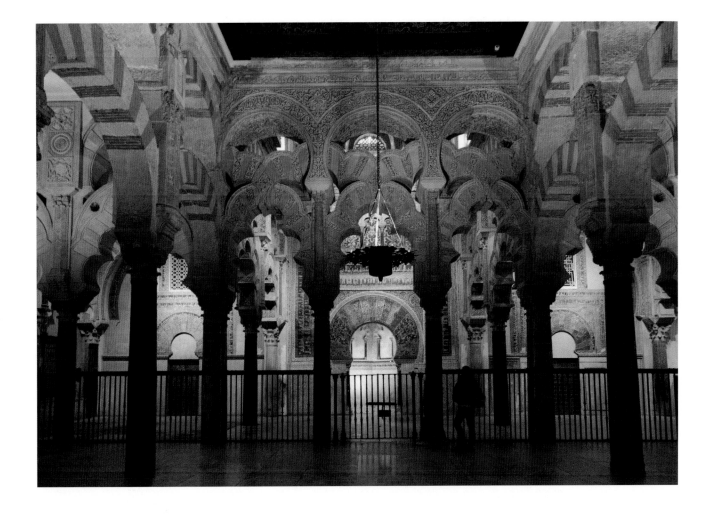

Fig. 6-1. Great Mosque, Córdoba, eighth–tenth century, plan. Drawing by Navid Jamali.

Fig. 6-2. Maqsura, Great Mosque, Córdoba, 961–76. Photo by the authors.

0 5 10 30 m

■ Original building (Abd al-Rahman I), ca. 785
■ Expansion by Abd al-Rahman II, 833-52
▨ Expansion by al-Hakam II, 961-76
⊠ Expansion by al-Mansur, 987

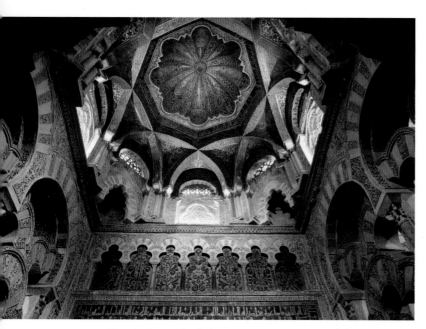

Fig. 6-3. Antemihrab dome, Great Mosque, Córdoba, 961–76. Photo by the authors.

dome. Such polychrome tiles were an important medium of Byzantine architectural decoration, used to cover walls and highlight architectonic features in churches and public buildings between the late tenth and early twelfth centuries. This kind of Byzantine revetment was itself inspired by ceramics in Samarra or Baghdad; from Constantinople the technique was exported to Bulgaria and beyond. The Córdoba tiles were probably manufactured locally, in which case they would mark a third phase in the transmission of this building material. Even though these decorative elements were adapted from elsewhere, the rib vaults in the Córdoba maqsura are unique. The ribs create a web-like structure that emphasizes where the facets of the complex vault come together while also easing the transitions between the octagonal walls and the central lobed dome.

Beyond the maqsura are the mihrab and its two flanking rooms, all of which have rich decoration. The left room served as a treasury, and the right one led to the caliphal palace. The horseshoe arch that opens into the mihrab and its surrounding *alfiz* (rectangular panel that frames the upper part of an arch) are extensively decorated with Kufic inscriptions and ornate plant motifs worked in carved marble, stucco, and mosaic (fig. 6-4a). Arabic sources report that al-Hakam requested artistic resources from the Byzantine emperor Nikephoros II Phokas (r. 963–69), who sent sixteen thousand kilos of glass tesserae and a master craftsman to train local slaves in the technique and supervise their work. Unlike mosaics in Byzantium, the tesserae at Córdoba are laid flat in the plaster setting bed, not angled to catch the light. The mosaics connoted imperial luxury and power, but viewers probably associated them less with Byzantium than with famed Islamic works that were also adorned with Byzantine mosaics: the Dome of the Rock

and especially the Umayyad mosque in Damascus (figs. 4-4 and 4-8). These venerable buildings were known in Spain thanks to descriptions by travelers and were understood as emblematic of Umayyad stature—hence their appeal to the survivors of that dynasty who now ruled al-Andalus.

This engagement with the past shaped other aspects of the mosque. Before 976, a new wooden minbar was modeled on one at Medina; it moved on four wheels and was stored in a closet newly cut in the qibla wall to the right of the mihrab (it was later destroyed in a Christian attack). The new Córdoba mihrab preserved the incorrect orientation of its eighth-century predecessor, which pointed south instead of southeast; maintaining that alignment expressed dynastic continuity and showed respect for tradition. The tenth-century mihrab has an unexpected form: a whole polygonal room with carved marble and stucco walls, all topped by a vault shaped like a scallop shell (fig. 6-4b). Such shells often appeared in earlier niches and apses, and textual sources indicate that both mihrabs at Damascus had them, as did the rebuilt mosque in Medina. Fragmentary remains suggest that 'Abd al-Rahman I's original eighth-century mihrab at Córdoba also was topped by a shell, so the tenth-century mihrab vault was another link in the chain of Umayyad references to the past. In Islam, the shell is a metaphor for divine light (Qur'an 24:35), and repeated images of a shell in the maqsura mosaics suggest that it also connoted caliphal power.

A dense epigraphic program inside and outside the Córdoba mosque conveyed important ideological messages by citing scriptural excerpts and historical texts. Most pious Muslims could complete a Qur'an verse after recognizing a few written words. The mihrab contains verses about proper prayer and ablutions (ritual washing) that are normally found in that location (Qur'an 2:238, 5:6), followed by a text that commemorates al-Hakam's order to sheathe the mihrab in marble. Inscriptions on the central alfiz combine verses that underscore the political and religious authority of the caliph seated in the royal enclosure (fig. 6-4a), referring explicitly to al-Hakam as the imam chosen by God who made the mosque "more spacious for his followers, in accord with his and their wishes." Above the door to the right of the mihrab, the inscription, like those in the Dome of the Rock, refutes the Christian Trinity: "Originator of the heavens and the earth! How could he have a son when he has no consort and he [himself] created everything?" (Qur'an 6:101). Such a message was directed toward converts and potential Muslim apostates (those abandoning the faith), whereas polemical verses on the exterior portals were aimed at Christians and Jews.

The three-bay maqsura and three doors in the qibla wall resemble the triple apses of many Visigothic and later Christian church sanctuaries in Spain and elsewhere, and this parallel may not be coincidental (fig. 6-2). It seems likely that the mosque's architects wanted to create a comparable performative space for their own precious relic,

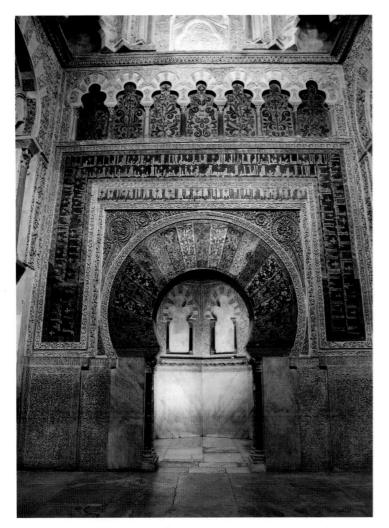
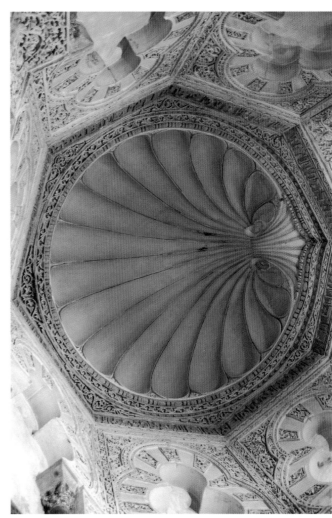

Figs. 6-4a and 6-4b. Mihrab, Great Mosque, Córdoba, 961–76, (*left*) entrance; (*right*) vault.
(*l*) Photo by the authors; (*r*) Wikimedia Commons/Manuel de Corselas, CC BY-SA 3.0.

kept in the mosque treasury. The relic was four bloody pages of a Qur'an codex intimately connected to the third caliph, 'Uthman, a relative of Muhammad and member of the Umayyad family. He oversaw the authoritative version of the Qur'an and was allegedly reading this book when he was assassinated in 656. Preserved within ornate covers, the relic was carried in candlelit processions and even into battle against Christians and other Muslims; Roman-rite and Orthodox Christian relics were often used the same way. And like holy Christian and Jewish remains, several places claimed to possess this book, so its daily exposure in the Córdoba mosque bolstered the status and authority of the mosque and the caliph against the competing caliphal claims of the Abbasids and the Fatimids.

The mosque attained its final size in 987, when a powerful hajib (chamberlain), al-Mansur (r. 978–1002), added another eight aisles to the prayer hall on its eastern flank, along with corresponding space in the courtyard (fig. 6-1). This addition brought the total number of interior columns to 514 and the overall size to 175 by 128 meters, large enough to accommodate the city's entire Muslim population. Al-Mansur rose to power because al-Hakam II's heir

was only eleven when his father died. In 997 al-Mansur's troops sacked the cathedral of Santiago de Compostela (northwestern Spain), the premier pilgrimage church north of the Alps, and carried off its bells to serve as lamps in the Great Mosque. They remained there until Christians captured Córdoba in 1236; a thirteenth-century chronicle reports that the bronze booty was returned to Santiago.

How a high-ranking official lived can be seen at Madinat al-Zahra', where a house in the central area of the city has been associated with Ja'far 'Abd al-Rahman (d. 971) (fig. 5-14c). Ja'far oversaw the construction of al-Hakam II's sections of the Great Mosque of Córdoba as well as the central pavilion at Madinat al-Zahra' under 'Abd al-Rahman III; the house was probably built after he was appointed hajib in 961 (fig. 6-5). It is configured around colonnaded courtyards, the core design element of many ancient and early medieval housing types both grand and modest in scale. In this case, the social and political status of Ja'far comes across in the multiplication of such spaces; there are three courtyards, the first demarcated by an arched colonnade that leads to a reception hall and a sizable latrine that suggests large gatherings. The tripartite layout, grand scale,

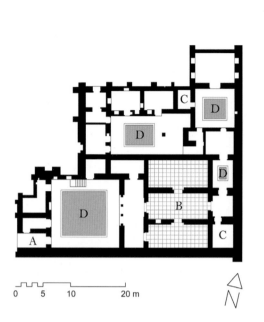

Figs. 6-5a and 6-5b. House of Ja'far, Madinat al-Zahra', before 971, *(left)* plan, A=west entrance, B=reception hall, C=latrine, D=courtyard with pool; *(right)* facade of reception hall. *(l)* Drawing by Navid Jamali; *(r)* Photo by the authors.

and enhanced ornamentation connect this hall to caliphal forms, including the maqsura at Córdoba and the Salón Rico down the hill (fig. 5-15). Adjacent to this opulent public space is a smaller courtyard, this one with a fountain, which leads to Ja'far's private quarters, including another, more private latrine. The final zone of the house, also arrayed around a courtyard, was for servants and services and incorporated older structures in this densely built part of the city. After Ja'far died, al-Hakam II had high-ranking members of his court move into the house as a sign of his esteem for the hajib.

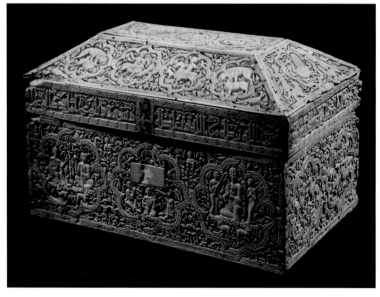

Fig. 6-6. Leire Casket, 23.6 × 38.4 × 23.7 cm, 1004/5; Museo de Navarra, Pamplona. Photo by Antonio García Omedes.

The Arts of Rule

An intricate box, the so-called Leire Casket, consists of nineteen carved ivory plaques produced in Córdoba or Madinat al-Zahra' (fig. 6-6). A master craftsman named Faraj is named in an inscription inside the lid, and additional artists' names appear elsewhere on the large box. A foliated Kufic inscription (in which the ends of some letters take on floral or leafy forms) around the base of the lid says that the box was made for 'Abd al-Malik, known as Sayf al-Dawla ("Sword of the State"), who succeeded his father al-Mansur as hajib (r. 1002–8). The rectangular casket may have been commissioned to commemorate Sayf al-Dawla's victory over the Christian kingdom of León in 1004/5. Twenty-one figural and animal medallions are separated by interlaced vegetation. Three polylobed medallions on the front, seen here, contain scenes from courtly life, including, from the right, a man seated on a platform supported by lions and flanked by smaller figures; three musicians; and two figures who hold drinking vessels and share a platform. The central seated man probably represents Sayf al-Dawla; the hajib's military activity is implicit in the numerous images of animal and human combat. This is a bold statement of power in a medium normally reserved for the caliph and his family.

In the mid-eleventh century the casket was repurposed as a Christian reliquary. The piece of Islamicate silk it contained wrapped the bones of two saintly sisters buried in the crypt of San Salvador de Leire, a monastery near Pamplona (northern Spain; the work is also known as the Pamplona Casket). The reuse of an originally secular box

for the bones of Christian saints helped preserve this and about thirty other tenth- and eleventh-century containers. Such luxurious Andalusi objects often entered Christian contexts through trade or diplomacy, not via conquest, and few alterations were undertaken to make them appropriate for such reuse. It is likely that a Muslim emir sent the saints' relics in their precious container to a Christian ruler, perhaps as partial payment of tribute or to signal a Muslim–Christian pact at a time of rapidly shifting alliances. Elites of both faiths appreciated the material, expense, and workmanship of the casket.

During the taifa period that followed the fall of the Umayyad caliphate in 1031, the principality of Saragossa (or Zaragoza, northeastern Spain) was ruled by another individual known as Sayf al-Dawla, the emir Abu Jaʿfar Ahmad b. Sulayman al-Muqtadir (r. 1049–82). Al-Muqtadir's fortified palace, the Aljafería (1064–82), is one of the best-preserved of the taifa residences, even though it was extensively renovated by later Christian rulers. Its austere exterior features high walls with crenellation (projecting rectangles, useful for defense) punctuated by regularly placed round towers that proclaim military strength. This aesthetic and its implied function contrast strongly with the interior, however, in which surfaces are dematerialized by sculpted ornament (fig. 6-7).

Rooms are separated from a central courtyard by intersecting polylobed arch screens even more intricate than those of the Córdoba maqsura. These arcades, carved in stucco, are replete with miniature columns and arches in relief. The lush plant motifs, which suggest paradise, provided a luxurious setting for the *majlis*, an intimate gathering that included such privileged and earthly pleasures as reciting poetry and drinking wine—activities that are also the prerogative of the blessed in heaven. The Aljafería provided settings for a new type of ruler, one who shared the palace's small spaces and secular delights with very close companions; the northern salon could seat only ten. A majlis would showcase the pleasure-seeking emir al-Muqtadir as a private host among his guests, very different from the public display of a pious caliph in a throne room or maqsura. In an unstable political and military landscape, the palace was a place to retreat from conflict and explore concepts of paradise, derived from Islamic ideas of spiritual ascent rooted in ancient Greek philosophy.

At Hagia Sophia in Constantinople, figural arts expressed the relationship of Byzantine emperors to their faith and their subjects. In addition to serving as the city's cathedral, the church was a setting for imperial ceremony when the emperor attended the liturgy. During five annual religious feasts (holy days) he entered the sanctuary to make a monetary donation, but on other occasions he sat upstairs, at the east end of the southern gallery, while the patriarch and his entourage occupied the middle of that gallery. In the eleventh century, a mosaic panel that depicts the imperial couple was placed above eye level

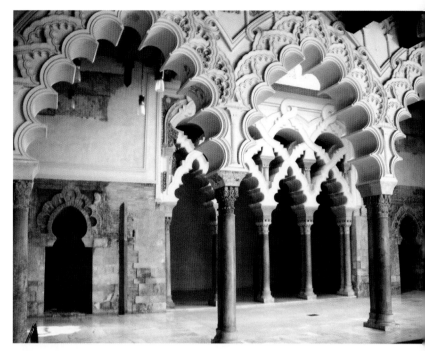

Fig. 6-7. Aljafería Palace, Saragossa, 1064–82. Wikimedia Commons/Escarlati, public domain.

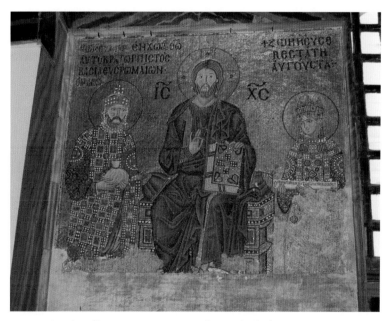

Fig. 6-8. South gallery mosaic, Hagia Sophia Cathedral, Constantinople, 1028–55. Photo by Vasileios Marinis.

on the south gallery's east wall. At the center Christ, on a backless throne between the imperial couple, makes a blessing gesture and holds a Gospel book (fig. 6-8). The empress, clad in an elaborate ceremonial costume, holds a scroll inscribed, "Constantine, in Christ the Lord, faithful emperor [*basileus*] of the Romans." The inscription over her head says, "Zoe, the most pious Augusta [Empress]." Opposite her, the emperor holds a sealed moneybag, an annual donation to the church. The inscription above his head reads, "Constantine, in Christ the Lord, Autocrat, faithful emperor of the Romans, Monomachos." Yet this

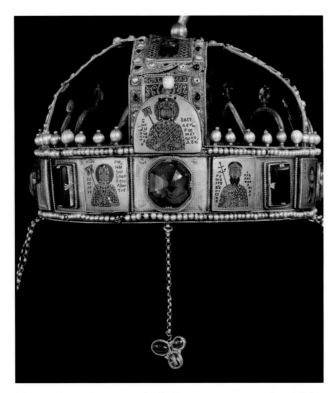

Fig. 6-9. Byzantine crown, back, D 20.9 cm, 1074–77; Országház, Budapest. Photo by Károly Szelényi, Hungarian Pictures.

last inscription and the one on Zoe's scroll show clear signs of alteration, and so do all three of the faces.

The emperor's face must have been updated when Zoe (b. ca. 978; r. 1028–50) remarried: the original emperor named in the inscriptions was either her first husband, Romanos III (r. 1028–34), or her second, Michael IV (r. 1034–41), whereas the face and names we see now are those of her third husband, Constantine IX Monomachos (r. 1042–55). Because the inscriptions seem to have been altered only once, the original emperor was probably Michael IV, who not only gave large sums to Hagia Sophia to atone for the murder of his predecessor but also put the then-unusual image of Christ on a backless throne on his coins. Christ's face evidently was modified to better resemble that of Constantine IX, whereas Zoe's may have been altered to turn her sideways in a more subservient pose or simply to update her. Sources report that Zoe loved cosmetics, manufactured potions and perfumes in the palace, and retained a youthful look until her death. The mosaic could reflect her actual appearance or how she wished to be perceived: much younger than her sixty-four years. The mosaic reminded imperial guests and the patriarchal retinue of who was responsible for their salaries and for the income of the church. At the same time, it documents the piety of the imperial couple and implicitly asks Christ to look upon them favorably.

The Hagia Sophia mosaic shows Zoe wearing a diadem with triangular points, while her husband's crown lacks the triangles but has hanging ornaments (*prependoulia*). A gold crown that combines these features was sent by the

Byzantine emperor Michael VII Doukas (r. 1071–78) to Géza I, *kral* (king) of Hungary (r. 1074–77), who from his capital at Esztergom sought to strengthen Christianity in a realm where paganism still persisted (fig. 6-9). The royal crown is decorated with Byzantine cloisonné enamel plaques that depict figures labeled in Greek (the cross-shaped upper part is a twelfth-century addition). On the front, above an enormous sapphire, Christ is represented in an arched frame, enthroned between schematic trees that symbolize paradise. Archangels flank the gem, and beyond them are military and medical saints. On the back, seen here, the Byzantine emperor occupies the same position as Christ on the front (above an equally large sapphire), demonstrating how the earthly court imitates the heavenly one. The flanking angels are replaced by Michael's son and by Géza himself, labeled in Greek "Geobitzas, faithful *kral* of Tourkia," the Byzantines' name for Hungary. Whereas the emperor and his son face forward, Géza's eyes turn toward them submissively, and he is also the only figure on the crown who lacks a halo. Even though he appears in this "family of rulers," the kral is clearly of lower status. The crown accompanied an even more important gift—an aristocratic Byzantine bride named Synadene—and both marriage and gifts were crucial components of Byzantine diplomacy. Michael VII hoped to acquire an ally and promote Orthodoxy over the Roman Church; Géza aspired to a prestigious dynastic tie. The crown is also known as the crown of St. Stephen or the Holy Crown of Hungary because of its medieval association with the country's first Christian king, a member of the important Árpád dynasty.

Art on the Move

Numerous objects from the decades around the year 1000 attest to the slow expansion of trade routes throughout western Eurasia, moving raw materials, finished products, people, and ideas. The gilt-copper objects known as weathervanes (Old Norse *veðrviti*) were once thought to be navigational instruments for Viking ships, but it is more likely that they were flags or standards, attached to a ship's bow or stern as a sign of social status and, if seen up close, family identity (fig. 6-10). Precious metals had to be imported into medieval Scandinavia, so these standards were expensive signs of rank; a thirteenth-century saga indicates that their use was restricted to kings and high Church officials. The small holes around the curved edge were for suspending streamers. The largest Viking warships were called *dreka*, dragons, and this is also the decorative motif on several of these objects (some late examples feature Christian iconography). This openwork example from Söderala (Sweden) of about 1000 depicts a large serpent being bitten by a smaller biped amid snaky tendrils, with a solid cast-bronze lion on top. The style of ornament is known as Ringerike, after the region in Norway where it was used on

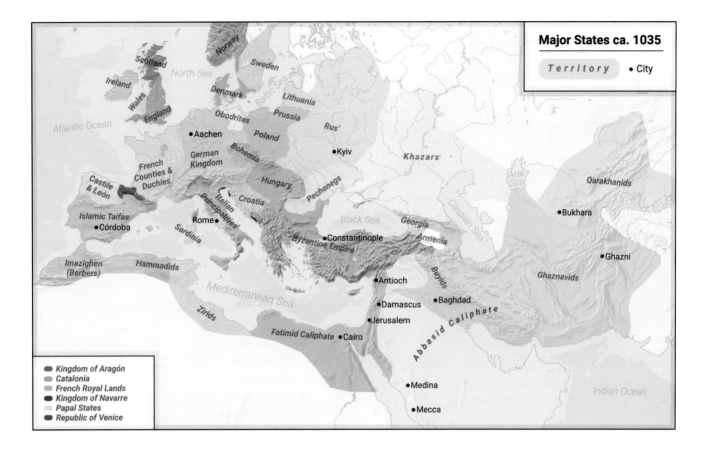

Major States ca. 1035

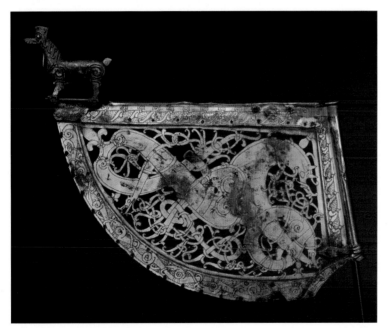

Fig. 6-10. Metal standard, Söderala, 25 × 36 cm, ca. 1000; Historiska museet, Stockholm. © Historiska museet 1995. Sören Hallgren SHM; CC BY 2.5 SE.

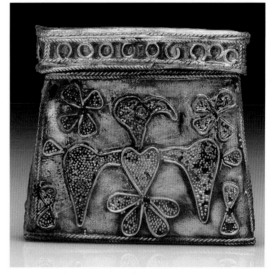

Fig. 6-11. Amulet case (kaptorga), Bodzia, 4.3 × 4.7 × 0.9 cm, ca. 980–1030; Państwowe Muzeum Archeologiczne, Warsaw. Institute of Archeology and Ethnology of the Polish Academy of Sciences, result of research carried out by them.

memorial stones between the late tenth and the first half of the eleventh century. As the Vikings began to settle and to accept Christianity, the metal standards were sometimes installed as weathervanes on churches, as at Söderala.

A cemetery at Bodzia, in central Poland, preserved a different kind of animal decoration on a precious-metal object. This is a silver amulet case (Polish *kaptorga*) from a chamber tomb dated between about 980 and 1030 on the basis of coin finds (fig. 6-11). The dead were buried in fabric-lined wooden coffins that contained a variety of grave goods, including coins from all over Europe and one Samanid dirham. Grave E72 held an adult woman and several coins, a knife, and silver jewelry, including the kaptorga suspended from her neck on a silver chain. The container is adorned with a stylized eagle and smaller shapes made with silver wire and fine granulation. Such amulet

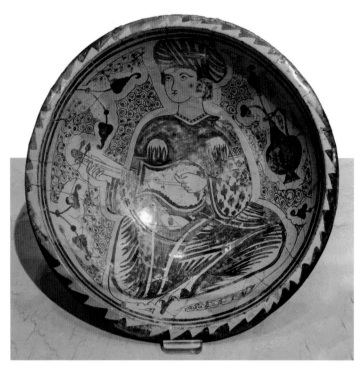

Fig. 6-12. Lusterware bowl with musician, 15 × 40 cm, eleventh century; Mathaf al-Fann al-Islami, Cairo. Photo by Bernard O'Kane.

Fig. 6-13. Gold ring, maximum L 2.5 cm, tenth–eleventh century; Aga Khan Museum, Toronto. © The Aga Khan Museum.

holders are reminiscent of larger purse reliquaries like the one from Enger (fig. 4-22), but there is no reason to connect them to Christianity. Prince Mieszko, ruler of the Slavic Polans, was baptized in 966, but conversion of the populace was slow, as in Hungary and Scandinavia. The amulet inside was probably something organic; other kaptorgi contain flax, resin, cloth, wax, bone, or beads. The eagle without talons was popular in the art of medieval Rus'—the area between the Baltic and the Black Seas, inhabited by East Slavic peoples—whose artists often imitated artifacts from Sweden. Duke Bolesław I Chrobry ("the Brave," r. 992–1025), the son of Mieszko and the first king of Poland (1025), looted Kyiv, the Rus' capital, in 1018 and brought back not only treasure but also princesses, warriors, and artists. The amulet case may have been produced by or for one of these transplanted people. Bodzia was located on important river trade routes that connected the Baltic Sea with Byzantium, and the individuals buried in the cemetery, of unknown ethnic origin and differing social classes, had ties to the Vikings in Scandinavia and Kyiv as well to the southern and western European worlds.

A very large monochrome lusterware bowl made in Fatimid Egypt was used or displayed in a well-to-do household in the early eleventh century (fig. 6-12). It portrays a musician in a turbanlike headdress playing a two-stringed instrument, the kind of elite entertainment that took place in homes and palaces around the Mediterranean. Even though twice-fired lusterware was the most expensive type of ceramic produced in medieval Egypt (box 5-2), it was probably not used at the Fatimid court, where even pricier Chinese porcelains and white stonewares were

preferred. Those vessels, along with silks and spices, reached the Fatimids via maritime trade routes linking southern China to the Indian Ocean and the Red Sea (box 6-1). Lusterware would have been purchased in the marketplace, and the figural style of this bowl—circular face, small almond-shaped eyes, tiny mouth—is typical of Fatimid arts across media. The Persian scholar Nasir-i Khusrow, who visited Cairo in 1047 and praised its unparalleled markets, reported that ceramic vessels produced there reveal different colors depending on how the piece is held. The Arabic and Persian term *buqalamun* signifies color-changing, and it describes perfectly the play of light on luster that makes the metallic designs take on different colors. Unfortunately, this iridescent effect scarcely comes across in photographs. The blue spot on the figure's face may be a drip of glaze from another bowl in the same kiln, which the artist then incorporated into the composition before the second firing.

Gold jewelry of very high quality was produced in Fatimid Egypt and Syria. This ring features techniques of filigree and granulation that place it in the tenth or eleventh century, and because it lacks any specific iconography, it could have been worn by wealthy individuals of any faith or gender (fig. 6-13). Unlike lusterware ceramics, which are never mentioned, such valuable jewelry is described in letters and bills of sale found in the Cairo Geniza. A *geniza* is a repository for documents that reference God's name and therefore, according to Jewish custom, cannot be destroyed; the Cairo Geniza, hidden in a synagogue in Fustat (later part of Cairo), contained more than three hundred thousand texts spanning ten centuries. This textual treasure trove has enabled historians to reconstruct medieval Jewish life and the artistic, cultural, and economic networks linking Jews with Muslims, Christians, and Hindus across the Mediterranean and Indian Ocean regions. The gold of this ring was acquired from African mines in Nubia or Ghana—testifying to another vibrant medieval trade route, across the Sahara Desert (box 9-1)—or melted down from an earlier object.

Box 6-1. TRADE ACROSS THE INDIAN OCEAN

Letters from the Cairo Geniza provide remarkable glimpses into the lives of merchants who traversed the Mediterranean Sea and Indian Ocean. Abraham ben Yiju, a Jew from Fatimid Tunisia, was one of many Jewish, Muslim, and Christian merchants who settled on the southwest coast of India in the mid-twelfth century. This region, which corresponds roughly to today's state of Kerala, attracted traders from around the medieval world in part because of its abundant black pepper and other valuable spices. These resources made the ports of Kerala key stopping points in the global network linking the Mediterranean Sea to China—the maritime Silk Routes. Muslim and Jewish businessmen worked together in this network, sharing information about shipwrecks, fluctuating prices, political unrest, swindlers, and pirates, as well as details of their personal lives: seasickness, good fortune, wayward children, divorce. Although sailing from Aden (Yemen) to Kerala was treacherous and took five to six weeks, Abraham and his colleagues made the trip multiple times, often accompanying their goods. They shipped raw materials like teakwood, copper, and iron (Abraham owned a foundry in India), along with valuable worked objects, including a carpet with zodiac imagery, silk garments, and Chinese ceramics. Artists were passengers, too; three Jewish metalworkers joined merchants on a ship sailing from Aden to Sri Lanka in the 1130s.

Merchants from North Africa and western Asia built institutions in Kerala to serve their semiautonomous communities, including synagogues, mosques, and churches. A synagogue in Cochin and a Christian church in Kollam were documented around the year 1000, and one of the earliest mosques in India was founded in Madayi about 1124. These buildings often followed local construction practices; mosques thus resembled nearby Hindu temples rather than prayer halls in the Islamicate world. They were built to provide religious and social support for the settlers, including shelter, storage, and meals for visiting business partners (food was a particularly important provision because the merchants had distinct dietary regulations that differed from those of locals). Strong trade winds and monsoons meant that merchants had to stay for at least one season, but many stayed for years, and some married local women. Being across the ocean did not mean being cut off from extended families, however. Personal letters went back and forth, as did favorite foods and gifts. Scholars traveled across the Indian Ocean as well, and consequently children could be well educated in matters of faith. Ibn Battuta, a scholar from Morocco, was surprised that the Muslim girls and boys he met in southern India in the 1340s were so learned.

Focus on Facture

An eleventh-century amulet uses a material and technique newly available in Fatimid Egypt: paper and block printing (fig. 6-14). Paper making had been invented in China; from there it was disseminated to Central Asia and then to the rest of the Islamicate world in the eighth century. Printing with wood blocks was also a Chinese invention: the oldest printed book, bearing the date 868, was found at Dunhuang (western China). This Islamic amulet was printed from two inked blocks; the upper square featuring the star is set at an angle different from the lower rectangle. The six-pointed star, sometimes called the seal of Solomon, was a protective sign used in many cultures throughout the Middle Ages. Within it is written "the authority," and around it, in a larger Kufic script, "God be praised! Praise be to God! There is no God but God!" Parts of two Qur'anic suras follow in the block below and precede repeated invocations to God, "punisher of demons." The amulet would have been

rolled up and kept in a case, something like the kaptorga from Bodzia. People of all faiths relied on textual amulets and other devices for protection, and printing on paper was a way to produce many such talismans inexpensively and make them accessible to those in need.

Like the amulets, books in the Islamicate world also used paper, although Qur'ans continued to be carefully copied by hand. A scribe named 'Ali b. Hilal, better known as Ibn al-Bawwab, meaning "son of a doorkeeper" (d. 1022), perfected a mathematically proportioned style of Arabic script that had been introduced a century earlier and also invented two scripts of his own. A Shi'i Muslim, he is said to have written sixty-four Qur'an manuscripts, but only one survives (fig. 6-15). A colophon records that the paper codex was written by Ibn al-Bawwab in Baghdad in 1000/1, "begging forgiveness for his sins." It was probably made to sell, because no patron is named. For the first time, the text is written in a cursive script instead of Kufic. Ibn al-Bawwab used a pen with a straight nib, so all the letters

are the same thickness, and his lines are straight despite the absence of horizontal ruling. The scribe also created the book's ornamental repertoire: the large palmette in the margin that marks each sura; the illuminated headpieces of the first two chapters (headpieces are ornamental panels that mark the beginning of a text); and facing polychromed carpet pages. This page shows the first sura and the beginning of the second. Ibn al-Bawwab's scripts were soon used in Qur'ans and in monumental epigraphy, and his inclusion of multiple colorful carpet pages was also widely imitated. When the Fatimid treasury was looted in 1068, pens sharpened by Ibn al-Bawwab and Qur'ans by his hand were among the prized objects that were stolen.

Fig. 6-14. Printed paper amulet, 23 × 8.4 cm, eleventh century; New York, Metropolitan Museum of Art. Gift of Nelly, Violet, and Elie Abemayor, in memory of Michel Abemayor, 1978 (1978.546.32). Image © Metropolitan Museum of Art.

Fig. 6-15. Sura 1 and beginning of 2, Qur'an of Ibn al-Bawwab, 17.5 × 13.5 cm, 1000/1; Dublin, Chester Beatty Library, MS K. 16, fol. 9v. © The Trustees of the Chester Beatty Library.

A rare image of scribes at work can be seen in the Tábara Beatus (fig. 6-16), a manuscript completed at the double monastery—one for men and one for women—of San Salvador in Tábara, not far from San Pedro de la Nave in the kingdom of León. The scriptorium is shown attached to the monastery's colorful stone bell tower, which features horseshoe arches familiar from Visigothic and Islamicate Spain. Three laymen scale the tower, and another one handles the ropes to ring the bells. In the scriptorium, the seated man at the right edge wields large scissors to cut the parchment while, in a separate room, two men in monastic dress hold pen and parchment. The man on the right, in the taller hat, is identified as "Emeterius the weary priest"; the figure on the left, a priest named Senior, is "ready for anything." The physical difficulties of writing are also emphasized in the colophon on the recto of this folio, which gives the date 970 and says that Emeterius was called to Tábara to complete the work begun by his master, Magius (d. 968), and that the "lofty stone tower" is where Emeterius "for three months sat hunched over and, despite shaking in every limb, overpowered the pen." Senior and Magius are also known from another Beatus manuscript, indicating that Tábara was an important center of book production and that Beatus's text was in demand. Originally from al-Andalus, Beatus became a monk in Liébana (northern Spain), where he wrote a commentary on Revelation in 776. Beatus believed that the end of the world would occur in the year 800, and his commentary was soon accompanied by illustrations, beginning with a map of the inhabited world. It became

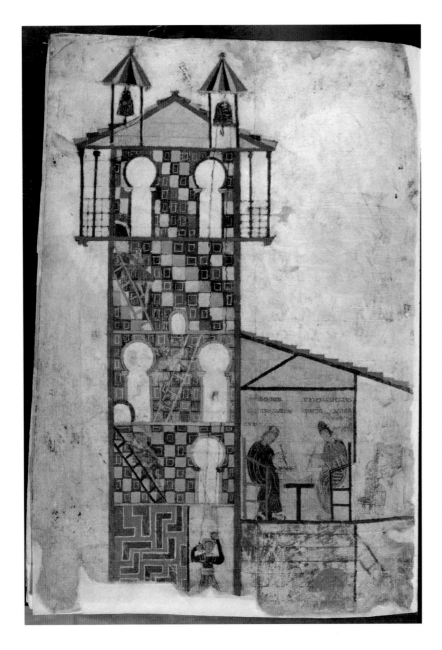

Fig. 6-16. Scriptorium and bell tower, Beatus from Tábara, 36 × 25.5 cm, 970; Madrid, Archivo Histórico Nacional, MS 1097B, fol. 167v. Album/Art Resource, NY.

Fig. 6-17. Reliquary plaque with goldsmiths, 6 × 4.5 cm, ca. 1060–80; State Hermitage Museum, St. Petersburg. bpk Bildagentur/Hermitage/Rheinisches Bildarchiv Cologne/Helmut Buchen/Art Resource, NY.

a very popular text, at least in Spain; twenty-nine illuminated copies survive.

A series of small ivory reliefs depicts the craftsmen who worked on the large reliquary or arca (over 1 m long and 0.58 m high) that in about 1067 was installed in the monastery church at San Millán de la Cogolla (northern Spain) (fig. 6-17). It held the remains of the Visigothic hermit Aemilian (Millán), and most of the reliefs showed stories of his life. One plaque lost in the Second World War depicted four men transporting the elephant tusk that provided the ivory. The plaque reproduced here bears a Latin inscription: "by Master Engelram and his son Redolfo." The father sits before a table and works on what is likely a sheet of gold, as the curved tool he holds was used to burnish gold leaf. Engelram and Redolfo, who are dressed as laymen rather than monks, were probably itinerant artists; throughout the Middle Ages, craft techniques were a closely guarded secret often shared among members of

a family who carried on generation after generation. An image in gold repoussé of Abbot Blasius, who commissioned the arca, appeared alongside those of the monastery's patrons, King Sancho IV of Navarra (r. 1054–76) and his wife, Placentia. At the time, King Sancho was receiving a tribute of one thousand gold coins per month from Emir al-Muqtadir of Saragossa to keep him from attacking the Aljafería; this money must have facilitated the production of the lavish reliquary. The arca was stripped to its wooden core in 1809 by Napoleon's troops, and its precious ivories, gold, and gems were stolen or destroyed.

It is not known who excavated the rock-cut settlement clustered around the eleventh-century masonry church of Çanlı Kilise (Bell Church) in Cappadocia (fig. 6-18), but it must have been a formidable undertaking. It used to be assumed that all the rock-cut structures in central Turkey were monastic, but most served other functions. The community around the Çanlı Kilise housed local landowners,

Fig. 6-18. Rock-cut settlement near Çanlı Kilise, tenth–eleventh centuries. Wikimedia Commons/Ingeborg Simon, CC BY-SA 3.0.

peasants, and soldiers assigned to a nearby garrison. Approximately twenty-five large houses and many more smaller ones extend for about one kilometer along the slopes of two adjacent plateaus; most face south or west to maximize sunlight. The bigger houses are grouped around three-sided courtyards cut into the slope of the hill, and their carved facades imitate multistory built architecture, including a rock-cut portico. Many had dovecotes at the upper level, hidden by the decorative facade (the pigeons were probably eaten, and their manure made excellent fertilizer). Most of the houses contain a large hall and a private chapel; there are about thirty such chapels in the settlement. Horse stables and numerous kitchens with ovens and smoke holes were also carefully cut out of the rock. The settlement was populated from the tenth century through the fourteenth, although its prosperity declined over time. On a wall of the church narthex is a rare piece of evidence for medieval architectural practice: compass-drawn curves and radiating lines that correspond to the arches of the facade must be remnants of the process of calculating the shape of the voussoirs. Usually such walls were plastered, making preparatory diagrams invisible.

As we have seen, artists were sometimes depicted in ancient (fig. 1-23) and medieval art. But with the exception of scribes—who may also have been illuminators (fig. 4-25)—artists' and architects' names were rarely recorded on their products. Wolvinus on the Altar of Sant'Ambrogio (fig. 5-30), numerous carvers of marble capitals at Madinat al-Zahra', and Faraj and others on the Leire Casket (fig. 6-6) stand out as exceptions, although many more names are known from written sources, and artists' signatures were relatively numerous in the Islamicate world. As the Middle Ages progress, more and more names of craftspeople were displayed on a diverse range of works.

An *enkolpion* (Greek for something worn on the chest) is a devotional pendant that protects the Christian wearer. Byzantine enkolpia could serve as personal insignia, be sent as gifts, presented as sacred offerings, or even pawned. This example, traditionally dated to the tenth or eleventh century, is made of gold, silver, and niello and meant to be suspended from a chain; it depicts on one side a Nativity scene above the Adoration of the Magi (fig. 6-19). At the top, an ox and ass venerate the horizontal, haloed Christ child, based on a long-standing Christian interpretation of Isaiah 1:3: "The ox knows its master, the donkey its owner's manger." On the other side, a monogrammed cross on steps is contained within an inscription that reads, "Sure deliverance and averting all evil." A second Greek inscription circles the exterior. It says "of saints Kosmas and Damianos," suggesting that a relic of those martyrs, who were famed as healing saints, may have been kept inside. Their curative powers were therefore accessible to the wearer of the enkolpion, supplemented not only by its words and pictures but also by its octagonal form. The saints' presence in the heavenly court also gave the wearer access to Christ, shown here being adored by men and beasts who recognize his holiness.

A larger Byzantine reliquary made of gilt-silver is also octagonal in form (fig. 6-20). It is a miniature domed building, complete with tiny oil lamps, figural and vegetal reliefs, and a long metrical inscription. On the doors are two military saints, Nestor and Loupos, thought to be disciples of St. Demetrios; on the opposite side, Emperor Constantine X Doukas (r. 1059–67) and his wife, Eudokia Makrembolitissa (d. 1096), are being crowned by Christ. Unusually, Eudokia holds an imperial orb just as the emperor does; because of his poor health, she had an active role in running the empire. In the inscription, the reliquary itself speaks: "I am a true image of the ciborium of the lance-pierced martyr Demetrios. On the outside I have Christ represented, who crowns with his hands the noble couple. He who made me anew is John of the Autoreianos family, by profession *mystographos* [probably private secretary]." The reliquary does indeed evoke the polygonal silver ciborium in the church of Hagios Demetrios in Thessaloniki (fig. 3-7 *left*), which centuries earlier had housed the saint's silver bed. By the reign of Constantine X, however, the saint's cult in Thessaloniki was focused not on the ciborium but, rather, on his tomb, from which a holy substance called *myron* allegedly began to flow by 904 (probably in competition with the myron exuded since 893 by another Thessaloniki saint, an abbess named Theodora). As a tangible sign of the saint's presence and power, this sweet-smelling oil was considered a potent, miracle-working relic and was collected in small flasks and distributed to pilgrims. Inside the octagonal reliquary are receptacles that originally held the myron and blood of the saint. The

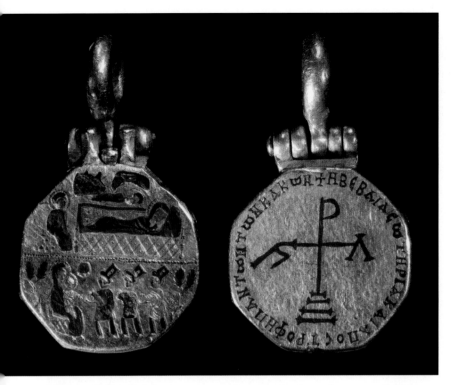

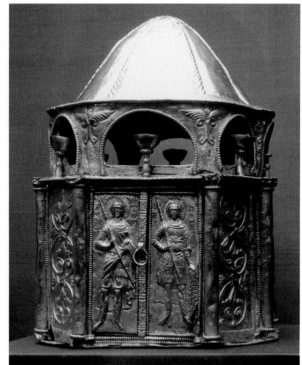

Fig. 6-19. Gold enkolpion, 3.7 × 2.1 × 0.8 cm, tenth–eleventh century; British Museum, London. © Genevra Kornbluth.

Fig. 6-20. Reliquary of St. Demetrios, 15 × 11.5 cm, 1059–67; Gosudarstvennyi istoriko-kul'turnyi muzei-zapovednik "Moskovskii Kreml'." Wikimedia Commons/Shakko, CC BY-SA 3.0.

miniature ciborium thus provided multiple kinds of access to St. Demetrios: it harked back to the earliest architectural focus of his veneration, and it contained a new, ever-replenishing liquid expression of the saint's power.

Using sumptuous materials to signify saintly power is also evident in the case of St. Foy (Faith), the third- or fourth-century martyr who became patron saint of the abbey at Conques (southern France) in the late ninth century after the monks of Conques stole a piece of her skull from a nearby monastery. Such pious thefts were common in the Middle Ages; it was assumed that if the saint did not want to go with the thieves, the theft would be impossible. Collected accounts of Foy's miracles date to the early eleventh century and indicate her contentment with her new home and caregivers. The saint's remains were originally placed in a bust-length reliquary with the skull relic inserted into her wooden abdomen. Around 1000 the reliquary attained its near-final form when it was turned into a full-length enthroned figure; the forearms, hands, crystal orbs, and abdominal window are later alterations (fig. 6-21).

The resulting object, called the Majesty of St. Foy in an eleventh-century text, combines new materials with old ones, including a late antique male mask with piercing inlaid eyes. Foy was understood to inhabit her gold reliquary statue and to act through it; she could fell skeptics with a glance from the oversize eyes, as a witness reported in 1013. The statue encouraged the faithful to believe in the saint's power; the gold, enamel, and gems that completely obscure the wooden core attest to the miracles she

performed, and these costly materials helped attract further donations. Whereas idols were alleged to be hollow, deaf, and dumb, the Majesty of St. Foy was believed to be responsive and active. The statue took the place of her earthly body without copying it, while also representing the saint's body in heaven.

Among the precious older pieces added to the statue is the large rock-crystal intaglio with an image of the Crucifixion (fig. 5-8). The carved gem was placed prominently on the back of the saint's throne, just below her neck (fig. 6-21 *right*). Its reflective convex form caught the viewer's eye while the statue was displayed in the monastery church or while it was being carried in a procession, in both cases elevated above onlookers. Looking up toward the saint's head from behind meant looking through the crystal and visually tying the martyr Foy to the ultimate martyr depicted on the gem, the crucified Christ.

The statue of St. Foy testifies to a significant trend that took place between the ninth and eleventh centuries: the reemergence of freestanding figural sculpture after centuries of absence. The first of these works were large crucifixes, followed by head and bust reliquaries, statues of Mary, and, in the eleventh century, full figures of saints. Not all of these new sculptures contained relics, however, so sacred contents cannot fully explain the new form. This development was motivated in part by the desire to make the intangible power of the saints as tangible and immediate as possible. By the eleventh century, for example, the Majesty of St. Foy was displayed in the east end of

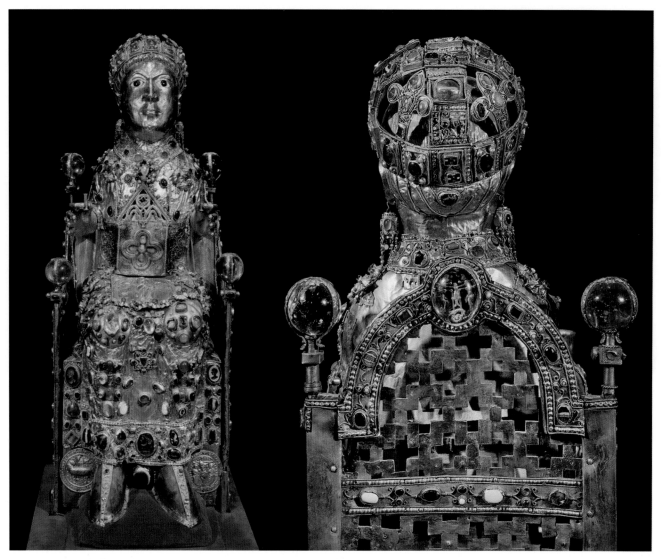

Fig. 6-21. Majesty of St. Foy, H 85 cm, ca. 1000; Trésor, Conques. Erich Lessing/Art Resource, NY.

the church, protected from potential theft by metal grates but still visible whenever the church was open, even from parts of the nave and transepts. The stone benches that ring the ambulatory at Conques suggest that pious viewers lingered in the presence of the statue. It also played a role outside the church, when it was carried in procession to raise funds, resolve conflicts, and promote peace. The large sculptural form of the reliquary enhanced its persuasive powers.

Around the year 1000 Jews adopted the codex format, and two volumes from Fatimid lands show a range of ways they created connections to the sacred Hebrew language. The first is a small parchment bifolium (one sheet folded to make two pages) that was part of a primer for a child learning Hebrew, one of about one hundred such pages found in the Cairo Geniza (fig. 6-22). On the verso, an image of the Temple menorah is flanked by six-pointed stars under an elaborate arch that supports a hanging oil lamp (in Jewish and Muslim books, recto and verso are the opposite of Christian codices because Hebrew, Arabic, and Persian are read from right to left). On the facing recto are the first

three letters of the Hebrew alphabet, *aleph-bet-gimel*, with variations in pronouncing them indicated by a dot inside the letters or by vowel marks underneath. The letters are outlined so the child can fill in the shapes and memorize them. After mastering the alphabet medieval Jewish children moved on to the biblical book of Leviticus. (Muslims learned the Qur'an; Christians studied the Psalms and also, in the Byzantine world, Homer's *Iliad*.) The addition of the menorah, a Jewish symbol that was highly charged, elevated the status of the educational book and underscored the value of Hebrew as the primary literary and liturgical language of Jews in the Middle Ages.

The most important text for Jews was the Hebrew Bible, and the oldest and most complete version was written in Fustat in 1008–10 for Mevorakh ben Joseph ben Netan'el, also known as Ibn Yazdad ha-Kohen (fig. 6-23). Because of its location in Russia since the nineteenth century, the book is called the St. Petersburg Bible (or the Leningrad Codex, after the former Soviet name of St. Petersburg). The patron was a Karaite, a member of a group that emerged in Abbasid Baghdad in the eighth century. This Jewish sect

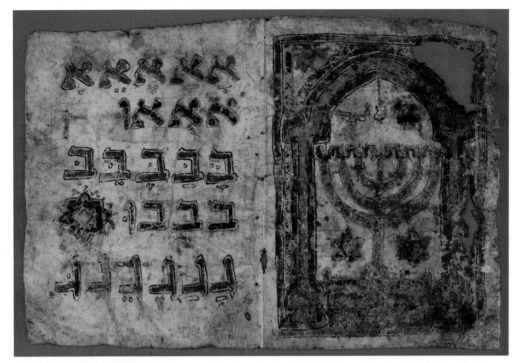

Fig. 6-22. Hebrew primer, 16.7 × 23.4 cm, ninth–twelfth century; Cambridge, University Library, T-S K5.13. Reproduced by kind permission of the Syndics of Cambridge University Library.

Fig. 6-23. Carpet pages, St. Petersburg Bible, 30 × 27 cm, 1008–10; St. Petersburg, Rossiiskaia natsional'naia biblioteka, Firkovitch MS B 19A, fols. 477v–478r. Photo from National Library of Russia.

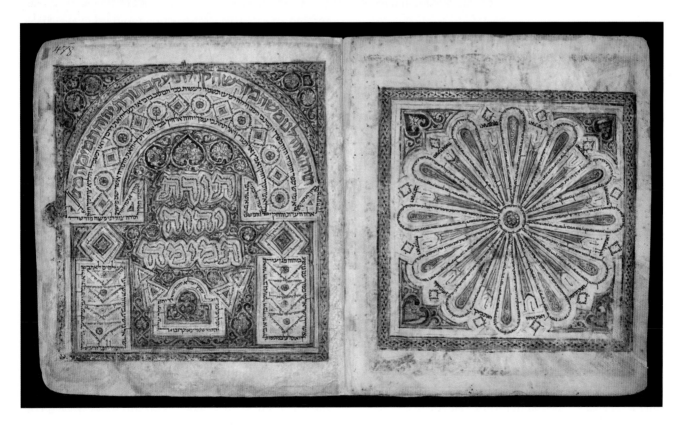

denies the Talmudic rabbinical tradition (the oral law) and recognizes only the written scriptures as the source of religious law. They were very numerous in the medieval Islamicate world and in the Byzantine Empire, where they lived alongside Rabbanite (or rabbinic) Jews who accepted the oral tradition. Notes in the codex give the name of the scribe, Samuel ben Joseph, who may have come to Egypt from northwestern Africa. Both patron and scribe are also mentioned in documents in the Cairo Geniza.

Not only did Samuel write the Hebrew text, but he was also responsible for the sixteen full-page illuminations, now grouped near the end, reminiscent of those in the contemporary Qur'an of Ibn al-Bawwab. On the opening shown here, the verso resembles a lobed dome, and the recto looks like a mihrab or an arch in a canon table; it probably represents the future Temple in Jerusalem, a site of longing that Jews believe will be rebuilt when the Messiah arrives. The gold inscription that outlines the arch says, "Moses gave us the law, the possession of the congregation of Jacob" (Deut. 33:4) and "the Torah [Law] of the

Lord is perfect" (Ps. 19:7). Below this line, the architectural representation is composed of miniature Hebrew writing, an innovative Jewish decorative form known as micrography. The white letters in the center, outlined in tiny script, repeat that "The Torah of the Lord is perfect." The arched rectangle below evokes the Ark of the Covenant, but its golden cherubs (Exod. 25:10–21)—whose representation is forbidden, according to a strict Karaite interpretation of the second commandment—are here replaced by twin triangles. The illuminations contain blessings, biblical verses, and complicated notes—a system of vowels, accents, punctuation marks, and other comments (masora) developed by medieval scholars called Masoretes. They were concerned that the divinely inspired pronunciation and understanding of Hebrew words would be lost because Hebrew was no longer a spoken language. The Masoretes also developed marginal instructions for scribes copying the sacred text in the codex format that was adopted for Hebrew Bibles. What made the St. Petersburg codex exceptional was the meticulousness of its script and decorative elaboration, both of which reflected the owner's knowledge and piety.

Projections of Power

When the St. Petersburg Bible was being written, the Fatimid caliphate was ruled from Cairo by Caliph al-Hakim bi-Amr Allah (r. 996–1021). He exhibited sporadic (and unusual) cruelty toward his non-Muslim subjects (dhimmi), who under Islamic law were normally free to practice their monotheistic faiths in return for loyalty to the state and payment of a special tax. This aggression included the destruction of synagogues and Torah scrolls around Jerusalem and the partial destruction of the Holy Sepulcher complex in 1009, which violated a treaty he had made with the Byzantines to protect it. In this way al-Hakim asserted Muslim domination of the contested city of Jerusalem, while in Egypt many churches were transformed into mosques. The caliph also expressed his power and desire to enhance Shi'i prestige through epigraphy: he blanketed Cairo with anti-Sunni epigraphy that curses the companions of the Prophet and the first three caliphs but praises the "people of the House"—the house or family of Muhammad and the Shi'i leaders descended from Fatima and 'Ali.

Some of these texts appear on the large congregational mosque outside the north wall of the city that was begun by his father in 990 but completed by al-Hakim (fig. 6-24a). Built of brick faced with stone, the mosque courtyard is enclosed by pointed arches supported on piers, a motif that continues into the five-aisle prayer hall and visually unites the interior and exterior spaces. A wider central aisle and an antemihrab dome on squinches emphasize the location of the mihrab, pointing southeast; additional domes at each end of the qibla wall further underscore the special status of this part of the prayer hall. A stucco band above the interior arches contains Qur'anic verses in foliated Kufic script, a lively calligraphic style developed and embraced by the Fatimids in many media. On the facade, a huge portal leads to the courtyard and contains two staircases that give access to the crenellated roof, from which the call to prayer was issued. This ornate monumental portal, which projects toward the city and features blind arcades and bands of epigraphy along with panels and friezes sculpted in foliate relief, was unprecedented in mosque design (fig. 6-24b). It may have had a specifically Shi'i significance; a hadith says, "I [Muhammad] am the city of knowledge and 'Ali is its gate; let those who want to acquire knowledge approach it by its proper gate." Such projecting portals became a regular feature of Fatimid mosques. Al-Hakim's provided an effective backdrop for Fatimid ceremonies, showcasing the caliph as the head of the faith.

After the Rus' leader Vladimir converted to Orthodox Christianity and married a Byzantine princess, he had Byzantine masons build the first stone church in Kyiv. His son, Grand Prince Jaroslav "the Wise" (r. 1019–54), inaugurated an extensive construction program in the city in 1036, replacing the wooden cathedral erected by Vladimir with a new one in stone dedicated to Holy Wisdom in imitation of the Hagia Sophia Cathedral in Constantinople (fig. 6-25). Sviata Sofiia was completed in a period (1037–46) when Jaroslav was firmly established as the sole ruler of Rus' after decades of fratricidal war and skirmishes with the kings of Poland. It was the model for a new cathedral in Novgorod, which was also dedicated to Holy Wisdom and built by the same Byzantine masons, but these buildings remained exceptional in the kingdom; wood structures continued to predominate, with stone churches only becoming common in Rus' in the twelfth century. The cathedral in Kyiv is based on the centralized layout of middle Byzantine churches (eighth/ninth–thirteenth century), with a large central dome over the naos. In smaller Byzantine churches, four tall vaults are arrayed around the dome, creating a cross-shaped design. Sviata Sofiia elaborated this idea with five aisles, five projecting apses, and multiple domes (now, in its expanded form, twenty-five) resting on tall, windowed drums that admit light to the interior. A novel feature is its two-story interior ambulatory and single-story external one, with two stair towers on the west facade.

Whereas Hagia Sophia and the finest Byzantine churches were decorated with mosaics above marble revetment, most of the interior of Sviata Sofiia is frescoed, from floor to ceiling—a much less expensive medium that can achieve very different aesthetic effects due to its flatter surface, wider range of colors, and capacity for fine detail. Only the sanctuary and the naos, the most sacred spaces, received mosaic decoration, some of it made with imported tesserae and the rest produced locally (fig. 6-25b). The apse is dominated by the Mother of God in the orant

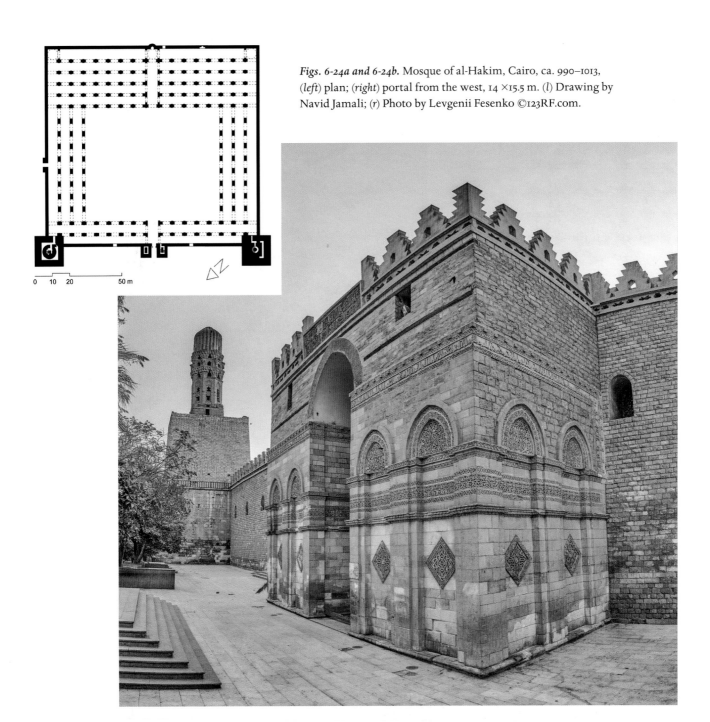

Figs. 6-24a and 6-24b. Mosque of al-Hakim, Cairo, ca. 990–1013, (*left*) plan; (*right*) portal from the west, 14 ×15.5 m. (*l*) Drawing by Navid Jamali; (*r*) Photo by Levgenii Fesenko ©123RF.com.

0 10 20 50 m

pose—standing with hands upraised and elbows bent—above a canopied altar from which Christ offers communion to the apostles. On one side of the altar he distributes wine to six apostles, who stand in line with hands outstretched; on the other he gives bread to a similar group. This variation on the Last Supper was rarely used before the mid-eleventh century, and it signals a new Orthodox interest in representing rituals: the biblical scene has become explicitly liturgical and echoes the contemporary mass enacted at the actual church altar below. By building stone churches and decorating them with Byzantine materials and images (and exclusively Greek inscriptions), Jaroslav attempted to model Kyiv on Constantinople and thereby elevate himself on the world stage.

In about 965, the Viking king Harald "Bluetooth" (r. ca. 958–87) erected a large granite stone at Jelling, in Denmark, to commemorate his parents and announce his principal achievements: unifying Denmark and, briefly, Norway, and converting its people to Christianity (fig. 6-26). (The precise meaning of his nickname is uncertain, but Bluetooth wireless technology was named after Harald because of his success in bringing people together; the company's logo superimposes the runic letters H and B.) One side of the tall stone has a runic inscription arranged in horizontal lines like a Latin text: "King Harald ordered these *kumbl*s [commemorative stones] made for his father, Gorm, and his mother, Thyra; the Harald who won for himself all of Denmark." The other two sides continue the inscription: "and

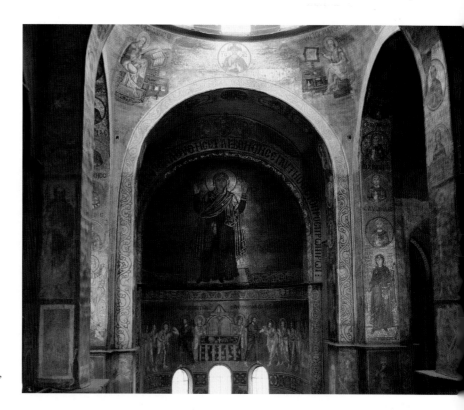

Figs. 6-25a and 6-25b. Sviata Sofiia Cathedral, Kyiv, (*left*) plan, with 1037–46 phase in black; (*right*) view toward the east. (*l*) Drawing by Navid Jamali; (*r*) Wikimedia Commons/A-bg78, CC BY-SA 3.0.

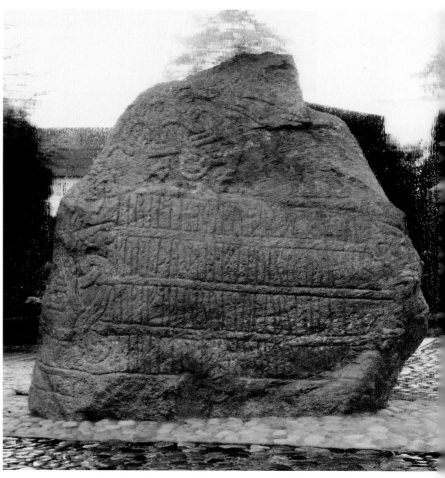

Fig. 6-26a. Commemorative stone, Jelling, side with main inscription, maximum H 243 cm, ca. 965. © Genevra Kornbluth.

Norway," "and made the Danes Christian." Although this content is unique, Viking-Age runestones are very common in Scandinavia; 168 survive in Denmark, 51 in Norway, and over 2,500 in Sweden. On the Jelling stone, the serpentine interlace that encloses the inscription also surrounds a quadruped, probably a lion, intertwined with a snake on the stone's second face; the crucified Christ (with arms extended, although no cross is visible) is on the third side. This monumental stone sculpture is the earliest known image of Christ in Scandinavia, and it shows him alive, clothed, and victorious over death. While it is characteristic of the Animal Style, the interlace around Christ is also vinelike, and the three-sided stone may have had a Trinitarian meaning. There could also be an allusion here to the Norse god Odin, who hanged himself on the World Tree for nine nights. A ropelike border interspersed with knots frames the figural scenes and suggests that they should be read together. The lion and snake are fighting in the kind of struggle commonly found in earlier imagery in northern Europe, as on the purse lid from Sutton Hoo (fig. 3-16). The lion, king of beasts, likely symbolizes Christ, defeating evil represented by the snake; but it could also refer to Harald, with his military victories and Christianizing efforts. Despite the stone's claim that Harald personally converted

Denmark, Christians are attested there by the eighth century, and polytheistic practices continued in Scandinavia after Harald's reign. The conversion of a whole population always required considerable time even after a ruler adopted a new faith.

Harald's stone at Jelling added to an earlier commemorative landscape. It was erected near a smaller stone offered by Harald's father in honor of his wife, halfway between two tall mounds. The northern one probably contained the body of Gorm before it was reburied in a new wooden church that Harald built on the site. That mound marks the center of what is known as a ship setting, a series of stones outlining the shape of a ship, here nearly 360 meters long and 80 meters wide (fig. 6-27). This huge ship setting was an ambitious realization in stone of the long tradition of elite Scandinavian ship burials, including Sutton Hoo and Oseberg. The stones, mounds, and symbolic ship were enclosed within an enormous, lozenge-shaped wooden palisade, covering an area of about 125,000 square meters; in one corner were longhouses and other buildings. This sturdy fence, which required over eleven hundred mature oak trees, is securely dated by dendrochronology to the reign of Harald. Such a sizable enclosure, which required an enormous amount of material and labor, has no

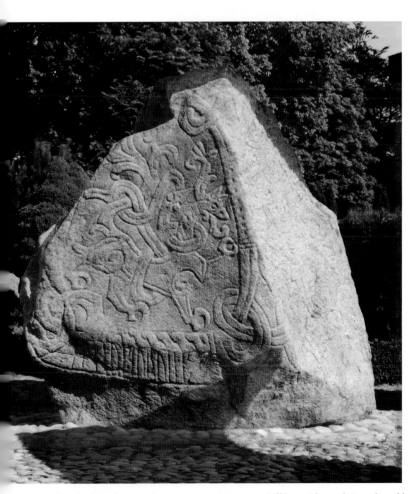

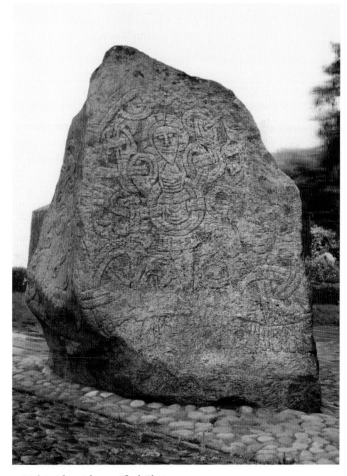

Fig. 6-26b and 6-26c. Commemorative stone, Jelling, side with interlaced beasts, *(right)* side with crucified Christ, maximum H 243 cm, ca. 965. © Genevra Kornbluth.

Fig. 6-27. Ship setting, Jelling. © 2019 Google, © Aerodata International Surveys, Maxar Technologies, Scankort, Map data © 2019 and the authors.

parallels in Viking-Age Scandinavia and must have been intended as a monumental statement of royal power. It was not there for long, however; a layer of charcoal indicates that the palisade was burned down before it suffered much natural deterioration. Nevertheless, the runestone remained to mark a royal cult site in which a church stood alongside more traditional expressions of power that helped legitimize the ruler's new faith.

An embroidered textile housed in Bayeux (northern France) chronicles the conquest of England in 1066 by the Normans, Scandinavians who had settled in northern France (Normandy) since the tenth century and adopted Roman Christianity (figs. 6-28 and 6-29). It is usually called the Bayeux Tapestry, but that name does not accurately describe the textile's production technique: a tapestry is woven on a loom, and this textile is embroidered (stitched) with multicolored wool yarns on nine pieces of linen. Made around 1080, the embroidery is now approximately sixty-eight meters long and between forty-five and fifty-three centimeters high. Over four hundred alterations or repairs make some of the images unreliable, and the end of the story is missing. Nevertheless, the Bayeux Embroidery complements contemporary written records as a source

of information about politics, warfare, and material culture in eleventh-century northwestern Europe. It shows that the English king Edward ("the Confessor," r. 1042–66) sent Earl Harold Godwinson to Normandy (in 1064). A key scene among a series of adventures shows Harold swearing an oath of allegiance to Duke William of Normandy on two portable reliquaries (fig. 6-28). The main action unfolds in the central strip of the embroidery, with short inscriptions labeling characters or describing major events; imagery in the narrow borders frequently comments on that action satirically or humorously, with details drawn from Aesop's ancient Greek fables, bestiaries (moralizing treatises about animals), and other literary sources. For instance, the long-tailed, two-color birds are probably magpies who symbolize Harold's greed, pride, and impending downfall. Despite his oath, Harold proclaimed himself king after Edward's death (fig. 6-29 *left*). As he sits unbalanced on his throne, above a border of ghostly ships that foretell the future, a strange star passes overhead (fig. 6-29 *right*): yet another bad omen for Harold (Halley's Comet was visible in England in March 1066). Using the pretext that Harold had sworn fealty to him and had no legal right to be king, William organized an invasion. The

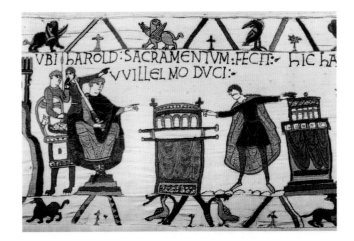

Fig. 6-28. Harold swears on relics, Bayeux Embroidery, ca. 1080; Musée de la Tapisserie de Bayeux. Wikimedia Commons/Myrabella, CC0 1.0.

Fig. 6-29. Harold enthroned and Halley's Comet, Bayeux Embroidery, ca. 1080; Musée de la Tapisserie de Bayeux. Wikimedia Commons/Myrabella, CC0 1.0.

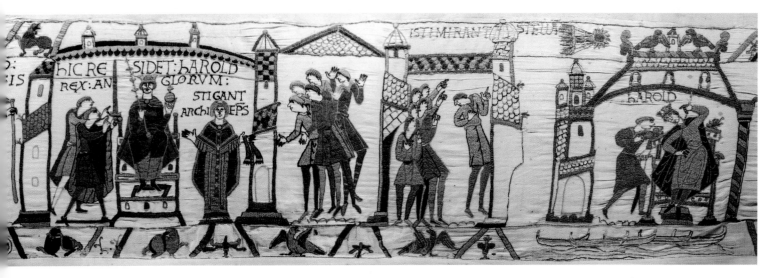

embroidery shows the ships being built and other preparations for sailing across the English Channel, culminating in the battle of Hastings on October 14, 1066, during which Harold was slain. William "the Conqueror" was crowned king of England (r. 1066–87) on Christmas Day.

The embroidery's commissioner has long been assumed to be William's half brother Odo (ca. 1032–97), who was bishop of Bayeux in Normandy and, after the conquest, earl of Kent in southeast England. The Bayeux Embroidery was most likely made at St. Augustine's Abbey in Canterbury (in Kent). Its inscriptions have Anglo-Saxon features, and some of its images echo those in manuscripts produced there. Moreover, many figures on the embroidery are included in the abbey's martyrology, the catalogue of the dead recited in an institution's prayers. Textile work is often associated with women, and Englishwomen in particular were famed for their needlework. Men were also professional embroiderers, however, and who stitched it remains uncertain. Odo probably paid for the embroidery, but Abbot Scolland of St. Augustine's (r. 1072–87), formerly a monk in Normandy, may have helped design it.

The work is not entirely a triumphalist piece of Norman propaganda. First, the way Harold and Edward reach out and nearly touch each other as Edward lies dying raises the possibility that the childless king changed his mind on his deathbed and chose Harold as his successor. Second, images of Harold piously attending church and rescuing Normans from quicksand might not have been included if the aim of the embroidery was to portray him as a villainous usurper. Another unusual feature of the work is its inscriptions. The most commonly repeated Latin word is *Hic*, meaning "here," which seems to be a cue for someone charged with narrating the action for viewers; the very first audience would have included people who participated in the events being retold. By 1476 the work was hung in the nave of Bayeux Cathedral on certain feast days, and it was probably displayed there in the late eleventh century also. In the modern age, the Bayeux Embroidery remains one of the most famous medieval works of art, used and abused for political purposes: whereas the Nazis valued it as a statement of Germanic power that legitimated their own conquering ambitions, a 2018 promise to loan it to England was intended as gesture of goodwill during Brexit negotiations. Meanwhile, debate continues about many aspects of its original manufacture, function, and meaning.

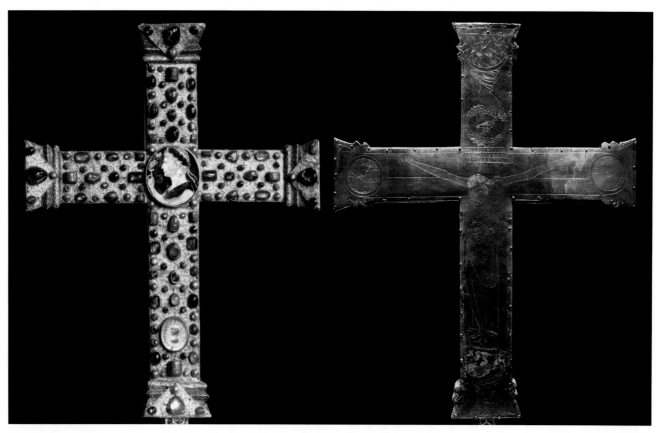

Fig. 6-30. Lothar Cross, front and back, 50 × 38.5 × 2.3 cm, ca. 1000; Domschatzkammer, Aachen.
(*left*) © Genevra Kornbluth; (*right*) Wikimedia Commons/Sailko, CC BY 3.0.

Ties to the Past

Otto III (980–1002) was only three years old when he was crowned king of Germany in Aachen on Christmas Day 983, the same day chosen for the coronations of Charlemagne and Otto II (and later William "the Conqueror"); in 996 he was crowned emperor in Rome by the pope. An object connected to Otto III is the Lothar Cross, named for the oval rock-crystal seal matrix of the Carolingian king Lothar II (r. 855–69) near the bottom of its gemmed front (fig. 6-30). A first-century cameo of Augustus dominates this side of the cross (fig. 1-6), along with 135 gems and pearls on a wooden core; the cameo may have come from Byzantium with Otto's mother, Theophanu, a Byzantine princess. On the other side, the engraved hand of God crowns a slumped, dead Christ on the cross with a wreath enclosing a dove that symbolizes the Holy Spirit (the roughly contemporary Cross of Herimann and Ida has similar imagery and also incorporates spolia; fig. 1-1). Otto III is not shown, but viewers looking at the cameo would have understood it as representing both an ancient Roman emperor and the current one. Otto maintained a palace in Rome and actively pursued a policy of renovatio, thus advertising Ottonian continuity with the Carolingians. This idea was reinforced in 1000 when Otto III opened Charlemagne's tomb in Aachen and reportedly found the corpse and contents intact, including the

quadriga silk (fig. 5-6). Following the example of Charlemagne, who initiated Aachen's prestigious collection of relics and objects, Otto may have donated the Lothar Cross to the Aachen treasury on that occasion.

Another Ottonian attempt to tie the eleventh-century present to the ancient Roman and Carolingian pasts is the freestanding bronze column erected by Bernward, who was the tutor of Otto III and bishop of Hildesheim (r. 993–1022; canonized 1192). An artist himself and a great patron of art and architecture for his diocese in northern Germany, Bernward commissioned the stone church of the abbey of St. Michael, along with its five-meter-tall bronze doors displaying Old and New Testament typologies and, around 1020, a freestanding bronze column that originally supported a bronze cross (fig. 6-31). The column base is decorated with small personifications of the four rivers of paradise; the capital is a nineteenth-century addition. The column displays twenty-eight scenes unfurling upward in a spiral, from Jesus's baptism to his entry into Jerusalem. Twenty-eight was considered a perfect number because it is the sum of its divisors, 1 + 2 + 4 + 7 + 14 (box 6-2). The column imitates the much larger spiral columns of the emperors Trajan and Marcus Aurelius that Bernward had seen in Rome in 1001 (fig. 1-27a). In addition to Roman imperial models, Bernward likely drew on local prototypes: freestanding columns, albeit not spiral ones, were dedicated to Jupiter and other divinities in Germanic lands between

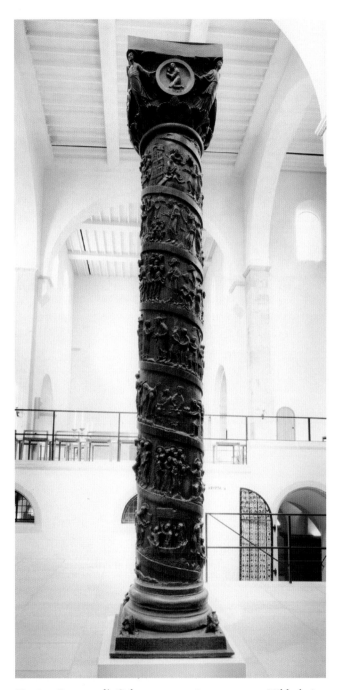

Fig. 6-31. Bernward's Column, 379 × 58 cm, ca. 1020; Hildesheim Cathedral. © Genevra Kornbluth.

the third and fifth centuries. Hildesheim was on the front lines of converting the pagan Slavs to the north and east, and at the center of Slavic temples a column or tree trunk was venerated as a cult image. Bernward's bronze column and doors thus drew on diverse antecedents to pose a Christian visual challenge to the nearby Slavs and un-converted Germans. To realize his monumental bronzes, Bernward employed the ancient lost-wax casting method that had been revitalized by the metalworkers who produced bronze railings and doors for the palace at Aachen (box 5-1). Since Charlemagne's time this method had been used to make smaller objects like church bells, but the scale of Bernward's bronzes was unprecedented, requiring

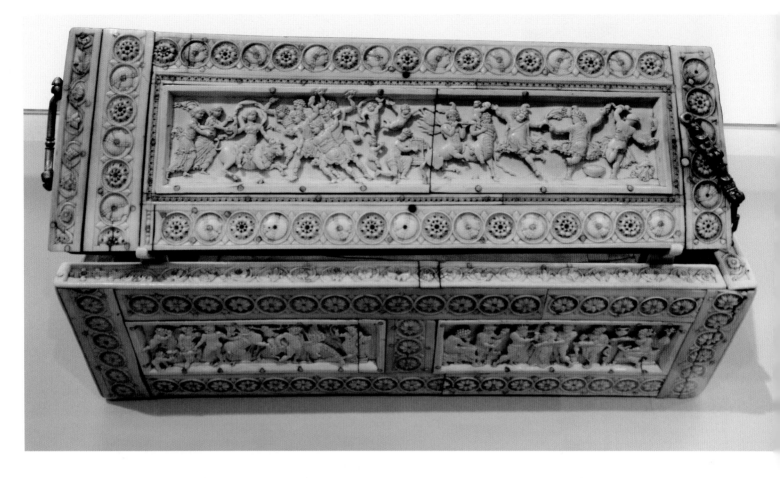

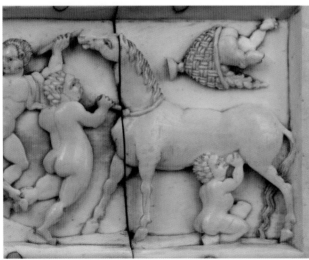

Figs. 6-32a and 6-32b. Veroli Casket, 11.5 × 40.3 × ca. 16 cm, later tenth or early eleventh century, (*top*) top and front; (*left*) detail of back; Victoria & Albert Museum, London. © Genevra Kornbluth.

a large and technologically proficient workshop. The column and doors at Hildesheim were the first freestanding bronze sculptures produced since ancient Rome; they are also significant for the development of biblical narrative in the medium of sculpture.

The Byzantines produced monumental bronze doors that postdate those of Bernward, but they did not craft freestanding sculpture in that medium. They preferred other materials and a smaller scale. The Veroli Casket, named for its location in Italy in the nineteenth century, is

a rectangular wooden box with a sliding lid, covered with carved plaques of ivory and bone that were further embellished with polychromy and gilding (fig. 6-32a). It was made in the later tenth or the early eleventh century for an elite patron. With its romantic and erotic imagery, it may have been a wedding gift, like the Projecta Casket (fig. 2-10); perhaps it held perfumes or jewelry. The Veroli Casket draws on classical antiquity for its mythological iconography and representations of nudity. On the lid are representations of a lyre-playing Herakles, centaurs, and dancers, with the Rape of Europa at the left (Zeus tricks a young princess by turning into a gentle bull and carries her out to sea as her friends try to prevent the abduction). On the front are a winged horse and the near sacrifice of Iphigenia, framed by Asklepios and his daughter Hygeia. On the back and sides are a procession of the god of wine and amorous vignettes (fig. 6-32b). Numerous erotes (child Cupids, often called putti) enliven all but one panel, propelling the action and introducing humorous and sexual motifs. On the lid, the

 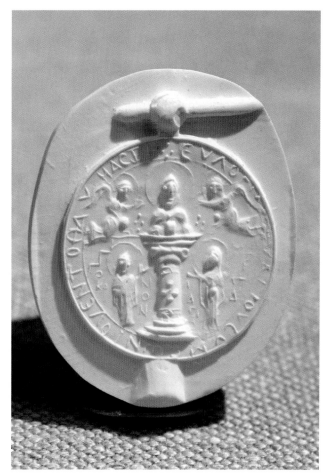

Figs. 6-33a and 6-33b. (*left*) Mold for St. Symeon the Younger pendant, 4.2 × 2.2 × 1.2 cm, late tenth century; (*right*) modern impression; Kelsey Museum of Archaeology, University of Michigan, Ann Arbor. © Genevra Kornbluth.

rosettes alternate with profiled heads that imitate ancient coins.

The Byzantines were familiar with mythological imagery—ancient statues were displayed prominently in Constantinople—but not all of the figures on the Veroli Casket are recognizable, and even the familiar episodes incorporate unexpected details. A viewer had to work hard to make sense of the stories' many interruptions and transformations. This challenge was an intentional part of the work. The Greek word for "ivory" (*elephas*) is related to the word "deceive" (*elephairomai*); on the Veroli Casket bone masquerades as ivory in the rosette strips, and the mythological scenes are filled with deception (Zeus's form in the abduction scene, the lie of Iphigenia's father that nearly leads to her death). Although some of the scenes on the box seem disturbing today, the ancient tales were generally perceived as erotic at the time of its creation. The casket was meant to entertain rather than edify, and its classicism provides a distancing filter through which Orthodox Christian viewers could enjoy the suggestive images.

In the later tenth century the Byzantines reconquered the area around Antioch, inspiring a revival of religious tourism to sites associated with the two sixth-century stylite saints named Symeon. The complex dedicated to Symeon the Elder at Qal'at Sem'an (fig. 2-28) became a fortified monastery until it was recaptured in 985 by the emir of Aleppo. The Miraculous Mountain of Symeon the Younger (d. 592) continued to be used by Georgian and Melkite monks (Orthodox, Chalcedonian Christians who used Arabic as their language of worship). Souvenirs were once again produced in this rejuvenated environment, but in a very different form. Instead of tokens made from earth sanctified by proximity to the saint's column (fig. 2-30), the tenth- and eleventh-century pilgrimage souvenirs were cast-lead pendants produced in molds made of steatite (a soft stone that is easy to carve) (fig. 6-33). The "blessings" produced from such molds lacked the innate holiness and medicinal potential of their earthen predecessors, and in theory they could have been manufactured anywhere— the Miraculous Mountain, Antioch, even Constantinople. Nevertheless, these new, durable objects forged a connection with saints whose ascetic practice had long since vanished but whose popularity surged with Byzantine control of their cult sites.

Work in Focus:
HOSIOS LOUKAS

The monastery dedicated to Hosios Loukas (Blessed or Holy Luke) near Steiri, in central Greece, is one of the paradigmatic works of middle Byzantine art and architecture and still a functioning monastery (fig. 6-34). Luke (896–953) was a peripatetic monk and healer who spent his last years there. He is said to have predicted the Byzantine reconquest of Crete (961), which had been an Islamic emirate since the 820s. When Luke died he was buried beneath his cell, and his tomb became known as a place of miracles. There was a church on the site during Luke's lifetime, but it was replaced in the second half of the tenth century by the current church of the Panagia (All-Holy; that is, Mary). Its plan is a cross-in-square—the most common posticonoclastic Byzantine church plan—preceded by a double narthex. A tall dome (diam. 3.5 m) caps the compact central

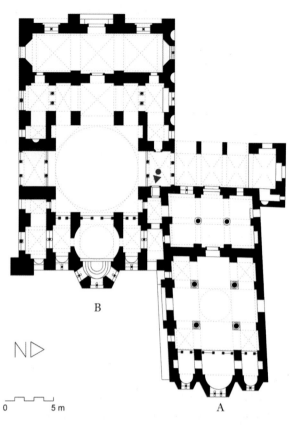

Figs. 6-34a and 6-34b. Monastery of Hosios Loukas, Steiri, second half of tenth–first half of eleventh century, *(top)* plan, A=Panagia church, B=katholikon, with relics' location in red; *(bottom)* exterior from the east. *(t)* Drawing by Navid Jamali; *(b)* Photo by Brad Hostetler.

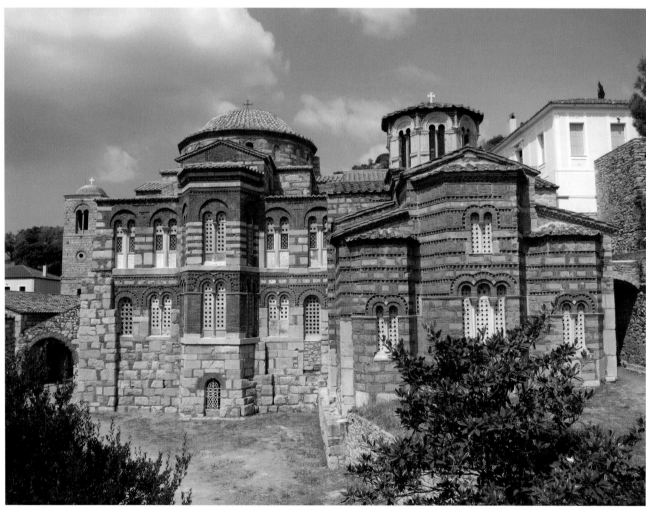

bay, which is defined by four monolithic columns and buttressed by barrel-vaulted bays on four sides; the eastern vault leads to the bema (sanctuary) and the central apse. The two side apses and their preceding bays serve important functions. The one to the north, called the prothesis, is where the components of the Eucharist were prepared; the southern one, the diakonikon, housed liturgical vestments (ritual garments), vessels, and sacred texts. The builders did not square the corners, so the building is a parallelogram in plan. The Panagia church never received mural decoration, but it does have carved capitals, parts of its original sanctuary barrier, and sculpted relief frames for the main icons on the piers that mark the entrance to the sanctuary.

As the fame of Holy Luke spread thanks to the appearance of myron and miracles at his tomb, the monastery attracted pilgrims, which necessitated a larger church and easier access to the relics. A large crypt covered with groin vaults (intersecting barrel vaults) was constructed around the tomb in the first half of the eleventh century, but Luke's remains were moved upstairs—almost directly above their original location—to a marble shrine at the juncture of the new katholikon and the narthex of the Panagia church. There the relics could be approached from two sides, and needy pilgrims sometimes practiced incubation nearby under the eyes of Holy Luke, represented in mosaic and fresco.

The katholikon, of unknown dedication, has a much larger naos than the earlier church dedicated to Mary (fig. 6-35). Its wider (8.8 m) dome on squinches is supported on eight piers, a so-called domed-octagon plan, with tall cross-arms and smaller chapels in the corners. The galleries on the north and south sides and a two-story narthex let in light through panels with multiple small openings, supplementing the light admitted by the windows in the dome, apse, and cross-arms (the original interior was thus darker than it is today, when clear glass fills some windows, and also darker than early Byzantine churches, which had large windows). Both cross-in-square and domed-octagon churches have a pyramidlike massing of forms, cascading downward from the tall dome. This structure lent itself to a hierarchical system of interior decoration. The most sacred imagery was situated at the highest point, the dome, which was associated with heaven. The next most sacred spaces are the apse and sanctuary vault, followed by the vaults of the cross-arms, and, finally, the lower walls and vaults. As in the finest late antique and Byzantine churches, the walls of the katholikon are clad in marble panels, and the mosaics are positioned above.

Hosios Loukas's dome mosaic was lost in an earthquake and later replaced by paintings that probably imitate the original iconography: a bust of Christ, usually called the Pantokrator (Ruler of All), surrounded by angels and Mary, with prophets between the windows. As was usual after iconoclasm, the Theotokos and Child are

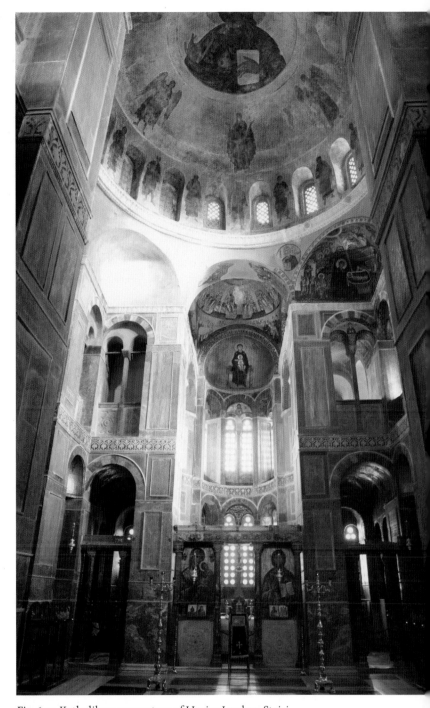

Fig. 6-35. Katholikon, monastery of Hosios Loukas, Steiri, first half of eleventh century. Wikimedia Commons/Hans A. Rosbach, CC BY-SA 3.0.

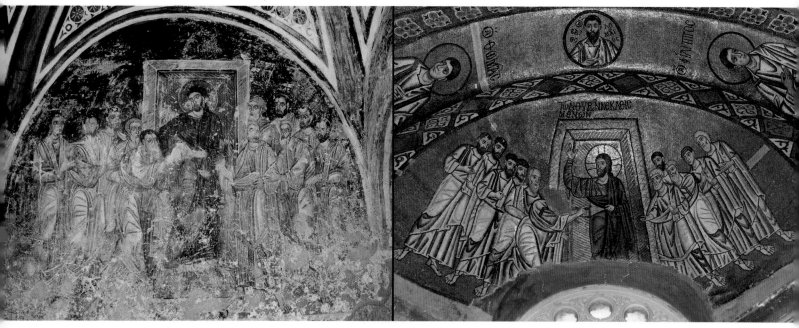

Fig. 6-36. Doubting Thomas scenes, monastery of Hosios Loukas, Steiri, first half of eleventh century, (*left*) crypt fresco; (*right*) narthex mosaic. Photos by the authors.

depicted in the apse conch, while the shallow dome above the altar contains the Pentecost scene, in which the Holy Spirit descends on the seated apostles from the Hetoimasia at the center, enabling them to preach the Gospel to the whole world. The pendentives represent the diverse tribes and tongues converted by the newly multilingual apostles (Acts 2). Four Christological scenes occupy the squinches of the central dome (the Annunciation, in the northeast, is now missing), and scenes of Christ's Passion and resurrection are in the narthex, which is dominated by a huge bust-length blessing Christ over the door into the naos (evoking once again the biblical "I am the gate"). Chapels in the northwest and southwest bays functioned as intimate funerary and baptismal spaces with relevant fresco decoration. Altogether, the 182 images of saints in the Hosios Loukas katholikon and crypt far outnumber the 16 Christological and feast scenes; of the saints' "portraits," about one-third are monks, an appropriate selection for a monastery. Details in these representations also reinforce the function and message of the monastery. Whereas Panteleimon, a physician saint, is shown holding his medical equipment, Luke's empty hands convey that he needs no tools to effect a cure. The location of certain scenes is also relevant to the monastic setting: Jesus washing the feet of the apostles was placed in the narthex, above the spot where, in a vivid imitation of Christ, the abbot of Hosios Loukas humbly washed the feet of a dozen monks on Holy Thursday before Easter. Byzantine narthexes were used for a wide variety of noneucharistic functions, such as communal prayers and meetings, annual celebrations and commemorations, baptisms, and funerals; and the narthex was as close to the church proper as certain

categories of people (menstruating women and the unbaptized, for example) were permitted to go.

The patronage of Hosios Loukas, including the expensively decorated katholikon, is unknown, but its opulence indicates elite and possibly imperial support. A vita of Holy Luke written soon after his death does not clarify this issue. The date of the complex is also controversial, but remains of wooden scaffolding in the katholikon have recently been radiocarbon-dated to the early eleventh century. Abbot Philotheos (r. ca. 1011) in the northeastern chapel of the katholikon is shown offering a model of the church to Christ, and one of the monastery's liturgical books credits him with translating the body of Luke from its original resting place to the katholikon, so he almost certainly initiated its construction. Portrait medallions in the southeastern vault of the crypt include Philotheos, two other abbots, and Theodosios, who was abbot about 1048, so the crypt paintings were probably completed soon after that. A slightly earlier date for the katholikon mosaics, in the 1030s or 1040s, seems likely: they resemble those at Sviata Sofiia in Kyiv, and mosaicists from Constantinople may have decorated both churches.

A scene can be represented in different ways in different media, even in the same church. At Hosios Loukas, versions of the Doubting Thomas episode (John 20:24–29) are rendered in fresco, at eye level in the crypt (fig. 6-36 *left*), and in mosaic, high up in the katholikon narthex (fig. 6-36 *right*). The Greek title for the scene, "The Doors Were Locked" (John 20:26), appears in the mosaic above the depicted doorway. The phrase underscores Christ's divinity: he could enter a room even though the doors were closed, and indeed, rays of light surround him in

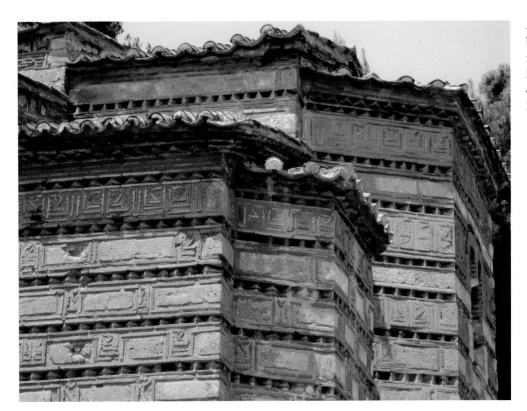

Fig. 6-37. Pseudo-Kufic brickwork, Panagia church, monastery of Hosios Loukas, Steiri, second half of tenth century. Photo by Brad Hostetler.

the doorway. The apostles who witness the event in the mosaic stand stiffly and do not interact. Christ raises his right hand to display the nail hole from the crucifixion. By contrast, the fresco highlights the emotional dynamism of the story. Several apostles turn their heads as if in conversation with one another and with the viewer, and Christ actively guides Thomas's hand to the wound in his side. As Thomas contemplates the reality of Christ's bodily resurrection, the viewer could touch Christ's side as well, affirming the tangible reality of the event and, by extension, the promise of salvation. The original fresco design called for Christ's arm to be raised, as in the mosaic—the vestigial pose is still visible against the painted door—but the modification created a more affective, empathetic image that anticipates later developments in Byzantine art. The primary audience for the crypt fresco was the monks who frequented this funerary space, whereas the mosaics upstairs would have been seen by many more visitors to the complex.

Other ornamental features at Hosios Loukas are also worthy of note. Both churches have opus sectile floors (slices of colored stone laid in decorative patterns), and the katholikon also has variegated marble walls. Byzantine viewers were sensitive to patterns in marble and interpreted them as naturalistic landscapes; as a tenth-century poet wrote about a church pavement in Constantinople, "Here another meadow is depicted, made from art, adorned with flowers that do not wither with time." The east exteriors of both churches, especially the older one, are marked by a profusion of brickwork that includes courses of dogtooth (projecting zigzag) ornament and friezes of imitation foliated Kufic (fig. 6-37). Pseudo-Kufic script, which rarely forms coherent Arabic words, was a very common decorative feature in Byzantine art in all media from the tenth century to the twelfth; at Hosios Loukas it enhances scenes and surfaces inside both churches as well as outside. Artists may have been inspired by Arabic inscriptions on portable works, such as spoils from the Cretan conquest. On the Panagia church, which was closely connected to Holy Luke's prophecy of Muslim defeat, pseudoscript likely connoted Christian victory over Islam—a victory urgently desired after Caliph al-Hakim's destruction of the Holy Sepulcher in 1009. Arabic was also associated with the Holy Land and therefore with Christ's life and sacred Christian sites. Spurred by Emperor Constantine IX Monomachos's rebuilding of the Holy Sepulcher, pilgrimage increased in the eleventh century to the Holy Land and also to newer destinations like Hosios Loukas.

CHAPTER 7

ca. 1070 to ca. 1170

Legend
- □ Location or findspot
 - Monument/object
- • Additional site
- ○ Approximate place of production

Urnes □
- Stave church

□ Mosjö
- Wood statue of Mary

Lindisfarne

Durham
□ - Cathedral
- Life of St. Cuthbert manuscript

□ **Lisbjerg**
- Golden Altar

Shrine of St. Patrick's Bell ○

○ Cloisters Cross

Kilpeck □
- Sheela-na-gig

•Helmarshausen

Santiago de Compostela •

Puente la Reina •
Burgo de Osma•
Saragossa•
•Cutanda

•Bologna
□ •Florence
•Rome

Pisa
- Bronze griffin
- Cathedral complex

□ **Bari**
- Marble throne

○Burgo de Osma silk
Almería

□ **Palermo**
- Cappella Palatina
- Mantle of Roger II

Thebes
Corinth

Atlas Mountains

Sahara

Stavelot □
- Triptych

Bingen

Caen•

Paris •□ **Saint-Denis**
- Abbey church
- Eleanor Vase

Disibodenberg
- Manuscript of Hildegard's Scivias

Fontenay □
- Abbey

•Cîteaux

•Cluny

□ **Conques**
- Abbey church of Sainte-Foy

Moissac□
- Cloister, Abbey of Saint-Pierre

Abbey Church of Saint-Denis, Saint-Denis

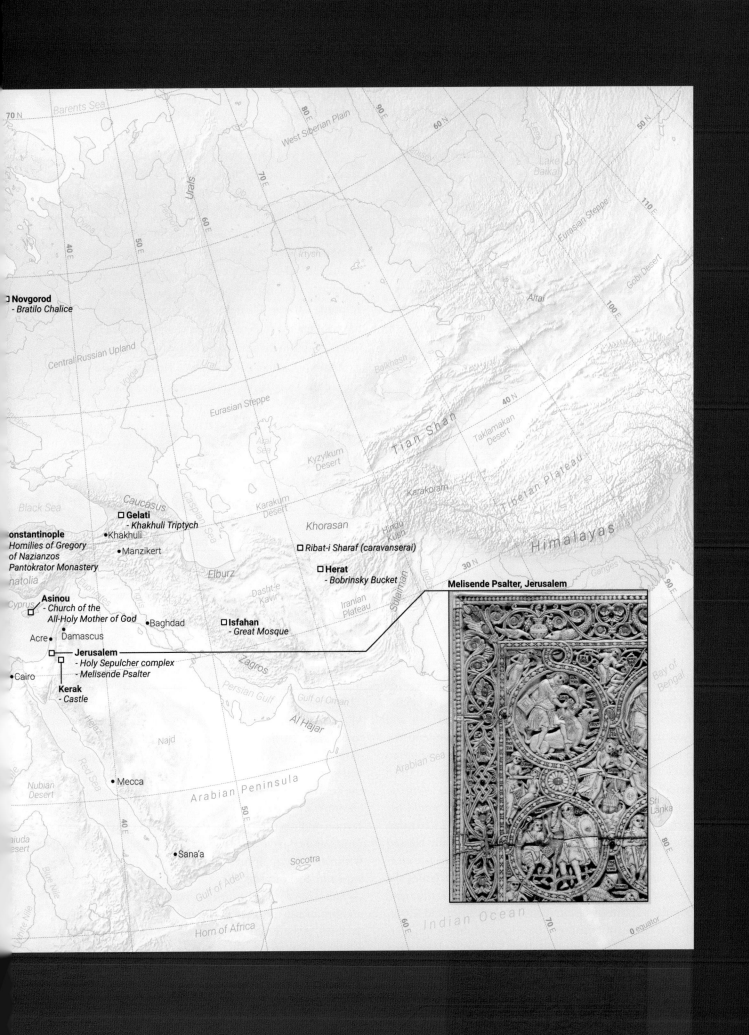

Novgorod
- *Bratilo Chalice*

Gelati
- *Khakhuli Triptych*

Constantinople
*Homilies of Gregory
of Nazianzos
Pantokrator Monastery*

• Khakhuli

• Manzikert

Ribat-i Sharaf (caravanserai)

Herat
- *Bobrinsky Bucket*

Melisende Psalter, Jerusalem

Elburz

Dasht-e
Kavir

Iranian
Plateau

Asinou
- *Church of the
All-Holy Mother of God*

Cyprus

Isfahan
- *Great Mosque*

• Baghdad

Acre •
• Damascus

Jerusalem
- *Holy Sepulcher complex*
- *Melisende Psalter*

• Cairo

Kerak
- *Castle*

Zagros

Persian Gulf

Gulf of Oman

Al Hajar

Najd

Hejaz

• Mecca

Arabian Peninsula

Nubian
Desert

Red Sea

• Sana'a

Arabian Sea

Sri Lanka

Bay of
Bengal

Socotra

Gulf of Aden

Horn of Africa

Indian Ocean

equator

Black Sea

Caucasus

Caspian Sea

Aral
Sea

Kyzylkum
Desert

Karakum
Desert

Khorasan

Hindu
Kush

Tian Shan

Taklamakan
Desert

Tibetan Plateau

Himalayas

Karakoram

Ganges

Eurasian Steppe

Balkhash

Lake
Baikal

Gobi Desert

Altai

Irtysh

West Siberian Plain

Urals

Ob

Barents Sea

Central Russian Upland

Volga

Ural

Lena

Yenisey

Anatolia

In the century covered in this chapter, a slow warming trend improved agricultural conditions in western Europe, and the invention of the horse collar allowed farmers to harness their horses for plowing for the first time. These developments produced higher yields generated by a smaller workforce. More people were freed from agricultural labor to move to urban centers; the economy transitioned from a barter system to a monetary one, and overall wealth increased. There was also a dramatic rise in travel, creating new opportunities for contact between individuals and states throughout the medieval world. In Rome, Pope Gregory VII (r. 1073–85) and his successors instituted the so-called Gregorian Reform to shore up the authority of the Church against the increasing power of rulers, particularly those called, after the late twelfth century, the Holy Roman emperors. These rulers insisted on their right to appoint bishops without the pope's authorization, a conflict known as the Investiture Controversy. In the Islamicate world, the geographer al-Idrisi (1100–ca. 1165) developed more accurate cartographic techniques, working mostly for the Norman king Roger II in Sicily. A new eastern dynasty, the Seljuq Turks, conquered Baghdad in 1055 and created a Sunni empire that still gave allegiance in theory to the Abbasid caliph. In 1071 the Seljuqs defeated a much larger army of Byzantines and mercenaries at the Battle of Manzikert (Turkey), opening Asia Minor to the Muslims. In the same year the Byzantines lost southern Italy to the Normans. Despite these territorial losses, the Byzantine Empire under the Komnenian dynasty (1081–1185) experienced a revival in urban life, a rise in intellectual and artistic production, and increased contacts with Europe. Pope Urban II (r. 1088–99) responded to the Byzantine emperor's request for military aid and encouraged war against the Turks. Those who heeded his call also attempted to regain Jerusalem and restore Christian access to sites in the Holy Land, which had become inaccessible because of war between the Fatimids and the Seljuqs. Despite violence and upheaval, many long-established religious and social structures remained in place and changed slowly over the course of the eleventh and twelfth centuries. Art and architecture continued to be made in traditional ways to meet local needs, even as new art forms emerged from such social phenomena as urbanization, pilgrimage, and religious war.

Pilgrimage

Despite incessant warfare and ever-shifting borders—or perhaps because of these things—pilgrimage remained a fundamental expression of piety in the eleventh and twelfth centuries. The promise of radical change in the present life and salvation in the next inspired people to leave the predictability of their lives at home, sacrifice months or years of income, and face untold risks along the way. Pilgrims who reached their destinations would become closer to God, and the official signs of a Christian pilgrim, the staff and satchel, were ceremonially blessed when their owner departed for a holy site. By the late eleventh century the tomb identified as that of St. James the Greater at Santiago de Compostela (Spain) was the most popular pilgrimage destination after Jerusalem and Rome. By the thirteenth century some sources, likely exaggerated, claimed that it attracted about five hundred thousand visitors each year.

A network of churches, monasteries, hostels, and other facilities to serve the needs of pilgrims spread along four major arteries in France, with one originating in Italy. These roads converged at Puente la Reina in the Pyrenees Mountains, and a principal road led across northern Spain to Santiago. A bustling service economy provided food, lodging, guides, and souvenirs for pilgrims and brought new prosperity to towns. Numerous major shrines along the routes were constructed or reconstructed in the late eleventh or twelfth centuries, and these churches share certain architectural features: soaring stone barrel vaults, round-arched nave arcades, and large portals embellished with narrative sculpture (box 7-1). Two tall towers at the west end, first introduced in Carolingian architecture (figs. 5-3 and 5-5a), made pilgrimage churches visible from afar and broadcast the status of these cult sites. On a practical level, stone vaults were more resistant to fire than the wooden roofs used earlier. Structural and stylistic similarities shared by many of the churches on the roads to

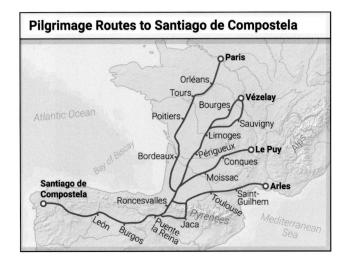

Pilgrimage Routes to Santiago de Compostela

Santiago de Compostela derive in part from their institutional affiliation: many belonged to monasteries associated with Cluny, a wealthy and powerful reform order centered in Burgundy (France) that sought to control the lucrative pilgrimage routes as part of its commitment to the salvation of laypeople's souls.

The basilica dedicated to St. Foy in the abbey at Conques (which contains her Majesty reliquary, fig. 6-21) is a good example of a pilgrimage church from this era. Rebuilt in the later eleventh century, it retains the symbolic cross plan of such influential early buildings as St. Peter's in Rome, but the transepts and nave are wider and longer (fig. 7-1). The two side aisles that flank the nave continue around the transepts, culminating in an elongated U-shaped area, the chevet (French for pillow), behind the main altar to the east. The spaces that protrude from the chevet are called radiating chapels, and each one held an altar and relics. With its wide and continuous side aisles, the plan offers a solution to the problem of circulation: how to get many people in and out of the church in an orderly fashion with minimal disturbance to religious activities taking place in the choir, the space between the nave and sanctuary (used by monks and clergy who sing during services).

In western Europe, church portals bearing relief sculpture and inscriptions mark the transition between the exterior world and holy space; visitors had to cross this threshold to achieve salvation. These portals often illustrate the theological unfolding of time (between Christ's past resurrection and the viewer's future one) and space (between the secular outside and sacred interior). The sculpture impresses upon viewers their place—desired or actual—within a narrative that culminates at the end of time. The west (main) portal at Conques, carved in the early twelfth century, is crowned with a tympanum that depicts the Last Judgment in process (fig. 7-2). Christ is enclosed in a mandorla and surrounded by symbols of the four evangelists, forming a composition known as the *Maiestas Domini* (Majesty of the Lord). In the rest of the

Box 7-1. "ROMANESQUE"

The word *Romanesque* was coined in the early 1800s to characterize European buildings, mostly of the eleventh and twelfth centuries, that have rounded arches, barrel vaults, and relief sculpture; the term underlined their monumentality and formal connections to ancient Roman architecture. Romanesque was also meant to suggest connections to specific Romance languages (those derived from Latin) and literary works (such as the Arthurian romances of Chrétien de Troyes) that were emerging at the same time as this type of architecture. An eleventh-century Romanesque building in France was thus seen to embody some of the same intrinsic national and even ethnic qualities as the French language. The word *Romanesque* today carries less nationalistic weight than in the past, and it has been broadly accepted as a convenient label and category for artistic production in Europe during the eleventh and twelfth centuries. Yet a label based primarily on style is too rigid to define such a large area and long span of time. Not every building of the "Romanesque" centuries shows these Romanizing tendencies or displays them in the same way. Furthermore, applying an architecturally derived term to manuscript illuminations, metalwork, or textiles that have little or no architectural imagery does not make much sense. Should the Bayeux Embroidery be labeled Romanesque? What about the bell shrine or the illuminations of Hildegard of Bingen discussed below? Because this label is truly apt only for a small percentage of works of European art and architecture made or built in this period, it is avoided in this book.

tympanum the artists focused not on theological symbols but on the fate that awaits different types of people. The saved stand to Christ's right (the viewer's left), the direction of his blessing hand, and the damned are to his left. Monstrous demons torture the damned, who are personifications of such sins as lust, greed, and pride, vividly rendered in contemporary garb as an adulteress, forger, and knight; the mouth of Hell stretches open to engulf this mass of humanity. Long Latin inscriptions crisscross the tympanum and warn readers to adopt and maintain proper Christian behavior: "O sinners, if you do not reform your ways, know that a harsh judgment awaits you." These words reminded the pilgrims, and especially local monks and clerics who were far more likely to be literate, that they had to improve their behavior before entering a sacred space. In contrast to the twisting of the demons and the damned, the blessed stand up straight and are arranged with symmetrical precision; this is a common medieval

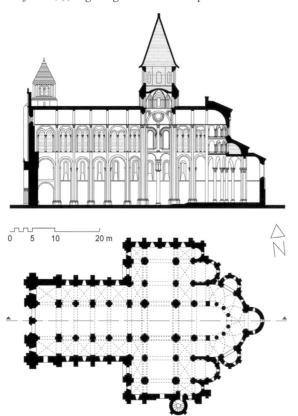

Figs. 7-1a and 7-1b. Abbey church of Sainte-Foy, Conques, late eleventh century, (*left*) plan and section; (*right*) view toward the east. (*l*) Drawings by Navid Jamali; (*r*) akg-images/Hervé Champollion.

0 5 10 20 m

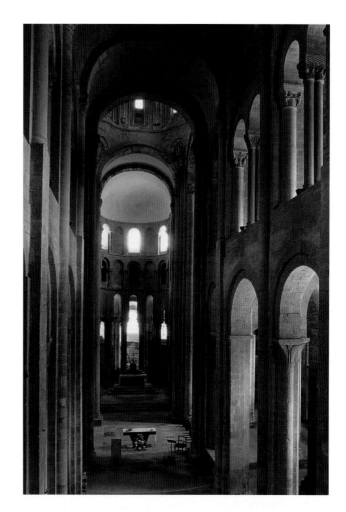

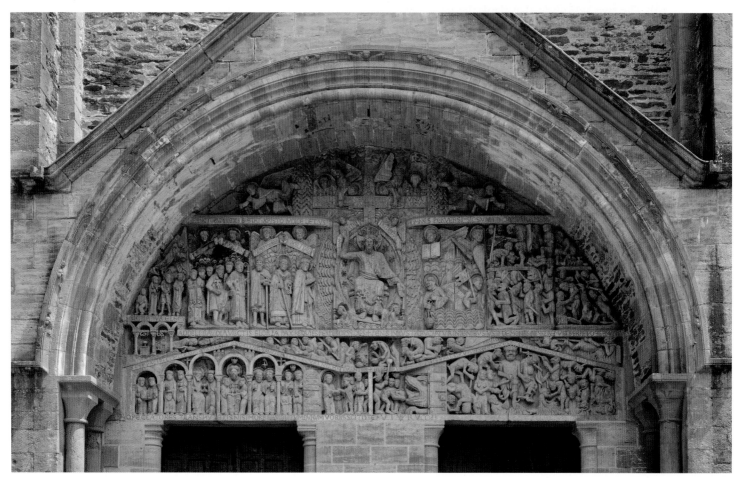

Fig. 7-2. Tympanum, abbey church of Sainte-Foy, Conques, early twelfth century. Wikimedia Commons/Velvet, CC BY-SA 4.0, modified.

formal device that suggests how a person's physical posture can reveal internal traits. Among these figures is St. Foy, her prostrate pose modeling the behavior of pilgrims who would enter the church and bow before her statue (the throne behind her resembles the throne of her reliquary). Behind her, shackles are suspended above an altar because Foy was well known for releasing people who were imprisoned unjustly; after such a miracle, the newly liberated traveled to Conques to deposit their fetters. Extensive remains of polychromy indicate that the tympanum was once even more vibrant and legible to viewers. The vivid text and imagery reinforced morally correct behavior and thereby sought to keep pilgrims—including those seeking forgiveness for sins—on the right path.

Three centuries after the monks of Lindisfarne fled with the body of St. Cuthbert from Viking attacks, his remains were reburied at Durham. After the Norman conquest in 1066 (narrated in the Bayeux Embroidery), the new rulers began an ambitious building campaign that transformed the English landscape with a series of imposing new structures that replaced smaller Anglo-Saxon

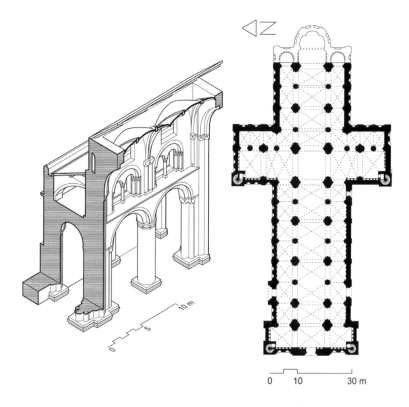

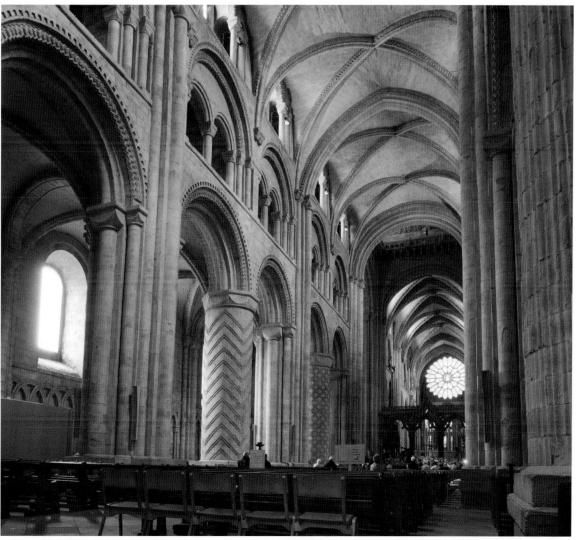

Figs. 7-3a and 7-3b. Cathedral, Durham, begun 1093, (*top*) plan and reconstruction; (*bottom*) view toward the east. (*t*) Drawings by Navid Jamali; (*b*) © Genevra Kornbluth.

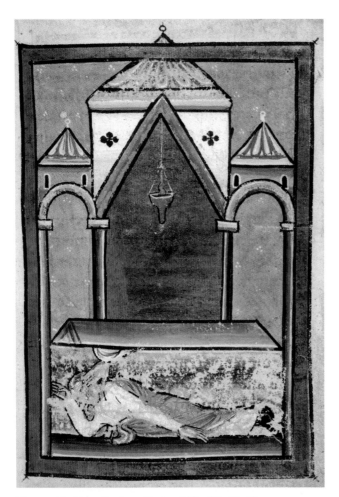

Fig. 7-4. Cuthbert heals a pilgrim, Life of St. Cuthbert, 13.5 × 9.5 cm, fourth quarter of twelfth century; London, British Library, MS Yates Thompson 26, fol. 83r. © British Library Board. All Rights Reserved/Bridgeman Images.

ones. One such church was Durham Cathedral, which was also a Benedictine monastery (fig. 7-3). Begun in 1093 under Bishop William of Saint-Calais (d. 1096), the imposing nave of the church was vaulted with stone ribs that form pointed arches, an innovation that permits arches of different spans to rise to the same height. The prominent ribs, which spring from compound piers, support the vault at critical points and allow the roof and walls to be thinner and lighter. Together, pointed arches and ribs enabled medieval masons to build taller structures with more openings. At Durham the elevation has three stories—arcade, gallery, and clerestory—versus two at Conques, which lacks a clerestory in the nave. After their introduction at Durham, pointed vaults with ribs were widely used, with increasing complexity, as were tripartite elevations.

Alternating with the compound piers in the Durham nave are massive column drums incised with chevrons, lozenges, or flutes (shallow vertical grooves). Some of these ornamental forms were widespread in England's earlier Anglo-Saxon architecture, but here they are magnified in scale. Others have different origins: columns incised with spirals deliberately recalled the prized spiral columns near

the tomb of St. Peter in Rome (fig. 3-11). Here they were used to mark altar spaces and the shrine of St. Cuthbert at the east end of the cathedral; his remains were translated there, still in their wooden coffin, in 1104. Through architecture and decoration, the Normans validated their new church by underscoring its continuities with a preexisting cult and earlier aesthetics. At the same time, the massive structure, which adjoined a new fortified castle, communicated the power and prestige of the Normans and linked Durham to similar buildings on the European continent, like the church of Saint-Étienne at Caen (France), the burial place of William "the Conqueror."

A late twelfth-century manuscript produced at Durham is an example of hagiography (from the Greek for *holy* and *writing*), biographical texts or images that emphasize a saint's holiness and miracles—in this case, St. Cuthbert's. The book's abundant miniatures constitute a hagiographic cycle and demonstrate the appeal of his cult. Forty-six of the original fifty-five images survive, and many illustrate posthumous miracles. Fol. 83r depicts a stylized cathedral interior that the text identifies as Lindisfarne, but it actually evokes contemporary Durham (fig. 7-4): an oil lamp is suspended from the tall nave, which is flanked by smaller, round-arched side aisles. The book reports that a paralyzed pilgrim fell asleep next to the sarcophagus of the saint after being given a pair of shoes removed from the uncorrupted corpse. During his overnight incubation the man felt sensations in his feet, but the illumination shows the hand of Cuthbert emerging from the tomb to heal the pilgrim through direct touch. In the morning the man could walk again. The lower part of the picture has flaked from repeated touching by readers who wanted to share in the miracle and participate in the cult of this wonder-working saint. Hagiographic cycles multiplied in this period in a variety of media.

The Crusades

Between 1095 and 1270 Christians undertook a series of coordinated military, political, religious, and mercantile (relating to merchants) campaigns against Islamic powers in the eastern Mediterranean. They were initially intended to relieve Seljuq pressure on Byzantium, but they ultimately sought to reclaim Jerusalem and the Holy Land for Roman Christians. These campaigns are commonly called the crusades—a fraught term, given its currency in contemporary geopolitics. The word *crusader*, coined around 1200, comes from the Latin *crucesignati*, signed with the cross, because the cross (Latin *crux*) was worn as a badge by the men, women, and children who made the perilous journey to "cleanse" Jerusalem, as Pope Urban II put it. Although the leaders of the campaign all came from western Europe, the fighters were drawn from across Europe and western Asia; recent DNA evidence from a crusader

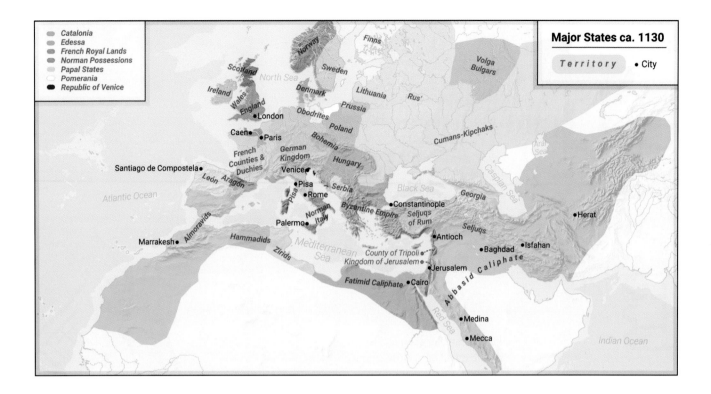

burial pit in Lebanon revealed great genetic diversity. The First Crusade captured Jerusalem in 1099; by 1141 the victors had transformed the Dome of the Rock (fig. 4-1), which they thought was the Temple of Solomon, into a church that was consecrated as the *Templum Domini* (Temple of the Lord). The nearby Umayyad mosque of al-Aqsa became the Christians' royal palace and the seat of the Knights Templar (Knights of the Temple), a powerful military group that built castles and churches and loaned money across Europe until they were disbanded in 1307. The Europeans established four independent kingdoms but lost most of them, including the one based in Jerusalem, in 1187. A few years later, that kingdom was reestablished at Acre (Akko, on the coast of modern Israel) and survived until its definitive loss in 1291. Beginning in the twelfth century, Jerusalem was at the center of western European maps, which were often appended to chronicles about Christian crusading activities in the eastern Mediterranean.

Caliph al-Hakim's partial destruction of the Holy Sepulcher around 1009—one of the events that galvanized crusader ideology—had already inspired two phases of Byzantine rebuilding in the first half of the eleventh century. After 1099 the European conquerors rebuilt the Holy Sepulcher complex yet again, completing the work in 1149 during the reign of Queen Melisende (see below). They unified the complex by eliminating the earlier small chapels in favor of a large choir east of the Anastasis Rotunda (fig. 7-5). The choir terminates at the east end in an ambulatory with radiating chapels, the architectural solution used at Conques and well known in western Europe. A new dome over the nave linked the rotunda with the choir

and apse and provided a distinctive setting for crusader coronations; it tied the rulers to Christ and also surpassed the single-domed Islamic buildings in Jerusalem. East of the new choir was a small underground basilica dedicated to St. Helena, the mother of Constantine, which connected the choir to the irregular chapel space where she allegedly discovered the True Cross. While the sanctity of the site required respecting the traditional locations of the crucifixion and resurrection of Christ, only the fourth-century rotunda form was maintained in the medieval reconstructions of the Holy Sepulcher (fig. 2-6). The association of this form with the site of the resurrection was so strong that many other rotundas were erected in twelfth-century Europe to link distant towns to Jerusalem and to Christian sacred history. In the mid-twelfth century, for example, a "copy" of the Holy Sepulcher was constructed in Bologna (Italy) within a large complex representing the city of Jerusalem (medieval architectural copies evoke their prototypes rather than replicate them in detail). On another level, such cities as Constantinople and Paris vied, in their literary self-representations, relic collections, liturgies, and architecture, for the status of "new Jerusalem."

One of the largest crusader castles was begun at Kerak (Jordan) in 1142 (fig. 7-6). It overlooked and thus controlled a critical commercial and military route from Damascus to Mecca and Egypt, and its monumentality was meant to inspire fear in Muslims (who nevertheless besieged it repeatedly and captured it in 1188). There were already Islamic and Byzantine fortifications across the region, but the new fortresses were even more imposing. The first patron of Kerak was Paganus Pincerna (Pagan the Butler),

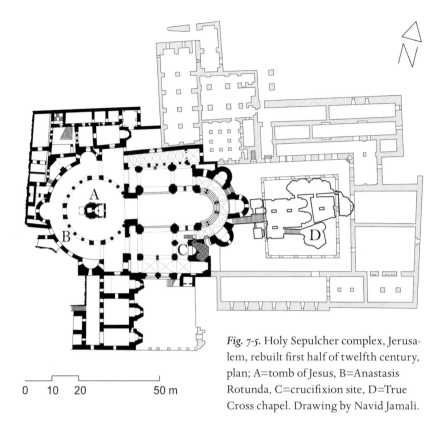

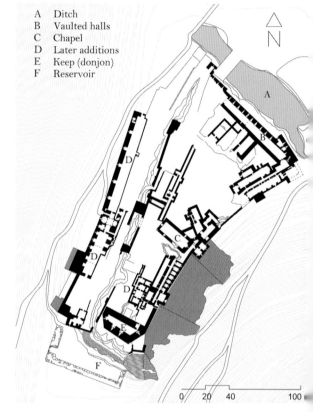

A Ditch
B Vaulted halls
C Chapel
D Later additions
E Keep (donjon)
F Reservoir

Fig. 7-5. Holy Sepulcher complex, Jerusalem, rebuilt first half of twelfth century, plan; A=tomb of Jesus, B=Anastasis Rotunda, C=crucifixion site, D=True Cross chapel. Drawing by Navid Jamali.

Figs. 7-6a and 7-6b. Castle, Kerak, 1142–thirteenth century, (*top*) plan; (*bottom*) exterior from the east. (*t*) Drawing by Navid Jamali; (*b*) Photo by Dana Katz.

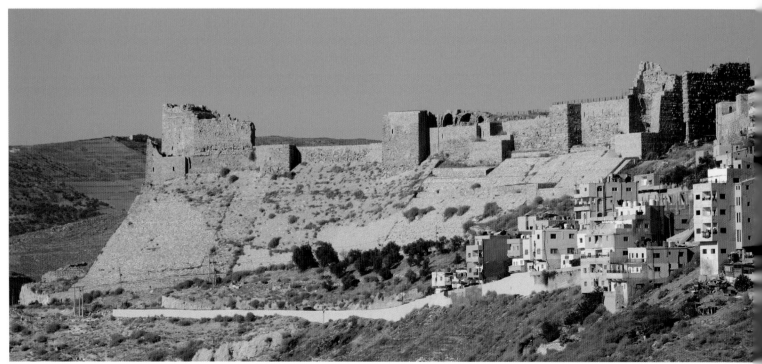

lord of Oultrejourdain, the part of the Kingdom of Jeru-salem east and south of the Jordan River. His castle was built of hard volcanic stone on a triangular spur of land about 220 meters long. It was protected by a deep ditch on the north, which separated the castle from the adjacent town, and by a steep glacis (a smooth, stone-lined slope) on the other sides. A single narrow gate in the massive north wall—135 meters long and up to 5 meters thick—led to huge, two-story vaulted halls used for storage and stables and, at the center of the enclosure, a large chapel and com-munal ovens. Pagan's successors added a second exterior wall with projecting square towers as well as a reservoir to the south that served as both a water supply and a de-fensive moat. Because of its strategic location Kerak con-tinued to be used as a military stronghold under Islamic control; in the thirteenth century, the prominent donjon or keep (main tower) at the southern edge of the site was erected to replace the original one.

Work in Focus:
THE MELISENDE PSALTER

A close look at a book of psalms produced in the mid-twelfth century reveals aspects of its patronage, produc-tion, and meaning and demonstrates the complex character of art in the eastern Mediterranean region at this time. Two intricately carved ivory covers studded with turquoise and gems echo the precious materials and intricate workman-ship of Islamicate arts and announce the book's exceptional quality (fig. 7-7). Inside, in keeping with the most elaborate Psalters made in western Europe, the book begins with twenty-four full-page miniatures, but they are all based on Byzantine models. The illuminations are followed by a cal-endar and then by the psalms themselves, each major sec-tion of which is introduced by a decorated initial that some-times demonstrates familiarity with Islamicate ornament.

The calendar provides crucial clues about the book's creation. On the whole it is demonstrably English and in-cludes saints venerated specifically around Winchester. Yet it also contains three entries related to the Holy Land: the capture of Jerusalem on July 15 (1099); the death on August 21 (1131) of Baldwin II, king of the Latin (that is, western

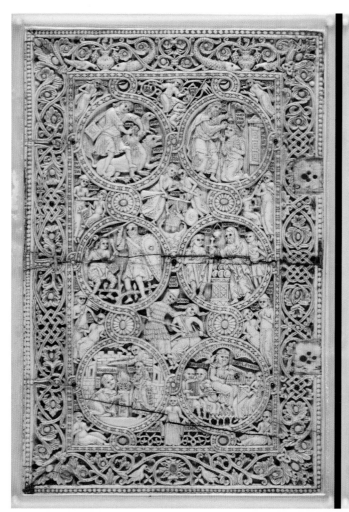
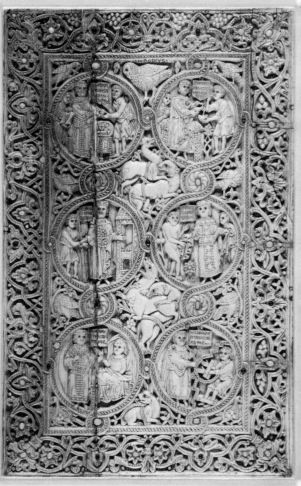

Fig. 7-7. Ivory covers, Melisende Psalter, 22 × 14.5 cm, 1131–43, (*left*) front; (*right*) back; London, British Library, MS Egerton 1139/1. © British Library Board. All Rights Reserved/Bridgeman Images.

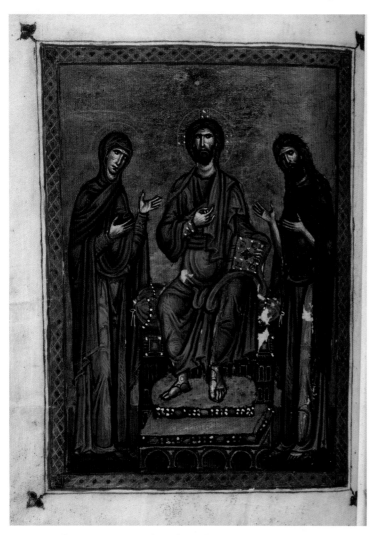

Fig. 7-8. Deesis, Melisende Psalter, 21.5 × 14.5 cm, 1131–43; London, British Library, MS Egerton 1139, fol. 12v. © British Library Board. All Rights Reserved/Bridgeman Images.

Fulk (fig. *7-7 right*). One possible scenario is that Fulk commissioned the book from William as a reconciliation gift for Melisende.

The small book was suitable for personal use, whether for Melisende or someone else; and its ivory covers were certainly conceived for a royal audience. On the front are linked roundels with scenes from the life of King David, and in the spaces around them are vignettes of the battle between personified Virtues and Vices described in a popular Latin allegorical poem, the *Psychomachia* (fig. *7-7 left*). On the back cover, the medallions represent the six acts of mercy (Matt. 25:31–46) being performed by a ruler depicted as a Byzantine emperor, surrounded by birds and other animals in combat. The ivories thus articulate a vision of good (male) leadership constructed with a blend of western European and Byzantine iconography, although all the inscriptions are in Latin.

This combination of features is also evident in the Psalter's illuminations. An example is the image of the Deesis (Greek for entreaty, petition), one of the standard pictures in the Orthodox repertoire, which depicts Mary and John the Baptist as intercessors before Christ (fig. 7-8). A faint Latin inscription on the lower golden footstool of Christ reads, "Basili[us] me fecit" (Basilius made me). There are many examples of the formula "*X* made me" in European medieval art, and *X* could refer to the artist or to the patron who caused the work to be made. The phrase can be difficult to interpret without corroborating evidence, but in the Melisende Psalter it seems clear that Basilius was the name of one of the painters. Compositions like the Deesis demonstrate that Basilius was familiar with Byzantine images, but a comparison with other eleventh- and twelfth-century works indicates that he was trained in Europe, despite his Greek-sounding name.

In illuminated Byzantine manuscripts, the Temptation of Christ is usually spread out over several scenes to give ample narrative space to the three times that the devil tempted Jesus (Matt. 4, Luke 4). In the Melisende Psalter, however, the artist condensed the entire story into a single page (fig. 7-9). The setting is Jerusalem: the domed building at the left evokes the Dome of the Rock, which Christians had reconsecrated as the Temple of the Lord. The key temptation that Jesus rejects—the offer of worldly power—is symbolized by the folded stool (used by Roman authorities and imitated in some medieval thrones) and the golden objects at the bottom; contemporary English Psalters feature similar emblems in this scene. The picture hinges on the confrontation between Jesus and the devil, both duplicated to show successive moments in time. The contrast between good and evil is emphasized through common medieval visual strategies. First, the devil is the only figure shown in profile, a convention often used for lower-class or wicked characters. Second, his hair is disheveled, a metaphor for unruliness and lack of control. Third, Christ and the protecting angels are clothed, whereas the

European) Kingdom of Jerusalem; and the death on October 1 (before 1131) of his queen, Morphia of Melitene (Armenia). Latin grammar indicates that some prayers in the Psalter were written for a woman or girl, presumably one of the daughters of Baldwin and Morphia. The most likely candidate is Melisende (1105–61), who upon her father's death became ruler of Jerusalem with her husband, Fulk V of Anjou (France). They were crowned in the Holy Sepulcher and then were estranged for several years.

The manuscript was made by a French scribe and six artists in a scriptorium probably based at the Holy Sepulcher, so it is likely that the patriarch of Jerusalem, William of Malines (r. 1130–45), was somehow involved in its manufacture. It is still not certain who commissioned the Psalter, however. Queen Melisende was a great patron of arts and architecture, founding convents, hospitals, and commercial centers in the kingdom. Yet the bird on top of the back cover, labeled "Herodius," suggests Fulk's involvement because *herodius* is a synonym for the Latin *fulica* (French *fulque*), or falcon, almost certainly an allusion to

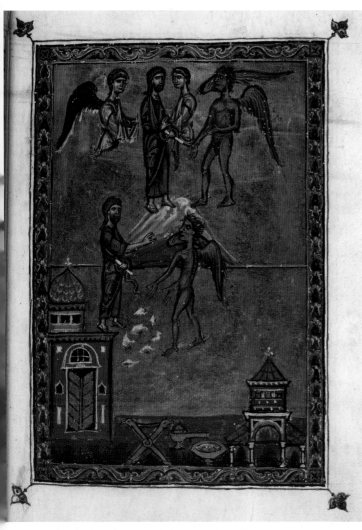

Fig. 7-9. Temptation of Christ, Melisende Psalter, 21.5 × 14.5 cm, 1131–43; London, British Library, MS Egerton 1139, fol. 4r. © British Library Board. All Rights Reserved/Bridgeman Images.

drew on the intricacy of Islamicate ornament. Made for a royal patron who must have appreciated, if not dictated, these characteristics, the Psalter reveals the variety of artistic models available in twelfth-century Jerusalem. The resulting work does not fit into any single conventional category of medieval art—western European, Byzantine, or Islamicate. This creativity derives from the movement of people, ideas, and goods around the Mediterranean during the crusades, a period better known for its intolerance and violence.

Intercultural Contacts and Expressions of Difference

The Melisende Psalter encapsulates the fluidity of this era in which references to cultural diversity were frequently deployed for ideological purposes. In the last third of the eleventh century the Normans gained control not only of Britain but also of mainland southern Italy, much of which had been a Byzantine province for the previous two centuries, and the island of Sicily, mostly under Muslim rule for two hundred years. In Sicily they ruled over a disparate population of Muslims, Jews, and both Roman-rite and Orthodox Christians. In 1130 Duke Roger II proclaimed himself king of Sicily, southern Italy, and Africa (he meant part of North Africa, not the entire continent). As king, Roger (r. 1130–54) and his successors used a variety of artistic languages and traditions to express and bolster the power of the new dynasty that he was establishing and legitimating from scratch. Even though Roger II's court at Palermo was multilingual and multicultural, the city itself had distinct ethnic-cultural neighborhoods, and after the king's death his successors were unable to maintain that fragile coexistence.

Roger's palace chapel, the Cappella Palatina dedicated to saints Peter and Paul, was one of his earliest and most ambitious commissions (fig. 7-10). Begun in 1130 over an existing church, it harmonized Byzantine, Islamicate, and western European components. The chapel consists of two principal spaces: a centrally planned eastern part with a dome joined to a longitudinal nave that includes a large, elevated throne at the west end. Both parts are adorned with mosaics and lavish marble wall revetment, and the entire floor (300 m²) is covered with varied and colorful opus sectile patterns; all of the marble is Roman-era spolia. The eastern area displays hierarchical imagery similar to that found at Hosios Loukas and contemporary Byzantine churches, including the Pantokrator in the dome (fig. 6-35). By contrast, the walls of the nave arcade present scenes from Genesis and the outer aisle walls stories of saints Peter and Paul, an arrangement inspired by Roman precedents. A complex wooden muqarnas ceiling crowns the nave (fig. 7-11). This honeycomb-like structure became an important feature of Islamic architecture in this period,

devil is naked. And fourth, the devil's unnatural greyish-black skin tone is noticeably darker than that of Jesus and the angels. This color contrast is rooted in medieval notions of light as divine and darkness as frightening and malevolent. In other representations made by Europeans, dark skin was associated with Africans, whose pigmentation had been "scientifically" explained since antiquity as a product of living in a hot climate. Some of these representations were overtly negative and racist. It is hard to know the extent to which the color of this devil derived from deeply rooted racializing tendencies or from a desire to underscore the figure's supernatural origins.

The Melisende Psalter contains many striking details, yet what stands out is its intertwining of three different artistic traditions. The book's covers and illuminations, as well as the silk used in its binding, upheld Byzantium as a paradigm for kingship and imitated its artistic style. Yet the structure of the Psalter was based on English precedents, and the book was enclosed in ivory plaques that

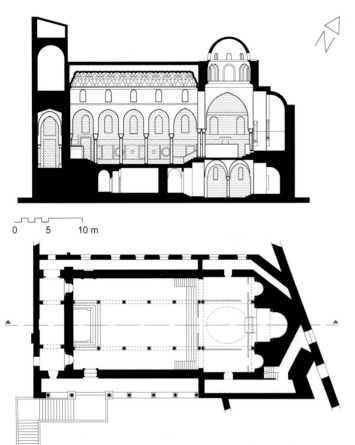

but the Palermo muqarnas is unusual because it was colorfully painted with some 750 figures and scenes. There are seated rulers, hunting episodes, buildings and gardens, everyday objects, and dancing women on its richly faceted surface. While many of the mosaics were completed decades later under his son William I (r. 1154–66), the basic concept for the chapel likely dates to Roger's reign.

The blending of Byzantine, western European, and Islamicate art forms and imagery at the Cappella Palatina has been interpreted as Roger's attempt to address the multicultural population of his kingdom—to use three visual languages of power to bolster his sovereignty. Stylistic evidence suggests that artists from Constantinople, Rome, and Cairo were involved in the construction and decoration of this space. Roger was citing, and thereby seeking to appropriate, the language of power used in those cities, places of immense prestige in the contemporary

Figs. 7-10a and 7-10b. Cappella Palatina, Palermo, 1130–ca. 1160, (*top*) plan and section; (*bottom*) view toward the east. (*t*) Drawings by Navid Jamali; (*b*) Alfredo Dagli Orti/Art Resource, NY.

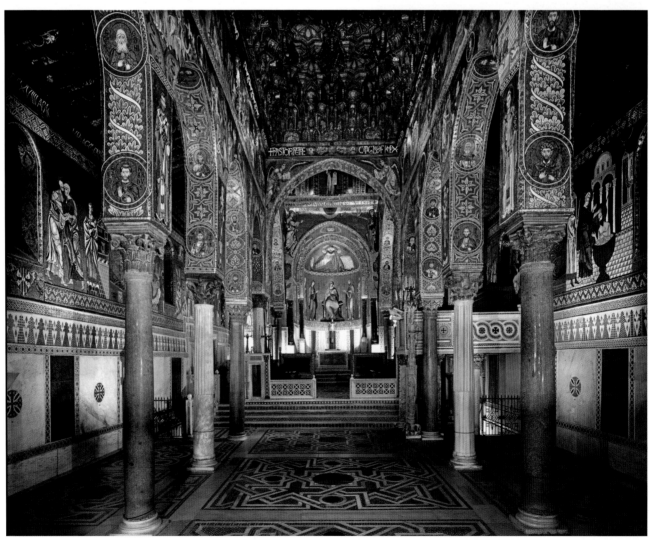

imagination due to their wealth and illustrious histories. Despite the diversity of these cultural and artistic points of reference, the Cappella Palatina joined an elevated throne on the west end to a Christian chapel in the east, and this combination of elements communicates the Christian foundations of Roger's kingship.

Concrete visualizations of the Normans' multicultural society distinguish the episcopal throne in the church of San Nicola in Bari, which was built after the saint's remains were stolen from Myra (Turkey) and brought to southern Italy in 1087. The throne was carved from a single block of marble that may have been an ancient Roman column shaft (fig. 7-12a). Bishops' thrones embody the power of the church and its local representatives, but the imagery here is not explicitly religious. Three figures struggle under the weight of the leader's seat. One of the bare-chested men has exaggerated and stereotyped features of Black Africans; the fully clothed man wearing a turbanlike hat and holding a walking stick is likely a Muslim. These figures seem to represent the groups whom the Normans ruled and sought to subdue in Italy, North Africa, and on crusade. On the back of the throne, two lionesses devour men with features similar to the African man's (fig. 7-12b). This violent imagery

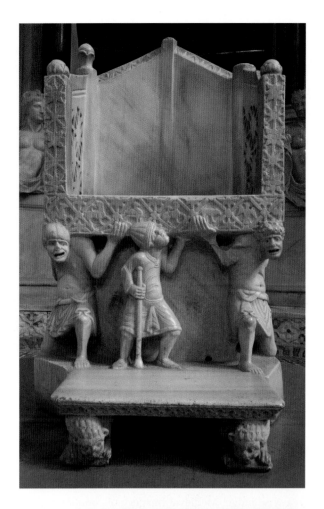

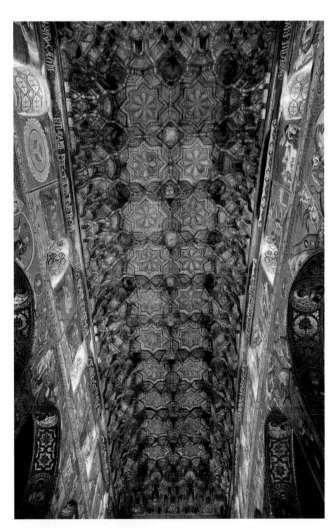

Fig. 7-11. Muqarnas ceiling, Cappella Palatina, Palermo, 1130– ca. 1160. Photo by the authors.

Figs. 7-12a and 7-12b. Marble throne, Church of San Nicola, Bari, H ca. 135 cm, ca. 1170, (*top*) front; (*bottom*) detail of back. Photos by the authors.

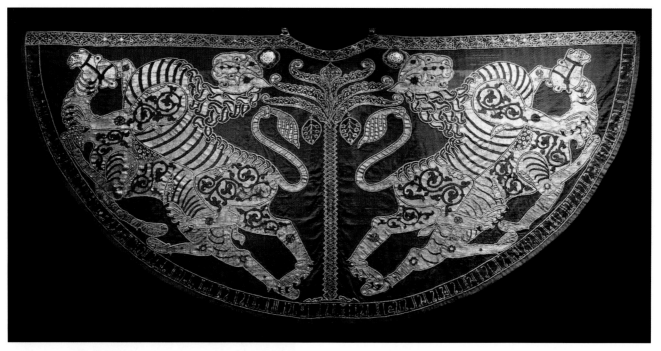

Fig. 7-13. Mantle of Roger II, 146 × 345 cm, 1133/34; Kaiserliche Schatzkammer, Vienna. Flickr/Dennis Jarvis, CC BY-SA 2.0.

presumably shows the risks of challenging authority, for lions were not only ferocious but also associated with the throne of the biblical king Solomon, who had a reputation as a wise judge. Medieval imagery of conqueror and conquered often has religious overtones, with Christ the victor subduing symbols of sin, death, or temptation. Such associations may be relevant here, but the physiognomic specificity of the men below the seat highlights the religious and ethnic diversity of the Norman kingdom. The naturalistic carving style facilitated medieval race-making—that is, defining and differentiating groups, here based on stereotyped physical characteristics and clothing, in order to place them in particular hierarchies of power.

An inscription on the throne names Elias (r. 1089–1105), the cleric who presided over the construction of the new pilgrimage church, but the work's dynamic sculptural style suggests that it was made decades later, probably after locals rebelled against Norman rule in 1166. The throne thus celebrated Elias's memory retrospectively and warned viewers to respect contemporary secular and religious authorities. There was no religious consensus in the city during Elias's rule or in the decades that followed. Part of the population maintained Byzantine Orthodoxy, Muslims lived freely in the region until 1300, and one of Elias's recent predecessors as archbishop converted to Judaism. Like Bari, most medieval cities attracted people of different religious, geographical, and cultural origins.

The so-called Mantle of Roger II also deploys lion imagery, in this case to embellish the body of the king (fig. 7-13). Capes or mantles had long been associated with authority, based on the biblical account of Elijah transferring his robe to Elisha (1 Kings 19:19); legitimacy passed through the mantle, a sign of the continuity of leadership. Roger's mantle also appropriated the visual and textual vocabulary of official "robes of honor" made for the Fatimid caliphs to distribute to high-ranking members of their administration and to visiting dignitaries. Although this mantle was produced after Roger II's coronation, it might have been used for the investiture of his sons and successors, impressing onlookers with the dynasty's wealth and power. Forming a half-circle if laid flat, the mantle depicts two lions subduing camels. Symmetrically disposed around a central image of a palm tree, the stylized writhing beasts symbolize the Normans' conquest of Islamic Sicily and noble rulers dominating lesser ones. The semicircle shape was well established in western European ceremonial garb, but the garment employs patterns and words associated with the Fatimids. A long rhyming Arabic inscription embroidered in Kufic script runs along the hem. In addition to attributing the work to the royal workshop (*tiraz*) in the palace in Palermo, it dates its manufacture to the hijra year 528 (equivalent to 1133/34) and gives a long list of the benefits of kingship, which include magnificence, prosperity, and glory. The text thus expresses the nature of the dynasty's new power to the numerous speakers and readers of Arabic in the kingdom (Roger himself spoke the language).

The samite that forms the base of the mantle must have been acquired from Byzantium, most likely from the famous workshops at Corinth and Thebes (Greece); in 1147, silk weavers from Thebes, many of them Jewish women, were forcibly brought to Sicily after a Norman raid. The red color was obtained from kermes, which was used in

Fig. 7-14. Burgo de Osma silk, 43 × 50 cm, early twelfth century; Museum of Fine Arts, Boston, Ellen Page Hall Fund 33.371. Photograph © 2022 MFA, Boston.

Byzantine textile workshops. The mantle is also embroidered with colored silk and gold thread (made by wrapping thin gold strips around yellow silk thread) and further adorned with gems, pearls, and enamels. Because the silk, the gold thread, and the pearls had to be imported, the mantle's production attests to large-scale trade and diplomatic networks and also suggests the involvement of Jewish silk workers, pearl merchants, and jewelers who were active in the Mediterranean, trans-Saharan, and Indian Ocean trade routes.

An early twelfth-century Islamicate textile reused as the shroud of a bishop who died in 1109 in Burgo de Osma (northern Spain) is related to much earlier Byzantine, Sasanian, and Sogdian silks decorated with linked roundels. In one sizable fragment paired lions attack harpies, human-headed birds wearing striped headdresses (fig. 7-14). The circles that enclose them depict men between winged griffins, and the smaller roundels bear circular inscriptions that repeat that the piece was made in Baghdad, "may God watch over it." This statement is an invention of the weaver, however: the spelling indicates that the multicolored silk brocade (made with gold-wrapped thread) was actually woven in southern Spain under the Almoravid dynasty (1040–1147), probably in the famous textile workshops of Almería. The claim of distant Baghdadi origin enhanced its aura and likely inflated the price of the cloth. Like the ivory casket of ʿAbd al-Malik a century earlier (fig. 6-6), the Burgo de Osma silk shows how works created for Muslim use were prized by Christians and even used to enshrine the bodies of saints. Sumptuous textiles were an important medium of cross-cultural communication and exchange.

Box 7-2. CRAFT MANUALS AND MARKET REGULATIONS

The secrets of artistic practice were generally passed orally from person to person throughout the Middle Ages, but in the twelfth century, when didactic literature flourished, so did manuals by and for artists. *On Diverse Arts*, written by a monk in northern Germany using the pseudonym Theophilus, is the only such manual to survive intact from medieval Europe. A book of techniques and recipes, it describes in detail how to make paintings, stained glass, and metalwork in the context of Benedictine life. Making art, for Theophilus, is both a functional way of manipulating the natural world and a spiritual practice that requires knowledge and patience as part of an anagogical ascent toward God. Artistic labor had moral value. Some scholars argue that Theophilus was the goldsmith Roger of Helmarshausen (formerly a monk at Stavelot), whose works correspond closely to objects described in the text.

In the Islamicate world, artistic practices are referenced in discussions of *suqs* (marketplaces), where most workshops were located. The economic and social theorist al-Damashqi (ca. 1175) wrote that suqs arise because people need community; builders need carpenters, carpenters need ironsmiths, ironsmiths need miners, and so on, suggesting the importance of expertise and collaboration in the arts. Twelfth-century manuals of market law (*hisba*), composed to uphold religious laws and honesty in the suqs, also address craft production. A hisba by a Syrian intellectual delineates the types of dishonesty found in the marketplace, including the fraud that might be perpetrated by goldsmiths, who "know mixtures and pigments that no one else knows." Artists and builders in Byzantium were also subject to regulations concerning price, quality control, and completing work on time; punishment for violating these regulations in tenth-century Constantinople included beating, shaving, and exile.

Manuals of artistic practice in the Islamicate world tend to focus on a particular craft. Treatises on calligraphy from the eleventh century emphasize the importance of masters training apprentices and safeguarding such trade secrets as ink recipes. The astrologer and alchemist Hobaysh Teflisi (ca. 1121–ca. 1203) wrote a treatise about making lusterware and colored and enameled glass. Omar Khayyam (1048–1131), a mathematician, astronomer, poet, and philosopher, compiled a treatise to help artists produce geometric patterns in architecture and architectural decoration. In Byzantium, the oldest extant painting instructions are found in a brief fourteenth-century text that discusses layering of pigments bound with egg to depict garments and faces in icons.

Fig. 7-15. Stavelot
Triptych, 48.4 × 66 cm
(open), eleventh century
and 1150s; Morgan
Library & Museum,
New York. © Genevra
Kornbluth.

Contacts among different Christian societies also facil-
itated the production of works that juxtaposed new and
old objects of both local and distant manufacture. The
most important religious "souvenir" for medieval Chris-
tians was a fragment of the True Cross, and there was a
renewed focus on this relic after the crusaders rebuilt the
Holy Sepulcher. The largest pieces of the cross were kept
in the imperial palace in Constantinople, but small slivers
of wood were in constant movement across the Christian
world. One of the most elaborate containers for a cross
fragment is the Stavelot Triptych (fig. 7-15). The two small
eleventh-century Byzantine triptychs at the center of the
larger reliquary were brought to the Benedictine abbey of
Stavelot (Belgium) by its abbot, Wibald (r. 1130–58), after
one of his trips to Constantinople on behalf of the Holy
Roman emperor Frederick I Barbarossa. Behind the Cru-
cifixion represented on the upper triptych was a pouch of
patterned Byzantine silk that enclosed pieces identified by
parchment labels as coming from the tomb of the Lord
(the Holy Sepulcher), the wood of the Lord (the True
Cross), and a garment of the Virgin. When the wings were
closed, Gabriel and the Virgin of the Annunciation were
visible. The triptych contains, in miniature, the whole of
Christ's human life, from conception to death. Inside the
lower Byzantine triptych, angels hover above the arms of
a cross while Constantine and Helena, both saints in the
Orthodox Church, stand below. The angels and the impe-
rial figures are dressed alike, in a long, jeweled ceremonial
scarf called the *loros*, which was one way that Byzantine

artists showed how the earthly court was a reflection of
the heavenly one.

In the Meuse River valley, possibly in Stavelot itself,
the two Byzantine reliquaries were modified slightly for
insertion into a larger frame. This new object, called the
Stavelot Triptych, was probably made in the late 1150s and
is an outstanding example of goldsmithing and enamel
work of that era. In addition to housing tangible links with
the sacred past—the relics of the cross in their Byzantine
containers—the new circular enamels on the wings nar-
rate the legendary history of Helena's discovery of the
cross in fourth-century Jerusalem. The sequence begins at
the lower left with key scenes of Constantine's conversion.
It continues on the right with Helena's search for the cross,
the discovery of three crosses, and the recognition of the
one True Cross by its ability to resurrect a dead man. The
cross in the final medallion, at the upper right, is labeled
"lignum Domini," wood of the Lord; its green color,
heightened by foil placed under the enamel to reflect light,
is meant to suggest that it was made from the original
Tree of Life in the Garden of Eden. The Stavelot Triptych
thus encapsulates Christian sacred history, in which the
age of paradise was succeeded by an era of Jewish law that
paved the way for the final period under Christ, the new
Adam. The reliquary stages its precious contents within a
detailed narrative in an impressive three-part format, one
new to Europe but already in use in Byzantium and in the
ancient world. In their new setting, the older Byzantine
triptychs are theatrically displayed as authentic imperial

Fig. 7-16. Khakhuli Triptych, 147 × 202 cm (open), first half of twelfth century; Sak'art'velos khelovnebis muzeumi, Tbilisi. Zaza Skhirtladze.

gifts to Wibald and his foundation, thus increasing the status of both.

A gold and gilt-silver triptych from another part of the Christian world is even larger and more complex (fig. 7-16). The Khakhuli (Xaxuli) Triptych—two meters wide when the wings are open—was made for the sanctuary of a monastery at Gelati (Georgia) that was begun and richly outfitted by the Georgian king Davit IV "the Builder" (r. 1089–1125). At its core the triptych contained a venerable Byzantine enamel icon of the Theotokos that had been a prized possession of a church in Khakhuli (eastern Turkey). In the nineteenth century this icon was stolen and eventually replaced by a plain white rectangle with the original enamel face and hands of Mary, all that remain of what was once the largest Byzantine enamel (54 × 41 cm). Davit's son, King Demetre I (r. 1125–56), incorporated this icon into a triptych and supplemented it with 118 Byzantine cloisonné enamels of the ninth through the eleventh centuries. Most of these were originally attached to other objects sent to Georgia as diplomatic gifts, so the triptych represents a staggering transformation of earlier precious materials. The enamel images of saints and angels are set into a gilt-silver pattern of repoussé foliage. Above the central image of Mary, the enamels compose the principal Byzantine scene of intercession, the Dee-

sis. The eleventh-century enamel at the top, the only one visible when the triptych wings are closed, shows Christ crowning the Byzantine emperor Michael VII Doukas and his Georgian consort, Maria of Alania (daughter of a Georgian king and later the wife of Michael's successor). Like the other rectangular enamels, it probably adorned a crown like the one sent to the Hungarian king Géza I (fig. 6-9) and may have been produced in the same imperial workshop in Constantinople. The idea of holy power legitimizing terrestrial authority continues on the wings, where oval enamels depict Mary crowning two Byzantine empresses, among other imperial figures.

For the Byzantine senders, such gifts signaled the inferior standing of the recipients, but in twelfth-century Georgia these heirlooms conveyed social and theological prestige, affirming the kingdom's historical and familial ties to the Byzantine Empire and implicitly arguing for equivalent status. A metrical inscription in Old Georgian on the wings compares Davit and Demetre to the biblical kings David and Solomon, and Demetre is further likened to Bezalel, who fashioned the biblical Tabernacle. Just as the Tabernacle contained the Ark, the Khakhuli Triptych is a new Tabernacle containing Mary, to whom the royal donors pray for a long life.

Many other objects, diverse in scale, attest to medieval Christian piety at all social levels. The Lisbjerg (Denmark) Golden Altar consists of two pieces (fig. 7-17): a frontal (the lower part, which covered the stone altar table) and a retable or reredos (the upper part, which stood on the altar). Both are made mostly of gilt-copper repoussé panels on an oak core. Color contrasts were heightened with the *émail brun* technique, in which linseed oil applied to the copper turns it dark brown when heated. Dendrochronological analysis indicates that the frontal was made around 1135, making it the earliest of a series of Scandinavian gilded-metal altars. It is also contemporary with the fresco decoration of the newly built stone church at Lisbjerg, which replaced an earlier wooden one—an architectural demonstration of Scandinavia's increasing integration with the rest of Christian Europe. The east wall of the church, against which the altar stood, depicted a row of mounted horsemen. This was a frequent subject in Danish churches at the time, presumably a reference to the crusaders who had recently reconquered the Holy Land; crusading

Fig. 7-17. Lisbjerg Golden Altar, 158 × 101 cm, ca. 1135; Nationalmuseet, Copenhagen. © Genevra Kornbluth.

success was important for many twelfth-century Christians, who believed it played a role in their salvation.

The Lisbjerg Golden Altar explicitly evokes Jerusalem: at the center of the frontal, a gilded cast-bronze Virgin and Child are enclosed in a city gate labeled "civitas Hierusalem" (city of Jerusalem). They are flanked by angels, scenes from Mary's life, prophets, saints, female personifications of Virtues, and evangelist symbols in the corners. Panels containing interlaced human and animal figures may refer to the non-Christian world; the Latin inscription on the arch says, in part, "Without knowledge of his Creator, man is a beast," excerpted from a letter of Jerome. Above Mary, a roundel with the Lamb of God connects her vertically to figures on the retable: an enthroned, blessing Christ flanked by apostles and roundels of the sun and moon, and a reused older piece with the crucified Christ above them. Jerusalem also symbolizes the Church, and the golden altar, with its large arch suggesting the dome of heaven, is meant to evoke the Heavenly Jerusalem, described as a "city of pure gold" (Rev. 21:18). As the mother of God, Mary had exceptional status, and on the Lisbjerg Golden Altar she is simultaneously the "gate" through which Jesus entered the world, an allegory of the Church as a whole, and a reminder of Jerusalem and the Holy Land. Along with the Virtues and the saints, she can be understood as a gate to heaven, through whom the worshiper can enter God's realm.

The increasing veneration of Mary is evident in over one hundred examples of large, sometimes almost life-size wood statues found across twelfth-century Europe. They represent Mary as the seat for Christ, and contemporary texts emphasize her role as the throne for divine wisdom; Jesus is shown as a small adult, rather than a baby or child, to underscore this idea. Despite the loss of the detachable Christ and the maternal forearms that held him, a monumental sculpture from Mosjö (Sweden) is in many ways a typical example (fig. 7-18). Its well-preserved polychromy is unusual, however, as is Mary's detailed clothing. Whereas her snug-fitting, belted tunic with very wide sleeves was the typical overgarment for women in the twelfth century, her cylindrical headdress, with its decorative braid in high relief, suggests a crown. The Virgin's huge, staring eyes, downturned mouth, and defeated posture emphasize her misery as she anticipates her child's death on the cross. The statue was originally placed on an altar to Mary on the north side of the Mosjö church, the side where women stood during the liturgy (a huge number of hairpins have been found under the wooden floorboards on the north side of Scandinavian churches). Like the Majesty of St. Foy (fig. 6-21), the Mosjö statue was likely used in liturgical processions and dramas, which provided other opportunities for people to approach and interact with such increasingly lifelike sculptures. The wood "Throne of Wisdom" statues communicated the majesty of Mary and Jesus even as they made the holy figures inviting and accessible focuses of prayer.

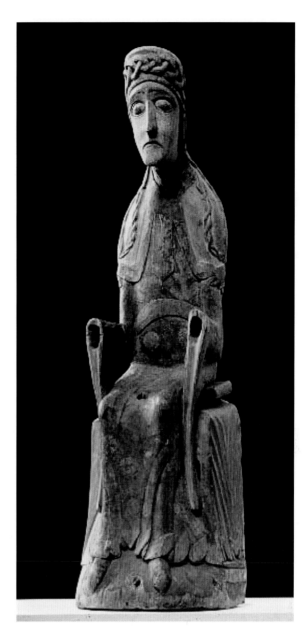

Fig. 7-18. Wood statue of Mary, H 71.5 cm, twelfth century; Historiska museet, Stockholm. © Historiska museet 1994. Lennart Karlsson SHM; CC BY 2.5 SE.

The late eleventh- or early twelfth-century gilt-silver Bratilo Chalice is one of a pair that originally adorned the altar of Novgorod's cathedral, dedicated to Holy Wisdom like the cathedrals of Kyiv and Constantinople (fig. 7-19). Niello inscriptions in Greek on the upper rim and the foot of the large two-handled cup speak directly to the function of the object. The top one says, "Drink from it, all of you. This is my blood of the covenant, which is poured out for many for the forgiveness of sins"—the words of Jesus at the Last Supper (Matt. 26:27–28). The inscription on the foot names Petrilo and Barbara as patrons, which explains the presence of saints Peter and Barbara on the sides of the cup, along with Christ, blessing and holding a Gospel book, and the orant Mother of God. On the base, not visible here, is an inscription in Church Slavonic, the literary and liturgical language introduced to the Slavic lands by

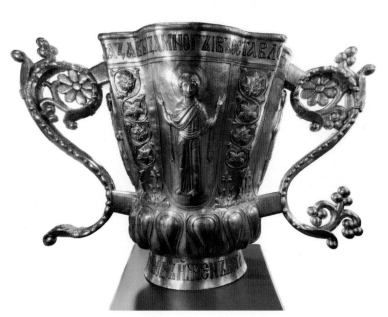

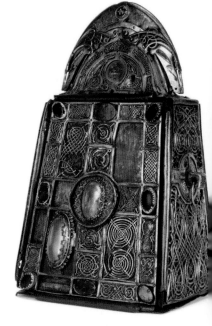

Fig. 7-19. Bratilo Chalice, ca. 21 × 31 cm, late eleventh–early twelfth century; Novgorodskii gosudarstvennyi ob"edinennyi muzei-zapovednik, Novgorod. © Genevra Kornbluth.

Fig. 7-20. Shrine of St. Patrick's Bell, H bell 20 cm, shrine 26 cm, 1091–1105; National Museum of Ireland, Dublin. Reproduced with the kind permission of the National Museum of Ireland.

ninth-century Byzantine missionaries. It asks God to "help Flor your servant. Bratilo made this." To identify himself as the metalworker, Bratilo gives his vernacular birth name, but in asking for divine help he uses his Latinate Christian name, Flor (after St. Florus, himself an artist). The inscriptions on the vessels brought the patrons and artist into the performance of the liturgy, placing the figures in direct contact with the sacramental blood of Christ; the presence of their names also prompted the celebrants to remember and pray for them. Ultimately the Novgorod cups imitate Byzantine silver work of earlier centuries, a reminder of how Kyivan Rus' was indebted to Byzantium for its Orthodox faith. Nevertheless, the Rus' were also open to Europe, making marriage alliances with Sweden, Hungary, Poland, Saxony (modern Germany), and France and importing new sources of artistic inspiration.

A bronze-covered iron bell that supposedly belonged to St. Patrick, the patron saint of Ireland who helped convert the Irish to Christianity in the fifth century, was enclosed in a trapezoidal shrine between 1091 and 1105 at the behest of Domnall Mac Amhalgaidh, "Ireland's most senior cleric," together with Domnall Ua Lochlainn, who was king from 1094 to 1121 (fig. 7-20). Another Irish inscription on the back also names the artist, Cú Duilig Ua hInmainen, along with his sons and the "keeper of the bell," Cathalan Ua Maelchallain, whose family preserved it until the late nineteenth century. The shrine is formed of bronze plates covered with finely worked gilt-silver and gold-filigree panels arranged in the shape of a cross with a ring at its center (the jewels are later); the sides, interrupted by suspension rings, depict elongated beasts interlaced with snakes; and the flatter back is covered with crosses. The crest at the top, over

the bell's handle, is decorated with facing peacocks flanking a stylized tree that echoes the cross below. Bell shrines are uniquely Irish reliquaries whose form announces their contents. The enshrined bells were originally rung in monasteries to structure communal time, but they came to be associated with specific holy figures who wielded the instrument to deflect demons and enemies. They could be suspended around the neck to become, in effect, the voice of the monk and his community. Some bells were buried with their users, including this one: when the grave of Patrick was opened in 553 by Colum Cille (St. Columba), the Irishman who spread Christianity among the Picts and Scots, the bell was found among other objects. Over five centuries later, the bell relic was placed into its decorated container, where it could "speak" to a larger community that included the king.

A combination of local artistic traditions and wider European trends is evident in a late Viking-Age stave church outside the village of Urnes (now Ørnes) in western Norway (fig. 7-21). Urnes is one of the best preserved and most richly decorated of approximately thirty extant Scandinavian churches built of wood; there may have been about two thousand in the Middle Ages. The staves that give these churches their name were the timbers that served as the vertical posts; vast forests and generations of Viking shipbuilding provided the requisite materials and expertise, with no nails used and only tiny porthole windows for light. In the eleventh century, the expansion of Christianity throughout Scandinavia required the construction of new churches; these earlier buildings do not survive, in large part because the staves were set directly into the ground and were prone to rot.

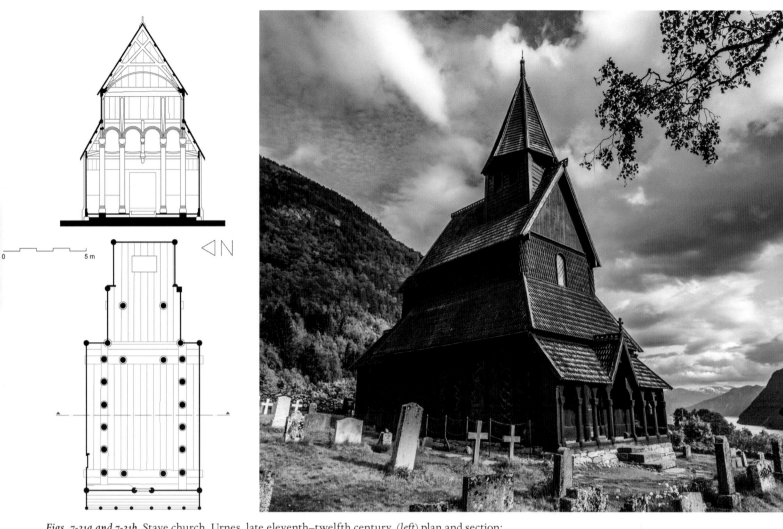

Figs. 7-21a and 7-21b. Stave church, Urnes, late eleventh–twelfth century, (*left*) plan and section; (*right*) exterior from the northwest. (*l*) Drawings by Navid Jamali; (*r*) Photo from Shutterstock/RPBaiao.

The church at Urnes is the fourth on this site, and it is remarkable for its profusion of relief sculpture and reuse of carved panels from the previous building. What was probably the original west portal from the 1070s was cut down at top and bottom and moved to the new north wall (fig. 7-22). This horseshoe-shaped door is outlined by an asymmetrical, writhing mass of elongated animal bodies, primarily dragons and a single fierce quadruped, intertwined in struggle and carved in deep relief (up to 7 cm). Because they frame a church door, these fighting animals have been interpreted both as powerful apotropaia meant to guard against evil and as references to Jesus vanquishing serpents and wild beasts (Ps. 91:13). The Urnes doorway marks the end of a long stylistic, iconographic, and technical woodworking tradition. The late phase of the Animal Style seen here, called the Urnes Style, was widespread in all media in Scandinavia and the British Isles from the second quarter of the eleventh century well into the twelfth. Both the Golden Altar at Lisbjerg and the Shrine of St. Patrick's Bell incorporate Urnes Style ornament.

The builders of the twelfth-century stave church (tree rings indicate a felling date of about 1130) also sought to

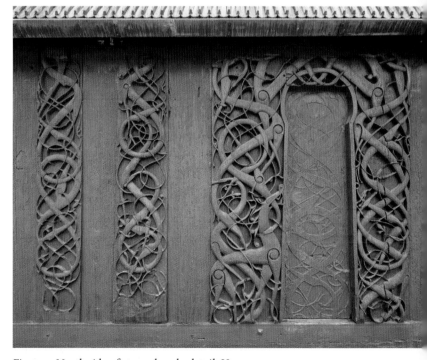

Fig. 7-22. North side of stave church, detail, Urnes, ca. 1070. Wikimedia Commons/Micha L. Rieser, public domain.

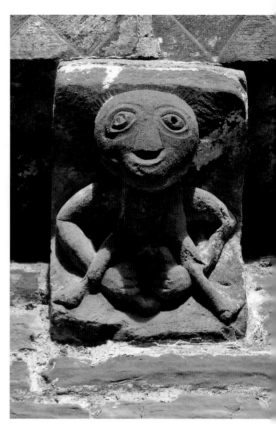

Figs. 7-23a and 7-23b. Kilpeck parish church, ca. 1140, (*left*) exterior from the south; (*right*) sheela-na-gig, 37.2 × 23 cm. (*l*) Photo by the authors; (*r*) Wikimedia Commons/Poliphilo, CC0 1.0.

incorporate features of contemporary stone churches from elsewhere in northern Europe. These include the emphasis on the portal, accentuated by a gabled portico (here in wood; fig. 7-21), and, inside the church, staves carved to emulate stone columns, complete with carved capitals, molded arches, and pilasters (pier attached to the wall), even though none of these serve any structural function here. The capitals, with their lions and fabulous beasts, can be linked iconographically to contemporary English manuscript painting and reveal the increasing integration of Norwegian art with that elsewhere in northern Europe.

Urnes also exemplifies one of the surprising features of churches in western Europe: the proliferation of architectural sculpture with unexpected iconography. The images known today as sheela-na-gigs, or simply sheelas—perhaps from an old Irish word meaning either "ugly as sin" or "old hag of the breasts"—may shock modern viewers despite their frequent appearance in European medieval art; they are especially common in Ireland and on churches. A well-known example decorates a corbel (projecting bracket) on the south exterior of the apse of the parish church at Kilpeck, England (fig. 7-23). The other eighty-eight carved corbels bear a great variety of human, animal, and imaginary figures, some inspired by illustrated bestiaries, but only this one is frankly sexual: a figure squats and holds open her huge vulva. Scholars disagree about how to interpret this and other sheelas. Were they meant to be moralizing warnings about men's lust or women's sexuality? Apotropaia?

Pre-Christian fertility figures? Talismans for childbirth? Are they to be read as erotic, obscene, frightening, titillating, or humorous, and did women and men perceive them differently? Does the sheelas' frequent placement near liminal zones (doors and windows) somehow protect those entry points by displaying a bodily point of entry? For the villagers of Kilpeck, who used the church built around 1140 for many religious and social functions, the sheela-na-gig probably had multiple meanings that prompted a range of individual responses. European medieval art is full of such sexual marginalia (images in the margins). The fact that so many examples survive means that they did not offend most viewers—at least until the postmedieval centuries, when they were often censured.

Individual and Communal Identity

In the eleventh century art patronage was available to more people than had been possible earlier; standards of living were increasing in many places, and more money was in circulation. An example of mercantile patronage from the Islamicate world is the Bobrinsky Bucket, named for its later Russian owner (fig. 7-24). It was made in Khorasan, a region that straddles the borders of several modern countries in Central Asia. The area was renowned for its rich metal resources, which is evident in this brass bucket inlaid with copper and silver. Inlaid metalwork can-

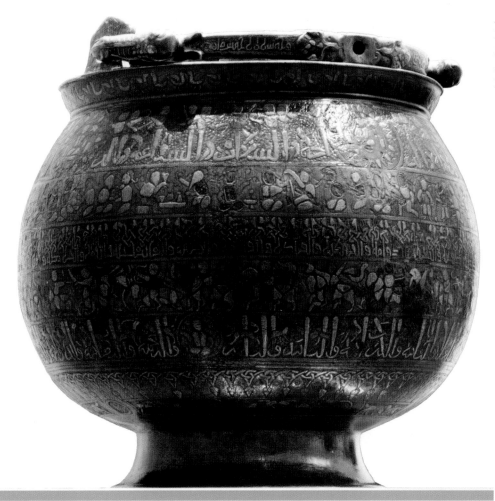

Fig. 7-24. Bobrinsky Bucket, H 18.5 cm to rim, D 22 cm, 1163; State Hermitage Museum, St. Petersburg. © Genevra Kornbluth.

not be placed over a cooking fire, and corroding copper would poison food, so the bucket was probably made for carrying water or toiletries in public or private baths. Dedicatory inscriptions on the rim and handle are in Persian, while the script employed on the body is a new type used only in metalwork. Bands of text include knotted and figured Kufic, in which letters terminate in zoomorphic or anthropomorphic heads, enhancing their visual vibrancy. Despite the hard-to-read scripts, the generic good wishes they convey would have been familiar to viewers. The text bands alternate with rows of human figures engaged in the good life of hunting, revelry, and games of chance and skill. As an elaborate version of an everyday object, the bucket attests to the emergence of an urban middle class that could commission, give, and receive elaborate works of art. In this case, the recipient was Rukn al-Din Rashid ad-Din 'Azizi ibn Abu'l-Husayn al-Zanjani, who is named in silver on the rim text and referred to as "glory of the merchants" and "ornament of the hajj and both shrines," which means he had completed the required pilgrimage to Mecca and Medina. Perhaps the bucket was ordered and personalized to commemorate this event by 'Abd al-Rahman ibn 'Abdallah al-Rashidi, who is also named on the rim. Additional inscriptions identify the bucket's two artists: it was "formed" or "struck" (cast) by Muhammad

ibn 'Abd al-Wahid and "made" (designed and decorated) by the hajib Mas'ud ibn Ahmad from Herat (Afghanistan) in December 1163. Despite the specificity of the inscriptions, none of the named individuals are known from other sources. Nevertheless, the inclusion of Muhammad and Mas'ud testifies to the fact that artists continued to enjoy a high social status in the Islamicate world.

To help unite their vast empire and facilitate long-distance trade and prosperity, the Seljuqs created a dense network of caravanserais, stopping points with accommodations. These were located about thirty-two kilometers apart and used by troops, the postal service, merchant caravans, and individual travelers. The Ribat-i Sharaf was built in 1114 in the Khorasan region (fig. 7-25); *ribat* is the Arabic word for caravanserai, and Sharaf al-Din was the local governor. Preceded by a large cistern—a key amenity for travelers and their pack animals—this rectangular baked-brick structure, over forty-eight hundred square meters in size, contains two courtyards, each with four large vaulted iwans and smaller flanking rooms. At least two stories high, it contained two mosques, and its monumental projecting portal with a tall rectangular frame (*pishtaq*) has a mihrab on the exterior to let late-arriving travelers know the proper direction for prayer. In 1154/55 the pishtaqs and some of the vaulted rooms were decorated with elaborately

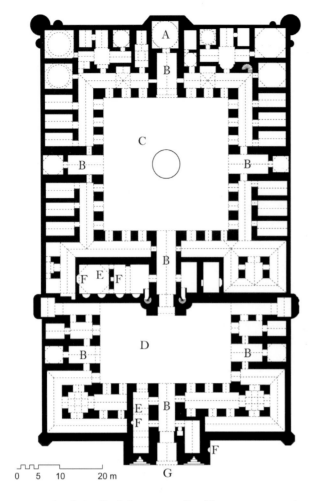

A	Antemihrab dome	E	Mosque
B	Iwan	F	Mihrab
C	Interior courtyard	G	*Pishtaq*
D	Public courtyard		

patterned brick and stucco by order of Turkan Khatun, the wife of Sultan Sanjar (r. 1118–57), making the building more elaborate than its basic function would seem to warrant. It is likely that the sultan and his entourage sometimes stayed in the larger, northern part of the ribat, which provided privacy and distance from travelers lodged around the smaller courtyard. The foundation was a visible manifestation of the power of the Seljuqs far from their urban centers, and its plan supported the religious practices of Muslim traders while affirming social hierarchies.

By the tenth century, the Abbasids had built at Isfahan (Iran) a typical hypostyle Friday mosque (fig. 7-26 *left*). In 1086 the Seljuq vizier Nizam al-Mulk removed columns to insert a freestanding domed pavilion in front of the mihrab (fig. 7-26 *right*), which produced a dramatically different space. The square base, tripartite squinches, and a sixteen-sided transition zone supported the largest masonry dome in the Muslim world (fig. 7-27). The vertical alignment of its brick arches gives this thirty-meter-tall dome an impression of soaring height. It may have been intended as the sultan's private prayer area, in imitation of the similar domed maqsura at the Great Mosque in Damascus. A long inscription inside the drum is typical of the Seljuq and later periods, in which titles for the ruler and his vizier multiplied extravagantly. The exterior of the dome bears a stern message for the people of Isfahan: "Blessed are the

Figs. 7-25a and 7-25b. Ribat-i Sharaf, Khorasan, 1114–55, (*top*) plan; (*bottom*) view from the south. (*t*) Drawing by Navid Jamali; (*b*) db images/Alamy Stock Photo.

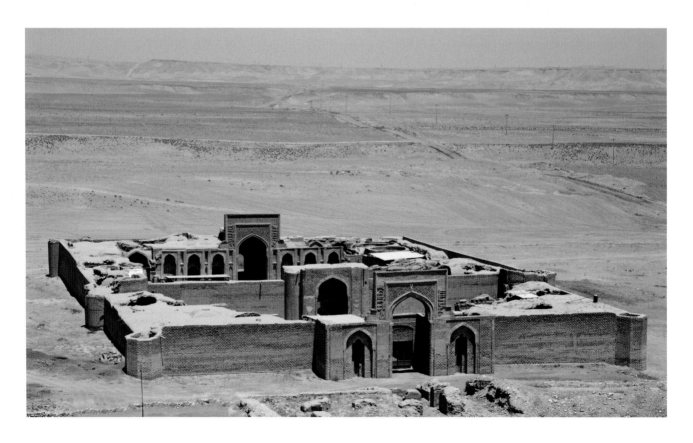

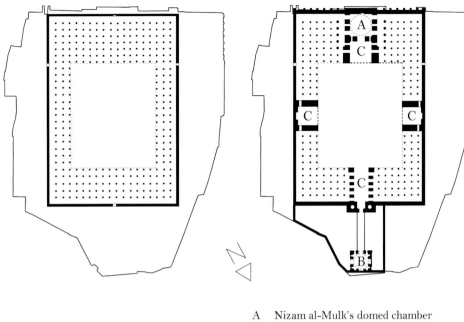

Fig. 7-26. Great Mosque, Isfahan, plans, (*left*) tenth century; (*right*) after 1121, both within outline of later mosque. Drawings by Navid Jamali.

A Nizam al-Mulk's domed chamber
B Taj al-Mulk's domed chamber
C Iwan

0 20 40 100 m

believers, who are humble in their prayers, who avoid vain talk, who give alms to the poor, who abstain from sex except with their wives and slave girls, for those are permitted to them" (Qur'an 23:1–6). This text was rarely used in architecture; it apparently responded to inappropriate behavior, including prostitution, that is reported in several historical sources and that Nizam al-Mulk intended to suppress. In 1088 Nizam al-Mulk's rival, Taj al-Mulk (who may have ordered Nizam's assassination), built a second domed chamber of uncertain function on the opposite (north) side of the mosque (fig. 7-26 *right*).

Probably after a fire in 1121, the freestanding south domed chamber was connected to its hypostyle surroundings, and an even more important innovation was introduced: an iwan replaced the columns between the courtyard and Nizam al-Mulk's south dome. The result was so practically and aesthetically satisfying that tall iwans were inserted symmetrically into the other three courtyard facades of the Isfahan mosque. Between the pointed barrel-vaulted iwans, the former hypostyle ultimately had over 470 individually vaulted bays. While the iwan was typical of Sasanian architecture (fig. 3-32) and already used in Islamic residences and caravanserais, the Seljuqs introduced it into mosques, where it became standard, as did domed antemihrab spaces. The four-iwan plan proved very flexible and was adapted in many kinds of buildings, including the Islamicate educational institutions called madrasas. Nizam al-Mulk established a network of madrasas (named, after him, *nizamiyas*) to standardize Sunni religious education across the Seljuq world.

Christians were interested in Islamic art for a variety of reasons. Some objects functioned as trophies, commemorative symbols of military might. In Pisa (Italy), a large

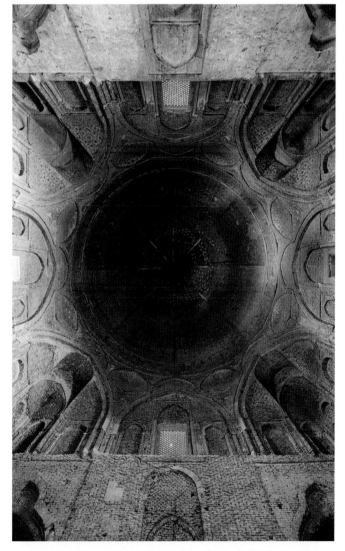

Fig. 7-27. South antemihrab dome, Great Mosque, Isfahan, 1086. Wikimedia Commons/Amir Pashaei, CC BY-SA 4.0, rotated.

cast-bronze statue of a griffin was placed on top of the cathedral in the first half of the twelfth century; it remained there until 1828, when it was moved inside and replaced by a copy (fig. 7-28). It is covered with incised designs, including lions, eagles, stylized feathers on its wings, and bands of angular Kufic inscriptions that promise generic blessings; many of these motifs derive from tiraz and other textiles. Local legends claim that the work was booty from the Pisan conquest of the Balearic Islands, near Spain, in 1115 (and there is a funerary relief from there in Pisa), but an inscription on the facade of the cathedral complicates matters; it states that Pisan soldiers in North Africa seized large bronzes and brought them home. Recent analysis suggests that the griffin was likely made in al-Andalus in the late eleventh or early twelfth century, although origins in Iran, Egypt, North Africa, or southern Italy have also been proposed. Regardless of its place of manufacture, the griffin was displayed in a distinguished public place for centuries. This symbol of Pisa's seafaring and military prowess was not only visual: a vessel inside the creature made it roar eerily when the wind blew. Such acoustic and other automata were common in Islamic and Byzantine courts, and contemporary texts record four roaring lions on the corners of a palace in Sana'a, Yemen. Contributing to the overall ideological message, a tenth-century marble

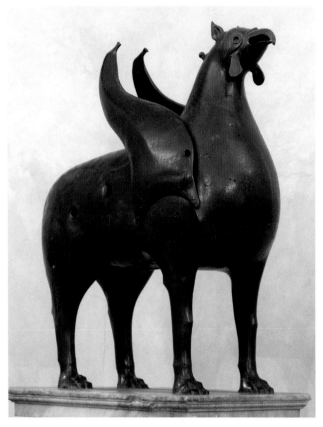

Fig. 7-28. Bronze griffin, 107 × 43 × 87 cm, late eleventh–early twelfth century; Museo dell'Opera del Duomo, Pisa. © Genevra Kornbluth.

capital from Madinat al-Zahra' was also displayed on the Pisa Cathedral roof.

Thanks to a flourishing commercial culture, including the establishment of trading posts at Constantinople, Pisa was one of several northern Italian cities competing for power locally and around the Mediterranean. By the late twelfth century it was larger and wealthier than its chief rival, Florence, which soon overtook it in fame and prosperity. Pisa erected its city walls around 1000, while most Italian cities began such structures at least fifty years later (those in northern Europe followed after another half century); new walls enclosing a larger space were constructed in 1156. A sense of civic pride and power lay behind the building of a grand cathedral complex, which included the griffin-topped basilica; a circular baptistery modeled on early Christian precedents, such as the Holy Sepulcher; and a bell tower, or campanile, the famous leaning tower of Pisa (fig. 7-29).

Despite being erected over centuries, the complex is unified by the similar heights, repeated round arches and blind arcades, and two-tone marble cladding of its three main components. The cathedral, begun in 1063 and consecrated in 1118, employed ancient spolia in a systematic way, and the baptistery, begun 1152, was the largest in Italy. In a revival of early Christian practice, baptisms took place during the Easter vigil, with the bishop inducting infants into both the Christian faith and the Pisan commune (city-state). This liturgical innovation allowed laypeople to confirm their identity as Christian members of a republic sanctified by God. The campanile, built on marshy ground with insufficient foundations, was begun in 1173 but not completed until two centuries later. The adjacent Campo Santo cemetery, which in the twelfth century already contained earth brought from the Holy Land, was later enclosed and decorated with frescoes. For centuries, then, the Pisa complex advertised the wealth and glory of the city. This ideology was explicit: three inscriptions on the cathedral facade laud at least five Pisan victories, and a record of its military victories is similarly inscribed on the interior.

The cathedral complex drew upon many references to assert the status of the city and achievements of its people. The names of many of the artists who brought the project to fruition were recorded, an unusual practice in western Europe that shows the esteem accorded to them and their work. Diotisalvus is noted as an architect and sculptor of the baptistery, and a marble lion on the facade of the cathedral is signed by Guidonis and Bonfilius. The first architect of the cathedral, Buschetus, was memorialized in ways that also conveyed how the Pisans perceived him and themselves in history. He was compared to the ancient Greek heroes Daedalus and Odysseus (Ulysses), clever engineers like him. His association with antiquity was strengthened by his burial in an ancient Roman sarcophagus; this visual marker of his identity was placed on the interior wall of the cathedral's west facade, a place normally reserved for

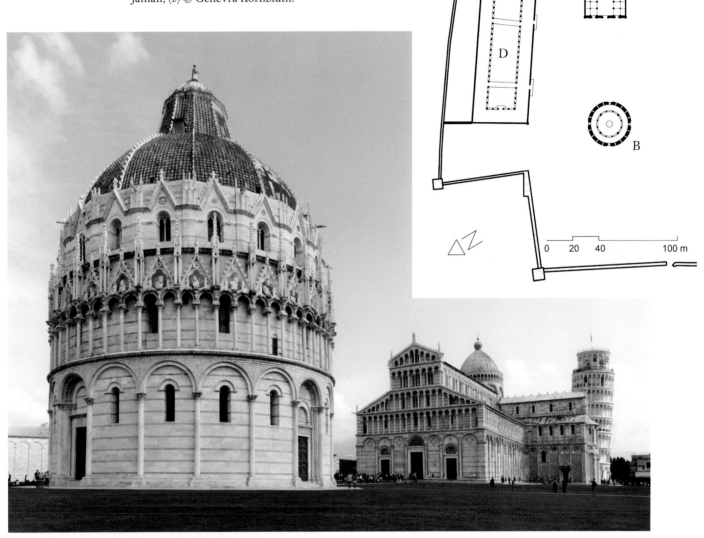

Figs. 7-29a and 7-29b. Pisa, cathedral complex, (*right*) plan, A=cathedral, 1063–1118; B=baptistery, 1152–1363; C=bell tower, 1173–1372; D=Campo Santo cemetery, begun twelfth century; (*bottom*) view from the west. (*r*) Drawing by Navid Jamali; (*b*) © Genevra Kornbluth.

the highest-ranking clergy. These commemorations of Buschetus signaled the intellectual aspects of the city's culture, while the complex as a whole displayed the worldly ambitions of the Pisans and their government.

Monasticism

In Byzantium, imperial patronage extended into the public realm, and establishing charitable foundations advanced a number of civic, religious, and political goals. Many such institutions were managed by monks. The Pantokrator Monastery in Constantinople (known today as Zeyrek

Camii) was established by Emperor John II Komnenos (r. 1118–43) likely with input from his Hungarian wife, Eirene. She died in 1134, before the completion of the monastery, which was planned in part as an imperial mausoleum. In the surviving typikon (foundation document) for the Pantokrator, dated 1136, John enumerated its multiple functions. In addition to housing a community of monks—a maximum of eighty, making it one of the largest documented monastic communities in the Byzantine world—it included a hospital with sixty beds and a separate women's ward, an old-age home, and a leper sanatorium. Scores of physicians, surgeons, students, pharmacists, bath attendants, and other medical practitioners served these insti-

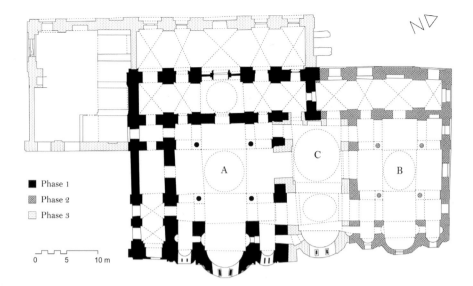

Figs. 7-30a and 7-30b. Pantokrator Monastery, Constantinople, 1118–36, (*top*) plan, A=Pantokrator katholikon, B=Theotokos church, C=St. Michael heroon; (*bottom*) exterior from the east. (*t*) Drawing by Navid Jamali; (*b*) Wikimedia Commons/A. Fabbretti, CC BY-SA-3.0.

■ Phase 1
▨ Phase 2
☐ Phase 3

0 5 10 m

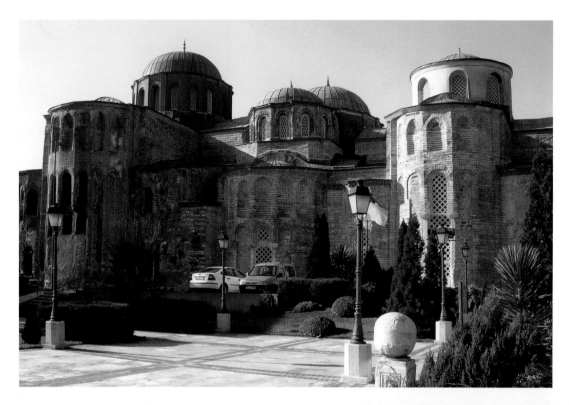

tutions, and large quantities of medicinal glass vessels and lamps have been found there. Although the expenditures involved in founding and maintaining all these ventures were immense, supporting them was part of the emperor's demonstration of his Christian piety and a way to validate the Komnenian dynasty, which ruled Byzantium from 1081 to 1185.

The typikon refers to many relics and works of art, including liturgical vessels, icons, mosaics, and their lighting, but what remains of the monastic complex are the three contiguous churches and fragmentary interior decoration, including small pieces of stained glass (fig. 7-30). The largest and earliest building was the katholikon dedicated to Christ Pantokrator; the smaller northern church was dedicated to the Theotokos; and the third, between them, to St. Michael the Archangel. The Pantokrator and

Fig. 7-31. Pavement detail, katholikon, Pantokrator Monastery, Constantinople, 1118–36. Photo by the authors.

Fig. 7-32. Author image and Anastasis, Homilies of Gregory of Nazianzos, 32.3 × 25.4 cm, 1136–55; Mount Sinai, Monastery of St. Catherine, MS gr. 339, fols. 4v–5r. By permission of Saint Catherine's Monastery, Sinai, Egypt.

Marian churches are domed, cross-in-square buildings that share a continuous narthex. The chapel of St. Michael, with two elliptical domes, housed imperial tombs; the archangel's role as weigher of souls at the Last Judgment made the dedication highly appropriate. John called the funerary chapel a *heroon*, or shrine of a hero, which in this case meant Christian heroes like Constantine. The walls of the three churches are clad with marble spolia culled from earlier buildings in the area. While colorful patterned floors were common in this period in both Byzantium and Europe (fig. 7-10b), the iconography of the opus sectile pavement in the Pantokrator church is unique. It combines sea creatures and birds from the repertoire of late antique nature imagery with the zodiac and such imperial motifs as hunting and combat scenes. Four vignettes illustrate the life of the Old Testament hero Samson (Judg. 13–16), who was considered a type for Christ, an archetypal warrior, and an appealing role model; men in the Komnenian family were compared to Samson in contemporary literature (fig. 7-31).

Another work from the Komnenian circle is a manuscript that contains selected liturgical homilies—sermons read on important feast days—written by the saintly bishop

Gregory of Nazianzos (d. 390). The colophon reveals that the book was commissioned by one of the first abbots of the Pantokrator Monastery, Joseph Hagioglykerites, so it dates between the monastery's foundation in 1136 and Joseph's death in 1155. Intended as a gift to a church where Joseph had previously been a monk, this is a deluxe version of the popular compendium of homilies (fig. 7-32). The headpiece on fol. 5r depicts the Anastasis, the Byzantine scene of Christ's resurrection, in which he descends into Hades, trampling on its gilded gates, to resurrect worthy individuals from pre-Christian sacred history. Adam, Eve, and Abel occupy the sarcophagus on the right, opposite kings David and Solomon and John the Baptist at the left; the raising of Adam and Eve is repeated in the initial *A* below. The golden text at the bottom introduces Gregory's first sermon for Easter, and on the opposite page the author is represented at his desk, like an evangelist, listening to a miniature Christ who inspires and appears to dictate to him (a second colophon refers to Gregory as a "mouthpiece of God"). The saint sits in an ornate architectural setting that includes gardens, fountains, an opus sectile pavement, porphyry columns, bronze doors, marble revetment, and multiple domes that frame a mosaic-like image of the

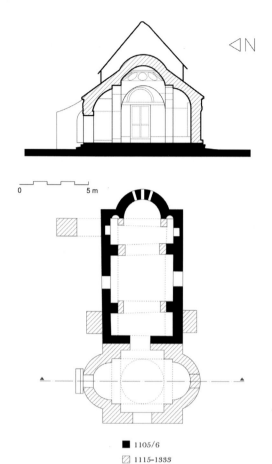

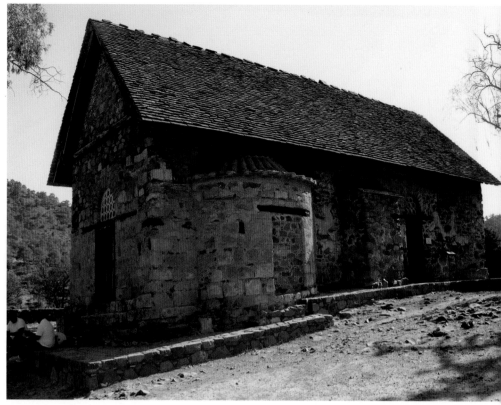

■ 1105/6
▨ 1115–1333

Figs. 7-33a and 7-33b. Church of the All-Holy Mother of God of the Spurges, Asinou, ca. 1100–1330s, (*left*) plan and section; (*right*) exterior from the southwest. (*l*) Drawings by Navid Jamali; (*r*) Photo by the authors.

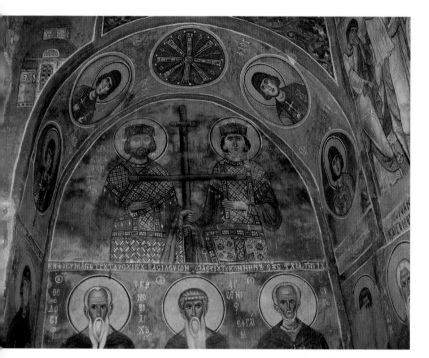

Fig. 7-34. Saints Constantine and Helena, church of the All-Holy Mother of God of the Spurges, Asinou, 1105/6, south wall of naos. Photo by the authors.

enthroned Mother and Child. The Pantokrator Monastery may have inspired some of the rich architectural detailing on the manuscript page, but the Heavenly Jerusalem is probably being visualized as well.

A modest barrel-vaulted stone church at Asinou, on the strategically important island of Cyprus, is a Komnenian-era monastery church built without imperial patronage (fig. 7-33). It was dedicated around 1100 to the All-Holy Mother of God of the Spurges, a flowering shrub (Panagia Phorbiotissa in Greek); she is depicted with a medallion of the Christ child over the original west entrance. The patron's name, Nikephoros Ischyrios, and the date 1105/6 appear on the south wall of the naos under images of saints Constantine and Helena (fig. 7-34). Nikephoros is identified as *magistros*, originally a high-ranking Byzantine dignitary but by the twelfth century a title without much significance. Multiple inscribed prayers indicate that the church was Nikephoros's offering to the Mother of God (and her son) in a campaign for personal salvation. The church became the center of a small monastery soon after its foundation, and a narthex was added to the west; prayers for the dead were recited there, and it may have sheltered tombs. The narthex was redecorated in the late twelfth century, and more paintings were added after that (discussed in chapter 9). While Asinou cannot compete with the lavish original decoration of the imperial Pantokrator

Monastery, its early twelfth-century paintings echo the style of the capital, and their blue backgrounds derive from costly lapis lazuli.

In western Europe, monasticism continued to be considered the most elevated spiritual path for emulation of and union with God. Men and women dedicated themselves to prayer and spiritual contemplation, often following the guidelines established in the sixth century by St. Benedict, which including meeting each day in the chapter house, a room or building used for biblical readings and discussion of monastery affairs (box 2-3). The most important monastic tasks continued to be the daily recitation of psalms and remembering departed members of the community. This was accomplished not only by means of liturgical prayers that sought the salvation of the deceased's soul but also by material aids to memory. For example, the cloister of Saint-Pierre (Peter) at Moissac (southwest France), dated by an inscription to 1100, has a marble pier carved in shallow relief that depicts Abbot Durandus (d. ca. 1072) (fig. 7-35). He revived the monastery after a devastating fire in 1042, and the sculpture asserts his saintliness with the inscription on the arch above his halo. It provided the monks with a perpetual reminder of the abbot and suggested his ability to oversee them and bless the community long after his death.

Durandus had previously been a monk at Cluny, Moissac's motherhouse (founding monastery of a religious community), which in the eleventh century was the wealthiest and most powerful of all Benedictine monasteries. At its height, Cluny's vast religious bureaucracy encompassed over three hundred daughter houses (dependent monasteries), including Sainte-Foy at Conques. The abbot of Cluny answered only to the pope in Rome and was free from episcopal or lay oversight. In accord with the reform efforts initiated by Pope Gregory VII during the Investiture Controversy, Cluniac monks were sent across Europe to improve monasteries where discipline had become lax. The reform emphasized liturgical celebrations: the recitation of extra psalms, extensive processions, and such additional offices (structured services) as prayers to the Virgin or on behalf of the dead. It had long been a practice for individual monasteries to offer prayers on behalf of laypeople in exchange for material donations, but Cluny institutionalized this on a grand scale and attracted large donations, especially from the Christian rulers in Spain, enriched by their victories over taifa emirs.

In the cloister at Moissac, monks could contemplate carved capitals in addition to the pier bearing the relief of Durandus. Many of the cloister capitals, which top single columns alternating with double ones and are visible on all four sides, are historiated (decorated with identifiable scenes or figures); most of the narratives are biblical. Others combine humans, animals, and vegetation in imaginative ways. On one capital, naked men reach out to grasp the wings of now-headless creatures whose bodies

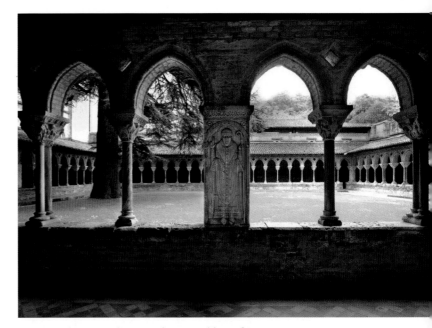

Fig. 7-35. Cloister with Durandus pier, abbey of Saint-Pierre, Moissac, ca. 160 × 72 × 52 cm, 1100. Photo by Lawrence Winder, 30-5-2011.

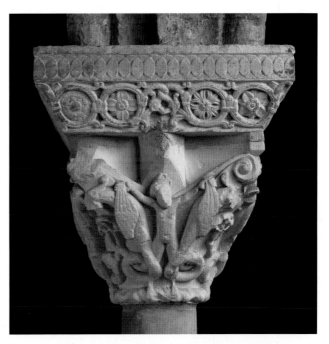

Fig. 7-36. Cloister capital, abbey of Saint-Pierre, Moissac, 51 × 60 × 50 cm, 1100. Photo from Kunsthistorisches Institut in Florenz–Max-Planck-Institut, Florence.

terminate in snakelike tails that wrap around the men's legs (fig. 7-36). These sculptures were made specifically for the Moissac cloister—an area normally restricted to the brothers of the monastery, a group that included highly educated and deeply spiritual men. Not every monk was an intellectual and religious giant, but as they walked around the cloister contemplating their reading or tending to domestic tasks (monks shaved and washed themselves and their clothes in cloisters), they would have understood

A Church
B Cloister
C Chapter house
D Dormitory
E Warming house
F Refectory
G Gate house
H Guest house
I Forge and workshop
J Infirmary
K Dovecote
L Bakery
M Chapel

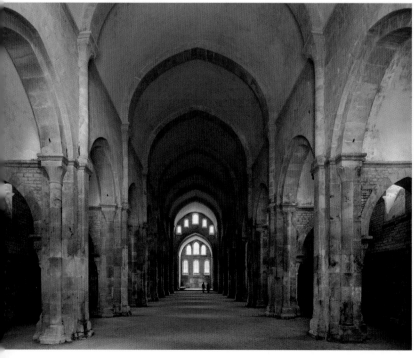

0 10 20 50 m

Fig. 7-37. Fontenay Abbey, 1140s–60s, plan. Drawing by Navid Jamali.

Fig. 7-38. Fontenay Abbey, church, 1147, view toward the east. Wikimedia Commons/Myrabella, CC BY-SA 4.0 modified.

the biblical stories and the fanciful or monstrous images in ways shaped by their monastic training, including as a metaphor for the spiritual battle against evil and temptation in which they themselves engaged.

The types of images sculpted at Moissac, which was on a pilgrimage route to Santiago de Compostela, were widespread in western European monasteries, but they were controversial. Bernard of Clairvaux (1090–1153), one of the most powerful religious figures in twelfth-century western Europe, wrote a scathing indictment of this kind of decoration:

> What excuse can there be for these ridiculous monstrosities in the cloister where the monks read, such deformed beauty and beautiful deformity? . . . The variety of diverse shapes is so numerous and so marvelous that one is tempted to read more in the marble than in books and spend the whole day marveling at these things rather than meditating upon the law of God. For God's sake, if men are not ashamed of these follies, why do they not at least shrink from the expense?

Bernard showed great sensitivity to the power of this kind of sculpture, which was, in his view, exactly the problem: monks should be focused on the words in their books rather than be prompted to contemplate such distracting visual representations. Bernard's disdain for the money spent on such sculpture was a critique of Benedictine monasticism as it was practiced at Cluny and its daughter houses. In 1115 he supported a new monastic order that aimed to replicate monastic life as it was imagined to have been at the time of St. Benedict, including manual and especially agricultural labor (the wealthy Cluniac monks hired laymen for that). Monks of this new Cistercian Order, named after the monastery at Cîteaux (France) where Bernard was trained, were also called White Monks to distinguish them from the black-clad Benedictines. By the end of the twelfth century, there were over five hundred Cistercian abbeys for men and an unknown number for women across Europe. Bernard was also an activist: after the death of the pope in 1130, Christians in western Europe were divided by a schism between supporters of two papal candidates, and he was called upon to adjudicate the dispute. He also preached against local dualist heresies and, in 1146, in favor of a new crusade against the Seljuqs. Bernard was canonized by the pope in 1174, relatively soon after his death.

The Cistercians initially followed the Benedictine Rule, but eventually they became more strict, emphasizing the reading of scriptures and greater simplicity in dress, food, and architecture, although some richly painted manuscripts were made at Cîteaux. A well-preserved example of early Cistercian monastic architecture is the abbey of Fontenay (France), begun in the 1140s but probably not completed until the 1160s (fig. 7-37). Although the order's

early stories tell of monks clearing the forest and building simple wooden structures, the movement did not reject permanent churches erected with expensive stone walls and vaulting. Even though Bernard of Clairvaux wrote little about architecture, anti-Cluniac features seen here and in other early Cistercian foundations include the absence of towers, crypts, tombs, and curved ambulatories with radiating chapels; instead, the east ends of early Cistercian churches like Fontenay are square, and the cult of relics was downplayed. Fontenay's church and monastic buildings are fairly austere, without the visual distractions Bernard attacked so vehemently (fig. 7-38). Cistercian edicts prohibited such things as bells, gold and gems, ornate pavements, colored window glass, and figural paintings and sculpture (except of Christ), in order to create a proper physical environment for spiritual contemplation. As the order grew, however, it attracted wealthy donors and their tombs, and some later Cistercian churches are indistinguishable from those of the Benedictines.

A cross carved in the 1150s of walrus ivory from the Arctic has an unusually complex program that indicates it was produced for a learned monastery (fig. 7-39). Often called the Cloisters Cross for its current location in the Cloisters (New York), the object is usually associated with the English Benedictine abbey of Bury St. Edmunds, but it may have been made and used in Germany. The cross contains over ninety carved figures and almost one hundred inscriptions. It was meant to be carried through the church during the liturgy, particularly on Good Friday, a day of special celebrations of the True Cross. Details of the carving and the profusion of Latin texts suggest that the object was also subject to close inspection by the monks. Learned members of the community probably provided the complex iconographic program to the artists. The front is carved as the Tree of Life, with terminal plaques containing scenes related to Good Friday, Easter, and Christ's ascension (fig. 7-39 *left*). The central medallion depicts Moses and the brazen serpent (Num. 21:5–9). That story, in which God punished the rebellious Israelites with poisonous snakebites and then healed them with a bronze serpent on a pole, was understood as a type for the crucifixion. The complex typology continues on

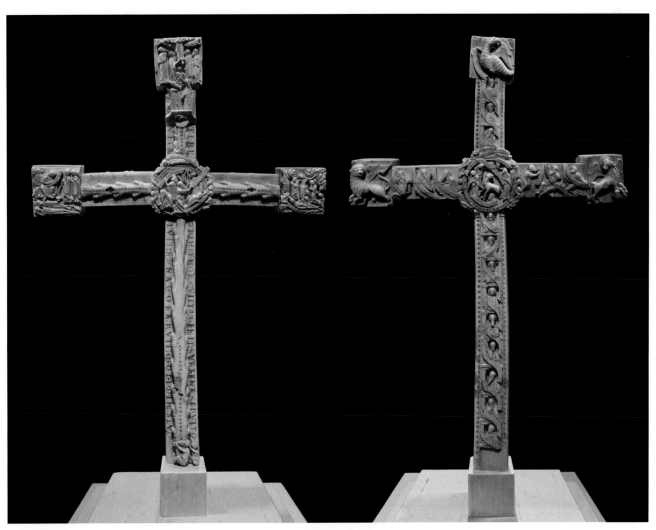

Fig. 7-39. Cloisters Cross, 57.5 × 36.2 cm, ca. 1150–60, front and back; Metropolitan Museum of Art, The Cloisters Collection, New York (63.12). © Genevra Kornbluth.

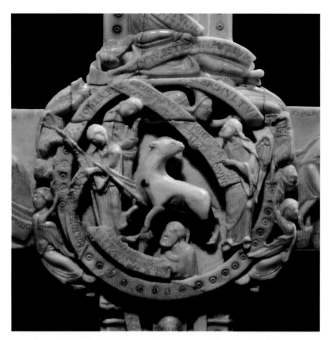

Fig. 7-40. Central medallion on back, Cloisters Cross, 6.7 cm, ca. 1150–60; Metropolitan Museum of Art, The Cloisters Collection, New York (63.12). © Genevra Kornbluth.

the other side, with evangelist symbols and eighteen Old Testament prophets holding scrolls that contain passages given a Christological interpretation (fig. 7-39 *right*). The program culminates with the Agnus Dei, the sacrificial Lamb of God, in the central medallion over whom the figure of John weeps, while a personification of the Jewish community, inscribed "Synagoga," pierces the lamb's side with a lance (fig. 7-40).

The representation of Synagoga is a variation on a Carolingian theme that became more violently charged in the twelfth century. While the typological meaning of the Cloisters Cross is consistent with traditional Christian theology, the cross proclaims an anti-Jewish polemic more forcefully than similar works. On the front and side are two longer texts, the most visible of the cross's many inscriptions:

> The earth trembles, Death defeated groans with the buried one rising; Life has been called, Synagogue has collapsed with great foolish effort.
>
> Ham laughs when he sees the naked private parts of his parent. The Jews laughed at the pain of God dying.

The second couplet refers to the episode of Noah's drunkenness, when his son Ham witnessed his father's nakedness (Gen. 9:20–27), which by the seventh century was understood as a reference to the crucifixion and the disbelieving Jews. This was a potent demonstration of the relationship of the Old Testament to the New and of Christians' belief in the promise of salvation through the liturgy and the cross. Given the increasing pressures on Jews in Europe

that began with the lethal attacks on Jewish communities in Germany in 1096 by crusaders on their way to the Holy Land, the Cloisters Cross might also be seen as contributing to a darker social landscape that included forced conversions and the expulsion of Jews from England in 1290 and France in 1306.

Hildegard of Bingen (1098–1179) was a Benedictine nun at the monastery of Disibodenberg who became abbess and, in 1150, transferred her community to Bingen (Germany). A prolific author, Hildegard composed liturgical music, wrote a morality play and a saint's vita, compiled treatises on natural history, medicine, and botany, and corresponded with such individuals as Bernard of Clairvaux, Pope Eugene III, and Emperor Frederick Barbarossa. She recorded the mystical visions she had experienced throughout her lifetime in the *Scivias* (a contraction of "Know the Ways" in Latin); some people have argued that they were in part a product of migraines. This work of the 1140s drew out the theological interpretations of what Hildegard understood to be divine messages for the reform of the Church. The frontispiece of one manuscript of the *Scivias*—lost during the Second World War but known from photographs and a hand-drawn color copy made by twentieth-century nuns at an abbey founded by Hildegard—shows the abbess being inspired by the flames of the Holy Spirit while Volmar, her confidant, advisor, and secretary, peers in to record the experience (fig. 7-41 *left*).

Other folios in the *Scivias* have unprecedented iconography. In the Creation and Fall scene (Gen. 1:26–27 and 2:21–23), instead of rising from Adam's side in human form, Eve is a wing-shaped cloud containing stars that represent her future descendants (fig. 7-41 *right*). She soars like a soul above the earthbound Adam, who lies above the fires of hell and its evil emanation, which includes Satan in the form of a serpent blowing black matter toward Eve. Hildegard described the scene:

> And lo! a pit of great breadth and depth appeared, having a mouth like the mouth of a well and belching forth fiery smoke with a great stench, from which the foulest haze [the devil], spreading itself out like a blood vessel, also touched one having the face of a deceiver. And in a clear part of the sky it wafted toward a white cloud [Eve] that had emerged from another beautiful cloud in the shape of a man [Adam] containing within itself many, many stars, and thus drove out that cloud and the man's shape from the area.

Although scholars recognize Hildegard's authorship, many have been reluctant to view her as an artist, preferring to see a second individual, perhaps Volmar, as the visual interpreter of her writings. Yet the wax tablet that Hildegard is shown holding in the prefatory miniature suggests that it was she who originally sketched out the visionary pictures. Moreover, in the twelfth century there

Fig. 7-41. *Scivias,* 1140s, *(left)* inspiration of Hildegard, fol. 1; *(right)* Creation and Fall, fol. 4; formerly Wiesbaden, Landesbibliothek, MS 1, copy by nuns at Eibingen Abbey, 1927–33. Erich Lessing/Art Resource, NY.

is increasing evidence for nuns acting as scribes and illuminators. In 2019, a nun buried around 1100 at a German convent not far from Bingen was found to have lapis lazuli residue in the tartar of her teeth, perhaps the result of licking the paintbrush while she worked on a manuscript.

Work in Focus:
THE ABBEY OF SAINT-DENIS

In the discipline of art history, one of the best-known patrons of medieval art is Suger, abbot (r. 1122–51) of Saint-Denis outside Paris. Beginning with Dagobert in the seventh century, French kings were customarily buried there, making the monastery one of the most important in France. Already enlarged during the Carolingian period and richly endowed by King Charles "the Bald," Saint-Denis had fallen into disrepair by the twelfth century. It experienced a renewed period of growth under the leadership of Suger, who wrote extensively about his activities. His texts, which are exceptionally detailed for an account of a medieval building project, admittedly reflect

his carefully crafted viewpoint, as do the many depictions of him in the church (fig. 7-42). Nonetheless, they establish that Suger, who had been a student at Saint-Denis before working his way up to the position of abbot, deserves much credit for reorganizing the monastery's administration, enlarging its holdings, rebuilding the church, and increasing the prestige of the foundation. Indicative of his reputation and administrative skill is the fact that he served as regent of France while King Louis VII (r. 1137–80) was fighting in the Second Crusade.

Suger recorded his motives for rebuilding the abbey church: it was overcrowded with pilgrims eager to venerate the relics of St. Denis (Dionysios), who had purportedly converted ancient Gaul and served as the first bishop of Paris. He wrote that terrified women cried out as though in labor and had to be lifted by men above the throng. Such dramatic exaggeration helped justify building a larger church with a major new shrine to contain the bodies of Denis and his companions, Rusticus and Eleutherius. In Suger's formulation, it was only fitting that the most precious materials should be used for the service of God—a clear response to the charges leveled by Bernard of

Fig. 7-42. Abbot Suger in the Infancy window, abbey church of Saint-Denis, Saint-Denis, 1140s. Wikimedia Commons/Vassil, public domain.

Fig. 7-43. Facade, abbey church of Saint-Denis, Saint-Denis, ca. 1140. Photo by the authors.

Clairvaux. Hence the centerpiece of the renewed church, the grand reliquary for the three saints, was made of stone, precious metals, antique gems, and at least one large Carolingian crystal. Like most of Saint-Denis's liturgical objects, it was destroyed in the French Revolution because of the abbey's long-standing associations with the monarchy. Those few items that survive, including the so-called Eleanor Vase discussed below, provide a tantalizing glimpse of the rich environment that Suger helped create at Saint-Denis.

The main altar, clad in gold, had been in use since the Carolingian period. Suger added three panels and an inscription: "Abbot Suger set up these altar panels / Except for the one King Charles had given before. / Make the unworthy worthy through your favor, O Virgin Mary; / May the fountain of mercy cleanse the sins of king and abbot." The last two lines express Suger's desire for personal salvation and memorialization. He underscored this hope by establishing guidelines for the annual observance of his death and having himself represented in texts and images throughout the church; this stained-glass panel shows him inserted into the very moment of the Annunciation. The verses also link the abbot to Charles "the Bald," the royal patron of Saint-Denis in the Carolingian era; the abbey's glorious past and its connections to the monarchy are the prevailing themes of the church. Not only were kings buried at Saint-Denis but they were also represented on Suger's new west facade, built in the 1130s. These jamb figures (statues flanking a doorway, often

attached to a column or wall) represented Old Testament kings, who were understood typologically as forerunners of the French monarchy—hence their destruction during the French Revolution (fig. 7-43). So important was the past, Suger wrote, that he hesitated to change the building at all. His reconstruction started at the west end because the Carolingian towers there were thought to be expendable, unlike Dagobert's basilica (fig. 5-3), which, according to legend, had been consecrated directly by Christ. Suger added four bays to the eighth-century nave, as well as a massive narthex and a new facade with three portals, a rose window, and two towers (the north one was dismantled after a nineteenth-century storm) (fig. 7-44a).

After the western renovations were completed about 1140, work begin on the east end, the site of the new reliquary for St. Denis. It is this chevet, the eastern part of the church consecrated in 1144, that has made Saint-Denis famous in the history of western European art. A comparison with the plan and elevation of Conques reveals the

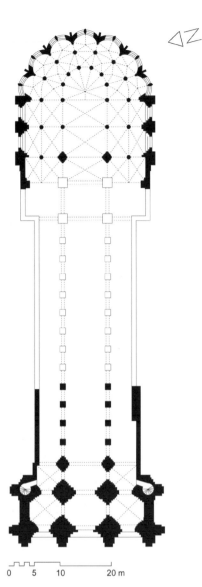

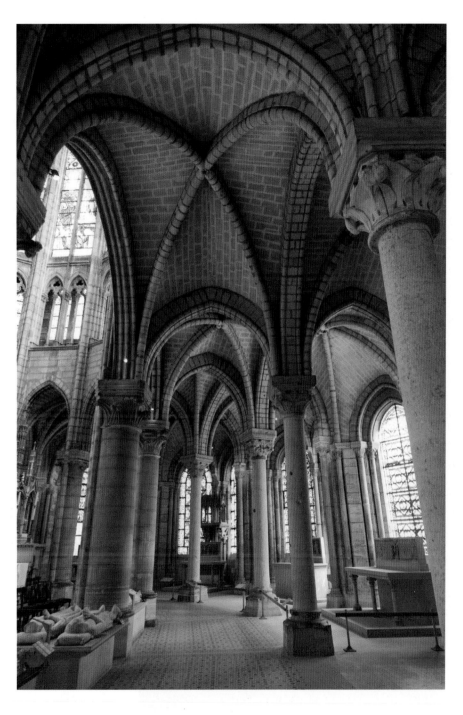

Figs. 7-44a and 7-44b. Abbey church of Saint-Denis, Saint-Denis, 1140s, (*left*) plan, with Suger's additions in black; (*right*) chevet. (l) Drawing by Navid Jamali; (r) Photo by the authors.

key changes (fig. 7-1). While both buildings employ an ambulatory and radiating chapels, at Conques the spaces are separate, with a rigid demarcation between aisle, ambulatory, and chapel; by contrast, the spaces are more fluid at Saint-Denis, due to pointed arches like those introduced in Norman architecture in England. Vaults on round arches are the hallmark of eleventh- and early twelfth-century buildings in Europe; their height is fixed by the distance between the vertical supports. Pointed vaults are more flexible because their height can vary depending on how steeply their arches are pitched. In addition, pointed vaults funnel their weight efficiently to a few limited places. At Saint-Denis, the weight of the vaults falls on particular points on the exterior wall and on the two rows of columns

that define the aisles of the ambulatory. Places where the weight does not fall can be eliminated, while the points where the weight is concentrated are reinforced; this creates a skeletal system that is strengthened visually and structurally by the masonry ribs that crisscross the vaults (fig. 7-44b).

With no need for a thick wall to support heavy round arches, this new construction technique allowed for large panels of glass. Stained glass was used in western Europe as early as the late tenth century and in Byzantium in the eleventh or twelfth, but never before had such an extensive use of glass been possible. In Saint-Denis, two large windows were inserted into each of the seven chapels of the chevet, creating an undulating wall of light, color, and

Fig. 7-45. Tree of Jesse window, abbey church of Saint-Denis, Saint-Denis, 1140s. © Jean Feuillie/Centre des monuments nationaux.

religious imagery. Although many of the individual panels have been lost, damaged, or rearranged, enough remains to indicate that the windows communicated complex theological ideas. One of them mentioned specifically by Suger is a diagrammatic image of the ancestors of Christ known as the Tree of Jesse (Isa. 11:1–3; fig. 7-45). A stout branch grows out of the loins of the recumbent Old Testament figure Jesse; it rises to incorporate his son King David and subsequent generations, leading up to Mary and then Jesus, here surrounded by seven doves representing the seven gifts of the Holy Spirit, derived from the same passage in Isaiah. Bernard of Clairvaux popularized the identification of the *virga* (rod or branch) of the Isaiah passage with the *Virgo* (Virgin) who would bear the Messiah (Isa. 7:10–14). As a summary of Christ's royal ancestry (Matt. 1:1–14), the Tree of Jesse is especially appropriate in a church used for French royal burials, but the scene became popular in church windows elsewhere after it was included in the Saint-Denis chevet. Unfortunately, the window was largely re-created in the nineteenth century, although several figures are original twelfth-century work.

The colored light filling the chevet of Saint-Denis contrasts dramatically with earlier interiors like Conques or Durham (figs. 7-1 and 7-3). It is evident that this light was appreciated, for the next generation of churches in France, and then throughout Europe, adopted and developed the structural innovations at Saint-Denis to achieve even greater light and height (this is the style known as "Gothic" architecture; box 8-2). Some of Suger's inscriptions indicate that light was not merely a by-product of a technical innovation; it symbolized the presence of God in his church. His description of the abbey's gold altar frontal suggests this way of apprehending God:

> So when, out of delight in the beauty of the house of God, the multicolor splendor of the gems called me away from external cares, (then) worthy meditation moved me to transfer the various sacred virtues from the material things to the immaterial, and I seemed to see myself as if I were lingering in some strange region of the world that was not entirely earthly filth nor entirely heavenly purity, and that I could—by the gift of God—be transferred from this inferior realm to that superior one in an anagogical way.

Some historians argue that Suger was only a second-rate thinker, an impresario whose real talents lay in assembling the best minds and the brightest objects for his project at Saint-Denis. They credit the church's complex iconography to Hugh of Saint-Victor, a noted theologian at a Parisian monastic school, and the skeletal system needed to construct the pointed vaults to a master mason whom Suger did not mention or name; he was curiously silent about the innovative vaulting, although not about

its effects. The abbot was more interested in the church's furnishings and their "multicolor splendor." He had a keen eye for both precious objects and a bargain, and he seems to have taken particular delight in a group of precious gems that he bought at a discount from a group of Cistercians. Suger does write about bringing in metalworkers from Lotharingia (western Germany), and he directed the abbey to hire two craftsmen to take care of its stained glass and metalwork. Yet despite his detailed writings, the precise nature of Suger's involvement in creating the architecture, iconography, and larger meaning of the church may never be known.

Characteristic of Suger's interests is the Eleanor Vase, either a seventh-century Sasanian or a tenth-century Fatimid rock crystal that was reset at Saint-Denis in a new gold mount (fig. 7-46). An inscription along the base, which Suger quoted, records the history of the object and how it came to the abbey: "As a bride Eleanor gave this vase to King Louis, Mitadolus to her grandfather, the king to me, and Suger to the saints." Not only are the immediate French royal owners highlighted, Eleanor of Aquitaine and her second husband, King Louis VII—both of whom were present at the consecration of the chevet in 1144—but also Eleanor's grandfather, Duke William IX, and a certain "Mitadolus" who originally owned the vessel. This name has been identified as a Latinized version of the Arabic title 'Imad al-Dawla ("Support of the State"), the Muslim ruler of Saragossa from 1110 to 1130.

The Eleanor Vase, as it is now commonly called (even though Suger turned it into a ewer by adding a spout), thus encapsulates a number of issues central to medieval art in the eleventh and first half of the twelfth centuries. Above all, it indicates the importance of precious material objects, as the vessel was transported from somewhere in western Asia or the eastern Mediterranean to Muslim Spain, from there to Christian Aquitaine (southwestern France), to the French royal family, and then to Saint-Denis, an abbey that cultivated relations with the monarchy for the mutual benefit of both institutions. Suger likely valued the rock crystal for its inherent worth and theological underpinnings: because rock crystal combined the solidity of stone with the liquidity of water, it symbolized the divine and human natures of Christ. The inscription also reveals Suger's appreciation of the object's prestigious provenance and its participation in networks of marital and diplomatic exchange during a crucial period of European refashioning. The vase was presumably a gift to Duke William from 'Imad al-Dawla after both men fought alongside King Alfonso of Aragón at the Battle of Cutanda in 1120 against the Almoravid rulers of Spain; that 'Imad al-Dawla had aligned himself with the Christians shows that the conquest of Spain was not simply a matter of Christian versus Muslim. In Suger's hands, the value and meaning of the rock crystal were transformed through the new gold mount and the

Fig. 7-46. Eleanor Vase, 33.7 × 15.6 cm, metalwork 1137–47; Musée du Louvre, Paris. © Genevra Kornbluth.

inscription that emphasized, above all, the abbot himself: it was he who completed the work and took it out of circulation by giving it to its final, eternal owners—the saints. In a similar manner, the church of Saint-Denis as a whole transformed traditional ideological and formal components that linked the abbey to a glorious past and created a new structure to serve the needs of monks, monarchs, pilgrims, and the patron, Abbot Suger.

CHAPTER 8

ca. 1170 to ca. 1250

Legend

□ **Location or findspot**
 - Monument/object
• Additional site
○ *Approximate place of production*

Urnes □
- Wood Calvary sculptures

Limoges □
- Becket reliquary

Esztergom
- City seal matrix

□ **Göss** • Óbuda
- Vestments

Santiago de Compostela•

Renedo de Valdavia □
- Baptismal font

•Albi
Milan•
•Venice

•Barcelona

Pescia
- Painted altarpiece of St. Francis

Rome•
•Assisi

Nerezi
- Church of St. Panteleim

Córdoba
Seville• •Las Navas de Tolosa

Manuscript ○ •Melfi
of Hunting with Birds

Kastoria• •Thessaloniki

□ **Ribat al-Fath**
- Friday mosque

Palermo•
Bilateral icon

Marrakesh•

Paphos
- Sgraffito bowl with dancer

Cathedral, Canterbury

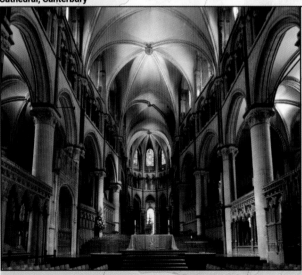

□ **Lincoln**
- Merchant's house

•Braîles •Norwich

□ **Oxford**
- De Brailes Bible-Missal

Isle of Purbeck

□ **Canterbury**
- Becket ampulla
- Becket badge
- Cathedral

Hildesheim
- Centaur aquamanile □

Portfolio of Villard ○ •Cambrai
de Honnecourt

Aachen

□ **Cologne**
- Shrine of the Three Kings

Friedberg □
- Mikvah

Chartres □ •Paris
- Cathedral

•Verdun

Sens•

□ **Fontevrault**
- Tomb effigy of Eleanor of Aquitaine

Hermitage of St. Neophytos, near Paphos

Vladimir
- *Cathedral of St. Dmitrii*

Moscow•

Central Russian Upland

Trebizond
- *Church of*
 Hagia Sophia

•Constantinople

Black Sea

Trebizond Akhlat

☐ Lori Berd
- *Khatchkar*

☐ Divriği
- *Mosque-hospital complex*

Anatolia

☐Sultan Han

Konya *(caravanserai)*

•Jurjan

Elburz

Mina'i bowl with couple in garden

☐ Kashan
- *Rooster ewer*

Cyprus

Syrian
Desert

Hermitage of St. Neophytos

Acre•

•Nazareth

Jerusalem•

Bethlehem

•Cairo

•Baghdad

Manuscript of al-Wasiti's Maqamat

•Basra

Zagros

☐ Mount Sinai
- *Heavenly Ladder icon*
- *Vita icon of St. Panteleimon*

Hejaz

Najd

Red Sea

Arabian Peninsula

Nubian
Desert

•Zabid

By the twelfth century the Shi'i Fatimid caliphate had declined, and in 1171 its remaining territory was conquered by Salah al-Din Yusuf ibn Ayyub (or Saladin, "Righteousness of the Faith," 1137–93). This Kurdish founder of the Ayyubid dynasty restored the former Fatimid lands to Sunni Islam and acknowledged Abbasid authority. In 1187 Salah al-Din captured Jerusalem, which prompted the Third Crusade (1189–92); the city was retaken by the Christians in 1229, but lost again in 1244. During the Fourth Crusade, supposedly against the Ayyubids, the Venetians encouraged a detour to Constantinople. Their conquest of the Orthodox Christian capital in 1204 ushered in a half century of rule by Latin (western European) emperors and brought numerous relics and works of art to Europe; for example, enamel plaques from the Pantokrator Monastery discussed in chapter 7 were reinstalled in the retable of San Marco, the cathedral of Venice, and the porphyry Tetrarchs were placed on its exterior (fig. 1-33). Three different Byzantine empires in exile were established, in Nicaea, Trebizond, and Epiros, and in 1261 the ruler of Nicaea retook Constantinople. On the other side of the Mediterranean, the pope initiated a crusade (1209–29) against Cathar heretics, mostly in the area around Albi; the Cathars' suppression by the French king brought much of southern France under royal rule. Other Christian movements found favor with the papacy: the Franciscan Order, founded by Francis of Assisi (ca. 1181–1226, canonized 1228), and the Dominican Order, founded by Dominic (1170–1221, canonized 1234). Members of both of these mendicant (begging) monastic orders encouraged poverty and penance in the growing cities of Europe. In southern Spain,

the strict Muslim Almohad dynasty was defeated by a Christian coalition at Las Navas de Tolosa in 1212; the Almohads were pushed into northwestern Africa but soon lost power there to the Marinids, another Indigenous group. In 1236 King Ferdinand of Castile captured Córdoba, and the Great Mosque there was converted into a cathedral. A dozen years later, the conversion of Seville's Friday mosque into a cathedral made it the second-largest church in Christendom.

The first Jewish–Christian public disputation was held in Paris in 1240; Jews were forced to counter charges that the Talmud was an anti-Christian text. A similar debate in Barcelona in 1263 focused on the nature of the Messiah. Popes, kings, and khans all sought to reform and systematize behavior. At the Fourth Lateran Council, held in Rome in 1215, bishops defined doctrine, encouraged discipline among the clergy, and ordered that non-Christians wear distinctive clothing. The Constitutions of Melfi (1231) issued by the Holy Roman emperor Frederick II provided new laws for the multiethnic inhabitants of southern Italy and Sicily. In the eastern Islamicate world, Chinggis Khan (ca. 1162–1227) and his sons and grandsons were creating the largest empire of all time, unifying much of Eurasia under the "Pax Mongolica" (Mongolian Peace) that was achieved through the military success of their superb archers and cavalry. Everywhere, cities were growing, and with them interurban trade. Paper was introduced into Europe via Spain, and water-powered paper mills were established in France by the late twelfth century and Italy in the thirteenth. This period witnessed rapid social and cultural change and shifting balances of power.

When the missionizing monk Augustine went from Rome to England in 597, he settled in Canterbury (southeast England), where he founded a monastery and the first cathedral in the British Isles. After being sacked by the Vikings and damaged by a fire in 1067, the cathedral was rebuilt by the Normans in the 1070s–1080s, with a new choir and presbytery (area around the main altar) dedicated in 1130. The archbishops of Canterbury had long held considerable political power in England, but under King Henry I (r. 1100–35) relations between church and state became strained, and this tension continued under Henry II (r. 1154–89). Much of the power struggle hinged on whether the king had the right to appoint Church officials and whether clerics accused of crimes should be tried in secular rather than ecclesiastical courts. Matters came to a head in December 1170, when Archbishop Thomas Becket (r. 1162–70) was murdered near the original north transept of the cathedral by knights acting on behalf of Henry II (they cut off the top of his head). Reports of healing miracles began within days of Becket's burial in the cathedral crypt, and his cult quickly spread across Europe. Continuous miracles and public enthusiasm led to canonization by the pope in 1173. The king was forced to do public penance for the murder in 1174, and later that year another fire destroyed much of the church. The ambitious new construction process was chronicled by a monk at Canterbury named Gervase, who provided one of the most detailed contemporary accounts of a building project to survive from the Middle Ages. Thanks to Gervase, we know that the east end of the church was rebuilt between 1175 and 1184 by the architects William of Sens (France) and William "the Englishman," who took over after the Frenchman fell from the scaffolding. The nave was rebuilt in the late fourteenth century and completed by 1405 in the form we see today (fig. 8-1).

The postfire rebuilding focused on repairing, elaborating, and elevating the east end of the church, adding prominence to the main altar and to the spaces where Becket's relics were eventually housed. The layout follows the curvature of the earlier Norman ambulatory, with the side aisles narrowing to accommodate preexisting chapels; the east end was further extended with two new chapels (fig. 8-2). Built of light and brownish-purple limestone (the latter called Purbeck marble, after its quarry in southern England), the elevation's pointed arcade, dark triforium, and clerestory imitate French models, such as Saint-Denis, but like other late medieval English cathedrals it is not as tall, and there are fewer windows than in comparable French churches. The two colors of limestone used to construct and ornament the interior also set it apart from European architecture; this interest in structural polychromy became a dominant feature of lavish buildings in England for the rest of the Middle Ages. Canterbury's east

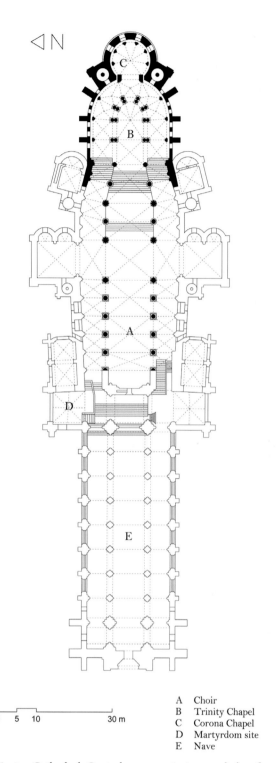

◁ N

A Choir
B Trinity Chapel
C Corona Chapel
D Martyrdom site
E Nave

0 5 10 30 m

Fig. 8-1. Cathedral, Canterbury, 1175–84 (east end), late fourteenth century–1405 (nave), plan. Drawing by Navid Jamali.

end boasts England's first flying buttresses—supports that extend through the air to strengthen the weakest point of the clerestory vaults—but they are cautious, hugging the slope of the aisle roofs. On a practical level, the geometric conception of the Trinity Chapel and its projecting Corona Chapel can also be said to come from a French model: it is based on nine-sided polygons, rare architectural forms used previously in the cathedral of Sens. On a symbolic level, however, the architectural choices made in the east end are very specific to Canterbury. As one moves

Fig. 8-2. East end, Canterbury Cathedral, 1175–84. © Genevra Kornbluth.

eastward and upward in the area around Becket's shrine, the church's material richness increases, with pink marble used to allude to the martyred saint's blood. The name and form of the Corona Chapel refer to the head relic: *corona* means "crown" in Latin, and it recalls Becket's mutilated head and his status as a crowned martyr with power greater than that of the king.

Two large collections of Becket miracles were compiled in the 1170s, more textual evidence than we possess for any other medieval saint. They identify 665 pilgrims between 1171 and 1177 and often indicate their social status: 8 percent belonged to the higher nobility, and 26 percent were knights. Even though many of the miracles occurred far from Becket's remains, Canterbury Cathedral became the most important pilgrimage destination in Europe after Santiago de Compostela and Rome. The earliest evidence for such activity was recently identified in a panel of stained glass previously thought to date to the nineteenth century. Datable to the 1180s, only a few years after Becket's death, the scene in the Trinity Chapel shows pilgrims (labeled "peregrini" in Latin) on foot and horseback, with one on crutches, on the way to Canterbury two centuries before *The Canterbury Tales* (1387–1400), written by Geoffrey Chaucer. The twelve large windows in the Trinity Chapel, the majority of which contain original medieval glass (ca. 1185–1220), depict narrative scenes drawn from the miracle collections. For example, one shows how the unnamed wife of the earl of Hertford used Becket relics stored in a casket in her local church to resurrect her dead son (fig. 8-3 *left*); when she pushed a piece of the martyr's clothing down the boy's throat, he revived. Healing miracles were primarily effected by the "water of St. Thomas," the martyr's blood diluted with water by the monastic clergy at Canterbury. Several early thirteenth-century windows show how ampullae filled with this liquid were used; one depicts the revival of the son of a knight (fig. 8-3 *right*). The consumption of Becket's blood made him an analogue for Christ, whose blood was uniquely sanctioned for human consumption in the form of the eucharistic wine. A Canterbury monk noted that only "the blood of Christ and the blood of Becket were chosen to be drunk."

Many European pilgrimage destinations sold mementoes with relevant imagery. Pilgrims to Santiago de Compostela purchased scallop shells culled from nearby Atlantic beaches, or imitations in cheap metal; travelers to Rome might come home with badges in the shape of St. Peter's keys (Matt. 16:19). The clergy at Canterbury promoted the sale of ampullae containing the water of St. Thomas that were decorated with a great variety of images: Becket's shrine, the bust reliquary that preserved the fragment of his head, his episcopal gloves, or tiny scenes of his murder (fig. 8-4 *left*). This one, from the mid-thirteenth century, depicts the murder in the church on one side and a frontal image of Becket blessing on the other; the circular frame is inscribed, "Thomas has become the best physician of the deserving sick." Souvenir badges, of the sort sold at other

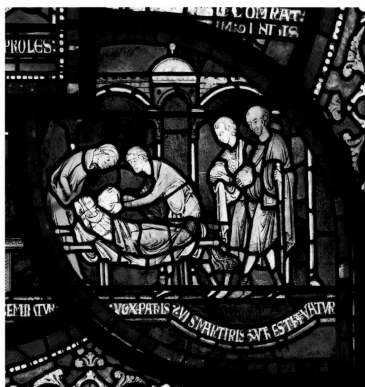

Fig. 8-3. Miracle windows, Trinity Chapel, Canterbury Cathedral, ca. 1213–20, (*left*) dead son revived;
(*right*) knight's son healed. (*l*) Rachel Koopmans; (*r*) Photo by the authors.

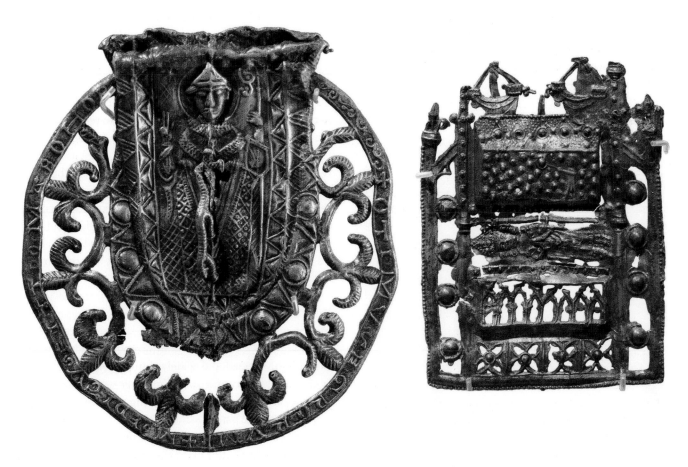

Fig. 8-4. Becket souvenirs, (*left*) ampulla, 9.6 × 8.8 cm, mid-thirteenth century; (*right*) badge, 7.5 × 5.6 cm,
fourteenth century; Museum of London. © Genevra Kornbluth.

sites from the late twelfth century on, were not produced at Canterbury until the fourteenth century (fig. 8-4 *right*). This badge shows Becket's gem-studded shrine, topped with offerings, above his effigy (full-body image of the deceased) clad in episcopal vestments. Thousands of these tin or lead badges survive, purchased by pilgrims to be worn on their hats, cloaks, or bags. They not only served as mementoes but also established the traveler's pious intentions—pilgrims received special services and charity and were exempt from tolls along their route—and proclaimed his or her success upon returning home. Such souvenirs are eloquent yet inexpensive objects that were treasured by the faithful and sometimes buried with them.

Becket's body was moved several times: from the site of his martyrdom in the north aisle, near the stairs leading up to the choir and down to the crypt; to the new easternmost chapel of the crypt; and, in 1220, up to the Trinity Chapel, with his head relic in the Corona Chapel that extends the main axis of the church to the east (fig. 8-1). Placing elevated tomb-shrines behind main altars was increasingly common in the wake of ambitious projects like Durham Cathedral and the abbey of Saint-Denis. Between 1198 and 1213 some two hundred kilos of votive offerings were documented at Canterbury, but in the year after the translation of the relics to the new shrine there were five hundred kilos of donations that included gems and crowns, coins, coiled candles (trindles) with wicks the length of a person, models of body parts, and worms or fish bones disgorged by people cured by the saint. A huge ruby given by the French king Louis VII in 1179 was especially renowned; it was transferred to the shrine in 1220.

When King Henry VIII stripped the English monasteries

of their property in 1538 after breaking with Rome and declaring the new Anglican faith, twenty-six wagons were needed to carry away the offerings from Becket's shrine alone. Fearful that Becket—a religious leader who defied the king—might be a dangerous precedent, Henry had the shrine dismantled and the archbishop's bones disinterred; the long-dead Becket was summoned to court, where he was found guilty and decanonized. All images of him were to be destroyed. Nevertheless, Becket's cult was so widespread that many such images and memorabilia survived, in diverse media, in England and beyond.

Artistic Production and Professionalization

A small casket made in Limoges (France) in the 1180s is one of the earliest to depict the death of Thomas Becket, and it must once have held a relic of the saint (fig. 8-5). The front of the box shows his murder at a Canterbury altar; on the roof-shaped lid are his funerary rites, with his soul being escorted to heaven by two angels. On the back, saints flank a pattern of circles between four unidentified haloed figures, and on the sides are Christ in Majesty and an open door. The crest along the roofline alternates rock-crystal and enamel medallions with twelve keyhole-shaped openings that may be meant to evoke the gates of the Heavenly Jerusalem (Rev. 21:12). Over fifty such Becket reliquaries were made in Limoges between 1180 and 1220, helping to spread the new cult.

Limoges enamels were produced for centuries and were prized for their animated figures, lively narratives, and vivid colors—especially the blue that dominates here, signifying heaven. The establishment of multiple workshops in the same town was initially a response to regional needs; the artists' expertise then created a much broader demand for their diverse range of products, both religious (such as reliquaries) and secular (such as horse fittings). The technique, called *champlevé*, involves chiseling a thick copper sheet to create cells to hold colored, powdered glass; the sheet is then heated repeatedly to melt the glass and fuse it to the copper. Three-dimensional heads and whole bodies were sometimes soldered to the sheets, and their metal surfaces were gilded and tooled (incised with ornament). Limoges products competed with enamels from the Meuse River region (fig. 7-15), and the term *opus Lemovicense*, Limoges work, became a common label for prestigious metalwork—a kind of "made in Limoges" trademark for these highly prized and widely diffused objects. Located at the intersection of major pilgrimage and trade routes, Limoges also had a long goldsmithing tradition; St. Eligius (ca. 588–660), the patron saint of that art, was born nearby. The city became a stronghold of the royal Plantagenet family of England after Eleanor of Aquitaine's marriage to Henry II in 1152, and its artists received commissions from that powerful family and the monasteries they supported.

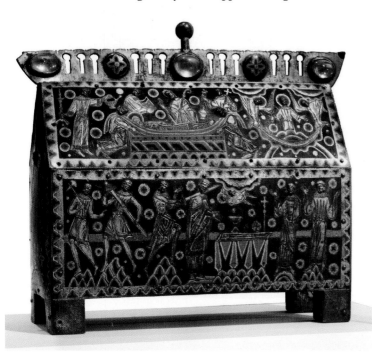

Fig. 8-5. Becket reliquary, Limoges, 29.5 × 34.4 × 12.4 cm, ca. 1180–90; Victoria & Albert Museum, London. © Genevra Kornbluth.

Papal actions also fueled the demand for Limoges work. The Fourth Lateran Council declared that all churches must have two pyxes (small containers) to hold the sacramental bread for the mass, and even though gold and silver were preferred, the council specified that one pyx could be of Limoges work, which was more affordable but still suitable. Patrons and purchasers of Limoges enamels were investing in colorful craftsmanship and durability rather than in more costly materials that might be melted down.

Specialized artists also manufactured textiles, but they were not necessarily professionals. The Göss Vestments were embroidered in colorful silk on linen by nuns at Göss (Austria), then donated by their aristocratic abbess, Kunegunde (r. 1239–69), to the clergy of the local cathedral. These garments, which include a chasuble (wide sleeveless mantle worn to perform a mass), cope (long semicircular cloak for other liturgical activities), dalmatic (loose garment with long sleeves), and tunic, along with an altar frontal, were only used during the annual mass for Göss's founder, a noblewoman named Adala (d. 1021), so they are very well preserved. Inscriptions in Middle High German, four of which name Kunegunde, help date the pieces to the 1250s. The chasuble depicts the Crucifixion with apostles on the front and Christ enthroned above angels and evangelist symbols on the back, seen here (fig. 8-6a). This imagery was visible at the climactic moment of the eucharistic liturgy, when the priest turned his back on the congregation to face the altar and elevate the host at the moment when it became the body of Christ. The chasuble was trimmed at a later date, and pieces were used to patch the cope; one of these shows Kunegunde praying (fig. 8-6b).

These are among the earliest examples of a trend to adorn liturgical vestments with detailed images of Christ, Mary, and saints. Such complex products could take years to make: a contemporary altar frontal at Westminster Abbey (England) required nearly four years of work by four women. Following a papal decree in 1210 that prevented abbesses from hearing confessions, reading from the Gospels, or preaching, even these powerful women were no longer permitted near the altar. Yet by making the Göss Vestments, representing on them the abbess and the founder, and referencing the community in inscriptions, the nuns could insert themselves into the convent's liturgical life. In clothing the altar and the men celebrating mass,

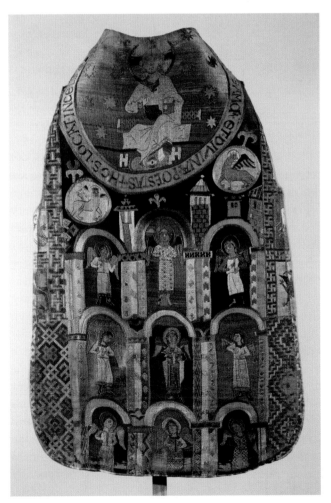

Figs. 8-6a and 8-6b. Vestments, Göss Abbey, 1250s, *(left)* chasuble back, now 123 × 76.5 cm; *(right)* cope detail, with kneeling abbess originally on chasuble; Museum für angewandte Kunst, Vienna. MAK–Museum of Applied Arts. ©MAK/Ingrid Schindler.

Fig. 8-7. Drawings, portfolio of Villard de Honnecourt, 24 × 15.4 cm, ca. 1220–40; Paris, Bibliothèque nationale de France, MS fr. 19093, fols. 14v (*left*) and 18r (*right*). Photos from Bibliothèque nationale de France.

the nuns overcame their physical marginalization and asserted their proximity to Mary and Christ.

Another remarkable survival from this era is a portfolio of about 250 ink and leadpoint (stick of lead used like a pencil) drawings on thirty-three sheets of parchment; many have comments in French and occasionally other languages, added when the sheets were bound (fig. 8-7). Scholars have attributed the sketches to three or four individuals, but only one name is recorded: Villard de Honnecourt. He probably compiled the portfolio between 1220 and 1240, and on the first page he tells us that useful devices, sound advice, and drawing techniques are to be found in its pages. Villard's inventive sketches deal with mechanics, surveying, carpentry, nature, animals, recipes, and religious subjects. While he seems to have been familiar with the latest developments in stonecutting and engineering, he often represented real buildings in simplified form; his perspectival drawings differ from all known thirteenth-century workshop drawings, which are plans or elevations, but not both. Although Villard may not have been an architect, he drew detailed plans (fig. 8-7 *left*). On

this page, a modular Cistercian church (compare fig. 7-37) is juxtaposed to the chevet of Cambrai Cathedral (identified in the caption underneath), with its radiating chapels and a continuous ambulatory. The adjacent sketch shows two men wrestling, but the page needs to be turned ninety degrees for them to be seen on their feet, so it is not clear what relationship, if any, they have to the church plans. Other drawings emphasize the geometric bases of design (fig. 8-7 *right*). This folio includes diagrammatic human figures, a stag, and a statue of the Virgin and Child, in which the geometric forms might serve as teaching or mnemonic tools. Contrasting with these schematic figures is the very naturalistic head, and twice the text declares that the lions in the portfolio were drawn from life. Villard presumably saw a lion in a game park or menagerie but made the drawings later, in a more controlled environment; he used a compass for one of them. Other sketches were certainly based on memory of works of art he had seen, including the Gospels of Saint-Médard de Soissons (fig. 5-7). On the whole, Villard's compilation demonstrates the close relationship between creativity and technology, combining

Box 8-1. VISUALITY, OPTICS, AND NATURALISM

Perceptions of the body and bodily functions change over time, and consequently they have histories that can be reconstructed and interpreted. In recent decades art historians have investigated vision not only as a scientific phenomenon but also as a cultural one. The concept of visuality addresses how sight works, how it relates to the other four senses, and how these ideas affect the production and reception of art and architecture.

In the course of the Middle Ages, scientific understanding of the mechanics of sight changed considerably. Before the eleventh century, the prevailing theory of vision held that the eye emitted rays that reached out and illuminated objects, thereby having an effect on them while also making them register in the mind or soul. This model, rooted in ancient Greek science, is called extramission. The polymath Abu 'Ali al-Hasan ibn al-Haytham (ca. 965–ca. 1040), who was born in Basra (Iraq) and worked in Baghdad and Cairo, overturned this theory. Building on ancient writings in philosophy, geometry, and medicine, his *Book of Optics* argues that rays emitted by objects pass into the eye and mind. This theory, called intromission, demonstrated that knowledge came through observation of the external world and the workings of the body, with the uniquely human faculty of cognition being completed in the brain. Thus, sight became the primary way to uncover truths that are outside of the body, ready and waiting to be sensed, absorbed, processed, and understood. This theory of vision and cognition spread through western Eurasia, and, around 1200, Latin translations of the *Book of Optics* (which called the author Alhacen) and later Persian commentaries carried his

findings beyond the Arabic-speaking world. At the same time, the works of Aristotle that underpinned Ibn al-Haytham's theories were being translated from Arabic and Greek into Latin; both authors became prominent in the curriculum of Europe's emerging universities, where scholars sought to reconcile their ideas with Christian concepts of creation. The writings of European intellectuals, including the Franciscan philosophers Roger Bacon (d. 1292) and John Peckham, archbishop of Canterbury (d. 1292), drew heavily on Ibn al-Haytham.

The *Book of Optics* had major implications for a range of human endeavors, from philosophy and astronomy to literature and art. Intromission is thought to have played a role in the rise of naturalism, an artistic approach that privileges representing the subject in an objective way, with little exaggeration, interpretation, or abstraction. European and Byzantine representations of people also became increasingly naturalistic at this time, but inner morality was still thought to shape outer appearances, so many such images confirm social stereotypes even while displaying lifelike qualities. Therefore, such representations are not portraits in the modern sense of the term—they do not convey the detailed physiognomies and characters of real people sitting as models—and, at least through the fourteenth century, they tend to idealize the subject. The influence of Ibn al-Haytham's work was lasting. It inspired experiments with light and lenses that led to the invention of eyeglasses in Europe and the Islamicate world in the late thirteenth century and fueled astronomical research at new observatories in Iran and Central Asia.

visual perception with geometry and empirical observations of nature.

A diminutive volume written in Oxford reveals the professionalization of manuscript production in the first half of the thirteenth century when urban workshops became prominent, especially in university towns that were centers of literacy and learning (fig. 8-8). Even as the market for books began to widen, the number of nonelites who owned books in the early thirteenth century remained very small, and the majority were still religious volumes. The Bible-Missal seen here contains not just biblical texts but also readings for particular masses. It includes a mass for St. Dominic, so it postdates his canonization and was

likely completed a few years thereafter (ca. 1234–40), making it an early witness to the cult of this mendicant saint in England. Earlier Bibles were large books intended for public reading, but Dominicans, and others, found the new, smaller books convenient for travel and personal use. The book of Genesis begins on this page with a large initial *I* (for *In principio*, In the beginning; Gen. 1:1) that extends the entire height of the folio. Within its gold borders, vines frame six scenes of God at work during the first six days of creation, culminating, at the bottom, in the Crucifixion. The historiated initial thus links the beginning of time with the pivotal moment of Christ's sacrifice that was evoked during the mass at which this book was used.

This Bible-Missal was produced in the workshop of William de Brailes, one of several such shops on Catte Street in Oxford (Brailes is a town north of Oxford). The workshop was composed of such specialists as parchment preparers, scribes, illuminators, rubricators (who execute titles and chapter headings in red), and flourishers (who make the pen curlicues in the initials). It served a diverse clientele: not just Dominicans, and not only students in need of textbooks, but purchasers who could afford richly decorated volumes. Ten de Brailes Bibles survive, including at least one other Bible-Missal, and de Brailes himself (active ca. 1230–ca. 1260) was wealthy enough to own land in Oxford. Around 1240 the de Brailes workshop produced what is now the earliest surviving example of a book of hours, a type of small book that became very popular among lay readers in the later Middle Ages; it facilitated personal devotion by stipulating prayers to be said daily at eight specific times. Like the miniature Bible-Missal, such books announced a new era of private reading.

Icons and Adaptations

By the twelfth century, an innovative type of icon emerged in parts of the Byzantine world: the vita icon, in which a large image of a saint is surrounded by small scenes from his or her life (fig. 8-9). This example of ca. 1200 from Mount Sinai shows St. Panteleimon, a physician who took no money from patients; he is dressed in blue, which according to literary sources was the color worn by Byzantine doctors. Famed for healing, both through divine grace and with medicines (like those in the flasks he holds in a box), Panteleimon was venerated across the Christian world. On the icon, the sixteen small scenes depict him learning medicine at the upper left and his martyrdom and burial along the bottom. The format of Byzantine vita icons was quickly adapted by the Franciscans, although in Italy the narrative scenes flank the saints rather than surround them (fig. 8-10).

Shown here is one of the earliest altarpieces of St. Francis, in a church dedicated to him in Pescia (Italy). It is signed by the artist, Bonaventura Berlinghieri, whose father and brothers were also painters, and dated (1235) in white letters at the saint's feet. Francis was considered by his followers an *alter Christus*, another Christ, in part

Fig. 8-8. Historiated initial, De Brailes Bible-Missal, ca. 16.5 × 11.5 cm, ca. 1234–40; Oxford, Bodleian Library, MS Lat. bib. e. 7, fol. 5r. © Bodleian Libraries, University of Oxford.

Fig. 8-9. Vita icon of St. Panteleimon, 102 × 72 cm, ca. 1200; Monastery of St. Catherine, Mount Sinai. Photo from New York Public Library/Science Source.

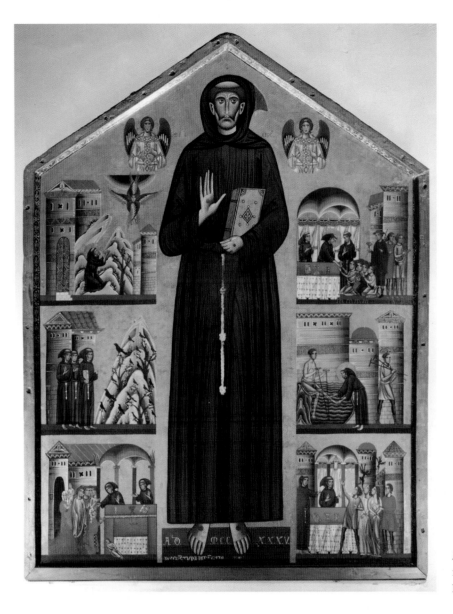

Fig. 8-10. Altarpiece of St. Francis,
160 × 123 cm, 1235; San Francesco,
Pescia. © Genevra Kornbluth.

because he reportedly had a gash on his chest and nail
holes (stigmata) on his hands and feet like those of Christ
on the cross. These miraculous stigmata became widely
known only after Francis's death in 1226. Images of Francis
helped promote his cult by representing him as Christlike,
worthy of receiving the marks as a sign of Jesus's favor.
With his habit (monastic garment) and rope belt obscuring
his form in the Pescia panel, Francis seems to float against
the gold ground: he is shown as a man of spirit rather than
body, who denied himself shoes, even in the winter. In
the scene at the upper left, Francis receives the stigmata;
below that, he preaches to a variety of birds. This imagery
echoes Jesus's request that his followers "preach the Gos-
pel to all creation" (Mark 16:15), even the lowliest creatures
(Matt. 6:26), which the Franciscans understood as their
mission. Life-size images like this one were meant to in-
spire devotion, including pilgrimage to the saint's shrine
in his hometown of Assisi. They also helped teach his
followers and potential devotees about Francis, "proved"
that he bore the stigmata, and created a communal Fran-
ciscan identity in the expanding Italian cities. For all these

reasons, the Franciscans were prolific patrons of art and ar-
chitecture in the thirteenth and fourteenth centuries and
were responsible for creating new markets for painters like
Berlinghieri.

The emergence of large painted altarpieces took place
in a religious environment that emphasized the presence
and visibility of Christ during mass. In its very first decree,
the Fourth Lateran Council crystallized the doctrine of
Transubstantiation—that at the moment of their conse-
cration in the mass the eucharistic elements change from
the substance of bread and wine to the substance of the
body and blood of Christ, and only the incidental features
(such as taste, color, smell) of the bread and wine remain.
It further declared that all Christians should receive Com-
munion at least once a year, although for most people this
remained a rare event. When the priest raised the conse-
crated eucharistic wafer high above his head, he did so
to make it visible even for those who did not receive it.
However, because he now stood in front of the altar, fac-
ing east and away from the congregation, figural panels
resting on top of the altar—altarpieces—became preferred

Fig. 8-11. Bilateral icon, Kastoria, 115 × 77.5 cm, last quarter of twelfth century; Byzantino Mouseio Kastorias. Ephorate of Antiquities at Kastoria, © Hellenic Ministry of Culture and Sports/Archaeological Receipts Fund and Expropriations.

over frontals. In the Pescia altarpiece, the eucharistic body of Christ would have stood out against Francis's bloodied feet and dark robe, while the altars, chalices, and patens painted on both sides of his feet mirrored those objects used in the church itself.

Beginning in the eleventh century, an increasing number of Byzantine icons were carried in urban processions. This was a way to unify communities and make the holy figures more vivid. A compelling example is a bilateral (two-sided) icon from Kastoria (northern Greece) dated on stylistic grounds to the last quarter of the twelfth century; square notches at the bottom center reveal where the carrying pole was attached (fig. 8-11). The front depicts two small angels adoring a pensive Mary who holds and gestures toward her blessing son. The pointing gesture gives this composition its name: the *Hodegetria* (She Who Points the Way). The original icon with this image—which the Byzantines believed was painted by the evangelist Luke using Mary and Jesus as live models—was housed in the Hodegon Monastery in Constantinople and paraded weekly; it was said to perform miracles and was copied in a range of media and sizes. In the Kastoria icon, the child has the face of an adult, and his mother is indicating his

fate. This fate is shown on the reverse, the oldest extant example of a composition invented in eleventh-century Byzantium. It is called in Greek "Utmost Humiliation" and in Latin the "Man of Sorrows," based on Isaiah 53:3 ("He was despised and rejected by mankind, a man of suffering, and familiar with pain"). Close examination reveals that Jesus is on the cross, and the pink of his upper lip suggests that he is still alive, despite his closed eyes. Yet his arms are at his side, as if prepared for burial, and his lower lip lacks the color of the upper one. Is he alive or dead? The image has been interpreted as an icon for Holy Friday (the Orthodox Good Friday), capturing the transitions from Christ's crucifixion to his death and resurrection. The artist's decision to push Jesus to the front of the picture plane and to reduce almost all sense of space and depth forges a compelling emotional relationship between spectators and icon. From the late twelfth century onward, artists in both Byzantium and western Europe created "living icons," images meant to create a deep emotional response in their viewers. Because viewers could see both sides of this icon during a civic procession, the painted images stimulated them to contemplate the whole life of Christ, their own salvation, and the well-being of their community.

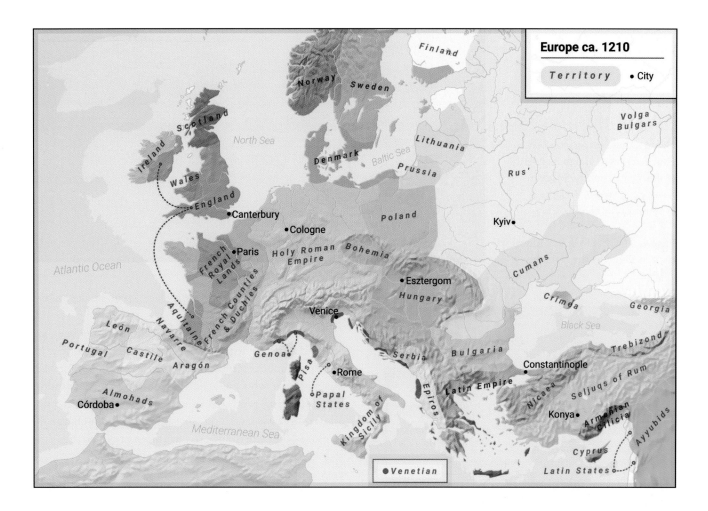

Europe ca. 1210

Territory • City

Urbanization and Urban Life

City seals emerged in this period as signs of civic identity and urban pride. Bishops, abbots and abbesses, rulers, and other secular elites had long used personal seals to affirm their authority and authorship of important documents, but from the second half of the twelfth century onward, cities also claimed distinctiveness and legitimacy with such devices, as did some universities. In these seals the city itself is represented, not the mayor or another prominent citizen. The city could be visualized as its walls or important landmarks, sometimes in combination with a patron saint. This gilded bronze two-sided seal matrix (mold) was produced in the first half of the thirteenth century for Esztergom, the first capital of Hungary and seat of both the king and an archbishop (fig. 8-12). The main image, to be impressed on the front of a wax seal appended to a document, depicts the walled royal precinct of Esztergom, with the connected kings' and bishops' palaces and the cathedral rising high above the town, the whole complex protected by towers (complete with arrow slits) and an elaborate gate. This lower town had neighborhoods for Jews and "Latins" (western Europeans, including Franciscans), who were attracted by the thriving trade along the Danube River, the resulting prosperity, and the protection of the royal residence above. The seal belonged specifically to the "Latin" population; the inscription on the front reads, "Seal of the Latins of the city of Esztergom." One of the earliest references to a town hall comes from Esztergom, another indication of emerging civic identity.

The counterseal, which would be imprinted on the reverse of the wax, features the city's coat of arms, which was also that of the Árpád family, Hungary's founding dynasty and its rulers from 1000 to 1301 (King Géza I was an Árpád; fig. 6-9). Coats of arms, or heraldry, initially were symbols placed on shields and flags to identify armies in battle or teams in tournaments. These designs, which had to be simple and easily deciphered, often elaborated the emblems associated with particular families and thus gained a genealogical function and meaning. Esztergom's counterseal, like those of many other cities in Europe, includes the heraldic emblem of the kingdom's overlord to honor him and to emphasize his protection. Despite the matrix's expression of civic and military power, the importance of Esztergom soon diminished: the Mongols attacked it in 1242 after pillaging eastern Hungary. The stone citadel (fortress with residential and military functions) held, but much of the city was destroyed along with the commodities in its warehouses, and the royal capital moved down the Danube to Óbuda (now Buda).

The town of Lincoln, in central England, became prosperous from producing wool in the mid-twelfth century; trade was facilitated by its location at the confluence of two rivers, and wool from Lincoln was prized as far away

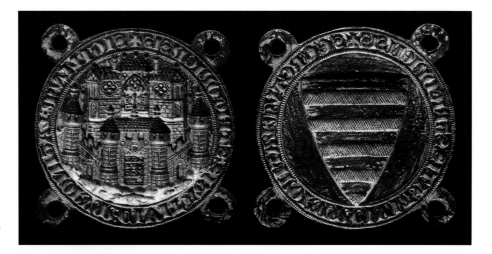

Fig. 8-12. City seal matrix, Esztergom, maximum 9.4 cm, first half of thirteenth century; Magyar Nemzeti Múzeum, Budapest. © Genevra Kornbluth.

Fig. 8-13. Merchant's house, Lincoln, ca. 1170. Photo by the authors.

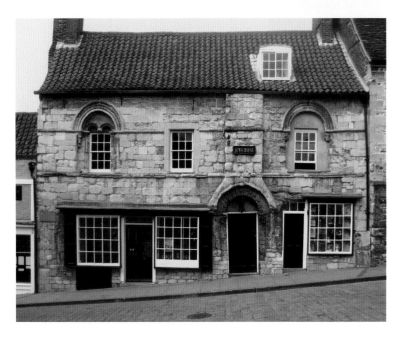

as Italy. It had access to stone quarries and a tradition of masonry construction that in this era moved into a new architectural arena: housing. Whereas houses in the earlier Middle Ages tended to be made of less durable materials like wood, daub (straw), reed, or brick, ashlar masonry became more common in Europe as prosperity spread and cities grew. A house built in Lincoln about 1170 is an example of this trend (fig. 8-13). While there may have been shops on the lower floor (but not the windows seen today), the main residential area was the large hall that filled the upper story. This hall, complete with a central fireplace, served as living, dining, entertaining, and sleeping space for the inhabitants. Its main facade along the city street is highly worked; molded and patterned stringcourses accentuate the upper story, and inset columns, capitals, and archivolts emphasize windows and the main door. With its foliate and rope patterns, the architectural sculpture resembles that on major buildings like Durham Cathedral. This elaborate workmanship suited a wealthy merchant owner and contrasted with the houses of poorer people, whose homes were built of perishable materials and who

could not afford an enclosed fireplace, let alone decorative sculpted flourishes.

This house, and another in Lincoln, has long been associated with the town's medieval Jewish community. Its most prominent member was Aaron (ca. 1125–86), a Jewish businessman who engaged in moneylending, pawnbroking, securing rent, and other activities. Jews were not allowed to own land, and Christians could not charge interest to other Christians, so Jews often provided the loans that Christians sought in the growing economy. With clients ranging from the kings of England and Scotland to earls, towns, abbots, and even the archbishop of Canterbury, Aaron was probably the wealthiest man in England; when he died, King Henry II seized his estate and spent years collecting from Aaron's many debtors. During Aaron's lifetime, anti-Jewish ideas and activities increased in western Europe. In England, the first accusation of Jewish ritual murder (a blood libel) occurred in 1144, when William of Norwich was supposedly crucified during Passover. Lincoln's Jewish community was attacked by a mob in 1190, and all Jews were expelled from England one hundred years later. The materials, size, and decoration of the stone houses in Lincoln attest to increasing prosperity and levels of comfort shared by urban Christians and Jews in the twelfth and thirteenth centuries, an era also marked by episodes of social disruption, dislocation, and violence.

As discussed in chapter 7, the Seljuqs created a network of caravanserais to shelter and protect merchants traveling between cities (fig. 7-25). The largest was the Sultan Han, northeast of Konya (Turkey), built in 1229 for Alaeddin Keykubad I (r. 1220–37), the sultan of Rum. He ruled a Turkic state in Anatolia named after the "Romans" (that is, Byzantines), established after the Muslims defeated the Byzantines at the Battle of Manzikert (1071). Rum, with its capital at Konya, flourished until it fell to the Mongols in 1243. Enclosing nearly five thousand square meters, the Sultan Han—*han* is the Turkish term for a ribat or caravanserai—has the imposing size and monumentality appropriate for a commercial stopping-point named for the ruler (fig. 8-14).

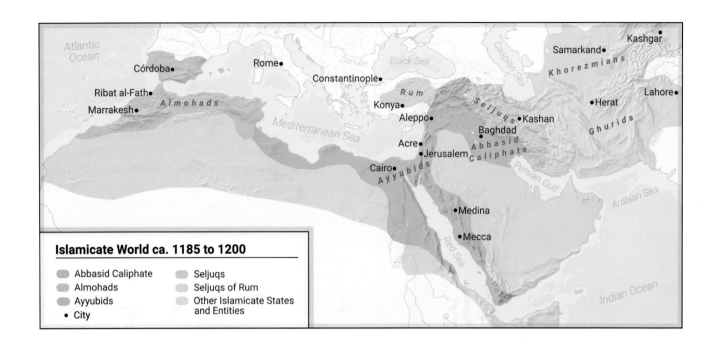

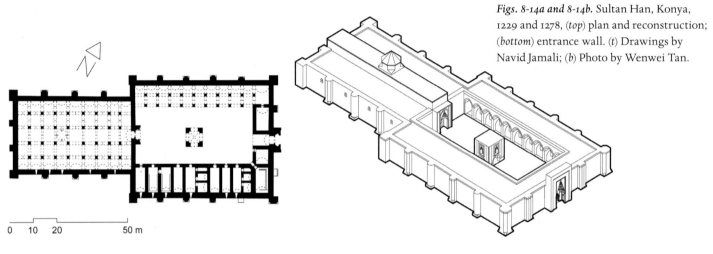

Figs. 8-14a and 8-14b. Sultan Han, Konya, 1229 and 1278, (top) plan and reconstruction; (bottom) entrance wall. (t) Drawings by Navid Jamali; (b) Photo by Wenwei Tan.

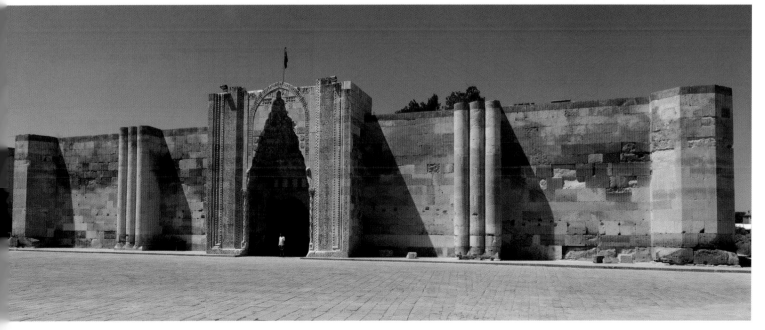

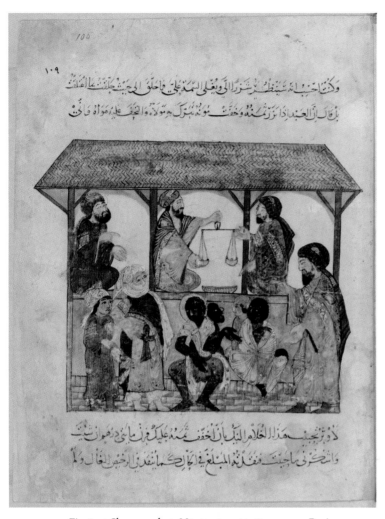

Fig. 8-15. Slave market, *Maqamat*, 37 × 28 cm, 1237; Paris, Bibliothèque nationale de France, MS ar. 5847, fol. 105r. Photo from Bibliothèque nationale de France.

The thirteen-meter-high pishtaq, visible from afar, is covered with richly carved decoration, including vertical bands of round lacelike patterns, columns with zigzags, medallions, and an arch framing a tall muqarnas vault. Inside the high stone walls, a courtyard contains a small freestanding mosque supported on the ground floor by wide pointed arches: the ancient chahar taq form. The courtyard, with latrines in the north corner, is surrounded on three sides by service rooms and accommodations for travelers, with stables below and sleeping quarters above. Opposite the entrance, a muqarnas portal closely resembling the main entrance has joggled (interlocking) voussoirs in contrasting gray and white marble; it opens into a five-aisle hypostyle hall used for shelter in cold weather. The high quality of the ashlar masonry throughout is complemented by the variety of carving around the portals. Like the house in Lincoln, this elaborate workmanship adds distinction to an otherwise utilitarian building, reflecting and augmenting the political, economic, and social stature of its patron, the ruler of Rum.

A sense of urban life in the Islamicate world can be inferred from a thirteenth-century copy of the *Maqamat*

(*Assemblies*), tales written in rhyming prose interspersed with poetry. A compilation of fifty of these stories by Muhammad al-Qasim ibn Ali al-Hariri (1054–1122) became extremely popular and spawned imitations in Hebrew, Persian, and Syriac. Only a few copies of the *Maqamat* are illustrated, however, and one likely made in Baghdad in 1237 stands out for its artistic quality and the large number (ninety-nine) and size of its images (fig. 8-15).

This manuscript was written and illustrated by Yahya ibn Mahmud al-Wasiti, whose colophon provides his name (painters' names are very rare in this period) but omits that of his patron. In the *Maqamat*, the narrator of the stories is presented as a simple traveling merchant named al-Harith, and the hero, a clever rogue who swindles merchants and officials, is called Abu Zayd. The episodes are an excuse to present the verbal acrobatics of Abu Zayd, filled with puns, palindromes, riddles, and letter play. In the story shown here (maqama 34), the setting is the slave market in Zabid, Yemen, which al-Harith visits after his slave has died. No new slave seems satisfactory until Abu Zayd, in disguise, offers his own son. The boy tells al-Harith that the sale is illegal because he's a free man, and a judge agrees to annul the transaction. In the lower register Abu Zayd presents his son, at the left, separated from al-Harith by dark- and light-skinned slaves. Above them, in the upper story of a reed-and-wood structure, two men weigh money on a scale before an unidentified witness at the left. Even though the tale is inventive rather than a journalistic report of a specific slave market, the image nonetheless reveals that lived experience in the Islamicate world included buying and selling people from different backgrounds. Slavery was widespread throughout the Middle Ages; individuals and whole groups could be enslaved, and in most of the societies considered in this book, many people—not only elites—owned slaves. Slave markets like the one depicted here were a negative manifestation of the increasingly affluent, urban, and interconnected medieval world.

The Life of Leisure

The illustrated *Maqamat* would have been enjoyed by wealthy, literate patrons whose tastes spurred an explosion of figural imagery and art in all media in the twelfth and thirteenth centuries. The use of art and architecture for pleasure and secular pastimes was not restricted to the Islamicate world. In Europe, one of the most important patrons in the thirteenth century was Frederick II (1194–1250), who, through inheritance and marriage, was successively king of Sicily, Germany (he was crowned on Charlemagne's throne at Aachen), Italy, and Jerusalem, and then Holy Roman emperor from 1220 to 1250. He led the Sixth Crusade in 1228, which resulted in a ten-year truce with the Ayyubids and the return of Jerusalem, Bethlehem, and Nazareth to temporary Christian control.

242 | CHAPTER 8

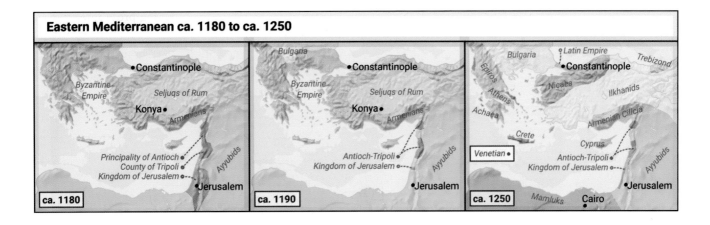

Praised by an English contemporary as "wonder of the world" (*stupor mundi*), Frederick was highly learned and a great patron of art, literature, and science; he even engaged in scientific experiments himself. Like his grandfather King Roger II, he attracted scholars writing in Latin, Greek, and Arabic to his court at Palermo, although after 1222 the court was itinerant. Frederick's legal code, the Constitutions of Melfi, issued the earliest laws against air and water pollution, and his *Art of Hunting with Birds* (*De arte venandi cum avibus*), which he wrote between 1241 and 1244, was the first Latin treatise on falconry, based on earlier texts in Arabic, which Frederick read and wrote well. The original manuscript was lost in battle, but Frederick's son Manfred re-created most of the work from his father's drafts and sketches. There are twelve copies; this one, with over nine hundred marginal images, was made in southern Italy and can be dated between 1258 and 1266 (fig. 8-16). In an era when the subjects of expansive visual programs were generally religious, this book is unusual in representing animal behavior and contemporary social practices. Frederick's text and the accompanying paintings derive from deep knowledge of the dynamics of human–animal interaction. The settings and material requirements of training birds to hunt are rendered in detail, from how to retrieve baby birds from their nests in the wild to how to put hoods on the birds, tie particular knots for their leads, throw decoys, and more. On the verso of this opening, two trainers slowly back away with their heads down to test the birds' ability to stay; one man displays the lead in his hands to remind his bird to remain close by, and the other holds a decoy of raw meat to catch the attention of the birds that are showing signs of hunger. On the recto, the men counter the birds' natural impulse to fly into open windows by covering the window and distracting them with food.

Many of the book's depictions are accurate enough to identify individual species and shed light on global trade routes and political relations in the thirteenth century. One bird, a female cockatoo represented in detail four times, was a gift to Frederick from "the sultan of Babylon" (probably the Ayyubid sultan of Jerusalem). This bird's natural habitat is southeast Asia, which attests to thirteenth-century maritime trade routes between eastern and western Asia. The sultan also sent Frederick a rare gyrfalcon probably sourced from Iceland, and the emperor reciprocated with a polar bear (from the Arctic) and a white peacock (from southeast Asia); both men used animals to assert their economic and political reach. Frederick often traveled with a large menagerie of exotic creatures and frequently sent them to other rulers, but he was known to prefer rare books and birds to large beasts or luxury items. Hunting with falcons was among Frederick's chief leisure activities, one that he shared with rulers from many other cultures.

Representations of birds also enlivened domestic interiors. A ceramic ewer in the form of a rooster was made of fritware, a challenging material and technique that was a specialty of the city of Kashan, Iran (fig. 8-17). Fritware (stonepaste) was developed in the mid-eleventh century to imitate the hard, bright-white body of Chinese porcelain. Ground glass (frit) and white clay were added to quartz powder obtained by grinding sand or pebbles; this artificial clay permitted a lower firing temperature and a wide range of shapes. To make the rooster, the inner flask for holding liquid was glazed and fired, poetic verses were incised into the black bands at the neck and base, the perforated exterior was molded and glazed, and then the whole vessel was fired again. The ewer, made around 1200, was one of hundreds deliberately buried in Jurjan (or Gurgan, near the Caspian Sea in Iran) before that city was destroyed by the Mongols in 1220. It was probably the property of a ceramic merchant, who carefully packed his vessels in sand inside large unglazed storage jars but never retrieved them; they were found by accident during the Second World War. There are ewers, bottles, bowls, plates, and tankards decorated in a wide variety of styles, including lusterware. As a group, they show the high quality of tableware available to upper-class diners in the Islamicate world.

Another fritware object evocative of leisure is a bowl made in Iran (fig. 8-18). A couple dressed in patterned silks with tiraz bands takes refreshment in a lush garden, a metaphor for paradise and prosperity. Birds encircle the garden

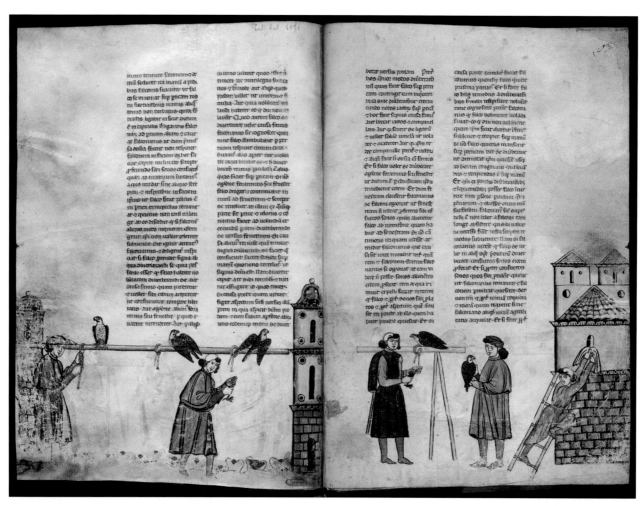

Fig. 8-16. Training falcons, *Art of Hunting with Birds*, ca. 35 × 24.5 cm, 1258–66; Vatican City, Biblioteca Apostolica Vaticana, MS Pal. lat. 1071, fols. 91v–92r. © 2020 Biblioteca Apostolica Vaticana, by permission, all rights reserved.

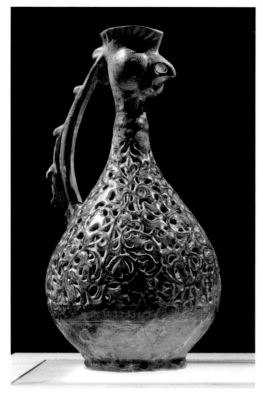

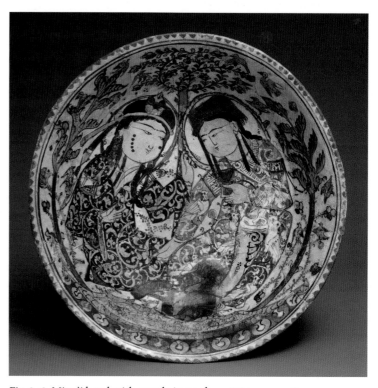

Fig. 8-17. Rooster ewer, 65 × 40 cm, ca. 1200; Musée du Louvre, Paris. © Genevra Kornbluth.

Fig. 8-18. Mina'i bowl with couple in garden, 18.8 cm, ca. 1180–1220. Metropolitan Museum of Art, New York. Robert Lehman Collection, 1975 (1975.1.1643). Image © Metropolitan Museum of Art.

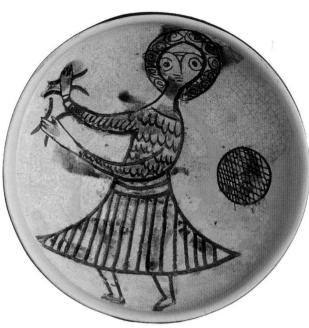

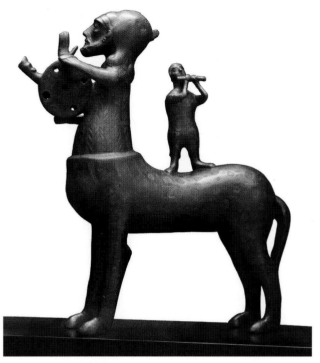

Fig. 8-19. Sgraffito bowl with dancer, 7.4 × 15 cm, thirteenth century; Mouseio Benaki, Athens. Velissarios Voutsas; © 2022 Benaki Museum Athens.

Fig. 8-20. Centaur aquamanile, 42.5 × 32.5 cm (chest–tail), 1200–50; Magyar Nemzeti Múzeum, Budapest. © Genevra Kornbluth.

and the bowl's exterior. The figures' small mouths are typical of Seljuq art, and the woman's face has numerous tattoos or artificial beauty marks (tattooing was very common in medieval Iran). The bowl's complex painting technique, used between the 1180s and 1220s, is known as *mina'i*, a Persian word for enameled ware (also called *haft rang*, seven colors). The bowl was covered with a transparent glaze and several blue tones before firing, and then additional opaque colors were added before a second firing. This technique allows for extensive detail reminiscent of manuscript illuminations, and some mina'i vessels have narratives from the *Book of Kings* or contemporary history. Modern collectors have found the narrative detail of mina'i ware appealing, and recent research indicates that some objects of this type have been altered or even falsified to enhance their market value. In some cases, fragments of different vessels are combined and glued together to make a new one, and in others, inscriptions have been added to invent places of production, dates, and artists' names. This bowl has no inscriptions; it shows signs of extensive repair, as do many centuries-old ceramics, but the pieces seem to belong together. Its imagery of a relaxing couple is not specific to any particular story. The small scale of the bowl presupposes an intimate setting in which the details of clothing and nature could be examined closely and at leisure.

A thirteenth-century bowl found at Paphos (Cyprus) is decorated in a simpler technique (fig. 8-19). Earthenware was painted with a slip and then incised with a sharp tool so the natural reddish-brown of the clay shows through. The vessel was then fired, and iron- and copper-oxide

solutions were applied with brushes under a lead glaze. This produced brown and green colors and a transparent surface after being fired again. Such ceramics are called sgraffito ware, from the Italian word for "scratched." This bowl shows a dancer holding castanets, and the artist has suggested lively movement by having her skirt splay out around her legs; the ball she uses as a prop is suspended in midair behind her. What looks like a halo is probably curly hair. Cypriot sgraffito tableware was exported around the eastern Mediterranean in the thirteenth and fourteenth centuries, and the Byzantines, Seljuqs, and Italians also produced very similar ceramics, attesting to a shared taste for figures engaged in entertaining pastimes.

An aquamanile (from the Latin words for water and hand) was originally a type of metal vessel used by Christian clergy for handwashing before mass, but eventually aquamanilia (plural) were used in monasteries and in secular houses for washing before and after meals. Made of a copper alloy using the lost-wax method, hundreds of examples survive. This one, from the first half of the thirteenth century, depicts a centaur playing a pierced tambourine from which the water would pour; a flutist stands on his back and performs (fig. 8-20). The work was cast in Hildesheim (Germany), long a center of bronze-casting expertise (fig. 6-31). Vessels in the form of animals were common across all medieval cultures, and hollow-cast examples from the Islamicate world may have inspired European aquamanilia. They are yet another example of how functional objects were shaped and transformed to delight their users.

Living a Religious Life

The small church of San Esteban in Renedo de Valdavia (Spain) possesses a late twelfth-century stone baptismal font used to hold holy water and initiate newcomers, usually infants, into the Christian faith. The font's sculpted reliefs depict baptismal rites and include a representation of this very type of vessel (fig. 8-21). Under an arcade, a priest leans over the font, flanked by a man wrestling a beast and an armed knight trampling a serpent. On the other side, filling five of the ten arches, the three Magi venerate the Virgin and infant Jesus while an onlooker leans on a T-shaped pilgrim's staff. Two unidentified standing figures, a man and a woman with hands clasped in prayer, each occupy one arch and may represent the parents or official witnesses required for the sacrament of baptism. The iconography communicates that the baptismal rite, performed in a church (represented by the arcade), protects against sin (the beast and serpent). The Magi, who recognized the newborn Jesus as God in the flesh, underscore that Christian salvation was made possible by Christ's incarnation and that baptism is the first step toward eternal life. The truncated conical form of the font is typical in this part of Spain, and the stylized figures, with large heads and hands and thick drapery that obscures the body, are characteristic of twelfth-century sculpture in Europe.

Medieval Jews also had an important water-related purification ritual, but it was undertaken only by adults. Immersion in a mikvah (plural mikvaot), a ritual bath, was necessary to restore the body spiritually, usually after such activities as menstruation, ejaculation, or childbirth. "Living" water (a biblical synonym for God, Jer. 2:13 and 17:13; used by Christians in John 4:10) was required, such

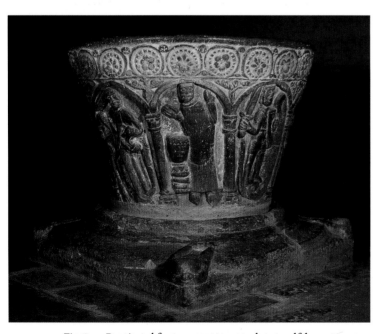

Fig. 8-21. Baptismal font, ca. 79 × 95 cm, late twelfth century; church of San Esteban, Renedo de Valdavia. Photo from Baptisteria Sacra Index.

as springs or groundwater, and no barrier was permitted between the water and the body. Because immersion in the sea or river might violate strictures on modesty, many communities accessed underground water sources that were reached by digging beneath a Jewish-owned property. An example in Friedberg (Germany) is one of many surviving medieval mikvaot, including eight in Germany alone (fig. 8-22). A Latin inscription gives the date 1260, and a Hebrew one names "Isaac of Koblenz," probably the founder. After entering through an arched doorway, a user had to descend multiple flights of stairs to reach the pool twenty-five meters below (groundwater levels fluctuate, so the lower steps were sometimes covered with water). Light from an oculus in the ceiling provided the only illumination, and users must have carried candles or lanterns. The masonry blocks that line the deep shaft, about three meters wide, are supported by relieving arches on columns. Distinctive marks on the elaborate foliate capitals indicate that they were carved by the same stonemasons who worked on the main church in Friedberg, which was founded in the same year and built of identical reddish stone. Jewish law affirms that a community's mikvah is more important to Jewish life than a synagogue, so Isaac provided an essential service for his coreligionists. Yet what is most notable here is the workmanship. The unnecessarily lavish structure with its up-to-date architectural sculpture demonstrates the ability of some European Jewish communities to hire the best masons available for their communal buildings.

Icons were central to the religious life of Orthodox Christians. While some were processed in public, others were venerated at home and in monastic communities. This late twelfth-century icon helped monks at Mount Sinai strengthen their commitment to a holy life (fig. 8-23). The subject is the ladder from earth to heaven seen in a dream by the Hebrew patriarch Jacob (Gen. 28:12), but it was given a Christian monastic interpretation by a saintly seventh-century monk and abbot at Mount Sinai known as John Klimakos (John of the Ladder). Each of the thirty chapters of John's treatise, *The Heavenly Ladder*, corresponds to a rung of the ladder and a vice to overcome (such as greed) or a virtue to attain (such as resisting vanity). In the icon, a row of monks ascends toward a blessing Christ, led by John and a white-robed archbishop named Antony, presumably the patron of the panel. Some monks fall to temptation and are attacked or dragged off the ladder by solid-black demons with wings; these unfortunates plummet toward Hell, rendered as a dark open mouth. The group of praying monks at the lower right is balanced by angels at the upper left who serve as guardians and guides to proper behavior (their burnished haloes are typical of twelfth-century Sinai icons). John's spiritual guide was an instant classic, translated from Greek into Syriac, Arabic, Armenian, and Church Slavonic, and later into Russian, Serbian, and Bulgarian, but a Latin translation made at the end of the thirteenth century had little impact on western

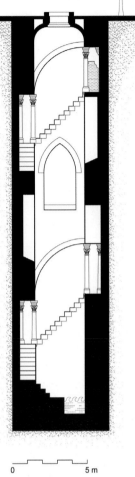

Figs. 8-22a and 8-22b. Mikvah, Friedberg, 1260, (*left*) section; (*right*) view down to pool. (*l*) Drawing by Navid Jamali; (*r*) © Genevra Kornbluth.

0 5 m

European monasticism. For monks in the eastern Christian world, the text and the images derived from *The Heavenly Ladder* provided important models for ascetic life that would lead to salvation.

A significant part of any religious life involves dealing with death. A tall basalt slab from the fortress at Lori Berd in northern Armenia memorializes an Armenian Christian (fig. 8-24). Beginning in the ninth century, such *khatchkars* (Armenian for cross-stones) could be used to commemorate a victory or a church construction, protect from natural disasters, or ensure the salvation of the living or the dead. They were inserted into existing church walls, as at Mren (fig. 3-27), or placed upright in a cemetery. On this one, the cross emerges from a symbolic Gospel book, represented as a codex-like rectangle in which the symbols of the four evangelists cluster. Unlike Orthodox Byzantines, Armenian Christians venerated Gospel books and relics but not icons. The khatchkar's cross and book are framed by elaborate and varied interlace patterns, and in the spandrels outside the upper arch paired birds symbolize the risen dead and affirm the slab's memorial intent. It was carved just before the Mongol conquest in

1238 initiated a decline in khatchkar carving, although the practice was revived in the sixteenth century.

The tomb of Eleanor of Aquitaine represents a type of funerary commemoration that became common in western Europe (fig. 8-25). Eleanor (ca. 1122–1204), who donated the Eleanor Vase to Saint-Denis (fig. 7-46), was one of the most powerful, wealthy, and well-educated women of the Middle Ages. Duchess of Aquitaine through her father and, through marriage, queen of France (r. 1137–52) and then England (r. 1154–89), she was also the mother of three kings. In 1194, after the death of her second husband, Henry II (of Becket infamy), Eleanor became a nun at Fontevrault (France). This large abbey, founded in the early twelfth century, attracted considerable royal patronage. Eleanor's brightly painted funeral effigy was originally displayed in a chapel in the south transept of the monastic church alongside effigy tombs of her second husband and their son Richard "the Lionheart," both of whom died before her; one of Eleanor's daughters-in-law joined the cluster of family tombs in the mid-thirteenth century. All the effigies are now in the nave. Figural tomb markers first appeared in eleventh-century Europe and were never used

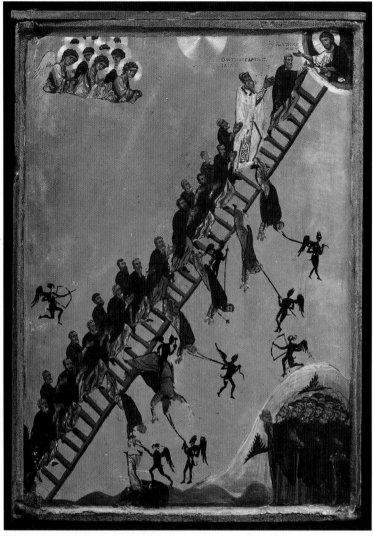

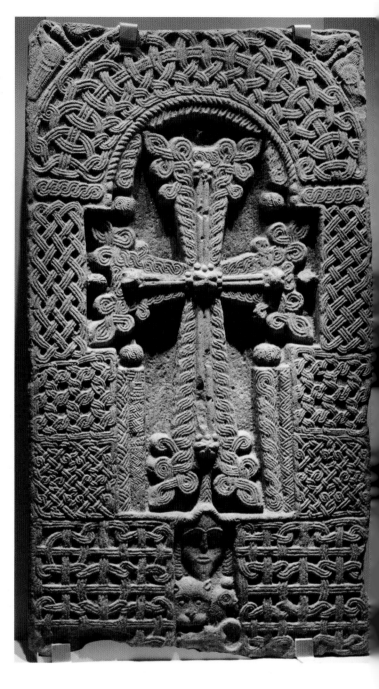

Fig. 8-23. Heavenly Ladder icon, 41.1 × 29.5 cm, late twelfth century; Monastery of St. Catherine, Mount Sinai. By permission of Saint Catherine's Monastery, Sinai, Egypt.

Fig. 8-24. Khatchkar, Lori Berd, 182.9 × 98.4 × 22.9 cm, early thirteenth century; Hayots' patmut'yan t'angaran, Yerevan. Photo by the authors.

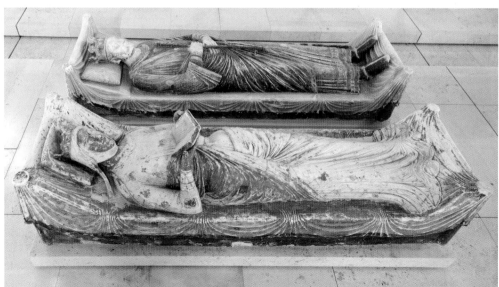

Fig. 8-25. Tomb effigy of Eleanor of Aquitaine (with Henry II), Fontevrault Abbey, Eleanor 217 × 60 cm, early thirteenth century. Photo by the authors.

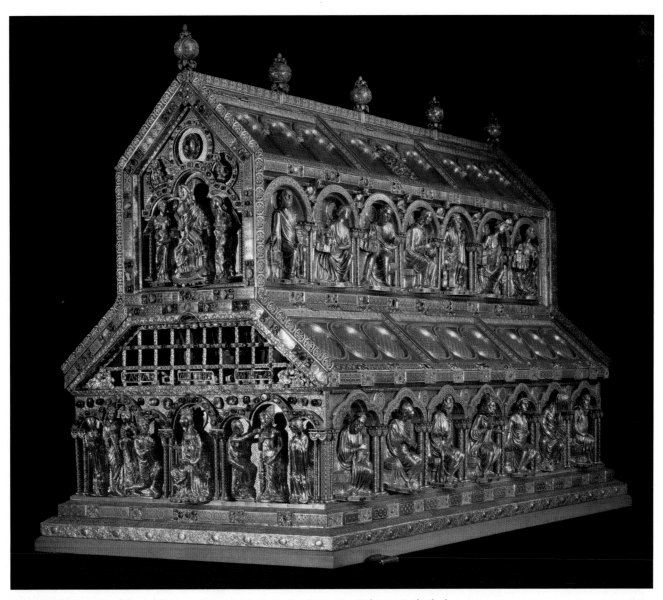

Fig. 8-26. Shrine of the Three Kings, 153 × 220 × 110 cm, ca. 1180–1220s; Cologne Cathedral.
Erich Lessing/Art Resource, NY.

in the Byzantine or Islamicate worlds. Henry is shown dead, crowned and holding his staff of rule, but Eleanor is depicted alive, more three-dimensional than her husband, and reading a book. She is the first person shown in tomb sculpture with a book and the only one in the act of reading (her hands and the book were restored on the basis of seventeenth-century drawings). The book is almost certainly a Psalter; devout reading of psalms was one of the chief activities of nuns. This effigy likely reminded the living nuns of Fontevrault about Eleanor's piety and generosity and also encouraged them to pray for the salvation of her soul. The lives of the medieval living and dead were often intertwined.

Decorated reliquaries also brought together the living and the dead—in this case, the holy dead and those who venerated them. The Shrine of the Three Kings in Cologne was one of the largest and most opulent medieval reliquaries, begun by the goldsmith Nicholas of Verdun about 1190

but completed by others in the 1220s (fig. 8-26). It holds parts of three skeletons, identified as those of the biblical Magi, which the Holy Roman emperor Frederick I Barbarossa (r. 1155–90) brought from Milan to Cologne. The relics transformed Cologne into an important pilgrimage destination and a site for rulers to display their piety. The Magi were connected with notions of Christian kingship because by this time they were understood not as wise men (Matt. 2:1–12) but as kings, the first sovereigns to recognize Christ's divine rule. The reliquary was intended to support a particular view of Christian kingship, in which the ruler's power derived directly from God and was not mediated by the pope. By the late thirteenth century, new German kings and Holy Roman emperors were crowned at Aachen (fig. 5-5)—where the relics of their recently sainted predecessor Charlemagne were placed into a new shrine in 1215—but then went immediately to Cologne to venerate their biblical forebears. On the sides of the

basilica-shaped reliquary are gilt-silver figures of prophets in high relief; above them are apostles and evangelists; and on the ends are Christological scenes, including the Adoration of the Magi on the solid-gold front seen here. When the trapezoidal plate above this scene is removed, three crowned skulls are visible behind the grille. The crowns were gifts (ca. 1200) from Otto IV, king of Germany, who stands behind the three depicted kings to legitimate his own disputed rule; although it is not clear exactly who commissioned the shrine and when, Otto IV likely played a key role. The Magi also came to symbolize the three continents shown on medieval maps (Europe, Asia, Africa) and the three ages of man (childhood, adulthood, old age), from birth and baptism to the grave.

Places of Worship

The stone-and-brick church dedicated to St. Panteleimon at Nerezi (North Macedonia) was commissioned by Alexios Angelos Komnenos, a prince of the Byzantine imperial family, who probably intended to be buried there. A marble inscription over the door from the narthex into the naos provides the date 1164 and the name of an abbot,

which means that the cruciform church, with tiny corner bays and five domes, was probably the katholikon of a monastery. The interior preserves its marble templon (chancel) screen as well as the elaborately carved frame around the large icon of the titular saint, and scenes from his life were painted in the narthex. In addition to the usual array of standing saints at ground level and Christological scenes on the vaults and upper walls, the fresco program emphasizes additional scenes of the Passion in the north cross-arm. A large image of Mary's lamentation over the dead Jesus occupies a prominent place on the north wall (fig. 8-27). As seen on the "Utmost Humiliation" side of the bilateral icon in Kastoria, Christ's human nature began to be emphasized in Byzantine art after the eleventh century by combining the depiction of his suffering and death with his mother's emotional response. In both the icon and the fresco, Mary's face shows terrible sorrow, in contrast to Christ's serenity; her tragic expression at Nerezi is shared by the young apostle John. In the Lamentation scene, Mary's splayed, bent knees recall the pose of childbirth: as in the icon, Jesus's whole lifespan is implied, and this is underscored by the scene on the opposite wall in which Mary holds the infant in his Presentation in the Temple (Luke 2:22–40). Below the Lamentation is an

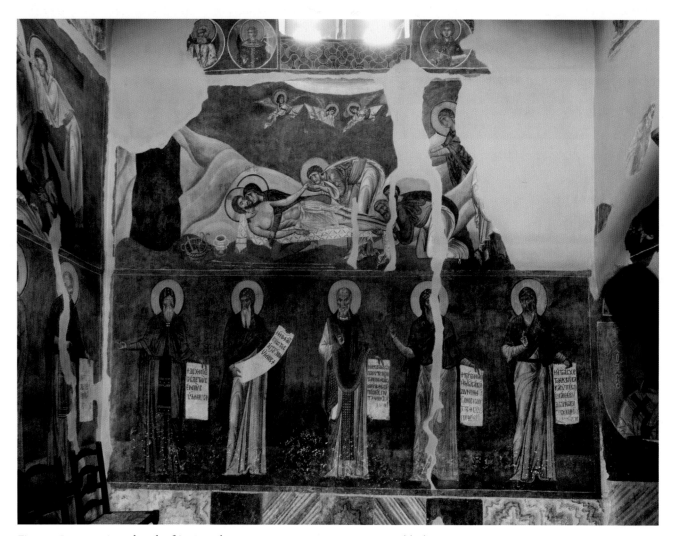

Fig. 8-27. Lamentation, church of St. Panteleimon, Nerezi, 1164. © Genevra Kornbluth.

unusual depiction of five men holding scrolls, most gesturing with their right hands. These five wrote the major poetic hymns sung during the monastic liturgy. Constant praise of God was the responsibility of all monks, and for those who specialized in singing, the painted composers were distinguished models. Indeed, their upraised hands seem to lead the Nerezi monks in song.

After the Latin conquest of Constantinople in 1204, the Byzantine Empire fragmented into three small states whose rulers all claimed the traditional title of "faithful emperor and autocrat of the Romans." The empire based in Trebizond was ruled by the Komnenos family, known there as the Grand Komnenoi, until 1461. Located on the Black Sea coast, the city was a military base and an important commercial center for goods moving west from Central Asia. A cross-in-square church dedicated to Hagia Sophia was built outside the town in the early 1250s by Manuel I Grand Komnenos (r. 1238–63) to serve as the katholikon of a monastery (fig. 8-28). Although it evoked the Constantinople cathedral, the only shared features are the dedication and the dome. The Trebizond church is built of ashlar over a rubble core, unlike the brick favored elsewhere by middle Byzantine architects; stone was plentiful in the region and widely used in Armenian, Georgian, and Seljuq architecture. Also exceptional are the church's elevation on a tall podium (1.4 meters high) and the presence of barrel-vaulted porches on three sides. The large south porch was the main entrance, and on its exterior is an eight-meter-long frieze with scenes from Genesis. Relief sculpture is relatively uncommon in Byzantine art, especially narrative sculpture; its use here may derive from the proximity of Armenian and Georgian models. Georgian church architecture may also have inspired the prominent south porch, although the trio of porches at Hagia Sophia have no comparisons there.

After passing through the porch, the worshiper saw a much more typical Byzantine interior, albeit an unusually bright and spacious one. Manuel's portrait (still visible in the nineteenth century but now lost) was prominently displayed on the south wall near his tomb; he held a scepter and an anointing horn of the type used by the prophet Samuel to consecrate King David (1 Sam. 16:1–13), the model for divinely sanctioned Christian rulers. The church was evidently planned to be the dynastic mausoleum of the Grand Komnenoi, and the tombs of monks and perhaps imperial family members were inserted into the podium. In this regard the building referenced not only Constantinople's Hagia Sophia but also the Pantokrator Monastery, built for earlier members of the Komnenian family (fig. 7-30). In multiple ways, then, Hagia Sophia in Trebizond advertised its patron's imperial identity and his ties to Constantinople.

In the 1190s the Rus' prince Vsevolod III (r. 1177–1212)—known as "the Big Nest" because he and his wife, Maria, had fourteen children—built a cathedral and palace church dedicated to St. Demetrios in his capital at Vladimir, in the northeastern part of Rus' where there was still a sizable population of polytheists (fig. 8-29a). Vsevolod, whose birth name was Dmitrii, spent his youth at the Komnenian court in Constantinople after being exiled by his half brother. Upon his return to Rus', he acquired relics of Demetrios from Thessaloniki—some of the saint's myron, his shirt, and a figural grave covering, perhaps an

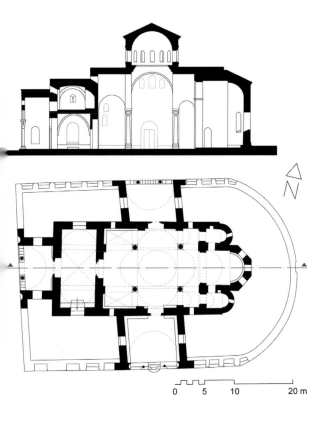

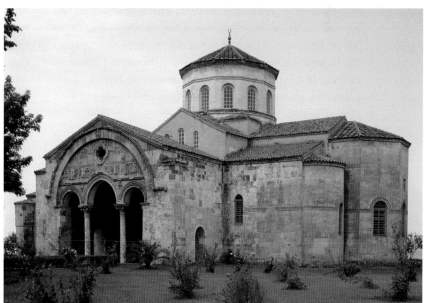

Figs. 8-28a and 8-28b. Church of Hagia Sophia, Trebizond, 1250s, *(left)* plan and section; *(right)* exterior from the southeast. (l) Drawings by Navid Jamali; (r) akg-images/Gerard Degeorge.

0 5 10 20 m

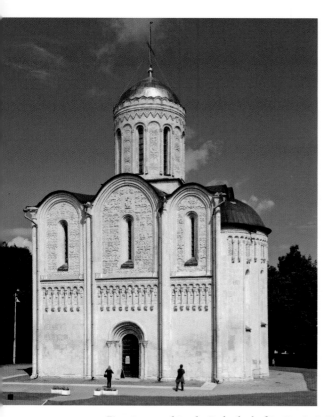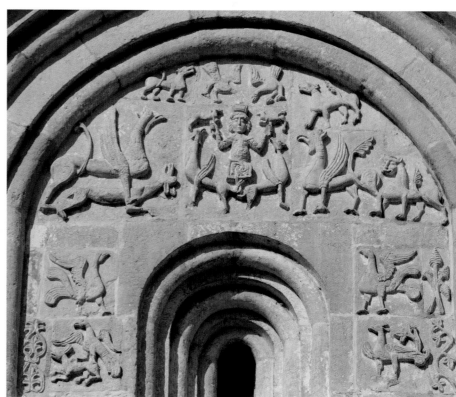

Figs. 8-29a and 8-29b. Cathedral of St. Dmitrii, Vladimir, 1190s, *(left)* south exterior; *(right)* detail of Alexander "the Great." *(l)* Wikimedia Commons/Ludvig14, CC BY-SA 4.0; *(r)* © Vladimir Ivanov/Photobank Lori.

icon—just as Byzantine rulers, especially the Komnenians, had done. The cathedral of St. Dmitrii in Vladimir has a Byzantine cross-in-square plan, and its frescoes belong to the late Komnenian stylistic repertoire, but its exterior elevation is very un-Byzantine. Like other local churches it is constructed of white limestone, but, unlike them, the upper zone of the building is profusely decorated with relief sculpture, as is the tall drum of the dome. In this type and degree of decoration it resembles a western European church, and artists from western or central Europe were probably involved; they also drew inspiration from Byzantium, the Caucasus, and the Balkans. There are about fifteen hundred preserved images, with King David holding a harp above the west entrance and, on the south, Christ's Baptism and the legendary scene of Alexander "the Great" ascending to heaven (fig. 8-29b). Boris and Gleb, brothers killed for their faith in 1015 and the first saints of Kyivan Rus', are represented both as martyrs and as mounted warriors. There are real and mythical beasts, stylized plants, wrestlers and hunters, and a row of saints in the engaged arcade that seems to support the carvings above (many of the saints are replacements). The overall composition evokes paradise, in which all of Vsevolod's sons are depicted on the north facade, including those still alive at the time the church was decorated; at the same time, it provides models for princely authority and military power. Nevertheless, Vladimir never recovered from its

destruction by the Mongols in 1238 and the emergence of the rival duchy of Moscow later in the thirteenth century.

In 1147 the Almoravids were overthrown by the Almohads, who were Indigenous Imazighen (singular Amazigh) people of North Africa and the Sahara (they are sometimes called Berbers, from the Greek for "barbarians"). In the second half of the twelfth century the Almohad dynasty extended its power over northwestern Africa and the southern Iberian Peninsula, building such mosques as the one at Tinmal (figs. I-8 and I-9). After defeating Alfonso VIII of Castile (Spain) in 1195, Abu Yusuf Ya'qub al-Mansur (r. 1184–99), the third Almohad ruler, claimed the title of caliph and moved his capital from Marrakesh to Ribat al-Fath (Fortress of Victory), now Rabat, in Morocco. The new Friday mosque, measuring 140 by 185 meters (fig. 8-30a), was second in size only to that of al-Mutawakkil in Samarra (fig. 5-12). It could have accommodated over twenty thousand worshipers, far exceeding the population of Ribat al-Fath in the twelfth century, so the project trumpeted al-Mansur's power and expansive realm. The stumps of over three hundred stone column drums survive. The use of columns rather than piers—the usual supports in Almohad mosques—probably imitated models in Spain; sources record that al-Mansur visited Córdoba and the ruins of Madinat al-Zahra'. Here, however, they are not monolithic but made of courses of cut stone. Three unroofed courtyards permitted light and air to enter the vast hypostyle.

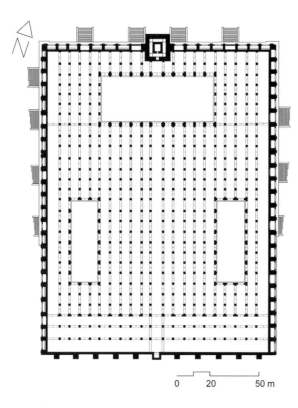

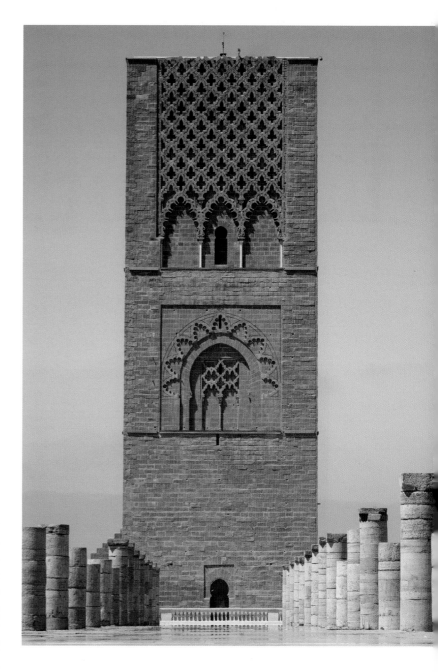

Figs. 8-30a and 8-30b. Friday mosque, Ribat al-Fath (Rabat), 1195–99, (*left*) plan; (*right*) view toward the minaret. (*l*) Drawing by Navid Jamali; (*r*) Wikimedia Commons/AMAJGAG Abdellatif, CC BY-SA 4.0 cropped.

The red sandstone minaret, at the center of the northern facade opposite the mihrab, is forty-four meters tall but only about half its intended height (fig. 8-30b). Traditionally known as the Tower of Hassan, the square minaret is decorated on each side with blind arcades, mostly lobed arches that increase in complexity with each rising story. This lacelike decoration contrasts with the solidity of the structure, which was also relieved by the addition of Andalusi spolia (one marble capital survives on the south side). Interior ramps, rather than the usual stairs, facilitated carrying building materials as the tower rose. Construction of the huge Friday mosque and minaret stopped after al-Mansur's death in 1199, when his successors moved the capital northward.

A mosque-hospital complex built at Divriği (Turkey) in 1229 was commissioned by members of the Mengujekid dynasty, rulers of central Anatolia who became nominal vassals of the Seljuqs of Rum in that year. Ahmadshah, who sponsored the mosque, was the local emir (r. 1229–51); the woman who founded the hospital, Turan Malik, was his cousin. The architect, Khurramshah ibn Mughith al-Khilati (i.e., from Akhlat, on Lake Van), was identified, like the patrons, by short inscriptions. The hypostyle mosque occupies two-thirds of the rectangular complex, with its mihrab on the south wall preceded by a dome (fig. 8-31a). The main entrances to the mosque and the hospital are richly adorned with bands and medallions of stylized

foliate and geometric carvings in high relief, akin to the sculpture at the Sultan Han. The mosque's north portal, facing the citadel, is especially ornate (fig. 8-31b). Its elaborate designs were worked out on paper before being transferred to stone via incised guidelines, which are still visible. The inventive exterior sculpture echoes the imaginative vaulting inside: all nineteen bays in the mosque have masonry vaults with blocks arranged in unique patterns, and the column bases and capitals also differ. The hospital interior, like that of a madrasa, is dominated by a large iwan opposite the door that has a complex groin vault with a central spiral design. Between the entrance and the iwan, the main room was well appointed for the purpose of diagnosis and teaching, with an octagonal pool at the center and natural light streaming through an oculus above; smaller rooms to the sides likely housed patients. Juxtaposing a place for communal prayer with a

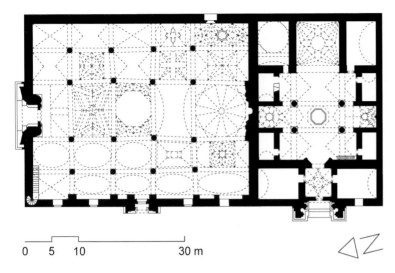

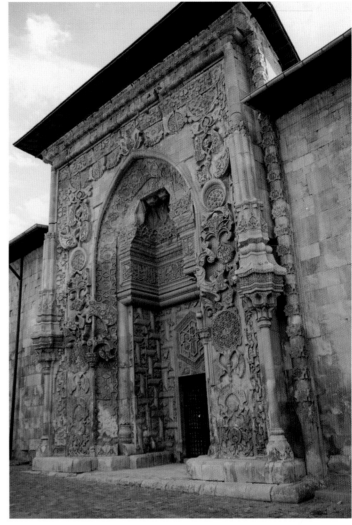

Figs. 8-31a and 8-31b. Mosque-hospital complex, Divriği, 1229, (*left*) plan; (*right*) north portal of mosque. (l) Drawing by Navid Jamali; (r) Wikimedia Commons/Bertramz, CC BY-SA 3.0.

Fig. 8-32. Wood Calvary sculptures, Urnes stave church, 118 × 118.7 × 37 cm (Christ), 116 × 20 × 19 cm (Mary), mid-twelfth century. Georg Berg/Alamy Stock Photo.

building for social services was typical in medieval Islamicate societies, but the attention paid to interior vaulting and exterior carving at Divriği was exceptional.

Many places of worship in western Europe continued to feature architectural sculpture both inside and out. An example of freestanding interior sculpture is in the stave church at Urnes in Norway (fig. 7-21). This Calvary group —the crucified Christ between Mary and John the Evangelist—was carved of hardwood in the middle of the twelfth century (fig. 8-32). It is now displayed on the eastern wall, but the figures probably topped a rood screen or beam

that supported a cross and separated the sanctuary from the nave. In that location, the group would have served as a focus for veneration. All the figures are painted on the back with a stippled red-and-white pattern, suggesting that they were initially seen in the round. Christ's polychromy is original and includes lapis lazuli; Mary, John, and the cross were repainted on the front in the thirteenth century for unknown reasons. Christ's arms are attached to his torso with pegs, whereas the other, more contained figures are carved from single blocks of wood. This is the oldest Calvary group in Norway and one of the oldest in Europe. Artistic models for the figures, albeit in stone, came from the Rhine River region and England; the latter had especially close ties to Norway during the long reign of King Hakon Hakonsson (r. 1217–63).

Chartres Cathedral was among the first churches in France dedicated to the Virgin Mary (Notre-Dame, meaning "Our Lady"). It housed a tunic that Mary allegedly wore when she gave birth to Jesus, which was a gift from Emperor Charles "the Bald" in 876. A new church was built in 1145, but a fire in 1194 destroyed all but the precious relic and the west end (fig. 8-33). Rebuilding after the fire continued until the completion of the choir in 1220, when the church became one of the largest in France. Changes in sculptural

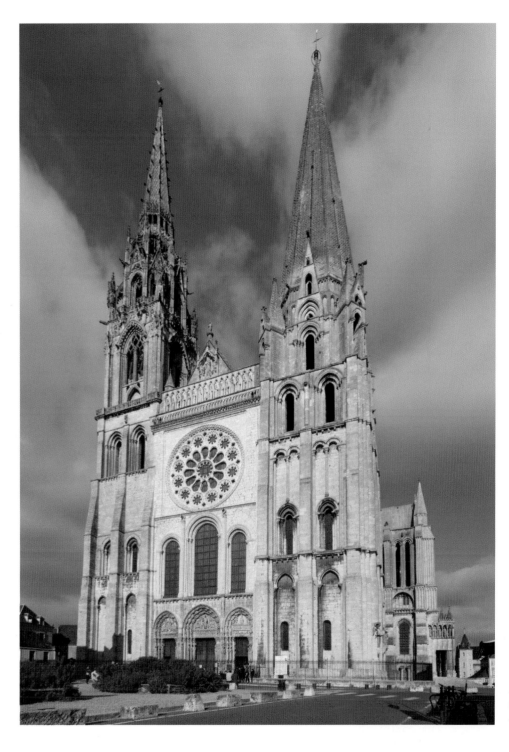

Fig. 8-33. Cathedral, Chartres, 1145 and later, view from the west. © Genevra Kornbluth.

style are apparent when the twelfth-century facade, the so-called Royal Portal, is compared with the north and south porches, which date to the mid-thirteenth century. The three portals on the west are flanked by elongated jamb figures representing the Old Testament ancestors of Christ. The tympana depict from left to right Christ's Ascension, Second Coming, and Infancy; further narratives from the life of Christ are on the supporting lintels. By contrast, the statues on the later transept jambs (Old Testament on the north side, Christ and saints on the south) have much more naturalistic proportions, lively gestures, and thick folds of drapery that reveal different postures.

Inside the early thirteenth-century church, the nave has a three-story elevation like that at Canterbury (fig. 8-34): a pointed arcade at the bottom, a triforium in the middle, and a clerestory at the top. The quadripartite rib vaults, of uniform design, spring from compound piers and are supported on the exterior by flying buttresses. Inlaid into the light-colored stone floor of the nave is a labyrinth, which pious visitors would walk as a devotional exercise, making a kind of spiritual pilgrimage. The church also boasts 176 stained-glass windows, most datable between 1200 and 1235; only the "Blue Virgin" now in the south ambulatory and the lancet (pointed) windows on the west facade predate the 1194 fire and are contemporary with the mid-twelfth-century facade. All three facades have rose

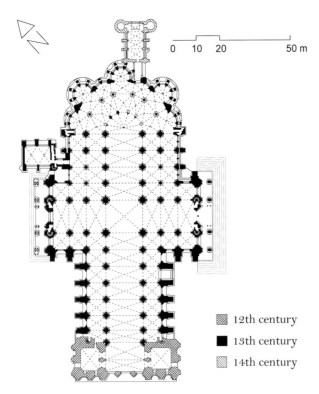

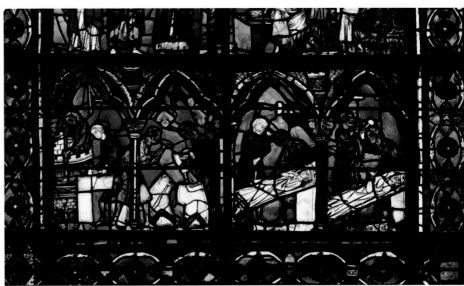

(left) **Figs. 8-34a and 8-34b.** Cathedral, Chartres, 1194–fourteenth century, (top) plan; (bottom) interior toward the east. (t) Drawing by Navid Jamali; (b) © David L. Martin.

☒ 12th century

■ 13th century

▨ 14th century

(above) **Fig. 8-35.** Masons and sculptors, ambulatory window, Chartres Cathedral, ca. 1220. © Genevra Kornbluth.

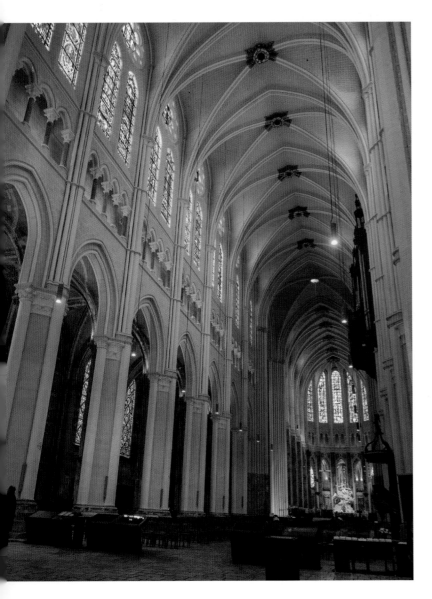

windows: that on the west has thick plate tracery (stone carved to accommodate glass), while the transepts use bar tracery (larger areas of glass separated by thin stone bars). The north transept rose window, which dates to about 1230, was a gift from Blanche of Castile, a granddaughter of Eleanor of Aquitaine and mother of King Louis IX (r. 1226–70); she ruled the French kingdom before her son reached maturity and again when he went on crusade (1226–34, 1248–52). Kings of Judah, ancestors of Christ, and Old Testament prophets surround the Virgin and Child at the center, creating a typological argument that Mary is the instrument through which all the Hebrew scriptural prophecies were completed and fulfilled.

Windows in the aisles and ambulatory illustrate the lives of Christ, Mary, Charlemagne, Thomas Becket, and other saints. At the base of many windows are depictions of laypeople—bankers, furriers, shoemakers, masons, and sculptors—busily engaged in their crafts and conversing with clients (fig. 8-35). Such images may have been donated by the respective craftspeople, or they may represent idealized visions of a society unified in support of the building that the clergy wanted to convey. The stained glass and sculpture are as complex theologically as they are plentiful. Much of the learned iconography was devised in the famous cathedral school, which attracted scholars to Chartres from all over Europe. But visitors from all walks of society must have found the building's height, flying buttresses, stained glass, and architectural sculpture remarkable. This combination of features was widely imitated in Europe for centuries, defining what came to be known as Gothic architecture.

Box 8-2. "GOTHIC"

Like the term *Romanesque* (box 7-1), "Gothic" was coined at a particular moment to highlight specific aspects of medieval art and architecture. The word was popularized by Giorgio Vasari (1511–74), a painter and writer from Florence (Italy) whose *Lives of the Artists* is often considered Europe's first modern art-historical text. In that work, Vasari emphasized the unique nature of Italy's *rinascita*—rebirth, or the French and now English equivalent *Renaissance*—and its relationship to classical antiquity. He attributed the "barbarous" artistic styles of the intervening centuries to the "Goths" and Germans; their tall, thin, pointed buildings, he wrote, were covered with so much ornamentation that they seemed to be made of paper, not stone. Thus Gothic was originally a pejorative term, and it remained so well into the 1700s. However, increasing competition among France, England, and Germany in the eighteenth and nineteenth centuries led many enthusiasts to trumpet their "native" medieval pasts as part of a unique and glorious national patrimony. That was also the period, not coincidentally, in which historians became more precise in outlining the contours of national and European history. Gothic eventually became a more neutral term referring specifically to the art and above all the architecture of the later Middle Ages in Europe, characterized by the pointed arch.

Although Vasari held the Goths and Germans responsible for the style he dismissed, one medieval term for Gothic architecture was *opus francigenum* (French work). This could refer to the components of the buildings—including high vaults, pointed arches, gables, and pinnacles—as well as to the sophisticated stonecutting and construction techniques that facilitated their integration in a single structure. The forms of "French work" embellished buildings as well as their contents (walls, windows, furnishings) in addition to sculpted and actual bodies, from head to toe, crown to shoes. This style spread quickly across Europe from France, and its architectural motifs penetrated all artistic media and scales in public, private, religious, and secular settings. In this way it differs from "Romanesque," which derived from architecture but is less useful for other types of art. Still, the "Gothic" label does not always illuminate individual works or the broader sweep of medieval art and architecture, so it is used sparingly in this book.

Work in Focus:
THE HERMITAGE OF ST. NEOPHYTOS

Cyprus was in Byzantine hands after its reconquest from the Arabs in 965, but in 1191 the Byzantines lost the island to the English crusader Richard "the Lionheart." He awarded it to the Lusignan family, French Christians who controlled it until 1489. The rural population of Cyprus remained largely Orthodox, however, and a large number of churches were built or decorated for their use during the later twelfth and thirteenth centuries.

In 1159 a hermit named Neophytos (1134–after 1214) enlarged a small cave in the face of a steep cliff north of Paphos (fig. 8-36). In his private cell he carved out storage niches, a shelf for a bed, and his future tomb. Next to the cell was a chapel, with its naos and bema divided by a wooden templon screen that preserves icons of about 1200. This chapel was dedicated to the Holy Cross after Neophytos obtained a particle of that relic, which was kept in the naos. As followers gathered around the saintly man, more monastic cells and a refectory were excavated nearby. Neophytos composed a typikon for the new monastery that permitted a maximum of eighteen monks. This rock-cut complex is known as the Hermitage or Refuge (Greek *Enkleistra*) of St. Neophytos. One construction detail not visible to the naked eye is the presence of clay vessels inserted into the walls of the cell and bema, with their openings just below the plastered surfaces. They must have had an effect on sound, perhaps reducing echoes in those tiny spaces.

Except for the replacement of some paintings in the naos in 1503, the decorative program of the hermitage remains much as Neophytos left it at his death. The bema and cell were frescoed in 1183 by Theodore Apseudes, who signed his work; the date is confirmed by Neophytos's statement in the typikon that his refuge was completely painted in his twenty-fourth year there. A second painting campaign was undertaken in the naos about two decades later by an unnamed artist. In both phases, Neophytos's piety—and his self-promotion—are on display. On the north wall of his cell he is shown kneeling in prayer at the feet of Christ in a monumental Deesis scene (ca. 2 × 1.5 m), clearly expressing hope that Mary and John the Baptist will intercede for him on Judgment Day (fig. 8-37). The same elderly, bearded figure is depicted on the ceiling in the bema, being escorted upward by two archangels next to the scene of Christ's Ascension; the letters *N* and *E* at chest level identify him as Neophytos the Enkleistos (hermit)

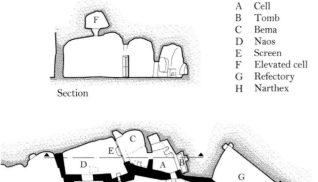

A	Cell
B	Tomb
C	Bema
D	Naos
E	Screen
F	Elevated cell
G	Refectory
H	Narthex

Section

Fig. 8-36. Hermitage of St. Neophytos, near Paphos, 1159–early thirteenth century. Drawings by Navid Jamali.

(fig. 8-38). The angels' wings meet over his shoulders in a way that makes Neophytos himself look as though he has wings, and the text in Greek above his head expresses his desire to join the angels. The image is thus the visual fulfillment of the prayer. Neophytos is represented again in the naos as the only monk without a halo. Portraiture is rare in medieval art, if we think of it as an image of a person in which identity is asserted through physiognomic likeness rather than, say, costume, heraldry, or inscription. Yet these three images of an elderly man were executed during Neophytos's lifetime, and their consistency and proximity to the subject argue for their status as portraits. They are, however, idealized, as the aged saint is smooth skinned and wrinkle free. They are thus exceptional representations of a living patron inserted into sacred scenes.

Neophytos's self-sanctification is even more apparent in the painting of the naos ceiling. Here, a narrow shaft allowed him to observe the liturgy in seclusion from a private hideaway excavated above the ceiling (fig. 8-36). The area around the shaft is decorated with another image of Christ's Ascension, so a monk looking upward would see Neophytos's face alongside that of Christ (now lost), both seemingly held aloft by angels (fig. 8-39). From that elevated position, already—at least figuratively—in heaven and at Christ's side, Neophytos delivered teachings to the monks and others who gathered in the chapel for special feast days. He was, in effect, a living icon.

Neophytos ensured that his body would be preserved at the hermitage by carving out his own tomb and giving explicit instructions in the typikon for his burial (his body remained there until the eighteenth century). He seems to have anticipated that his relics would be miraculous, and miracles were indeed recorded by the fifteenth century. Surrounding the arcosolium tomb, now obscured by a plastic panel that Neophytos intended to be a solid wall,

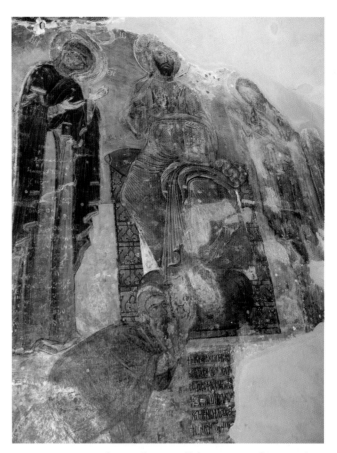

Fig. 8-37. Deesis with Neophytos, cell, hermitage of St. Neophytos, near Paphos, 1183. Photo by the authors.

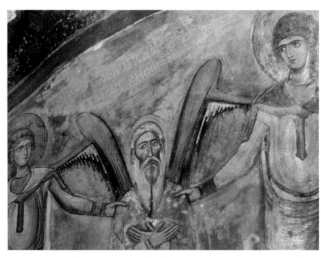

Fig. 8-38. Neophytos escorted to heaven, bema, hermitage of St. Neophytos, near Paphos, 1183. Photo by the authors.

are images relevant to the occupant's hoped-for resurrection (fig. 8-40). There is a Crucifixion on the left and, nearer the head of the dead saint, the Anastasis scene. In the adjacent niche the painted Mother of God holds a scroll beseeching the Child in her lap to grant remission of sins "to the one who lies here"; Christ's scroll, now illegible, read, "I give it, moved by your prayers." While personal prayers for salvation are common in Byzantine art, this image is

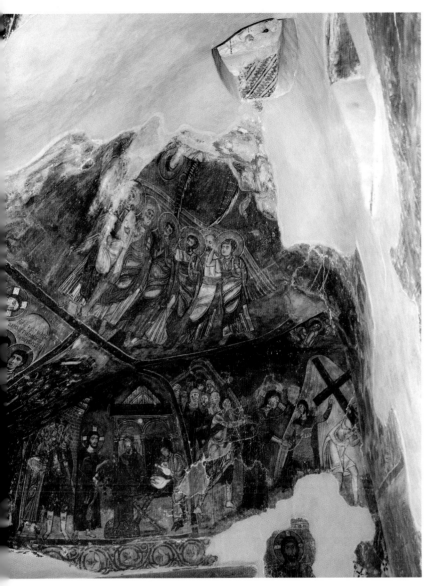

Fig. 8-40. Frescoes over the tomb of Neophytos, hermitage of St. Neophytos, near Paphos, 1183. Photo by the authors.

Fig. 8-39. Passion scenes near opening to elevated cell, naos ceiling, hermitage of St. Neophytos, near Paphos, ca. 1200. Photo by the authors.

Fig. 8-41. Ascension, bema, hermitage of St. Neophytos, near Paphos, 1183. Photo by the authors.

unique in showing Mary already interceding and Christ actively granting the request. Neophytos devoutly hoped that this would be the case, and the image was meant to help make it so.

A flat, linear style dominates in the naos, emphasizing that the monks depicted there are strict ascetics. Elsewhere the style reflects a different strand of late twelfth-century Byzantine art: elongated figures with agitated drapery, best seen in the apostle at the left of the Ascension scene in the bema (fig. 8-41). Such drapery is found in late Komnenian churches around the Orthodox world; here, it presumably indicated the spiritual nature of the angels, whose clothing did not need to conform to the rules of earthly gravity.

This chapter began and ended with works that promoted and reflected the Christian cult of individual saints, Thomas Becket at Canterbury and Neophytos on Cyprus. Unlike the English martyr, the Byzantine hermit anticipated his death and took pains to express his hopes for salvation visually. The cult of Neophytos never achieved the scale of Becket's cult, however; he did not have a large architectural setting in which his memory could be promoted, his life and death did not involve royal power, and, as far as we know, visitors did not leave with souvenirs, although such pious mementoes were available at other Byzantine pilgrimage sites. Across Christendom, the cult of saints reached its apogee in the twelfth and thirteenth centuries.

CHAPTER 9

ca. 1250 to ca. 1340

Legend

☐ **Location or findspot**
 - Monument/object
• Additional site
○ Approximate place of production

☐ **Nidaros**
- Altar panel of St. Olav

Hereford ☐
- Mappa mundi

☐ **Oxford**
- Merton College

Amiens •

Paris
- Hours of Jeanne d'Evreux
- Mirror back with chess players
- Sainte-Chapelle
- Table fountain

☐ **Paris**

☐ **Zurich**
- Manesse Codex

Avignon •

☐ • Venice

Padua
- Scrovegni Chapel

Florence •

☐ **Saga**
- Altar frontal of St. Eugenia

Sarajevo ○
Haggadah

Manuscript of ○
the Cantigas
de Santa María

☐ **Siena**
- Palazzo Pubblico and Hall of the Nine

☐ **Dečani**
- Monastery church

Nicae

Epitaphios of Stefan Uroš II

Asinou
- Church of the All-Holy Mother of Go

☐ **Fez**
- 'Attarin Madrasa

• Sijilmasa

• Wadan

• Durbi Takusheyi

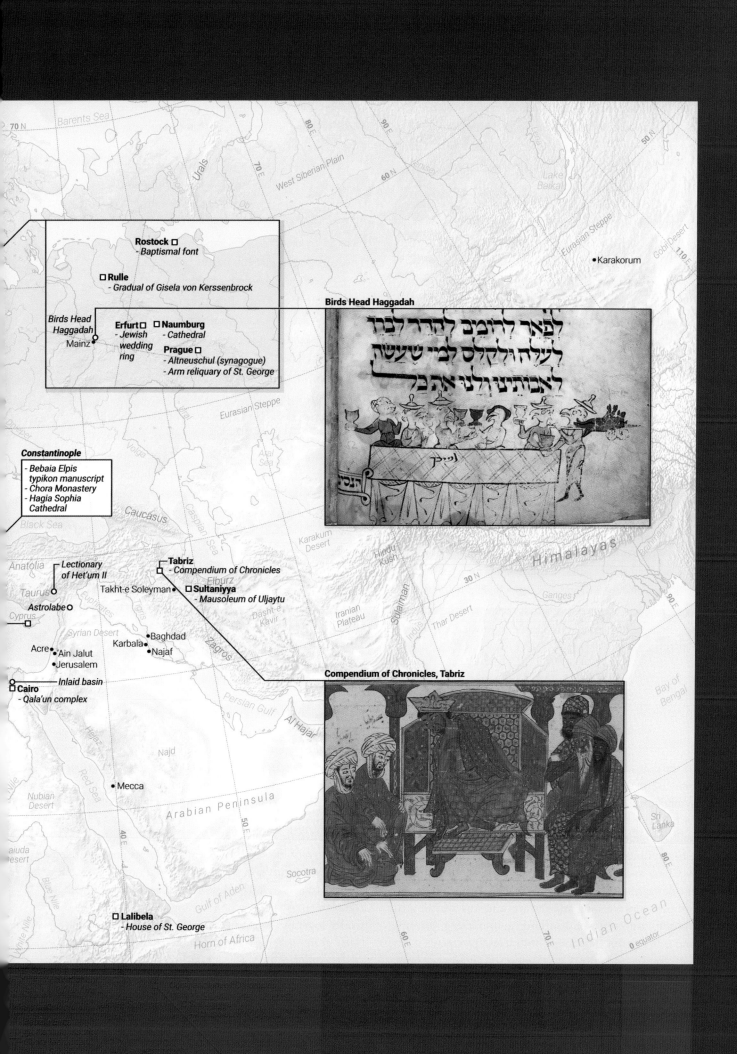

Rostock □
- Baptismal font

□ **Rulle**
- Gradual of Gisela von Kerssenbrock

*Birds Head
Haggadah*
Mainz •

Erfurt □ □ **Naumburg**
- Jewish - Cathedral
wedding **Prague** □
ring - Altneuschul (synagogue)
- Arm reliquary of St. George

Constantinople
- Bebaia Elpis
 typikon manuscript
- Chora Monastery
- Hagia Sophia
 Cathedral

Birds Head Haggadah

לפאר לרומם להדר לברך
לעלה ולקלס לפי שעשה
לאבותנו ולנו את כל

Lectionary
of Het'um II

Astrolabe ○

Tabriz □
- Compendium of Chronicles
□ **Sultaniyya**
- Mausoleum of Uljaytu
Takht-e Soleyman •

Acre • • Ain Jalut
• Jerusalem
□ Cairo ——— Inlaid basin
- Qala'un complex

• Baghdad
Karbala • Najaf

Compendium of Chronicles, Tabriz

• Mecca

□ **Lalibela**
- House of St. George

The mid-thirteenth century was tumultuous. In the 1250s the huge Mongol Empire fragmented into four smaller khanates: the Golden Horde in the northwest (including parts of Rus'); the Yuan dynasty based in Beijing; the Chagatai in Central Asia; and the Ilkhanids (literally, Lesser Khans) in southwestern Asia, from the Indus River to Anatolia (1256–1353). Led by Hulagu (or Hülegü) Khan (1218–65), a grandson of Chinggis (or Genghis) Khan, and a Chinese general named Guo Kan, the Ilkhanids sacked Baghdad in 1258, captured the caliph, and brought about the end of the Abbasid dynasty. Two years later, the formerly nomadic Kipchak Turkic slave-soldiers now known as Mamluks (Arabic for owned or property) defeated the Mongols at 'Ain Jalut (Israel)—the first significant Mongol defeat. The Mamluks had mutinied against the Ayyubids and captured King Louis IX of France, ending the Seventh Crusade. The victorious commander at 'Ain Jalut, Sultan Baybars I (1223–77), made his capital at Cairo the dominant city of the Muslim world, and the Mamluks continued to rule Egypt and Syria until 1517. In 1291 they captured Acre, the last European outpost in the Holy Land, which had been in Christian hands for a century. The western European kings who had held Constantinople since 1204 lost the city in 1261 to the exiled Byzantine emperor in Nicaea. In Europe, conflicts between the French kings and the popes led to seven popes residing in Avignon (southern France) rather than Rome between 1309 and 1377.

In the second half of the thirteenth century, members of the Polo family of Venetian merchants traveled to several Mongol courts and served as diplomats in eastern Asia; Marco Polo (ca. 1254–1324) dictated an account of his travels after he returned. The Muslim traveler Ibn Battuta (1304–ca. 1370) went even farther, from his birthplace in Marinid Morocco to East Africa, Byzantium, India, China, and Indonesia. The increasing mobility of people had a negative side effect: traveling microbes. Bubonic plague (*Yersinia pestis*), the pestilence widely known as the Black Death because of the swollen black pustules that form on the skin of the infected, began in China or Central Asia in the 1330s and was spread by rats and fleas along land and sea routes. It decimated Mongol and Mamluk lands, Byzantium, and Europe, killing about one-third of the population. As the Muslim historian Ibn Khaldun (1332–1406) wrote after his parents in Marinid Tunisia died in the pandemic (1349), it was "a terrible plague that devastated nations and made populations disappear . . . cities and buildings were destroyed, roads and signage obliterated, settlements emptied . . . the whole inhabited world changed."

Work in Focus:
THE COMPENDIUM OF CHRONICLES

As the nomadic Ilkhanids moved west, they settled in Iran, establishing their capital at Tabriz. They linked themselves symbolically with the prestige of the ancient Sasanian kings by building a summer palace near the former fire temple and coronation site at Takht-e Soleyman (fig. 3-35). In 1295 Ghazan Ilkhan (r. 1295–1304) severed ties to the Great Khan in China and converted from Buddhism to Islam, taking the name Mahmud (Muhammad). He became an important patron of learning and the arts and was also an artist himself, expert in woodworking, goldsmithing, painting, and other crafts. The focus of Ilkhanid patronage in the early fourteenth century was books, and illuminated books became a highly prized art form in lands where Persian was the dominant literary language. There was a flurry of copying earlier literary works and the first sustained effort to illustrate them, including Ferdowsi's Iranian epic, the *Book of Kings*, and the animal fables *Kalila and Dimna*. Mahmud Ghazan instructed his vizier Rashid al-Din, a recent Muslim convert from Judaism, to compose a history of the Mongols in a new illustrated text that would promote Ilkhanid dynastic ideology. That work, the *Blessed History of Ghazan*, grew into an even more ambitious project under Ghazan's brother and successor, the sultan Uljaytu (Öljeitü) (r. 1304–16), who commissioned from Rashid al-Din a complementary history of non-Mongolian peoples. These works together constitute the *Compendium of Chronicles* (*Jami' al-Tawarikh*), a history of the world (figs. 9-1 and 9-2).

To complete the project, Rashid al-Din established a charitable complex outside Tabriz called, after him, the

Fig. 9-1. Moses, *Compendium of Chronicles*, 45.1 × 33.6 cm, 1314/15; Edinburgh, University Library, Or MS 20, fol. 8r. © Centre for Research Collections, Edinburgh University Library.

Rab'-i Rashidi or Rashidiyya ("suburb of Rashid"). Even though the complex does not survive because it was plundered after the founder's death, its endowment deed (*waqfiyya*) of 1309 records the resources used to create a suitable environment for promoting literary production and community well-being. It included such structures as a paper mill, caravanserai, teaching hospital, *khanaqah* (a lodge for the Muslim mystics known as Sufis), and the founder's future tomb site. These surrounded a four-iwan courtyard with two mosques and a *kitabkhana* (scriptorium; the Arabic word for book is *kitab*) in which Rashid al-Din's work was copied on large sheets of high-quality paper for circulation across the Ilkhanid realm. Illustrated copies in Arabic and Persian were to be sent to urban madrasas for study and further copying. The complete *Compendium of Chronicles* was divided into four volumes

with about 540 paintings. Volume 1, Mahmud Ghazan's initial commission, included Mongol and Turkic history and legends, from Chinggis Khan to Ghazan. Volume 2 contained a biography of Uljaytu and the histories of the non-Mongol peoples of Eurasia: prophets and patriarchs, beginning with Adam; Muhammad and the succeeding caliphs; Islamic Persia; and the Turkic peoples, China, Jews, "Franks" (Europeans), and India. The third volume consisted of genealogies of the Arabs, Jews, Mongols, Franks, and Chinese; and the fourth was a work on geography and climate. No complete original Ilkhanid copy survives, but parts of the second volume, in Arabic and dated 1314/15, are preserved, with 132 illustrations.

Rashid al-Din's preface to the *Compendium of Chronicles* describes his willingness to recount the histories of non-Islamic lands based on their own oral and written sources,

Fig. 9-2. Negus of Abyssinia (*top*), birth of Muhammad (*center*), Shakyamuni and the devil (*bottom*), *Compendium of Chronicles*, 1314/15; (*t, c*) Edinburgh, University Library, Or MS 20, fols. 52r, 42r, © Centre for Research Collections, Edinburgh University Library; (*b*) London, Nasser D. Khalili Collection of Islamic Art, MS 727, fol. 34a, © Khalili Family Trust.

and his work expresses openness to diverse peoples, religions, and artistic models. In the section on prophets, for instance, the life of Moses is based on the Hebrew Bible and rabbinic sources, including several by the doctor and philosopher Maimon ben Joseph, known as Maimonides (d. 1204), whose family had fled Almohad Spain for Egypt and who is called in Jewish tradition a "second Moses." In the surviving Arabic *Compendium*, the biblical Moses receives special attention in five paintings, plus two more in the section on Jewish history (fig. 9-1). Moses is depicted as a lawgiver, national leader, and administrator of justice who speaks directly to God, here imagined as clouds, following Islamic and Jewish prohibitions against representing the divine (the billowing clouds, rendered with patterns of blue curlicues, resemble those found in contemporary Chinese painting). Just as Moses distributed the Torah to each of the twelve tribes, so too the formerly

Jewish vizier oversaw production and distribution of copies of his world history. Maimonides was a model for Rashid al-Din, who also came from a family of physicians, lived under foreign rule, and immersed himself in political and intellectual life.

Tabriz was a cosmopolitan hub that had two Franciscan monasteries, and the waqfiyya tells us that the Rashidiyya staff was multiethnic: it comprised Turks, Greeks, Georgians, Indians, Ethiopians, Slavs, Armenians, and others, both freemen and slaves. Illustrations in the *Compendium of Chronicles* differentiate among the peoples of Eurasia, including the dark-skinned inhabitants of Ethiopia (fig. 9-2 *top*). In this scene, the pious Christian ruler of Abyssinia (Ethiopia), whose formal title was *negus*, is refusing to release to hostile Arabs about one hundred Muslims who, at Muhammad's urging, had fled across the Red Sea to avoid persecution in Mecca. This event, which supposedly

occurred in 615, marked the first spread of Islam beyond the borders of the Arabian Peninsula. The crowned negus addresses the polytheistic Arabs (members of Muhammad's tribe, the Quraysh), who are light-skinned and wear turbans, while the bearded, dark-skinned Muslims sit on the opposite side of the throne. Abyssinian servants are at the edges; their colorful patterned skirts resemble the garments of the Muslims and the negus. Differences in skin color and clothing indicate who is allied with whom.

Copyists in the Rashidiyya kitabkhana could consult a wide range of models, from Chinese scrolls and woodcuts to Armenian, Byzantine, and European manuscripts. An example of foreign artistic inspiration is seen in the illustration of the birth of Muhammad (fig. 9-2 *center*), which resembles a Byzantine Nativity scene. Muhammad's mother lies prone in the center, like Mary; above her an angel holds a censer of the type used in Christian churches; the three women at the left stand in for the three Magi of the biblical account or for the attendants often shown helping Mary at the birth; and Joseph is here replaced by the Prophet's grandfather. Images of Muhammad (and of earlier prophets) are not prohibited in the Qur'an, although some strictures appear in the hadith and in later legal literature. Such images were especially common in the Persian literary realm from the time of the Mongol invasion until the seventeenth century, but only in manuscript painting—and thus for a restricted, elite audience.

Another illumination reveals reliance on a Chinese model to depict a scene associated with India. In this episode, which Rashid al-Din learned about from a Buddhist priest, the seated Shakyamuni—the founder of Buddhism, who lived during the sixth century BCE—gives food to the devil (fig. 9-2 *bottom*). The Buddha here resembles the many imperial images in the *Compendium of Chronicles* except for his shoeless, turned-out feet; instead of being shown bare-headed, he wears the headgear of a Chinese sage. The devil greedily reaches for the pomegranate, and his hunched posture indicates his submissiveness to the erect Buddha.

Rashid al-Din used legendary, scriptural, literary, and historical sources to create a work for his Mongol patrons that portrayed them in words and images as the culmination of a line of Eurasian conquerors. This line went back not only to their Iranian and Turkic predecessors but also to Alexander "the Great" and Alanqua, the mythical ancestress of the Mongol tribes (who was impregnated by a ray of light). The work thereby justifies Ilkhanid rule in Iran, negating Mamluk claims. Just as the Ilkhanate controlled and absorbed many different peoples, the *Compendium of Chronicles* was multicultural in its contents and production, and its author facilitated cultural exchange and knowledge transmission along the Silk Routes. Yet even though Rashid al-Din produced this ambitious work of propaganda for the sultans he served, he was falsely accused of poisoning Uljaytu and was executed in 1318.

A Wider World

The Ilkhanids promoted cultural cross-fertilization at a time when many types of objects and images addressed connections among diverse peoples and far-flung places. A map produced in England about 1300 represents a global and even heavenly perspective (fig. 9-3). The largest surviving medieval *mappa mundi* (Latin for map of the world), it was commissioned by the Hereford bishop Richard Swinfield (r. 1282–1317) to display inside his cathedral. Inked on a single calfskin and enhanced with color and gold leaf, the map was originally part of a wooden triptych in which it was flanked by images of Mary and Gabriel on the wings and Christ in the Last Judgment above (the wooden triptych is lost, but its form and imagery are known from an eighteenth-century drawing). In this way, all of God's creation shown on the map was embedded in a context of Christ's incarnation and human salvation. At the center of the map, the crucified Christ dominates the earthly Jerusalem. With almost eleven hundred Latin labels that identify places, biblical events, animals and plants, people, and mythological scenes, the Hereford mappa mundi is a compendium meant to stimulate understanding and appreciation of the divinely ordained world. The walled Garden of Eden is at the eastern edge, at the top, and England is at the northwestern edge, in the lower left corner. Nearby, the Roman emperor Augustus, anachronistically wearing a papal crown, orders three surveyors to map the world, as if the medieval mappa mundi were the product of an ancient imperial commission. Near the sub-Saharan (right) and Arctic (left) edges of the map are exotic creatures drawn from the first-century *Natural History* by Pliny the Elder; their placement on the periphery underscores their non-Christian, debased status. These include, among many others, sirens, centaurs, hermaphrodites, and cannibals who consume their dead parents; the Ambari (also known as Abarimon), people without ears whose feet face backwards; Blemee (Blemmyae) with mouths and eyes in their chests; and Griste (Gryphae) who cover themselves with the skins of their enemies. An Anglo-Norman inscription in the lower left corner urges, "All who have this history, or will hear or read or see it, pray to Jesus in his divinity to have pity on Richard of Haldingham and Lafford, who made and planned it, and to grant him joy in heaven." Richard was the treasurer of Lincoln Cathedral, which is represented very accurately on the map, but it was the patron's initials—R and S for Richard Swinfield—that were clearly legible to Christ looking down at the map. Through their inclusion in the mappa mundi, both men were interwoven with the broader ethnographic and spiritual geography of the world overseen by Christ.

A portable astrolabe helped sailors navigate the actual world rather than its theological or metaphorical landscapes (fig. 9-4). The device is a two-dimensional representation of a three-dimensional celestial sphere (a projection

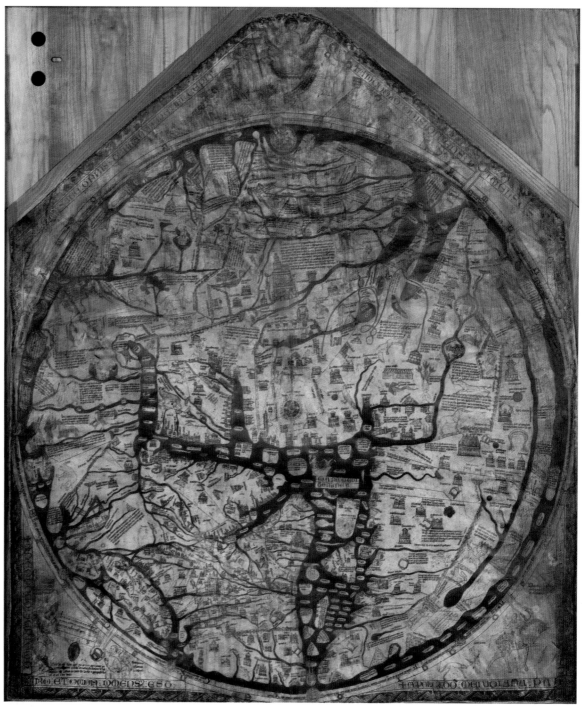

Fig. 9-3. Mappa mundi, 159 × 134 cm, ca. 1300; Hereford Cathedral. Photo from the Chapter of Hereford Cathedral.

of the sky in which the observer is at the center). Circular brass plates represent different latitudes on Earth, marked with local horizons and altitudes. Above this, the silver overlay called the spider or rete has a ring to represent the path of the sun through the sky and pointers to indicate bright stars. The whole device sits in a solid frame, on the back of which is a viewer that can measure the altitude of heavenly bodies, plus scales for determining the position of the sun, the qibla direction for Muslim travelers, and other data. Even though the Greeks had astrolabes by the third century BCE, they were most fully developed as astronomical tools in the Islamicate world, which also produced

numerous treatises on their use. Shown here is one of some 150 extant medieval astrolabes, which were produced from Spain to Central Asia. Its precise date is uncertain because the inscribed titles could refer to several Ayyubid princes of Syria, but it was made sometime between about 1180 and 1300. The artist who designed the spider, the otherwise unknown al-Sahl al-Asturlabi al-Nisaburi (Sahl the Astrolabe Maker from Nishapur), emphasized ornamentation over utility: he depicted the constellations and some individual stars as puppetlike human and animal figures that point only indirectly, with various body parts, to the stars they supposedly represent. Moreover, these stars

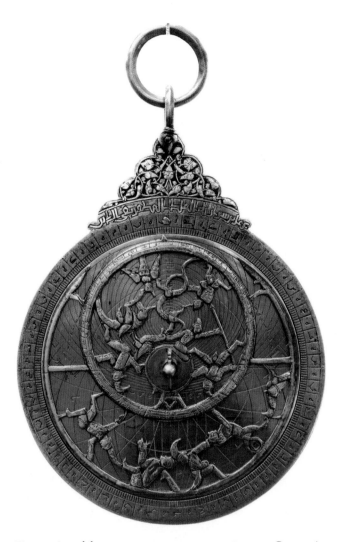

Fig. 9-4. Astrolabe, 25.3 × 16.6 × 2.8 cm, ca. 1180–1300; Germanisches Nationalmuseum, Nuremberg. Wikimedia Commons/Daderot, CC0 1.0.

himself. Four manuscripts survive of a project that must have rivaled in ambition the *Compendium of Chronicles*. Almost all of the poems are illustrated and set to music, and most—353 out of 420 total—narrate miracles associated with the Virgin Mary. Cantiga 25 is typical, and in one manuscript the story is illustrated on facing pages. On the verso, a Christian merchant who borrows money from a Jew shows him a statue of Mary as security for the loan. The merchant neglects to repay the loan until the last minute, when he puts money into a chest and throws it into the sea. On the recto, it floats to Byzantium and is retrieved by the moneylender and his servant (fig. 9-5); the Jew hides the chest and pretends that the money never arrived. The dispute is resolved when the debtor and the lender meet in a church and a statue of the Virgin miraculously speaks in support of the debtor; the Jew converts to Christianity. As in all the songs, Mary ultimately triumphs.

The artist emphasized social, theological, and visual cues about difference. The moneylender wears a distinctive peaked cap, and until his baptism he is shown in profile, highlighting his large, hooked nose, a stereotype that emerged in this period to caricature and identify Jews. In the bedroom where he hides the chest (the scene at the upper right), a curtain parts to reveal his deception. It is decorated with a panel of pseudo-Arabic script, which connects the Jew with another group perceived as anti-Christian, and with two six-pointed stars, a geometric form associated with protection (fig. 6-14). Prominently displayed on the wall behind the Jew's head is a swastika, an ancient protective symbol used from India to western Asia (and in the Americas); like the stars, it was thought to have apotropaic powers and only became associated with racial bias and hatred under the Nazis. The decoration of the moneylender's personal chamber suggested to Christian viewers the Jew's otherness as well as his association with magical power, making Mary's ultimate victory that much greater.

While the Cantigas drew upon diverse peoples and landscapes to assert the primacy of Mary and the Christian identity of Alfonso X, other works that result from cross-cultural fertilization affirm status without such a triumphalist ideology. A large brass basin usually called the "Baptistère de Saint Louis" (Baptistery of St. Louis) was made in the Mamluk-controlled eastern Mediterranean region in the 1320s or 1330s (fig. 9-6). The artist's prayer is incised under the rim—"The work of Master Muhammad ibn al-Zayn, may God pardon him"—and his name reappears five more times. Inlaid with gold, silver, and niello, the vessel's exterior depicts courtiers who hold pets, official insignia, and beakers, while horsemen in roundels fight animals or grasp polo sticks. The band of figural images is sandwiched between friezes of vegetation and running mammals. On the interior, aquatic creatures fill the bottom of the basin; above them, hunters and warriors alternate with enthroned rulers. The quantity and types of

reflect antiquated understandings of the night sky, ones that were current around the year 600. Even though up-to-date astronomical observations were readily available, al-Sahl al-Nisaburi must have copied an older astrolabe or treatise. As a work of little practical value that is more decorative than other examples, this astrolabe may have been made to allude to a patron's travels or learned reputation, enhancing his status. In the fifteenth century, the device shown here was probably owned by Regiomontanus, the leading European astronomer of that time; like its original owner, he must have considered it a compelling showpiece rather than a useful tool.

Traversing the sea and navigating cultural difference are prominent themes in the *Cantigas de Santa María* (*Canticles of St. Mary*), a large collection of poetic songs in medieval Galician, a language related to Portuguese and Spanish. The songs were composed at the behest of King Alfonso X "the Wise" (r. 1252–84) at his court in Castile (Spain). A knowledgeable patron of art, literature, science, music, and law who employed Christian, Muslim, and Jewish scholars, Alfonso may have written some of the songs

Fig. 9-5. Story of the Jewish moneylender, *Cantigas de Santa María*, 50 × 35 cm, ca. 1270–84; El Escorial, Real Biblioteca de San Lorenzo, MS T.I.1, fol. 39r. Photo from Biblioteca del Real Monasterio de San Lorenzo de El Escorial, Patrimonio Nacional.

Fig. 9-6. Inlaid basin, 22 × 50.2 cm, ca. 1320–40; Musée du Louvre, Paris. © Genevra Kornbluth.

figural decoration are unusual in the corpus of contemporary Mamluk metalwork, which typically features floral decoration and inscriptions in a few ornamental bands.

The basin's courtly iconography, unusually dense and varied decoration, and high-quality workmanship suggest that it was destined for a European ruler. Supporting this hypothesis are the small fleurs-de-lys engraved above and below each scene, superimposed on European-style heraldic emblems of a lion and a key. Apparently the piece was personalized after it was complete, most likely for the Lusignan court of Cyprus; Lusignan heraldry incorporated lilies in imitation of the Capetians in France, and their patronage often brought together European fashions, such as the hats, capes, and boots represented on the basin, with western Asian art forms and techniques. Other vessels signed by Ibn al-Zayn are also figural, so he may have specialized in works for foreign clients who preferred such imagery. In the fourteenth century, elites throughout the medieval world valued Islamicate metalwork, and similar basins were exported widely; one was found in the tomb of a late fourteenth- or early fifteenth-century woman in Nigeria (box 9-1). Despite the basin's current name, there is no connection with St. Louis (King Louis IX); it only received this name after being used as a baptismal font for the infant Louis XIII in 1601. With marine life "swimming" on the inside, the inlaid Mamluk basin's original function was most likely for handwashing. It also served to display status and courtly identity in a widely recognizable language.

The Armenians were another Christian community in the eastern Mediterranean region that used artistic motifs associated with other cultures. By the thirteenth century the old kingdom of Armenia, in the South Caucasus region, was no longer intact; it was under Seljuq and then Mongol control. A new kingdom composed of Armenian refugees emerged in the twelfth century at the northeastern edge of the Mediterranean, an area corresponding to the ancient Roman province of Cilicia; after the first king was crowned in 1198, it was known as the Armenian Kingdom of Cilicia. Its rulers made strategic alliances with the Mongols and others and survived for two centuries. Armenian patrons were exposed to artistic and cultural ideas from the nearby crusader kingdoms as well as to motifs from farther east. In a lectionary (a book with scriptural readings arranged in liturgical order) made in 1286 for Prince Het'um II, two headpieces depict phoenixlike birds, dragons, and lions with spiral curls and knotted tails (fig. 9-7). On this page, a clipeus containing an image of the youthful Christ Emmanuel (Isa. 7:14; Matt. 1:23) heads the readings for the feast of the Annunciation. In Chinese art, the dragon and phoenix often represented rulers, and here they may allude to the Armenian king and queen, respectively (Levon and Keran, the parents of the unmarried Het'um). These iconographic motifs probably arrived in Cilicia via Ilkhanid or other Mongol intermediaries. Several Armenian princes and kings visited the Mongol courts in Iran and Central Asia and returned laden with luxurious gifts. It is likely that the Armenian artist adopted motifs that he saw on textiles, metalwork, or ceramics acquired by such travelers and combined them with traditional Christian iconography.

Fig. 9-7. Headpiece, Lectionary of
Het'um II, 33.5 × 24.5 cm, 1286; Yere-
van, Matenadaran MS 979, fol. 293r.
© Mesrop Mashtots Matenadaran.

In this period, popes and kings repeatedly sent envoys
to the Mongol court, often with the goal of converting to
Christianity the people they called "Tatars" or "Tartars,"
after Tartarus, the fearsome underworld in Greek mythol-
ogy. The Franciscan missionary William of Rubruck en-
gaged in a public debate about religion in Karakorum, the
Mongol capital (which he compared unfavorably to Saint-
Denis), before giving up and moving to Cilicia in the 1250s.
Het'um II himself later rejected Armenian Christianity
and became a Franciscan monk, although he remained
active in political affairs; he was assassinated in 1307 by a
Mongol general. After Ghazan Ilkhan converted to Islam
in 1295, the Mongols abandoned the Armenians, resulting
in a decline of royal patronage there until Cilicia fell to the
Mamluks in 1375.

New Realms of Power and Prestige

Uljaytu was the patron not only of Rashid al-Din and the
Compendium of Chronicles but also of another massive proj-
ect: completing the construction of a new capital city, Sul-
taniyya ("Imperial"; Persian Soltaniyeh), initiated by his
father in northwestern Iran. Begun in 1305, the city soon
contained mosques, madrasas, Sufi hospices, palaces, and
other urban amenities, now almost all destroyed. The
largest building was to be Uljaytu's mausoleum, but he

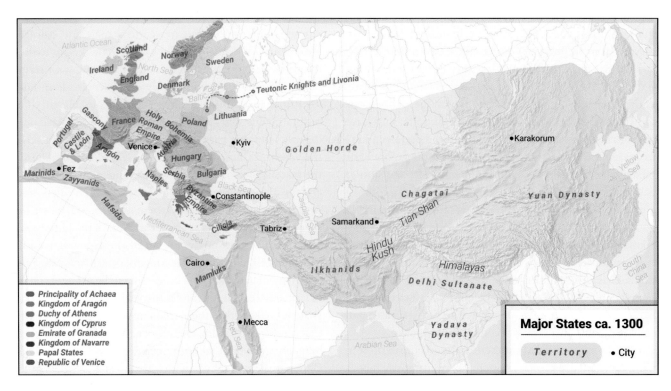

- Principality of Achaea
- Kingdom of Aragón
- Duchy of Athens
- Kingdom of Cyprus
- Emirate of Granada
- Kingdom of Navarre
- Papal States
- Republic of Venice

Major States ca. 1300

Territory • City

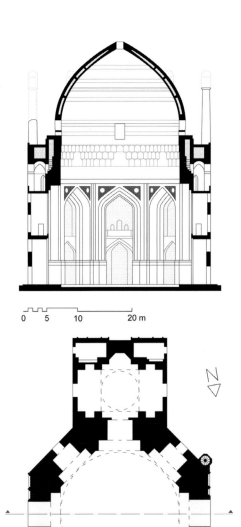

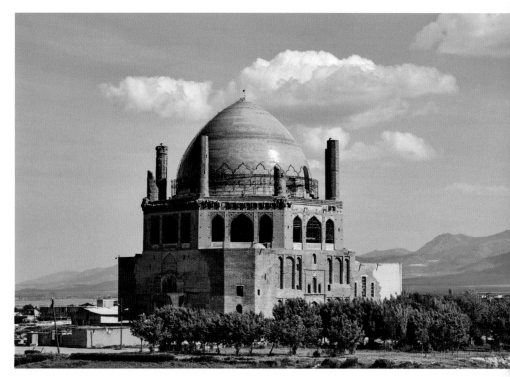

decided that it also would be a shrine to 'Ali and Husayn, the two saints of Shi'i Islam, to which he had recently converted after periods as a polytheist, Christian, Buddhist, and Sunni Muslim. Uljaytu intended to move the bodies of the Shi'i martyrs from Najaf and Karbala (Iraq), but this never happened, and the only person buried in the Sultaniyya mausoleum was Uljaytu himself. In plan it is a massive octagon, thirty-eight meters in diameter (fig. 9-8). This domed building recalls the tenth-century Samanid mausoleum in Bukhara (fig. 5-26), and its octagon evokes the Dome of the Rock (figs. 4-1 and 4-3), but Seljuq mausolea in Iran provided more direct inspiration. The tomb is aligned with the four cardinal points, in accord with Mongol tradition, rather than being oriented toward Mecca. The facade is decorated with tall blind arches below an open gallery arcade. A tall, cylindrical minaret rises at each corner, framing an enormous, pointed dome that rises fifty meters above ground and is clad on the exterior with turquoise glazed bricks. The total of eight minarets is very unusual; the Great Mosque at Mecca had only seven, and it seems that Uljaytu intended to create an even grander Islamic

monument. Indeed, the building, with its complex silhouette and massive turquoise dome, dominates the landscape and proclaims Uljaytu's presence and power. In the two-story interior, the two main axes are distinguished from the corner bays by their more elaborate tilework and by muqarnas vaulting in the upper story. Between the building's completion in 1313/14 and Uljaytu's death in 1316, a space for family cenotaphs (tomb monuments without bodies) was added to the south side, separated from the main gathering space by a metal grille. The whole interior was then redecorated: stuccoed ornament on the wall and dome is painted with decorative patterns and inscriptions, and Qur'an excerpts and hadiths about pilgrimage and circumambulation draw connections between the building and the Ka'ba. Both the scale of Uljaytu's works and the design of his domed tomb inspired his successors and rivals in Iran, Central Asia, and India for centuries.

Mamluk architectural patronage focused on multifunctional public structures, a new architectural typology that showcased the sultan's largesse. In 1284 Sultan al-Mansur Sayf al-Din Qala'un (or Qalawun; r. 1280–90) commissioned a large pious foundation (*waqf*) in Cairo that was completed in less than two years; the speed with which it was finished, and the resources needed to make that happen, signaled the project's importance and the ruler's power. Facing the city's main north–south avenue on the site of a destroyed Fatimid palace, the sixty-seven-meter-long crenellated facade with a three-story minaret at the

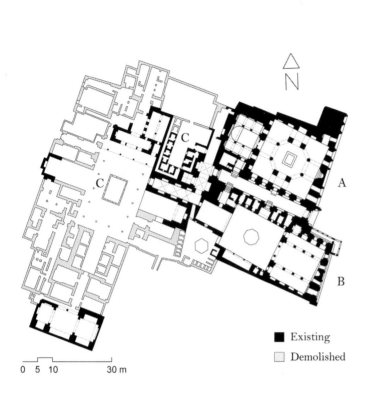

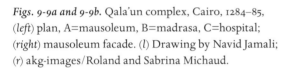

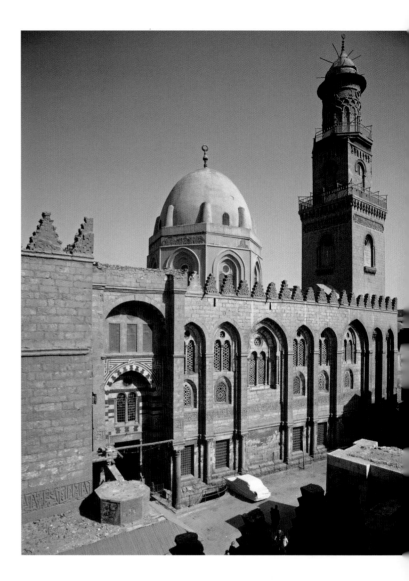

Existing

Demolished

0 5 10 30 m

Figs. 9-9a and 9-9b. Qala'un complex, Cairo, 1284–85, (*left*) plan, A=mausoleum, B=madrasa, C=hospital; (*right*) mausoleum facade. (*l*) Drawing by Navid Jamali; (*r*) akg-images/Roland and Sabrina Michaud.

right (north) end is dominated by a large relief inscription that gives the name of the sultan, his many titles, and the date (fig. 9-9b). This grand facade served as a monumental backdrop for Mamluk military processions. At the center of the facade, a massive entrance adorned with contrasting black-and-white joggled voussoirs and strapwork (intertwined bands) leads to a narrow, roofed corridor that bisects the complex (fig. 9-9a). At the far end is the large hospital, which reused carved wood from the earlier palace. According to the foundation document, the hospital was to serve Muslims free of charge regardless of sex, age, social status, or moral standing, prioritizing those in greatest need of care. The hospital was rebuilt, with some of the same functions, in the twentieth century. Off the corridor to the left is the madrasa, with four iwans of different sizes to house the four Sunni schools of jurisprudence; the largest, with a mihrab, was also used for prayer.

To the right of the corridor is Qala'un's domed mausoleum (the current concrete dome is an early twentieth-century replacement) (fig. 9-10). It is decorated with marble panels, stucco, and a gilded vine frieze that imitates Umayyad predecessors in Damascus and Jerusalem. The octagonal space that contains the cenotaphs of Qala'un and his

youngest son, Sultan al-Nasir Muhammad (r. 1299–1309, 1310–41), is separated from the surrounding ambulatory by a wooden screen donated by the latter. In its architecture, materials, and iconography, Qala'un's complex refers to earlier revered buildings: the Dome of the Rock, the Great Mosque of Damascus, and the first combined madrasa and mausoleum in Cairo, built in the 1240s by a grandson of Salah al-Din just across the street. That other complex was where new Mamluk emirs had sworn allegiance to the sultan, but the tomb of Qala'un took over this function. In addition, the tomb became a site of public devotion and perpetual prayer, recited around the clock and audible on the street outside due to the large windows on the facade.

On the other side of North Africa and at a much more intimate scale is a madrasa erected by the Marinid sultan in Fez (Morocco) between 1323 and 1325 (fig. 9-11). Called the 'Attarin (Perfumers') Madrasa for its location at the entrance to the spice and perfume market, this was one of nine such educational institutions erected by members of this Amazigh dynasty in their capital city. The rectangular courtyard of the madrasa is sumptuously decorated with glazed mosaic tiles below densely carved stucco and a carved wooden cornice. It opens into a square prayer hall

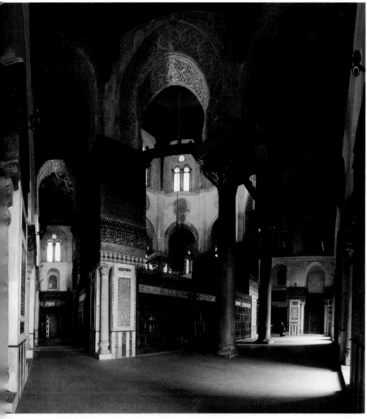

Fig. 9-10. Mausoleum interior, Qala'un complex, Cairo, 1284–85. AhmedAlbadawyPhotograph © 2020.

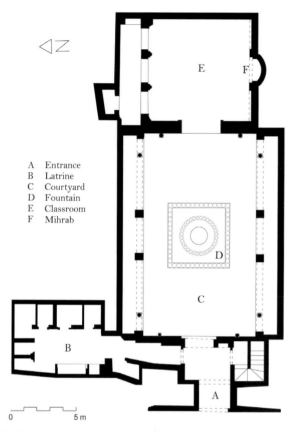

A Entrance
B Latrine
C Courtyard
D Fountain
E Classroom
F Mihrab

0 5 m

Figs. 9-11a and 9-11b. ʿAttarin Madrasa, Fez, 1323–25, (*top*) plan; (*bottom*) courtyard. (*t*) Drawing by Navid Jamali; (*b*) Jeremy Rodriguez, Miami, FL.

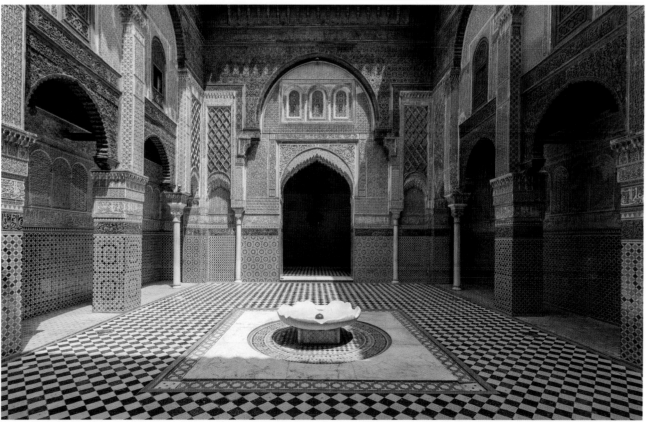

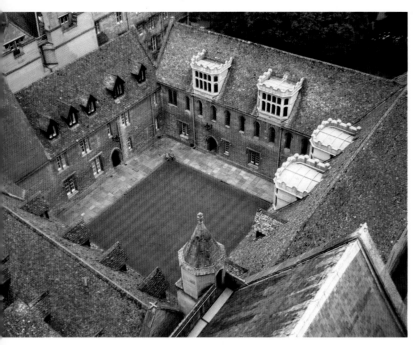

Fig. 9-12. Merton College Quadrangle, Oxford, ca. 1288–1310. Wikimedia Commons/DWR, CC BY-SA 2.5.

adorned with tiles, carved wooden arches, stained glass, stucco, and a cedarwood dome. The thirty rooms for students are undecorated; their classes were held in the prayer hall. An inscription on a marble capital in the courtyard is one of many that praise the generosity of the madrasa's founder, Sultan Abu Sa'id Uthman II (r. 1310–31): "the sciences will spread, thanks to those who support them with teaching." Madrasas like this one educated jurists who spoke Amazigh languages and were loyal to the Marinid sultans. Arabic-speaking scholars worked at the adjacent Qarawiyyin Mosque, a venerable center of learning that contains one of the world's oldest functioning libraries. The concentration of teachers and students in Fez needed books and fueled the local economy. A twelfth-century report claimed that four hundred mills manufactured paper from linen and hemp, making the city the largest center of paper production in the western Mediterranean region. Weekly book markets at the Qarawiyyin Mosque attracted buyers from across the Islamicate world; Muslim scholars in the Sahel and savanna regions of West Africa traversed the Sahara in caravans to purchase items in Fez (box 9-1).

In Europe, universities were shifting from loosely organized and decentralized places of learning to well-defined institutions, and wealthy patrons helped give many of them a permanent location and a lasting identity. In the early thirteenth century, students tended to gather in university towns like Oxford and stay in private houses with halls for lectures and study. By 1260, however, benefactors began endowing colleges, in part to "give back" but also to benefit from students and teachers praying for them. Walter de Merton, a high-ranking figure in England's ecclesiastical and royal courts who had served as chancellor of England, founded Merton College in Oxford in 1264 in

order, as he later wrote, to "make some return in honor of [God's] name for the abundance of his bounty toward me in this life." His foundation provided room and board for scholars to teach the seven liberal arts—grammar, rhetoric, logic, geometry, arithmetic, music, and astronomy—while they continued their own studies. The idea of a centralized endowed college was new, without an architectural tradition to guide Merton and his builders. They looked to monasteries and large rural houses for models for this innovative kind of communal living. The chapel, dining hall, and warden's house were built first; they were arranged around a quadrangle much like a monastic cloister. A second residential quadrangle was begun on the south side of the chapel about 1288; it included a treasury, library, and dormitories for students (fig. 9-12). This residential ensemble, later called the Mob Quad, was completed around 1310 and still serves as a dormitory. Student rooms are accessed through entries on the quadrangle, where stairways lead to two rooms per story. No one had private lodgings. Three or four students shared a sitting and sleeping room of roughly thirty-five square meters. Small niches with windows were for their narrow desks; private space was considered more important for study than for sleep. The dorms had no fireplaces, the windows lacked glass, and the ground story's floors were bare earth, yet the quadrangle and others like it shaped campus architecture for centuries.

In Constantinople, the katholikon of the Chora Monastery (now Kariye Camii) was renovated from ca. 1315 to 1321 by the statesman and scholar Theodore Metochites (1270–1332), personal advisor to Emperor Andronikos II Palaiologos. The Greek word *chora* has multiple meanings, including the countryside (the monastery was outside the city walls), the dwelling place of God (i.e., the Theotokos), and the "land of the living" (Ps. 116:9), here referring to Christ. Metochites added additional spaces to the Komnenian core of the church, including a funerary parekklesion to the south and inner and outer narthexes to the west (fig. 9-13a). A bell tower (now replaced by a minaret) and a single flying buttress, both features of European church architecture, were also built, imitating additions made to Hagia Sophia during the period of Latin occupation. At the Chora, the mosaic in the lunette over the central door into the naos depicts the patron, echoing Hagia Sophia's similarly asymmetrical mosaic of an emperor and Christ in the same location (fig. 9-13b; compare fig. 5-10). Metochites wears an elaborate headdress and offers a model of the church to Christ. The inscription on the left gives him the empire's most important official title, in charge of imperial revenue, and his role as chief tax collector may have inspired a mosaic in the outer narthex. In this unusual image, Christ's Nativity is juxtaposed with his parents' enrollment in the census for the purpose of taxation (Luke 2:1–3), implying that taxes are an important feature of good government and citizenship; the biblical tax official's

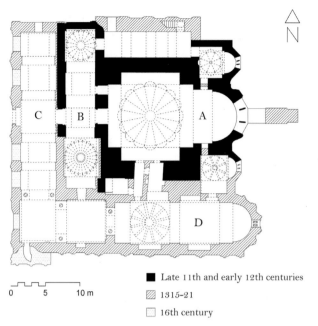

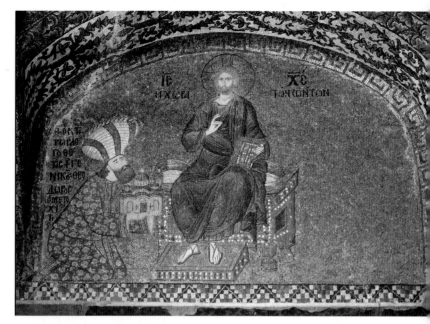

Figs. 9-13a and 9-13b. Chora Monastery, Constantinople, (*left*) plan, eleventh–sixteenth centuries, A=naos, B=inner narthex, C=outer narthex, D=parekklesion; (*right*) mosaic above central door, inner narthex, ca. 1315–21. (*l*) Drawing by Navid Jamali; (*r*) Photo by Brad Hostetler.

Legend:
- ■ Late 11th and early 12th centuries
- ▨ 1315–21
- ☐ 16th century

0 5 10 m

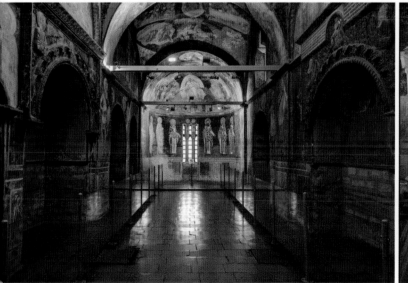

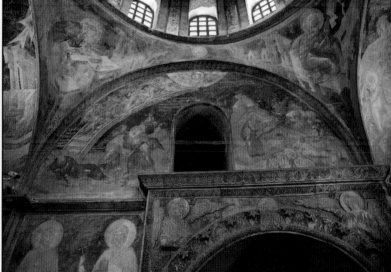

Fig. 9-14. Parekklesion, Chora Monastery, Constantinople, ca. 1315–21, (*left*) interior toward the east; (*right*) frescoes and top of Theodore Metochites's tomb. (*l*) depositphotos/Koraysa; (*r*) Images&Stories/Alamy Stock Photo.

prominent headdress also echoes that of Metochites. Renovation of the Chora was intended, like all medieval church and monastery foundations, to advertise the donor's piety and ensure future salvation, but in this case it also helped dispel the popular notion that Metochites was greedy and exploitative.

Whereas the Chora naos and narthexes were decorated with marble revetment, stained glass, and mosaics that narrate the lives of Mary and Christ, the funerary chapel was covered with frescoed scenes of the Last Judgment and Anastasis, expressing the hopes of the aristocratic individuals whose arcosolium tombs were inserted into its side walls (fig. 9-14 *left*). Gilded, painted marble frames

bear commemorative inscriptions and shelter images of the deceased. Metochites occupied the largest tomb, at the far left in the photo, which was connected to the naos by a passageway and illuminated by windows in the ribbed dome above. Above the tomb and to the left is a fresco of Jacob's ladder, one of many Old Testament types for the Theotokos depicted in the parekklesion (fig. 9-14 *right*). Mary was understood as a link between humanity and salvation, and the biblical passage about Jacob's ladder (Gen. 28:12) was read before major feast days in her honor. In the pendentive above, a hymn writer who was a monk at the Chora in the ninth century is shown composing a chant to Mary that was recited during funeral liturgies.

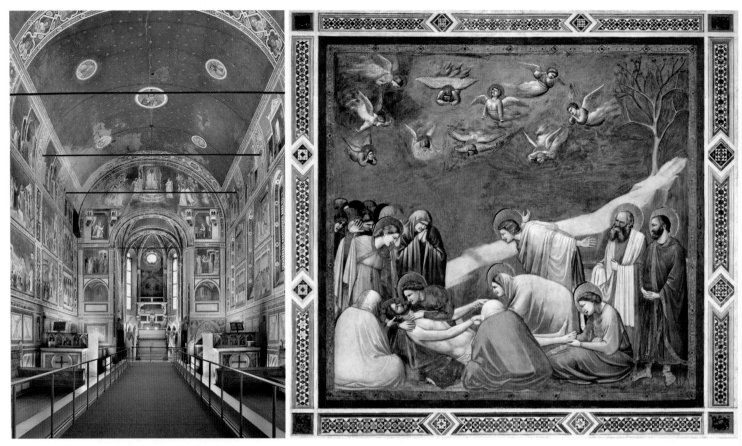

Fig. 9-15. Scrovegni Chapel, Padua, ca. 1305, (*left*) view toward the east; (*right*) Lamentation.
(l) © 2020 Gabriele Croppi/Scala, Florence; (r) Alfredo Dagli Orti/Art Resource, NY.

And in the Last Judgment fresco in the domical vault to the east, Christ himself gestures with his right hand toward Metochites's final resting place. The patron's exalted presentation throughout the Chora thus demonstrates not only his status and self-importance but also how he was favored by Christ, from whom he hoped to benefit especially after death. This favor did not last in life: when Andronikos II was overthrown by his grandson in 1328, Metochites was stripped of his power and possessions, and he died a poor monk at the Chora.

Anxieties about wealth also lay behind the chapel in Padua (Italy) dedicated to St. Mary of Charity but better known as the Scrovegni Chapel, after its patron, Enrico Scrovegni (fig. 9-15 left). Like his father before him, Enrico was a banker, and the poet Dante Alighieri (1265–1321), in his famous *Inferno*, placed Enrico's father in the worst circle of Hell because he was a usurer: he loaned money at interest. Most historians think that Enrico was also a usurer and that his patronage of the chapel, adjacent to the family's palace, was intended to atone for this family sin; others assert that the Scrovegni Chapel advertised family status without an undertone of guilt. What is certain is that Enrico hired well-known artists, the Florentine painter Giotto di Bondone (ca. 1270–1337), who may also have been the architect, and the Pisan sculptor Giovanni Pisano (ca. 1250–ca. 1315). The single-nave, barrel-vaulted chapel was begun around 1303 and consecrated in 1305.

Giotto's fresco cycle, which covers the entire interior, begins on the arch that frames the apse, where God, painted on an inserted wooden panel, calls Gabriel to announce to Mary that she will bear a son. The narrative begins on the upper register, where scenes of Mary's life expand beyond biblical accounts to include her parents, conception, and childhood; Christians in this period sought to understand her life more fully and to see how it paralleled that of Jesus. The Marian stories move into scenes of Jesus's life, wrapping around the sides of the chapel from top to bottom in three registers and culminating in the Last Judgment that fills the west wall. In the lowest zone are grisaille (monochrome) figures of Virtues and Vices. The blue backgrounds and vault are lapis lazuli, which, because it was applied on top of the plaster rather than being integrated with it, has flaked more than the other colors.

Giotto's innovation was to paint monumental, solid-looking figures who display natural emotions and fill convincing spatial and architectural settings; the sacred stories seem physically present and psychologically authentic (fig. 9-15 *right*). His interest in antiquity is seen in the corporeal figures and profile faces reminiscent of antique coins (fig. 2-1), reversing the pejorative connotation of this pose. Yet even though the Italian artist Cennino Cennini (ca. 1370–ca. 1440) asserted that Giotto "changed the art of painting . . . and made it modern" by breaking with the Byzantine-influenced painters who came before

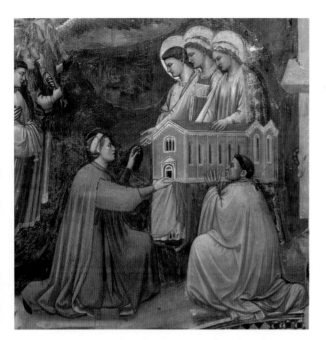
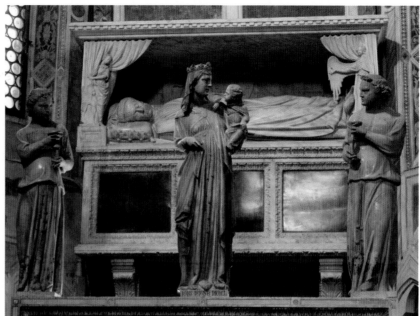

Figs. 9-16a and 9-16b. Scrovegni Chapel, Padua, ca. 1305, *(left)* detail of Last Judgment; *(right)* tomb of Enrico Scrovegni, ca. 1336. (*l*) akg-images/Cameraphoto; (*r*) Wikimedia Commons/Oursana, CC0 1.0.

him, this emotionalism was not new; it had precedents in western European and Byzantine art, as the Lamentation scene at Nerezi shows (fig. 8-27). Nevertheless, Giotto's work brought him lasting fame and was widely imitated.

In the Last Judgment scene, Enrico Scrovegni leads the elect on their way to Heaven as he and a white-robed priest present a model of the chapel to the Virgin flanked by women saints (fig. 9-16a). On the other side of the composition, usurers hanging from money bags are prominent among the tortured damned. Enrico (d. 1336) was buried behind the altar at the chapel's east end in a tomb designed by Giovanni Pisano. Small angels pull back the curtains on a bier tilted to reveal Enrico's unidealized body, his brow deeply furrowed as if he has just died (fig. 9-16b). This naturalism had precedents in ancient Roman sculpture, which artists in Italy in the late thirteenth century were studying. By engaging the most talented artists, Enrico Scrovegni rehabilitated his reputation and perpetuated his memory. Other wealthy or distinguished patrons in this period also hired the best available talent, but outside of Italy, the names of the majority of European artists and architects are no longer known.

After Byzantine control of the Balkans weakened in the eleventh century, a new Slavic principality known as Serbia emerged in what is now Serbia, Kosovo, and North Macedonia. A former ally of Byzantium, Stefan Nemanja (1112–99; Grand Prince of Serbia, r. 1166–96), achieved independence from the Byzantines in the late twelfth century and inaugurated a new ruling dynasty, the Nemanjids. After he died and myron reportedly began to flow from his tomb, he became the first Serbian national saint and was venerated under his monastic name, Symeon. The Nemanjids were great patrons of architecture, establishing

monasteries that would hold their tombs and solidify Church support for their rule. The monastery church at Dečani (Kosovo) was founded by Nemanja's great-great-grandson Stefan Uroš III (r. 1322–31); it was dedicated to the Pantokrator in honor of the monastery of the same name in Constantinople where he had been exiled (fig. 7-30b). King Stefan Uroš III is known as Stefan Dečanski because of this building (fig. 9-17).

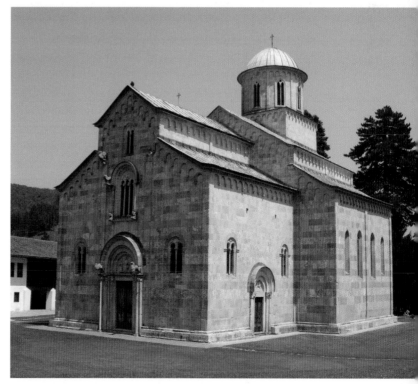

Fig. 9-17. Monastery church, Dečani, 1322–31. Wikimedia Commons/Julian Nyča, CC BY-SA 4.0.

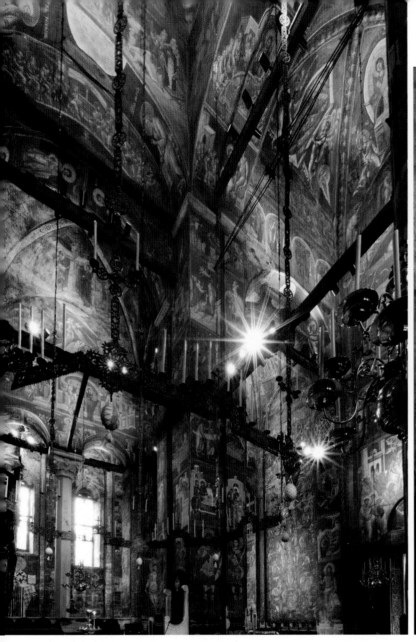

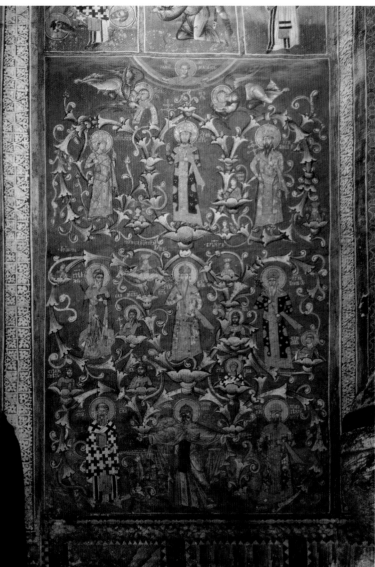

Fig. 9-18. Monastery church, Dečani, 1332–55, choros and interior toward the southwest. © Genevra Kornbluth.

Fig. 9-19. Serbian royal family tree, narthex, monastery church, Dečani, 1332–55. © Genevra Kornbluth.

According to an inscription on the lintel of the south portal, the architect of Dečani was a Franciscan monk named Vita from Kotor (Montenegro), on the Adriatic coast, and on the outside the monastery church looks more European than Byzantine. It is a five-aisle basilica sheathed in marble with figural relief sculpture, including a continuous blind arcade supported by figural corbels in the western European fashion. Yet it still has the Byzantine-style dome over the naos, and its original bronze *choros* (circular chandelier) is suspended from the dome, in imitation of Byzantine church lighting (fig. 9-18). Furthermore, the interior is covered with Byzantine-style frescoes dated by Slavonic inscriptions to the reign of Dečanski's eldest son (and likely murderer), Stefan Uroš IV Dušan (r. 1331–55). Dečanski was buried with his wife in the naos, but after miracles occurred at his tomb and he was proclaimed a saint in 1343, his intact body was moved to a carved wooden coffin positioned alongside the stone chancel screen, next to the entrance into the sanctuary. An image of the sainted founder, dressed as

a Byzantine emperor and presenting the church to Christ, was painted immediately above the reliquary.

Dečani boasts the largest assemblage of frescoes from the Orthodox world. It contains thousands of individual figures and hundreds of scenes, from the expected Christological cycles to saints' lives, scenes from the Acts of the Apostles, and a painted menologion (calendar of saints) in the narthex that shows who is venerated each day of the year. One prominent image, on the east wall of the narthex behind the baptismal font, is a family tree of the Nemanjid dynasty in the form of a Tree of Jesse (fig. 9-19). The root of the tree is not the biblical Jesse (fig. 7-45), however, but St. Symeon, and the uppermost "fruit" is not Christ but Stefan Uroš IV Dušan; the image therefore conveys his saintly origins. In a clear proclamation of Serbian ideology, this final patron of Dečani—who in 1346 adopted the title of tsar (emperor, from the ancient Roman title *caesar*) of the Serbs, Greeks, and Bulgarians—is being blessed by Christ and adored by angels.

Collective Identities

The palace chapel in Paris known as the Sainte-Chapelle (Holy Chapel) exemplifies French power and Capetian identity (fig. 9-20). The Capetian dynasty ruled an expanding kingdom in France beginning in 987, but its heyday was from the late twelfth century to 1328, when the last king had no male heir and the family died out. The most famous member of the family was King Louis IX (r. 1226–70), the only French ruler to be canonized (1297). Deeply devout, Louis helped strengthen Christian identity in part by actively prosecuting Christians he considered heretics in southern France and by overseeing the burning of Jewish books in Paris (1243). He also commissioned a two-story chapel akin to a monumental reliquary to display relics of Christ purchased in 1239 from the Latin emperor of Constantinople. The most notable of these relics was the crown of thorns allegedly placed on the head of Jesus before his crucifixion (fig. 4-23). Attached to the royal palace in Paris and a two-story treasury tower, the Sainte-Chapelle was begun in 1239 and completed in 1248. While its dimensions accord with those of Solomon's palace in 1 Kings 7, a likely model for the scale, porch, and decorative splendor of Louis's building was the relics chapel in the imperial palace at Constantinople, where the relics had previously been housed. Nevertheless, the particulars of its architectural and sculptural forms were more local, inspired by such buildings in northern France as the cathedral of Chartres. The style of the Sainte-Chapelle is called *rayonnant* (French for radiating); this term comes from the

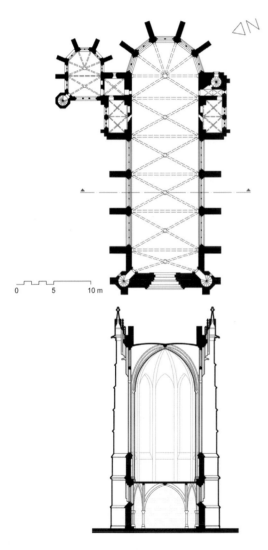

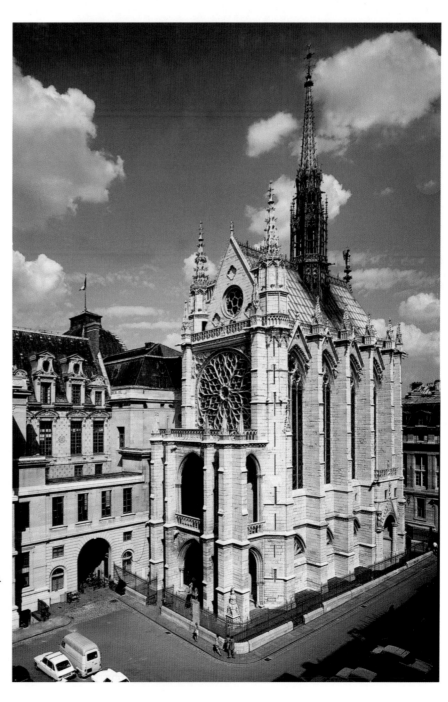

Figs. 9-20a and 9-20b. Sainte-Chapelle, Paris, 1239–48, (*left*) plan and section; (*right*) view from the southwest. (*l*) Drawings by Navid Jamali; (*r*) De Agostini Picture Library/Bridgeman Images.

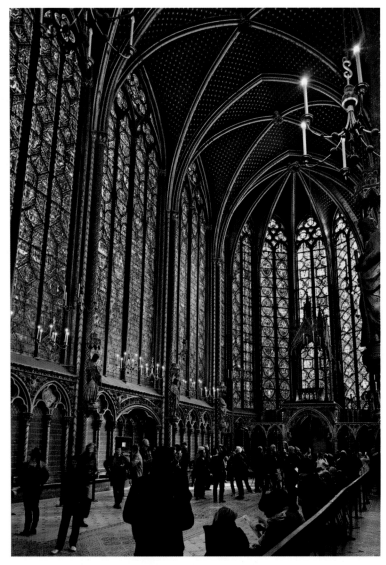

Fig. 9-21. Upper church, Sainte-Chapelle, Paris, 1239–48, view toward the east. Photo from Shutterstock/Heracles Kritikos.

thin bars of radiating tracery used in many rose windows of the time (the Sainte-Chapelle's current rose is later in date, however). Other motifs associated with the rayonnant style include thin walls, steep gables, and tall, spiky pinnacles. A building boom in thirteenth-century Paris led to many churches being constructed in this style, thereby giving the city a unified and distinctive visual identity linked to the king.

Inside the upper church of the Sainte-Chapelle, a dado embellished with paintings, enamels, and figural sculpture supports walls of stained glass reinforced by narrow strips of masonry (fig. 9-21). Most of the fifteen windows have Old Testament subjects, but the apse windows are Christological. When the crown and other relics were displayed in their large, elevated case, they aligned with the Passion window at the center of the apse, where Christ is depicted wearing the crown of thorns. Among the other windows, themes related to kingship—coronation, genealogy, justice, protection of the kingdom from evil, good government— underlay the choice of scenes. Heraldry is prominent, with

Louis's emblem, the fleur-de-lys, alternating with the castles that represent his mother, Blanche of Castile (d. 1252), who had fostered Louis's intense Christian piety. The first window on the right, visible to anyone entering and well lit thanks to its location on the south side, narrates the story of the Passion relics' arrival in France. In glass, texts, and civic and liturgical performances, these relics became tools of propaganda that created a new cultural and national identity for their royal owners. They affirmed that Christ had selected France as the latest site for veneration of his Passion, making Paris a new Jerusalem, France a new Holy Land, and the Capetian kings the divinely anointed protectors of Christendom. The fact that all the Capetian-led crusades failed to achieve their goals did not undermine this view. Louis IX himself died in Tunis on his second crusading mission.

The reign of the Capetians coincided roughly with that of the Zagwe dynasty (ca. 1000–1270), which ruled the central Ethiopian highlands. Its most revered king was Lalibela, whose patronage is associated with the complex of eleven churches that bears his name (see figs. I-14a, I-15, and I-17). Like the House of Mary, the nearby House of St. George (Beta Giyorgis) is monolithic, connected to the rest of the complex by a system of trenches (fig. 9-22). It, too, was excavated from the top down, by subtracting small chips of stone. Its plan is that of an equal-arm cross, and the cross shape is also repeated in relief on the roof. The church was carved sometime between the thirteenth and fifteenth centuries. A hagiographic vita of King Lalibela (written in the late fourteenth or early fifteenth century) identifies the House of St. George as the last of the site's churches; it also asserts that its dimensions were dictated by God and created with the help of angels. Some of the churches are named for Christian sites (Golgotha, Cross, Bethlehem), and the vita states that the complex was a symbolic representation of Jerusalem, a substitution for the original that was less accessible because it was in Muslim hands. Flowing through Lalibela is a stream that the Zagwe renamed the Yordanos (Jordan) River, and the House of St. George is surrounded by rock-hewn baptismal fonts that evoke Jesus's baptism in the Jordan. This sacred topography affirmed the Christian identity of northern Ethiopia in general and of Lalibela in particular, contrasting it with the Muslim lands in the south. Like the Sainte-Chapelle, the monumental rock-hewn churches of Lalibela are a remarkable display of technological achievement in the service of royal aggrandizement that celebrate the king's—and his people's—connections to the Holy Land.

Medieval Jews were also determined to demonstrate their connection to the land of the Bible, even if they no longer wielded any political control there. One way this was expressed was during the holiday of Passover, when Jews recall their enslavement in Egypt and exodus toward the land promised to them by God, retelling the story at the ritualized meal, the seder. This key example of God's

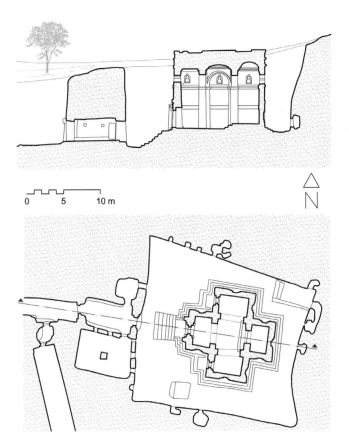

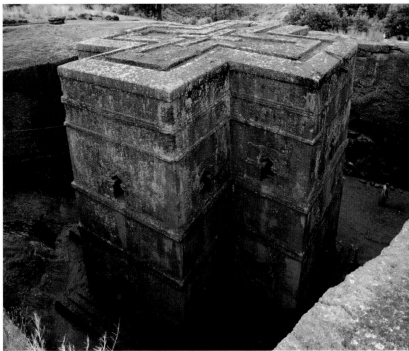

Figs. 9-22a and 9-22b. House of St. George, Lalibela, ca. thirteenth–fifteenth century, (*left*) plan and section; (*right*) exterior. (*l*) Drawings by Navid Jamali; (*r*) Photo from TravelMuse/Alamy.

aid was commemorated in Jewish liturgy from the outset, but only in the thirteenth century was a separate book used for family celebrations. This book, the haggadah, began to be illustrated around 1300, contemporary with the increased illustration of Christian books for laypeople. The Sarajevo Haggadah was made in the kingdom of Aragón (northeastern Spain) in the second quarter of the fourteenth century (fig. 9-23). Jewish people who lived in the Iberian Peninsula, and later in Morocco, are known as Sephardic Jews, and their haggadot (plural) begin with biblical scenes from Genesis, Exodus, and Deuteronomy, followed by images of the future rebuilt Temple in Jerusalem and then scenes of contemporary practices for Passover. In the opening shown here, a seated head of the household oversees the distribution of food to men in the community: first *charoset*, a blend of fruit and wine meant to suggest the mortar used by the Jewish slave laborers in Egypt, and then matzo, the flat bread that, in the Jews' haste to leave Egypt, did not have time to rise. In the facing scene, parents and children leave the synagogue, heading home to their own family seders. The synagogue is depicted as a stone building with arched windows and a doorway through which the open case for the Torah scrolls is visible; a woman reaches up reverently toward them. The scrolls are covered in patterned textiles and flanked by hanging lamps of the type used in mosques. In its scenes of biblical history and medieval Sephardic life, the Sarajevo Haggadah affirmed a proud Jewish identity and, at the same time, indicated Iberian Jews' participation in the wider world of illustrated books and material culture.

Jewish identity was also evident in communal synagogues and mikvaot. The oldest synagogue in continuous Jewish use is the Altneuschul in Prague (Czech Republic); Altneuschul is Yiddish (a Jewish vernacular related to German) for Old-New Synagogue; it was called "new" when it was constructed in the 1260s, but after other synagogues were built nearby, it acquired its current name (fig. 9-24). Its two-aisle plan, preceded by a vestibule, was used for synagogues across central Europe among Ashkenazi Jews (those in German- and French-speaking lands, as opposed to Iberian and North African Sephardic Jews). Such a layout was common in secular buildings like markets and hospitals, and it may have been chosen to distinguish the synagogue from contemporary three-aisle church architecture. The unusual fifth rib added to each vault also helped differentiate the space from Christian ones, which favored quadripartite vaulting. The masons and sculptors have nevertheless been identified as the same ones who worked on a local Franciscan convent built at the same time. In the synagogue, the rib-vaulted bays spring from two octagonal piers in the center. These piers also define the *bimah* (bema), the elevated central space where the Torah was read. When not in use, the Torah scroll was housed in a niche in the east wall, facing Jerusalem. Above this niche, the deeply carved tympanum depicts a tree (with twelve roots, for the twelve tribes of Israel), pinecones, and leaves. This is the Tree of Life in the Garden of Eden, understood as a metaphor for the Torah (Prov. 3:18). The same image is carved above the main entrance, and the piers and corbels where the ribs terminate are also carved with a variety of

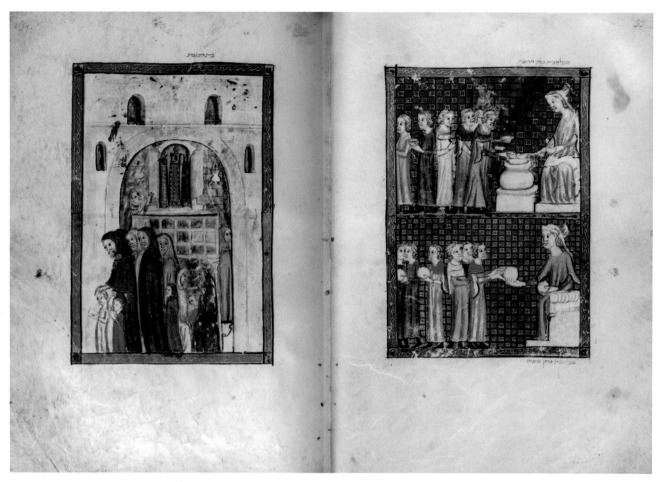

Fig. 9-23. Passover preparations and Jews leaving synagogue, Sarajevo Haggadah, 22.8 × 16.5 cm, ca. 1325–50; Sarajevo, Zemaljski Muzej (no shelf mark), fols. 33v–34r. Photo courtesy National Museum of Bosnia and Herzegovina.

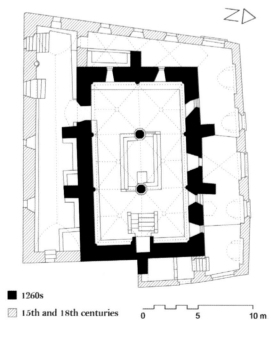

■ 1260s
▨ 15th and 18th centuries 0 5 10 m

Figs. 9-24a and 9-24b. Altneuschul, Prague, 1260s, (*left*) plan, 1260s and later; (*right*) view toward the west. (*l*) Drawing by Navid Jamali; (*r*) © Genevra Kornbluth.

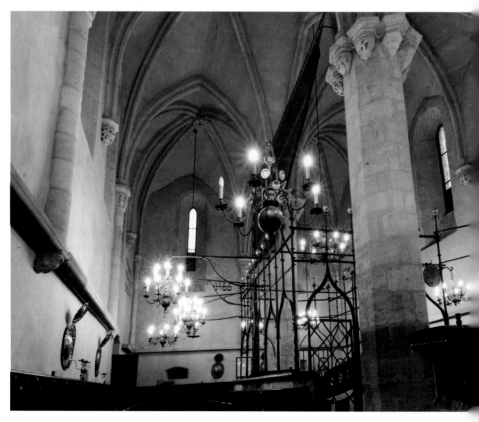

vegetal motifs. A contemporary Jewish sage, Rabbi Meir of Rothenburg (Germany; ca. 1215–93), ruled that such sculpted plant decoration did not violate the second commandment, and even animals would be acceptable as long as they were not too distracting to worshipers. Among potential distractions in synagogues, women were probably perceived as the greatest ones, but they rarely attended. At the Altneuschul, the low rooms later added to the west and north sides are for women's use.

As was the case earlier in the Middle Ages, Christian communal identity could be formed around a saintly figure; this configuration was particularly powerful when that figure was a member of a royal family, as with Louis IX and Lalibela. Olav (or Olaf) Haraldsson (995–1030) was a polytheistic Viking who converted to Christianity, probably in Normandy. After he became king of Norway in 1015, he forcibly promoted the new faith. He was challenged by Cnut (Canute), king of England, Denmark, and Norway; he then fled to Rus' and died trying to regain his kingdom. Olav's body was buried in what would later become the cathedral of Nidaros (now Trondheim, Norway). It was exhumed a year after his death when several miracles reportedly occurred at the tomb. When the body was found to be intact—his hair and nails allegedly continued to grow—Olav was considered a saint by the people of Norway, and this status was confirmed by the pope in the twelfth century (he was also venerated in Europe, Byzantium, and Rus').

Olav is celebrated on a wooden altar frontal or retable probably painted in Nidaros in the early fourteenth century (fig. 9-25); it attests to the increasing elaboration of the altar in Roman-rite churches (fig. 8-10). The haloed saint stands at the center in what looks like an up-to-date thirteenth-century church and is surrounded by scenes from his life and death: counter-clockwise from upper left, he is seen dreaming before his fateful last battle (note the ladder between earth and heaven); he embarks for the battle; he dies from three stab wounds; and his body is found intact in 1031, his wounds still fresh. Earlier images of Olav show him holding the cross-topped orb and scepter that signify rulership, but in the second half of the thirteenth century the scepter was replaced by a tall axe (Olav's actual axe was kept as a relic at Nidaros). The cult of St. Olav blended religion and politics. The Norwegian kings who followed him legitimated their rule by claiming descent from the saint and by building churches in Nidaros. An archbishopric was established there in 1153 because of the presence of Olav's relics, and it became the most important pilgrimage site in Scandinavia; badges of St. Olav were produced beginning in the fifteenth century. Olav was a focus of Norwegian pride and the only Scandinavian saint venerated outside the region until the rise of the cult of St. Birgitta of Sweden in the late fourteenth century.

In 1269 the commune of Siena (Italy), which supported the Holy Roman emperor, fell to its rival, Florence, which

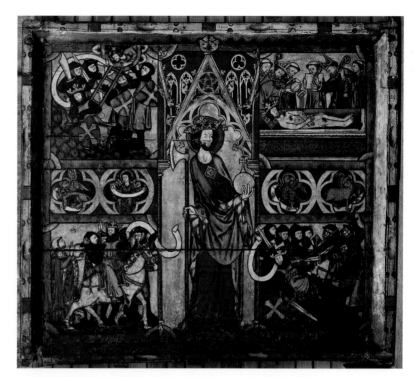

Fig. 9-25. Altar panel of St. Olav, 96 × 108 cm, early fourteenth century; Museet Erkebispegården, Trondheim. © Torgeir Suul, Restoration Workshop of Nidaros Cathedral.

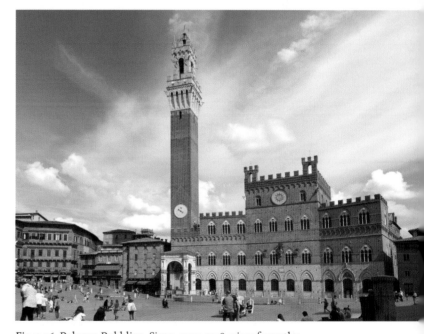

Fig. 9-26. Palazzo Pubblico, Siena, 1297–1348, view from the northwest. © Genevra Kornbluth.

favored the pope and his allies. As a hill town with a limited water supply, Siena could not compete with Florence in textile manufacturing, but its merchants and bankers were involved in the circulation of luxury goods across the Mediterranean and Eurasia, the latter made possible by the Mongols' integration of markets. A new type of government was initiated in Siena in 1286: a small group of men drawn from the leading families who supported the pope. This Council of Nine, elected annually until 1355

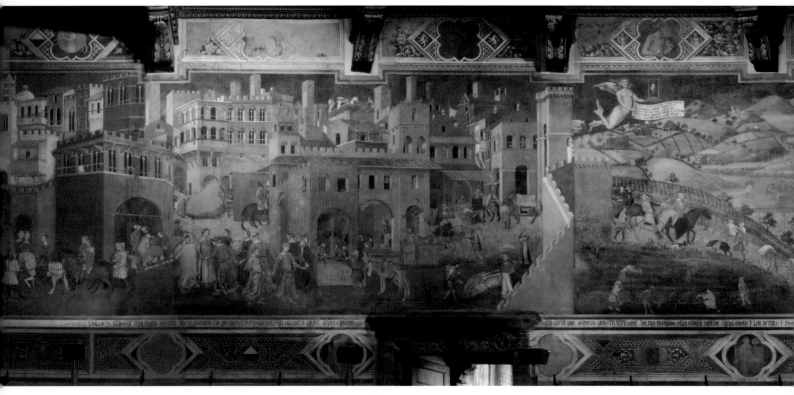

Fig. 9-27. Effects of Good Government, L 14.4 m, Hall of the Nine in the Palazzo Pubblico, Siena, 1338–39. © Genevra Kornbluth.

when it was overthrown, commissioned a new town hall, the Palazzo Pubblico (fig. 9-26). Begun in 1297, it required decades to complete. Its angled facade dominates a semicircular market plaza, the Campo (field), Siena's economic, political, and social center where its main streets converge. The building's ground floor is clad in limestone and the upper stories in brick, below a decorative crown of projecting crenellation. It is likely that brick was chosen to tie Siena visually to Rome, where such early Christian basilicas as St. Peter's and Santa Maria Maggiore were built of that material; in addition, the only sculptures on the Palazzo Pubblico's facade depict she-wolves suckling Romulus and Remus, the mythical founders of ancient Rome (Siena claimed to have been founded by descendants of Remus). The adjacent brick bell tower (88 m tall) was built between 1338 and 1348 to compete with a new tower in Florence. Siena's governing council decreed that all new windows of buildings facing the plaza were to replicate those of the Palazzo Pubblico in order to create a harmonious visual backdrop for public activities. This was a novel attempt to create an urban space with a uniform design that would foster civic pride in a way that was no longer focused solely on the Church.

Council members lived in the Palazzo Pubblico during their two-month term of office, leaving only on feast days or in case of illness. They had it painted with allegorical scenes related to governance. The largest room on the second floor, used for meetings of the legislative council, is decorated with a fresco by Simone Martini of the Virgin and Child adored by saints and angels. In a rhyming text in Italian inscribed on her throne, Mary urges the Nine to govern in accord with moral and theological principles that will ensure harmony. The adjacent Hall of the Nine was painted by Ambrogio Lorenzetti in 1338–39, with some repainting in the late fourteenth century. Opposite the entrance, visitors saw an allegory of bad government and its effects on the city and countryside: personified Terror, complete with fangs and horns, presides over vices and the bound figure of Justice. The personifications are as creative as they are disturbing. Division, who wears a black-and-white shirt that says "Si" (yes) on one side and "No" on the other, saws herself in half, and Cruelty strangles a baby while scaring it with a snake. Turning to face the north wall, visitors saw painted personifications of Justice, Wisdom, Peace, and the Good Commune. At the feet of Good Commune, a wolf suckles Romulus and Remus. Finally, as visitors exited, they walked past the depiction of the effects of good government on the city and countryside (fig. 9-27).

The city is clean and filled with life, including a group of people holding hands and dancing; they might be a troupe of traveling male actors rather than local women. Outside the city gates, well-dressed hunters carry their birds of prey and farmers sow and harvest peaceful fields; agricultural activities undertaken at different times of the year are shown happening simultaneously (like the summer and winter plants blossoming on the Ara Pacis, fig. 1-8).

Scenes of celebration, leisure, commerce, and labor all unfurl along the Via Francigena, an ancient Roman road that passed through Siena and linked French pilgrimage sites with Rome, southern Italy, and ultimately the Holy Land. Lorenzetti's frescoes are the largest depictions of cities and landscapes in all of medieval art, apart from the idealized landscapes in the Great Mosque of Damascus (fig. 4-8). The Palazzo Pubblico and its art both responded to and helped shape Siena's identity as a prosperous city under Mary's protection.

Sex and Gender

An altar frontal probably painted about 1330 for the church of St. Eugenia at Saga in the Pyrenees (northern Spain) offers clearer evidence of medieval attitudes toward cross-dressing than the ambiguous dancers in Siena (fig. 9-28). Dozens of examples in histories, hagiographies, and literary works suggest that it was not uncommon for medieval women to pose as men in order to escape traditional female roles. Hildegard of Bingen, for example, permitted cross-dressing to preserve a woman's chastity or a man's life, and a thirteenth-century Jewish source from Germany permits Jewish women travelers to disguise themselves as Christian nuns or as men to avoid sexual assault. A Dominican chronicle of about 1250 even recalls a pope who gave birth during a procession—the fictitious Pope Joan, who was stoned to death as a result. The altar frontal

Fig. 9-28. Altar frontal of St. Eugenia, 100 × 150 cm, ca. 1330; Musée des Arts Décoratifs, Paris. © Les Arts Décoratifs, Paris/ Jean Tholance/akg-images.

Fig. 9-29. Historiated initial, Gradual of Gisela von Kerssenbrock, 35.5 × 26 cm, ca. 1300; Osnabrück, Diözesanarchiv, Ma 101, fol. 13v. Photo from Bistumsarchiv Osnabrück/ Wachsmann.

shows the story of Eugenia, an educated Roman teen in third-century Egypt whose vita was written a few centuries later. Beginning at the upper left, Eugenia leaves her parents' home in the company of two eunuchs and is baptized: the halo anticipates her saintliness, while her hands draw attention to her breasts. Eugenia becomes a monk named Eugenius and then an abbot. According to the written sources, which continue to use feminine pronouns, she visits and heals a wealthy woman, whose romantic interest she rejects; the woman then accuses her of seduction. In the final scene in the top row, Eugenia is about to reveal her breasts at a trial over which her father presides as judge. In the text, the virile virgin is reunited with her parents and converts them to Christianity, after which they are all martyred. In the painting, the bottom row shows her trial before the Roman emperor and subsequent torments (she

is thrown into a river, then a furnace) that lead to Eugenia's decapitation; her soul is carried up to heaven in the final scene. Conventional masculine attributes in the top register contrast with feminine ones below, but that binary is disrupted in the trial scene. By shifting gender expression, the saint maintained sexual purity, and her charisma and devotion helped to convert her parents. But it was fervent religious faith, rather than cross-dressing, that led to her condemnation, martyrdom, and saintly status in the Roman, Byzantine, and Armenian Churches.

At the turn of the fourteenth century, a nun produced a book for her Cistercian convent at Rulle (Germany). This Gradual, which contains all the chants performed during the eucharistic liturgy, is known as the Gradual of Gisela von Kerssenbrock after its scribe and illuminator (fig. 9-29). A figure identified as "Gisle" appears in the

Fig. 9-30. Nuns, Bebaia Elpis convent typikon, 23.5 × 17 cm, 1330s; Oxford, Bodleian Library, Lincoln College MS gr. 35, fol. 12r. © Bodleian Libraries, University of Oxford. By permission of the Rector and Fellows of Lincoln College, Oxford.

scenes for Christmas and Easter, which are depicted in the historiated initials that open the chants for those days. In the Christmas *P* (for "Puer natus est," A child is born), she holds a songbook at the head of a choir of nuns and points to the Latin words, "Let us all now render praise to the Lord God." Gisela was presumably the leader of the convent's choir. The nuns are shown under Mary's bed, as if the bed is their church, and the name *Gisle* is written on the Virgin's sheet. They are accompanied by two angels in the upper corners who play a stringed instrument and a harp, demonstrating that the nuns are united in their religious and musical activity with the heavenly beings. A fellow nun added an opening inscription to the book soon after Gisela's death: "This excellent book was written, illuminated, notated, paginated, and decorated with gold letters and beautiful images by the venerable and devout

virgin Gisela of Kerssenbrock in her own memory. Year of the Lord 1300. May her soul rest in holy peace. Amen." The book is thus a tangible expression not only of Gisela's many talents and activities but also of her pious devotion as expressed in liturgy, music, and art.

In Constantinople, at the same time, another literate nun wrote the typikon of a foundation dedicated to the Theotokos of Bebaia Elpis (Mother of God of Sure Hope). The convent had been founded about 1285 by Theodora Synadene (ca. 1265–ca. 1330), a niece of Emperor Michael VIII Palaiologos (fig. 9-30). Of forty preserved Byzantine monastery foundation documents, five were written by women for their institutions. This one specifies that Bebaia Elpis should house thirty nuns; such a small size is typical of Byzantine monasteries, which were usually established by families to provide burial places and continuous prayers

Fig. 9-31. Betrayal of Christ and Annunciation, Hours of Jeanne d'Evreux, 9.2 × 6.2 cm, 1325; New York, Metropolitan Museum of Art, The Cloisters Collection, 1954 (54.1.2), fols. 15v– 16r. Image © Metropolitan Museum of Art.

for deceased family members. Byzantine nuns were often widows, or wives whose husbands gave them permission to enter a convent, not unmarried girls and women as was typical in Europe. Unusually, Theodora's daughter, Euphrosyne, was with her mother in the convent from a young age, and it seems likely that each of them wrote parts of the typikon at different times; the images were added in the 1330s. A series of frontispieces depicting family members concludes with the group portrait of the Bebaia Elpis nuns seen here, with the five youngest in the front row. The group should be understood as following Theodora and Euphrosyne on the preceding page, shown offering the typikon and their pious selves to the Theotokos. Added text entries on the last folios of the manuscript indicate that it was in use until at least 1402, in the generation of Theodora's great-granddaughters, when the convent was still producing "holy brides" of Christ. According to the typikon, the nuns were to transcend their feminine weakness and "assume a manly and masculine temperament" to better resemble Jesus, the perfect man. The women would have heard this instruction repeatedly because the typikon was read aloud in the refectory every month.

In 1325 the last Capetian king, Charles IV (r. 1322–28), gave a tiny book of hours to his third wife (and first cousin), Jeanne d'Evreux (1310–71), probably as a wedding gift (fig. 9-31). This type of book was often associated with women readers who used it for private recitation of prayers and psalms. Jeanne's book was illuminated by the well-documented Parisian artist Jean Pucelle with twenty-five full-page miniatures, numerous marginalia, and historiated initials. In the opening shown here, the beginning of the Hours of the Virgin, the Betrayal of Christ (Matt. 26:47–50, Mark 14:43–46) on the verso is executed in the grisaille technique. Facing it is the slightly more colorful Annunciation, which takes place in a fourteenth-century interior rendered in a perspective view that Pucelle learned from Italian artists. This fictive interior is both permeable and enclosed, like the Virgin's womb at the depicted moment. Jeanne herself appears in the large initial *D*, echoing the pose of the angel above while kneeling in prayer. The open book she holds, implicitly this very book of hours, connects her with Mary, who holds a closed book. The text introduced by the *D* is "Domine labia mea aperies" (Lord, open my lips), from Psalm 51; this biblical verse takes on new meaning here, given the pressure on Jeanne to open her labia and bear a male heir to the throne.

Sexual messaging is reinforced by the marginalia at the bottom of both pages, which show activities that the teenage queen should avoid. On the recto is a game like blindman's buff; on the verso, under the lewd kiss of Judas, men riding rams attempt to penetrate a barrel on a pole. Inventive marginalia proliferated in European manuscripts of this period. These hybrid creatures and humorous vignettes sometimes comment on or subvert the main text, but often they defy explanation. Later in the book, a larger image of Jeanne in prayer opens the Hours of St. Louis,

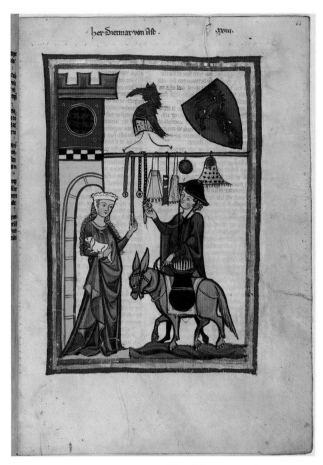

Fig. 9-32. Dietmar von Aist as peddler, Manesse Codex, 35.5 × 25 cm, first half of fourteenth century; Heidelberg, Universitätsbibliothek, Cod. Pal. Germ. 848, fol. 64r. Photo from Heidelberg University Library.

Fig. 9-33. Mirror back with chess players, 10.5 × 10.4 × 1.7 cm, ca. 1300; Victoria & Albert Museum, London. © Genevra Kornbluth.

illustrated with scenes from the life of the king who built the Sainte-Chapelle, became a saint, and was Charles's and Jeanne's great-grandfather. Thus, the central and marginal images in the Hours of Jeanne d'Evreux were meant to educate its owner with both positive and negative examples of proper queenly behavior. This was especially important to Charles, who was desperate for a son to inherit the kingdom. The royal couple had three daughters, however, bringing the Capetian dynasty to an end.

While gender played important roles in spiritual aspects of medieval life, evidence of it in the secular sphere becomes more plentiful in the later Middle Ages. The Manesse Codex contains almost six thousand love songs and poems written in German between the mid-twelfth and the late thirteenth century (fig. 9-32). Although Latin continued to be the language of religious texts in western Europe, vernacular languages were increasingly used for literary and historical works from the thirteenth century onward. The codex was compiled in Zurich (Switzerland) in the first half of the fourteenth century and named for a local man who had collected the lyrics. Works by 137 *Minnesänger*, the German term for composers and performers of love songs, are included, arranged according to rank—kings are first—and introduced by a full-page illustration

for each author. Unlike the author "portraits" in Gospel books, those in the Manesse Codex are not shown in the act of writing or singing. On this page, the twelfth-century poet Dietmar von Aist is named in red at the top; his heraldic symbol, the unicorn, appears on the shield over his head. Disguised as a peddler who travels by mule (a pun on *diet mar*, "the people's mule"), Dietmar offers a brooch and shows his beloved his stock of belts, purses, and a mirror suspended from a rail or branch (German *Ast*). These wares were common courtship gifts, considered sexually suggestive because of their proximity to the body when worn. The well-dressed lady grasps the end of the belt seductively, and her furry lapdog alludes to her genitalia while symbolizing a tension between desire and fidelity. Such visual and verbal puns would have been very clear to those who knew the romantic songs.

Personal objects like those depicted in the illumination also incorporated erotic imagery. An ivory mirror back carved in Paris about 1300 shows a couple engaged in a game of chess that doubles as a game of sexual conquest (fig. 9-33). As the man makes a move, he grasps the phallic tent pole, and the woman touches his hand in response. Her garment is carved to indicate a deep opening between her legs, and an opening is further implied by the framing curtains, which were often hung around the marital bed in medieval European households. Mirrors had multiple meanings: they were associated with lust and the body (personifications of the vices of Lust and Carnality often hold a mirror), but they can also be metaphors for moral reflection. In the context of courtship, mirrors could facilitate beauty routines thought to enhance desirability. Moreover, ivory becomes warm when handled, making this material an apt signifier for romantic entanglements.

Box 9-1. TRANS-SAHARAN TRADE

The Sahara is the largest desert on Earth (*as-Sahra'* means "desert" in Arabic). Often imagined as a vast sea of sand, in reality most of it is rocky, with oases of water and vegetation plentiful enough to support permanent habitation and networks of trade. From the twelfth through the sixteenth centuries, the Sahara was less a barrier than a busy thoroughfare between North Africa and the Sahel, the transitional zone between the desert and the savannas of central Africa. Many people lived in the desert, and many others traveled and traded across it, usually in caravans of camels led by the Imazighen. Cooperation among Amazigh communities allowed them to control many trade routes. The Sahara did not have caravanserais; guides led travelers to oases and other places where locals provided food, drink, and other necessities.

The emergence of Islam and expansion of trade networks during the Umayyad and Abbasid caliphates fueled the demand for gold, to be made into currency. Because the world's largest deposits of gold were located around West Africa's major rivers, trans-Saharan trade intensified. Gold, salt, indigo, dates, and grain were the primary items of exchange, but other raw materials and artifacts were also traded. From the Sahel came copper, tanned hides, alum (a fixative for dyeing cloth), ebony, and tusks of the African savanna elephant, whose ivory was preferred by European, Byzantine, and Islamicate artists and patrons. Garnets, chalcedony, and other stones came from the Sahara, and from North Africa and its ports came ceramics, brass and copper vessels, textiles, paper, books, and glass. Slaves were also bought and sold. Merchants and pilgrims converged in such emporia as Sijilmasa (Morocco) to join caravans going south to the empire of Ghana or east toward Mecca. Trade intensified when Italian cities engaged in international commerce began minting pure (24-karat) gold coins in 1252, as major Islamicate centers already did, and the

economy of war-torn western and Central Asia revived during the "Pax Mongolica." These events helped lay the foundations for an integrated global economy, sometimes called the "world system" of the thirteenth century.

Trans-Saharan trade also prompted cross-cultural encounters and intellectual exchange. Local Jewish populations and Jews from western Asia lived and traded in and around the Sahara. People from the Sahel and savanna engaged with North Africans and other Muslims. Islam spread into West Africa through these commercial networks, and by the eleventh century many local kings had converted. The empire of Mali became a political, economic, and intellectual powerhouse; scholars from across the Islamic world went there to live and teach, and the city of Wadan (Ouadane, in Mauritania) was a center of learning by the twelfth century. Emphasis on the Qur'an made Arabic a common language that facilitated communication among the disparate peoples of Africa from the Mediterranean to the savanna.

West African gold provided the raw material for Islamicate, Byzantine, and European coinage and for many objects made of the precious material. Yet trans-Saharan trade was multidirectional and enriched many of the peoples involved. Tombs in Durbi Takusheyi (Nigeria) contained precious fourteenth- and fifteenth-century objects from distant locales. One burial included a large Mamluk copper bowl with incised foliate decoration and Arabic inscriptions, a less ornate version of the inlaid basin in fig. 9-6. The deceased wore a belt that incorporated beads possibly made in China. In another grave in the same cemetery, a woman had a cap made of cowrie shells from the Indian Ocean, showing the vibrancy of exchange along the desert's east–west axes, which at times were safer for pilgrims and merchants than sailing across the Mediterranean Sea.

Connecting Present and Past

In 1261 Michael VIII Palaiologos, then coruler in Nicaea, retook Constantinople from its last Latin ruler and made it once again the capital city of the Byzantine Empire. Michael (r. 1261–82) reestablished trade with Venice and spent lavishly to restore the city to its former splendor after the decades of neglect that followed the Fourth Crusade in 1204. He rebuilt the walls and palaces, restored derelict churches, and erected many new ones; he also built a new mosque to replace two that were destroyed in the early thirteenth century, showing his embrace of the city's multifaith population. A now lost purple and gold textile

that the patriarch commissioned for Hagia Sophia showed Michael VIII as a new Constantine, refounding the city established by and named for the fourth-century Roman emperor. Michael VIII probably commissioned the huge Deesis mosaic in the south gallery of Hagia Sophia (fig. 9-34), opposite two mosaic panels that depict earlier emperors (fig. 6-8). The imposing image of Christ flanked by Mary and John the Baptist may originally have been accompanied by a kneeling figure of the emperor, but the lower part of the mosaic has been lost. The Deesis figures are much larger than those in the earlier gallery mosaics, but the tesserae are tiny, which permits facial modeling more subtle than in previous medieval mosaics. Commissioning

this mosaic in Byzantium's most important church would have demonstrated Michael's commitment to restoring the empire to its former grandeur.

Despite many accomplishments, the reign of Michael VIII was difficult. He tried to unite the Roman and Orthodox Churches, offering to recognize the primacy of the pope and agreeing to the Roman-rite use of unleavened bread in the Eucharist and the doctrine that the Holy Spirit proceeds from both God the Father and the Son—all three concessions despised by the Orthodox faithful. The union did not outlive the emperor, and when Michael VIII died, he was denied Orthodox last rites and buried outside the city he had liberated.

The interplay of Byzantine and European religious art and practice can be seen in Cyprus, where artists drew on multiple artistic traditions to create something distinctively local. At Asinou (fig. 7-33), the early twelfth-century All-Holy Mother of God of the Spurges was redecorated in several stages; new paintings reasserted the monastery's dedication to Mary while also signaling the changing devotional practices and needs of the community. Around 1200 a large fresco of St. George on horseback was added to the south apse of the narthex, using lapis lazuli for the background and gold for the horse fittings and halo (fig. 9-35). A Greek epigram under the saint's billowing cloak records the motivations of the patron, a veterinarian ("healer of

horses") who, like the early twelfth-century founder of the monastery, was named Nikephoros; he hopes that the saint and the prayers of the Asinou monks will help him at the Last Judgment. This icon must have been considered a powerful one, for burn and wax marks on its painted surface indicate that worshipers sought close contact with it. Frescoes added nearby in the 1330s depict individual devotees. To the right of St. George a woman named Anastasia venerates St. Anastasia, and above him a mother and two sons kneel with clasped hands while the Virgin extends

Fig. 9-34. South gallery Deesis mosaic, Hagia Sophia Cathedral, Constantinople, ca. 1265. Wikimedia Commons/Myrabella, CC0 1.0.

Fig. 9-35. Narthex frescoes, church of the All-Holy Mother of God of the Spurges, Asinou, late twelfth century–1330s, view toward the south. Photo by the authors.

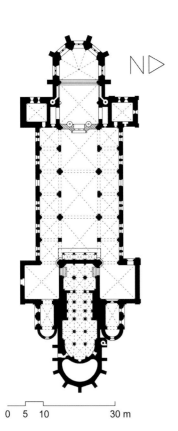

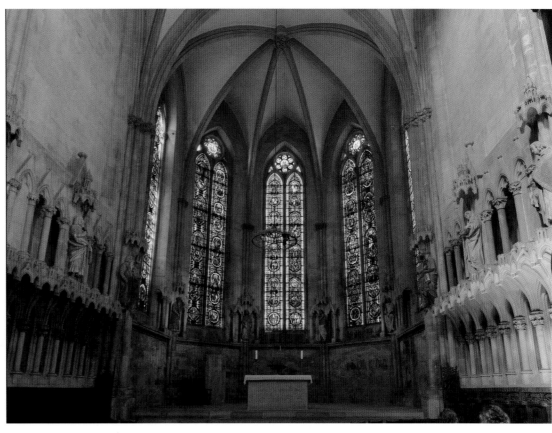

Figs. 9-36a and 9-36b. Cathedral, Naumburg, ca. 1250, (*left*) plan; (*right*) west choir.
(*l*) Drawing by Navid Jamali; (*r*) © Genevra Kornbluth.

her cloak protectively toward the woman. These people, dressed in European garb, assume the kneeling pose and clasped-hands prayer gesture of the Roman Church, not the Orthodox one, and the iconography, known as the Madonna (My Lady) of Mercy, is also typically western European. The Asinou narthex was a focus of patronage by monks and laypeople, both women and men, who brought together different Christian traditions and engaged artists from around the eastern Mediterranean. This combination of features in a single small church derives from cultural cross-fertilization, a dominant trend in Lusignan-ruled Cyprus in the fourteenth century.

In the early eleventh century, Count Ekkehard II and his wife, Uta, moved a German bishopric to Naumburg and were remembered thereafter in its funerary liturgies. Over two hundred years later, around 1250, they were further commemorated as part of a group of twelve individualized "founder" figures carved in the west apse and choir of the new Naumburg Cathedral, near their graves on the site of the original church (fig. 9-36). Ekkehard and Uta, identified by inscriptions, stand together to the right of the altar (Uta's sculpture was the model for Snow White's evil stepmother in the Disney film of 1938) (fig. 9-37). Polychromy enhances their lifelike effect. The sculptors' interest in physiognomy parallels contemporary translation of ancient treatises on the subject. Although the realism of the works is suggestive of portraits, they could not convey the physical appearances of the long-dead Ekkehard

and Uta. Given the differentiation of the twelve figures and their mid-thirteenth-century fashions, it is tempting to infer the use of live models. Yet it is unlikely that contemporary aristocrats served as models for the dead and even less likely that ordinary people were used as aristocratic prototypes. Rather, the sculptures are invented and idealized likenesses meant to communicate the founders' standing as secular aristocrats. Their placement, in a context normally reserved for saints and royalty, derives from their elevated status as founders, for whose souls the cathedral clergy were required to pray. Naturalism—an aesthetic sought by the artists and patrons even if what was represented was not "real"—created a link between contemporary Naumburg aristocrats and their most distinguished predecessors (box 8-1).

A stone screen carved by the same workshop separates the founder figures from the nave, marking off the west end of the cathedral as a space for liturgies performed on behalf of its benefactors (fig. 9-38). Tall screens became increasingly common in European churches, such as Chartres Cathedral, in the thirteenth century in order to monumentalize the separation between celebrants and the laity; they also provided platforms for preaching and singing. Many were torn down after the Middle Ages when ritual practices and architectural preferences changed. In Naumburg's west screen, one of the earliest and best preserved, the sculptors worked in several ways to shape the viewer's experience. In the upper zone, painted scenes

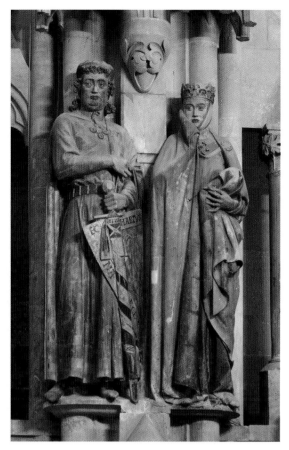

Fig. 9-37. Ekkehard and Uta sculptures, Naumburg Cathedral, Uta 172 × 58 × 40 cm, ca. 1250. © Genevra Kornbluth.

unfold against a blind arcade with most columns missing so the viewer can see the episodes from the Passion of Christ without obstruction (the two scenes at the far right are later replacements in wood). In addition, the Naumburg artists presented the scenes at an angle to enhance their visibility from ground level; the Last Supper table, in the first scene at the far left, tilts downward to reveal its abundance of bread and fish. The diners are depicted with a range of table manners that conform to guidelines in contemporary courtly handbooks.

The artists placed the Calvary group, normally on top of the structure, lower down in the center of the screen to incorporate churchgoers into the scene as witnesses to the crucifixion, alongside the life-size figures of Mary and John. Christ's wounds gape and bleed, part of the increasing emphasis on pathos and the suffering human body of Christ in later medieval art, as seen in the work of Giotto in Padua. The way that Christ and the other figures peer down at the faithful suggests that the screen was interactive and theatrical. Indeed, it had an important role in church performance: numerous processions passed before and through the screen, and staircases at the back lead up to a platform from which the Gospels were read by a cleric who was partly visible at the top. Although the screen did separate parts of the liturgical ritual from the laity in the nave, the artists strove to give immediacy to the sacred biblical stories and Christ himself, thereby enhancing laypeople's connections to both of them.

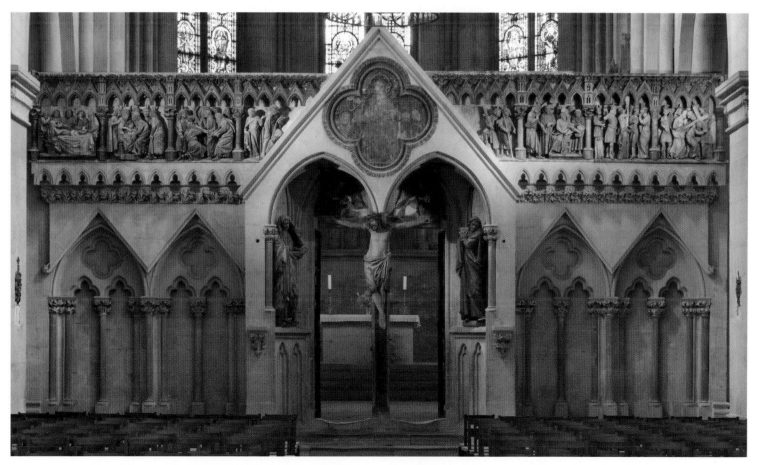

Fig. 9-38. West choir screen, Naumburg Cathedral, ca. 1250. © Genevra Kornbluth.

Experiments with Scale

Architects and artists throughout the Middle Ages were often occupied with questions of scale, including how works in one medium might relate to those in another. An embroidered silk *aër*, a small veil that covers the bread and wine as it is brought to the altar during the Orthodox Eucharist, symbolizes both the burial shroud of Jesus and the canopy of heaven. Byzantine artists experimented with much larger versions of the aër that render the full size of the dead Christ (fig. 9-39). Such a textile, known as an *epitaphios*, was used in church processions on Holy Friday and Holy Saturday (before Easter Sunday), when it was displayed in the naos (it may also have been visible at other times, perhaps as tomb covers). This example, likely made in Constantinople in the early fourteenth century, bears

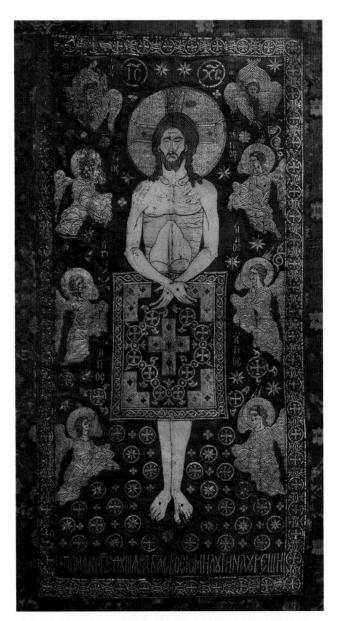

Fig. 9-39. Epitaphios of Stefan Uroš II Milutin, 143.5 × 72 cm (excluding border), early fourteenth century; Muzej Srpske pravoslavne crkve, Belgrade. © Genevra Kornbluth.

a prayer in Slavonic on behalf of the soul of Stefan Uroš II Milutin (r. 1282–1321), father of the founder of Dečani; the velvet border dates to the sixteenth century. The embroiderers have emphasized the connections between the consecrated eucharistic bread and the physical body of Christ by representing him naked with a small, simulated aër covering his genitalia—the body part that most clearly signals his humanity. Christ is accompanied by mourning angels, the heavenly equivalent of the earthly clergy; the liturgies on heaven and earth were understood as mirror images, an idea also expressed in the Gradual of Gisela von Kerssenbrock. Veils are important in many faiths—the Jewish Temple veil that hid the Holy of Holies, the kiswa of the Kaʿba, veils over the eucharistic elements in the Orthodox Church—because they simultaneously draw attention to sacred things and conceal them, screening mortal eyes from holiness and the holy from mortal eyes.

Just as the epitaphios magnified the scale of the aër, a bronze baptismal font in Rostock dramatically enlarged the size of this essential piece of church furnishing (fig. 9-40). By the thirteenth century fonts were usually made on a modest, human scale, as seen in San Esteban in Renedo de Valdavia (fig. 8-21). Like that font, the one in Rostock communicates ideas about its primary function. It bears a Latin inscription that dates its casting or consecration to Easter 1290; Easter was the traditional time for baptisms. Its material also contributes to its meaning, connecting the font to the large bronze basin commissioned by King Solomon for the Temple in Jerusalem (1 Kings 7:23–26; 2 Chron. 4:2–5). Most earlier fonts in the Baltic Sea region were made of limestone from Gotland (Sweden), but the Rostock font was inspired by an earlier thirteenth-century one at Hildesheim, which had a long tradition of bronze casting (fig. 6-31). Here, four kneeling figures support the basin. They hold vases inscribed with the names of the four elements (earth, water, air, and fire), but they also represent the four rivers of paradise, underscoring a connection between the waters of Eden and of baptism. Above them, the basin has twenty-one scenes of the life and Passion of Christ, from the Annunciation to a post-resurrection appearance. The Baptism and Ascension are represented in the lowest zone of the tall conical cover, on which standing female saints and the Wise and Foolish Virgins (Matt. 25) underscore that baptism is an important step toward salvation. At the top, the bird with outstretched wings represents the Holy Spirit, which descended on Jesus at his own baptism. All this iconography theoretically could be found on any European font; what makes the Rostock example exceptional is its scale.

In the thirteenth century Rostock was part of the Hanseatic League, a powerful consortium of German merchants in over two hundred harbor towns on the North and Baltic Seas (the League survived into the fifteenth century). The town's prosperity came from shipping beer and fish, and it was wealthy merchants who commissioned the font and,

in the 1230s, built the brick church overlooking the market square that later housed it. Such an enormous font—almost three meters high—was not necessary in practical terms, but it advertised the wealth of the town and the abilities of its artists, who also cast the church bell at the same time.

While some artists experimented with magnifying scale, goldsmiths created a miniature gilt-silver fountain in the form of an elaborate structure with towers, columns, arcades, vaults, and parapets drawn from contemporary French architecture (fig. 9-41). Translucent enamel panels depict humans, animals, and hybrid creatures, some of whom play instruments. The fountain entertained guests in an elite western European home during the second quarter of the fourteenth century. It would have been placed on a customized pedestal or table that hid the lead pipes that

fed it. Water, probably scented, was pumped up through the central tube to emerge from the mouths of four animals at the top and gargoyles (openmouthed creatures serving as waterspouts) below; it cascaded down, making wheels rotate and bells tinkle as the water descended into an attached catch basin (now missing). The movement, sounds, and smells must have delighted guests. Hydraulic and mechanical automata of varying forms date back to antiquity, and medieval examples are well attested in Islamicate lands in the fourteenth century. Many such devices are mentioned in European inventories and other documents, including the portfolio of Villard de Honnecourt, but this is a rare surviving example. The object's function was to perfume, entertain, and enhance the multisensorial experience of feasts and to broadcast the tastes and wealth of its owner. At the same time, the fountain advertised the ingenuity of its artists; Paris, where the fountain was almost certainly made, had 251 practicing goldsmiths in 1300 and was the main European center for luxury enamel work.

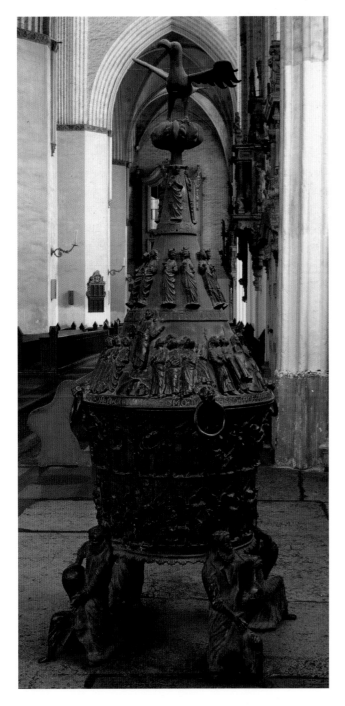

Fig. 9-40. Baptismal font, ca. 289 × 95.5 cm, 1290; church of St. Mary, Rostock. akg-images/Bildarchiv Monheim.

Fig. 9-41. Table fountain, 33.8 × 25.4 × 26 cm, ca. 1320–40; Cleveland Museum of Art. Photo from CMA, CC0 1.0.

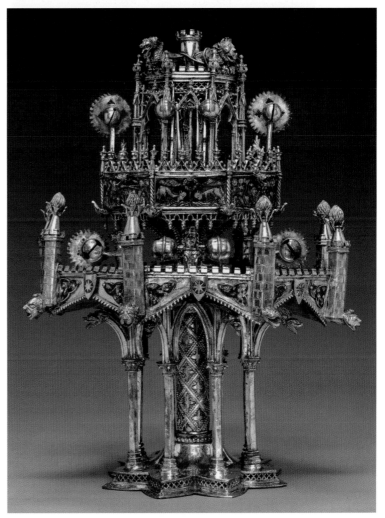

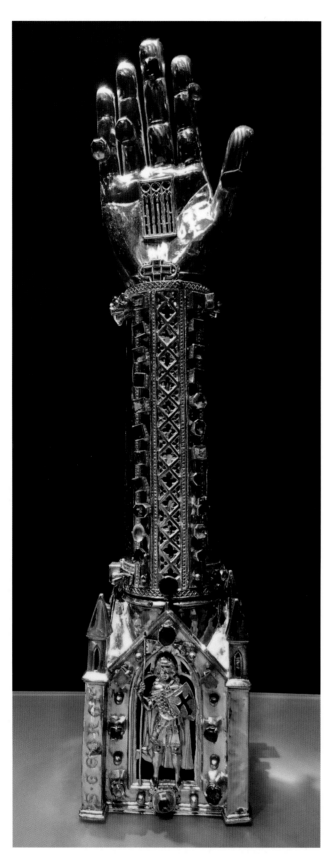

Like their competitors in Paris, Czech gold- and silver-smiths were famed for their artistry and technical expertise; theirs was the only artists' guild recognized by the king of Bohemia (the Czech lands, plus parts of Germany and Poland). A demonstration of their skill is a reliquary that contains the humerus (upper-arm bone) of St. George, made in the first quarter of the fourteenth century for a convent in the castle of Prague that was dedicated to the saint (fig. 9-42). It is in the shape of an arm and belongs to a long line of relic containers shaped like body parts, of which an early example is a finger of St. Denis that was enshrined in a (now lost) hand-shaped container in the Carolingian era. Such an echoing of forms was not required for the relic's efficacy, yet there is something uncanny about the body-part reliquary. Like the Armenian reliquary of John the Precursor (fig. I-6), reliquaries in the shape of the right forearm and hand were often associated with holy bishops and martyrs. They were used as liturgical props, extensions of the spiritually powerful arm of the bishop or priest who would hold one to bless his congregation. Here that same form is used for St. George, a soldier saint who implicitly protects the Church by military means. Two features of the reliquary can be attributed to the creativity of the artists. First, the "lacing" down the middle of the jeweled "armor" permits a view of the precious textile that wraps the bone, which is also visible through the window tracery in the palm. Second, the arm is simultaneously a tower emerging from an architectural base that looks like a church. Ornate portals on four sides frame relief images of saints, including George himself, bedecked in armor.

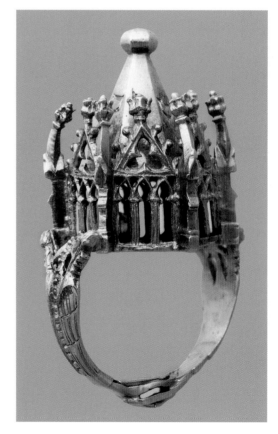

Fig. 9-42. Arm reliquary of St. George, H 56.4 cm, first quarter of fourteenth century; Metropolitini Kapitula u. Sv. Vita, Prague, K19. © Genevra Kornbluth.

Fig. 9-43. Jewish wedding ring, H 4.78 cm, second quarter of fourteenth century; Museum für Ur- und Frühgeschichte Thüringens, Weimar. © Brigitte Stefan, Thüringisches Landesamt für Denkmalpflege und Archäologie.

Making the reliquary in the shape of a church was a powerful way to monumentalize the saint himself.

A gold wedding ring excavated at Erfurt (Germany) in 1998 evokes architecture on an even smaller scale (fig. 9-43). It is one of five similar Jewish rings with Hebrew letters that spell "mazel tov" (good luck) on the hexagonal roof, which rises from an arcade with gables and crockets—very European-looking architecture meant to suggest both the lost Temple and the newlyweds' new home. The miniature building is supported by two winged dragons whose tails form the hoop of the ring before becoming buttoned sleeves from which two clasped hands emerge. The handshake was a symbol of marital fidelity, doubtless copied from medieval Christian exemplars but with its origins in ancient Rome. At almost five centimeters high, the ring was much too bulky to wear regularly; it was placed on the right forefinger of the bride during the wedding ceremony, then passed along to other family members for the same purpose. Large rings like this one are depicted in illuminated Jewish marriage contracts beginning in the late fourteenth century, but on the basis of the style of its architectural motifs, the Erfurt ring can be dated to the second

quarter of the fourteenth century. It was part of a large hoard of silver and gold jewelry, coins, and vessels that was hidden in the middle of that century (the latest coin was minted between 1328 and 1347), probably in response to attacks on Jews who were fleeing the Black Death and the anti-Semitism it spurred: one thousand Jews were massacred in Erfurt in 1349. The Erfurt Hoard (total weight 28 kg) was discovered by accident in 1998, buried near the town's late eleventh-century synagogue, one of the oldest in Europe; the nearby mikvah dates to about 1250.

Work in Focus:
THE BIRDS HEAD HAGGADAH

The Sarajevo Haggadah, produced in Aragón in the first quarter of the fourteenth century, was discussed above. Haggadot made in Ashkenaz look very different. The first Hebrew books in that region were written and illuminated in the 1230s, such as the Hebrew Bible commentaries made for Joseph ben Moses (figs. I-7 and I-18); Jewish scribes copied the texts, but the pictures could be added

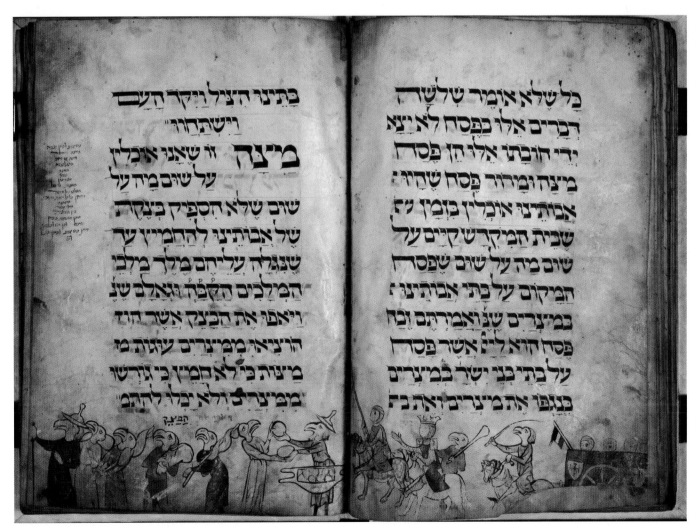

Fig. 9-44. Exodus scenes, Birds Head Haggadah, 27 × 18.2 cm, ca. 1300; Jerusalem, Israel Museum, MS 180/57, fols. 24v–25r. © The Israel Museum by Moshe Caine.

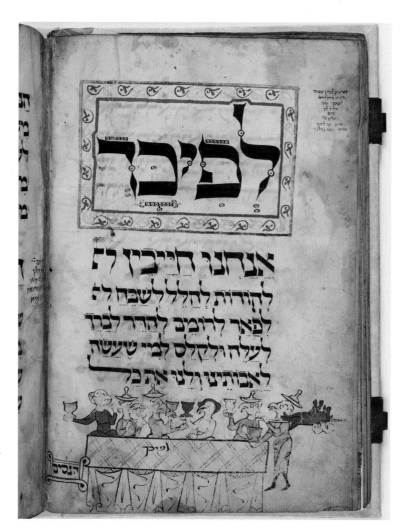

Fig. 9-45. Seder scene, Birds Head Haggadah, 27 × 18.2 cm, ca. 1300; Jerusalem, Israel Museum, MS 180/57, fol. 26v. © The Israel Museum by Ardon Bar-Hama.

by Jews or Christians in local urban workshops. Because Hebrew manuscript illumination was new, its visual language sometimes borrowed from surrounding Christian art forms. Haggadot began to be illuminated in Ashkenaz only at the end of the thirteenth century, and the Birds Head Haggadah—written by a scribe named Menachem in the middle or upper Rhine area, perhaps in Mainz, about 1300—is one of the earliest examples.

Most of the figures depicted on its forty-seven extant folios have the heads of birds and the ears of animals, a feature shared with other Ashkenazic manuscripts that is never seen in Sephardic books (fig. 9-44). At first glance, it seems that Jewish artists must have been operating under a strict interpretation of the second commandment, which prohibits the making of "an image in the form of anything in heaven above or on the earth" (Exod. 20:4); the importance of the prohibition in Ashkenaz can be seen in the erasure of the figure of God in the Hebrew Bible commentaries (fig. I-18). Yet this does not explain why birds were acceptable: simply avoiding any painted images would be an easier way to adhere to this interpretation of the commandment. Moreover, the heads of Jewish figures are all those of griffins: powerful, noble, heroic creatures with the heads of eagles and bodies of lions (hence the mammalian ears). The patron's choice of griffins' heads would have

satisfied scholars such as Rabbi Ephraim of Regensburg (Germany; 1133–1200), who forbade the depiction of human faces but allowed two-dimensional images of birds and animals. This novel iconographic choice simultaneously elevated the Jews and satisfied Jewish critics of figural art.

Blank human faces are used for non-Jews and nonhumans, such as angels or personifications of the sun and moon. The featureless faces of the Egyptians who pursue the Jews on the right-hand folio were not products of iconoclasm, because there is no damage to the parchment. Rather, Jewish users of the manuscript saw these non-Jews as deficient: the potential power of both the Egyptian army and the celestial creatures was literally and figuratively effaced. (The empty faces bothered some later viewers, who added a few features.) Pharaoh's forces are outfitted like contemporary German knights, complete with the black-eagle flag of the Holy Roman Empire. On the left side of this opening, the Jews, led by Moses in red, depart Egypt with their possessions and with bread (matzo) that did not have time to rise. Both the man who distributes the matzo and Moses wear the conical pointed hat that was sometimes compulsory for Jewish men in northern medieval Europe. The hat often identifies Jews in Christian art in that region (as in the second scene on the Naumburg screen), and it was also incorporated into art made by and for Jews.

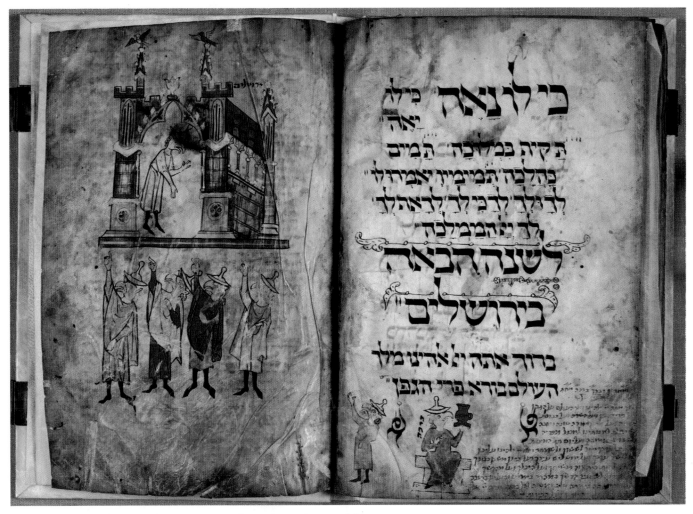

Fig. 9-46. Last cup of wine and messianic Temple, Birds Head Haggadah, 27 × 18.2 cm, ca. 1300;
Jerusalem, Israel Museum, MS 180/57, fols. 46v–47r. © The Israel Museum by Moshe Caine.

The hat is worn by all the adult men in a scene of the seder, whereas the two women in the scene modestly conceal their hair (fig. 9-45). All of the figures at the table hold a goblet of wine, and a man carries in a roasted ram with golden horns. The large title word on the page says "Therefore," and this is repeated on the seder table itself: the text says, "Therefore we are obligated to thank, to praise, to extol, to glorify" God, who performed miracles for our ancestors. The hat-wearing, griffin-headed Jews are pious members of the community, so the hat is a positive marker without the negative meaning it held for contemporary Christians. The imminent consumption of a roasted lamb—the original Passover sacrifice (Exod. 12:1–11) prior to the destruction of the Temple—reveals that this is not the contemporary early fourteenth-century seder but, rather, the seder of the messianic future. Jewish law prohibited the consumption of a roast at Passover to avoid giving the impression that the Jews were reinstating the Passover sacrifice before the Messiah had arrived.

Most of the images in the Birds Head Haggadah occupy the margins, but there is a full-page image at the very end, preceded by the seated head of the household holding a cup and making a blessing before drinking the last of the seder's required four cups of wine (fig. 9-46). This blessing is the final text on the page, following the hopeful declaration that "for the next year, [may we be] in Jerusalem." (Slightly later, someone added in tiny script the blessing to be said after the wine has been drunk.) A standing figure gestures toward the facing page, which depicts Jerusalem, labeled near the top, or perhaps specifically the Temple in Jerusalem. It is the messianic Jerusalem of the future, but, as on the Erfurt ring, the Temple or city resembles a contemporary Gothic building with a buttress, pinnacles, and crockets. The four men wearing traveling cloaks represent Jews coming together from the four corners of the earth. They point upward to convey their hope for the redemption of all Jews, symbolized by the rebuilt Jerusalem and the welcoming figure who already inhabits it and beckons them in. The images in the Birds Head Haggadah thus interweave past, present, and future hopes just as the accompanying text does, but by representing the Jews as proud, aggressive griffins, the pictures express attitudes not made explicit in the text.

CHAPTER 10

ca. 1340 to ca. 1450

Legend

☐ **Location or findspot**
 - *Monument/object*
• *Additional site*
○ *Approximate place of production*

Wienhausen
- *Convent*
- *Sculptures of Christ*
- *Tristan and Isolde embroidery*

○ *Shrine Madonna*

Northleach
- *Memorial brass*

☐ **Wienhausen**

London
- *Book of the Great Khan*

Bruges •
○ *Painted panel with Mary in a church*

Arras •

Wrocław
- *Christus dolorosus sculpture*

Saint-Denis
- *Byzantine manuscript of Pseudo-Dionysios's writings*

Karlštejn ☐ **Prague**
- *Castle* - *St. Vitus Cathedral*

Paris
- *Romance of the Rose manuscript*

Angers ☐
- *Apocalypse Tapestry*

○ *Très Riches Heures manuscript*

• Constance

A l p s

Salamanca •

Lleida
- *Sant Llorenç retable*

Avignon •

Ferrara • • Venice

Florence • • Belgrade

Fabriano
- *Painted panel with Coronation of Mary*

Toledo
- *Samuel Halevi Synagogue*

Barcelona
- *Maimonides's Guide for the Perplexed*

Rome • • Pristina

Paterna ☐
- *Saltcellar with khamsa*

Granada ☐
- *Alhambra*

○ *Catalan Atlas*

Mystras ☐
- *Peribleptos Monastery katholikon*

Alhambra, Granada

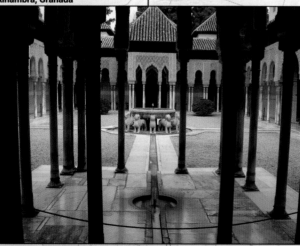

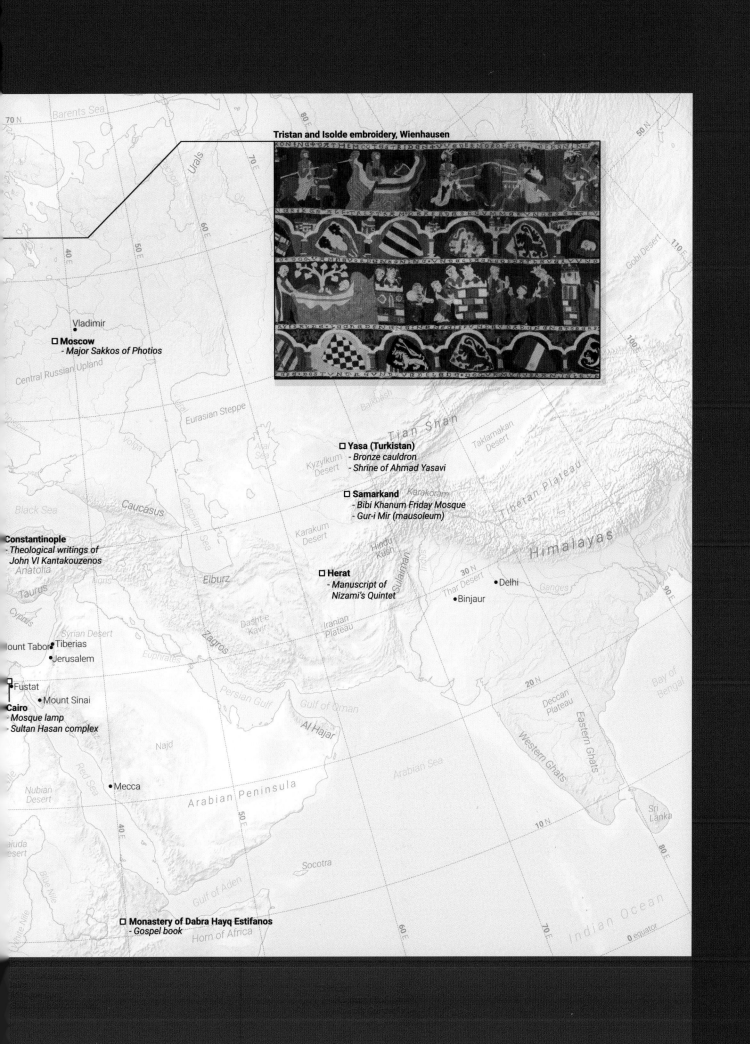

Tristan and Isolde embroidery, Wienhausen

□ **Moscow**
 - *Major Sakkos of Photios*

• Vladimir

Central Russian Upland

□ **Yasa (Turkistan)**
 - *Bronze cauldron*
 - *Shrine of Ahmad Yasavi*

□ **Samarkand**
 - *Bibi Khanum Friday Mosque*
 - *Gur-i Mir (mausoleum)*

Constantinople
- *Theological writings of*
 John VI Kantakouzenos

□ **Herat**
 - *Manuscript of*
 Nizami's Quintet

• Delhi

• Binjaur

Mount Tabor • Tiberias
 • Jerusalem

□ Fustat

Cairo
- *Mosque lamp*
- *Sultan Hasan complex*

• Mount Sinai

• Mecca

□ **Monastery of Dabra Hayq Estifanos**
 - *Gospel book*

After the bubonic plague devastated much of urban and rural Eurasia and North Africa in the 1340s, it was followed by less virulent occurrences into the fifteenth century. Christians often blamed Jews and other minorities for these epidemics, and several Jewish communities were exterminated; in Egypt, women were held responsible and their public movement was curtailed. A positive outcome of the Black Death was an increase in social mobility, particularly in Europe. Land was cheaper, meaning more of it could serve for animal pasture, and diet improved. Prosperity also increased in western Africa, where the wealthiest individual of the entire Middle Ages, Mansa Musa (d. ca. 1337), ruled the empire of Mali. When the last Capetian king died without an heir in 1328, disputes among his successors resulted in the so-called Hundred Years' War between France and England (1337–1453); their distinctive national identities were strengthened as a result. After the pope returned to Rome from Avignon, western Christendom experienced forty years of schism (1378–1418) until a Church council held at Constance (Germany) elected a pope agreeable to all parties. The council also condemned the Czech reformer Jan Hus (ca. 1372–1415) to death, but Hussite teachings had an impact a century later on Martin Luther, the key Protestant reformer.

Another Church council that also lasted several years was held in Florence and Ferrara (northern Italy) from 1438 to 1445; its principal goal was to reconcile the Roman and Orthodox Churches. The Byzantines, under siege from the Ottoman Turks, were desperate for help from the West. Ottoman rule had been established in Anatolia by Osman I in the late thirteenth century, and in 1354 the Ottomans moved westward into the Balkans. They defeated the Serbs near Pristina in the Battle of Kosovo (1389), and the Serbian principalities became Turkish vassals. In 1453 the Ottomans took Constantinople; the last Byzantine outpost, the thriving cultural center of Mystras (or Mistra), in southern Greece, fell in 1460. Byzantine intellectuals fled to Italy and contributed to the revival of classical learning and art already under way there.

The Turks' progress westward was stopped in 1456 by Hungarian forces at the siege of Belgrade. At the western edge of Europe, the Nasrid emirate based in Granada (southern Spain) was the longest-ruling Muslim dynasty on the Iberian Peninsula (1230–1492) until it surrendered to the Christian rulers of Castile in 1492.

While the Ottomans were expanding their territory in western Asia and eastern Europe, the Ilkhanid Empire of the Mongols in Iran was breaking up. It collapsed in 1353, but in 1370 the Timurid Empire emerged and soon became the third largest empire in Eurasian history after those of Alexander "the Great" and Chinggis Khan. Timur, also known as Tamerlane (Timur the Lame), was a Turkic soldier in the Chagatai khanate who defeated the Mamluks and Ottomans and ruled Central Asia, Afghanistan, and Iran (r. 1370–1405); he sacked Delhi (India) in 1398 and died while preparing to invade China. Because he was not descended from Chinggis Khan himself, Timur married a Mongol princess who was, and he used the more modest title of emir instead of khan. The Timurids ruled over the Turkic-Mongol and Iranian societies in their empire until 1507. Whereas Timur was a major patron of architecture, his son Shahrukh (r. 1405–47) was a bibliophile who affirmed the family connection to Mongol history by having copies of the Ilkhanid *Compendium of Chronicles* updated to his own time.

A notable invention in northern Europe in this period was the printing press. After Johannes Gutenberg introduced movable type in the 1430s, mass-produced books on paper quickly changed European literacy and culture—although printing on paper was widespread much earlier in parts of the Islamicate world. Another notable innovation was oil paint, which, like printed books, was used earlier in Asia. It became increasingly prevalent in Europe during the thirteenth century, and by 1425 artists like Jan van Eyck were exploiting its expressive capacities. Less salutary inventions were the trigger mechanism for rifles (gunpowder, invented in China, was already available), and cannons, first documented outside China during the Hundred Years' War.

A monastery for aristocratic women founded in Wien-hausen (Germany) by the widowed noblewoman Agnes of Landsberg (d. 1266) is still operating today, although the nuns now follow Lutheran (Protestant) norms rather than the Cistercian customs in place from the thirteenth century to the late sixteenth. Wienhausen's convent was a very wealthy establishment whose nuns endowed it with properties and sizable dowries when they "married" Christ by joining it. It also possessed a miracle-working vial of Jesus's blood, supposedly brought from Rome by Agnes, which attracted pilgrims and pious donations. Around 1330 the convent was rebuilt in red brick with the stepped gables typical of northern Germany (fig. 10-1). The nuns' choir, on the upper floor over the west end of the church, was reached by a corridor on the south side of the cloister. The corridor, choir, and church were decorated in the 1330s, and these spaces all played an active role in the spiritual and liturgical life of the convent.

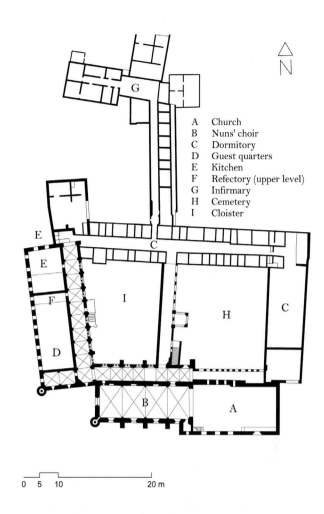

A	Church
B	Nuns' choir
C	Dormitory
D	Guest quarters
E	Kitchen
F	Refectory (upper level)
G	Infirmary
H	Cemetery
I	Cloister

0 5 10 20 m

Figs. 10-1a and 10-1b. Convent, Wienhausen, ca. 1330, (*top*) plan; (*bottom*) exterior from the southwest, with nuns' choir at right. (*t*) Drawing by Navid Jamali; (*b*) © Genevra Kornbluth.

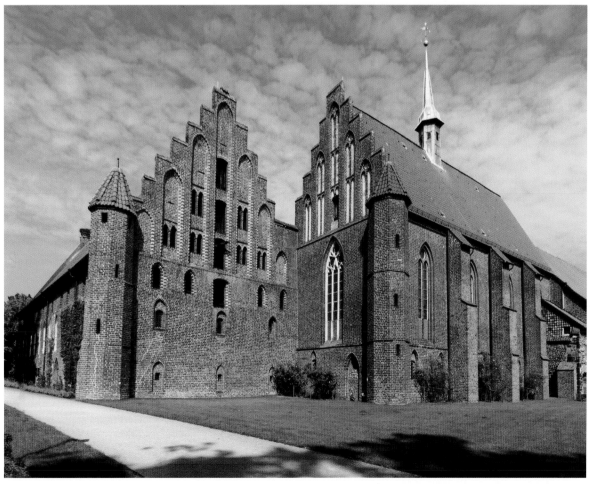

The vaulted passage leading from the nuns' cells in the dormitory to the choir retains some of its original stained glass. The window of the Crucifixion just outside the choir depicts Christ on the cross flanked by Mary and John, but with a startling addition: a female personification, Karitas (Love), who stabs Christ in the chest with a dagger (fig. 10-2). Two other personifications (Justice and Peace) crown Christ as two more (Mercy and Truth) look up approvingly. The Wienhausen nuns who passed this scene repeatedly each day saw in it echoes of the medieval Latin

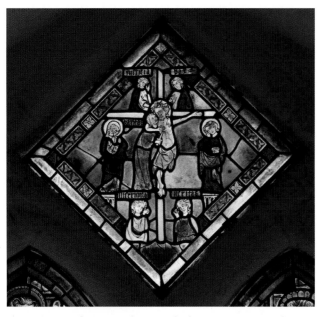

Fig. 10-2. Crucifixion window, south cloister range, Wienhausen Convent, 67.5 × 71 cm, ca. 1330. Photographer Wolfgang Brandis, © Kloster Wienhausen.

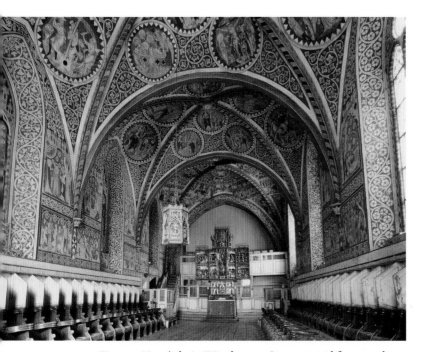

Fig. 10-3. Nuns' choir, Wienhausen Convent, mid-fourteenth century, view toward the east. © Genevra Kornbluth with permission of Kloster Wienhausen.

of the biblical Song of Songs (or Song of Solomon, 4:9), "You have wounded my heart, my sister, my bride." This Old Testament verse was long understood typologically as Christ urging his symbolic bride, the Church, to emulate and return his love and devotion, but the juxtaposition of intimacy and violence here is unusually direct. It places women at the literal heart of the Christian narrative and suggests that Christ wanted to be pierced by the nuns' love when he died for his love of humanity. Medieval interpreters also saw the wound in Christ's side as the vaginalike opening through which the Church was born, and the metaphor of Christ as mother was widespread in late medieval religious literature.

The paintings in the nuns' choir, the space from which the women would watch the mass performed in the church below while singing their parts, were extensively restored in the nineteenth century, but the original mid-fourteenth-century iconography was largely maintained (fig. 10-3). At one end was a polychromed wooden statue of the Risen Christ, stepping out of his tomb over the sleeping guards who were supposed to keep his followers from stealing the body (Matt. 27:65–66) (fig. 10-4a). Carved in the 1290s, it may have served as a retable so that the altar became the foundation of the tomb, doubling the presence of Christ in the form of the Eucharist and the sculpture. The large, drilled wound in Christ's side, enhanced with painted blood, is emphasized by the opening in his golden robe. The lifelike statue provided another compelling focus that allowed the nuns to forge an intimate relationship with their beloved Christ.

Another painted wood effigy of Christ, also carved in the late thirteenth century, lies inside a lidded sarcophagus donated by Abbess Katharina von Hoya in 1448 (fig. 10-4b). The sarcophagus was placed in a chapel built by the abbess that was dedicated to St. Anne, the mother of Mary; the chapel was originally outside the convent enclosure (and thus not in fig. 10-1a), accessible by the nuns through one door and by lay visitors through a different one. The front of the sarcophagus bears images of the sleeping guards, obscured when the gabled lid is folded down to reveal the effigy. On both inner faces of the lid are painted scenes of Christ's life, Passion, and resurrection; his wound figures prominently. The base of the sarcophagus contains cavities under the head and feet of Christ in which body-part relics belonging to a large number of saints (including Bernward of Hildesheim) are preserved, along with their identifying labels. These saints were thereby present at Wienhausen to hear the prayers of the nuns and intercede on their behalf. Small doors at both ends of the sarcophagus allowed pious visitors to touch or kiss the head and feet of the dead Christ; the head also contained a drilled recess for additional relics. Such life-size replicas of the holy tomb, made of wood or stone, became popular beginning in the late thirteenth century. The Wienhausen sepulcher must have been especially meaningful between Good Friday

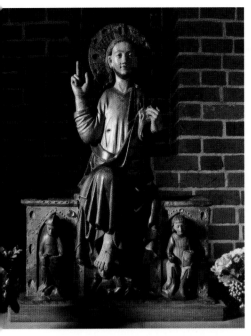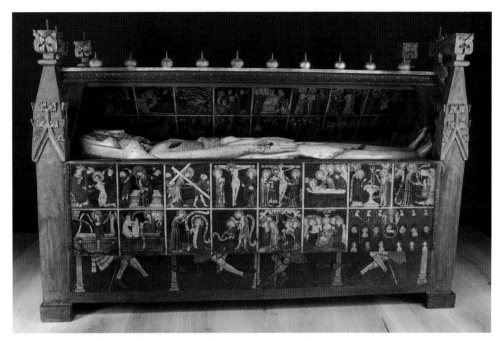

Fig. 10-4a. Sculpture of Risen Christ, 95.5 × 36 × 34.5 cm (Christ), 1290s; Wienhausen Convent.
© Genevra Kornbluth with permission of Kloster Wienhausen.

Fig. 10-4b. Sculpture of Christ in painted sarcophagus, Christ effigy, late thirteenth century;
sarcophagus (167 × 250 × 80 cm), 1448; Wienhausen Convent. Photographer Wolfgang Brandis,
© Kloster Wienhausen.

and Easter, when the nuns reenacted Christ's Passion. Oil residue on the figure suggests that the nuns anointed the sculpted body of Christ; by doing so, they completed the task that the biblical Marys had planned when they went to anoint Jesus's body with spices and found the tomb empty (Mark 16:1, Luke 24:1).

Such hands-on encounters with the sacred are typical of late medieval women's spirituality in Europe. So too is imaginative pilgrimage, in which specific places in the convent stood in for sites in Jerusalem that Jesus had passed on the way to his crucifixion. The circuit at Wienhausen began and ended in the nuns' choir. Manuscripts narrate an itinerary through the convent, and even though they date to the late fifteenth century they probably reflect earlier practices. Such spiritual travel could also be performed by concentrating mentally on the distant holy sites. This was widely done in the late Middle Ages by laypeople as well as by nuns and monks, in part because it was so difficult to visit the actual Holy Land.

Wienhausen also sheds light on aspects of the nuns' lives that seemingly have little to do with their Christian beliefs. Three embroideries made and preserved at the convent are entirely secular in their iconography (fig. 10-5). They all narrate the love story of Tristan and Isolde, which by the fourteenth century was part of the large body of chivalric tales loosely concerned with King Arthur's legendary knights; an oral tradition with Celtic roots, the stories were written down beginning in the late twelfth

century. In the embroidery shown here, made in the early fourteenth century, three figural registers are divided by rows of shields and inscriptions in the local vernacular language, a dialect of German. What this romantic tale meant to the nuns is unclear: Was it a warning against secular love? An allegory of divine love? Or were the textiles destined not for the nuns' spaces but for the monastery's guest quarters or a nearby noble hunting lodge?

In 1953 the floorboards of the nuns' choir were removed and over two thousand lost or deliberately hidden objects were rediscovered. Most of the finds were connected with textiles: the nuns were constantly making new clothes for all of their effigies of Christ, some large and others small, even doll-size. Many of these garments were stiffened with pages recycled from sacred texts, including a fragmentary Easter play. Other objects included plaster plaques with Passion imagery, the oldest pair of eyeglasses in Europe, metal pilgrimage badges, and miniature prayer books from about 1400. An unexpected find was a mandrake root in a fourteenth- or fifteenth-century box. The mandrake is a medicinal plant well known as an aphrodisiac; on the Hereford mappa mundi it is labeled "a marvelously potent plant" (fig. 9-3). Its root looks like a miniature man, and according to ancient and medieval medical literature its shriek when uprooted would kill anyone within earshot. (To avoid this fate, one could tie a string around the upper part of the root, attach it to a dog's leg, and let the dog suffer the consequences.) Another important find was a small bundle

Fig. 10-5. Tristan and Isolde embroidery, 233 × 404 cm, early fourteenth century; Wienhausen Convent. Photographer Ulrich Loeper, © Kloster Wienhausen.

of relics that included a silk cloth with a Kufic inscription, fragments of Chinese porcelain, and an arm bone, labeled as being from Byzantium, inside a gilded sleeve inscribed "St. Silvanos" in Greek. This bundle, which also contained parchment lists and labels from the thirteenth and fourteenth centuries, may have come from an altar and was probably hidden during the Protestant Reformation, when the nuns were ordered to renounce Roman Catholicism and its relic cult. Like the spiritual itinerary and the Arthurian textiles, these items demonstrate the interactions of the Wienhausen nuns with the wider world, despite their physical enclosure within the walls of the convent.

Sacred Bodies

In the fourteenth century, images of Christ's suffering became more graphic to intensify the emotional effect on the beholder. Called "Christi dolorosi" or "crucifixi dolorosi" (from *dolor*, Latin for "pain"), wooden images like one from Wrocław (Poland) carved in the 1370s show the martyred body of Jesus on a Y-shaped, treelike cross, here a modern replacement (fig. 10-6). His head slumps on his chest, and his body is covered with wounds inflicted by his torturers; thick clots of blood in high relief give his pain a physical and tangible reality. String was used to make the distended veins, and the crown of thorns is woven from actual buckthorn. This Christus dolorosus represents a

type of devotional image that was widespread in Franciscan and Dominican monasteries. The influential Dominican philosopher Thomas Aquinas (d. 1274, canonized 1323) justified the use of images, which the Dominicans had not originally permitted, and wrote extensively about how all of Christ's senses and body parts suffered on the cross. The emotive crucifixes may have inspired, or been inspired by, penitential practices: their emergence paralleled that of the flagellants, people who whipped themselves in public to atone for sin and bring themselves closer to God. When this innovative form of crucifix was introduced in London in 1305, it was condemned by a bishop who found its imagery disturbing because it departed dramatically from iconographic tradition.

Another type of religious sculpture that emphasizes the body is the so-called Shrine Madonna, a representation of the Virgin and Child that emerged in the late thirteenth century. This example, from the early fifteenth century, was made in Pomerania, a region of Germans, Poles, and Lithuanians bordering the Baltic Sea (fig. 10-7). At forty-eight centimeters high, it is twice the size of the smallest examples, but others are nearly life-size. The work is hinged at the level of Mary's arms to be opened along the vertical seam that runs from her neckline to the foot of her throne. When open, it forms a triptych: at the center, the enthroned God the Father supports a three-dimensional crucifix (the figure of Christ may be a later replacement), and on the flanking wings are painted worshipers, from

Fig. 10-6. Christus dolorosus from Wrocław, 177 × 131 × 44 cm, 1370s; Muzeum Narodowe v Warszawie, Warsaw. © Genevra Kornbluth.

crowned rulers to a pope, bishop, nun, and unidentified elites. Mary's arms are visible at the top of the wings, so she seems to be spreading her mantle to enclose the congregation as in the Mother of Mercy iconography (fig. 9-35). In the Pomeranian statue Mary is not only the "Throne of Wisdom"; she also contains Jesus and God the Father in her womb or heart. This type of image was criticized as impious by some contemporaries because Mary gave birth to Jesus, not to God the Father, but the sculptures expressed popular ideas about Mary's maternity and were not banned by the Church until the eighteenth century. Other Shrine Madonnas open to reveal narrative scenes from the life of Mary or Christ; in some cases the Virgin on the exterior is breastfeeding her child, and occasionally the material is ivory or gold instead of wood. These works appeared all across Europe, from Portugal to Poland and as far north as Scandinavia. The Teutonic Knights, a German military order based in the Holy Land that controlled Pomerania in the fifteenth century, commissioned portable Shrine Madonnas to serve as focuses of communal prayer during their military campaigns. Life-size versions were opened on specific feast days as a grand spectacle, whereas smaller ones were used for personal devotions. By physically opening the Virgin's carved body, pious Christians attained an intimate relationship with the divine.

The idea of the body of Mary as the vessel of God was also important in the late Byzantine world, where pictorial cycles of her life became increasingly widespread. At Mystras, an important town in southern Greece that the

Figs. 10-7a and 10-7b. Shrine Madonna, 48 × 29 × 12.5 cm, early fifteenth century, (*left*) closed; (*right*) open; Musée de Cluny, Paris. (*l*) Michel Urtado, © RMN-Grand Palais/Art Resource, NY; (*r*) © Genevra Kornbluth.

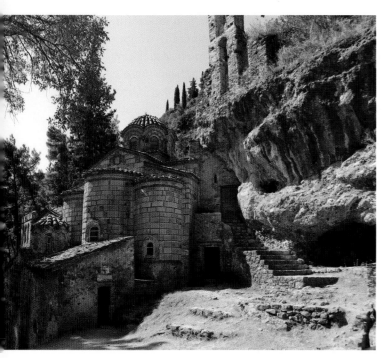

Figs. 10-8a and 10-8b. Peribleptos Monastery katholikon, Mystras, ca. 1365–74, (*left*) view from the south; (*right*) Marian scenes. (*l*) Photo by Geoff Godden; (*r*) Sharon Gerstel; under the jurisdiction of the Ephorate of Antiquities of Laconia, rights belong to the Hellenic Ministry of Culture and Sports/Archaeological Resources Fund.

Latins ceded to the Byzantines in 1262, numerous monastic churches were founded in her honor. One of these was the Peribleptos (The One Who Watches Over All), probably built in the 1360s by Isabelle of Lusignan, of the royal house of Cyprus and Armenia, whose heraldic emblems are carved in the monastery. She was married to the first despot (lord) of the Morea (southern Greece), Manuel Kantakouzenos (r. 1349–80). The elongated cross-in-square katholikon, constructed of stone interspersed with decorative brickwork, abutted a preexisting cave shrine (fig. 10-8a). Its wall paintings are Byzantine in style and Orthodox in iconography, and in the absence of extant paintings in Constantinople, the monuments of Mystras provide critical evidence for the final stages of Byzantine painting. The focus of the Peribleptos decoration is the Theotokos: the church contains twenty-five scenes of her infancy and childhood, the most extensive Marian cycle in any Byzantine interior (fig. 10-8b). The stories derive from the second-century *Protoevangelion of James*, a popular apocryphal text that informed Christian and Muslim traditions about the early life of Mary and the birth of Jesus; there is no information about Mary's early life in the Gospels. The scenes depicted here focus on Mary's elderly parents, Joachim and Anne (Anna in the Orthodox Church): at the upper left, their meeting at the Golden Gate of Jerusalem after Anne was told she would bear a child (their embrace represents Mary being conceived without sin); the couple bringing offerings to the Temple, shown as a rotunda; and the birth of Mary, with Anne surrounded by attendants. In the lower register are scenes from Mary's childhood. Even the church's most prominent image, the Pantokrator in the dome, is encircled by rows of prophets whose inscribed scrolls underscore Mary's role in the Incarnation.

In the first quarter of the fifteenth century, a Franciscan confraternity (lay brotherhood) in Fabriano (Italy) commissioned a famous artist originally from that town, Gentile da Fabriano (ca. 1370–1427), to paint a two-sided wooden panel that would serve as the group's standard during processions in honor of Mary. One side of the panel depicts her coronation by Christ (fig. 10-9), and the other showed St. Francis receiving the stigmata. The panel was cut in two, probably in the nineteenth century when paintings with multiple parts were often divided into smaller pieces and sold to collectors; the Francis panel is now in a private collection in Italy. The golden background of the Coronation scene (made from coins then in circulation) and the presence of angels place the event in heaven, where the youthful Virgin is elevated as queen and ruler with her son. This western European iconography highlights Mary's exalted status: she is blessed and crowned by Christ under the dove of the Holy Spirit and God the Father, who was depicted at the (now lost) apex of the panel. The painting's richly patterned surface is marked by texture: the haloes and garment hems are tooled, and the crown, textiles, and beaded halo rims are molded with gesso (animal glue, chalk, and pigment). Gentile's resplendent surfaces and sumptuous textiles helped make the image more striking and would have been especially appealing to new types of patrons like the confraternities and wealthy merchant families who were involved in the textile trade.

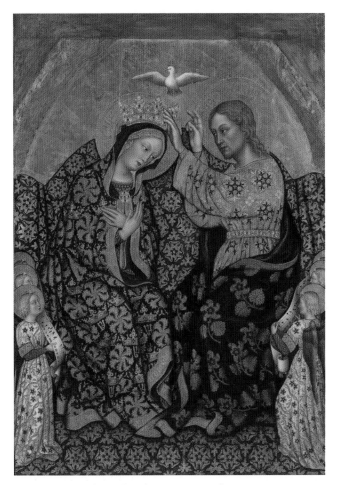

Fig. 10-9. Painted panel with Coronation of Mary, 93 × 64.1 cm, ca. 1420; J. Paul Getty Museum, Malibu. Digital image courtesy of Getty's Open Content Program.

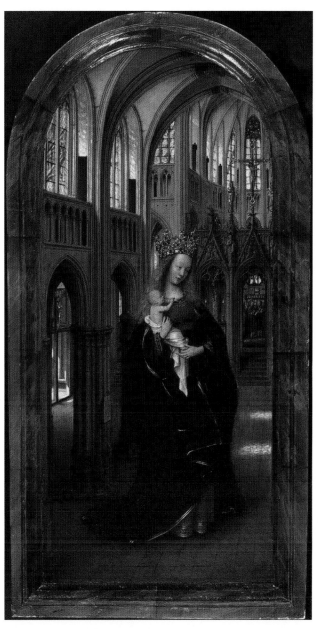

Fig. 10-10. Painted panel with Mary in a church, 31.1 × 13.9 cm, ca. 1440; Gemäldegalerie, Staatliche Museen zu Berlin. bpk Bildagentur/Gemäldegalerie/Joerg P. Anders/Art Resource, NY.

Jan van Eyck was another painter who flourished at this time, working for such aristocratic patrons as Philip "the Good," the duke of Burgundy (r. 1419–67). Jan was born around 1390 and spent much of his career in Bruges (Belgium), where he may have been trained as a manuscript painter. Like Gentile, he specialized in wood panels, but his technique was very different: he mixed his pigments with oil (rather than egg tempera) and layered them, creating subtle effects of light and color. Oil paints had been used in northern Europe in previous centuries, but the detailed naturalism that Jan developed with the material draws viewers into his compositions in new ways. This panel of about 1440 depicts Mary inside a church (fig. 10-10). She is massive in scale, her height reaching past the nave arcade into the triforium. Rather than asserting Mary's heavenly status with a gold background, as Gentile and Byzantine icons did, Jan placed her in a familiar-looking earthly environment: a Gothic church, with a tripartite elevation, quadripartite vaults, stained-glass windows, and figural sculpture, including a choir screen supporting a Calvary group—all rendered in tiny detail. Behind the screen, angels sing before a carved altarpiece. The angelic bodies help show that this is not a representation of an actual

church but, rather, an invented and perfected heavenly one. Light streaming in through the portal and windows on the left illuminates Mary's skin and intricate jeweled crown, emphasizing her status as queen of Heaven. In this work, Jan van Eyck demonstrated his virtuosity with scale: the grand figure of Mary and the church interior convey monumentality, but the entire panel is only thirty-one centimeters high, which makes the clarity of the painted details even more astonishing. The panel with Mary was originally half of a diptych, and the lost half depicted the patron kneeling toward the Virgin (copies show a male devotee). While contemplating these panels, the patron would have seen an image of Mary looking at an image of him looking at her, as if he were witnessing the effective

interplay of his own devotions. Mary both symbolizes the Church and acts as an intercessor for the viewer.

In the Muslim world, Sufi confraternities were divided into numerous orders with distinct rituals. Many adopted a lifestyle of poverty that incorporated such devotional acts as meditation, reciting prayers, counting prayer beads, or ecstatic dancing. The goal was union with God, which some Sufi poetry compares to an insect approaching a brilliant flame and being subsumed within it—enlightenment that is a kind of death of the self before physical death. At the end of the fourteenth century, Timur rebuilt the mausoleum of a Sufi mystic, teacher, and poet, Ahmad Yasavi (1093–1166), who had played a key role in the spread of Islam in Central Asia (fig. 10-11).

Located in Yasa, now Turkistan (Kazakhstan), this huge brick structure reveals Timur's ambition and the talents of artists and architects gathered from across his empire, characteristics of Timurid arts discussed further below. The shrine's towering entrance iwan and central dome, which are of equal height, serve as beacons in the flat landscape. A striking variety of architectonic volumes, textures, and ornamentation enliven the shrine. The exterior glazing covers the entire building (except for the iwan left unfinished at the time of Timur's death), not just the dome as in Ilkhanid buildings. *Banna'i* (Persian for builder's technique) patterns, in which plain bricks alternate with glazed ones, cover its walls with a web of geometric

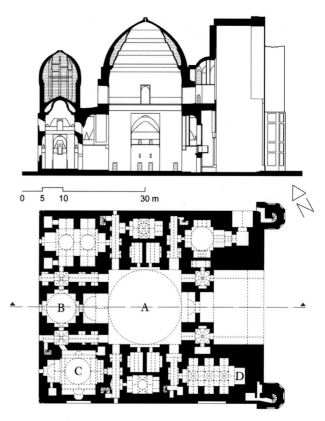

Fig. 10-11a. Shrine of Ahmad Yasavi, Yasa (Turkistan), 1389–1405, A=central dome, B=tomb, C=mosque, D=refectory. Drawings by Navid Jamali.

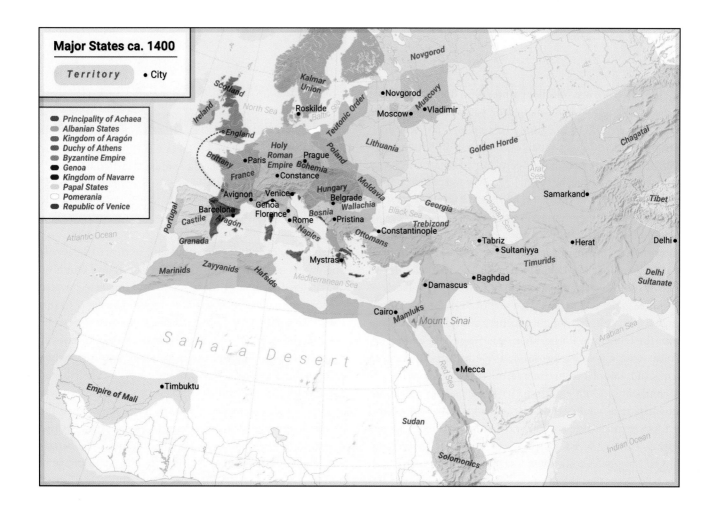

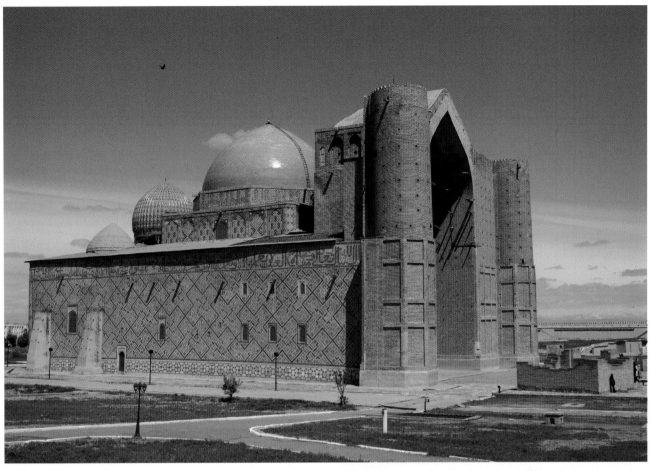

Fig. 10-11b. Shrine of Ahmad Yasavi, Yasa (Turkistan), 1389–1405, view from the southeast.
Wikimedia Commons/Petar Milošević, CC BY-SA 3.0.

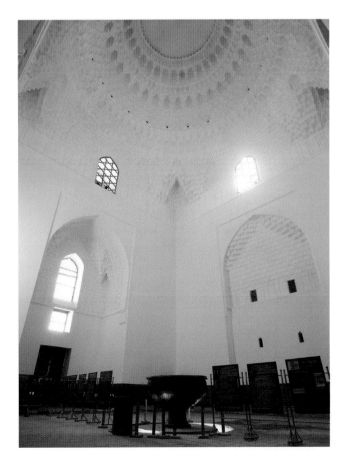

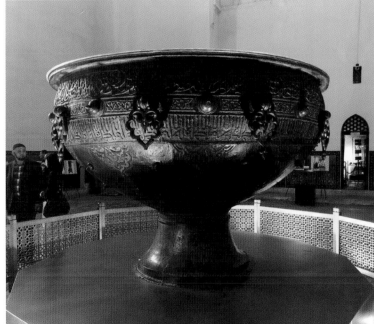

Figs. 10-12a and 10-12b. Shrine of Ahmad Yasavi, Yasa (Turkistan), 1389–1405, (*left*) central dome; (*right*) bronze cauldron, 1.6 × 2.4 m, 1399. (*l*) © Our Place World Heritage Collection; (*r*) Wikimedia Commons/Davide Mauro, CC BY-SA 4.0, modified.

calligraphy in black, blue, and turquoise. Beyond the massive entrance are dozens of rooms and passageways spread over two stories; they utilize so many inventive ceiling designs that the shrine has been called a museum of vaulting. The entrance leads into the central space of the complex, a square room topped with the largest dome in Central Asia (18.2 m diam.; fig. 10-12a). Its double shell is typical of Timurid architecture; the outer dome rests on an inner one in order to maximize its height and prominence in the landscape. This space holds an enormous cast-bronze cauldron (fig. 10-12b). A gift of Timur, it bears the date 1399 and the name of the craftsman, 'Abd al-Aziz from Tabriz (Iran). It was used for drinking water and for serving porridge at the end of the annual fast that commemorates the martyrdom of Husayn in 680 (box 3-1).

The entrance iwan and square hall with the cauldron define an axis that leads to the tomb of Yasavi, located in a smaller domed chamber at the center of the qibla wall (fig. 10-11a). To its side is a mosque with four shallow iwans. A kitchen, refectory, and small spaces for sleep and prayer are on the southeast side. Additional meeting rooms and a library for studying Yasavi's Sufi teachings served religious leaders, students, and pilgrims. While the building's

scale, inventive design, and details display Timur's ability to marshal human and material resources, they also attest to the spiritual power of the mystic's body at the center of the mausoleum. Pilgrimage to the tombs of Shi'i saints—ziyarat, versus the hajj—was common, and under the Timurids, funerary architecture for Sufis became increasingly monumental. Such elaborate buildings were controversial, however, because the hadith and Sunni jurists held that tombs were but temporary abodes where the dead awaited judgment. The construction of the shrine suggests Timur's desire to appease key allies, the Turkic-speaking people of the steppes whom Yasavi had converted to Islam. Ahmad Yasavi is commonly known as "Father of the Turks"; a visit to his grave was often the first stop on the pilgrimage to Mecca, and the shrine later became the national symbol of Kazakhstan.

A page in a late fourteenth- or early fifteenth-century Ethiopian Gospel book brings us back to the body of Christ (fig. 10-13). Written in Ge'ez like the much earlier Garima Gospels (fig. 3-25), even though that was no longer a spoken language, the book was made at the powerful monastery of Dabra Hayq Estifanos, dedicated to Stephen, the first Christian martyr (Acts 7:55–60). It may have been commissioned by one of the Solomonics, the dynasty that succeeded Lalibela and the Zagwe; they claimed descent from the biblical King Solomon through his marriage to the queen of Sheba, as narrated in the Ethiopian *Glory of the Kings*. The Gospel book contains evangelist portraits and twenty full-page scenes from the life of Christ; its wooden binding is original. Two artists used a bright but restricted color palette, strong outlines, and linear patterning with no modeling to create forceful two-dimensional images that draw from Coptic, Byzantine, and other models. This page depicts the Transfiguration (Matt. 17:1–8, Mark 9:2–8, Luke 9:28–36), in which Jesus's true nature was revealed on Mount Tabor: his clothes and the space surrounding him became bright white, and the voice of God identified Jesus as his son. The Transfiguration confirmed Christ's divinity and previewed his glorified body at the resurrection; the event was celebrated as a major feast in the medieval Ethiopian and Byzantine Churches. Standing in an arched mandorla that echoes the entrance into the sanctuary of Ethiopian churches, Jesus points to a codex—surely a Gospel book. Flanking him are the enthroned figures of Moses and Elijah, both of whom were denied a direct vision of God on Mount Sinai; they point with exaggerated forefingers to bear witness that Jesus is the Messiah foretold in the Old Testament. Looking on from above are the three apostles who witnessed the metamorphosis, and their frontal poses, gazes, and energetic gestures draw viewers into the painted narrative, helping them, like their biblical forebears, to see the miraculous revelation of Jesus's divinity.

The Transfiguration (Greek Metamorphosis) is represented very differently in a manuscript of 1370–75 that contains the theological writings of the Byzantine emperor

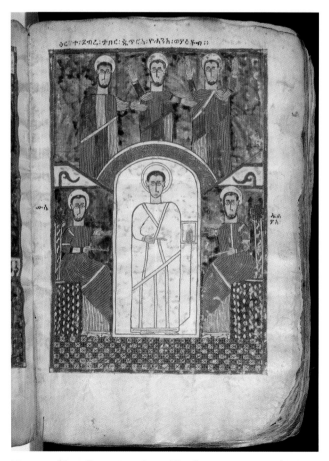

Fig. 10-13. Transfiguration, Gospel book, 41.9 × 28.6 cm, late fourteenth–early fifteenth century; New York, Metropolitan Museum of Art, acc. no. 1998.66, fol. 9r. Rogers Fund, 1998. Image © Metropolitan Museum of Art.

Box 10-1. MYSTICISM AMONG JEWS, CHRISTIANS, AND MUSLIMS

Many religions maintain that a person can transcend the physical limitations of being human and somehow see or even spiritually merge with the divine. This goal and associated practices are often described as mystical, a word derived from the Greek for "mystery" because they were difficult to achieve and often required secret knowledge. The theology and especially the practices developed for achieving such a state were complex, varied, and subject to change. The view that union with God was blocked by the inherently negative materiality of the human body, which thus had to be denied and overcome, was favored in late antiquity, but it shaped ascetic and monastic practice well into the sixteenth century and beyond in all three faiths. The alternative idea—that basic features of being human, such as the capacity to see, to desire, and to love, could be harnessed toward perceiving and melding with God—became especially strong in the twelfth century (Rabbi Bahya ibn Paquda's *Duties of the Heart*, Bernard of Clairvaux's sermons on the *Song of Songs*, Jalal al-Din Rumi's *Diwan-e Shams*). The religious question might be put this way: Was the seeker's goal to understand the intrinsic nature of God (Maimonides) or to develop a state of individual perfection (Abu'l-Qasim al-Qushayri)? Did understanding of the immaterial Divine come only through rational and intellectual philosophy (Ibn al-'Arabi, Robert Grosseteste), or was the mind incapable of comprehending God, so that a mystical encounter was only possible through irrational and emotional experience (Gertrude of Helfta)?

Many of these questions had been considered in other forms by the Greek philosopher Plato, and much mystical speculation throughout the Middle Ages relied on Neoplatonic ideas. Mysticism was often concerned with "hidden" things, such as the meanings of God's secret names, the nature of angels, or the relationship between the human soul and a cosmic counterpart (Pseudo-Dionysios). Medieval mystics often claimed that their knowledge was received through direct divine revelation, often in the form of visions (Hildegard of Bingen). By contrast, the dominant mystical ideas in Islam were promoted by Sufis, whose paths toward unity with God were rooted in their understanding of Muhammad's life, sayings, and family. Sufi practices were taught by gifted mystics at special khanaqahs that were often founded or endowed by local elites, like Timur at the shrine of Ahmad Yasavi. Medieval Sufism had a stronger public and communal character than Jewish and Christian mysticism, which more often highlighted individual experience. Yet it is difficult to generalize about medieval mystical thought because there was no one dominant mystical expression within each religion, and there was often cross-fertilization among them. For example, twelfth- and thirteenth-century Iberia was home to important Muslim mystics and is also where the Jewish *Zohar* was developed. This is the fundamental work of kabbalah, which focuses on understanding the ten divine qualities underlying all existence.

Mystical thought and experience often had visual manifestations, as in the kabbalistic diagrams that mapped the emanations of the Godhead, the sculptures of Jesus toward which late medieval women (like the nuns at Wienhausen) directed their devotions, or the Byzantine Transfiguration illumination discussed below. In Islam, Sufism became an important catalyst for architectural innovation, particularly in Iran and Central Asia where shrines and khanaqahs proliferated in the later Middle Ages.

John VI Kantakouzenos (r. 1347–54) (fig. 10-14 *left*). Here the scene takes place in a craggy landscape that resembles the real Mount Sinai, but the gold background pierces the peaks and subverts the impression of naturalism. The apostles are so overcome by Christ's metamorphosis that two are losing their sandals and plummeting to earth while the one at the left, Peter, shields his eyes. The light shining from Christ is blue and white, multilayered and with striking rays. The iconography was strongly influenced by a new mystical movement in Byzantine religious thought in the fourteenth century: hesychasm (from the Greek word for stillness). Hesychasts held that God imparts himself directly to humankind through his incarnation and his uncreated light and that repeating the "Jesus prayer" ("Lord Jesus Christ, son of God, have mercy on me") could spark a vision of divine light. Originally a monastic and mystical practice, hesychasm became much more widespread and officially part of Orthodox doctrine in the mid-fourteenth century, when the teachings of its major proponent, Gregory Palamas (ca. 1296–1359), were approved and his

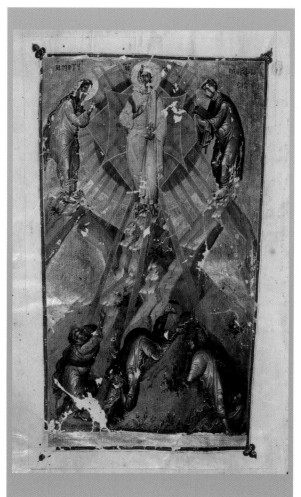

Fig. 10-14. Theological writings of John VI Kantakouzenos, 33.5 × 25 cm, 1370–75, (*left*) Transfiguration, fol. 92v; (*right*) John as emperor and as monk, fol. 123v; Paris, Bibliothèque nationale de France, MS gr. 1242. Photos from Bibliothèque nationale de France.

adversaries condemned at Church councils convened by John VI. In this manuscript of John's writings, the Transfiguration image appears in the middle of a discussion about the divine light perceived by the apostles. The analogy of Mount Tabor to Mount Sinai is prominent in hesychast texts and underscored here by the barefoot apostles, whose lack of footwear echoes that of Moses on Sinai (Exod. 3:5). The oddly tapered format of the image emphasizes the sense of movement up toward the divine light, which prefigures the glory of Christ at the Second Coming. Hesychast practitioners who attained a vision of this light through prayer and contemplation thus anticipated the eternal illumination granted to the faithful in the future.

Power, Prestige, and Piety

The same manuscript of theological writings contains an unusual double portrait of the author, framed like the Transfiguration image but larger in scale (fig. 10-14 *right*). John VI Kantakouzenos came to power after a civil war in the 1340s against Emperor John V Palaiologos, who

eventually returned and forced him to abdicate. John VI then became a monk in Constantinople, taking the name Ioasaph. In his portrait as emperor, he wears ceremonial garb and stands on a footstool adorned with double-headed eagles. He is frontal and immobile, in accord with traditional Byzantine ruler imagery, and around his head his titles and distinguished lineage are inscribed in red. As the monk Ioasaph, he is not labeled, showing his new humility. He wears a black monastic habit and gestures toward an image of the Hospitality of Abraham, when three men or angels visited the Jewish patriarch (Gen. 18:1–2). This episode is a type for the Trinity, an idea the painter made explicit by adding a cross to the central angel's halo. The scroll in Ioasaph's left hand says, "Great is the God of the Christians," the first words of the anti-Muslim treatise that follows this page (other texts in the manuscript polemicize against Jews and Christian opponents of hesychasm). Double portraits were not uncommon during the late Byzantine era—they appear in the arcosolium tombs in the parekklesion of the Chora Monastery—but they were limited to a funerary context, and this dual depiction in a manuscript is exceptional. John-Ioasaph eventually

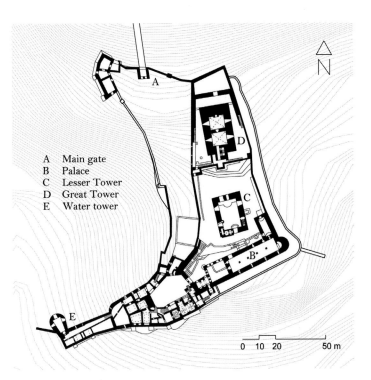

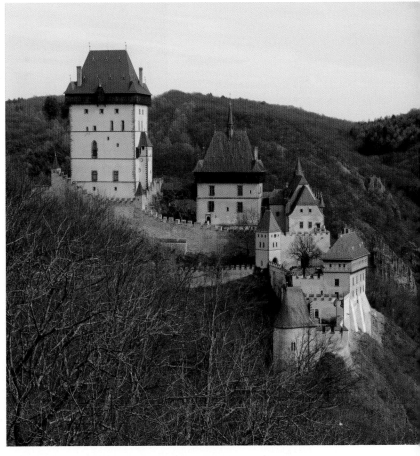

A Main gate
B Palace
C Lesser Tower
D Great Tower
E Water tower

0 10 20 50 m

Figs. 10-15a and 10-15b. Castle, Karlštejn, 1348–65, (*left*) plan; (*right*) view from the west. (*l*) Drawing by Navid Jamali; (*r*) Wikimedia Commons/gampe, CC BY-SA 3.0.

left Constantinople for Mystras, where he had previously named his son Manuel as despot, and he died there in 1383.

Contemporary political and theological concerns are also apparent in images of Charles IV, the first Bohemian king to become Holy Roman emperor (r. 1346–78), in his castle at Karlštejn (Czech Republic). Built by an unknown architect about thirty-five kilometers from the Bohemian capital of Prague, the castle was substantially completed between 1348 and 1365 (fig. 10-15). Its three main structures ascend a hill, with the residence of the emperor and his court below the Lesser Tower and the Great Tower at the top. The residential building once depicted the genealogy of Charles IV, tracing his ancestry through his namesake Charlemagne all the way back to Noah.

In the Chapel of Our Lady (Mary) on the second floor of the Lesser Tower, Charles appears six times, as emperor, relic collector, and instrument of God. Surrounded on three sides by the most extensive cycle of Apocalypse images in European wall painting, he is the representative of Christ on Earth and leads the battle against the Antichrist. This vivid imagery of the end of the world must have seemed particularly meaningful for Charles and his contemporaries, given that plague and famine had recently devastated their kingdom. On the south wall Charles receives relics from a French king and another unidentified ruler, possibly John V Palaiologos, and then places them into the golden reliquary cross that he commissioned to

hold them (fig. 10-16). The translation of relics documents a twin transfer of religious and secular power, culminating in Charles IV and his imperial status. The reliquary was melted down in the 1370s, at Charles's orders, to make an even grander one.

Even the stairwell of the Great Tower glorifies Charles. It is painted with the genealogy of the Přemyslids, the Czech royal dynasty since the ninth century, to which Charles belonged through his mother. It narrates the history of Christianity in Bohemia, including twenty-eight scenes of the life of the tenth-century martyr "good king Wenceslas," of Christmas-carol fame, who is shown with the features of Charles IV. The stairs culminate in the Chapel of the Holy Cross, which housed the largest collection of Passion relics in Europe (acquired by Charles in 1356), including two thorns from the crown kept in the Sainte-Chapelle in Paris, a nail, and pieces of the lance and sponge that tormented Jesus on the cross. It held not only the gold reliquary cross (now in the Prague Cathedral treasury) but also 129 iconlike busts of saints and prophets (fig. 10-17 *left*). Some of them had political associations, such as St. Charlemagne (canonized in 1165, but the act was never confirmed), St. Louis, and St. Maurice, a third-century martyr who became a patron saint of the Holy Roman Empire (fig. 10-17 *right*). According to legend Maurice was an Egyptian in the Roman army, and he is depicted here as Black, following thirteenth-century precedents in

Fig. 10-16. Scenes with relics, Chapel of Our Lady, Lesser Tower, Karlštejn Castle, 1348–65. © Genevra Kornbluth.

Fig. 10-17. Chapel of the Holy Cross, Great Tower, Karlštejn Castle, 1348–65, (*left*) north wall; (*right*) St. Maurice, east wall. (*l*) © Genevra Kornbluth; (*r*) Collection of The National Heritage Institute, Regional Historic Sites Management in Prague, Karlštejn Castle.

Germany; elsewhere Maurice was shown with white skin. In the racialized image in the Chapel of the Holy Cross, Maurice's very dark skin color, curly hair, and facial features reflect the artist's stereotype of African appearance. His expensive knightly dress and cross-bearing shield are clear signs that his supposed origin in Africa in no way diminished his status. In this case, Maurice's stereotyped features have positive connotations, affirming the presence of Blacks among the saintly elect.

Most of the gilded frames of these painted wood panels contain relics, visible through crystal covers. The busts were painted by Master Theodoric, the court artist and head of the Prague guild of painters, with a team of helpers. They were executed with layered pigments of egg-based tempera and oil, which allowed for subtle gradations of color and modeling, creating highly reflective images of the saints that glittered along with the rest of the chapel's decoration. The dado is sheathed in crosses formed of precious and semiprecious stones and gold, and the vault sparkles with tiny gems and Venetian glass. The resemblance to the shining Heavenly Jerusalem described in Revelation would have been even stronger with the original crystal chandeliers and over thirteen hundred candles. The focus of the room is the altar on the north wall (shown here), which contained relics of St. Wenceslas, and the paintings arrayed above it: the Virgin and Child, the Man of Sorrows, and the Crucifixion, all of which contain embedded relics and thus blur the distinction between images and relics.

The multilayered message at Karlštejn Castle is that Christ, present in the Passion relics, will redeem humankind, and that Charles IV, as an acquirer of Christ relics, is a divinely sanctioned ruler and a new incarnation of Charlemagne.

Rulers of smaller domains also sought out innovative art and artists in their efforts to demonstrate their status and piety. Jean, the powerful duke of Berry (France) (1340–1416), was the son, brother, and uncle of three French kings and an avid collector and patron. He hired three gifted teenage brothers—Paul, Jean, and Herman de Limbourg, from Nijmegen (Netherlands)—to illuminate manuscripts he commissioned. By 1409 they had completed one book of hours for the duke, and two years later they created another, the *Très Riches Heures* (*Very Rich[ly Decorated] Hours*) (box I-3). The book comprises 206 folios of the highest-quality calfskin, and full-page illuminations in the calendar feature scenes of contemporary life that are appropriate for each month. The image for January, signaled by the zodiac signs for Capricorn and Aquarius at the top of the page, reveals the Limbourg brothers' talents and Jean de Berry's tastes (fig. 10-18). The duke—seated behind the table in the foreground, with his profiled head outlined by a halo-like firescreen—oversees the ritualized exchange of New Year's gifts between his well-to-do associates and himself. Costly goods are piled on tables, including the large *nef*, a ship-shaped receptacle for salt, pepper, and perhaps the powdered "unicorn" horn used to detect poison. At the left end of the duke's table, a servant slices bread into squares to serve as trenchers, plates to soak up juices from the meats being carved nearby; someone tests the wine from a golden bowl at left. In the background, a tapestry depicts knights emerging from a castle, and the duke's coat of arms, with fleurs-de-lys, swans, and bears, is displayed over the fireplace (a swan and bear also adorn the *nef*). The elegant, elongated figures and decorative patterning on the garments and elsewhere were widespread in European painting in the decades around 1400, in part because artists moved from one court patron to another. The Limbourg Brothers did not live to finish the *Très Riches Heures*; they died of plague in 1416, and other painters finally completed it in the 1480s.

Like the duke of Berry, the Timurid prince Baysunghur, a grandson of Timur, was a famed bibliophile. A talented calligrapher himself, he established a royal library and kitabkhana in his capital at Herat (Afghanistan) that attracted esteemed painters and scribes from across the Timurid world. One was the master calligrapher Jaʿfar (fl. 1412–31), who in 1431/32 dedicated a copy of the *Quintet* (*Khamseh*) of Nizami to his patron. Nizami (1141–1209) was the greatest romantic and epic poet in medieval Persian literature. The *Quintet*'s five parts recount dramatic episodes in the lives of historical and legendary figures, including Alexander "the Great" and Bahram Gur. One tells the popular love story of Layla and Majnun (fig. 10-19). Layla and her cousin Qays, the poet eventually known

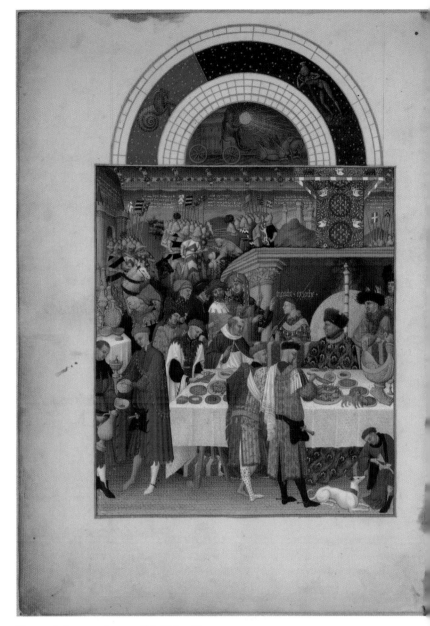

Fig. 10-18. January image, *Très Riches Heures*, 30 × 21.5 cm, ca. 1411–16; Chantilly, Musée Condé, MS 65, fol. 1v. René-Gabriel Ojéda; © RMN-Grand Palais/Art Resource, NY.

as Majnun ("Madman," because of his passion for Layla), fall in love as children, but her father prohibits their marriage and they die of broken hearts. In Nizami's telling, the story became a Sufi allegory about the search for divine love and beauty: the star-crossed lovers are reunited after death, and their common grave (in Binjaur, northwest India) became a place of pilgrimage. On this page, groups of young students congregate in a mosque or madrasa, the setting for the coed elementary school. In the upper register, Majnun is highlighted against the curtained mihrab as he converses with Layla, next to him in a yellow robe; the color, according to Nizami, signified beauty and truth. The painting is remarkably detailed; the faces, headgear, and clothing of the students are differentiated, and every

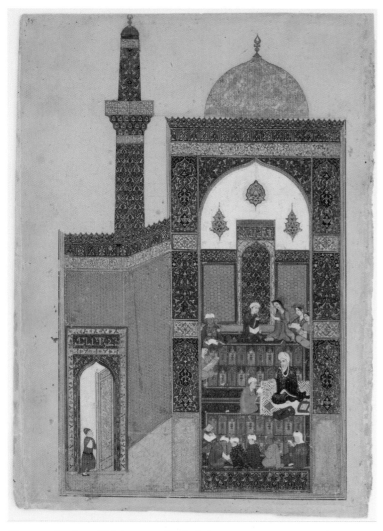

Fig. 10-19. Layla and Majnun at school, *Quintet,* 31.3 × 22.9 cm, 1431/32; New York, Metropolitan Museum of Art. Purchase, Lila Acheson Wallace Gift, 1994 (1994.232.4). Image © Metropolitan Museum of Art.

surface of the architecture is embellished with calligraphic inscriptions, colorful tiles, textiles, and foliate patterns. Whether reading, sitting with their teacher, or discussing among themselves, the students hold open books, on which tiny letters are visible. The image suggests the importance of books in this love story, as well as to Baysunghur and the Timurid court. Yet the name of the painter is not recorded, only the scribe's, a reminder of the elevated status of calligraphy in the Islamicate world.

Baysunghur's focus on manuscripts differed from the patronage of his famous grandfather Timur, who broadcast his power in monumental works like the shrine containing the holy body of Ahmad Yasavi. Timur's capital at Samarkand (Uzbekistan) contains several examples of architecture that proclaim his status and political ideology. His stated goal was to make Samarkand the center of the world and the threshold of paradise, and the surrounding villages were named after "lesser" cities in Islamicate lands: Sultaniyya, Baghdad, Damascus, Cairo. The Bibi Khanum ("Our Lady") Friday mosque, named for Timur's favorite wife, Saray Mulk Khanum, a descendant of Chinggis Khan, was begun in 1399 but left incomplete at his death in 1405; it survives only in impressive fragments (fig. 10-20). Measuring 167 by 109 meters, it was then the largest mosque in the world. The four-iwan plan is familiar, but the presence of domed chambers behind each iwan is new. Nearly five hundred stone columns supported shallow brick domes between the iwans; the stone was brought from India on the backs of almost one hundred elephants. The tallest double-shell dome precedes the mihrab on the west side, opposite the monumental entrance. It was rebuilt in the fifteenth century after collapsing; the builders from Iran and India had not taken local earthquakes into

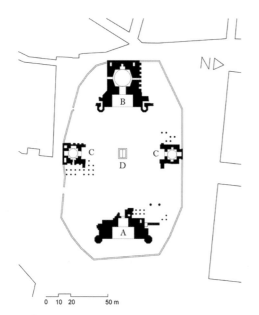

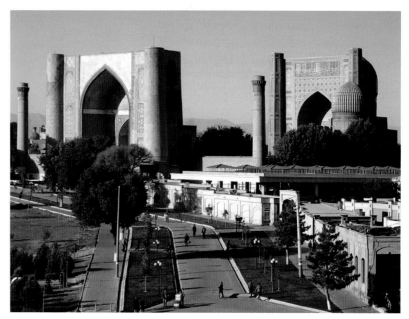

Figs. 10-20a and 10-20b. Bibi Khanum Friday mosque, Samarkand, 1399–1405, (*left*) plan, A=entrance, B=qibla iwan, C=side iwan with domed chamber, D=current location of Qur'an stand; (*right*) view from the northeast. (*l*) Drawing by Navid Jamali; (*r*) Wikimedia Commons/David Stanley, CC BY 2.0.

account. Four minarets at the outer corners of the complex and four enormous buttress towers flanking the entrance and the qibla iwan were probably intended to compete with the eight minarets at Uljaytu's mausoleum at Sultaniyya (fig. 9-8). Like the shrine of Ahmad Yasavi, the Bibi Khanum mosque was covered in tiles that spell out sacred names, which, along with huge scale, are the hallmark of Timurid architecture.

The great marble Qur'an stand originally near the mihrab and now in the mosque courtyard was donated by another grandson of Timur, Ulugh Beg (r. 1447–49). It is large enough to hold a two-meter-high Qur'an, and one of that size was made for Timur, using huge sheets of polished paper and a reed pen with a one-centimeter nib. Ulugh Beg also built a large madrasa, a Sufi khanaqah, and a huge observatory in Samarkand, although the observatory was vandalized after its patron's assassination. He is buried in the same dynastic mausoleum as Timur. Known as the Gur-i Mir (Tomb of the Emir, 1400–1404), the mausoleum is octagonal in plan with a projecting portal, topped by a bulbous ribbed dome clad in turquoise tiles (fig. 10-21a). Around the drum, a monumental inscription in black-and-white tiled Kufic reads, "God is eternal." In the square tomb chamber are marble and jade cenotaphs of Timurid family members who are buried in the crypt underneath (fig. 10-21b). Soviet archaeologists examined one set of bones in 1941 and confirmed that they belonged to a man with injuries to his right knee and shoulder consistent with Timur's nickname "the Lame." The walls of the Gur-i Mir are decorated with muqarnas and semiprecious stones, and molded paper (papier-mâché) was gilded and used in the dome, one of the earliest examples of this ancient Chinese technique employed in Central Asia.

While the Timurids sought to monumentalize their presence in a rebuilt Samarkand, Mamluk rulers asserted their political power in the Cairo cityscape. The complex of Sultan an-Nasir Hasan was built between 1356 and 1363 on the site of former emirs' palaces, which the new sultan demolished (fig. 10-22). Its scale was meant to complement the citadel and palace that it faced and to surpass the Pharaonic monuments of Egypt (its stone was spolia from ancient sites); contemporary accounts also claim that it rivaled the great Sasanian Taq-i Kisra (fig. 3-32). The complex has three main parts: a four-iwan Friday mosque that also functioned as a madrasa, with adherents of the four schools of Islamic law living and studying in four-story blocks between the mosque iwans; a domed mausoleum located behind the mosque mihrab; and a hospital. An interior inscription names Sultan Hasan (r. 1347–51, 1354–61) as the patron and Muhammad ibn Bilik al-Muhsini as the building supervisor. The portal, on the northeast, is on a different axis, unusually angled outward so that the entrance iwan could be seen from the citadel and vice versa. Its muqarnas hood and stone bands in contrasting colors (ablaq) are typical of Mamluk architecture. Some of the carvings on the portal feature lotus blossoms, which entered the Mamluk visual repertory from Chinese ceramics and textiles. On the interior, decoration is concentrated in the lower zones of the mausoleum and the qibla wall of the mosque; both have multicolored marble and joggled voussoirs in the ablaq technique. Above the marble zone in both spaces are monumental Qur'an inscriptions in plaster.

In the mosque, chains suspended from the qibla iwan supported polychromed glass lamps by the suspension rings on their bulbous bodies (fig. 10-23). Sultan Hasan commissioned hundreds of these oil lamps for his complex,

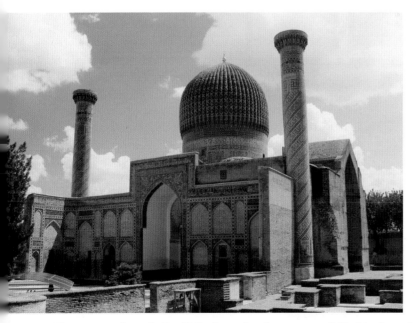

Figs. 10-21a and 10-21b. Gur-i Mir, Samarkand, 1400–1404, (*left*) view from the northwest; (*right*) tomb chamber.
(*l*) Wikimedia Commons/Willard84, CC BY-SA 4.0, modified; (*r*) Photo by Vicente Camarasa Domínguez.

(below) *Fig. 10-22a.* Sultan Hasan complex, Cairo, 1356–63, A=mausoleum, B=mosque, C=madrasa, D=hospital. Drawings by Navid Jamali.

(right) *Fig. 10-22b.* Sultan Hasan complex, Cairo, 1356–63, view from the citadel toward the mausoleum. Wikimedia Commons/Mohammed Moussa, CC BY-SA 3.0.

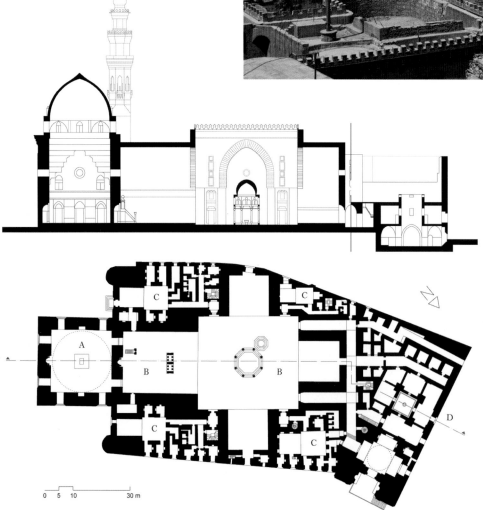

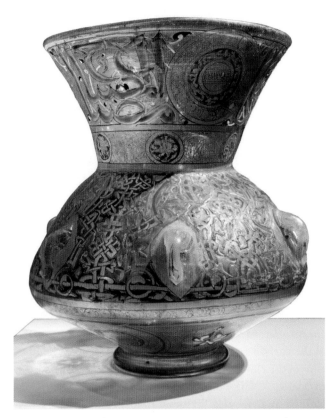

all decorated with paint, gilding, and thick enamel. Encircling the tall neck is part of the Light verse from the Qur'an (24:35): "Allah is the light of the heavens and the earth; a likeness of his light is like a niche in which is a lamp." The three medallions on the neck and above the low foot repeat "Glory to our lord the sultan," while the body is covered with colorful interlace patterns. The lamps thus reminded pious Cairo Muslims of God's radiant presence while also multiplying references to the terrestrial ruler.

A synagogue in Toledo (Spain) dedicated in 1357 was built for Samuel Halevi (also called Abulafia, the Arabic name of this Sephardic family). It was called the "El Tránsito" Synagogue after it became a church dedicated to the Transit or Assumption of the Virgin following the expulsion of the Jews from Spain in 1492. The chief treasurer and tax collector for King Pedro I "the Cruel" of Castile, Samuel constructed the synagogue next to his own palace; like the Scrovegni Chapel (fig. 9-15 *left*), the Samuel Halevi Synagogue was a private prayer space open only to invited guests. It was, however, public in its scale and its presence in the neighborhood. It soared to two stories and could hold about one hundred men downstairs and fifty women in the second-story gallery on the south side. The undecorated exterior contrasts with the sumptuous interior: a carved wooden roof, patterned floor tiles, and walls covered with carved and painted stucco in exuberant vegetal and interlace patterns (fig. 10-24).

On the eastern wall, facing Jerusalem, three polylobed niches held the Torah scrolls, which in Sephardic lands

Fig. 10-23. Mosque lamp, 33.6 × 30.5 cm, 1356–63; National Museum of Asian Art, Smithsonian Institution, Washington, DC. © Genevra Kornbluth.

Figs. 10-24a and 10-24b. Samuel Halevi Synagogue, Toledo, 1357, (*left*) plan; (*right*) view toward the southeast. (*l*) Drawing by Navid Jamali; (*r*) Photo by the authors.

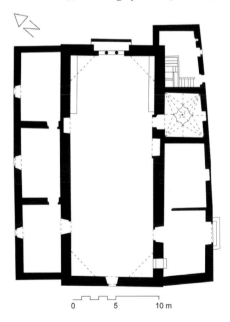

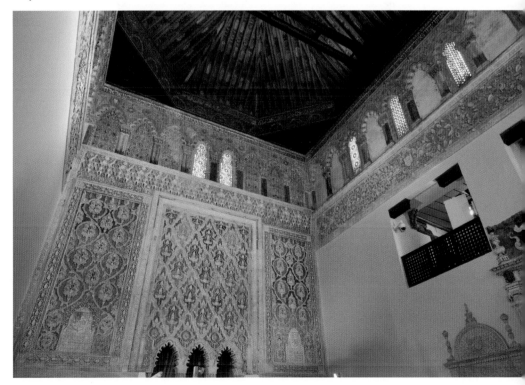

were kept in cases hidden by colorful textiles (fig. 9-23, left page). Hebrew dedicatory inscriptions in carved stucco exalt Halevi's lineage as a Levite—a member of the tribe of Levi, which served in the Temple in Jerusalem—and list his contributions (the building, its furnishings, the scrolls of the Law, and so on). They praise King Pedro and liken the synagogue to the Jewish Tabernacle and Samuel to its chief artisan, Bezalel (Exod. 31). Below the roof, a painted inscription in Arabic offers generic blessings of "happiness, well-being, glory, and honor." Some sculpted biblical verses in Hebrew and Arabic correspond with their location in the building: for instance, one in the women's gallery quotes Exodus 15:20, "Then Miriam the prophet, Aaron's sister, took a timbrel [tambourine] in her hand, and all the women followed her, with timbrels and dancing." The decoration of the synagogue looks very much like that of non-Jewish palaces and places of worship, including the Alhambra (see below). It underscored Samuel's desire to show Jews and non-Jews alike that his personal tastes matched those of other elites in multicultural Spain, while also inspiring in his coreligionists pride and hope for the future. The repeated image of a heraldic castle, the Castilian coat of arms, demonstrated Samuel's (and the Jewish community's) loyalty to the king, but it did him (and them) no good: Pedro charged Samuel with corruption and had him executed in 1360, and after increasing persecution, many Jews were murdered in Castile and elsewhere in Spain in 1391.

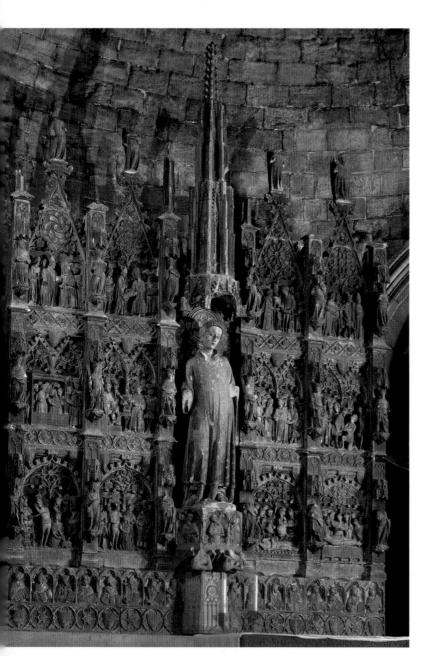

Fig. 10-25. Sant Llorenç retable, ca. 1390; church of Sant Llorenç, Lleida. Album/Alamy Stock Photo.

Innovative Art Forms and New Consumers

In northern Spain, a new type of altarpiece evolved during the second half of the fourteenth century. It combined the retable with the tabernacle, the container for the eucharistic bread when it was not in use during mass. One of the earliest surviving examples is still behind the high altar of the eleventh-century parish church of Sant Llorenç in Lleida (Catalonia), carved in limestone and vividly painted by Bartomeu de Robió i Lleida and his workshop around 1390 (fig. 10-25). Like a vita icon, the central figure of St. Lawrence, to whom the church is dedicated, is surrounded by twelve scenes of his life. He is nearly freestanding and probably once held as an identifying attribute the iron grill on which he was roasted to death. His dramatic martyrdom is sculpted in high relief below, enhanced by polychromy. Lawrence and the narratives are set within an architectural structure complete with arcades, elaborate blind tracery, gables, crockets, and pinnacles—the major components of Gothic design, here reduced in scale and placed at the focal point of Sant Llorenç's interior. The monumental retable not only resembled a building but also functioned as a wall, with the space behind it in the apse serving as a sacristy for storing liturgical implements. Catalan retables predate those in other parts of Europe and are made of stone, rather than wood. The works of Bartomeu de Robió show familiarity with the latest sculptural and pictorial styles from northern Italy, indicating that he synthesized those ideas with local traditions of carved and painted stone.

In the Orthodox Church, one way that the visual power of the liturgy was enhanced was through the *sakkos*, worn by bishops during the three most important annual feasts, Christmas, Easter, and Pentecost. Two such decorated vestments are associated with Metropolitan (Archbishop) Photios in Moscow (consecrated 1408); shown here is the so-called Major Sakkos (fig. 10-26). It is made of blue silk embroidered with gold and silver thread, colored silk, and

pearls; on the sides are silver bells and gilt-silver tassels. The entire feast cycle depicted in Byzantine churches is embroidered in 27 scenes containing 109 labeled figures, but the feasts are not in historical or liturgical order. Scenes with eucharistic associations are concentrated on the front. Large cruciform images depict the Crucifixion and Anastasis; between them, at the center of the garment, the cupola of the Holy Sepulcher shelters Christ lying in his tomb. He is labeled "Jesus Christ the *epitaphios*," literally Christ at or on the tomb, which also evokes the textile that shows Jesus laid out for burial (fig. 9-39). Prophets and saints complete the figural decoration, with forty holy bishops—including Photios—on the sides. At key moments during the liturgy, the curtain that hid the sanctuary was parted, making the priest visible to the congregation. The sakkos would have transformed Photios into something like a billboard, his embroidered images echoing in miniature those on the sanctuary barrier and on the walls of the church. When wearing the textile, the metropolitan became a living icon, ministering in place of Christ, his movements causing the bells to jingle and signal the presence of the holy.

The sakkos also testifies to the shifting political dynamics of the early 1400s. A century earlier Moscow had replaced Vladimir as the most important principality of Rus', and in the late fourteenth century the Muscovites began to free the rest of Rus' from Mongol domination. In the fifteenth century Moscow was the capital of an empire so powerful that ambassadors from Constantinople sought its support to help repel the Ottoman Turks. The lowest register of the sakkos depicts Grand Prince Vasily of Moscow and his wife, Sophia (daughter of the ruler of Lithuania); their daughter, Anna; and her husband, the future Byzantine emperor John VIII Palaiologos (r. 1425–48). This family portrait suggests that the garment was manufactured in Constantinople between 1414 and 1417—between Anna's marriage and her death from plague—and sent as a gift to Moscow. Photios is represented to the left of the family; he was a Byzantine bishop who had been appointed to his office by the patriarch in Constantinople. The garment thus asserted the control of the patriarch over episcopal appointments across the Orthodox world, while also acknowledging the importance of Moscow as a new political and religious center.

Prague was also a site of artistic commemorations and innovations in the fourteenth century. In 1356 the German-born architect and master mason Peter Parler (1332–99) was engaged by Emperor Charles IV to complete the choir of the new St. Vitus Cathedral, which had been under construction by the French architect Matthias of Arras (d. 1352) since its foundation in 1344 (fig. 10-27a). It was on the site of earlier churches built over the tomb of the sainted duke Wenceslas, who had acquired an arm of St. Vitus in 929 (Charles obtained the rest of the body). The cathedral became the mausoleum of the Bohemian royal dynasties and

the coronation church of its kings. Its architecture was inspired by recent German and English churches, but Parler introduced a number of innovations. The triple-arched entrance to the south transept has a mosaic of the Last Judgment (ca. 1370); in the central panel, six Bohemian patron saints are interposed between Christ in Majesty and Charles IV kneeling in veneration with his fourth wife (fig. 10-27b). There were few mosaics north of the Alps, so Charles was probably inspired by his travels in Italy, where he would have seen them on the exterior of numerous churches; the nearly one million glass tesserae needed for the eighty-two-square-meter mosaic were manufactured in Bohemia. Behind this entrance—called the Golden Gate, after the mosaic as well as the gate in Jerusalem—Parler

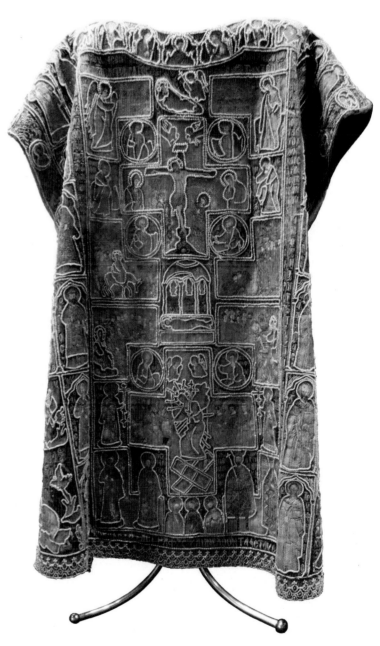

Fig. 10-26. Major Sakkos of Photios, front, 1414–17; Oruzheinaia palata, Moscow. © Genevra Kornbluth.

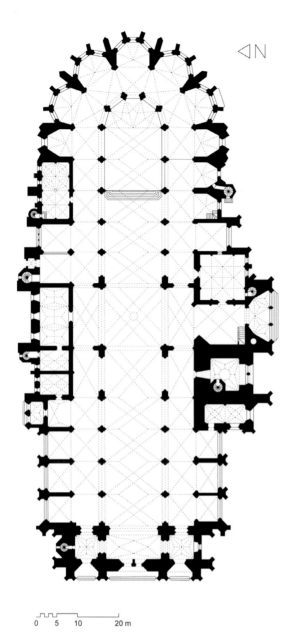

0 5 10 20 m

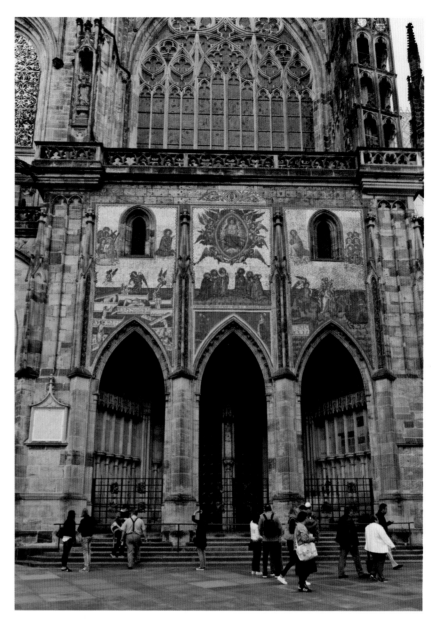

Figs. 10-27a and 10-27b. St. Vitus Cathedral, Prague, begun 1344, *(left)* plan; *(right)* south transept exterior, ca. 1370. (l) Drawing by Navid Jamali; (r) Photo by the authors.

furnished the new tomb chapel of St. Wenceslas with an elaborate ribbed vault and walls lined with semiprecious stones, like parts of Karlštejn Castle. The chapel was deliberately made dark and ancient-looking, in contrast with the bright choir with its huge clerestory windows.

Parler and his workshop embellished the triforium with twenty-one polychromed relief busts of the Bohemian patron saints, the cathedral's most important clergy, the emperor, and his family, all accompanied by coats of arms and biographical inscriptions painted in gold and silver. The portraits likely served a memorial function, commemorating figures involved in the cathedral's liturgy and important benefactors. Included in this distinguished group is the chief architect and sculptor himself, Peter Parler (fig. 10-28), as well as his predecessor, Matthias of Arras. These sandstone busts were carved at a time when self-portraits

were emerging in European art, but to a certain degree the images are generic: Parler's thinning hair and shorter beard are all that distinguish him from Matthias, who had died more than thirty years earlier. Nevertheless, Parler must have been recognizable as the man in the contemporary bust, for he was the first medieval architect whose image was captured during his lifetime, by carvers who saw him daily. This points ahead to the numerous depictions of artists in early modern Europe: we know what Dürer, Michelangelo, and Leonardo looked like from their own self-representations.

In the late fourteenth century and especially throughout the fifteenth, an increasing number of laypeople had the means to arrange for funerary commemorations inside churches. The parish church at Northleach (England) contains a representative example of a funerary monument in

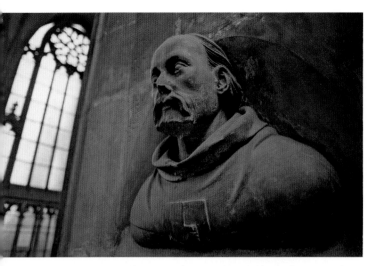

Fig. 10-28. Bust of Peter Parler, St. Vitus Cathedral, Prague, last quarter of fourteenth century. Petr Bonek/Alamy Stock Photo.

a new medium for these patrons (fig. 10-29). Even though the town only had about two hundred inhabitants around 1400, it had grown wealthy from trade in wool, which generated fully half of England's wealth at that time. Most parish churches were still built of wood, but the merchants of Northleach were able to build a very large church in stone, with memorials that showed them and their families inserted into the floor. This unnamed merchant stands on a woolpack, a canvas bundle in which fleeces were packed for shipping; his ornamented belt and dagger confirm that he is well-to-do. His wife wears a ring and has at her feet a dog, a symbol of fidelity; its collar is adorned with bells. The material is latten, very similar to brass: a gold-colored alloy of copper, zinc, lead, and tin, imported in sheets from what is now Germany and Belgium but still affordable to middle-class merchants. Even though memorial brasses, as they are called, were produced in the thirteenth century for knights and other elites, only in the fourteenth century did merchants begin to favor this medium, and over the next two centuries it became the principal material for middle-class memorials in England. The dissemination of patterns from important workshops likely explains their similar forms, although no two brasses are exactly alike. These panels were made in two parts (note the horizontal seams at thigh level) to facilitate manufacture or transport.

Wool was the basic material used for tapestries, textiles produced by weaving on a loom. The largest preserved medieval example was rediscovered in the nineteenth century at Angers (western France), where its pieces were being used as horse blankets and rugs (fig. 10-30 *left*). It originally consisted of six pieces, each twenty-three meters wide and six meters high. Payment records indicate that it was designed and woven between about 1377 and 1382 by several artists, including Jean Bondol, who created the cartoons (preparatory drawings on paper), and Robert Poinçon, a master weaver in Arras (northern France).

Fig. 10-29. Memorial brass, 144.8 × 40.6 cm (man), ca. 1400; parish church, Northleach. Photo by the authors.

Nicholas Bataille, a merchant who owned tapestry workshops, may have overseen production. The reverse of the tapestry is a perfect mirror image of the front, which required exceptional skill; and it has preserved the vibrant original colors better than the front, which was more exposed to light.

The tapestry's patron, whose heraldry is repeated numerous times, was Duke Louis I of Anjou (1339–84), brother of the French king and of Jean, the duke of Berry. These Valois family members—Valois was the name of the northern French dynasty that succeeded the Capetians and ruled France until 1589—were prolific patrons of art, but the tapestry dwarfed their other commissions in scale and in cost. The work depicts episodes from the book of Revelation and is therefore known as the Apocalypse Tapestry. Each of the six pieces begins at the left with a tall, ornate structure containing a large figure who holds a book or scroll. He represents John the Evangelist, the author of Revelation but also a kind of model "reader" of the tapestry's images. To his right were fourteen scenes disposed in two registers, for a total of eighty-four scenes (sixty-seven are preserved), in which red and blue backgrounds

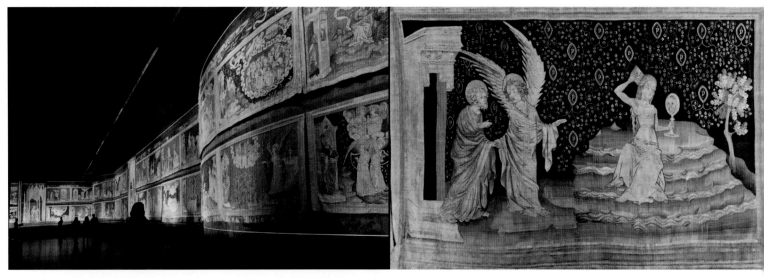

Fig. 10-30. Apocalypse Tapestry, now 4.5 × 106 m, ca. 1377–82, (*left*) approximately half of the tapestry; (*right*) Whore of Babylon scene; Musée de la Tapisserie, Chateau d'Angers. Photos by the authors.

alternate. The tapestry is meant to be "read" along the top and then the bottom row, piece by piece. In the detail shown here (fig. 10-30 *right*), the Whore of Babylon (Rev. 17:1–2) combs her hair while holding a mirror, a symbol of the sins of vanity, pride, and lust (fig. 9-33).

The Apocalypse subject matter is unique among contemporary tapestries; patrons generally favored scenes from mythology, romance, or history. The iconography derives from a thirteenth-century illuminated manuscript made in England (but written in French), although it does not follow the text of Revelation in all its details. It seems likely that Louis commissioned the unusual subject as a response to contemporary turbulence, especially the Hundred Years' War in which he was personally involved, and in the hope that a king—ideally himself—would usher in a messianic age (Emperor Charles IV probably had the same motivation for the Apocalypse imagery at Karlštejn Castle two decades earlier). The Apocalypse Tapestry was displayed in the cathedral of Angers on important occasions; its regular location is unknown. Thick tapestries were used to keep out drafts and stimulate conversation, and beginning in the late fourteenth century in France and Flanders (roughly, modern Belgium and Luxembourg), they became one of the premier art forms of the late Middle Ages. Large-scale commercial production required collaboration among painters, draftsmen, and weavers in workshops consisting only of men.

In thirteenth- and fourteenth-century Europe literacy increased among the laity, creating a market for religious texts like the Apocalypse and secular works like the *Romance of the Rose* (French *Roman de la Rose*). This allegorical poem about courtly love became a late medieval bestseller. Some four thousand lines written by Guillaume de Lorris (ca. 1200–ca. 1240) around 1230 were supplemented forty years later by Jean de Meun (ca. 1240–ca. 1305), who

added another seventeen thousand lines. The composite tale, in Old French—the Romance language widely used between the eighth and the fourteenth centuries, not only in France—inspired authors in other vernaculars across Europe. The manuscript shown here was written and illuminated in mid-fourteenth-century Paris by the husband-and-wife team of Richard and Jeanne de Montbaston, who produced nineteen copies of the *Rose* and depicted themselves doing so (fig. 10-31). In these miniature self-representations, Richard (who died of the plague in 1348) writes the text, while Jeanne, who led the book workshop after his death, draws birds; pages of text are drying on racks behind them.

In the manuscript's first miniature (fig. 10-32), the narrator of the story, shown in all four panels, dreams of and falls in love with the Rose, which remains out of reach in the walled garden at lower right. In Jean de Meun's more erotic and philosophical continuation, the Rose—which represents women's virginity—is deceived and finally plucked. The story is essentially a secular allegory about the transformation of the soul, but it is also misogynistic and homophobic; for example, the male personification of Genius compares the act of writing (by men) to sexual penetration of the passive page; *tool* can mean both pen and penis in French (and in English slang). Jeanne de Montbaston responded in the form of marginal pictorial glosses, including a nun and monk copulating and a nun gathering penises from a tree—perhaps parodying courtly and spiritual love by humorously subverting sexual roles. The marginalia on this prefatory folio consists of birds, a rabbit, and composite beasts. Christine de Pizan (1364–ca. 1430), a woman writer at the royal French court, published criticisms of the work's obscenity and defamation of women. The *Roman de la Rose* manuscript demonstrates the growing importance of secular themes in medieval art

Fig. 10-31. Richard and Jeanne de Montbaston at work, *Romance of the Rose*, mid-fourteenth century; Paris, Bibliothèque nationale de France, MS fr. 25526, fol. 77v, detail. Photo from Bibliothèque nationale de France.

and the professionalization of artists in the fourteenth century. As with the English brasses, professional artists in an expanding market economy now worked for a much wider clientele, from French royalty to people who previously were unable to afford illuminated manuscripts.

Crossing Late Medieval Worlds

A volume now in Oxford contains the so-called Alexander Romance, collected legends about Alexander "the Great," copied in 1338 in Old French. Two texts were appended to this manuscript in England in the first decade of the fifteenth century. One was another Alexander episode; the other, in Old French, was the Italian merchant Marco Polo's (ca. 1254–1324) account of his travels among the Mongols, called here *Book of the Great Khan* but more commonly titled *Description of the World*. Polo's alleged autobiography, recounting his journeys with his father and uncle from Venice to Asia between 1271 and 1295, was dictated upon his return to Rustichello of Pisa, who added many elements from contemporary romances. The Old French text of Polo's travels became very popular and was sometimes illustrated for wealthy clients (Jean, the duke of Berry, owned several copies). This Polo manuscript contains thirty-eight miniatures by Jehan de Grise, an artist from Flanders who was probably the head of a workshop in London. One illumination depicts a birthday banquet in Beijing (then called Khanbaliq) for Khubilai Khan, a grandson of Chinggis and founder of the Yuan (Mongol) dynasty in China; Polo spent seventeen years at his court as an ambassador and tax assessor (fig. 10-33 *left*). Along with the book's readers, Jehan de Grise presumably had not encountered Mongols;

Fig. 10-32. Dream of the Rose, *Romance of the Rose*, 25.5 × 18 cm, mid-fourteenth century; Paris, Bibliothèque nationale de France, MS fr. 25526, fol. 1r. Photo from Bibliothèque nationale de France.

his attitudes about what power should look like, derived from western European contexts, shaped his imagery of the Asian court. In the banquet scene, the attendees have light brown or red hair; the Great Khan's four wives have skin tones that nearly match the white tablecloth, while the men's faces vary from light brown to ruddy. The Great Khan is shown crowned and enthroned under a canopy, and the women, wearing European-style crowns, sit within Gothic niches. The tables are set with golden vessels, and a servant fills wine goblets from a fountain while musicians play at the upper corners. Marco Polo and his relatives kneel at the lower right. Polo claims in the book that the banquet refreshments moved magically across the room and that a parade of five thousand elephants preceded the festivities.

In another image, barons are engaged to manage the khan's property (fig. 10-33 *right*). The round white objects are the artist's interpretation of Mongol money: Jehan de Grise could not imagine the printed paper currency Polo

Fig. 10-33. Scenes from *Book of the Great Khan*, ca. 1400–1410, (*left*) banquet, fol. 239r; (*right*) barons, fol. 242v; Oxford, Bodleian Library, MS Bodl. 264, pt. III. © Bodleian Libraries, University of Oxford.

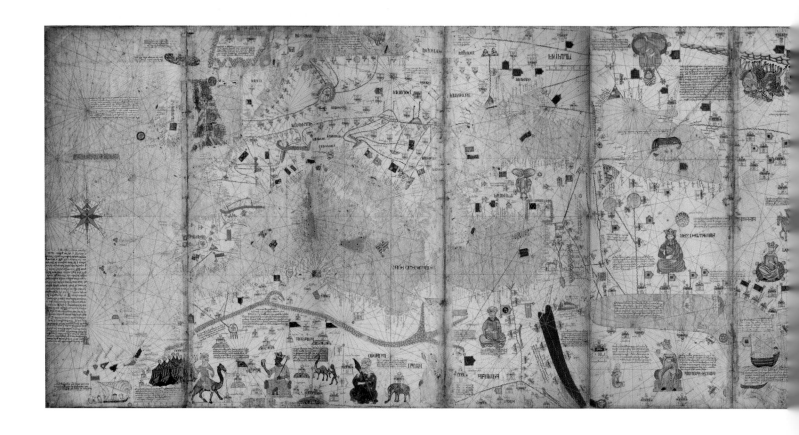

described (used in China since the eleventh century), so the man at the feet of the khan is painting the coin-shaped money by hand. Like Katerina Ilioni, whose tombstone in Yangzhou testifies to her mobility (fig. I-4), Marco Polo and other travelers crossed the Eurasian landmass. Their accounts detail cultural differences, but the paintings in these books show the limits of European artists' understanding of the wider world.

Marco Polo's travel account was known to the Jewish map- and compass-maker Elisha ben Abraham Cresques (also known as Cresques ben Abraham, 1325–87), who lived on the island of Majorca (off the coast of Spain). The so-called Catalan Atlas, dated 1375, is attributed to him (fig. 10-34). This atlas may have been commissioned by Pedro IV, king of Aragón (r. 1336–87), as a gift for Charles V, king of France (r. 1364–80); it was certainly in French hands by 1380. Elisha Cresques combined a portolan—a detailed chart of coastlines, used by Italian mariners in the Mediterranean and Black Seas since the twelfth century—with a mappa mundi for the less well-known regions east of the Mediterranean. This eastern portion is more fanciful, but it nevertheless incorporates up-to-date information from travelers, Christian missionaries, and diplomats who had visited Asia. Unlike circular world maps from medieval Europe (fig. 9-3), which show regions from Iberia to India, the Catalan Atlas has an expanded worldview. It includes sites from the Canary Islands to China and employs an unusual rectangular format composed of tall parchment sheets folded vertically. The rectangular form, already used in some Islamicate maps, was ultimately based on the work of the ancient world's premier geographer and astronomer, Claudius Ptolemy.

The beginning of the atlas, not shown, contains diagrammatic and textual information in the Catalan language about the world and the universe based on medieval sources. In the sheets reproduced here, Jerusalem is near the center above the patch of red that represents the Red Sea. Toward the lower left, a crowned, dark-skinned figure flanked by camels holds a nugget of gold (fig. 10-35). This is Mansa (lord) Musa Keita, king of the western African empire of Mali (r. 1312–37) and a key figure in trans-Saharan trade networks (box 9-1). He was famed in Europe and the Islamicate world after he distributed so much gold during his hajj to Mecca that the gold market collapsed. The caption behind him says, "This Black lord is called Musse Melly, lord of the land of the Blacks of Gineua [Guinea?]. This king is the most rich and the most noble lord of this whole region because of the abundance of gold that is collected in his land." The enormous wealth of Mansa Musa fascinated Europeans long after his death and piqued their interest in Africa. Elisha Cresques died before the forcible conversion of Jews in Majorca in 1391, when his wife and son, Jafudà (Judah), were baptized. Judah, also a cartographer, resettled in Barcelona and worked in the 1420s for the Portuguese prince Henry "the Navigator," who financed explorations along Africa's west coast.

People, vestments, maps, and books moved across the medieval world. Testifying to this mobility is a manuscript containing the works of the sixth-century Neoplatonic theologian Dionysios the Areopagite (known as Pseudo-Dionysios), who was confused in the Middle Ages with the first-century Christian convert in Acts 17:34 and the third-century missionary to Gaul known as St. Denis. Between 1399 and 1402, the Byzantine emperor Manuel II

Fig. 10-34. Catalan Atlas, sheets 5–12, 64.5 × 200 cm, 1375; Paris, Bibliothèque nationale de France, MS esp. 30. Photo from Bibliothèque nationale de France.

Fig. 10-35. Mansa Musa, detail of Catalan Atlas, sheet 6, 1375; Paris, Bibliothèque nationale de France, MS esp. 30. Photo from Bibliothèque nationale de France.

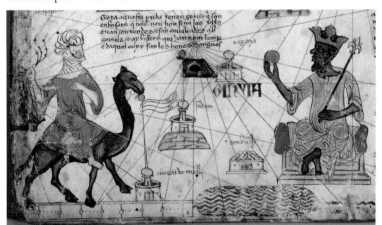

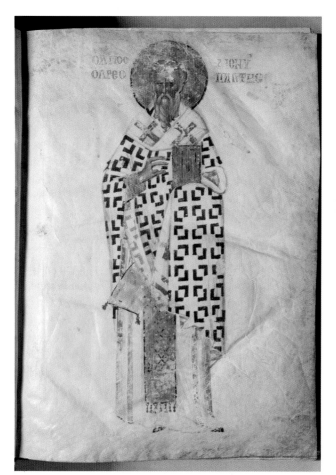
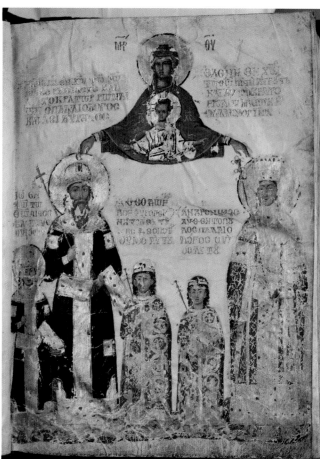

Fig. 10-36. Writings of Pseudo-Dionysios, 27.3 × 20 cm, 1403–5, (*left*) St. Dionysios, fol. 1r; (*right*) family of Emperor Manuel II Palaiologos, fol. 2r; Paris, Louvre, Département des Objets d'Art, MR 416. Daniel Arnaudet; © RMN-Grand Palais/Art Resource, NY.

Palaiologos traveled in Italy, France, and England seeking funds for his faltering empire, which had been weakened by civil wars and Ottoman attacks (while he was away, Timur defeated the Ottomans, providing a brief respite). Manuel gave away relics and icons to encourage a western European crusade against the Turks, but the promised support never materialized. In the early fifteenth century, the Byzantines sent a targeted appeal for aid directly to France: a volume of Pseudo-Dionysios's work, delivered to the abbey of Saint-Denis in 1408 by a Byzantine ambassador, as the book's colophon records. In this volume, a text copied in the fourteenth century was enhanced with two full-page images painted between 1403 and 1405. The first, an author "portrait" of St. Dionysios, depicts him in the garments of a late Byzantine bishop, blessing in the Orthodox manner and holding his writings, which are enshrined in gold like sacred books and relics (fig. 10-36 *left*). Although his face is carefully modeled, no attempt is made to show his bodily volume or placement in space: the saint is an incorporeal member of the heavenly court, floating on an empty page. On the next folio, the Theotokos and Christ child bless the imperial family, who stand on a red carpet (fig. 10-36 *right*). The text above the emperor's head says, "Manuel, faithful in Christ the Lord, emperor and autocrat

of the Romans, Palaiologos, eternal Augustos"; the unusual last clause is meant to suggest the longevity of Byzantium and its Roman roots, going back fourteen hundred years to Emperor Augustus. The rank of each son is expressed by his size and proximity to Manuel II; the future emperor John VIII Palaiologos stands to his father's right and is also dressed like him. The gift was intended to show that the saint whose works were contained in the book, who was understood in France as protector of the royal house, was Byzantine, and that the giver was the divinely sanctioned leader of the ancient Roman Empire and a crucial link to St. Dionysios himself. The pictorial language was comprehensible across cultures, even if the textual language required translation. The French appreciated the gift and bound it in ivory covers, but they chose not to bail out the Byzantines.

Another manuscript that reveals a crossing of cultures is the *Guide for the Perplexed* (Hebrew *Moreh Nevukhim*) now in Copenhagen (fig. 10-37). Copied in Barcelona (Spain) in 1347–48, the *Guide* was composed in Judeo-Arabic (Arabic in Hebrew letters) in twelfth-century Fustat by Maimonides, whose work was used as a source in the *Compendium of Chronicles*. Maimonides's family had fled Spain during the Almohad invasion, during which Jews and Christians

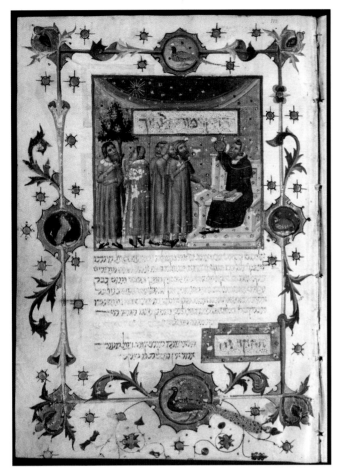
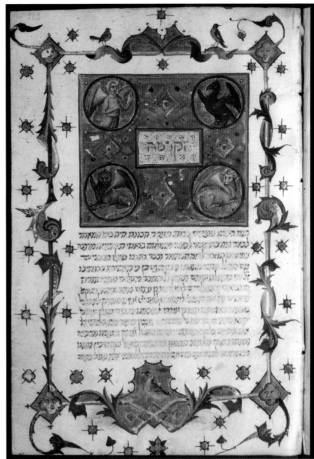

Fig. 10-37. *Guide for the Perplexed*, 19.4 × 13.3 cm, 1347–48, (*left*) Aristotle with astrolabe, fol. 114a; (*right*) Ezekiel's vision, fol. 202a; Copenhagen, Det Kongelige Bibliotek, Cod. Heb. 37. Photo from the Danish Royal Library.

were threatened with the choice of conversion or death. The *Guide*, the foremost work of medieval Jewish philosophy, attempted to reconcile Jewish theology with the writings of Aristotle, the ancient Greek philosopher (Thomas Aquinas did the same for Christian thought). The book was quickly translated into Hebrew and disseminated widely, although its philosophical viewpoint was controversial in many Jewish communities. The colophon in this copy credits Levi, son of Isaac, from the region of Salamanca (Spain), who wrote it for the physician Menachem Betsalel, who worked for King Pedro IV of Aragón. The illuminator, however, was Ferrer Bassa, a Christian painter in Barcelona who also worked for Pedro IV and whose art is known from other manuscripts. In one image (fig. 10-37 *left*), a seated teacher holds an astrolabe at the beginning of Maimonides's discourse about the unity of science and the cosmos. The teacher is Aristotle, but he also alludes to Maimonides and to Menachem Betsalel. A second miniature (fig. 10-37 *right*), titled "Introduction" (*Hakdamah*), precedes Maimonides's attempt to rationalize and scientifically explain Ezekiel's vision of the four creatures (Ezek. 1:5–10), which Christians understood typologically as symbols of the evangelists and the beasts of Revelation 4:6–8. Ezekiel describes the creatures as identical, but Ferrer

Bassa has differentiated them in line with Christian conventions. The manuscript thus encapsulates several kinds of "crossings": Maimonides's own movements, the translation history of his *Guide*, and the collaboration of a Jewish scribe and patron with a Christian artist. When Maimonides himself crossed from life to death, the inhabitants of Fustat and Jerusalem—Jews, Muslims, and Christians alike—observed public mourning, and his body was taken to Tiberias (Israel), where his grave became a major Jewish pilgrimage destination. Both Menachem Betsalel and Ferrer Bassa died around 1348, probably victims of the plague.

A small, shallow bowl meant to hold salt or spices is a less costly ceramic version of the gold *nef* on Jean de Berry's New Year's banquet table. Made at Paterna in eastern Spain, this humble object nevertheless demonstrates the movement of materials and the fluidity of iconography. The area around Paterna had been conquered by Christian Aragón in 1238, but written contracts indicate that numerous Muslims worked in the large commercial workshops that began to produce glazed pottery there at the beginning of the fourteenth century. This production was fueled by the demand for ceramic vessels, which replaced wooden tablewares in the increasingly wealthy households of the kingdom of Aragón. Still, the fact that

Fig. 10-38. Saltcellar with khamsa, 4.5 × 12.5 cm, fourteenth century; Museo Nacional de Cerámica y de las Artes Suntuarias "González Martí," Valencia. Photo by Anna McSweeney.

the exteriors of the Paterna works were left unglazed indicates that their consumers were not at the luxury end of the market. Whereas the copper and manganese used to make the green and brown colors were mined locally, the potters relied on imported tin to make their opaque glazes; they likely acquired it from southwestern England (around Cornwall) via sea routes plied by Italian and Catalan ships. This vessel depicts a hand-shaped emblem known as a *khamsa* (Arabic for five [fingers]); it is sometimes called the Hand of Fatima, after Muhammad's daughter, or the Hand of 'Abbas, after the son of 'Ali whose arm was cut off during the Battle of Karbala in 680 (an event that helped galvanize the Shi'i movement) (fig. 10-38). The hand was a symbol of power in many ancient cultures; for example, God's "strong hand" (Deut. 5:15) is visible in many scenes in the Dura-Europos synagogue (figs. 1-17–1-19). These connotations of power and blessing made the khamsa a popular apotropaic device, one widely used by both Muslims and Jews in North Africa and the Iberian Peninsula in the twelfth century. On the Paterna saltcellar, the hand is augmented by additional protective features: a cross shape at the wrist and a six-pointed star in the palm (and possibly the heart shape to the right). The owners of this and comparable pieces must have been happy to protect their food and families with such devices, which crossed religious lines just as the glazing materials crossed political borders. Indeed, the varied iconography on the Paterna ceramics—human figures, heraldry, animals, pseudo-Arabic script, geometric and vegetal motifs—belonged to a pictorial language shared around the Mediterranean and beyond.

After Christian forces defeated the Almohads in 1212, the last taifa territory in southern Spain was at Granada, under the rule of the Nasrid dynasty beginning in 1230. It was never conquered. Instead, the Nasrid emirate surrendered in 1492 to the rulers of a newly unified Spain, King Ferdinand and Queen Isabella, who immediately broke their promise and exiled all Muslims (and Jews) who refused to convert to Christianity. Before that happened, however, the Nasrids built a series of palaces and gardens outside Granada. This fortified complex is called the Alhambra (Arabic *al-Hamra'*, the Red, after the color of its stone; red was also the Nasrid dynastic color, used for their flags, seals, and paper). Begun under Sultan Ismail I (r. 1314–25) and linked to an older fort, the Alhambra reached its apex under Sultan Yusuf I (r. 1333–54) and his son, Muhammad V (r. 1354–59, 1362–91), who constructed the Comares Palace and the Palace of the Lions, respectively (fig. 10-39). Their interlocking spaces are covered with rich ornamentation that is strikingly varied in its forms, techniques, subjects, and materials. Innumerable artists from far and wide were brought together to craft a monumental statement of the Nasrids' wealth, sophistication, and control of nature.

Visitors, including ambassadors and merchants from near and far, would have approached the Alhambra complex from the west and entered the Comares Palace, a name of uncertain derivation, where the Nasrids conducted official business. The first such space was the Mexuar (from Arabic *mashawar*, place of counsel), followed by the Patio of the Gilded Room, whose wooden ceiling is partly gilded and where ambassadors awaited their meeting with the sultan; women could watch the visitors from grilled windows on the upper floor. The patio leads to the Court of the Myrtles, which surrounds a long reflecting pool framed by marble walkways, adjacent to the so-called Hall of the Boat; its coffered wooden ceiling, a replica of the original destroyed by fire, resembles an inverted ship. In these spaces and throughout the Alhambra, some ten thousand Arabic inscriptions adorn nearly every surface, on stucco, marble, wood, and tile; ephemeral architecture, such as curtains hung on the walls, must have added significantly to this number.

The Hall of the Boat precedes the most significant official space in the Comares Palace, the Hall of the Ambassadors, a reception area protected inside the Alhambra's most imposing tower (fig. 10-40). Built for Yusuf I, this square room features tall, deep niches on three sides; the one opposite the entrance was for the enthroned sultan. The room is entirely covered with tile on the lower walls and with stucco, originally painted red, green, blue, yellow, and black, above; the effect must have been akin to the textiles produced by the Nasrid workshops. Poetic

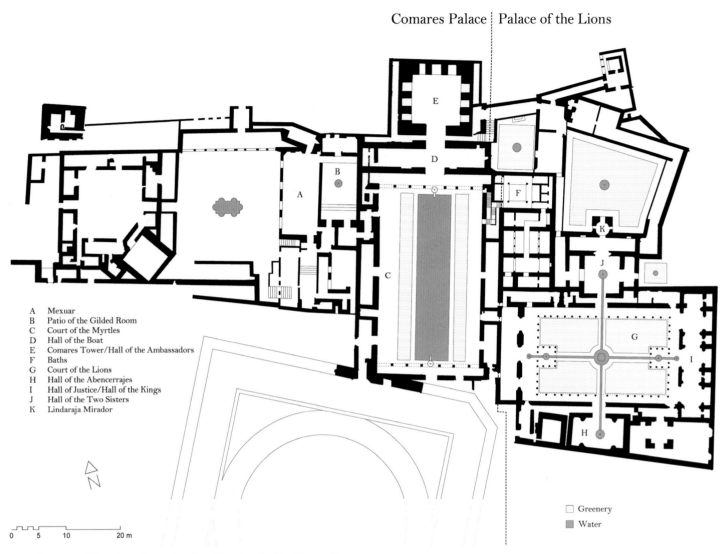

A Mexuar
B Patio of the Gilded Room
C Court of the Myrtles
D Hall of the Boat
E Comares Tower/Hall of the Ambassadors
F Baths
G Court of the Lions
H Hall of the Abencerrajes
I Hall of Justice/Hall of the Kings
J Hall of the Two Sisters
K Lindaraja Mirador

N

0 5 10 20 m

☐ Greenery
■ Water

Fig. 10-39. Alhambra, Granada, plan. Drawing by Navid Jamali.

inscriptions, once highlighted in gold and silver, praise God or the ruler or quote the Qur'an and the Nasrid motto. The pyramidal vault (18 m high) is made of pieces of cedarwood arranged in intricate star patterns with painted centers; it therefore resembles a starry sky, suggesting that the heavens are sheltering the throne of the divinely guided ruler. The elaborate decoration was intended to impress guests and confirm Nasrid power.

Select visitors were probably admitted to the second palace in the Alhambra, now called the Palace of the Lions, which adjoins the Court of the Myrtles. It contains royal chambers and a bath complex and may also have served as a madrasa for teaching Sufi doctrine. At its heart is the Court of the Lions, surrounded by galleries supported by paired marble columns; the arcades create transitions between open exterior space and the interior rooms arranged around it (fig. 10-41). At its center is the fountain for which the courtyard and palace are named, a large basin supported by twelve marble lions. On the basin's border are verses by the vizier Ibn Zamrak (1333–93) that say, in part, "water and marble seem to be one." The fountain and the

four water channels that emerge from it create a four-part garden (whether paved or planted) that represented paradise in Sasanian and Islamic thought. The running water created a pleasant soundscape while cooling the courtyard and adjacent spaces.

Hydraulic technology was also employed for the functional and pleasurable uses of water in the baths, built mostly under Yusuf I. Three vaulted steam rooms, for progressively increasing temperatures, have star-shaped ceiling openings with movable glass covers to permit light to enter and steam to escape. Furnaces and vents under the floor regulated heating and cooling. A larger room with tiled walls and floors and carved stucco had an upper gallery for musicians, making the baths a sensual space for socializing and entertainment as well as for cleansing and ritual purification. Ibn al-Khatib (1313–74), who became vizier after his predecessor died of the plague in 1349, wrote a book about the disease that considers hygiene more generally. He noted that bathing and wine produce similar pleasurable effects on the body, which is why people sing while they bathe.

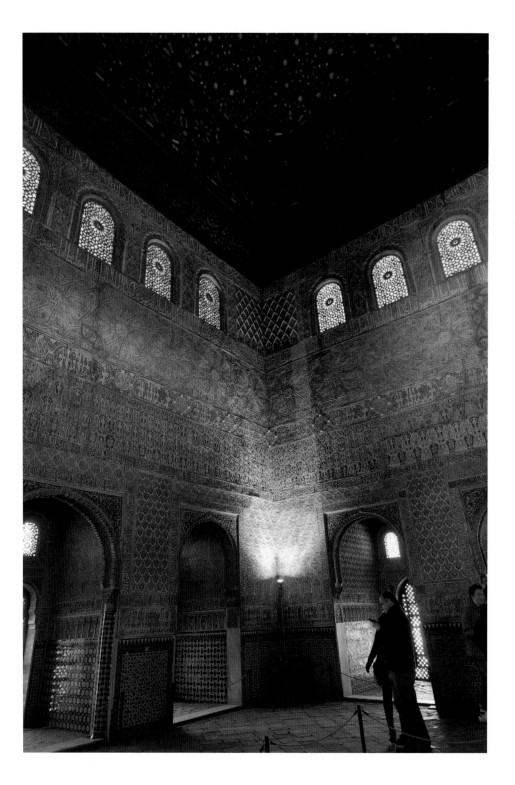

Fig. 10-40. Comares Tower/Hall of the Ambassadors, Alhambra, Granada, 1333–54. Photo by the authors.

Not all visitors would have entered the palace baths, but they likely saw the large room south of the Court of the Lions: the Hall of Abencerrajes, the name of a prominent Nasrid family. Used during winter festivals, the room features a muqarnas vault raised on a windowed drum supported by muqarnas squinches; the star-shaped vault suggests the heavens in motion. East of the Court of the Lions is the elongated Hall of Justice (or Hall of the Kings), an ideal location for entertaining guests with a banquet. Three of its eastern side alcoves are notable for a decorative technique not used elsewhere in the Alhambra: they are painted in egg tempera on leather, then varnished with wax

(fig. 10-42). They are also unusual for their imagery, given that there are few surviving examples of monumental figural painting in Islamicate art. In the vault of the central room are ten seated figures who probably represent Nasrid ancestors; this link to the past was intended to shore up Muhammad V's disputed claims to the Nasrid throne. In the side rooms the ceilings display scenes of hunting and chivalry, the latter seen here. Turban-wearing Muslims fight Christian knights for the love of a woman—imagery drawn from romances popular across Europe in the fourteenth century and executed in a European figural style.

North of the Court of the Lions is a room known as

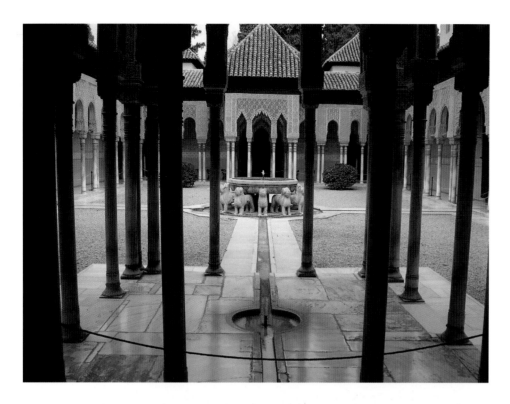

Fig. 10-41. Court of the Lions, Alhambra, Granada, 1354–91. Wikimedia Commons/Armandoreques, CC BY-SA 2.0.

Fig. 10-42. Ceiling with chivalry scenes, Hall of Justice/Hall of the Kings, Alhambra, Granada, 1354–91. Photo by J. M. Grimaldi/Junta de Andalucía, CC BY-SA 2.0.

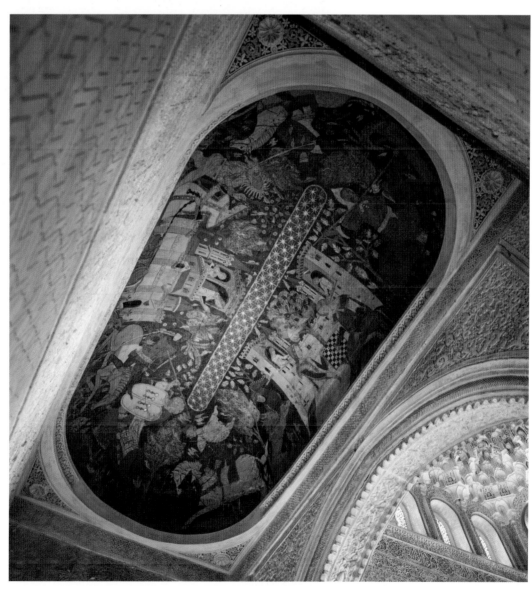

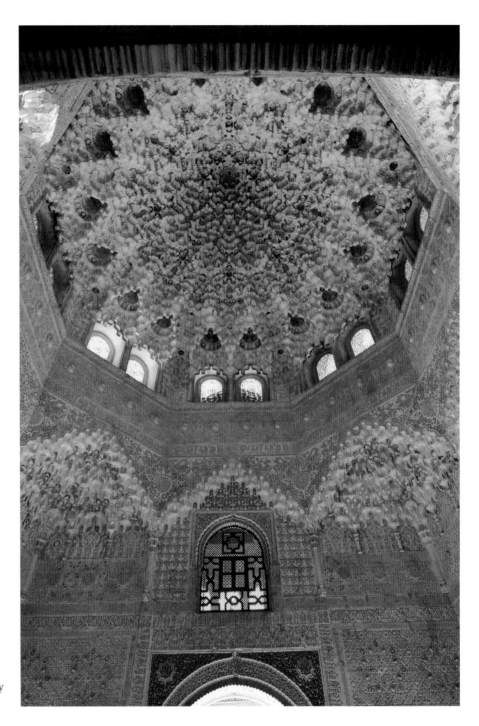

Fig. 10-43. Hall of the Two Sisters, Alhambra, Granada, 1354–91. Photo by the authors.

the Hall of the Two Sisters on account of two very large marble panels in the floor. Like the Abencerrajes chamber across the courtyard, this room has an elaborate muqarnas vault (fig. 10-43). It is lit by multiple small windows above a cornice supported by muqarnas squinches, and another poem by Ibn Zamrak on the dado makes the heavenly analogy explicit: the vault represents the perpetual rotation of the heavenly spheres.

A muqarnas arch on the north leads to the small Lindaraja (or Daraxa) mirador, from which the garden below (and originally the city of Granada beyond) can be viewed through paired openings (fig. 10-44). The name seems to be derived from *dar 'A'isha* (house of 'A'isha), the Prophet Muhammad's favorite wife (and therefore a likely allusion to Muhammad V); she was said to have transmitted hadiths about the gardens of paradise. As in other rooms in the Alhambra, there is tile decoration on the lower walls and inscribed and vegetal stucco ornament above, but only here is the ceiling inlaid with colored glass. In this space Ibn Zamrak's verses make explicit ideological claims on behalf of his patron, Muhammad V, for the room itself speaks in a stucco inscription that surrounds the entrance and the windows: "In this garden I [the window] am an eye filled with delight and the pupil of this eye, truly, is our lord, Muhammad [V]. . . . In me [the mirador] he looks from his caliphal throne toward the capital of his entire

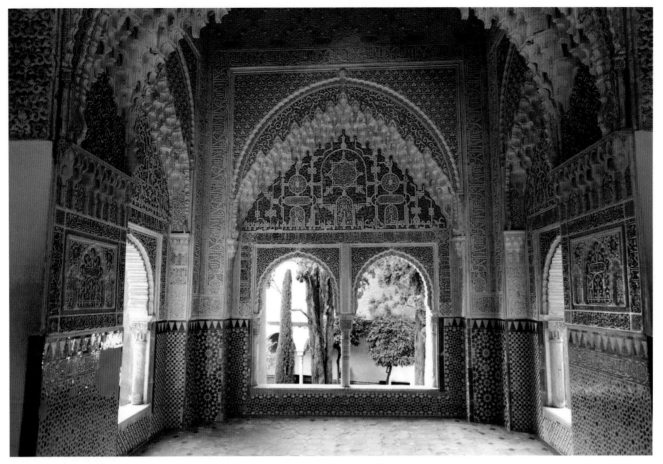

Fig. 10-44. Lindaraja mirador, Alhambra, Granada, 1354–91. Photo by the authors.

kingdom." Looking out from the mirador, the sultan could relish how the vegetal ornament depicted throughout the palaces merged with the actual gardens within the Alhambra and outside its walls. The text inscribed on one of the garden fountains adds, "No better house than I has ever been seen . . . nor has any ruler, Christian or Muslim, ever had a fountain like me."

The court poet was engaging in flattery, for Muhammad V had no credible claim to the title of caliph. But the Alhambra is indeed exceptional, especially today, when so little medieval residential architecture remains. In its careful coordination of space, ornament, and ceremony, it relates fundamentally to other late medieval monuments, from the convent at Wienhausen to the shrine of Ahmad Yasavi. The diversification of building types and of spaces geared to particular functions is characteristic of this era; so, too, is the proliferation of new artistic media, like oil painting and brass memorials, and the wider diffusion of older ones, like glazed tablewares and embroidered vestments. The increasing interconnectedness of Eurasian societies in this period created greater affluence, leading to the production of more works of art and architecture for more diverse consumers. A greater proportion of these works survives than from earlier centuries, yielding abundant evidence for the religious, social, and political lives of late medieval people.

CHAPTER II

Afterlives of the Middle Ages

Legend

☐ **Location or findspot**
- Monument/object
• Additional site
○ Approximate place of production

Queen Mary Harp ○

Book of hours ○ • Amsterdam
Wittenberg •

• Paris

☐ **Prague**
- Printed Haggadah

Basel ———— ☐
- "Insula hyspana"
woodcut print

○ "Jewish
Sow" and Crucifixion
woodcut print

Milan ☐
- Cathedral

Moldovitsa ☐
- Monastery
katholikon

• Venice
Ferrara •
○ John VIII Palaiologos medallion

Santiago de Compostela •

Monastery
of Saint-
Michel-de-
Cuxa

Florence •
Rome •

Batalha ———— ☐
- Monastery of
Santa Maria
de Vitória

☐ **Toledo**
- Painting
of St. Luke

Madeira •

☐
• Granada
• Ceuta

Córdoba
- Cathedral (former
Great Mosque)

Istanbul (Constantinople) ☐
- Suleymaniye complex
- Tughra of Suleyman
- World map

Icon of St. Luke as painter ○

The Americas

North America

Washington, DC •

☐ **New York**
- The Cloisters,
Metropolitan
Museum of Art

Haiti–Dominican
Republic

The Cloisters, Metropolitan Museum of Art, New York

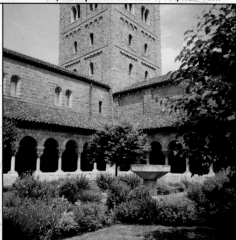

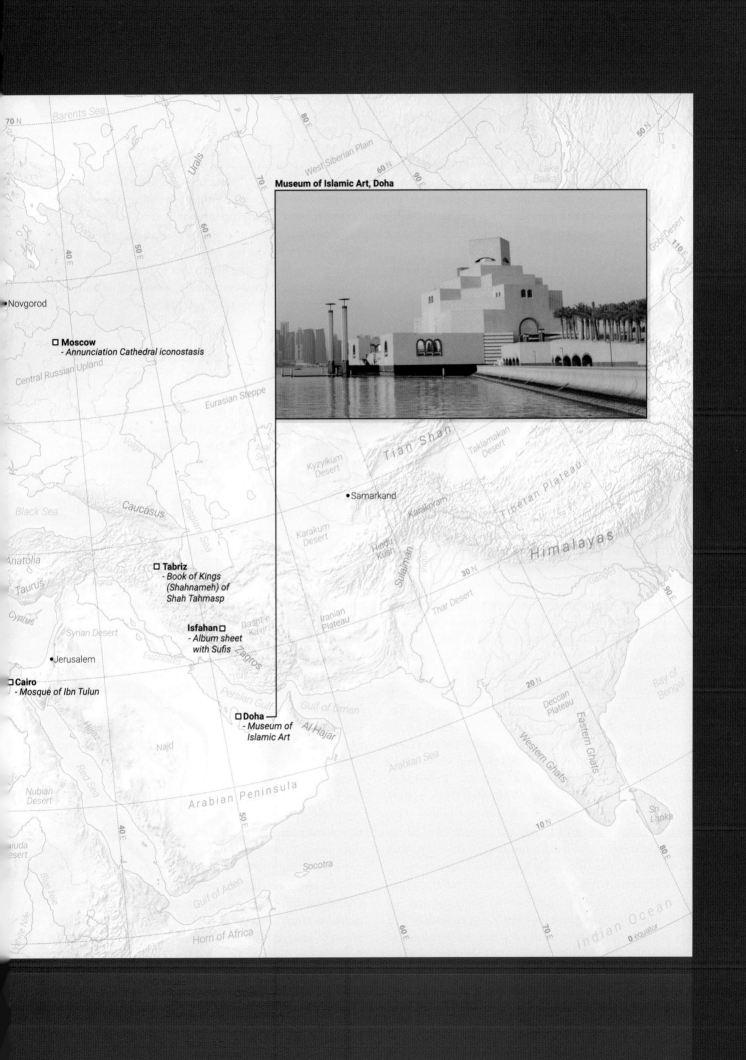

Museum of Islamic Art, Doha

□ **Moscow**
- *Annunciation Cathedral iconostasis*

□ **Tabriz**
- *Book of Kings
(Shahnameh) of
Shah Tahmasp*

Isfahan □
- *Album sheet
with Sufis*

□ **Cairo**
- *Mosque of Ibn Tulun*

□ **Doha**
- *Museum of
Islamic Art*

•Novgorod

•Jerusalem

•Samarkand

When did the Middle Ages end (fig. I-3)? There are many ways to answer this question, just as there are many ways to envision the era's beginnings. Most scholars agree that the fifteenth century was a time of significant changes in multiple arenas of human activity that together signal a new period, which historians tend to call the early modern era. Yet even a single site can show the artificiality of this chronological divide. The Alhambra is identified as medieval on account of its date, forms, functions, and political context, as are the Nasrid rulers who built it. Yet Jan van Eyck, who is usually considered an early modern artist because of his style, the subjects he painted, and the technique he mastered, visited Sultan Muhammad VIII there on a diplomatic mission in 1429 (Jan was conducting state business in the region while negotiating the marriage of his patron, Philip "the Good," duke of Burgundy, to Isabella, the daughter of King João I of Portugal). The Flemish painter's encounter with the Nasrid ruler inside the spectacular palace also serves as a reminder that the Islamicate world and western Europe were not separate entities; they were connected to each other, to Byzantium, and to diverse cultures around and within them, as this book has shown.

Some of the pronounced changes of the fifteenth century that do signal a new era derived from technological innovations. For example, Gutenberg's invention of a printing press that used movable type initiated the widespread distribution of printed books and the slow demise of handwritten illuminated manuscripts in Europe. Other shifts stemmed from geopolitical rupture, like the Ottoman conquest of Constantinople in 1453; Mehmet II's victory brought the Byzantine Empire to an end, and Constantinople (eventually renamed Istanbul) became a new creative center of Islamicate arts under the Turks. The year 1492 provides another major pivot, for in that year the Nasrids were expelled from Granada, and Spain's rulers, Ferdinand and Isabella, forced Muslims and Jews in their kingdom to convert to Christianity or depart. Exiled Muslims moved to North Africa, and Jews went there, to Italy, or to the Ottoman Empire, which welcomed them. That same year, the monarchs authorized Christopher Columbus to sail west in search of a more direct route from Spain to South Asia, one that would bypass the Islamicate ports that had supported lucrative Indian Ocean trade networks for centuries. His "discovery" of the Americas and, six years later, the Portuguese explorer Vasco da Gama's voyage around the southern coast of Africa marked a definitive rupture with the past. These events precipitated waves of exchange, colonization, slavery, disease, and genocide

that remade the cultural, political, economic, ecological, and biological map into a truly global one.

This chapter concludes *Art and Architecture of the Middle Ages* by considering the salient technological and political changes of the fifteenth century and their impact on artistic production. While pointing out some new aspects of early modern art, it also shows how many medieval art forms continued during and after the fifteenth century. It concludes by looking briefly at the priorities and challenges of historic preservation and museums and how they have grappled with the medieval past.

Long-Resonant Styles

While Timur marshaled enough human and material resources to build on a huge scale very quickly, many late medieval monuments took decades or even centuries to complete. If construction dragged on, designs might shift to incorporate new ideas, materials, or forms, leading either to contrasting parts of a building, as with the Great Mosque of Isfahan or Canterbury Cathedral, or to unusual combinations of forms within a single space. The second scenario can be seen at the cathedral of Milan (Italy). It was begun in 1386 in the Gothic style, which at that time was less common in Italy than in other parts of western Europe (fig. 11-1). From the beginning, the cathedral displayed the city's ambitions. It is one of the largest churches in the world, 157 meters long with a nave 45 meters high. Instead of brick, the usual building material in the region, it is made of pink marble, transported by river from quarries in the Alps. Its planning process was also exceptional. The archbishop and his cousin, Duke Gian Galeazzo Visconti, held a public competition to attract talented architects, build enthusiasm for the project, and increase the prestige of the city. Engineers, architects, masons, glaziers, and sculptors came from other parts of Italy, France, Germany, Hungary, and elsewhere. The building supervisors maintained a vast archive of learned opinions, public debates, contracts, drawings, and models that reveal how construction plans evolved, often alternating between traditional (local) and "modern" (trans-European) tastes and techniques. The high altar was consecrated in 1418, but money ran out and construction stalled. When it resumed at the end of the fifteenth century, the challenge of erecting a ribbed octagonal cupola over the crossing of the nave and transept engaged the greatest architects of the day. This is also when the west facade was completed; its windows with triangular pediments and pilasters, emblematic of

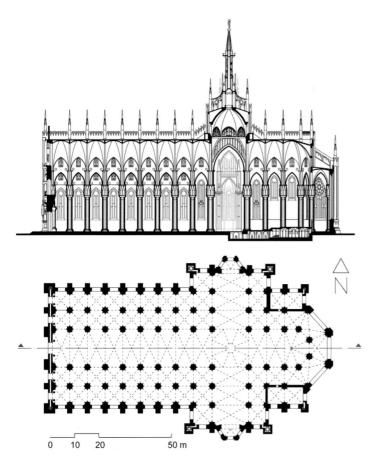

Fig. 11-1a. Cathedral, Milan, begun 1386. Drawings by Navid Jamali.

the classicizing style then preferred by Italian architects, contrast vividly with those featuring pointed arches and swirling tracery. Still, the cathedral was not done. Napoleon, who was crowned king of Italy there in 1805, financed its completion, and finishing touches came only in the twentieth century. The cathedral of Milan thus shows how the Gothic style was employed by northern Italian rulers to demonstrate their European status and how that same style resonated, albeit with overlays of classicism, for centuries.

Santa Maria de Vitória at Batalha (Portugal) was a similarly grand late medieval project. João I (1357–1433) had vowed to construct a monastery in Mary's honor of if she would help his army defeat the invading Castilians, who sought to claim Portugal's throne. The Portuguese, with the help of English longbowmen, prevailed in the battle fought in 1385 near Batalha (Portuguese for "battle"), and João was named king of Portugal as a result of this victory. Begun around 1388, Santa Maria de Vitória became the new dynasty's main building project for the next two centuries, executed, like the cathedral of Milan, in local versions of late medieval Gothic (fig. 11-2a). The first architect, Afonso Domingues, was from the region; he designed the layout of the complex and supervised the construction of the strikingly tall, narrow church. The Royal Cloister, on the north side of the church, has conventional monastic spaces arrayed around it—chapter house, refectory, and

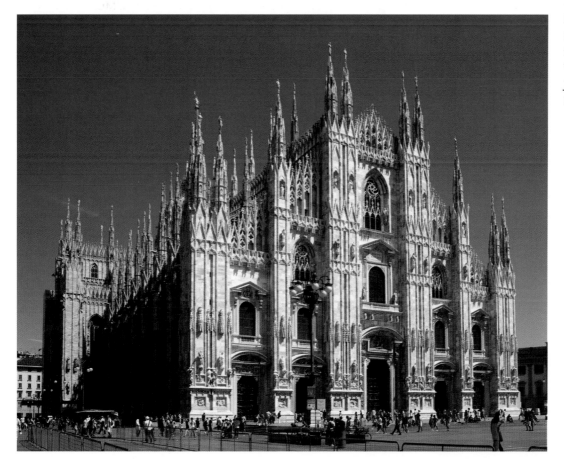

Fig. 11-1b. Cathedral, Milan, begun 1386, view from the northwest. Wikimedia Commons/ Jiuguang Wang, CC BY-SA 3.0.

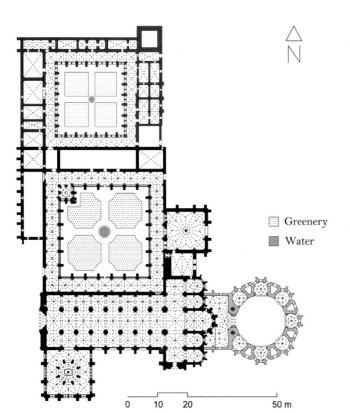

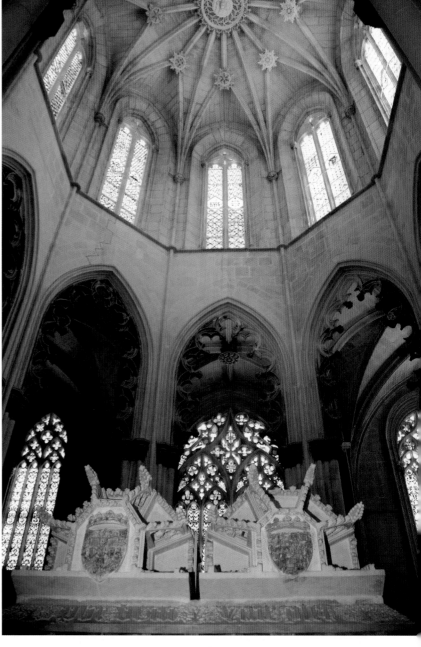

Figs. 11-2a and 11-2b. Monastery of Santa Maria de Vitória, Batalha, 1388–1533, (*left*) plan; (*right*) founder's chapel, 1426–34. (*l*) Drawing by Navid Jamali; (*r*) Heritage Image Partnership Ltd/Alamy Stock Photo.

N

☐ Greenery
■ Water

0 10 20 50 m

dormitory—although some of their exuberant ornament was designed by Afonso's successor, Master Huguet; his name and building style have led historians to think he was Catalan, English, or French. Although the complex was given to the Dominicans soon after its foundation, it became a site for courtly ceremonies and displays of power. A second cloister was added farther to the north during the reign of King Afonso V (r. 1438–81), known as "the African" for his conquests there.

An ornate square funerary chapel designed by Huguet was built adjacent to the southwest corner of the church (1426–34) (fig. 11-2b). At the center, below an innovative star-shaped rib vault, are the sculpted effigies of João I and his English queen, Philippa of Lancaster; they lie atop their tall polychromed tomb chest, holding hands. Arcosolium tombs for the couple's sons and their spouses fill a side wall, including one for João's son Henry "the Navigator," who spurred Portugal's explorations of Africa. Here, then, the complex articulated the dynasty's emerging military, political, and maritime powers—powers that precipitated centuries of Portuguese colonization in Africa and the Americas—and did so by incorporating exuberant ornamental details into a pan-European style that was two hundred years old.

Gothic was not the only medieval European idiom to thrive in settings distant from its original place and time. The abstract geometric and interlace designs of such works as the Sutton Hoo belt buckle or the Lindisfarne

Gospels remained in use for centuries (figs. 3-17a, 4-25, and 4-26). The so-called Queen Mary Harp, whose name may derive from a coin once affixed to it, was likely made in Scotland in the fifteenth century (fig. 11-3). This harp, or *clarsach*, is one of the oldest surviving musical instruments of a type common in Scotland and Ireland from the Middle Ages through the eighteenth century. Despite its functional purpose—making music—it is highly worked. The harp is made of willow and features zoomorphic, foliate, and interlace carvings, including a griffin and lion; red pigment emphasizes some of the designs. Giving this object a distinct visual identity to accompany the sounds it produced was evidently a priority of its maker and users. These particular visual forms, found in the earliest medieval art in Ireland, Scotland, and England, were perhaps thought to underscore the local roots of the harpist and the music he or she performed. Centuries later, these ornamental forms became signs of Irish heritage embraced by the descendants of immigrants who fled during the potato famine in the 1840s; interlace and geometric patterns still appear in jewelry, tombstones, and tattoos. Some of these forms have been appropriated by people who see in them the superiority of Europe and Christianity, but European and Christian identity was never a single thing; it was neither "pure" nor fixed but, rather, constantly changing as a result of centuries of migration and cultural interaction across Eurasia and North Africa.

Before and After 1453

In the decades preceding the Ottoman conquest of Constantinople, Byzantine emperors tried to align with European rulers in various ways. John VIII Palaiologos (r. 1425–48) traveled to Italy and Hungary to encourage a crusade against the Turks who were threatening what was left of his empire. At the ecumenical council in Ferrara and Florence in 1438–39, he signed an agreement with the pope to unite the Orthodox and Roman Churches, but the Byzantine clergy refused to endorse it. Still, western Europeans found John's presence at the council noteworthy, and the Italian artist Antonio Pisano, better known as Pisanello (ca. 1395–1455), was commissioned to make a medal to commemorate the visit. Several casts of this bronze portrait medal survive (fig. 11-4). On the front, an inscription in Greek around the subject identifies him as "John Palaiologos, emperor and autocrat of the Romans"; on the back, texts in Greek and Latin identify the artist and surround the main image of the emperor praying on horseback. Pisanello's medal inspired other artists to use this format for representing figures from long ago or far away.

For the medal's likely patrons, the ruler of Ferrara Niccolo d'Este and his son Lionello, the object embodied many ideas: their support of a Christian warrior-emperor fighting the Turks, their role in papal politics, their endorsement of

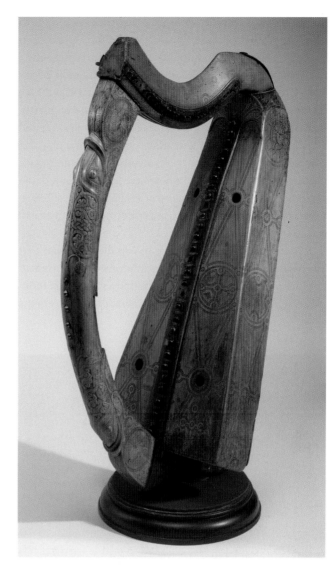

Fig. 11-3. Queen Mary Harp, 79.5 × 29.8 × 46.2 cm, fourteenth–fifteenth century; National Museum of Scotland, Edinburgh. © National Museums Scotland.

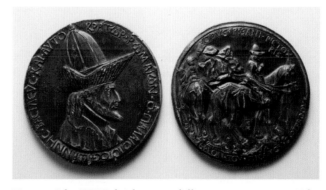

Fig. 11-4. John VIII Palaiologos medallion, 10.1 cm, ca. 1438; Yale University Art Gallery, New Haven. Photo from Yale University Art Gallery.

the ecumenical council, their piety, and their own right to rule—important because for decades the d'Este had been born from illegitimate unions. Furthermore, representing the emperor in profile was a deliberate emulation of ancient Greek and Roman imagery, and both Lionello d'Este and Pisanello collected ancient coins, a fashionable pursuit in a time of deepening interest in classicism (figs. 1-3 and 2-1). Imitation of prestigious models, ruler portraits, and complex desires on the part of patrons all have abundant medieval precedents. What is new here is the absence of the patrons' names and the presence of Pisanello's; the achievements of some artists led to increasing fame and high social status.

The defeat of Constantinople in 1453 did not mean that all Byzantine artists or artistic traditions disappeared. A number of works created after the empire's demise demonstrate significant continuities with Byzantine precedents

as well as some differences from them. An example is the sanctuary barrier in the cathedral of the Kremlin, the citadel of Moscow. After 1453, the Grand Duchy of Moscow (or Muscovy) became the largest Orthodox state, and in 1480 its political subservience to the Mongols ended. The Annunciation Cathedral was built in 1484–89 as a palace chapel for the grand prince Ivan III ("the Great"; r. 1462–1505), whose second wife, Sophia Palaiologina, was a niece of the last Byzantine emperor. Ivan looked to Italy for his architects and to Byzantium for his court ceremony, titles, and imperial ideology. Ivan IV "the Terrible" (meaning "fierce"; r. 1547–75), Sophia's grandson and the first Russian tsar, promoted Moscow as a "second Constantinople" and "third Rome." In the Annunciation Cathedral and other post-Byzantine Orthodox churches, the screen between the naos and the sanctuary became an iconostasis, a multistory wooden wall entirely filled with icons (fig. 11-5).

The six tiers of this iconostasis completely block the sacred areas of the church from view. Some of its icons were reused from the earlier cathedral on the site; others were added after the iconostasis survived a fire in 1547. The early icons, in the third and fourth tier from the ground, were painted in 1405 by Feofan Grek (Theophanes the Greek), Prokhor of Gorodets, and Andrei Rublev (or Rublyev). As his name suggests, the icon and fresco painter Theophanes was a Byzantine, born in Constantinople, but he spent his career in Novgorod and Moscow. Rublev, the youngest of the three, became the most famous and since 1988 has been venerated as a saint in the Russian Orthodox Church; he is also one of the few medieval artists about whom a film has been made, Andrei Tarkovsky's drama of 1966. The Kremlin iconostasis is much taller and more solid than earlier Byzantine templon screens. Those did become increasingly opaque and acquire more icons over time, but they never reached the height and complexity of their descendants in Russia and the Balkans.

Other echoes of Byzantine icon painting can be seen in the works of Domenikos Theotokopoulos, known as El Greco, "the Greek," who was trained in Venetian-ruled Crete as an icon painter (fig. 11-6a). In this early work, the evangelist Luke (now damaged) is painting an icon of the Theotokos and Child: the miraculous Hodegetria that was venerated in Constantinople and widely copied (fig. 8-11). The depicted saint—shown being crowned by an angel—is Theotokopoulos's alter ego; the artist has emphasized the holiness of his creative act by extending the gold background of the Hodegetria icon into the space around Luke's hand. The importance of the hand is also signaled by its depiction at the center of the panel and by the words of the artist's signature, "[by the] hand of Domenikos," under the box of pigments on the bench below the easel.

This icon was painted before 1567, when the artist moved to Venice; there he studied contemporary painters' treatment of perspective, anatomy, composition, and narrative. He later moved to Rome and then to Spain,

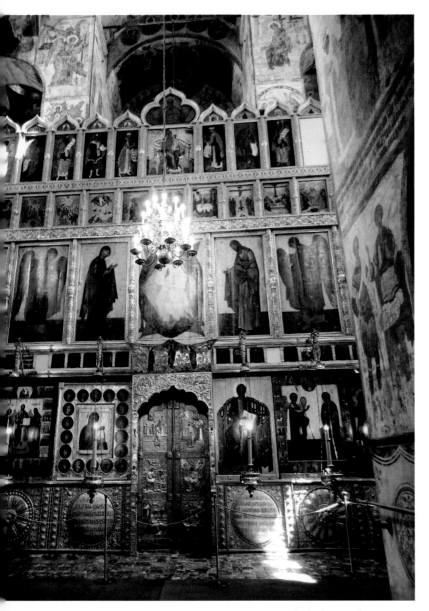

Fig. 11-5. Iconostasis, Annunciation Cathedral, Kremlin, Moscow, begun 1484. © Genevra Kornbluth.

settling in Toledo and painting altarpieces, portraits, and landscapes. A later version of St. Luke, executed about 1605 for the cathedral of Toledo, is more than twice the size of the earlier icon (fig. 11-6b). It uses oil paint, not egg tempera, and canvas, not wood; the artist likely learned about this support in Venice, where the watery environment prompted artists to use it instead of wood. The Byzantine-style gold background has been eliminated, and the evangelist now points with his brush at an image in a printed Gospel book. Like his early icons, El Greco's later paintings were intended to inspire devotion; they were instruments of spiritual ascent and personal salvation, the essential goals of medieval Christian art. Yet at the same time they differ in fundamental ways from medieval paintings and signal the aesthetic priorities of early modern art, including the importance of the autonomous large painting, the type of object that came to define European "high" art for centuries. Other early modern features are the artist's self-conscious approaches to the process of painting, illusionism, and seeing—such as the open paint box and the painted representation of a printed book—and his life as a cosmopolitan artist who traveled and studied as he went. El Greco did well as a professional painter, although he was not proclaimed a "genius" like some of his contemporaries in Europe. The distorted bodies, expressive faces, and unusual colors of his spiritual and dramatic work were, however, much appreciated by early twentieth-century artists such as Picasso, who found inspiration in El Greco and in medieval painting and sculpture more broadly.

After the Golden Horde retreated from the lower Danube region during the Black Death, the new principality of Moldavia (modern Moldova and part of Romania) was founded in 1359. Its rulers adopted the Orthodox faith but, by the early fifteenth century, paid tribute to the Ottomans in exchange for being left in peace. Beginning in the fifteenth century, and particularly during the reign of Prince Peter Rareş (r. 1527–38, 1541–46), they built a series of fortified monasteries in which the katholikon is frescoed on the outside, not only on the interior (fig. 11-7a). The exteriors of some Byzantine churches were painted, but little is preserved. At the monastery of Moldovitsa (Romania), built in 1532 and painted in 1537, the scenes on the katholikon dedicated to the Annunciation supplement the expected Christian imagery with depictions of historical events.

On the south exterior facade, below scenes culled from the Akathistos hymn (the oldest Orthodox hymn to Mary), the lowest register depicts an attack on Constantinople (fig. 11-7b). This detail shows the famous Persian and Avar siege of the city in 626, which was allegedly repulsed when the patriarch paraded a miracle-working icon of the Theotokos around the walls—the one El Greco alluded to in his early icon—while the city's inhabitants sang the Akathistos hymn. At Moldovitsa, however, multiple famous images and relics are shown protecting the painted city: a

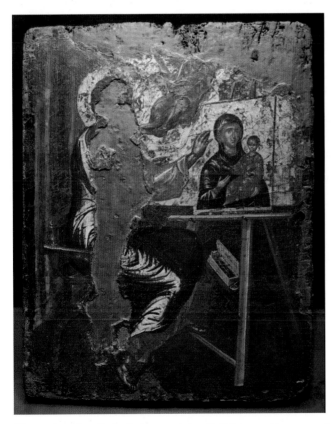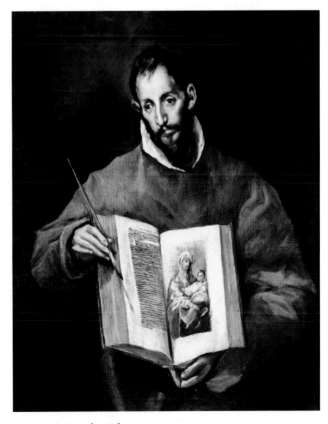

Figs. 11-6a and 11-6b. St. Luke as painter, (*left*) icon, 41 × 30 cm, 1560–67, Mouseio Benaki, Athens; (*right*) painting, 98 × 72 cm, ca. 1605, Toledo Cathedral. (l) Brad Hostetler; (r) © 2020. White Images/ Scala, Florence.

Figs. 11-7a and 11-7b. Monastery katholikon, Moldovitsa, 1532–37, (*top*) view from the southwest; (*bottom*) detail of siege of Constantinople. Photos by Alice Isabella Sullivan.

processional icon of the Hodegetria, at the back left corner, is likely the one paraded by the patriarch; the image of Christ's face miraculously imprinted on a cloth, a relic brought to Constantinople in the tenth century; and, in the foreground, a Gospel book, the Virgin's mantle, and a relic of the True Cross. Moreover, Emperor Herakleios—who was off fighting the Sasanians at the time and not in Constantinople—is present in the foreground, wearing a purple garment with a golden loros and crown. The scene also includes details from another attack by land and sea, in which the Umayyads (in 717/18) catapulted incendiary liquid, a Byzantine invention known as Greek fire, through tubes toward the city walls; a sudden hailstorm quelled the fires. That these historical events stand in for the recent Ottoman conquest of Constantinople is clear from the weaponry: in addition to arrows, both sides have

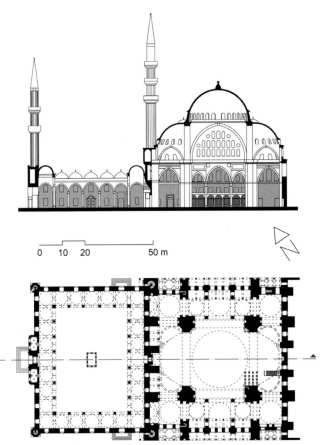

modern cannons. The message here, and in the eight other Moldavian churches that include this scene, is that the divine aid extended to pious Byzantines in the seventh and eighth centuries would surely come to help their Orthodox descendants in the sixteenth. The Byzantine past thus offered some hope for the Orthodox future.

When Sultan Mehmet II (r. 1451–81) conquered Constantinople, he destroyed the church of the Holy Apostles, which contained the tombs of such early Byzantine emperors as Constantine, Herakleios, and Justinian, and built his own tomb-mosque-madrasa complex on the site. Hagia Sophia, however, was not demolished. It became a Sunni mosque with a mihrab inserted into the apse, minarets added at the corners, and plaster covering some of the figural mosaics (fig. 3-1). The imposing Byzantine cathedral was not merely tolerated; it inspired a new type of mosque, with a central dome supported by half-domes, which supplanted the earlier hypostyle and four-iwan types across the growing Ottoman Empire. A domed mosque is the centerpiece of the Suleymaniye, a multifunctional complex in Istanbul commissioned in the 1550s by Sultan Suleyman (r. 1520–66) (fig. 11-8). He was known to his subjects as "the Lawgiver" because he updated the Ottoman law codes and in Europe as "the Magnificent" because of his

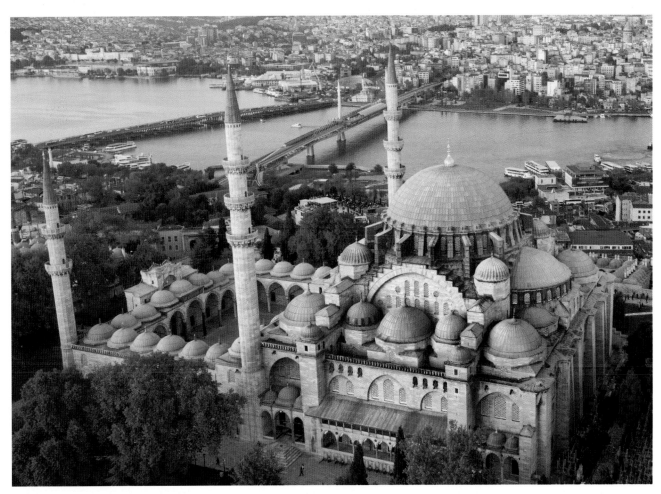

Figs. 11-8a and 11-8b. Mosque in Suleymaniye complex, Istanbul, 1550s, *(top)* plan and section; *(bottom)* aerial view from the south. *(t)* Drawings by Navid Jamali; *(b)* Photo from iStock/Explora_2005.

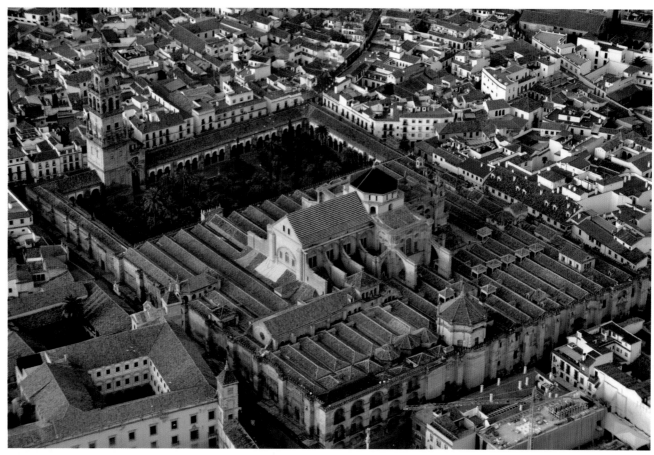

Fig. 11-9. Cathedral (former Great Mosque), Córdoba, aerial view from the southwest.
Wikimedia Commons/Toni Castillo Quero, CC BY-SA 2.0.

extravagant regalia, including a gold parade helmet made in Venice. The four huge granite columns that support the dome of the mosque were spolia collected from around the eastern Mediterranean (a specially built barge carried two from Alexandria), expressing the geographical and technological reach of Ottoman power. Sinan, a Christian architect who converted to Islam, claimed that each stone of the mosque was famous and that some came from Solomon's palace, thereby connecting his patron with his biblical namesake (Suleyman is Turkish for Solomon); similarly, the Suleymaniye waqfiyya calls the sultan "the Solomon of the age." Contemporary texts likened the mosque to both paradise and heaven, much like descriptions of Hagia Sophia a millennium earlier; the waqfiyya asserts that the mosque is illuminated by divine light, which on the qibla wall enters through stained-glass windows. Below these windows, ceramic panels with floral motifs underscore the paradisiacal theme.

Like the Pantokrator Monastery nearby and earlier foundations across the Islamicate world, the Suleymaniye also contained charitable and educational buildings prominently inscribed with prayers for the sultan. The domed tombs of Suleyman and his favorite wife, Roxelana (d. 1558), an eastern European who had been captured in a raid and sold into Suleyman's harem, occupy a walled enclosure behind the mosque. The sultan's tomb (Turkish *türbe*) is octagonal with an exterior colonnade, a classical layout that evoked the Dome of the Rock on the site of the Solomon's Temple in Jerusalem. Suleyman's father had conquered Jerusalem in 1516, and Suleyman refurbished the exterior of the Dome with the Turkish tiles still visible today (fig. 4-1). Sinan himself was remarkably prolific, responsible for almost eighty mosques, dozens of palaces and baths, and many more utilitarian structures. He, too, was buried in the Suleymaniye complex. Sinan helped establish a consistent architectural style across the vast expanse of the Ottoman Empire, which at his death included Hungary, the Balkans, western Asia (including the holy cities in Arabia), and almost all of North Africa. This empire lasted, although much reduced, until 1923.

Just as Mehmet II retrofitted Hagia Sophia without altering its essential form, and Sinan developed that form into a new Ottoman aesthetic, the Christian conquerors of al-Andalus had some respect for the Islamicate buildings they possessed after they removed the Nasrids, the last taifa rulers, from power in 1492. Rather than destroying the Alhambra or the Great Mosque of Córdoba, they altered them to suit their religious needs and assert their ideological goals. King Charles V (1500–58)—a member of the Habsburg dynasty, which ruled the Holy Roman

Empire from 1438 until it was dissolved in 1806—built a classicizing palace inside the Alhambra that kept the castle in use and helped preserve many of its Nasrid structures. In Córdoba, despite resistance from the town council, architects working for the same Spanish king inserted a church into the body of the mosque (fig. 11-9). The Great Mosque had already been used by non-Muslims after the Christian conquest of Córdoba in 1236; it was rededicated to Mary, and a cross was displayed on top of the former minaret. The intervention that began in 1523 was far more dramatic, however. Parts of the existing hypostyle hall were removed to accommodate a vaulted cruciform basilica, its soaring nave parallel to the qibla wall and its altar facing east. This insertion transformed the mosque into a highly visible statement of Christian and Habsburg power, especially when viewed from outside. Upon seeing the transformed building, Charles reportedly remarked, "You have built here what you or anyone else could have built anywhere, and you have destroyed something that was unique in the world." The monument still serves as the cathedral of Córdoba, and requests to accommodate Islamic prayer services have repeatedly been denied. On the other side of the Mediterranean, churches that became mosques after 1453—including Hagia Sophia and the Pantokrator katholikon in Constantinople and Hagia Sophia in Trebizond—have been returned to Islamic use. Meanwhile, the Samuel Halevi Synagogue in Toledo became a church in 1492, a national monument in 1877, and a museum of Sephardic culture in 1910, which it remains today. The changing fortunes of medieval worship spaces are interwoven with larger historical trends.

Book Arts

In the sixteenth century, the Ottomans' rival to the east was the empire ruled by the Safavid dynasty (1501–1722), which controlled the area from the Caucasus to Central Asia and India. Originating in a Sufi brotherhood, the Safavids gradually converted the Sunni population to Twelver Shiʻism (box 3-1) and established the first major Shiʻi state since the Fatimids. Under Shah Tahmasp I (r. 1524–76), the Safavid capital at Tabriz (Iran)—the former Ilkhanid capital—once again became an important artistic center. A painter and calligrapher himself, the shah was the major patron of the illuminated *Book of Kings* (*Shahnameh*) that bears his name, although in 1556 he renounced the arts (and other "sins") and disbanded the imperial painting workshop. Based on the epic poem composed by Ferdowsi around 1000, the book narrates Iranian history from the creation of the world to the Arab conquest of the Sasanian Empire. Specific events from that history were depicted on Sasanian and later objects, but illustrated manuscripts of Ferdowsi's poem were only produced centuries after his death, especially under the Ilkhanids around 1300. The *Shahnameh* of

Fig. 11-10. Ship of Shiʻism, *Book of Kings (Shahnameh)* of Shah Tahmasp, 47 × 31.8 cm, ca. 1530–35; New York, Metropolitan Museum of Art, acc. no. 1970.301.1, fol. 18v. Gift of Arthur A. Houghton Jr., 1970. Image © Metropolitan Museum of Art.

Shah Tahmasp, with 258 full-page illustrations on 759 paper folios, is the most luxurious extant copy (fig. 11-10).

Commissioned by the shah's father about 1522 and completed by fourteen artists over the following two decades, its large pages with gold-flecked borders show that manuscript illumination was still flourishing as a prestigious art form. This page, probably painted by Mirza ʻAli (active ca. 1525–75), depicts a parable in which Ferdowsi recounts how God launched seventy ships whose passengers represent all faiths; stereotypical physiognomies of Africans, Chinese, and Europeans show the artist's desire to convey

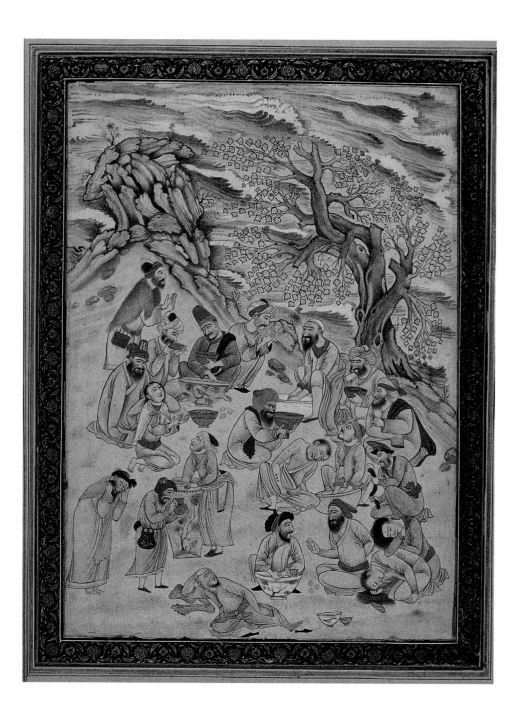

Fig. 11-11. Album sheet with Sufis, 41.9 × 19.3 cm, ca. 1640; British Museum, London.
© Trustees of the British Museum; all rights reserved.

the world's diversity. Almost all of the ships will sink over time, and only the ship of the proper faith will endure. In Shah Tahmasp's volume, the largest ship represents Twelver Shi'ism. On that ship Muhammad and his son-in-law 'Ali are seated together, while 'Ali's sons, Hasan and Husayn, stand beside them; they all have flaming haloes and wear veils that hide their shining faces. They (and others) have a red baton wrapped in their turbans, which was an emblem of the Safavid court; it emphatically ties the founders of the faith to the dynasty. The book therefore expresses not only a fictive continuity with ancient Iran but also the divine authority of kings, attained through war, a potent theme at a time when the Safavids were menaced by the Ottomans to the west and the Uzbeks to the east. In fact, Shah Tahmasp sent the book as a diplomatic gift to

the Sunni sultan Selim II, son of Suleyman, probably when Selim succeeded to the Ottoman throne (r. 1566–74). The book thus continued a long line of gifts with ideological messages, in this case that the Safavids are a noble line of true Muslims that can be traced back through 'Ali to the Persian kings.

In addition to creating book manuscripts with sumptuous illustrations, Safavid elites also embraced a newer art form: individual paintings that were not anchored to a narrative text. Although some of these autonomous sheets were collected in albums, each was meant to be appreciated as a single work that emphasized artistic skill. This paper album sheet was painted in watercolor in Isfahan around 1640 (fig. 11-11). It depicts Sufi mystics in a landscape, engaged in various activities associated with their

spiritual practice: praying, washing, preparing intoxicants, and drinking them; a few look exceedingly relaxed. The artist's attention to differing and vivid physiognomies, dress, postures, and states of communication with the divine displays the diversity of Sufi practitioners and their many devotional approaches. He also rendered carefully the objects they wear and use, including the striking Chinese blue-and-white porcelain vessels that were highly prized in Iran at this time—another manifestation of the collecting habits of wealthy Safavids.

The prestige of calligraphy as an Islamic art form did not cease with the Middle Ages. It was employed in new settings outside of Qur'anic texts, as in the *tughra*s (official signatures) of the Ottoman sultans. These kinds of insignia were first used in the fourteenth century, but their designs became increasingly complex as the empire expanded. Calligraphers and illuminators collaborated to create samples for a new sultan, who would select one of them as he came into power; that tughra would then be used at the beginning of his official documents. The tughra of Suleyman spells out the names of the sultan and his father in a dense knot of blue letters, with his title and epithets below ("the eternally victorious," "the shadow of God on Earth") (fig. 11-12). This intricate signature, which represented the sultan's presence and authority on the documents it embellished, was made by calligraphers and illuminators working together. The ornate result was difficult to copy and thus assured the authenticity of imperial documents.

In Europe, it took some time for printed books to replace illuminated manuscripts after Gutenberg's invention, in part because a handmade book's ability to contain sumptuous and personalized images continued to make it a treasured type of object in both religious and secular contexts. A book of hours made in Flanders about 1490 reveals the continuity of medieval iconography and material culture while also displaying new approaches to rendering space (fig. 11-13). This page depicts the adoration of Jesus by three angels soon after his birth. The scene takes place not in a humble manger or cave (the settings of the Nativity in European Christian and Byzantine art) but, rather, in a paved room with a wood ceiling and arched stone windows that reveal a castle and landscape beyond. The paving stones, window ledge, and ceiling beams recede into the distance in accord with one-point perspective, a precise geometrical method of depicting spatial depth that developed in fifteenth-century Italy. The wide border is decorated with strawberries, flowers, and white acanthus scrolls that cast their own shadows, increasing the illusionism of the page and stimulating the viewer to think about what is real. At the top left corner, a thin, stamped-metal pilgrimage badge has been sewn onto the page. Inside a heart is a scallop shell, usually associated with Santiago de Compostela (Spain); a schematic Virgin and Child is superimposed on it. Multiple badges were inserted into

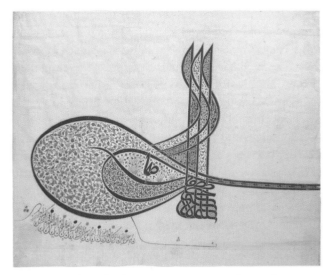

Fig. 11-12. Tughra of Suleyman, 52.1 × 64.5 cm, from a document of ca. 1555–60. New York, Metropolitan Museum of Art. Rogers Fund, 1938 (38.149.1). Image © Metropolitan Museum of Art.

Fig. 11-13. Illuminated page with metal badge, book of hours, 13.5 × 9.6 cm, ca. 1490; Oxford, Bodleian Library, MS Douce 51, fol. 45v. © Bodleian Libraries, University of Oxford.

this book to stimulate the lay reader to imagine a pious pilgrimage or to reinforce the painted images they accompany. They may have been acquired at pilgrimage sites, but they also could have been purchased from traveling merchants or local artisans; the origin of this particular badge is unknown. At the very end of the fifteenth century, the owner of this book was continuing medieval practices of collecting religious souvenirs and engaging in pilgrimage (real or imagined), and he or she was also appreciating new perspectival techniques that draw the eye into the page.

The production of books printed on paper and the wide distribution of inexpensive woodcut prints eventually made more texts and images available to a much less wealthy clientele. Jewish books were printed in such cities as Venice, Amsterdam, and Istanbul, all places with sizable Sephardic communities exiled from Spain after 1492. One of the earliest printed haggadot was produced in Prague in 1526 by the printer Gershom Cohen, to whom the

Bohemian king gave an exclusive monopoly on Hebrew printing in his kingdom. As in many medieval haggadot from Ashkenaz, the opening image depicts a Jewish man searching for leaven before Passover (fig. 11-14). The wide border full of acanthus scrolls evokes the layout of pages in the Flemish book of hours, but here it is based on classicizing Italian woodcut patterns. While the textual contents of the haggadah had been consistent for centuries, the new printed format made illustrated versions less expensive and, in a clever marketing strategy, Cohen seems to have directed his artists to produce relatively simple, generic images that would be palatable to a wide audience. Indeed, the Prague Haggadah's woodcut images became a popular iconographic source for generations of European Jews even into the twentieth century.

Other uses of printing were not beneficial to Jewish life in German-speaking lands. A popular woodcut print of the 1470s showed a "Jewish Sow" (German *Judensau*), with Jewish men and boys—identified by their distinctive hats and the pseudo-Hebrew on one garment—sucking on a pig's teats while others focus on its rear (fig. 11-15). Elaborating on the imagery are floating scrolls with German verses; the one at the bottom reads, "This is why we do not eat roast pork, and thus we are lustful and our breath stinks." The scene was reproduced on the other side of a standard Crucifixion image, implying that piglike Jews have a direct connection to the death of Jesus. It also appeared in public settings; roughly fifty "Jewish Sows" are preserved in stone reliefs, often on church exteriors. An early fourteenth-century example is still prominent on the facade of the parish church at Wittenberg (Germany), where Martin Luther referred to the relief, preached about reforming the Church in Rome, and catalyzed the movement known as Protestantism. The hardening of anti-Jewish attitudes apparent in these sculptures on prominent buildings and in the widely disseminated print marked a new stage in Christian positions toward Jews, one exacerbated by a new blood libel in 1475. There had been periods of Jewish persecution throughout the Middle Ages, especially around the First Crusade and the Black Death; Jews had repeatedly been expelled, and then often recalled, from western European countries (England in 1290, the royal domains of France in 1306 and 1394). Yet the Jewish expulsion from Spain in 1492 was numerically larger and its effects longer lasting, and in the sixteenth century, Jewish stereotyping in Protestant lands and in the Holy Roman Empire became increasingly degrading, furthered by the new mass media of prints and leaflets. Images of the "Jewish Sow" based on the original fifteenth-century woodcut were printed into the eighteenth century.

Printed pamphlets with woodcuts also disseminated images and accounts of the fifteenth-century event that had the most profound effect on all aspects of world history: Christopher Columbus's encounter with the Indigenous peoples of the Americas. His *Letter on the Recently Discovered*

Fig. 11-14. Printed page, Prague Haggadah, 29 × 20 cm, 1526; Braginsky Collection, Zurich. Photo from Braginsky Collection, Zurich, Switzerland.

Fig. 11-15. "Jewish Sow" and Crucifixion, two sides of a woodcut print, 32 × 46 cm, fifteenth century; Harvard Art Museum, M13648.A-B, Cambridge, MA. Harvard Art Museums/Fogg Museum, Gift of Mr. and Mrs. Philip Hofer. © President and Fellows of Harvard College.

Islands (*Epistola de insulis nuper inventis*) was printed soon after his "discovery," and an accompanying woodcut was the first representation of North Americans to circulate in Europe (fig. 11-16). In the foreground is a ship whose social and political hierarchy is established by the oars, captain's house, and flags with emblems of the Spanish monarchs. The artist contrasts this orderly technological world with the wildness of the land in the background, whose inhabitants cluster together, their naked bodies touching. Columbus wrote that the Taíno (Arawak) people, whom he called "Indians," were "timid and full of terror," and they do look apprehensive. One woman covers her breasts as if suddenly aware of her nudity; the clothed men in the boat represent cultural change coming to shore. The two groups offer each other gifts, demonstrating to European viewers that the locals were willing to share their wealth with the explorers. The inscription above the horizon line encapsulates the ideological claims of the image and the event it portrays: "Insula hyspana," Island of Spain (later called Hispaniola, or Little Spain; now the Dominican Republic and Haiti). As soon as Columbus and his men went ashore, they claimed the lands—and their inhabitants—for Spain, an act that would have devastating consequences for the Indigenous peoples of the Americas.

By the early sixteenth century, naval explorations were rapidly expanding geographical knowledge and fueling power struggles among the Spanish and Portuguese, the Holy Roman Empire under the Habsburgs, the Ottomans, and the Safavids. A large map drawn in 1513 by the Ottoman sea captain Piri Reis ("Captain Reis," ca. 1470–1554) can be connected with Ottoman ideological claims of universal sovereignty (fig. 11-17). Only partly preserved today, this map (inked on gazelle skin) shows western Africa,

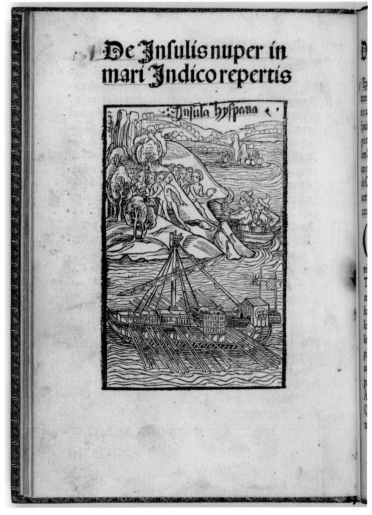

Fig. 11-16. "Insula hyspana," woodcut print in Christopher Columbus, *Letter on the Recently Discovered Islands*, 20.6 × 14.8 cm, 1494; Washington, DC, Library of Congress, Incun. 1494.V47 Vollbehr Collection. Photo from Library of Congress.

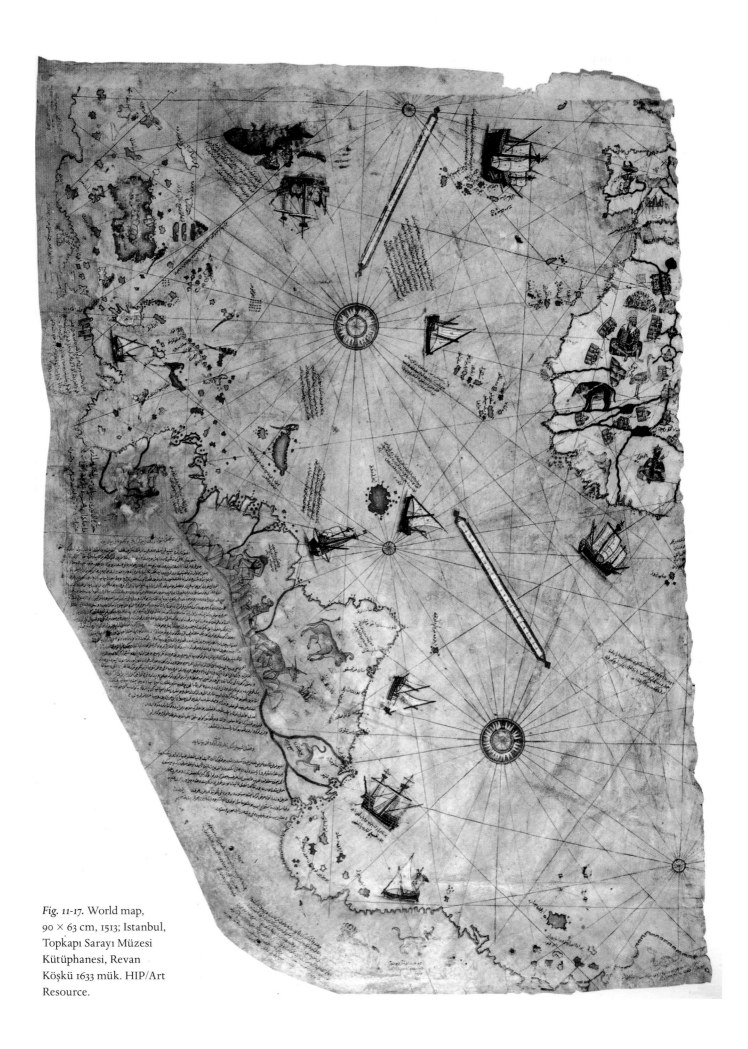

Fig. 11-17. World map,
90 × 63 cm, 1513; Istanbul,
Topkapı Sarayı Müzesi
Kütüphanesi, Revan
Köşkü 1633 mük. HIP/Art
Resource.

southwestern Europe, and the eastern parts of Central and South America (a second map by Piri Reis, of 1528, is more fragmentary but includes parts of North America). The Americas are not accurately drawn because explorers were still unsure whether the lands were part of Asia or a different continent entirely. Reis based his work on Arab, Portuguese, and other maps, including one made by Columbus, as well as on his own travels around the Mediterranean Sea; he knew the Mediterranean well because he had helped evacuate Muslims and Jews from Spain after 1492. The map contains numerous figural vignettes: rulers in Portugal, Morocco, and Guinea (perhaps Mansa Musa, fig. 10-35); an elephant and ostrich in Africa; a llama and puma in South America; parrots on islands; and ships and sea creatures in the Atlantic Ocean. Although some of these are mythical creatures like those that populated the earlier Hereford Map (fig. 9-3), there are fewer of them, and there are no religious figures or scenes of the sort seen on the Catalan Atlas (fig. 10-34). Indigenous peoples are absent, however, as if the vast American continents were uninhabited. The map also has many labels, in the Ottoman Turkish language written in Arabic script. The long introduction at the left, filling the space of South America, asserts, "In this age, no one has seen a map like this . . . just as the sailors of the Mediterranean have reliable, well-tested charts at their disposal, so too the present map is correct and reliable for the Seven Seas."

Traces of the ambitions of the sovereigns who competed to dominate the Seven Seas remain in the last phases of construction at Santa Maria de Vitória at Batalha. Duarte (r. 1433–38), one of King João I's sons and his successor after João died of the plague, commissioned the architect Huguet to build a second royal mausoleum outside the east end of the church (fig. 11-2a). This one was to surpass in size and splendor the founder's chapel where his parents and siblings were buried, thereby doubling the royal presence at the Dominican complex and proclaiming the superiority of Duarte's reign. The new space is a huge octagon with tall, ornate pointed arches framing chapels and exterior walls of stained glass. The building was not complete when Duarte died, however, and work on the complex continued only intermittently thereafter. Under King Manuel I (r. 1495–1522), the upper part of the arcades of the Royal Cloister were filled with elaborate sculpture featuring marine motifs and plants from lands newly "discovered" or colonized by the Portuguese, including the Senegal River delta, Madeira, and Ceuta (in North Africa). But the massive octagonal mausoleum, draped in lavishly carved surfaces, was left unroofed and incomplete in 1533 (fig. 11-18). Duarte and Huguet had envisioned that the Gothic structure could be spanned, and indeed the builders tried; seven massive compound piers reach into the sky, holding the beginnings of ribs that might have fanned upwards, touched, and formed a vault. The will required

Fig. 11-18. Unfinished mausoleum, monastery of Santa Maria de Vitória, Batalha, 1433–1533. Photo by the authors.

to make them touch died with the ambitious king, however, in part because the massive scale he desired exceeded the engineering capacities of his time. The mausoleum remained open to the sky while the era of building in the Gothic style came to a close.

Restoration, Reinvention, and Reinterpretation

In April 2019 people around the world watched as the cathedral of Notre-Dame in Paris was engulfed in flames. Although the building was begun in 1163 and completed in the thirteenth century, what fell first was not medieval; it was the wood and lead spire erected in 1859 by Eugène-Emmanuel Viollet-le-Duc (1814–79). The original spire had been damaged and dismantled around 1790, so Viollet-le-Duc had never seen it. In fact, much of what we see today at Notre-Dame was a product of Viollet-le-Duc's imagination. Called the father of modern restoration, he either altered

or created the exterior sculpture, the flying buttresses, and even the famous gargoyles. Viollet-le-Duc argued that the dilapidated monument had to return to its former glory, not just be propped up to ensure its survival, because it retained its original practical and symbolic functions. For him, "former glory" meant the time before the jamb figures and statues of kings on the facade were hacked off during the French Revolution in 1793. In many ways, then, his nineteenth-century restoration reinvented an idealized medieval past. Now, in the twenty-first century, architects, donors, scholars, politicians, and the public must decide what to preserve, restore, or renew. The issue is especially fraught at Notre-Dame because it is not merely a church; it is a national symbol and a treasured world monument, a UNESCO World Heritage site supported by the United Nations. Should the spire be rebuilt in the form Viollet-le-Duc gave it, in some other form, or not at all? The fire also destroyed the huge timbers gathered from medieval forests that originally supported the cathedral's lead roof, and trees no longer grow to such dimensions; should they be replaced with modern fireproof materials alien to the medieval structure? What if they prove too heavy for its rib vaults and walls? The structural integrity of the building and national pride are at stake, along with hundreds of millions of euros (almost a billion U.S. dollars) pledged by wealthy individuals, companies, and government entities.

Large-scale restoration projects can express contemporary perspectives and ideologies. After Uzbekistan became independent in 1991, the new nation embarked on an extensive program of reconstruction that drew upon the enormous monuments of Timur's time to make its own statements about political power (fig. 10-20). Even though he was not an Uzbek and was born two centuries before any Uzbeks settled in Samarkand, Timur was adopted as the national symbol. His huge but crumbling buildings were partly rebuilt, using reinforced concrete to withstand the region's frequent earthquakes. In many cases new inscriptions were added, with Qur'anic excerpts selected to emphasize ideas that fit with Uzbek nation-building. Few Uzbeks can read Arabic, however, so the messages encourage a wider Muslim audience to recall the power and legacy of Timur and connect it with a modern state never imagined by the Mongol conqueror.

While the buildings discussed in this book remain for the most part in their original locations, the smaller works of art are found primarily in museums, the major forum for preserving, interpreting, and debating the past's material remains. As with architectural restoration, they too often emerge from political circumstances and have specific goals. In the nineteenth century, European scholars, cultural leaders, and politicians founded museums to discover, recover, and even invent a past that was specific to a particular place; consequently, some aspects of heritage were prized and others ignored or suppressed. Collecting and displaying medieval art in North America and

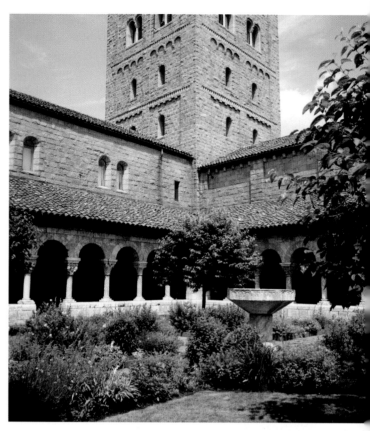

Fig. 11-19a. The Cloisters, New York, view of the Cuxa Cloister, ca. 1130–40. Metropolitan Museum of Art, New York. The Cloisters Collection, 1925 (25.120.398.954). Image © Metropolitan Museum of Art.

Australia, far from its places of origin, brought somewhat different dynamics into play. The Cloisters in New York City was one of the earliest and largest collections of this sort. Housing the sculpture and architectural fragments assembled by the sculptor George Grey Barnard (1863–1938) and the financier John D. Rockefeller Jr. (1874–1960), it became a branch of the Metropolitan Museum of Art in 1926. The Cloisters opened in its current location in 1938, where its objects from Europe are displayed in spaces that look, and often are, medieval in part (fig. 11-19). One of the four cloisters that gives the museum its name is made from fragments of the twelfth-century Benedictine monastery of Saint-Michel-de-Cuxa in the French Pyrenees, but it is only about half the size of the original, and many of its pieces were made in the twentieth century (fig. 11-19a). The collection itself grew from objects displaced after the First World War, whether sold by needy individuals, loaned by European governments, or pillaged by agents working for wealthy Americans. This acquisition of pieces of the European medieval past could be seen as a neocolonialist enterprise, but it preserved the works (Saint-Michel-de-Cuxa, abandoned in 1791, was in disrepair) and made them available to new audiences who had no access to genuine medieval art and architecture.

Just as works of medieval art may reveal aspects of their users' worldview and how they wished to be perceived, so

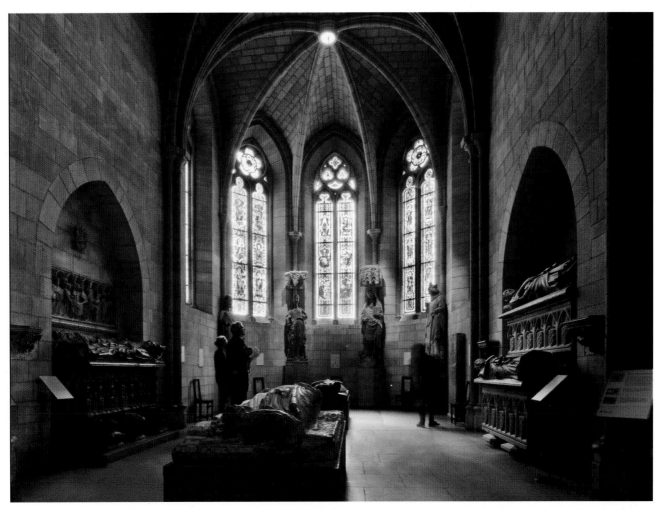

Fig. 11-19b. The Cloisters, New York, view of the Gothic Chapel, with windows (fourteenth century) and tombs (thirteenth–fourteenth century). © Genevra Kornbluth.

collectors who donated medieval art to museums sought to project a particular image of themselves. The early history of the Cloisters and the Metropolitan Museum of Art was shaped by patrons' desire to promote themselves through public displays of their wealth and cultural capital. In addition, donors and museum leaders wanted to establish New York as a great urban and cultural center akin to Europe's sophisticated capital cities. The expansion of the Metropolitan Museum in the late twentieth century to include African, Oceanic, and contemporary art indicates a more global perspective, although here, too, debates rage about the ethics of such collections and colonialist appropriation. Such questions are faced by an array of institutions around the world that seek to balance the local and the global, as with the Museum of Islamic Art in Doha (fig. 11-20a). Opened in 2008, it houses one of the largest and most encyclopedic collections of Islamic art in a purpose-built complex enclosing some forty-five thousand square meters. The collection alone testifies to the cultural standing of Qatar, but the building most clearly establishes a dialogue between local and global, past and present. The Chinese-American architect I. M. Pei was coaxed out of retirement to design it; museums were his specialty. His most famous

commissions include the East Building of the National Gallery of Art in Washington, DC, and the Louvre renovation, including the glass-and-metal pyramid that has become a symbol of Paris. Pei's work at Doha thus stylistically and ideologically connected the new institution with great museums that had established international reputations. At the same time, he drew on architectural forms that he thought best reflected the Islamic character of the collection, particularly the ninth-century Mosque of Ibn Tulun in Cairo (fig. 11-20b).

These museums and the major restoration projects mentioned above show the continuing process of re-creating, reinventing, and reinterpreting medieval culture in postmedieval times. They also raise larger questions about the preservation of works of art and architecture. Should they be restored to a pristine moment of origin, or to what they looked like at some later time in their long history? If the latter, to which time, and why? Who should decide which parts of the past are preserved for the future and determine who will be able to encounter that past? Should historical monuments, like the "Jewish Sow" reliefs, be preserved and displayed even if they commemorate or represent controversial figures or odious ideas and

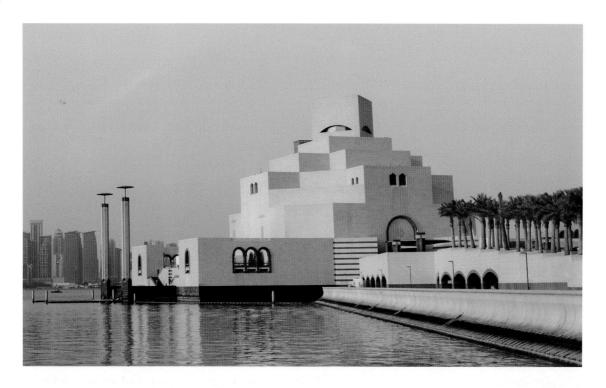

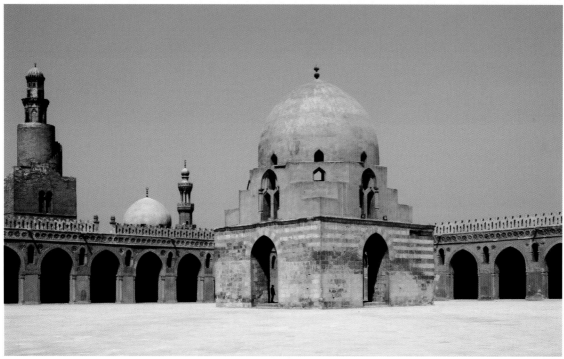

Figs. 11-20a and 11-20b. (*top*) Museum of Islamic Art, Doha, Qatar, 2006–8; (*bottom*) courtyard, Mosque of Ibn Tulun, Cairo, 876–79. (*t*) Photo from iStock.com/ajansen; (*b*) Wikimedia Commons/Diego Delso, delso.photo, CC BY-SA.

evoke a shameful past? Should we keep offensive images to remind us of our history so we are less likely to repeat it, or does the risk of stoking new hatred, deepening old wounds, and inflicting new injury mean that they should be removed? Such questions have no easy answers. They do, however, underscore the important roles that art and architecture of the past play in the present day. Just as works of medieval art testify to the worldviews of the people who made and used them centuries ago, and just

as restorers and collectors assert their own priorities and identities through medieval remains, *your* views about historical art and architecture matter and have implications today and for the future. We hope this book has helped you gain insight into the monuments and objects of the medieval world, think about the circumstances and meanings around their creation and use, and consider how they might continue to inform our twenty-first-century experience.

GLOSSARY

*Words can have multiple meanings; the definitions
in this glossary correspond to the meaning in this book.*

abbey: Roman-rite monastery ruled by an abbot or abbess

acanthus: Mediterranean plant whose leaves were imitated in ancient and medieval sculpture

aedicula: small niche or shrine

aër: veil that covered the bread and wine as it was brought to the altar during the Orthodox Eucharist

Agnus Dei: Latin for "Lamb of God," a Christian iconographic motif based on John 1:29

al-Andalus: Arabic name for the Iberian Peninsula, parts of which were under Muslim control from 711 to 1492

alfiz: rectangular panel that frames an arch, usually the upper, rounded part

alloy: two or more metals that fuse together when heated

altar: elevated block or table on which religious ceremonies are performed; in the Jewish Temple, used for animal sacrifices and other offerings to God; in Christian churches, used for consecration of the eucharistic elements

altarpiece: object atop or behind a Christian altar, usually painted or carved with images of the altar's dedicatee

Amazigh, pl. Imazighen: Berbers, the Indigenous peoples of North Africa and the Sahara

ambulatory: aisle to facilitate circulation, especially one that curves around the east end of a church

ampulla: small portable flask to hold sanctified liquid, often decorated

amulet: protective device, often worn on the body

anagogical: rising upward, toward heaven

Anastasis: Greek for resurrection; the rotunda over the tomb of Christ in Jerusalem, and the Byzantine scene of Christ descending to Hades to retrieve such pre-Christian figures as Adam, Eve, John the Baptist

aniconism: tendency to avoid or opposition to representational imagery

antemihrab dome: dome in front of the mihrab in a mosque

apocryphal: religious texts not considered canonical by some, but often widely read

apostates: people who abandon a faith

apotropaic: referring to a protective device that turns away envy or evil; apotropaia is the collective plural for such devices

apse: vaulted semicircular space, often in the end wall of a longitudinal church

arca: Latin for box for valuables, such as the Ark of the Covenant

arcade: row of arches carried on columns, piers, or pilasters

archbishop: bishop who heads an ecclesiastical province that contains multiple bishops

archivolt: projecting band or molding that surrounds an arched opening; often carved

arcosolium: arched niche in a wall, often for burial

ascetic: strict, self-denying religious practice; or a person who practices asceticism

ashlar: precisely cut stone masonry

atrium: unroofed courtyard in front of a house or public building

axonometric: architectural drawing in which a building is rotated to show multiple sides

baldachin: canopy, freestanding or attached to a wall, often above an altar or tomb

barrel vault: continuous semicircular, tunnel-like vault

basilica: longitudinal building, often with a wider, taller central nave and narrower, lower flanking aisles; adopted for Christian religious use from Roman civic architecture

basmala: Arabic acronym, from "In the name of God, the merciful, the compassionate," which is the most common expression of Muslim piety and appears at the beginning of all but one chapter of the Qur'an

bay: unit of a building defined by vertical supports, such as two piers or columns, including the vaults above that space

bema: sanctuary area of a synagogue or church

Berbers: Imazighen, the Indigenous peoples of North Africa and the Sahara

bestiary: moralizing treatises about animals

bezel: top of a ring attached to the hoop, with images, stones, or other decoration

bishop: Christian clergyman, ranking higher than a priest, who heads a bishopric or diocese

blind arch: filled-in arch

blood libel: false charge that Jews murdered a Christian for ritual purposes

brass: alloy of copper with zinc, tin, or other metal, which makes the product stronger than copper

bronze: alloy of copper with tin and sometimes a small amount of another metal, making the product stronger than copper or brass

bronze casting: method of producing bronze objects or sculptures in a mold

buttress: projecting mass of masonry perpendicular to the exterior of a building that supports it at points of stress

caliph: Arabic for a successor of Muhammad, leader of the Muslim community

caliphate: political-religious state ruled by a caliph

calligraphy: from Greek for beautiful writing, as in a manuscript

Calvary: place outside Jerusalem where Jesus was crucified, known as Golgotha in Aramaic, enshrined within the Holy Sepulcher complex; also, the group of Jesus on the cross flanked by Mary and the apostle/evangelist John

cameo: small relief sculpture made by carving a gem or stone that has layers of different colors

canon, canonical: collection of authoritative works or texts; also, part of the Christian eucharistic liturgy

canonize: declare a deceased person a saint, or elevate a work or text to canonical status

canon tables: concordance of the four Gospels showing shared passages, systematized by Eusebius in the fourth century; often decorated

capital: architectural element that crowns a pier or column and separates it from what it supports; often carved

caravanserai: Persian for roadside lodging for travelers and merchants

carbon-14: a radioactive isotope of carbon; when organic material (wood, fiber, bone, etc.) dies, it stops absorbing carbon and the isotope decays at a known rate, making it datable

carpet page: page in a manuscript that resembles a carpet because it is covered with symmetrical and usually nonfigural ornament

casket: box or chest, often portable

catacomb: underground cemetery with multiple narrow passages that open into rooms

cathedral: main church of a bishopric or diocese; contains a bishop's throne (cathedra)

Catholic: Greek for universal, as in the early undivided Christian Church; more narrowly, the Roman-rite Church (versus Orthodox) and its liturgical system and doctrines

cenobitic: type of monasticism in which monks live together in communities

cenotaph: tomb or funerary monument that does not contain a body

censer: vessel for burning incense, usually made of metal

centaur: composite creature from Greek myth, half man and half horse

chahar taq: Persian for four arches; the traditional form of a Zoroastrian fire temple, with four arches or short barrel vaults between four corner piers that support a dome; adopted in Islamicate architecture

Chalcedonian: Christians who accept the decisions about the nature of Christ promulgated by the Fourth Ecumenical Council, held at Chalcedon in 451

chalice: cup or goblet used in the Christian mass

chancel screen: low barrier, often of stone, that separates a church sanctuary (chancel) from the naos or nave; also called the templon

chevet: east end of a Roman-rite basilica, including the apse, ambulatory, and radiating chapels

chip-carving: hand carving by removing small chips, and the decoration that results

choir: space in a Roman-rite church between the sanctuary and the nave, used by clerics and sometimes singers

ciborium: roofed structure over an altar

circumambulate: walk around something, such as a shrine or worship space, usually in a ritualized way

citadel: fortress with residential and military functions

clerestory: window zone of a wall

clipeus, pl. clipeae: in antiquity, a round shield; a circular frame that encloses figural or other decoration

cloisonné: metalwork technique in which thin gold strips are attached at right angles to a base; the resulting cells are then filled with glass or gems

cloister: unroofed multipurpose space in a monastery or cathedral, enclosed by roofed walkways, usually connecting the south side of the church with other buildings

codex: book composed of folded sheets, often sewn or bound together on one edge

colophon: text, often at the end of a manuscript, that contains information about its production

commune: medieval Italian city-state

compound pier: vertical support composed of multiple shafts around a central core

convent: complex built for religious seclusion of celibate monastics, usually nuns

Coptic: belonging to the Miaphysite (non-Chalcedonian) Christian Church in Egypt as it developed under Muslim rule, especially after the ninth century; or the language used by Christians in Egypt, the last phase of Egyptian

corbel: masonry block or bracket that projects from a wall, sometimes carved

crenellated, crenellation: projecting rectangular pattern at the top of a wall, usually used for defense

crockets: small hook- or leaf-shaped carvings along the upper edges of late medieval European buildings, imitated in smaller-scale works

cross-in-square: typical middle Byzantine centralized church plan with nine bays, in which four columns or piers define a cross shape and support a central dome braced by tall vaulted cross arms; the lower corner spaces are also vaulted

cross-nimbus: circular halo of light with a cross that identifies Christ

crypt: vaulted space in a church, often for tombs or relics, usually under the main story

cubit: ancient unit of measurement based on the length of an adult man's arm from the elbow to the tip of the middle finger

cult: system of religious beliefs and rituals associated with worship

dado: lowest zone of a wall, often given distinctive decoration

Deesis: Greek for petition; Byzantine depiction of Christ flanked by Mary and a saint, usually John the Baptist, who are witnesses to Christ's divinity and intercede with him on humans' behalf

dendrochronology, dendrochronological: method of dating wood by studying tree rings, which share growth patterns across a wide geographical area

despot: Greek for master or lord of a despotate (polity)

diptych: two panels, of any material, hinged together

dirham: Islamicate silver coin

doctrine: something taught as true and supported by authorities

drum: cylindrical or polygonal structure that supports a dome; or a cylindrical block, one of several that compose a column

dualist: faith that believes the universe is dominated by two opposing principles, dark and light or bad and good

early Byzantine: period of Byzantine history from the fifth or sixth century through the eighth or ninth

Eastern Orthodox: Churches under the patriarchate of Constantinople, regardless of liturgical language, including such autonomous Churches as Greek Orthodox and Russian Orthodox

ecumenical: from the Greek word for the inhabited world, used to describe Church councils that drew bishops and others from across the Christian world

effigy: any likeness or image of a person, especially the full-body sculpture of the deceased on a tomb

elevation: side view of an architectural structure or its projection onto a vertical plane

embroidery: work, usually textile, decorated with stitched designs made of thread or fine wire

emir: Arabic for commander, leader of an emirate (province)

enamel: powdered glass and pigment, melted and fused to a metal, glass, or ceramic support

entablature: parts of a wall supported by columns

epigram: concise poem

epigraphy, epigraphic: monumental inscriptions, in any medium

episcopal: from the Greek for overseer; relating to bishops, who oversee Christian practice

epitaphios, pl. epitaphioi: Greek for on the tomb; large textile depicting the dead Christ used in Orthodox churches

epithets: descriptive names or titles for an individual

eremitic: ascetic practice of living alone, like a hermit, and a type of monasticism that emphasizes solitary life

Eucharist: from the Greek for giving thanks; the consumption of bread and wine representing the body and blood of Christ, the most important Christian liturgical activity

ewer: tall vessel for liquids with a pouring lip and handle

facture: process or manner in which something is made, including its materials

feast: Christian holy day, usually associated with an event or saint

fibula, pl. fibulae: large pin to fasten a garment, often ornamented

filigree: jewelry technique using gold or silver wires

findspot: place where an object has been found, rather than where it was produced

finials: ornaments at the end of a spire or other vertical feature

fleur-de-lys: stylized iris, the royal emblem of France

flutes: shallow vertical grooves on a column

flying buttress: buttress with arches that extend through the air to strengthen points of stress on exterior walls

foliate: leafy decoration

foliated Kufic: type of angular Arabic script in which the ends of some letters take on floral or leafy forms

folio: page or leaf of a manuscript (abbreviated as fol.)

font: basin used for Christian baptism

form, formal: basic shapes, designs, and components, such as lines, colors, volumes; and artistic concepts associated with form rather than with content

fresco: painting on wet plaster, so pigments adhere firmly

Friday mosque: masjid al-jami', congregational mosque in which a sermon is delivered on Fridays to the local Muslim community

fritware: ceramic technique, using a body of ground quartz, clay, and ground glass; yields a firmer, whiter body than stoneware

frontal: carved, painted, or textile panel displayed in front of a Christian altar

gable: roof with two sloping sides that meet at a ridge, or the triangle at the end of a roof

gilt-silver: gold applied to a silver object

glaze, glazed: thin, opaque coating applied to ceramics after initial firing, then refired at a lower temperature to vitrify it; and the product that results

granulation: tiny grains or balls of precious metal applied to a metal base

grave goods: objects, often of value, deliberately deposited in or near a grave

griffin: mythical composite creature with the head and wings of an eagle and body of a lion

groin vault: four-part vault formed by the intersection of two barrel vaults

habit: everyday clothing worn by a monk, nun, or priest

hadith: sayings of Muhammad and, in Shi'i Islam, the traditions of the imams

hagiography, hagiographic: idealizing biography (vita) of a saint

hajib: chamberlain, a high administrative position in an Islamic court

hajj: annual pilgrimage to Mecca and Medina, required of all Muslims

headpiece: ornamented panel or frame that marks the beginning of a text in a manuscript

Hetoimasia: Greek for preparation; in iconography, the empty throne prepared for Christ's Second Coming

hijra: Arabic for emigration or flight, specifically Muhammad's journey from Mecca to Medina in 622 CE, the beginning of the Muslim calendar

hippodrome: racetrack for chariots or horse racing

historiated: decorated with identifiable scenes or figures, such as a manuscript initial or a capital

hoard: deliberately hidden group of objects

Hodegetria: Greek for She Who Points the Way; an important icon of Mary in Constantinople and its copies

hypostyle: from the Greek for many rows of columns, supporting a roof

icon: Greek for image, not restricted by medium or size but often painted on a wooden panel; depiction of a holy figure or sacred event used to inspire devotion to the prototype

iconoclasm: image-breaking; period in which figural images were destroyed, including, in the Byzantine world, 726–87 and 815–43

iconoclast: one who destroys images, or a supporter of such destruction

iconography: subject matter and meanings of an artistic representation

iconophile: lover of images; a supporter of icons, who believes that prohibiting the making of images of Christ denies his human incarnation

imam: Muslim spiritual or prayer leader; also a descendant of 'Ali and leader of a Shi'i community

Imazighen: Berbers; plural of Amazigh

impost: architectural element inserted between a capital and what it supports

incubation: practice of sleeping in a sacred space, in hope of a divinely inspired dream or cure

intaglio: sculptural technique in which a design is sunk into the surface by carving or incising

investiture: ceremonial conferring of symbols of office, especially robes (vestments)

Islamicate: art in regions in which Muslims are culturally dominant, but not necessarily religious art

itinerant: traveling, like some artists and courts

iwan: Arabic for a large barrel-vaulted space with walls on three sides

jamb figures: statues flanking a doorway, often attached to a column or wall

joggled voussoirs: masonry units that interlock, like puzzle pieces, to form an arch

Ka'ba: Arabic for cube; building in Mecca, focus of the hajj

katholikon: main church of an Orthodox monastery

kermes: red dye from an insect that lives in oak trees near the Mediterranean

khagan, khaganate; or khan, khanate: Turkic titles for the chieftain of a territory in the Eurasian steppes, or the names for such a territory; among the Mongols, a khagan was superior to a khan

khanaqah: Sufi lodge

kiswa: veil of the Ka'ba

kitabkhana: Arabic for scriptorium; from kitab, book

Kufic: angular Arabic script with clear vertical and horizontal lines

lapis lazuli: blue semiprecious stone, mined in Afghanistan

late antique, late antiquity: the period of Roman imperial decline and its aftermath, roughly between the third and seventh centuries CE

late Byzantine: period of Byzantine history from 1204 (Latin conquest of Constantinople) or 1261 (Byzantine recovery of Constantinople) to 1453 (Ottoman conquest of Constantinople)

lintel: horizontal element that spans a door, window, or other opening

liturgy, liturgical: from the Greek for public duty; the collection of rituals, including movement, recitation, song, prayer, and blessing, prescribed for worship; or things connected to a liturgy, such as vestments or objects

lobe, lobed: two- or three-dimensional shape or space composed of curved or rounded parts

loros: long, jeweled ceremonial scarf worn by Byzantine rulers and angels

lost-wax method: casting technique, usually for a sculpture, in which a wax mold is covered with plaster; after the wax is melted away, molten metal is poured into the plaster cast to produce the desired sculptural form, revealed after the outer mold is broken

lunette: half-moon shape, such as one framed by archivolts over a doorway

lusterware: ceramic technique in which metallic oxide is applied over opaque white glaze, then refired

madrasa: Islamic educational institution, especially for religious studies

mandorla: area of light, often oval or almond-shaped, that surrounds the representation of a holy person (usually Christ) as an indication of sanctity

mappa mundi: Latin for world map

maqsura: screened area near a mosque mihrab that creates a private prayer space

Marian: having to do with Mary, the mother of Jesus

marginalia: figures or scenes on the edge of a page, object, or building

martyrium: shrine built in memory of a martyr

masjid al-jami': congregational or Friday mosque, in which a sermon is delivered on Fridays to the local community

masonry: building material made of cut or carved pieces of stone or brick

mendicant: someone who begs, of any faith, including a member of one of the religious orders dependent on charity that emerged in Europe in the thirteenth century

menorah: stand holding oil lamps, the principal symbol of Jewish faith in the Middle Ages

mercantile: related to merchants or trade

metrical: text or inscription composed in poetic meter

middle Byzantine: period of Byzantine history from the eighth or ninth century until 1204 (Latin conquest of Constantinople) or 1261 (Byzantine recovery of Constantinople)

mihrab: arched niche in the qibla wall of a mosque that indicates the direction of prayer, toward Mecca

mikvah, pl. mikvaot: underground bathing pool used for Jewish purification rituals

millefiori: Italian for thousand flowers; colored glass tubes sliced and embedded in clear glass to form patterns

minaret: tower, usually of a mosque

minbar: elevated pulpit in a mosque, with stairs leading to a platform from which sermons are delivered

mirador: Spanish for a balcony or window that provides a scenic view

monastery: complex built for religious seclusion of celibate monks or nuns

monotheist: belief in or worship of one God

mortar: material used for binding brick or masonry; usually a mix of lime (a calcium compound) or plaster, sand, and water

mosaic: decorative technique for walls or floors that uses small tesserae to create images or patterns

muqarnas: Islamicate decorative vaulting system based on repeating tiers of small nichelike elements that resemble honeycombs or stalactites

myron: Greek for oil or unguent with miraculous healing properties, emitted by the body of some saints

naos: main worship space in a Byzantine centrally planned church, including the area under the dome but excluding the sanctuary

narthex: vestibule that precedes the entrance into the main space of a church, often extending the width of the facade

nave: central aisle of a longitudinal building, often wider and taller than the side aisles from which it is separated by columns or piers

Nestorians: followers of Nestorios, bishop of Constantinople (d. after 451), who distinguished two persons in Christ, the son of Mary and the son of God, and denied that Mary was the mother of God (Theotokos)

niello: shiny, dark metal alloy used as inlay in precious metalwork

nimbus: halo around the head of a ruler (in Roman and Sasanian art) or holy person (in Christian and Islamic art)

nomisma, pl. nomismata: Byzantine gold coin, equivalent to the Roman solidus, pl. solidi

numismatic: relating to coins

opening: in manuscripts, pages that face each other when a book is open

openwork: perforating a material with decorative intent, or a work made in this technique

opus sectile: slices of stone, often of different colors, inlaid in patterns on walls or floors

orant: ancient pose of prayer with hands upraised and elbows bent

Orthodox, Orthodoxy: Greek for right belief; correct doctrine and worship, and adherents of this who follow the Byzantine liturgy and doctrines

palmette: motif of radiating palm leaves

Panagia: Greek for All Holy, referring to Mary

Pantokrator: Greek for Ruler of All; an image of Christ as a mature, bearded figure holding a Gospel book, often depicted in the dome of a Byzantine church

parchment: animal skin that has been scraped and dried to produce a writing surface

parekklesion: side chapel of a Byzantine church, often funerary

parish church: main church of the smallest Christian administrative unit

Passion: from the Latin for suffering, the period in the life of Jesus from his entry into Jerusalem through his crucifixion, sometimes including his resurrection and ascension

paten: plate to hold bread in the Christian mass

patriarch: the biblical Abraham, Isaac, and Jacob; or one of the most prominent Christian bishops, especially the archbishop of Constantinople, head of the Byzantine Orthodox Church

pendentive: curved triangle that makes a transition from a square base or bay to a circular dome

personification: abstract idea or inanimate object represented in human form

pier: vertical support in architecture, usually rectangular and of stone

pilaster: pier attached to the wall

pilgrim, pilgrimage: person who travels to a sacred place primarily for purposes of devotion, and devotional journeys

pinnacle: decorative vertical structure, often on buttresses or furnishings, that tapers to a spire

pishtaq: tall arch framing an iwan, or a monumental projecting portal in Islamicate architecture

plan: horizontal projection of an architectural structure or complex, as if seen from above

plaster: mix of water, lime, and sand, often bound with other materials, used to cover a wall

polychromy: multiple colors

polylobed: two- or three-dimensional shape or space composed of multiple curved or rounded parts

polysemy, polysemic: having multiple meanings

polytheism: belief in or worship of multiple gods

pope: bishop of Rome, head of the Roman-rite or Catholic Church

porphyry: hard purplish stone quarried in Egypt, originally reserved for imperial use

portico: roofed space open on one side

prototype: original on which something is modeled; in icon theory, the holy figure "behind" the artistic representation

psalms: songs recited in Jewish and Christian worship, traditionally attributed to King David; collected in the Psalter

punching: decorating a surface with a pattern of small depressions made with a punch (tool)

putti: Italian for nude, male, winged toddlers derived from personifications of Cupid

qibla: the direction of prayer for Muslims, toward the Ka'ba

rabbinic: having to do with rabbis, teachers who made Jewish legal rulings after the destruction of the Temple in 70 CE led to the disappearance of Temple priests

radiating chapels: spaces that project from the apse or ambulatory of a church

radiocarbon: see carbon-14

recto: the front of a manuscript page or leaf, abbreviated as r; in Latin and Romance-language manuscripts, it is on the right of a two-page opening, but in Hebrew, Arabic, and Persian manuscripts, in which the text is read from right to left, it is on the left

refectory: dining hall in a monastery or other religious institution

relic: body part, clothing, or other object associated with a deceased holy person or in contact with one

relief: sculpture that projects from a background

reliquary: container to protect or display relics, in any medium

repoussé: metalwork technique that involves hammering from the reverse to create designs in relief

reredos: ornamental screen behind an altar, rising from ground level; it may be as wide as the nave and as tall as the vaults

retable: decorative panels or a shelf atop an altar or on a pedestal behind it

revetment: cladding or facing added to a surface

ribs: bands of protruding masonry that support a vault or dome

rib vault, ribbed vault: ceiling unit supported by a framework of protruding masonry that divides the vault into sections

rose window: large circular window filled with tracery and stained glass

rotunda: round building, usually covered by a dome

rules, ruling, ruled: straight lines to guide the scribe writing a medieval manuscript

runes, runic: angular characters used in alphabets in medieval Scandinavia, Britain, and Mongolia

saga: narrative about heroic characters, primarily Scandinavian

samite: lustrous, heavy silk, made with a compound twill technique often using gold or silver thread

sarcophagus: Greek for flesh-eater; stone coffin used for burial, often carved

sardonyx: gem with translucent layers of sard (a mineral) and another mineral different in color

scribe: person who writes or copies a text by hand

scriptorium: room used for writing (and sometimes illustrating) books and documents; or a group of scribes and artists working together

scripture: body of religious writings considered authoritative or sacred

scroll: roll of flexible material used for writing and rolled up for storage

section: drawing that depicts a building as if cut vertically

sgraffito: Italian for scratched; ceramic in which the slip is scratched away to reveal the clay color underneath

shahada: profession of faith for Muslims, "There is no God but God, and Muhammad is his prophet [messenger]"

shahanshah: Persian for king of kings; emperor of an Iranian realm

Shahnameh (Arabic Shahnama): Persian for Book of Kings, the national epic poem written by Ferdowsi around 1000 but based on earlier legends

Silk Routes: network of overland and sea routes that linked China with western Asia, Byzantium, and Europe

slip: watery clay, sometimes with additional materials, used to decorate ceramics

soffit: underside of a building part, such as an arch

spandrels: triangular wall surfaces above the springing of an arch

spolia: materials or artifacts taken and reused in a setting culturally or chronologically different from that of their creation

squinch: concave masonry sections, often arches, set across the corners of a square bay to make the transition to a circular dome

stained glass: molten glass to which metallic oxides are added to produce colors; after cooling, the pieces are cut, framed in lead or stone, and assembled into windows

staves, stave church: wooden posts and planks, and churches made of wood in Scandinavia from the ninth century onward

steatite: very soft stone, easily carved and cut; also called soapstone

steppes: grassland prairies; the largest spans Eurasia from the Danube River to Mongolia

stonepaste: see fritware

stoneware: ceramics made of clay and stone, fired to become impervious to liquids

stringcourse: continuous projecting horizontal band in architecture

stucco: thick plaster made of lime (a calcium compound), sand or powdered stone, and water; because stucco sets more slowly than plaster, it is more easily carved

style: distinctive characteristics of a work that connect it with others of its time and place

stylite: monk who stood atop a column (Greek stylos) to increase his proximity to heaven and distance from the world

Sufis: Muslim mystics who emphasize spiritual rapture and repetitive devotional formulas to attain union with God

sultan: ruler of an Islamicate state

sura: chapter of the Qur'an

taifa, pl. taifas: a post-Umayyad Islamic principality in the Iberian Peninsula ruled by an emir; or the period of their rule

tapestry: textile handwoven on a loom, often with figural imagery

tempera: painting method that uses egg (especially the yolk) as a binder

templon: low barrier, often of stone, that separates a church sanctuary from the naos or nave; also called chancel screen

tesserae: cubes of stone, glass, or other material that constitute the building blocks of a mosaic

tetradrachm: ancient coin worth four drachmas, originally of pure silver but gradually debased before disappearing ca. 300

Theotokos: Greek for God-bearer, an epithet for Mary proclaimed at the Third Ecumenical Council (431)

tiraz: royal workshop; or textiles with a woven, embroidered, or painted Arabic inscription band made there

tooled, tooling: intentionally incising ornament and leaving toolmarks on a surface

torc: rigid neck ring, usually made of precious metal

tracery: ornamental stonework in window or arch openings in late medieval European architecture

transept: wide aisle perpendicular to the nave and aisles in a basilica; usually toward the east end in a Christian church, before the apse, creating a cross-shape plan

translation: transfer of relics, often into a larger or more ornate shrine

treasury: collection of precious offerings and sacred objects

triconch: part of a building with a semicircular apse on three sides of a rectangular space

triforium: intermediate level in a basilica elevation above the ground-level arcade; may contain a narrow passageway, but if the passage is wide this level is called a tribune

triptych: image in three parts, in any medium, in which the side wings often fold over the central panel

triumphal arch: ancient Roman victory arch

tympanum, pl. tympana: semicircular surface above a door, often decorated

type: in Christian thought, an Old Testament prefiguration of an event fulfilled in the New Testament

typikon: foundation document for a Byzantine monastery that establishes its regulations

typology: Christian interpretation of how New Testament events were prefigured in the Old Testament

vault: roof or ceiling based on the principle of an arch, usually made of stone

vernacular: local language, such as English, French, or Yiddish, as opposed to literary or foreign language, such as Latin

verso: the back of a manuscript page or leaf, abbreviated as v; in Latin and Romance-language manuscripts, it is on the left of a two-page opening, but in Hebrew, Arabic, and Persian manuscripts, in which the text is read from right to left, it is on the right

vestments: special garments worn for liturgical or other ritual occasions

vita: Latin for life; idealized biography of a Christian saint

vita icon: image of a saint surrounded by small scenes from his or her life

vizier: minister or high-ranking executive of an Islamicate state

votive: from the Latin for vow, objects offered to God or a saint in fulfillment of a vow or expressing a range of personal relationships with a divinity

voussoirs: wedge-shaped stones that create an arch

Vulgate: late fourth-century Latin translation of the Bible by St. Jerome; the Bible of the Roman-rite Church throughout the Middle Ages and beyond

waqfiyya: deed for a pious or charitable endowment (waqf) in the Islamicate world

workshop: group of artists and apprentices collaborating to produce a particular type of work

zoomorphic: having the form of an animal

INDEX

Iconographic subjects are not included in the index.
Names that begin with *al-* or *el-* are alphabetized under the capital letter that follows.

Aachen, 130, 178
 palace chapel, 130–32, 152, 242, 249
Abbasids, 7, 106, 117, 128, 132, 136, 146, 156, 262, 290
abbeys. *See* monasteries
Aberlemno, picture stone, 143–44
Achaemenids, 27–28, 48
Adamclisi, Tropaeum Traiani, 31–32, 64
Afghanistan, 5, 29, 209, 317
Afrasiab, painted chamber, 100–101
Aksum, 18–19, 93, 95
 funerary monument, 18
Almohads, 21, 228, 252, 264, 332
Alps (mountains), 55, 130, 131, 132, 159, 323, 340
altar decoration and liturgical implements (Christian), 19, 78,
 82–85, 192, 233, 237–38, 294, 323
 Altar of Sant'Ambrogio, Milan, 148–49, 168
 altarpiece of St. Francis, Pescia, 236–38
 ark of Melchizedek, 20
 baldachins, 54–55, 85
 Bratilo Chalice, 205–6
 censers, 82
 chalices, 82, 84, 205–6
 Cross of Herimann and Ida, 4–6, 10, 14, 16–17, 178
 Eleanor Vase, 225, 247
 frontal of St. Eugenia, Saga, 285–86
 Golden Altar, Lisbjerg, 204–5, 207
 Gourdon Treasure, 84
 Karlštejn Castle, 315–16
 Khakhuli Triptych, 203
 Lothar Cross, 178
 panel of St. Olav, Nidaros (Trondheim), 283
 panel with Coronation of Mary, 308–9
 patens, 82, 84
 Radegunde Lectern, 85
 Risen Christ, Wienhausen, 304
 Saint-Denis, 222, 224
 Sant Llorenç retable, Lleida, 322
 Sion Treasure, 82–83, 118
 wood statue of Mary from Mosjö, 205
 See also baptismal fonts; relics and reliquaries; textiles
altars, pagan, 26–27, 30, 34, 88
amulets and tokens, 23, 41, 165
 amulet case (kaptorga) from Bodzia, 163–64
 Crucifixion amulet, 41
 enkolpion, Byzantine gold, 168–69
 Freyr figurine, 23

 mold for St. Symeon pendant, 181
 printed paper amulet, 165–66
 token of St. Symeon the Elder, 74
 See also apotropaia
Anastasis Rotunda. *See* Jerusalem: Holy Sepulcher complex
Andalus, al-, 151, 156, 158, 160–61, 212, 253, 348
Angers, Apocalypse Tapestry, 325–26
Anglo-Saxon, use of term, 87
Anglo-Saxons, 52, 88–89, 118, 119, 144, 191–92
aniconism, 109, 110
Animal Style, 62, 86–88, 140, 175, 207
Antioch, 74, 98, 181
apotropaia, 36, 62, 64, 103, 117, 125, 165–66, 207, 208, 267, 332.
 See also amulets and tokens
Aragón, 156, 225, 281, 297, 329, 331
Arians, 57, 80, 116
Ark of the Covenant, 19, 36, 148–49, 203
Armenian Kingdom of Cilicia, 9, 269
Armenians, 47, 72, 102, 269–70
Árpáds, 162, 239
Arthur (king), tales of, 189, 305
artists, architects, and scribes, 15–17, 20, 28, 42, 62, 66, 72, 108,
 109, 112, 117, 118, 138, 149, 164, 165, 167, 168, 201, 212, 232, 295,
 296, 297, 324, 327, 344
 'Abd al-Aziz (artist), 312
 Anthemios of Tralles (architect), 78
 Apseudes, Theodore (artist), 257
 Bartomeu de Robió i Lleida (artist), 322
 Basilius (artist), 196
 Berlinghieri, Bonaventura (artist), 236–37
 Bezalel. *See* biblical figures
 Bondol, Jean (artist), 325
 Buschetus (architect), 212–13
 Cohen, Gershom (printer), 352
 Cresques, Elisha ben Abraham (mapmaker), 329
 De Brailes, William (artist and workshop head), 236
 Domingues, Afonso (architect), 341
 Eadfrith (monk, abbot, and scribe), 123–25
 El Greco (*see below* Theotokopoulos, Domenikos)
 Emeterius (priest and scribe), 166
 Engelram and Redolfo (artists), 167
 Faraj (artist), 160, 168
 Ferrer Bassa (artist), 331
 Gentile da Fabriano (artist), 308
 Ghazan Ilkhan (ruler and artist), 262
 Giotto di Bondone (artist), 276–77, 293

artists, architects, and scribes, *continued*
 Huguet, Master (architect), 342, 355
 Ibn al-Bawwab (scribe), 165–66
 Isidore of Miletus (architect), 78
 Ja'far (scribe), 317
 Jan van Eyck (artist), 302, 309, 340
 Jehan de Grise (artist), 327–28
 Limbourg brothers (Herman, Jean, Paul; artists), 317
 Lorenzetti, Ambrogio (artist), 284–85
 Magius (scribe and artist), 166
 Mas'ud ibn Ahmad (artist and hajib), 209
 Matthias of Arras (architect), 323–24
 Mirza 'Ali (artist), 349
 Montbaston, Richard and Jeanne de (scribes and artists), 326–27
 Muhammad ibn 'Abd al-Wahid (artist), 209
 Muhammad ibn al-Zayn (artist), 267, 269
 Nicholas of Verdun (artist), 249
 Niketas (physician and scribe), 153
 Odo of Metz (architect), 131
 Parler, Peter (architect), 323–25
 Pisano, Antonio, known as Pisanello (artist), 343–44
 Pisano, Giovanni (artist), 276–77
 Poinçon, Robert (artist), 325
 Pucelle, Jean (artist), 288
 Rublev, Andrei (artist), 344
 Sahl al-Nisaburi, al- (astrolabe maker), 266–67
 Samuel ben Joseph (scribe), 171
 Senior (scribe), 166
 Sinan (architect), 348
 Solomon ben Samuel (scribe), 10, 15–16, 20
 Theodoric, Master (artist), 316
 Theophilus (artist, writer, and monk), 201
 Theotokopoulos, Domenikos, known as El Greco (artist), 344–45
 Tuotilo (monk and artist), 153
 Vasari, Giorgio (writer and artist), 257
 Villard de Honnecourt (artist), 234, 295
 Wasiti, Yahya bin Mahmud al- (artist), 242
 Wigerig (artist), 86
 William of Sens (architect), 229
 William "the Englishman" (architect), 229
 Wolvinus (artist), 149, 168
Asinou, All-Holy Mother of God of the Spurges (church), 216–17, 291–92
Avars, 95, 118–19, 131, 345
Avesta, 23, 47, 68
Ayyubids, 228, 242, 262, 266

Baghdad (Madinat al-Salam), 106, 136, 139, 146, 150, 151, 158, 170, 188, 201, 262, 318
baptismal fonts, 38, 53, 269, 280
 Dura-Europos, 38–40
 Lateran Baptistery, Rome, 53, 133
 Neonian Baptistery, Ravenna, 69
 San Esteban, Renedo de Valdavia, 246
 St. Mary, Rostock, 294–95
Bari, 156, 200
 marble throne, 199–200
Batalha, Santa Maria de Vitória (monastery), 341–42, 355
Bayeux Embroidery, 17, 176–77, 191
bells, 159, 179, 206, 219, 295, 323

bell towers, 166–67, 212–13, 274, 284
Bethlehem, 40, 69, 90, 106
biblical figures
 Abraham, 20, 36, 101, 106
 Bezalel, 149, 203, 322
 David, 36, 95, 129, 135, 136, 203, 251
 Elijah, 200, 312
 Jesus, historical figure of, 7, 38, 40, 56, 90
 John the Baptist (or Precursor), 10, 38, 40, 101, 111
 Jonah, 43, 101
 Mary, mother of Jesus, 40, 57, 93, 106, 308
 Melchizedek, 20, 65
 Moses, 19, 36, 264, 314
 Samson, 215
 Solomon, 19, 131, 165, 200, 203, 279, 312, 348
 See also Church figures; prophets; saints (Christian)
books, manuscripts, and prints, 66, 165, 290, 302, 340, 351–52
 Abba Garima Gospel book, 94–95
 album sheet with Sufis, 350–51
 Art of Hunting with Birds, 243–44
 Beatus from Tábara, 166–67
 Bebaia Elpis convent typikon, 287–88
 Birds Head Haggadah, 297–99
 Blue Qur'an, 149–50
 book of hours with metal badge, 351–52
 Book of Kings (Shahnameh), 47, 64, 146, 262, 349
 Book of Kings (Shahnameh) of Shah Tahmasp, 349–50
 Book of the Great Khan, 327–28
 books of hours, 236, 288–89, 317
 Cantigas de Santa María, 267–68
 Catalan Atlas, 328–29
 Columbus, Christopher, *Insula hyspana*, 352–53
 Compendium of Chronicles (Jami' al-Tawarikh), 262–65
 De Brailes Bible-Missal, 236
 Gospel book from Dabra Hayq Estifanos, 312
 Gradual of Gisela von Kerssenbrock, 286–87
 Guide for the Perplexed, 330–31
 haggadot, 281–82, 297–99
 Hebrew Bible commentaries, 10, 16–17, 20–21, 297, 298
 Hebrew primer, 170–71
 Homilies of Gregory of Nazianzos, 215–16
 Hours of Jeanne d'Evreux, 288–89
 "Jewish Sow" and Crucifixion woodcut, 352–53, 357
 John VI Kantakouzenos, theological writings of, 312–14
 Khludov Psalter, 128–29
 Lectionary of Het'um II, 269–70
 Life of St. Cuthbert, 192
 Lindisfarne Gospels, 17, 122–25, 342
 Manesse Codex, 289
 Maqamat, 242
 Melisende Psalter, 195–97
 paper amulet, 165–66
 Paris Psalter, 135–36
 Plan of St. Gall, 151–53
 portfolio of Villard de Honnecourt, 234–35, 295
 Prague Haggadah, 352
 prayer book of Charles "the Bald," 134
 Psalters, 128–29, 135–36, 170, 195–97, 249
 Pseudo-Dionysios, writings of, 313, 330
 Quintet (Khamseh), 317–18
 Qur'an frontispiece from Sana'a, 112–13
 Qur'an of Ibn al-Bawwab, 165–66, 171

Romance of the Rose, 326–27
Rossano Gospels, 17, 89–90
Saint-Médard de Soissons Gospels, 132–33, 234
Sarajevo Haggadah, 281–82
Scivias of Hildegard of Bingen, 220–21
St. Augustine Gospels, 89, 123
St. Petersburg Bible, 170–72
surgery manuscript of Niketas, 153
Très Riches Heures, 17, 317
tughra of Suleyman, 351
Vatican Vergil, 66–67
world map of Piri Reis, 353–55
Bohemia, 296, 315, 323–24, 352
bubonic plague (Black Death), 6, 78, 262, 297, 302, 345, 352
Bukhara, 111, 146
Samanid mausoleum, 146–48, 271
Bulgarians, 128
buttresses, flying, 229, 255–56, 274, 356

Cairo, 156, 164, 172, 262, 272, 318
Geniza, 164–65, 171
mosque of al-Hakim, 172–73
mosque of Ibn Tulun, 357–58
Qala'un complex, 17, 271–73
Sultan Hasan complex, 319–21
See also Fustat
calendars, 7, 71, 90, 101, 195, 278, 317
caliphs, 101, 106
'Abd al-Malik, 108–11, 112
'Abd al-Mum'in, 10
'Abd al-Rahman III, 138–39, 159
Hakam II, al-, 139, 156–58, 159–60
Hakim bi-Amr Allah, al-, 172–73
Hisham, 114
Ma'mun, al-, 108
Mansur, al- (Abbasid), 136
Mansur, Abu Yusuf Ya'qub, al- (Almohad), 252–53
Mutawakkil, al-, 136–37, 150, 252
'Uthman, 112, 159
Yazid II, 114
cameos and gems, 29
Augustus Cameo, 29–30, 178
Crucifixion amulet (jasper), 41
rock crystal with Crucifixion, 133–34, 169
Shapur I Cameo, 48, 99
Canterbury, 89, 177
cathedral, 229–32, 340
Capetians, 269, 279–80, 288–89, 302
Cappadocia, 145, 167
settlement near Çanlı Kilise, 167–68
Tokalı Kilise complex (Göreme), 144–45
carbon-14, 6–7, 57, 58, 95, 116, 140, 184
Carolingians, 106, 129–34, 178
Castile, 156, 228, 252, 267, 302, 321–22, 341
Celtic, Celts, 33–34, 72, 118, 125, 141, 305
ceramics (including fritware, lusterware, mina'i, porcelain, sgraffito), 151–52, 164, 243, 269, 290
bowl with couple in garden, 243–45
bowl with dancer, 245
bowl with musician, 164
epigraphic bowl, 148
incantation bowl, 103

pharmaceutical jar, 8–9
rooster ewer, 243–44
saltcellar with khamsa, 331–32
tiles, 35, 108, 137, 156, 158, 272–74, 319, 321, 336, 348
See also Chinese ceramics
chahar taq, 99, 146, 242
chancels. *See* screens
Chartres, 256
cathedral, 254–56, 279, 292
China, 8, 57, 79, 99–100, 128, 146, 156, 262, 263, 302, 327–29
Chinese arts, 8, 100, 165, 264, 265, 269, 290, 319
Chinese ceramics, 148, 152, 164, 165, 243, 306, 351
Chinggis Khan, 228, 262, 302, 318, 327
Chungul Kurgan (tomb), 8–9
Church councils, 40, 55–56, 57, 65, 91, 92, 109, 111, 121, 228, 233, 237, 302, 314, 343–44
churches. *See individual churches by location*
Church figures
Aethelwald (monk and bishop), 123
Agnes of Landsberg (convent founder), 303
Aldred (priest and scribe), 122–23, 125
Ambrose (bishop and saint), 148–49
Angilbertus II (bishop), 148–49
Augustine (theologian and saint), 84
Augustine of Canterbury (monk, archbishop, and saint), 89, 229
Beatus of Liébana (monk), 166
Becket, Thomas (archbishop and saint), 229–32, 259
Benedict (monk and saint), 153
Bernard of Clairvaux (abbot and saint), 218–20, 221–22, 224, 313
Bernward (bishop and saint), 178–79, 304
Billfrith (monk), 123
Colum Cille, known as Columba (monk and saint), 206
Cuthbert (abbot and saint), 122–23, 125, 191–92
Durandus (abbot), 217
Eadfrith (monk, abbot, and scribe), 123, 125
Eugene III (pope), 220
Eusebius of Caesarea (bishop and biographer), 52, 55, 68, 95
Eutychianos (bishop), 82, 118
Fulrad (abbot), 129–30
Gisela von Kerssenbrock (abbess), 286–87
Gozbert (abbot), 152
Gregory I (pope and saint), 85, 89
Gregory VII (pope), 188, 217
Gregory of Nazianzos (theologian and saint), 215
Gregory of Nyssa (theologian and saint), 74
Haito (abbot), 152
Herimann (archbishop), 5, 16–17
Hildegard of Bingen (abbess and saint), 220–21, 285, 313
Ida (abbess), 5, 16–17
Ioasaph (monk and former emperor), 314
Jerome (monk and saint), 55, 68, 69, 205
Joan (fictitious pope), 285
John "the Grammarian" (patriarch), 129
Joseph Hagioglykerites (abbot), 215
Katharina von Hoya (abbess), 304
Kunegunde (abbess), 233
Luther, Martin (reformer), 302, 352
Neophytos (monk and saint), 257–59
Odo of Bayeux (bishop), 177
Palamas, Gregory (archbishop and saint), 313
Pelaez, Diego (bishop), 16
Philotheos (abbot), 184

Church figures, *continued*
 Photios (metropolitan), 322–23
 Photios (patriarch), 128–29
 Suger (abbot), 221–25
 Theodora (abbess), 168
 Theodora Synadene (convent founder), 287–88
 Tuotilo (monk and artist), 153
 Urban II (pope), 188, 192
 Wibald (abbot), 202–3
 William of Malines (patriarch), 196
 William of Rubruck (missionary monk), 270
 William of Saint-Calais (bishop), 192
 See also biblical figures; saints (Christian)
ciborium of St. Demetrios, 80, 168–69
Cluny, 189, 217, 218
coats of arms. *See* heraldry
coins, 6, 27, 28, 46, 49, 62, 118, 163, 276, 290, 297, 308, 344
 ʿAbd al-Malik, 109–10, 112
 Alexander "the Great," 27–28, 29
 Byzantine, 84, 86, 96, 110, 111, 162
 Charlemagne, 130
 Constantine, 52, 55
 Islamicate, 109, 110, 167
 Italian, 290
 Justinian II, 111
 Merovingian, 87
 Samanid, 146, 163
 Sasanian, 47, 48, 99
Cologne, 5, 58, 249
Conques, Sainte-Foy (abbey and church), 134, 169–70, 189–91,
 192, 193, 217, 222–23, 224
Constantinople, 52, 60, 118, 145, 153, 181, 185, 193, 198, 201, 212, 251,
 290, 323, 344
 Bebaia Elpis convent, 287–88
 Chora Monastery, 274–76, 314
 Church councils in, 56, 57, 91
 conquests of, 228, 251, 290, 302, 340, 345–46, 347
 Hagia Sophia, 78–80, 82, 98, 128, 135, 153, 161–62, 172, 274,
 290–91, 347–48, 349
 Hodegetria icon, 238, 344, 346
 obelisk base of Theodosius I, 60
 Pantokrator Monastery, 213–16, 228, 251, 277, 348, 349
 porphyry Tetrarchs, 49
 relics in, 55–56, 202, 279, 346
 works likely made in, 128–29, 135–36, 153, 180–81, 203, 294,
 314, 323
 See also Istanbul
convents. *See* monasteries
corbels and corbeling, 122, 208, 278, 281–82
Córdoba, 106, 117, 138, 146, 228, 252
 cathedral, 228, 348–49
 Great Mosque, 117, 138, 156–59, 348–49
Corinth, Asklepeion, 26–27, 34, 75
craft manuals, 201
crusades, 192–95, 197, 199, 202, 204–5, 218, 228, 257, 262
 Byzantine encouragement of, 330, 343
 Frederick II and, 242–43
 Jews and, 220, 352
 Louis IX and, 221, 256, 262, 280
crypts, 85, 130, 183–85, 219, 229, 232, 319
Ctesiphon, 45, 96, 98
 palace with Taq-i Kisra, 98–99
 stucco panel, 99, 137

Dabra Hayq Estifanos, monastery of St. Stephen, 312
Damascus, 95, 106, 109, 318
 Great Mosque, 111–12, 117, 158, 210, 272, 285
Danube River, 31, 43, 239, 345
Dečani, monastery church, 277–78
dendrochronology, 6, 116, 140, 175, 204
diptychs and triptychs, 61, 66, 202, 203, 265, 306–7, 309–10
Divriği, mosque-hospital complex, 253–54
DNA, 6, 140, 192–93
Doha, Museum of Islamic Art, 357–58
doors, significance of. *See* portals, gates, and doors,
 significance of
dukes and earls
 Bolesław I Chrobry, 164
 Harold Godwinson, 176–77
 Jean of Berry, 317, 325, 327
 Louis I of Anjou, 325–26
 Philip "the Good," 309, 340
 Roger II, 197
 Wenceslas, 323
 William IX, 225
 William "the Conqueror," 176–77
Dura-Europos, 34
 baptistery, 38–40, 103
 Mithraeum, 34–35
 synagogue, 35–38, 66, 70, 332
Durham, 125
 cathedral, 191–92, 232, 240
 Life of St. Cuthbert manuscript, 192

emirs
 ʿAbd al-Rahman I, 106, 117
 Abu Ibrahim Ahmad, 150–52
 Ismaʿil ibn Ahmad, 146, 147–48
 Muqtadir, Abu Jaʿfar Ahmad b. Sulayman, al-, 161, 167
 Shahrukh, 302
 Timur, 302, 310–12, 318, 330, 340, 356
 Ulugh Beg, 319
 Ziyadat Allah, Abu Muhammad, 150
emperors
 Alexander "the Great," 7, 27–28, 29, 31, 252, 265, 302, 327
 Andronikos II Palaiologos, 274, 276
 Augustus, 29–31, 265, 330
 Basil I, 128
 Charlemagne, 119, 128, 129–32, 178, 249, 315
 Charles IV, 315–17, 323, 326
 Charles V, 329, 348–49
 Charles "the Bald," 254
 Constantine I, 52–53, 54, 55–56, 215, 290, 347
 Constantine VII, 135
 Constantine IX Monomachos, 161–62, 185
 Constantine X Doukas, 168
 Constantius I, 56
 Frederick I Barbarossa, 202, 220, 249
 Frederick II, 228, 242–44
 Herakleios, 95–97, 99, 346, 347
 Ivan IV "the Terrible," 344
 John II Komnenos, 213–14
 John V Palaiologos, 314
 John VI Kantakouzenos, 312–14
 John VIII Palaiologos, 323, 330, 343–44
 Justin II, 84
 Justinian I, 78–82, 90, 106, 131, 347

Justinian II, 111
Louis "the Pious," 132–33, 153
Mansa Musa, 302, 329, 355
Manuel I Grand Komnenos, 251
Manuel II Palaiologos, 329–30
Michael IV, 162
Michael VII Doukas, 162, 203
Michael VIII Palaiologos, 290–91
Nikephoros II Phokas, 158
Otto I, 156
Otto II, 178
Otto III, 178
Romanos II, 20–21, 153
Romanos III, 162
Septimius Severus, 45–47, 55
Stefan Uroš III (Dečanski), 277–78
Stefan Uroš IV Dušan, 278
Theodosius I, 60–61, 95
Zeno, 72
See also kings; shahanshahs and shahs; sultans
empresses and queens
Bathild, 119–20
Bibi Khanum, 318–19
Blanche of Castile, 256, 280
Eirene, 213
Eleanor of Aquitaine, 225, 232, 247–49
Eudokia (Bertha), 20–21
Eudokia Makrembolitissa, 168
Helena, 56, 84, 193, 202
Irene, 109
Isabella, 332, 340
Jeanne d'Evreux, 288–89
Maria of Alania, 203
Melisende, 195–97
Radegunde, 84–85, 120
Theodora, 79, 82, 92
Zoe, 161–62
enamels, 14
Altar of Sant'Ambrogio, 148
bucket from Oseberg, 140, 142
Byzantine crown (Holy Crown of Hungary), 162
champlevé, 232
cloisonné, 120, 140, 162
Khakhuli Triptych, 203
Limoges, 232–33
Majesty of St. Foy, 169
Mantle of Roger II, 201
mosque lamp, Sultan Hasan complex, 321
Pantokrator Monastery, 228
reliquary from Enger, 120–21
Stavelot Triptych, 202
table fountain, 295
Tara Brooch, 118
Ethiopia, 18–20, 68, 93, 95, 114, 264, 280–81, 312

Fatimids, 128, 152, 156, 164–65, 172, 188, 200, 228
Ferrara, 302, 343
Fez, 272, 274
'Attarin Madrasa, 272–74
fire temples, 47, 99–100, 136, 146, 262
Flanders, 326, 327, 351
Florence, 212, 283, 284, 302, 343
Fontenay (abbey), 218–19

Fontevrault (abbey), 247
tomb effigies of Eleanor of Aquitaine and Henry II, 247–49
Frankish, Franks, 52, 80, 84, 102, 106, 121, 129–30, 132, 263
fresco. *See* wall painting, techniques of
Friedberg mikvah, 246–47
funerary sculpture. *See* sarcophagi and funerary reliefs
Fustat, 164, 170, 330–31. *See also* Cairo

Ganzak. *See* Takht-e Soleyman
garments. *See* textiles
garnets, 62, 84, 85, 86, 87–88, 120–21, 290
gates, significance of. *See* portals, gates, and doors, significance of
gems. *See* cameos and gems
Georgians, 72, 181, 203, 251, 264
glass and rock crystal, 58, 80, 84, 98, 214, 222, 232, 243, 290, 316
Alhambra, 333, 336
Battersea Shield, 33
bowl with gold-glass roundels, 58
brooch from Wittislingen, 85–86
drinking horn from Sutri, 86
Eleanor Vase, 225
enameled glass, 201
eyeglasses, 235, 305
lamps and polykandela, 82–83
Lothar Cross, 178
Majesty of St. Foy, 169–70
millefiori, 88, 137, 140
mosque lamp, Sultan Hasan complex, 319–21
objects from Sutton Hoo ship burial, 88
reliquary from Enger, 120–21
rock crystal with Crucifixion, 133–34
Samarra, 137
silver cup with inlay, 8–9
Tara Brooch, 118
See also mosaics: apse; mosaics: wall and vault; stained glass
Golgotha, 56, 90, 96
Gothic, as term, 257
Gotland, 62, 142–43, 294
Granada, 302, 340
Alhambra (palace), 332–37, 340, 348–49
Gur (Firuzabad), 136

Habsburgs, 349, 353
hadiths, 101, 102, 106, 172, 265, 271, 312, 336
Hadrian's Wall, England, 31, 33, 35, 143–44
hajibs and viziers, 159
'Abd al-Malik, known as Sayf al-Dawla, 160
Ibn al-Khatib, 333
Ibn Zamrak, 333, 336–37
Ja'far 'Abd al-Rahman, 138, 159–60
Mansur, al-, 157, 159
Mas'ud ibn Ahmad, 209
Nizam al-Mulk, 210–11
Rashid al-Din, 262–65
Taj al-Mulk, 211
Hammat Tiberias synagogue, 70–71
Heavenly Jerusalem, 96, 113, 131, 148, 179, 205, 216, 232, 316
heraldry, 239, 269, 280, 317, 322, 324, 325, 332
Hereford mappa mundi, 265–66, 305, 355
Hildesheim, 178, 294
Bernward's column, 178–80
centaur aquamanile, 245

Himyarites, 72, 93
hoards, 34, 95, 99
 Erfurt, 297
 Esquiline Treasure, 58–59
 Lambousa, 13–15
 Sion Treasure, 82
 Wittislingen, 86
Holy Wisdom, churches dedicated to. *See* Constantinople:
 Hagia Sophia; Kyiv, Sviata Sofiia; Novgorod; Trebizond:
 Hagia Sophia
hospitals, 80, 153, 196, 213–14, 253–54, 263, 272, 281, 319–20
Hungarians, 156, 162, 164, 206, 213, 239, 302
Huns, 52, 61, 64
hypostyle, 28–29, 111–12, 137, 150, 210–11, 242, 252–53, 347,
 349

iconoclasm, 106, 109, 111, 113–14, 121, 128–29, 135
icons, panels, and canvases, painted, 109, 120, 129, 145, 183, 201,
 238, 247, 257, 291, 330
 altarpiece of St. Francis, Pescia, 236–38
 bilateral icon, 238, 250
 Crucifixion icon, 121
 Heavenly Ladder icon, 246, 248
 Hodegetria icon, 238, 344, 346
 icon of Christ, 91–92
 Isis and Serapis panels, 41
 Karlštejn Castle, 315–16
 Kremlin iconostasis, 344
 Mary in a church panel, 309
 St. Luke as painter canvas, 345
 St. Luke as painter icon, 344–45
 St. Panteleimon vita icon, 236
 Theotokos icon in Khakhuli Triptych, 203
Ilkhanids, 100, 262–63, 265, 269, 302, 310, 349
Imazighen (Berbers), 252, 272, 274, 290
Indian Ocean, 164, 165, 201, 290, 340
Isfahan, 350
 Great Mosque, 210–11
Istanbul, 55, 340, 347, 352
 Suleymaniye complex, 347–48
ivories and ivory, 153, 181, 289, 290, 330
 Ascension ivory, 59–60
 Cloisters Cross, 219–20
 Leire Casket, 160–61, 201
 Melisende Psalter covers, 195–97
 mirror back with chess players, 289
 reliquary plaque with goldsmiths, 167
 Romanos II and Eudokia ivory, 20–21
 Stilicho Diptych, 61
 Veroli Casket, 180–81

Jelling
 commemorative stone, 173–75
 ship setting, 175–76
Jerusalem, 36, 56, 74, 95, 96–97, 106, 135, 172, 280, 305, 331
 crusades and, 188, 192–97, 228, 242
 direction of prayer toward, 70, 71, 107, 281, 321
 Dome of the Rock (shrine), 106–9, 110, 112, 149, 158, 193, 271,
 272, 348
 Golden Gate, 308, 323
 Holy Sepulcher complex, 56, 80, 193–94
 Kathisma church, 106

 messianic Temple, 94–95, 171, 281, 299
 Temple of Solomon, 19, 36, 40, 54, 72, 78, 102, 106–7, 193,
 294, 322, 348
 See also Heavenly Jerusalem
Jesus. *See* biblical figures

Kaʻba, Mecca, 101, 102, 179, 271, 294
Kairouan, 150
 Great Mosque, 150–52
Karlštejn Castle, 315–17, 324, 326
Kastron Mefaʻa (Umm er-Rasas), St. Stephen (church),
 113–14
Kerak castle, 193–94
Khazars, 146
Khirbe, el-, Samaritan synagogue, 72
Kilpeck, parish church, 208
kings
 Aethelbert, 89, 103
 Afonso V "the African," 342
 Alfonso X "the Wise," 267
 Bolesław I Chrobry, 164
 Charles IV, 288
 Charles Martel, 106
 Charles "the Bald," 134, 221, 222
 Clovis, 120
 Dagobert I, 129, 221–22
 Davit IV "the Builder," 203
 Demetre I, 203
 Duarte, 355
 Edward "the Confessor," 176–77
 Ferdinand, 228, 332, 340
 Fulk V, 196
 Géza I, 162, 203, 239
 Gorm, 173, 175
 Hakon Hakonsson, 254
 Harald "Bluetooth," 173, 175
 Harold Godwinson, 156
 Henry II, 229, 232, 240, 247–48
 Henry VIII, 232
 João I, 340, 341–42, 355
 Lalibela, 18–20, 280, 283, 312
 Louis VII, 221, 225, 232
 Louis IX, 256, 262, 269, 279–80, 283
 Manuel I, 355
 Olav Haraldsson, 283
 Otto IV, 250
 Pedro I "the Cruel," 321–22
 Pedro IV, 329, 331
 Pippin "the Short," 129
 Raedwald, 88
 Roger II, 188, 197–99, 200, 243
 Sancho IV, 167
 Stefan Uroš II Milutin, 294
 Stefan Uroš III (Dečanski), 277–78
 Theoderic, 131, 132
 William I, 198
 William "the Conqueror," 176–77, 178, 192
 See also emperors; shahanshahs and shahs; sultans
Kipchaks, 8, 262
Komnenians, 188, 214–15, 251–52, 259, 274
Kyiv, Sviata Sofiia (church), 172–74, 184
Kyivan Rus', 156, 164, 206, 252

Lalibela, 18, 280
 ark of Melchizedek, 20
 House of Mary (Beta Maryam), 18–19
 House of St. George (Beta Giyorgis), 280–81
lamps and lighting devices, 74, 80, 82–83, 159, 168–69, 214, 281–82
 choros, Dečani, 278
 mosque lamp, Sultan Hasan complex, 319–21
 See also menorahs
lapis lazuli, 5, 17, 100–101, 133, 145, 216–17, 221, 254, 276, 291
La Tène. *See* Celtic, Celts
Lepcis Magna
 basilica, 45–46, 54
 forum, 45–46
 lighthouse, 45–46, 150
 triumphal arch, 45–47, 60
Limoges, 232–33
Lincoln, 239
 cathedral, 11–13, 265
 merchant's house, 239–40, 242
literary and scholarly figures
 Ahmad Yasavi (Sufi teacher), 310–12
 Aquinas, Thomas (Dominican philosopher and saint), 306, 331
 Aristotle (philosopher), 235, 331
 Dioskorides (physician and botanist), 153
 Einhard (biographer), 131, 132
 Ephraim of Regensburg (rabbi), 298
 Ferdowsi, Abu'l Qasim (poet), 146, 349
 Guillaume de Lorris (poet), 326
 Ibn al-Haytham, Abu ʿAli al-Hasan (scholar), 235
 Ibn Battuta (traveler), 165, 262
 Ibn Zamrak (vizier and poet), 333, 336
 Idrisi, al- (geographer), 188
 Jean de Meun (poet), 326
 Maimon ben Joseph, known as Maimonides (physician and philosopher), 264, 313, 330–31
 Meir of Rothenberg (rabbi), 283
 Niketas (physician and scribe), 153
 Nizami (poet), 317
 Piri Reis (sea captain and mapmaker), 353–55
 Polo, Marco (merchant and traveler), 262, 327–29
 Ptolemy, Claudius (astronomer), 136, 329
 Rashi (biblical and legal scholar), 10
 Rashid al-Din (vizier and historian), 262–65
 Snorri Sturluson (scholar-poet), 22–23
Lusignans, 257, 269, 292, 308

Madinat al-Zahra', 138–39, 159–60, 168, 212, 252
 house of Jaʿfar, 159–60
 Salón Rico, 138–39, 160
madrasas, 211, 253, 263, 272, 319, 319–20, 333, 347
 ʿAttarin Madrasa, Fez, 272–74
magical formulae, 41. *See also* amulets and tokens; apotropaia
Mamluks, 262, 270, 271–73, 302, 319–21
manuscripts. *See* books, manuscripts, and prints
maps
 early modern, 353–55
 medieval, 114, 166, 193, 250, 265–66, 305, 328–29, 355
maqsuras, 112, 150–51, 156–58, 161, 210
Marinids, 228, 262, 272–74
mausolea, 129, 146–48, 213–15, 251, 270–71, 272–73, 310–12, 319–20, 323–24, 342, 355

Mecca, 7, 101, 102, 106–7, 109, 117, 148, 209, 264, 271, 290, 312, 329
 Kaʿba, 101, 102, 179, 271, 294
Medina, 7, 101, 109, 209
 house of Muhammad, 102–3, 111, 112, 158
menorahs, 36, 56–57, 58, 70, 71, 72, 170
Merovingians, 52, 84, 87, 119–20, 129, 131
metalwork (including champlevé, chip carving, cloisonné, lost-wax casting, niello, repoussé techniques), 33, 62, 84, 132, 165, 179–80, 201, 225, 232, 269
 Aachen bronzes, 132
 astrolabe, 265–67
 Bahram Gur plate, 64
 Battersea Shield, 33
 belt buckle from Sutton Hoo ship burial, 87–88
 Bernward's column, 179–80
 Bobrinsky Bucket, 208–9
 bracteate from Funen, 64
 brooch from När, 62–63
 brooch from Wittislingen, 85–86
 bucket with enamels from Oseberg ship burial, 140–42
 Celtic, 33–34, 118
 centaur aquamanile, 245
 collar, from Ålleberg, 62–63
 crown, Byzantine (Holy Crown of Hungary), 162
 cup, Byzantine silver, 8–9
 cup, lidded, 8–9
 David Plate, 95, 96, 99, 135
 enkolpion, Byzantine gold, 168–69
 fibulae, 62, 82, 86
 Freyr figurine, 23
 griffin, 211–12
 inlaid basin by Ibn al-Zayn, 267, 269
 medallion of John VIII Palaiologos, 343–44
 Nagyszentmiklós Treasure, 118–19
 plaque of St. Symeon the Elder, 74–75
 Projecta Casket, 59
 purse lid from Sutton Hoo ship burial, 87–88, 175
 ring, Byzantine marriage, 116–17
 ring, Fatimid, 164
 ring, Jewish wedding (Erfurt), 296–97
 seal matrix from Esztergom, 239–40
 shoulder clasps from Sutton Hoo ship burial, 87–88
 Snettisham Great Torc, 33–34
 spoon, copper, 13–14
 spoons from Lambousa Hoard, 13–15, 17
 standard from Söderala, 162–63
 sword from Vendel, 86–87
 table fountain, 295
 Tara Brooch, 118
 Vermand Treasure, 62
 See also altar decoration and liturgical implements (Christian); hoards; relics and reliquaries
Meuse River, 202, 232
mihrabs, 11, 21, 102, 112, 137, 138–39, 150–51, 156–59, 209–10, 253, 272, 317, 318, 319–20, 347
Milan, 49, 52, 148, 249
 cathedral, 340–41
minarets, 111, 137, 138, 150, 253, 271, 272, 319, 347, 349
minbars, 112, 150–51, 158
Moissac, Saint-Pierre (abbey), 217–18
Moldovitsa (monastery), 345–46

monasteries
 Asinou, 216, 291–92
 Bebaia Elpis, Constantinople, 287–88
 Bingen, 220
 Canterbury, 229–32
 Dabra Hayq Estifanos, 7, 312
 Dečani, 277–78
 Chelles, 120
 Chora, Constantinople, 274–75, 314
 Durham, 192
 Enda Abba Garima, 95
 Fontenay, 218–19
 Fontevrault, 247–49
 Gelati, 203
 Göss, 233–34
 Gourdon, 84
 Hagia Sophia, Trebizond, 251
 Hermitage of St. Neophytos, 257–59
 Holy Cross, Poitiers, 84–85
 Holy Sion, 82
 Hosios Loukas, Steiri, 182–85
 Lindisfarne, 122–25
 Miraculous Mountain, 181
 Moldovitsa, 345–46
 Mount Gerezim, 72
 Mount Sinai, 90, 121, 246, 248
 Nerezi, 250–51
 Pantokrator, Constantinople, 213–15, 228, 251
 Peribleptos, Mystras, 308
 Qal'at Sem'an, 72–75, 181
 Red, Sohag, 92–93
 Rulle, 286–87
 Saint-Denis, 129–30, 221–25
 Sainte-Foy, Conques, 134, 169, 189–90
 Saint-Médard, Soissons, 132–33
 Saint-Michel-de-Cuxa, 356
 Saint-Pierre, Moissac, 217–18
 San Millán de la Cogolla, 167
 San Salvador, Leire, 160
 San Salvador, Tábara, 166–67
 Santa Maria de Vitória, Batalha, 341–42, 355
 Skellig Michael, 121–22
 St. Gall, 151–53
 St. George, Prague, 296
 Stoneworker (Hosios David), Thessaloniki, 67–68, 109
 Wienhausen, 303–6
monasticism, 69, 84, 121–22, 151–53, 166–67, 169, 213–21,
 246–47
 Benedictine, 153, 201, 217–19, 220
 Byzantine, 72–74, 92–93, 182–84, 213–14, 251, 257–58,
 287–88, 291, 313–14
 Cistercian, 218–19, 286–87, 303–6
 Cluniac, 189, 217, 218
 Dominican, 228, 235–36, 306, 341–42, 355
 Ethiopian, 93–95, 312
 Franciscan, 228, 236–37, 264, 270, 308
Mongols, 146, 239, 240, 252, 262–63, 269–70, 283, 327–28, 344.
 See also Ilkhanids
mosaics, 53, 79, 158, 290, 323
 apse, 67–69, 75, 80–81, 128, 172–74
 exterior, 323–24
 floor, 70–71, 72, 113–14

wall and vault, 53–54, 57, 65–66, 69–70, 79, 80–82, 108, 112, 114,
 131, 135, 137, 156–59, 161–62, 172–74, 183–85, 197–98, 274–75,
 290–91
Moscow, 252, 322–23
 Kremlin iconostasis, 344
mosques. *See individual mosques by location*
Mount Sinai, 36, 90–92, 109, 121, 236, 246–48, 312–14
Mren (church), 95–98, 247
Muhammad, 7, 15, 101, 102–3, 106, 109, 112, 156, 159, 172, 264–65, 313,
 336
Muhammad, family of, 159, 332, 336
 'Ali, 101, 148, 156, 172, 271, 350
 Fatima, 101, 156, 172, 332
 Husayn, 101, 271, 312
muqarnas, 147, 197–99, 242, 271, 319, 334, 336–37
music and musicians, 64, 153, 164, 220, 251, 267–68, 286–87, 289, 333,
 343
myron, 168, 183, 251, 277
mysticism, 179, 220, 313. *See also* Sufis
Mystras, 302, 307–8, 315
 Peribleptos Monastery, 308

Naqsh-e Rostam, Shapur I relief, 48
narthexes, 78, 80, 135, 144, 168, 182–84, 215, 216, 222, 250, 274–75, 278,
 291–92
Nasrids, 302, 332–37, 340, 348–49
naturalism, 235, 277, 292, 309, 313
Naumburg Cathedral, 292–93, 298
Nemanjids, 277–78
Nerezi, St. Panteleimon (church), 250–51, 277
New York, the Cloisters (museum), 356–57
Nicaea, 56, 57, 109, 228, 262, 290
Nidaros (Trondheim), 283
Nishapur, 148, 266
Normans, 156, 176–77, 188, 191–92, 197–200, 223, 229.
 See also Scandinavians; Vikings
Northleach, memorial brass, 324–25
Novgorod, 172, 205–6, 344
number symbolism, 178, 179

oil painting, 302, 309, 316, 337, 345
opus sectile, 185, 197, 225
Oseberg ship burial, 140–42, 143, 175
Ostrogoths, 52, 61, 78, 80, 106, 131
Ottomans, 302, 323, 330, 340, 343, 345–46, 347–48, 349–50, 351, 353–54
Ottonians, 156, 178
Oxford, 235–36
 Merton College, 274

Padua, Scrovegni Chapel, 276–77, 293, 321
palaces and castles
 Aachen, 130–32, 179
 Cairo, 271–72, 319
 Constantinople, 202, 279, 290
 Ctesiphon, 98–99
 Durham, 192
 Granada, Alhambra, 332–37, 349
 Jerusalem, 193, 348
 Karlštejn, 315–17
 Kerak, 193–95
 Madinat al-Zahra', 138–39
 Persepolis, 28–29

Prague, 296
Qusayr 'Amra, 114–16
Samarra, 136–37
Saragossa, Aljafería, 161
Takht-e Soleyman, 99–100, 262
See also Palermo: Cappella Palatina; Paris: Sainte-Chapelle
Palaiologans, 274, 287, 290, 314–15, 323, 329–30, 343, 344
Palermo, 197, 200, 243
Cappella Palatina, 197–99
Paphos, 245
Paphos (near), Hermitage of St. Neophytos, 257–59
Paris, 130, 131, 193, 221, 224, 228, 280, 288, 289, 295–96, 326, 357
Notre-Dame (cathedral), 355–56
Sainte-Chapelle (palace church), 279–80, 315
See also Saint-Denis
parish churches, 131, 208, 322, 324–25, 352
Persepolis (palace complex), 28–29, 112, 137
Picts, 87, 143–44, 206
pilgrimage, 16, 290
Christian, 16, 72–75, 80, 85, 90, 113, 130, 159, 183, 185, 188–89,
190–91, 192, 200, 218, 221, 230, 232, 237, 249, 255, 283, 285,
303, 305, 352
Jewish, 36, 331
Muslim, 21, 101, 102, 107, 148, 209, 271, 290, 312, 317, 329
souvenirs, 74, 90–91, 120, 168, 181, 230–32, 259, 283, 305, 351–52
spiritual or imaginative, 255, 305, 352
Zoroastrian, 99
See also relics and reliquaries
Pisa
cathedral complex, 212–13
griffin, 212
Poitiers, 84–85, 106
Polans (Poles), 164, 172
porphyry, 49, 53, 69, 148, 215, 228
portals, gates, and doors, significance of, 96, 135, 148, 172, 184,
205, 207, 208, 232, 323
Prague, 316
Altneuschul (synagogue), 281–83
arm reliquary of St. George, 296
Haggadah, 352
St. Vitus Cathedral, 323–25
princes and princesses
Baysunghur, 317–18
Henry "the Navigator," 329, 342
Het'um II, 269–70
Ivan III "the Great," 344
Jaroslav "the Wise," 172–73
Mieszko, 164
Peter Rareş, 345
Sophia Palaiologina, 344
Stefan Nemanja, 277
Vladimir of Kyiv, 156, 172
Vsevolod III, 251–52
Walid ibn Yazid, al-, 114
processions, 28, 78, 80, 91–92, 138, 150, 159, 169–70, 205, 217, 238,
246, 272, 293, 294, 308, 346
prophets, 43, 47, 68, 101, 108, 109, 111, 114, 251, 264, 265, 322.
See also biblical figures; Muhammad
Pyrenees Mountains, 188, 285, 356

Qal'at Sem'an, monastery and pilgrimage complex, 72–75, 121,
181

qibla, 11, 12, 111–12, 117, 137, 150, 156, 158, 172, 266, 312, 318–19, 348,
349. *See also* mihrabs
queens. *See* empresses and queens
Qusayr 'Amra (palace), 114–16

Ravenna, 106, 131, 132
Neonian Baptistery, 57, 69–70, 137
San Vitale (church), 80–82, 131
relics and reliquaries, 9, 55, 56–57, 74, 80, 85, 95, 111, 132, 178, 219,
228, 247, 254, 257–58, 279, 283, 330, 345–46
Altar of Sant'Ambrogio, 148–49
Bathild garment, 119–20
enkolpion, Byzantine gold, 168–69
Enger, 120–21
Holy Land relics box, 90–91, 117
Hosios Loukas, 182–83
John the Precursor, 9–10
Karlštejn Castle, 315–17
Leire Casket, 160–61, 201
Lindisfarne Gospels, 123
Majesty of St. Foy, 169–70, 189
Saint-Denis, 221–22, 293
Sainte-Chapelle, 279–80
San Millán de la Cogolla, 167
Radegunde, sent to, 84–85, 103
Shrine of the Three Kings, 249–50
Stavelot Triptych, 202–3
St. Demetrios, 168–69, 251
St. George, 296
St. Patrick bell shrine, 206
St. Thomas Becket, 230–32
'Uthman codex, 158–59
Wienhausen, 304, 306
Ribat al-Fath (Rabat), mosque, 252–53
Ribat-i Sharaf (caravanserai), 209–10
Romanesque, as term, 189, 257
Rome and Vatican City, 40, 42, 49, 52, 55, 56–57, 58, 60, 74, 75, 132,
188, 228, 230, 284, 302, 344
Ara Pacis, 30–31
church of St. Peter, 53–55, 85, 130, 132, 189, 192
column of Marcus Aurelius, 43–44, 178
Esquiline Treasure, 58–59
Lateran Baptistery, 53, 80, 131, 133
Lateran basilica (church), 53, 95
rulers crowned in, 130, 156, 177, 178
Santa Maria Maggiore (church), 65–66
Tomb of the Julii, 53–54
Villa Torlonia catacomb, 57–58
Rus', 140, 172, 251–52, 262, 283, 323. *See also* Kyivan Rus'

Safavids, 349–51
Sahara Desert and trans-Saharan networks, 21, 149, 164, 201, 252,
274, 290, 329
Saint-Denis, 129–30, 152, 221–25, 229, 232, 270, 330
saints (Christian), 16, 85, 120, 148, 161, 169, 201, 259, 304
Aemilian, 167
Barbara, 205
Benedict, 153
Boris and Gleb, 252
Charlemagne, 132, 249, 315
Constantine, 202
Demetrios, 80, 168, 251

saints (Christian), *continued*
 Denis (Dionysios), 129–30, 221, 329–30
 Dominic, 228, 235
 Foy, 134, 169
 Francis, 228, 236–37
 Helena, 84, 193, 202
 Holy Luke, 182–85
 James the Greater, 16, 188
 Kosmas and Damianos, 168
 Louis IX, 279, 283, 288–89
 Maurice, 315–16
 Nestor and Loupos, 168
 Olav Haraldsson, 283
 Paul, 40, 85, 88, 197
 Peter, 53–55, 65, 85, 96, 197
 Radegunde, 85, 120
 Stefan Nemanja, 277
 Stefan Uroš III (Dečanski), 277–78
 Symeon the Elder, 72–74, 85, 121, 181
 Symeon the Younger, 181
 Vitalis, 80, 85
 Vitus, 323
 Wenceslas, 315–16, 323
 See also biblical figures; Church figures
Samanids, 146–48
Samaritans, 72
Samarkand, 7, 100, 111, 146, 148, 318, 319, 356
 Bibi Khanum mosque, 318–19
 Gur-i Mir (mausoleum), 319
 See also Afrasiab, painted chamber
Samarra, 136, 138, 139, 151, 158
 mosque of al-Mutawakkil, 137, 150, 252
 stucco panel from, 137
San Pedro de la Nave (church), 116–17
Santiago de Compostela, 16, 188–89, 218, 230, 351
 cathedral, 16, 159
Saragossa, 161, 167, 225
 Aljafería (palace), 161
sarcophagi and funerary reliefs
 artist in workshop, 42
 butcher-shop relief, 42
 Jonah sarcophagus, 42–43
 Seasons sarcophagus, 56–57, 58
 shepherd sarcophagus, 42–43
Sardis synagogue, 71–72
Scandinavians, 7, 62, 64, 86, 88, 142, 175, 204, 205, 206, 283.
 See also Normans; Vikings
scholars. *See* literary and scholarly figures
screens, 85, 113–14, 116, 250, 254, 257, 278, 292–93, 344.
 See also maqsuras
Seljuqs, 156, 188, 209–11, 218, 245, 253, 271
 of Rum, 240–42, 253
Serbia, 277–78, 302
shahanshahs and shahs, 47, 64, 99, 108, 114
 Ardashir I, 136
 Bahram Gur, 64, 317
 Khosrow I, 98, 99
 Khosrow II, 95, 98–99
 Shapur I, 47–48, 99
 Tahmasp I, 349–50
 See also emperors; sultans
sheela-na-gigs, 208

shells, 36, 74, 158, 230, 290, 351
Siena, 283
 Hall of the Nine, 284–85
 Palazzo Pubblico, 284
Sijilmasa, 21, 290
Silk Routes, 7, 99, 146, 165, 265
Skellig Michael (monastery), 121–22
Skripou, Koimesis church, 144
slaves, 119, 146, 151, 158, 211, 242, 262, 264, 290
Sogdians, 7, 99–100, 102, 141, 146, 147, 201
Sohag, Red Monastery church, 92–94
Solomonics (dynasty), 312
spolia, 17, 71–72, 108, 117, 129–30, 131–32, 144, 150, 178, 197, 212, 215, 253, 319, 348
stained glass, 201, 214, 219, 222, 223–25, 230–31, 255–56, 274, 275, 280, 304, 355
Steiri, Hosios Loukas (monastery), 182–85, 197
steppes, Eurasian, 8, 29, 47, 52, 99, 118, 146, 312
Sufis, 263, 270, 310–12, 313, 317, 319, 333, 349, 350–51
Sultan Han (caravanserai), 240–41, 253
Sultaniyya, 270, 318
 mausoleum of Uljaytu, 270–71, 319
sultans, 146, 243
 Abu Sa'id Uthman II, 272–74
 Baybars I, 262
 Hasan, an-Nasir, 319–21
 Ismail I, 332
 Keykubad I, 240
 Mehmet II, 340, 347, 348
 Muhammad V, 332, 334, 336–37
 Muhammad VIII, 340
 Nasir, Muhammad al-, 272
 Qala'un, al-Mansur Sayf al-Din, 271–73
 Salah al-Din Yusuf ibn Ayyub (Saladin), 228
 Sanjar, 210
 Selim II, 350
 Suleyman, 347–48, 351
 Uljaytu, 262–63, 265, 270–71
 Yusuf I, 332, 333
 See also emperors; kings; shahanshahs and shahs
Sutton Hoo, ship burial and treasure, 87–88, 119, 140, 175, 342
synagogues, 36, 70, 113, 164, 165, 172, 246, 283
 Dura-Europos, 34–38, 332
 Erfurt, 297
 Hammat Tiberias, 70–71
 Khirbe, el- (Samaritan), 72
 Prague, Altneuschul, 281–83
 Sardis, 71–72
 Toledo, Samuel Halevi, 321–22, 349

Tabernacle (Jewish), 36, 72, 149, 203, 322
Tabriz, 262, 264, 312, 349
 Rab-i Rashidi (Rashidiyya), 263–65
Takht-e Soleyman (fire temple and palace), 99–100, 146, 262
templons. *See* screens
textiles, 201, 233, 269, 281, 290, 296, 308, 322, 332
 Apocalypse Tapestry, 325–26
 Bathild garment, 119–20
 Bayeux Embroidery, 17, 176–77, 191
 Burgo de Osma silk, 201
 epitaphios of Stefan Uroš II Milutin, 294
 Göss Vestments, 233–34

Hestia tapestry, 92
on Ka'ba, 102, 294
Major Sakkos of Photios, 322–23
Mantle of Roger II, 200–201
Oseberg ship burial, 141–42
quadriga silk, 132–33, 178
Sasanian, 79, 99–100, 147
silk with winged horses, 99–100
tapestry fragment from Sampul, 29
tiraz, 200, 212
Tristan and Isolde embroidery, 305–6
Thessaloniki, 168, 251
Hagios Demetrios (church), 80–82, 168
Monastery of the Stoneworker (Hosios David), 67–69, 109
Timurids, 302, 312, 319
Tinmal, Friday mosque, 10–12, 14, 21, 252
Tjängvide, picture stone, 142–43
Toledo, 116, 345
Samuel Halevi Synagogue, 321–22, 349
tombs and tomb markers
Ahmad Yasavi, Yasa, 310–12
Bodzia, 163–64
Charlemagne, Aachen, 178
Chora Monastery, Constantinople, 275–76, 314
Chungul Kurgan, 8–9
Durbi Takusheyi, 290
Eleanor of Aquitaine and Henry II, Fontevrault, 247–49
Gur-i Mir, Samarkand, 319
Ilioni, Katerina, Yangzhou, 8, 329
Jelling stones and ship setting, 173–76
João I and Philippa of Lancaster, Batalha, 342
Julian family, Rome, 53–54
Leo, Skripou church, 144
Naqsh-e Rostam, 48
Northleach, 324–25
Oseberg ship burial, 140–42
Scrovegni, Enrico, Padua, 277
Suleyman, Istanbul, 348
Sutri, 86
Sutton Hoo ship burial, 87–89
Vendel, 86
Vermand, 62
Villa Torlonia Catacomb, 58
Wittislingen, 85–86
See also Jerusalem: Holy Sepulcher complex; mausolea; pilgrimage; saints (Christian)
Trebizond, 228, 251
Hagia Sophia (church), 251, 349
triptychs. See diptychs and triptychs

Turkic peoples, 7, 99, 114, 118, 128, 146, 263, 265, 302, 312. See also Kipchaks; Ottomans; Seljuqs

Umayyads, 7, 106–12, 114–16, 117, 128, 136, 137, 138–39, 145, 147, 156–59, 161, 193, 272, 290, 346
Urnes stave church, 206–8
Calvary sculptures, 254

Valois (dynasty), 325
Vatican City. See Rome and Vatican City
Venice and Venetians, 228, 262, 290, 316, 327, 344–45, 348, 352
porphyry Tetrarchs, 49, 228
San Marco (church), 49, 228
Vikings, 125, 132, 139–42, 146, 162–63, 164, 173–75, 191, 206, 229, 283. See also Normans; Scandinavians
Visigoths, 52, 60, 61, 78, 114, 116, 117, 158, 166, 167
viziers. See hajibs and viziers
Vladimir, 252, 323
St. Dmitrii (church), 251–52

wall painting, techniques of, 36, 114, 172, 334. See also lapis lazuli
Wienhausen Convent, 303–6, 313, 337
wood (including sculpture, furnishings, and architecture)
animal-head post from Oseberg ship burial, 140–41
ark of Melchizedek, 19–20
Calvary sculptures at Urnes, 254
carved cart from Oseberg ship burial, 140–41
ceilings in the Alhambra, 332–34
Christ in painted sarcophagus from Wienhausen, 304–5
Crucifixus dolorosus, 306–7
maqsura and minbar at Kairouan, 150–51
muqarnas ceiling, Palermo, 197–99
Oseberg ship, 140
Queen Mary Harp, 343
Radegunde Lectern, 85
Risen Christ from Wienhausen, 304–5
screen in Qala'un Mausoleum, 272–73
Shrine Madonna, 306–7
statue of Mary from Mosjö, 205
Urnes stave church, 206–8

Yangzhou, tombstone of Katerina Ilioni, 8, 329
Yasa, shrine of Ahmad Yasavi, 310–12, 313, 319, 337
Yuan (dynasty), 262, 327

Zagwe (dynasty), 280, 312
Zoroastrians and Zoroastrianism, 23, 37, 41, 47, 68, 74, 99–100, 101, 103, 108–9, 136, 146